The
Romantics
to Rodin

The
Romantics
to Rodin

French Nineteenth-Century
Sculpture from
North American Collections

Organized and edited by
Peter Fusco and H. W. Janson

Los Angeles County Museum
of Art
in association with
George Braziller, Inc.

This exhibition and its catalog
are funded in part by
a grant from the National
Endowment for the Arts.

Copublished by the
Los Angeles County Museum of Art
5905 Wilshire Boulevard
Los Angeles, California 90036
and George Braziller, Inc.
One Park Avenue
New York, New York 10016

Distributed by George Braziller, Inc.

Edited by Jeanne D'Andrea, Alison Hirsch,
and Stephen West
Designed in Los Angeles by
Rosalie Carlson

Text set in Garamond typefaces by
R S Typographics, Los Angeles

Printed in an edition of 1,500 hardcover
and 56,700 softcover on Patina Matte
paper by Alpine Press, South Braintree,
Massachusetts

**Library of Congress
Cataloging in Publication Data**

Main entry under title:

The Romantics to Rodin.

 Bibliography: p.
 1. Sculpture, French—Exhibitions.
2. Sculpture, Modern—19th century—
France—Exhibitions. 3. Sculpture,
French—United States—Exhibitions.
4. Sculpture, French—Canada—
Exhibitions. I. Fusco, Peter, 1945–
II. Janson, Horst Woldemar, 1913–
III. Los Angeles Co., Calif. Museum
of Art, Los Angeles.
NB547.R65 730'.944 79-27101
ISBN 0-8076-0953-4 [Braziller]
ISBN 0-8076-0953-6 pbk. [Braziller]
ISBN 0-87587-091-0 pbk. [Museum of Art]

Participating Museums:

Los Angeles County Museum of Art
March 4–May 25, 1980

The Minneapolis Institute of Arts
June 25–September 21, 1980

The Detroit Institute of Arts
October 27, 1980–January 4, 1981

Indianapolis Museum of Art
February 22–April 29, 1981

Front cover:
Feuchère, *Satan* (detail),
Los Angeles County Museum of Art

Back cover:
Rodin, *The Thinker* (detail),
B. Gerald Cantor Collections

Contents

Contributors to the Catalog

G. A. Gerald Ackerman, Chairman, Art Department, Pomona College

J. A. Judith Applegate, Assistant Curator, Department of European Decorative Arts and Sculpture, Museum of Fine Arts, Boston

G. B. Glenn Benge, Associate Professor, Art History Department, Tyler School of Art, Temple University

M. B. Marie Busco, Research Assistant, Los Angeles County Museum of Art

R. B. Ruth Butler, Chairman, Art Department, University of Massachusetts, Harbor Campus

A. D. Alan Darr, Assistant Curator of European Art, The Detroit Institute of Arts

P. F. Peter Fusco, Curator of European Sculpture, Los Angeles County Museum of Art

J. E. H. June E. Hargrove, Associate Professor, Art Department, Cleveland State University

J. H. James Holderbaum, Professor, Department of Art, Smith College

J. M. H. John M. Hunisak, Associate Professor, Art Department, Middlebury College

H. W. J. Horst W. Janson, Professor Emeritus of Fine Arts, New York University

F. L. Fred Licht, Professor, Art History Department, Princeton University

C. W. M. Charles W. Millard, Chief Curator, The Hirshhorn Museum and Sculpture Garden, Smithsonian Institution

G. S. Gail Stavitsky, Intern, Los Angeles County Museum of Art

A. W. Anne Wagner, Research Assistant, Department of European Paintings, The Metropolitan Museum of Art

Key to Catalog Use

The catalog section of this book is alphabetized by sculptors' last names.

For frequently cited literature in the notes to both essays and catalog, references are abbreviated. Books, articles, and permanent collection catalogs are referred to by: (1) author's last name, (2) date of publication, and (3) volume and page numbers or catalog numbers. Temporary exhibition catalogs are referred to by: (1) city in which exhibition was held, (2) date of publication, and (3) page numbers or catalog numbers. Complete titles of abbreviated references in the notes to the essays are in the General Bibliography. For complete titles of abbreviated references in the notes to sculptors' biographies and entries, first consult the Selected Bibliography on the sculptor concerned; if a title does not appear there, or appears only in abbreviated form, consult the General Bibliography. The General Bibliography is alphabetized by authors' last names and cities of exhibition catalogs.

For each object in the exhibition the following information is provided when available or pertinent: title, medium, measurements, signature, inscriptions, foundry marks, provenance, lender (with credit line for institutional lenders). For the location of dates, signatures, inscriptions, and marks on bronzes, the indication "on the base" should be understood as meaning "on the self-cast base" unless otherwise noted. All measurements exclude socles, frames, and separate bases unless otherwise noted (h. = height; l. = length; d. = depth; w. = width; diam. = diameter). For flat objects including paintings, drawings, prints, reliefs, and medallions, the locations of dates, signatures, inscriptions, and marks are given from the spectator's point of view. For three-dimensional objects, locations are given as they appear on the object proper; thus, in the case of a figure in the round, "on the right" indicates on the figure's right side.

Preface

The Romantics to Rodin aims to reveal the aesthetic and historical importance of French nineteenth-century sculpture. It would seem to be a prime moment for such an undertaking. In the last decade new interest in nineteenth-century sculpture has been reflected in pioneering exhibitions, in an increasing number of publications in the field, and in rising values on the art market. Yet nineteenth-century sculpture remains in large part a *terra incognita* for the general public, and it is still one of the areas most neglected by art historians. To redress this situation it seems reasonable to focus first upon France, since after Canova and Neoclassicism the center of gravity of western European sculpture shifted from Rome to Paris. Not only did French sculpture exert considerable influence upon work produced elsewhere—especially upon American sculpture at the end of the century (see cat. no. 66)—but France in the nineteenth century probably produced more sculpture than any other country at that time or at any previous time in history. This was partially due to technological innovations which facilitated production, to new attitudes toward reproduction, and to new patronage in the form of an ever growing, wealthy bourgeoisie. Along with the large quantity of surviving French sculpture of the period, there is an equally extraordinary amount of contemporary criticism and documentation, provided in part by an extremely active and diverse Parisian press. Both in terms of works exhibited and their documentation, *The Romantics to Rodin* represents only an initial sampling.

The exhibition deals with the period from about 1830 to 1900. As our title implies, we begin with artists active during the heyday of Romanticism, the 1830s. We have, however, excluded important artists such as Bosio (1768–1846), who continued to work until the mid 1840s but was fully formed and made his major contributions as a Neoclassical sculptor. On the other hand, we have included works dated as early as 1817 and 1819 by David d'Angers and Barye, since they were major innovators in French sculpture of the 1830s. The exhibition ends with Rodin and the sculptors of his generation. Gérôme's *Corinth,* dated 1904, is the latest work. We have excluded works of earlier date by sculptors such as Bourdelle since, unlike Gérôme, he was formed under Rodin's influence. It was felt that Gauguin, the Symbolists, and other forward-looking artists and movements which chronologically overlapped with Rodin at the end of the century might better be dealt with in a separate exhibition. In sum, we have stressed the pre-1900 Rodin, his colleagues, academic contemporaries, and their predecessors.

Within these parameters, there are certain areas that are less well represented than one might have liked. A number of the secondary early Romantic sculptors, such as Chaponnière, Moine, and Félicie de Fauveau, are unrepresented in North American collections, and thus they do not appear in the exhibition. The arch-Romantic Préault is represented only by his four known works in this country. These are artists whose extant works are very restricted in number. Many of them produced mainly small terracottas which met with little approval at the time; occasionally they were cast in bronze but usually only later, in the 1850s (when they became more acceptable), and then only in limited editions or unique examples which have remained in France. In addition to some of the Romantics, we have neglected the severer exponents of academic classicism—artists such as Guillaume and Simart who are unrepresented in collections on this side of the Atlantic. Although their works were often conceived as large, unique marbles rather than as models for more portable and collectible bronze editions, their absence must also reflect the taste of American collectors, for museums here contain many less stern, more decorative large marble statues by Italian contemporaries. Restricting ourselves to works in North American collections was intended not only to keep costs and organizational problems at a sane level, but also to engender a better knowledge and appreciation of works close at hand Our riches in sculpture by Barye and Rodin are well known, but many others are not. By including works of fifty-eight other sculptors we hope to resurrect a few important, neglected talents and also to provide a context for evaluating the achievements of the more famous and familiar.

Whenever possible, objects were selected to encourage a variety of approaches and responses to nineteenth-century French sculpture. For example, one series of works (Feuchère's *Satan,* Carpeaux's *Ugolino,* Dalou's *Lavoisier,* and Rodin's *Thinker*) illustrate different uses of a similar formal motif—a seated figure with his chin resting upon one hand—and the continuity of an emotion-laden pose. Certain works, including some by Carrier-Belleuse and Rodin, were selected to stress teacher-pupil relationships. Another group presents three different portraits of one extraordinary personality, Sarah Bernhardt (cat. nos. 1, 28, 155). Other works, such as the drawing and two bronzes of Carpeaux's *Ugolino,* are intended to give an idea of the process of sculptural creation. The exhibition also includes seven different representations of Joan of Arc, thus dealing in some depth with one important iconographic theme. Moreover, works have been selected to indicate the enormous gamut of media and technical means of production available. Included are bronzes, marbles, terracottas, plasters, porcelains, silver statuettes, a number of useful objects, multimedia sculpture, and a photo-sculpture. In addition, the exhibition includes a limited number of paintings and graphic works which depict sculptors and their works or provide a visual commentary on them. Bronzes predominate not only because works in this medium are the most accessible for loan. A major development of the period under review was the proliferation of sculpture created expressly for large commercial editions in bronze. Also, emphasis shifted from the primacy of carved sculpture in Neoclassical aesthetics to an exploration of the potentialities of modeled sculpture as an end in itself, capable of being preserved in permanent form by means of bronze casts.

It would seem that sculpture, even more than painting, was susceptible to the great changes of the nineteenth century. Sculpture had traditionally been more dependent for its commissions upon Church and State which now were separated after a linkage of centuries. At the same time, technological advances had a much more direct impact upon the way that sculpture, as opposed to painting, is made. It seems curious, therefore, that general histories of French art have usually considered nineteenth-century sculpture only in passing and insofar as it relates to the history of painting or to a succession of stylistic "isms" which, after Neoclassicism, were all defined in terms of painting. *The Romantics to Rodin,* in contrast, attempts to provide a better understanding of sculpture on its

own terms by stressing continuities and changes in sculptural traditions. Nevertheless, the thrust of the exhibition is an expansive one; we have tried to point up the variety of styles, themes, techniques, and socio-political functions of sculpture in nineteenth-century France. This seemed a necessary prelude to the writing of a much needed synthetic art history of the period.

The Romantics to Rodin has been funded in part by a grant from the National Endowment for the Arts. Lenders to the exhibition, contributors to the catalog, participating museums, and the trustees, staff, and volunteers of the Los Angeles County Museum of Art have worked together to make the exhibition possible. For their collaboration and support, the organizers are extremely grateful. Special thanks are due to Karen Goodall for her secretarial help during the past three years, and to Betty Foster for her help in proofreading the catalog. We would also like to thank the following people who have supplied help and information: Leon A. Arkus, Jean Sutherland Boggs, Dorothy Brokow, David S. Brooke, Robert T. Buck, Jr., Thérèse Burollet, Jean K. Cadogan, Jacques de Caso, Charles Chetham, William J. Chiego, Muriel B. Christison, Andrew Ciechanowiecki, Ralph T. Coe, Michael Conforti, Frederick C. Cummings, James David Draper, Albert Elsen, Ann Gabhart, Jean-Réné Gaborit, Henry G. Gardiner, Henry Hawley, Olga Hammer, Anthony F. Janson, Donald Jenkins, Harold Joachim, William R. Johnston, Robert Kashey, Lois Katz, John Keefe, Sherman E. Lee, C. Douglas Lewis, Jr., Lee Malone, Roger Mandle, Edward Maser, Michael Milkovich, Robert C. Moeller, Dewey F. Mosby, Steven A. Nash, Andrea S. Norris, Edward J. Nygren, Merribell Parsons, Anne Pingeot, Olga Raggio, Brenda Richardson, Joseph J. Rishel, Samuel Sachs II, Alan Shestack, Richard E. Spear, Robert A. Sobieszek, Frank Trapp, Evan H. Turner, Clare Vincent, and Eric Zafran. The organizers would like to express their gratitude to Michael Hall for discussions, more than three years ago, that led to the idea of this exhibition.

Peter Fusco

Learning to Sculpt in the Nineteenth Century: An Introduction*

Anne M. Wagner

Early in 1848, David d'Angers set down in one of his notebooks a description of sculpture students at the Ecole des Beaux-Arts. The tone of the passage suggests that his words were inspired by a particular experience: perhaps he stood one Monday night outside the Ecole in the Rue des Petits Augustins watching the students. He also wrote from general knowledge accumulated in more than twenty years as a professor there and four decades as one of France's leading sculptors.

Monday nights, if you find yourself near the Ecole des Beaux-Arts, you see the young sculpture students, bent over, gasping under the weight of a board filled with clay which they'll use to model a figure from life. These children of the people come down from their ill-protected mansards. Sometimes they hardly have enough to live on. Yet they are joyful in a future which seems to come to them on golden clouds. And then the clay comes to life under their feverish fingers. They don't yet understand the poem which is posing before them. In the same way a child forms the letters which he will use to convey ideas that will move men, revealing to them the mysterious guises of humanity and the marvels of the world which our senses perceive.

Wretched sculptors! You are men of harsh labor. Sublime workers! The gilded crowd does not appreciate you, but the future is yours. It is your works which will perpetuate, for the most far-

off ages, the images of great men and the most remarkable deeds of nations.[1]

This text is initially striking in its description of harsh physical realities—gasping workers, leaden loads, attic lodgings—combined with a lofty evocation of sculptors' dreams. David made clear both his knowledge of the students' daily lives and his elevated view of the sculptor's profession, a view his contemporaries shared. The relative permanence of sculpture and its public role in the nineteenth century dictated its destiny: it was to express the highest thoughts of humanity and to confirm society's noblest values and achievements—even if critics often denied that it fulfilled its mission.

David's observations contain that complicated mixture of partial truths and shaded fictions used in the nineteenth century both to obscure and to explain changes in the social purpose and market of sculpture, as its industrialization and increasing association with architecture transformed its practice and eroded its status as "art." These changes, which took place primarily from 1820 to 1870, colored the training of sculptors, and modifications in instruction in turn reflected developing awareness of the actual attributes necessary for a sculptor to have.

When David called future sculptors *"enfants du peuple," "ouvriers,"* he was speaking literally. In the nineteenth century, most sculptors followed the traditional artisan's path in taking up a métier that made use of the tools and materials their fathers handled in their trades.[2] Not all sculptors' fathers were sculptors, although this was the case with Clésinger, Duret, Elschoëcht, and others including David himself. Many had fathers in the trades: masons, plasterers, wood carvers, chasers, jewellers, stonecutters, blacksmiths. Most often a beginning sculptor had either an informal apprenticeship to his father or a formal agreement with another artisan.

After 1830 these traditional means of instruction changed increasingly. Rudimentary drawing skill, considered as basic for the artisan as for the artist, began to be disseminated both by new, widespread *écoles de dessin* and by traditional *académies des beaux-arts* reoriented to this new purpose. In many new provincial drawing schools, teaching equipment was largely limited to printed drawing courses, published in Paris on a scale that had reached some one hundred fifty per decade by mid-century.[3] The courses were composed of loose, lithographed sheets, inserted unbound between flimsy paper covers and placed on an easel for one or several students to copy (hence the term *modèles*

9

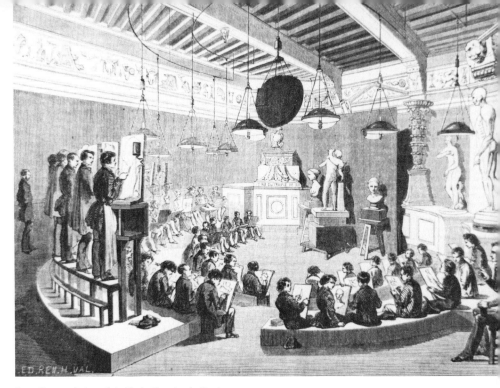

fig. 1. Engraved view of the Ecole Gratuite de Dessin, *Salle d'étude*, drawing and modeling after casts (reproduced in *L'Illustration*, April 26, 1848).

estampes). Their lessons were progressively complex, based on the traditional method of drawing instruction. The student began by copying the simplest outline of an eye or a profile—a *dessin au trait*—and then graduated to a shaded version of that same drawing. As he increased his mastery of the drawing implement (usually a crayon) and his repertoire of strokes, he proceeded to drawing whole bodies from lithographs made after casts of antique statues and later from prints of nudes in the traditional repertoire of studio poses. These cheaply produced printed drawing courses reduced the burden on teachers as class enrollment mounted sharply in the 1840s and 1850s. Used on this rudimentary level, their aim was imitative rather than interpretative drawing.

Modèles estampes were purchased in Paris, as were most of the casts of antique statues usually included in the equipment of a town drawing school. Although drawing courses were published by many houses, those by H.G. Chatillon and B. Julien were among the most popular. Their titles reflected the introductory nature of the contents: *"Principes de Dessin," "Eléments de Dessin," "Premiers Principes."* They were sometimes dedicated to the students at the school where their author had developed the course, or to the government official who had supported their publication. Casts

too were purchased in Paris, many from the *atelier de moulage* at the Ecole des Beaux-Arts, which had a stock of more than nine hundred casts by 1855.

The Ecole Gratuite de Dessin in Paris also provided provincials with advice on establishing a school or revising a curriculum. This school was founded in 1766 by the painter J. J. Bachelier for the purpose of instructing young workers in mathematics and drawing, and it maintained this purpose late into the nineteenth century.[4] The Petite Ecole, as it was called, was directed from 1831 until 1866 by Hilaire Belloc. His guidance decisively shaped the school during this perhaps most interesting phase of its history. His liberal beliefs, shared with friends like César Daly, David d'Angers, Michelet, and Harriet Beecher Stowe,[5] led him to initiate an active program of reform as soon as he took office. Discarding the worn collection of ornamental *modèles estampes,* the legacy of the eighteenth-century school, he undertook the development of new *cours de dessin,* with a wider selection of ornamental motifs. He began to assemble a young, committed teaching staff, including E. Viollet-le-Duc, Horace Lecoq de Boisbaudran, Constant Dufeux, and later Ruprich Robert. These men actively approached the

problems of teaching ornament and drawing; they experimented and developed courses over the years. Belloc's influence was an important stimulus; as director he required reports and analyses from his staff, asking them to criticize the efficacy of the school's approaches. His administration contrasted sharply with that of the more traditional Ecole des Beaux-Arts, where, despite scattered, unfocused attempts at reform, the curriculum proceeded with a kind of time-honored autonomy.

Wood engravings of classes in session published in April 1848 show diligent students learning to sculpt at the Petite Ecole (figs. 1, 2). Courses were offered in anatomy and in modeling and drawing, both from nature and from casts. Courses in the history of ornament gave students a visual and factual repertoire on which to base their own efforts. To test these skills, contests were held presenting specific problems, such as the decoration of a coffer or a fountain. The lessons aimed at equipping students to supply ornamental motifs to luxury industries and the building trade, both of which were expanding rapidly. Statistics of the school's enrollment in both day and night classes show that its growth echoed that larger expansion: the total number of students climbed from 866 in 1843, when the school's record-keeping began, to a high of 1,369 in 1862.[6] Over

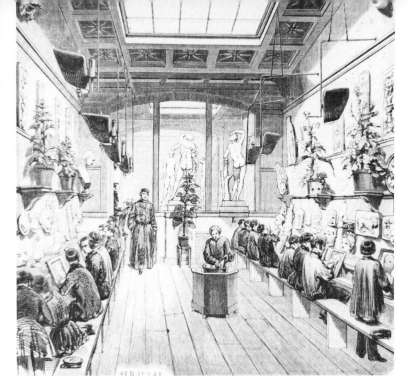

fig. 2. Engraved view of the Ecole Gratuite de Dessin, *Salle d'étude,* modeling from figures, ornaments, and living plants (reproduced in *L'Illustration,* April 26, 1848).

the same period, enrollment of would-be sculptors nearly tripled. Other drawing schools in both France and Belgium show similar growth and emphasis on training ornamental workers.[7] All of these developments, to be sure, coincided with growth in the instruction of workers in general.

In nineteenth-century France, ornamental sculpture and "artistic" sculpture were more closely linked than most decorative painting was to easel painting. The range of ornamental sculpture inflects the character of contemporary architectural monuments such as the enormous beribboned garlands of the Chapelle Expiatoire (Pierre Fontaine, architect, 1816–26), the heavily encrusted surface of the Opéra (Charles Garnier, 1861–73), and the sculpted tiers of the Hôtel de Ville (T. Ballu and E. Deperthes, 1874–85). The completion of the Nouveau Louvre, begun under the Second Republic, employed not only sculptors like Duret, Simart, Guillaume, and Carpeaux, whose official training and connections are well known, but also literally hundreds of other primarily ornamental sculptors. Many of them were trained at the Petite Ecole; thus the school played a vital part in remaking the physical appearance of Paris in the nineteenth century—in fact, in creating a period style.[8]

The Petite Ecole not only trained ornamental sculptors but also schooled a yearly quota of students who went on to the Ecole des Beaux-Arts. The names of major sculptors who began at the Petite Ecole are frequently cited—Carpeaux, Chapu, Rodin, Dalou—but it is difficult to make a close comparison between enrollments at the two schools because of lacunae in the archives of both. Undoubtedly, many students who left the Petite Ecole for its elder relative did so to learn the language of "art," though the use of that language in the industry of ornament was still open to them. For example, Jules Salmson wrote that he and the young Carrier-Belleuse enrolled at the Ecole des Beaux-Arts "not to pursue the profound study of sculpture but only for some general knowledge," and for the "tour de main" Carrier wanted for his intended profession as a *ciseleur* and Salmson felt he needed as a would-be engraver.[9] Others must have had similarly modest goals, limited to adding a certain polish to skills they already had.

Students needed to be armed with previous training just to be accepted at the Ecole des Beaux-Arts. The school required students to present certificates testifying that

they had studied with a "known" master.[10] Belloc was in a position to confirm a student's status, as he did for those who applied to copy at the Louvre. Students with certificates from provincial masters had to have additional testimony of good conduct. All students had to be under thirty. Initially, the student obtained only *inscription,* or the right to follow all courses at the school. Actual *admission,* or active participation, brought the right to participate in competitions. This distinction between *admission* and *inscription* shows that the Ecole and competition were synonymous; as one critic wrote, "qui dit école dit émulation."[11] For sculptors and architects, moreover, *admission* required further proof of earlier training, substantiated not just by a professor's word, but by active demonstration of drawing skills. This consisted of drawing from a cast in three two-hour sessions. The requirement is significant, because it assumed, indeed insisted, that the entering sculptor had attended a drawing school, either in Paris or in the provinces. We can thus assume that most entering sculpture students at the Ecole had been exposed to some aspects of drawing instruction. Only on demonstrating his drawing skill could an aspirant compete for admission in one of the two annual *concours des places.* This test consisted of six three-hour sessions of drawing or modeling a

figure from nature. The aspirant competed with students who had already been admitted but who had not yet received a medal in any of the school's competitions. All were ranked together, and as many students were admitted as there were places in the Salle des Etudes. Rank in the contest thus determined seating in other competitions, and student enrollment was maintained at a constant level.

The rules that governed the *Section de Peinture et Sculpture* at the Ecole des Beaux-Arts were complex, although not as complicated as the almost byzantine system of classes and points that controlled a student's progress through the *Section d'Architecture*.[12] The lengthy regulations on admission, student production, and competitions show as much about the Ecole's goals in teaching as any work executed there. They controlled production in much the same way as a church might control the shape, size, or iconography of a commissioned altarpiece. The school year was spent sculpting. A complicated yearly calendar measured progress through twelve *concours d'émulation,* the *concours de la tête d'expression,* the four *concours de composition,* and—most important in the life of the school—the three steps of the *concours pour le prix de Rome.*

Time not devoted to *concours* was given to *études libres,* free study of a specific problem set by the professor in charge that month. He chose the model's pose or the cast for the *études nature* or *antique,* which until late in the century were given to both painters and sculptors. Each problem was set for a total of two weeks; the odd and even sections into which the school was divided gave a week to each. Students took their seats in these studies according to their achievements in the school's competitions; previous success guaranteed a more privileged view of the model.

Yet previous successes were not necessary to compete for the Prix de Rome. Competitors were not even required to be enrolled in the school, as it was open to any French citizen under thirty. A lengthy screening process weeded out the contestants. In sculpture, the final number varied from forty-five to seventy-five per year. Their first contest, the *premier essai* on the second Thursday in May, was to execute within the day a sketch of a mythological or historical subject chosen by the professors that morning. Sixteen students were selected from the first group and their names posted in the order in which the judges had ranked their works. Within fifteen days, they returned for the *deuxième essai,* taking places according to their rank,

to mount a figure from the living model posed by the *Section de Sculpture.* The model's name was announced a week before the contest, so there was the chance to see his body, if not the actual pose, before the contest. In the second judgment, both the *premier* and *deuxième essais* were taken into account; the first measured skill at composition, while the second tested knowledge of the human figure. On the basis of both works, the field was reduced to eight contestants. Once again, they were asked to produce a sketch in a day's time. Its subject could be mythological, historical, or religious, while the final form alternated yearly between bas-relief and *ronde bosse.* After the students emerged from their day *en loge,* the sketches were stamped and sealed away by the school secretary. Two months later, when the completed sculptures went on view, the secretary brought out the original sketches. As the works were judged, the finished relief or figure was checked carefully against its sketch. In principle, changes were not allowed, although adjustments were often tolerated. A student was expected to be true to his original conception, even though critics protested that such conditions were unrealistic.

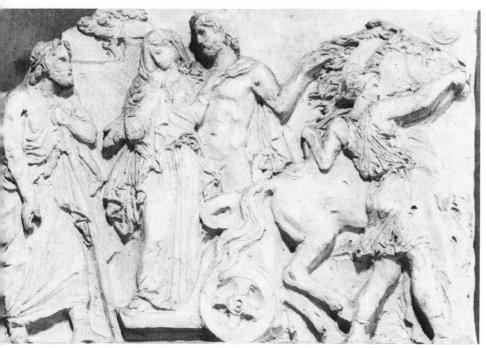

fig. 3. Henri Chapu, *Departure of Ulysses*, terracotta sketch for the *concours de composition* of 1856, Musée Chapu, Le Mée.

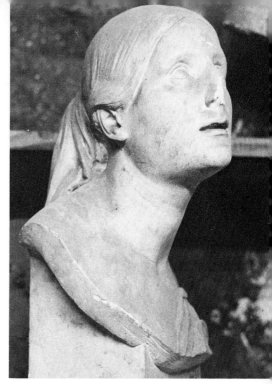

fig. 4. Pierre Cavelier, *Celestial Contemplation*, plaster *tête d'expression*, 1841, Ecole des Beaux-Arts, Paris.

In competitions like the *concours de tête d'expression* or *de composition,* as well as in the various steps of the Prix de Rome, the subject to be treated, the *program,* was read to the students only minutes after it had been chosen. The professors at the Ecole selected the theme for the *concours d'émulation,* while the Grand Prix subjects were determined by the sculpture section of the Academy. The latter were chosen by lot from a list the academicians had submitted. The themes were consistently taken from ancient history and mythology, rarely from religion. In more than forty-five years, from 1820 to 1864, a religious subject was assigned only five times in the *premier essai* for the Grand Prix, and five times in the definitive *concours,* as opposed to eighteen and nineteen times respectively in the equivalent painting competitions.[13] Only rarely did a contemporary reference slip into the lesser contests. For example, in the *concours de composition* held June 11, 1852, the subject was *Sculpture Mourns One of Her Glories,* a theme suggested by Léon Cogniet "in allusion to the death of M. Pradier buried June 9, 1852."[14]

The language of the programs gives a good indication of what was expected from students. General subjects were given only in lesser competitions, for example the *concours de composition* of March 1, 1835, when

the subject was simply *Two Wrestlers.* It was more usual for professors to supply a very explicit text. For example, in the *concours de composition* on August 9, 1834, a specific *moment désigné* was given for the subject, *The Sacrifice of Abraham* — the moment at which the patriarch sacrificed the ram. Sometimes clarifying information would be supplied: for the *Death of Hercules,* students were advised that they could include the hero's traditional attributes, his weapons and lion skin (*concours de composition,* June 26, 1856). At other times, the Academy warned them against obvious mistakes. For *Theseus and the Minotaur,* students were enjoined: "The minotaur, as one knows, had a man's body with the head and neck of a bull," lest some ignoramus miss the point completely.

This careful wording indicates a desire that the student clearly understand and precisely represent a subject; it also assumes that such understanding might not already exist. Often the description supplied was lengthy; whole chunks of Pausanias or Sophocles were read out, or the synopsis of a story preceded the actual moment to be shown. Clearly a student was not meant to have all antiquity at his fingertips, but rather to recognize the nature of the prob-

lem and arrive at the appropriate solution. The program made clear the essential components of an adequate response. In presenting his program for the *Departure of Ulysses* on February 10, 1854, Duret quoted from Pausanias: "Ulysses, having mounted his chariot with his wife, and then having left to her the choice of going back with her father or of following her spouse, Penelope blushed and did not answer except to cover her face with her veil."[15] This program cited only a few elements: three people, one chariot, one veil. Henri Chapu's interpretation, which did not win a prize (fig. 3) gave all necessary ingredients and more: virile Ulysses, gesturing homeward; veiled, demure Penelope; aged father; chariot; excited horse; restraining groom. His additions lent the incident a logical completeness, supported by the detailing, variation, and relative degree of finish he managed to give his figures in the day alloted. Chapu supplied all the program demanded, but since the winning composition does not survive, it is impossible to tell if the extra elements he offered worked for or against him.

In the *concours de tête d'expression,* the programs were even more specific. The 1841 assignment of *Celestial Contemplation* called for the following: "In this expression full of innocence and candor, one must portray the love of god! The head must be raised, the neck extended, and the eyes fixed

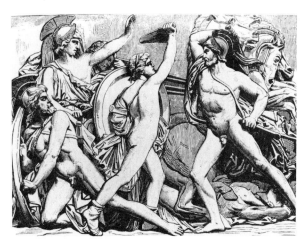

fig. 5. Engraving after Alexandre Falguière, *Mezentius Wounded,* first Grand Prix de Rome, 1859 (reproduced in the *Gazette des beaux-arts,* 1859, IV, p. 125).

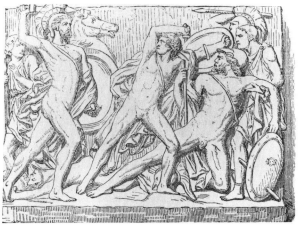

fig. 6. Engraving after Léon Cugnot, *Mezentius Wounded,* second Grand Prix de Rome, 1859 (reproduced in *L'Illustration,* 1859).

sweetly on the heavens. The mouth and nostrils must be half open, finally a great calm on all the features. The modeling must be suave and pure."[16] Pierre Cavelier's winning bust satisfied all the required clichés of expression. If dilated nostrils are not apparent because of the damage the sculpture has suffered, nonetheless the young artist clearly fulfilled the program point by point. Among the surviving *têtes d'expression* there are those which are more lively—and more truly expressive— than Cavelier's vapid rendering (fig. 4). The goal of the competitions, however, was not expressive art. From its inauguration in the eighteenth century by the Comte de Caylus, the contest was intended to promote a language of expressions akin to the language of gesture and expression used on the French stage. That language assumes the existence of one ideal form, the composite of a particular conformation of features.

The competition for the Prix de Rome was based on a similar assumption: that for a particular subject there is only one best solution. This aspect of academic thinking, and students' response to it, gave rise to persistent criticism of the lifeless uniformity of student performance. Paul Mantz stated the problem clearly:

What is this? Ten young men are born at different times in this France where the irregu- *larities of local temperament are still so strong; they are unequal in intelligence as well as in emotions. But they go to the same school, and thanks to the mechanism of an equivalent education they transform themselves, they sweeten the spice of their individual characters, and finally end up producing identical works, absolutely the way young draftees learn to keep in step and do their exercises as a perfect ensemble.*[17]

Learning to sculpt, says Mantz, is keeping in step to a set tempo. In 1859, the year Mantz wrote, the exercise was *Mezentius Wounded,* with a program from Virgil: "Mezentius has just been wounded by Aeneas; at once Lausus throws himself between the two warriors and protects his father from the Trojan hero." Here, "keeping in step to a set tempo" meant composing a relief in which the opposing lines established by the naked male bodies expressed their struggle. First and second Grands Prix were awarded that year to Alexandre Falguière and Léon Cugnot, respectively. There are fine degrees of difference in their two compositions, as they were recorded in wood engravings published that year (figs. 5, 6); Falguière, for example, seems to make slightly clearer Lausus' young age. Neither student,

however, questioned the premise behind the specific battle scene, and thus their solutions resemble every other combat sculpted there.

The policy of displaying former winning works facilitated the maintenance of tested solutions, and that policy had been built into the interior decor of the school. In 1816 the Comte de Forbin suggested that laureates' paintings and sculpture be collected and shown as a *leçon continuelle* for generations of aspirants.[18] The sculptures were cast at school expense and put on view in Félix Duban's Palais des Etudes, which he designed as Architect of the Ecole des Beaux-Arts, a post inherited from his brother-in-law François Debret. Sculpture students sketched from these casts, learning the right treatment of a subject like the *Death of Epaminondas* or *Achilles Wounded in the Heel,* just as architecture students made notes of a winning plan or elevation of the previous year. During his stay at the Ecole, Carpeaux was thorough in such studies: he often sketched a Grand Prix first in pencil, then strengthened it in ink, and finally traced it onto a second sheet, again in ink, as if by setting it down three times he could commit it to memory. He pasted both sketch and tracing into two pocket-sized notebooks, compiling his own handy dictionary of approved Ecole

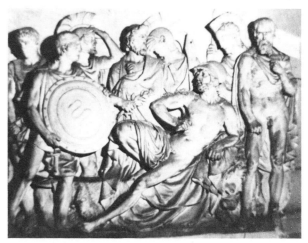

fig. 7. Jean-Baptiste Carpeaux, after Maréchal's *The Death of Epaminondas*, pencil, c. 1847–52, Musée des Beaux-Arts, Valenciennes.

fig. 8. Ambroise-René Maréchal, *The Death of Epaminondas*, plaster, Grand Prix de Rome, 1843, reproduced from a photograph in the Ecole des Beaux-Arts, Paris.

compositions.[19] A comparison of Carpeaux's thumbnail sketch of Maréchal's *Death of Epaminondas* (fig. 7), which received the Grand Prix in 1843, with the relief itself (fig. 8) shows how a student could absorb the elements of a composition: its placement of figures, patterns of drapery, and underlying geometry. Other students must have developed similar systems of study.

Maréchal and Hubert Lavigne, who won the second Grand Prix in 1843 (fig. 9), took a common approach to the problem and employed similar elements. The program naturally dictated a great deal of the resemblance between the two winning sculptures:

Epaminondas, mortally wounded at the battle of Mantinea... has been brought back to camp. Before expiring he wanted to assure himself that his arms had been saved. He is shown his shield. He asks who was victor, and is told it was the Thebans. At these words he himself removes the weapon from his wound and draws his last breath in the midst of the warriors who surround him.[20]

The program's emphasis falls on a dramatic moment comprised of two interrelated actions. If one critic dismissed the subject, the "eternal Epaminondas," as hackneyed,[21] others took it seriously and challenged

the professors themselves to treat it successfully. Its lesson, wrote the critic for *L'Artiste*,[22] was the triumph of patriotism over physical agony. To render it, a sculptor needed an elevated style, a profound knowledge of history and Greek art, and heartfelt study — in short, everything this critic found lacking in the Ecole's ateliers. In a lengthy discussion he analyzed the hierarchical arrangement of figures that its representation demanded, the necessary clarity achieved through focus, gradual diminution of planes, and subordination of secondary elements — all the opposite of the general melée the eight contestants presented. In fact, he called for observance of the rules ordering Neoclassical relief, the rules which guided David d'Angers in his own prize-winning *Death of Epaminondas* of 1811 (fig. 10). The contrast between David's subdued composition and the strong patterning, high relief, and clogged surface of the 1843 reliefs reflects the stylistic changes in French sculpture over thirty years, changes which both Academy and critics alike termed a harmful pictorialism, but which must be seen as the root of later style. The similarities from 1811 to 1843 demonstrate the tenacity of tested compositional solutions, as

suggested above. As students, David, Maréchal, and Lavigne produced reliefs whose style, even if imperfectly manipulated, is embedded in the dominant mode current among their older contemporaries, professional sculptors. David's relief, however, was more consistently measured by contemporary standards, while his students, generations later, were still being assessed against those same standards. The Academy did not take into account its own members' contributions to changes in sculptural style, which in the cases of David or Pradier were considerable. This disparity between theory and practice, attitudes and actuality, characterizes academic instruction.

Similarly, while critics censured nearly every aspect of the Academy's approach to the *concours* and sculpture education, they were also influenced by the restraints felt to govern that noble art, which made them almost equally conservative in their own demands on individual works. They also occasionally relaxed their blanket condemnation of institutions in discussing student efforts. Despite the general criticism of the 1843 contest, the critics praised qualities in several works: the natural, noble pose Maréchal found for Epaminondas; the movement and life he gave his composition, despite its confusion; Lavigne's sage arrangement.

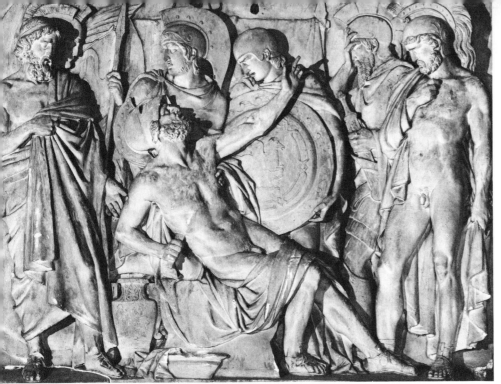

fig. 9. Hubert Lavigne, *The Death of Epaminondas,*
plaster, second Grand Prix de Rome, 1843, Musée des
Beaux-Arts, Nancy.

In awarding the Prix de Rome, the
Academy's sculpture section recorded an
explanation of its decision, the *motif de
jugement.* These comments were for the
Academy's own files and not for public
record, so they leave a great deal unstated.
They express the group view that an
individual work approaches a certain stan-
dard, but the criteria for that standard are
not explained because they were tacitly
understood by everyone at the school.
The Academy commented on Maréchal's
work: "The principal figure is well ren-
dered, the composition is well understood,
each figure is well placed, and there are
some heads either well made or with
remarkable expressions."[23] Good render-
ing, good placement: these judgments
confirmed first of all the student's techni-
cal competence in the eyes of the Academy,
and then his adherence to its standards.
Matters of aesthetic doctrine were ac-
cepted rather than debated. In assessing
student work, the academicians were look-
ing for likely candidates to follow in
their footsteps as traditional sculptors.

One of the most criticized aspects of
sculpture instruction, in fact, was the
contribution of professors. Since only the
results and not the motivations of their
judgments were made public, their
main contribution to students took place

through personal contact in Ecole study
rooms. What occurred there clearly varied
according to each man's inclinations.
Painters and sculptors supervised studies
in monthly stints, and their competence
varied greatly. One contemporary wrote:

*During his month, the professor comes to the
room where the students are drawing or model-
ing after casts from nature, and going from
place to place, he makes this student lengthen a
too-short leg, that one shorten a too-long arm.
I knew one professor — a sculptor — who
stayed seated in a corner of the study room; he
waited there for students to come to show him
their work, and even though from his arm-
chair he could see only the model's back, he
nonetheless corrected equally figures seen in
profile, or at three quarters, or full-face.*[24]

This method of teaching, even if lazily per-
formed, was a fundamental element in the
curriculum of traditional art academies.
It aimed at encouraging mastery of anatomy
as the basic element of artistic vocabulary;
thus proficiency could always be measured
and critiqued against a living model or a
cast. Some writers asserted that *maîtres*
taught only drawing and modeling with
no regard for content, a failing common to
private ateliers as well as to those of the

Ecole. This criticism runs counter to
the Academy's own view of its instruction
at mid-century with its self-avowed sub-
ordination of technique to meaning. The
dichotomy was not resolved in the Acad-
emy's approach to art, and the contribution
of métier to message was not openly ac-
knowledged. As a student firmly enmeshed
in the system, Carpeaux saw the conflict:
"The Institut [the Institut de France, of
which the Académie des Beaux-Arts, with
its Ecole, was a branch] takes pleasure in
saying that the arts in general exist more
in feelings than in measurements which
make cold copyists, aware only of the ma-
terial spirit of what we are doing, while
they. . . ."[25] He broke off there, leaving the
comparison clear but unstated, asserting
rather that these were pretentious ideas
which he personally did not accept. He
personally experienced two extremes of in-
struction, the methods of François Rude
and those of the Ecole. Professional critics
who wrote as observers outside the system
they described maintained that, despite its
intention, the school disseminated only
technique. Art, they claimed, is a nobler,
more elevated phenomenon which must be
taught in a way that will awaken capabil-
ities to produce it. Fundamentally, then,
the Academy and many of its critics agreed
about the purpose of art instruction;

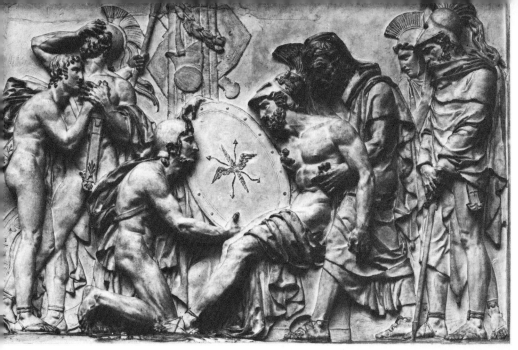

· DAVID d'ANGERS · 1811 ·

fig. 10. David d'Angers, *The Death of Epaminondas*,
plaster, 1811, Ecole des Beaux-Arts, Paris.

their conflict arose over how it might be achieved, and who could bring it about.

In 1863, the curriculum and administration of the Ecole des Beaux-Arts were reformulated.[26] The changes aimed to resolve some, if not all, of these problems. The monthly rotation of professors was replaced by an atelier system, which gave charge of the three sculpture studios to Jouffroy, Dumont, and Duret, all of whom had previously been professors at the school. Each teacher had a fixed group of students whom he supervised for a year. For the first time in the history of the school, all of a sculptor's pupils were sculptors. He was required to supervise and report on their progress. Unfortunately the teachers' observations convey little about their teaching methods. When, for example, Jouffroy wrote about Ernest Barrias, his remarks were a standard official paragraph: "Louis Ernest Barrias, born April 13, 1841, in Paris, 2nd Grand Prix of 1861, has no awards since then. This year he received a mention in the *tête d'expression* and a medal for the large *esquisse modelée*. Thus I recommend him to our goodwill." When Duret wrote about Dalou in 1864, his remarks took the same tone: "Aimé Jules Dalou, born December 3, 1838, in Paris, a student with a future, but obliged to work for a living. Not admitted *en loge* this

year. Deserves to be encouraged. 1st medal, composition."[27] Concluding his report, Duret added that Dalou and four of his contemporaries would be capable of executing "des ouvrages de bâtiment" for the government, a remark, like Jouffroy's comment recommending "goodwill," that indicates the purpose of these reports. Rather than assess creativity directly, they approached such judgments only obliquely. Instead they addressed more practical matters head-on: the fact of poverty, the necessity to work, the need for encouragement, all of which could be logged in bureaucratic records with some hope of results.

By virtue of the 1863 reforms the professor's voice, in fact, carried greater weight than ever before. He alone was in contact with a student's daily performance; moreover, admission to the school no longer rested on competition but rather on the decision of the individual professor. An entering student presented himself directly to the *chef d'atelier,* who exercised his own standards of selection. The changes legislated the institutionalization of the private atelier training system, in almost a return to an earlier method of professional training. In the previous decade, other sugges-

tions for modifications in the curriculum had pointed to the need to reassess art education as professional training. Léon Delaborde, for example, urged instruction which would mate the progressive development fostered by the Ecole *concours* to a "practical education equivalent to apprenticeship." He proposed a plan recognizing that artistic study should prepare for the moment when the artist, "feeling himself incapable of raising his thoughts above a certain level and of creating in the elevated sphere of art, resets his sights on goldsmithery, or sculpture destined for furniture, or apartment decoration, or ceramic ornament"[28]—in short, on an avowedly commercial application of skills learned at the school. Even curricular modifications proposed within the Ecole itself were motivated by similar reasoning. This is stated clearly in the recommendations of a committee appointed by the Conseil d'Administration in May 1860 to investigate ways of encouraging students to study widely rather than confine themselves to their own preferred medium. They did not propose liberal breadth of learning, but rather a more practical kind of instruction that would set sculptors composing pediments and friezes "to habituate them to decorate architecture and to familiarize them with its sentiment and needs."[29] The committee suggested that sculptors and architects should col-

laborate in exercises designing objects like candelabra, pulpits, thrones, and vases, as well as fountains and mausolea (similar plans were proposed for painters and architects). As outlined in the proposal, they resemble the various problems set in *concours* at the Petite Ecole. In spirit, if not in specific recommendations, they are early ancestors of the program of *Enseignement simultanée des trois arts* inaugurated in 1883.

Such modifications and proposals point to a growing consciousness among art educators and administrators in mid-nineteenth-century France of the actual uses to which their instruction would be put. They had begun to acknowledge that the majority of sculpture students would not be following a noble career in "Art," but would use their training in mundane daily practice, an admission which parallels similar administrative recognition of drawing's use not just for art but as a language of communication essential for industry. The Petite Ecole, traditionally the training school for sculpture as a decorative art, lost enrollment immediately following the 1863 reforms at the Ecole des Beaux-Arts, as if some of its function had indeed been ceded to its *beaux-arts* sister.

Similar changes were not made at the French Academy in Rome, which jealously guarded its status as a "true artist's" train-

ing ground. There, a five-year novitiate was measured in *envois,* exacted (sometimes painfully) by a *règlement* which underwent only minor, much-debated modifications over the decades. In the first year, a copy of an antique marble, with restorations when necessary, was demanded; in the second, a *tête d'étude* and the completed copy; in the third, the model of a life-size freestanding figure and the sketch of a bas-relief of no less than eight figures; in the fourth, the model of a figure of the student's own composition and the sketch of a group of at least three figures; in the final year, the marble of his fourth-year figure. Each set work was exhibited in Paris and received the criticism of the Academy, communicated directly to the student and eventually published. These public analyses offered the chance, one frequently seized, of reasserting fundamental values. Often the Academy made such statements when, as the 1840 report put it, "one does not sense strongly enough in the *envois* that noble character of art, which banishes vulgar thoughts while it leads to serious study. Sculpture is a weighty art demanding, equally from those who pursue it and those who enjoy it, an elevated sentiment."[30] Although a conventional homily, this was read out with a specific purpose. The

report continued, "Thus one cannot recommend too strongly to young sculptors of our school to immerse themselves in the importance and dignity of their art in the presence of admirable monuments in Rome and to reserve, at the very least for another time than that of their studies, the lucrative application they can make of their talents." This solemn enjoinder was provoked in particular by the fourth year *envoi* of A. Ottin. He had sent a *Danaïde,* which arrived broken. Yet despite its fragmentary state, it was clear to the Academy that it was destined for commerce.

Ottin's marble no longer exists to explain the Academy's criticism. What is evident, however, is the suggestion of a threat that was not to be allowed to penetrate the cherished isolation of the Roman cloister. Critics attacked that isolation, suggesting that Paris, as the new European art capital, might be a richer, more valuable place to study. In fact reviewers often treated the Rome prize as some lingering stigma manifested in artistic mediocrity unjustly rewarded by State commissions. This case against the Prix de Rome and its recipients was overstated. The efforts required under the terms of the *règlement* were perfectly consonant with the range of sculpture simultaneously being produced in Paris. Good work was done in Rome: Guillaume's *Gracchi,* Perraud's *Adam,* Duret's

Neapolitan Fisherboy (cat. no. 122), and Falguière's *Winner of the Cockfight* are only a few examples. Despite rules, despite the attitudes of the Academy and its maintenance of an ideal of art instruction, room was allowed winners of the sculpture prize to develop their individual talents in far greater measure than their counterparts in painting.

What Roman laureates shared with their uncrowned fellow students, the hundreds who passed through the Petite Ecole and the Ecole des Beaux-Arts, was the assimilation of a certain approach to making sculpture. Even before administrative changes began to orient the Ecole des Beaux-Arts more directly to "professional" training, the curriculum offered a preparation for performing the mundane tasks of sculpture more often demanded of them than the sublime efforts David d'Angers saw it their destiny to produce. These tasks can be clearly stated, just as they were listed in the 1860 proposal: pediments, candelabra, fountains, as well as caryatids, lampposts, and drinking fountains. These sculptural works created an urban decor with both public and private manifestations, and served to confirm the prosperity of the times and the values of culture. Despite individual variations and stylistic modifications—and both did occur—characteristics of that decor are remarkably

consistent through the 1880s. Sculpture became a sign which was to be read independently of its ostensible content.

The Petit Ecole prepared its sculptors to produce that decor as its avowed purpose and with a self-conscious, self-critical awareness fostered by Belloc. It professed a language of ornament to be manipulated according to the commission. The lessons of the Ecole des Beaux-Arts also taught an artistic language. It was disseminated not only as style, but also as a pattern of thought or formulation that resisted change. The course of study at the Ecole des Beaux-Arts thus confirmed the basis of academic instruction: the linear construction of a simple thesis and an ordained conclusion. This method was immensely practical, since it offered the means for the production of standard solutions to a wide range of problems. It did not offer, however, the means to question its process or to establish new models.

Notes

*The material presented here is taken from my doctoral dissertation, "Learning to Sculpt: Jean-Baptiste Carpeaux, 1840–1863" Harvard University, [1980], hereafter referred to as Wagner, [1980]. I am happy to acknowledge the support of

the National Gallery of Art, Washington, D.C., and the Samuel Kress Foundation, New York.

1.
A. Bruel, ed., *Les Carnets de David d'Angers,* Paris, 1958, II, p. 285.

2.
Based on two samplings taken from Lami, 1914–21, I–IV. While Lami is not always complete, the evidence is conclusive; see Wagner, [1980], chapter I.

3.
See D. Harlé, *Les cours de dessin gravés et lithographiés du XIX^{me} siècle conservés au Cabinet des Estampes de la Bibliothèque Nationale: Étude critique et catalogue,* unpublished thesis, Ecole du Louvre, n.d.

4.
Information on the Ecole Gratuite de Dessin derived from the school archives, deposited at the Archives Nationales, Paris, under the code AJ53, and discussed at length in Wagner, [1980], chapter II. On the eighteenth-century history of the school, see L. Courajod, *L'Ecole royale des élèves protegés, précédé d'une étude sur le caractère de l'enseignement de l'art français aux differents époques de son histoire, et suivie des documents sur l'Ecole royale gratuite de dessin,* Paris, 1874.

5.
For Stowe's description of the school and Hilaire Belloc, see H.B. Stowe, *Souvenirs Heureux: Voyage en Angleterre, en France et en*

Suisse, trans. E. Fourcade, Paris, 1857, IV, pp. 311–14.
6.
Archives Nationales AJ53134, Statistique des élèves présents, 1843–68.
7.
L.-J. Alvin, *Les académies et les autres écoles de dessin de la Belgique,* Brussels, [c. 1865], esp. chapter 3, and P. de Chennevières, "L'Ecole de Dessin de Rouen," *Nouvelles archives de l'art français,* 1888, pp. 216–21.
8.
For contemporary recognition of this fact, see T. Gautier, "Ecole Impériale et Spéciale de Dessin: distribution des prix, discours de M. J. Pelletier," *L'Artiste,* 1858, III, p. 8.
9.
Salmson, 1892, p. 70.
10.
This and other information on Ecole rules taken from school archives deposited at the Archives Nationales, Paris, under the codes AJ52, 1, 2.
11.
O. Merson, *De la réorganisation de l'Ecole Impériale et Spéciale des Beaux-Arts,* Paris, 1864, p. 13.
12.
See R. Chafee, "The Teaching of Architecture at the Ecole des Beaux-Arts," *The Architecture of the Ecole des Beaux-Arts,* ed. A. Drexler, New York, 1977, esp. pp. 82–88.

13.
Tabulated from Archives Nationales AJ52194. Programmes des concours des Grands Prix.
14.
Archives Nationales AJ5264. Section de Sculpture: Programmes des concours de composition, 1819–1900.
15.
Ibid.
16.
Archives Nationales AJ5267. Programmes des concours de tête d'expression.
17.
P. Mantz, "L'Ecole des Beaux-Arts: les concours, les envois de Rome," *Gazette des beaux-arts,* 1869, IV, pp. 121–23.
18.
Archives Nationales AJ52445. Comte de Forbin, letter of August 29, 1816.
19.
Musée des Beaux-Arts, Valenciennes, CD 1, 2.
20.
Cited in "Concours pour les Prix de Rome. Sculpture," *L'Artiste,* IV, 1843, p. 178.
21.
A. Guillot, *La Revue Indépendante,* September–October, 1843, XVI, pp. 414–19, and A.H.M., *Journal des Artistes,* 1843, XXXIV, pp. 179–84.

22.
L'Artiste, IV, 1843, p. 178.
23.
Archives Nationales AJ5275.
24.
O. Merson, *De la réorganisation de l'Ecole Impériale et Spéciale des Beaux-Arts,* Paris, 1864, p. 15.
25.
Carpeaux to Dutouquet, January 1850, cited in Mabille de Poncheville, *Carpeaux inconnu ou la tradition recueillie,* Brussels and Paris, 1921, pp. 74–75.
26.
For a general description, see A. Boime, "The Teaching Reforms of 1863 and the Origins of Modernism in France," *The Art Quarterly,* 1978, I, pp. 1–39.
27.
Archives Nationales AJ5251, Rapports de Professeurs de Sculpture Jouffroy, Dumont, Duret, 1864.
28.
L. Delaborde, *De l'Union de l'Art et l'Industrie,* Paris, 1856, p. 275.
29.
Archives Nationales AJ5215, Registre des Procès Verbaux, Conseil d'Administration, Meeting of May 19, 1860.
30.
"Rapport sur les ouvrages envoyés de Rome par les Pensionnaires de l'Académie Royale de France, Année 1840," Archives Villa Medici, carton 37.

The Public Monument*

June E. Hargrove

As for the Place Louis XV, it was bare; it had the shabbiness, the melancholy and abandoned air of an old amphitheater; one passed by quickly.[1]

So Chateaubriand described the Place Royale on his return to Paris after the decade of violence unleashed in 1789 by the French Revolution. The masterpiece of Gabriel, the Place was originally constructed as a setting for Bouchardon's equestrian *Louis XV* raised on its elegant pedestal. But the statue no longer dominated the scene from its altarlike height; in the wake of insurrection on August 10, 1792, an angry mob vented their frustrations by toppling every royal monument in Paris.[2] These vestiges of royal pride — statues of *Henri IV, Louis XIII, Louis XIV, Louis XV* — were demolished even before *Louis XVI* was guillotined. Purging France of the despised Bourbon dynasty decimated existing public monuments, long a sovereign privilege, as it would radically change future ones. Thus the nineteenth century, in which the monument was to attain its zenith as a public art form, opened with the stage bare to an expectant audience.

The public monument grappled during the century with a philosophical dilemma, spawned by the ideals of the Enlightenment, that could never be entirely resolved and that gives the monument its richness and vitality. For two centuries, the secular monument had been the instrument of propaganda for the monarchy of divine right. Whatever concessions were made to imply a more socially responsive ruler in the eighteenth century, the monument was primarily the glorification of a single individual, removed and hieratic, to promote his authority. The repudiation of absolutism recognized the validity of other opinions, and therein lay the dilemma. How could the monument answer the needs of a society that wanted both to abolish individual control and to extol individual thought?

Public sculpture was closely tied to the political vicissitudes of France, and the rapid turnover in regimes not only reflected the inchoate ideologies; it also affected the criss-crossing path of the monument. The rise of nationalism, of more constitutional political systems, and of the middle and then the working class were crucial to the development of monuments that would reflect the broader participation of individuals in the institutions governing their lives.

Architectonic compositions, historical references, and allegories (see the essay on "Allegorical Sculpture") helped convey more abstract themes. The allegory shifted from its supporting role as an accessory to the monarch's representation to a central one that summarized as well as channeled public opinion. Changes in social values also led sculptors to express their subjects in ways that were more accessible, literally and metaphorically. But as the concept of the individual gained importance, the homogeneity of the social fabric began to unravel, leaving the artist with the perplexing task of finding a universal language flexible enough to communicate with the diverse segments of his audience.

At the same time, monuments honoring the individual proliferated and assumed a complex responsibility. As a result of the greater awareness of genius and the idea of a linear progression to perfection, fostered by the eighteenth century, distinguished individuals — past and present — became examples to emulate. Thus the monument to genius both honored the specific individual and served as a universal role model. The full-length nude portrait, the "significant moment" — that is, the choice of the decisive instant of action as opposed to Neoclassical repose — and the essays in distilling the physical essence of genius were among the attempts to resolve the monument's dual mission. While that mission remained constant, it was complicated

by the growing desire to identify or empathize with these paragons on a more human level. The inherent contradiction between immortalizing the unique and glorifying the communal generated a conflict that was both philosophical and aesthetic. The subsequent tension between realist and idealist styles engendered an opulent array of monuments that may be interpreted as alternative solutions to this paradox.

The Revolutionary leadership, saturated with the spirit of the Enlightenment, well understood the power of monumental art to inculcate political ideology. Since Diderot advocated that art serve "to make us love virtue and hate vice," art assumed the functional task of secular moral guidance. Art could be the instrument of reform.[3] The monument began to replace religious sculpture as the communicator of social values, just as those values became more civic than sacred. The painter Jacques-Louis David was appointed "Coordinator of Public Festivals for the Committee of Public Instruction" to implement an intensive program of artistic propaganda. For the committee's schemes, a more capable champion of the synthesis of art and politics could not have been found. David promptly organized a series of vast public festivals in which colossal allegories played a major part. Ephemeral images—Nature,

Truth, Law, Equality—touted the Revolutionary principles to the illiterate masses. Whatever the ideological inclination of the spectator, the desecration of old icons and the elevation of new ones made a potent impression. The destruction of monarchist monuments was, in fact, elevated into an allegorical subject for monumental sculpture.

At Napoleon's downfall, Lemot's *Henri IV,* a plaster ghost of his former image, was hastily spirited back onto the Pont Neuf to greet Louis XVIII on his return to Paris.[4] The founder of the Bourbon dynasty incarnated at once the continuity and the virtues of a benevolent monarchy, on which the Restoration desperately needed to capitalize. The emigré king ascended the throne imbued with the mentality of the *ancien régime;* absence had left him pathetically out of touch with the political realities of post-Revolutionary France. Earlier monuments such as the Vendôme *Napoleon* and Claude Dejoux's colossal statue of the Napoleonic hero, General Desaix (1810), which themselves had come from royal fragments, in turn fell victim to the casting of Lemot's *Henri IV.* The composite substance metaphorically parallels the ideological climate so fatefully misjudged by the Bourbon entourage. The

king assumed that he could impose the old brand of absolutism as methodically as he could resurrect the images of royal authority. In restoring his ancestors' statues, he was paying more than token tribute to them as individuals; he was visually reinstating sovereign rights.[5] The Restoration would appear to be a regression, since themes of collective values were suppressed and sovereign effigies overshadowed those of genius, but both tendencies were too deeply implanted to be easily uprooted. Even the regal replacements were more than simple propaganda; they introduced broad political motives to the accelerating taste for the historical and the specific.

If the statues of individuals could be easily disposed of, other imperial monuments posed delicate problems. Since the Vendôme Column celebrated the French soldier as much as Napoleon, demolition was too inflammatory, so the Bourbon flag was exchanged for *Napoleon.* Diverting the message seemed to be the obvious solution to the embarrassment posed by all the remnants of the First Empire, and the Restoration devoted more effort to reshuffling Napoleonic imagery than to creating a fresh monumental message.

One of the most ambitious renovations centered around the bridge that connects the Place de la Concorde with the Left Bank. Napoleon had designated the

bridge, built by Perronet in 1787, as a Gallic version of the Ponte St. Angelo in Rome and lined with portraits of eight of his generals killed in battle. When Louis XVIII usurped the plan for a *Pont Louis XVI,* marbles from d'Angiviller's *Great Men* were considered, but twelve new statues were finally chosen. They brought d'Angiviller's idea of a commemorative series into the realm of the public monument proper.[6] The project was well underway when Charles X was crowned in 1825. To persuade the new ruler to sustain the plan, Frémy justified the idea in language similar to that employed by the former minister.

To honor the memory of illustrious men is to propagate the sacred fire that kindles the same virtues. A statue, a public homage can awaken in the crowd...the emotion that pushes it irresistibly toward something...grand.... Charles X arrives in the tracks, still rather confused, but so deep of the empire: thus one hopes that he will complete the edifices begun twenty years ago in order to further elevate the national splendor.[7]

Frémy added that such deeds are "popular in all classes" and would "excite...public gratitude," evidence of the increasing sensitivity to public sentiment. The conciliatory note is particularly revealing, as is the appeal to the popular opinion, in light of

the Bourbon ineptitude at both. The ensemble was finished by 1827 and remained *in situ* for a decade before Louis-Philippe ordered it transported to Versailles.[8] Of the series, David d'Angers' *Grand Condé* (cat. no. 92) elicited the greatest contemporary response.

Street fighting on the barricades of July brought France a moderate constitutional monarchy in 1830, led by the cadet branch of the Bourbons, the Orléans. In *Lion Crushing a Serpent* Barye marked the transition with an allegorical sculpture, using the animal protagonists as the vehicle for his sanguine expectations of Louis-Philippe (see cat. no. 17). The Citizen-King assumed the throne determined to pursue a policy of something for everyone. He sought to profit from the combined legacy of dynastic legitimacy, martial glory, and egalitarianism of his predecessors, and his political strategy guided his policies governing the public monument. Not only did he preserve the monuments of the past; he actively appropriated them for his own glory. It was to promote himself that he completed the major projects interrupted in 1815. The artists, most of whom were ardent republicans, hoped to benefit from what they perceived as a more liberal atmosphere.

Because problems of weight and humidity jeopardized the structure of the Bastille fountain, Alavoine was asked to transform the plan to honor those killed in the July skirmishes. One year later, in 1831, the first stone was laid for a column in the manner of Trajan's, recalling a similar plan by d'Angiviller when the question of razing the old prison first arose. J.-L. Duc took charge after Alavoine's death and completed the *July Column* by 1840. Barye sculpted a walking lion in relief, where the stars of the Milky Way affirmed its astrological role (see cat. no. 17). Augustin Dumont's winged *Genius of Liberty* (fig. 59), putting aside the broken chains of tyranny for the torch of freedom, balances on the pinnacle. The only monument built expressly for the 1830 Revolution, the *Column* surmounts a crypt where victims of 1848 are also interred, another reminder that many monuments are compromised by history.

To complete the *Arc de Triomphe,* begun by Napoleon in 1806, four commissions for the large reliefs on the pylons were issued in 1833, but they diffused the focus from the Grand Army to incorporate all who had served the fatherland.[9] In Rude's *Depart of the Volunteers of 1792* (fig. 71) a screeching Liberty, wings distended, marshals her compatriots, transposed as Gallic warriors, to the national defense. The com-

23

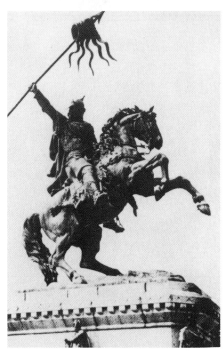

fig. 11. Louis Rochet, *William the Conqueror*, bronze, 1847–51, Falaise.

pelling momentum of the appeal and response sweeps us into the emotional urgency of the call to arms: "Will they return? What does it matter?... Those who die for *la Patrie* awaken to glory."[10] The other reliefs, such as Cortot's *Triumph of 1810*, pale against the Romantic fervor of Rude's total concept. Rude might have been Louis-Philippe's Canova, had a conservative reaction not driven the sculptor into virtual retirement.

The Arc stands today as it did at the 1836 unveiling, with the projected crowning group never realized. Rude wanted an *Apotheosis of Napoleon,* but the government thought it politic "this time to contain the Napoleonic enthusiasm that threatened to overwhelm it." Neither would it approve his quadriga nor his enormous France, seated on a gilded globe, crowned with rays of light, her feet on an eagle with broken crowns and scepters.[11] David d'Angers' *Liberty, Cherished Liberty* aborted, as did Falguière's much later *Triumph of the Republic.*

The monarch's initial liberalism subsided as he realized that some might push their freedom beyond the limits of his control, and his discovery that the arts could stimulate yearnings, conflicting opinions, and ultimately action made him leary of artists, many of whom were known to oppose him.

His anxieties, as much as the economic crises, stifled the public works of the forties. David d'Angers nearly lost his commission for the Panthéon pediment over his refusal to exclude Lafayette. He denounced Louis-Philippe's high-handed manipulation of the arts: "The king always wanted to direct compositions himself.... The government does not want to consecrate public places to great men, but rather to reserve them exclusively for kings."[12] However, he suffered no lack of opportunities from other sources. The *Thomas Jefferson* (fig. 26a and cat. no. 99) for the U.S. Capitol, 1833, and the *Gutenberg* (cat. no. 102) for Strasbourg, 1840, represent the realistic portrait monument that, though he did not invent, he certainly popularized. Attributes referring to the person, like Gutenberg's press, are tacked to the base. Bas-reliefs embellish more affluent commissions such as the *Gutenberg,* where four illustrate the benefits of printing throughout the world.

David d'Angers' obsession with the expression of genius partly explains why the independent (non-serial, fixed) monuments to individuals of cultural rather than military prestige were fundamental to his career. His writings were as influential as

his work in injecting fact and feeling into the prevalent idealized style: "The statue must be the expression of the idea. The idea is the criterion of genius. Compare the face of the nonentity and the traits of a superior man; if you know how to observe, you will be struck by their dissimilarity."[13] He managed to survive the political tremors, despite his Romantic flourishes, through his own fundamental conservatism. At his death in 1855 he left more monuments than his combined rivals, Préault and Pradier.

The craze for things "Gothic," the Troubadour Style of the 1830s, coupled with the cult of historical celebrities, encouraged Romantic confections *à la Ivanhoe* that still color our perception of the Middle Ages. Falaise, "scandalized" that no memorial stood to her native son, William the Conqueror, approved one in 1844, for which Louis Rochet, a student of David d'Angers, signed a contract in 1847. His statue (fig. 11) has a more picturesque exuberance than any works by the older master, though it descends from the *Grand Condé* (cat. no. 92). William directs the Battle of Hastings from his rearing steed; his banner swirls in the breeze. Such monuments scattered across Europe from the 1830s with the debut of bronzes like Marochetti's *Emmanuel Philibert* in Turin. Louis Rochet collaborated with his brother

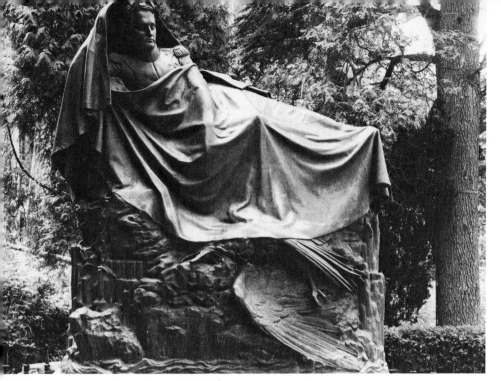

fig. 12. François Rude, *Napoleon Awakening to Immortality*, bronze, 1845–47, Fixin.

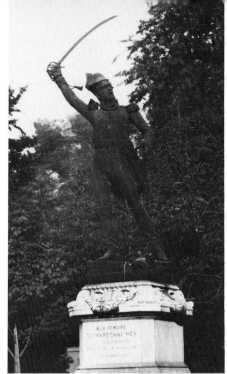

fig. 13. François Rude, *Marshal Ney*, bronze, 1853, Place de l'Observatoire, Paris.

Charles—each a scholar as well as an artist. Their academic bent was intensified by the contemporary zeal for historical accuracy, evident in the intricate detail of the chain mail. The crowd's appreciative gasp at the 1851 denouement assured Rochet's career as one of the most sought-after monument makers of the Second Empire, yet he is almost unknown today.[14]

As dreams of liberty under the July Monarchy faded, hopes for a savior in the Napoleonic vein mounted. The return of Napoleon's ashes to the Invalides fanned the embers of a phoenix. In expressing his personal feelings, Rude summarized the secret emotions of many. With the aid of a former captain of the Grand Army, Noisot, the sculptor undertook one of his greatest works, *Napoleon Awakening to Immortality* (fig. 12). While his public works are fewer than those of David d'Angers, Rude compensated with consistently more powerful images. His talent emerged in themes that allowed him to unfurl his patriotic convictions. His conflict lay in reconciling his devotion to Napoleon the general, liberating through victory, with the despotic emperor. Preparatory studies show that the imperial attributes diminished little by little until the group became an "allegory of eternal awakening of liberty and victory."[15] Napoleon rises from the rocky summit of Elba, only his laurel-crowned head visible

from under the shroud of his military cape. The imperial eagle, immune to immortality's beckon, lies inert at his feet. Noisot paid for the casting; Rude worked without remuneration. The bronze rests on Noisot's property near Dijon, on the crest of a hill surrounded by trees in a Romantic setting, quasi-religious in tone. The simple inscription reads: "To Napoleon/Noisot, grenadier of the Isle of Elba, and Rude, statuaire." Several thousand veterans attended the solemn ceremony of September 19, 1847.[16] A private fixation became a public statement. Rude's baroque concept recalls Roubillac's tomb of *General Hargrave,* 1753, in Westminster Abbey, where, out of the ruins of a mountainous pyramid, the General pushes back his shroud for the Last Judgment. Rude's adaptation of Christian iconography to secular ends underscores the degree to which civic monuments superseded religious statuary after the Revolution.

From the 1848 uprising that sent Louis-Philippe into exile, the ill-starred Second Republic struggled in the shadow of the Napoleonic epic. Too brief to foster any substantial endeavor, the new Republic commenced with a flurry of temporary objects, like those that had accompanied 1789. For the Festival of Concord, Clésinger executed

a colossal *Fraternity* on the Champ de Mars. Rude built a large plaster *Republic* on a wooden armature and then draped her in wool to celebrate the Festival of Schools at the Panthéon.[17] Barely three weeks in power, the newly appointed Federal Committee of Artists proclaimed an ambitious contest for a sculpture of the "true Republic." No sooner had J.-F. Soitoux polished the marble version of his chosen *Republic* than Louis Napoleon's coup d'état of 1852 banished it directly from studio to storeroom. The new minister of arts, Count Nieuwerkerke, offered to pay the sculptor to transmute it into "Justice" or "Liberty," but Soitoux politely declined.[18]

Rude's *Marshal Ney* (fig. 13) fared better with the coronation of Napoleon III. Ney had served the first emperor steadfastly during the bitter Russian campaign as well as the Hundred Days. Deeply revered by most Frenchmen, he nonetheless faced a firing squad as a traitor to Louis XVIII. The legend of his martyrdom elevated him definitively to the pantheon of stoic patriots. When the 1848 government tentatively considered a monument on the Place de l'Observatoire, the execution site, Rude requested the honor of being asked.[19] The sculptor started a model showing the calm general baring his chest to the bullets, but Louis-Napoleon, then still President, requested a less lurid moment. Rude obliged

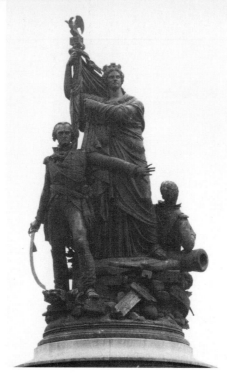

fig. 14. Amedée Doublemard, *Defense of the Barrier of Clichy by Marshall Moncey,* bronze, 1869, Place Clichy, Paris.

with the dramatic gesture, derived from the *Marseillaise,* of Ney leading the charge of his troops. The statue, finished in 1853, was the first of many portraits of generals, obviously political, inaugurated during the Second Empire.

Whatever dubious claim to legitimacy the Second Empire could muster depended directly on the First, and Napoleon III exploited his trump without a qualm. Moreover, he venerated his uncle as much for his utopian aspirations as for his personal ambitions. Both men envisioned their magnificent capital as the outward manifestation of the order and wealth of their nation, the scintillating emblem of their power. To this end, Napoleon III appointed Georges Hausmann to administer a vast program of public works that reorganized Paris. Major edifices—the Opéra, the Louvre—siphoned off what monies were spared for artistic embellishment after the utilitarian construction. Hausmann provided the parks and boulevards but did little to help sculptors fill them. The more subtle result of this urban plan was to assign sculptures to existing spaces rather than create new environments around them, as had been the practice for royal monuments.

The adulation of the heroes of the Grand Army, never dormant, generated more

memorials than any other topic, but Napoleon I was inevitably the single most exalted person.[20] Napoleon's 1821 will, executed by his nephew, allocated to the town of Brienne (where the minor Corsican noble had attended military academy) the sum of 400,000 francs, out of which 25,000 francs was to defray the cost of a statue to preserve his memory.[21] Louis Rochet's *Napoleon* stands by a globe, holding a book, distinguished from any schoolboy by the legendary pose, hand tucked in vest, that foreshadows the "man of destiny." Napoleon need not have fretted, from Rochet's student to Barye's godlike equestrian emperor, portraits in every conceivable guise cultivated his myth.

The prophetic *Defense of the Barrier of Clichy by Marshal Moncey* (fig. 14), executed by Doublemard in 1869, resulted from a municipal competition in 1863. To mark the site of the 1814 defense of Paris from allied troops, Doublemard grouped the allegory of the city, crowned with ramparts in the antique custom and enveloped in the flag, and a portrait of the marshal, brandishing his sword in one hand, shielding Paris in the other, while a wounded student from the Ecole Polytechnique leans against a broken cannon. Three bas-reliefs,

one copying Horace Vernet's painting of the battle, decorate Edmond Guillaume's high base. Doublemard blended realism and allegory to accommodate the demand for specificity within the heroic ideal. "A new testimony to the national gratitude toward the glorious defenders," this combination was the pattern for military sculptures that followed the Franco-Prussian War.[22]

The humiliation that France suffered in the 1870 war with Prussia dramatically altered the meaning of related monuments. An astonishing number of monuments were erected as an outpouring of collective indignation, a way to externalize the despair and the rage. If the French could not rejoice in victory, they could at least salve their psychological wounds through the heroism of defeat. The whole of French history could be marshaled as a lesson in endurance despite adversity. While the Romantic movement had popularized subjects drawn from the distant past, 1871 elevated them to the status of national icons. Statues such as Rochet's *William the Conqueror* not only embodied an inherent nationalism, they also carried latent connotations of royalism that the new government was anxious to avoid.[23]

Sculptors filled the Salons of the 1870s with subjects culled from the national folklore. Joan of Arc enjoyed the rare dis-

fig. 15. Engraving after Ernest Barrias, *Defense of Paris,* bronze, 1878–82, Rond-Point de la Défense, Paris.

tinction of having been commemorated before the Revolution through public monuments. Charles VII erected a bronze statue in 1458 at Orléans, the city of her conquest, and Slodtz's marble image was unveiled in 1755 at Rouen, where she was burned at the stake, but her significance remained regional until 1871 when she emerged as the heroine of nationalism.[24] Not only did she incarnate victory against foreign invasion; her example was all the more poignant because of her origins in the amputated province of Lorraine. The first State commission erected after the war was Emmanuel Frémiet's *Equestrian Joan of Arc* (cat. nos. 141, 142). Dubois' saintlier Joan (cat. no. 121) and Barrias' chained prisoner (cat. nos. 8, 9) were among the seemingly inexhaustible variations that followed.

"La Résistance" preoccupied sculptors from the war's onset. During the bitter siege of Paris, Falguière's makeshift monument in snow (see cat. no. 128) enthroned a defiant nude on a cannon, presumably as impervious to the Prussians as to the cold. The harsh terms of peace gave more subtle connotations to the plethora of war memorials that covered France. Ostensibly to honor the dead for their sacrifice, these monuments also served as visual reminders of the nation's humiliation. Without defiling their commemorative sincerity, they were tacitly meant to perpetuate the thirst for

revenge. The flip side of "La Résistance" was "La Revanche."

Because of the pressures of time and the modest funds available, the majority of these war memorials are simple, geometric shapes—pyramids, obelisks, columns—with inscriptions. In their haste to contribute, sculptors revamped old compositions or modified those in progress. Frédéric Bogino altered only the title when he placed his *Italy Delivered,* first exhibited in the Salon of 1861, in a Parisian park as *Liberty.*[25] Mercié's *Gloria Victis!* (cat. no. 167) also became a monument after the fact. Paul Cabet's *Résistance* was destroyed the year it was erected, 1875, in Dijon, by soldiers who mistook it for a personification of the 1871 Commune.[26]

Under the rubric of *La Défense,* a number of monuments combined the allegorical female with a realistic soldier, in the manner of the earlier *Marshal Moncey.* Paris initiated a competition in 1878 for the *rond-point* at Courbevoie (now la Défense) on the city's outskirts. From the thirty finalists, Barrias was chosen (fig. 15). His allegory of *Paris,* still wearing her turreted crown, dons a military uniform complete with sword. A curiously active combatant sprawls at her feet—in reality to balance

the composition with the flag and cannon. Sculptors sometimes had the awkward task of forcing illogical components, specific and metaphoric, into an amalgam that even conservative critics vaguely understood as a problem. As one noted, "the defense of Paris has to become a legend before it can be adapted to immortal sculpture."[27] But they reinforced the taste for academic realism and allegorical content through their critical reviews. The otherwise warm reception to *Paris* inspired Barrias to expand the formula the following year with the *Defense of St. Quentin,* in which a change of wardrobe makes "St. Quentin" a woman of the people, whose emblematic status resides in her crown. Mercié profited from Barrias' idea when he undertook *Nevertheless (Quand Même)* in 1884 to commemorate the defense of Belfort by Thiers and Denfert-Rochereau. As a fallen soldier clutches her skirts, "Belfort," thoroughly regionalized by her Alsatian costume, raises the soldier's gun over her shoulder in a gesture of defiance. Mercié applied the "significant moment" to a classicizing personification dressed in an authentic picturesque fashion. The group was so popular that a marble version was done for the Tuileries Gardens in Paris. (Alas, that city was never personified in gowns by Worth!) These monuments reflect the desire to modernize within the existing tradition, but the conventions were so firmly

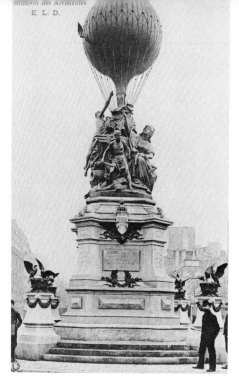

fig. 16. Frédéric-Auguste Bartholdi, *Aeronauts and Homing-Pigeon Trainers of the Siege of Paris,* bronze, completed 1906, formerly Neuilly (destroyed).

entrenched that radical innovations could only be met with perplexed indifference.

Rodin entered his sketch *Call to Arms* (cat. no. 192) in the preliminary 1878 competition for "La Défense" to no avail. The explosive aggression of the *Call to Arms* hit an exposed nerve so sensitive that the jury refused even to acknowledge the sketch's brilliant originality. Human vulnerability, deaf to Liberty's bellicose call, had no place in the iconography of a demoralized France. Through its profoundly personal and antiheroic meaning, contrary to the collective, honorific nature of the public monument, *Call to Arms* anticipates the eventual demise of the very type of monument that defeated it in 1878.

Ironically, the most famous monuments of the late nineteenth century were mediocre sculptures, successful precisely because of their innocuousness and sheer size. The lion had long been a symbol of courage and, more recently, of the French people, and Bartholdi borrowed for his *Lion of Belfort* (cat. no. 12) from the Danish Thorvaldsen's relief of the *Lion of Lucerne* of 1821. A hammered copper version was acquired for Paris in 1880 as the colossal (72 foot high) red sandstone relief was inaugurated in Belfort, both to celebrate Denfert-Rochereau. In the spirit of his *Statue of Liberty,* then underway, Bartholdi aggrandized the scale as he modified Thorvaldsen's composition.

Bartholdi's persistent war themes stemmed from the loss of his native Alsace to the Germans, and he spent twenty years on his *Aeronauts and Homing-Pigeon Trainers of the Siege of Paris* (fig. 16). The figure of Paris gestures with hope to the messenger pigeons, while she guards an infant on her lap. A youthful soldier bestrides a slain one, as another hangs precariously on the side of the balloon. Pairs of bronze pigeons decorate the four corners of the base. Bartholdi combined elements of the eighteenth-century Montgolfier monument maquettes, most of which included a sphere, with the formula of the Defense monuments in a realistic style.[28] He had wanted the balloon in alabaster or glass to be illuminated at night, a possibility he had explored for the *Liberty.* He died shortly before the unveiling of the seven-meter bronze in 1906, at which five thousand pigeons were released as the drapery slid away.[29]

"Resistance" and "Defense" were concepts upon which the French could unanimously agree, but "Liberty" and the "Republic" remained sensitive issues through the 1870s. Liberty was suspect because no one could agree on what it actually meant (or exactly who would be liberated).

It was under these circumstances that the intellectual republicans around the historian Edouard de Laboulaye first conceived of a colossal *Liberty Enlightening the World* (cat. no. 13), a gift from the French to the Americans, as a political ploy to reinforce the republican message at home by linking "France's destiny with the greatest modern republican state."[30] They turned to Bartholdi, who had recently been experimenting with the colossal for his proposed anthropomorphic lighthouse on the Suez Canal. The French Romantics had kindled the taste for the gigantic as an ingredient of the sublime, but their instinctive restraint limited its practical application, and other nations, notably the Germans, advocated it more actively.[31] Bartholdi's 151-foot-high image stemmed from a long succession of Liberties. Among its immediate prototypes were his teacher Soitoux's *Republic* and Carpeaux's pedimental *Liberty Enlightening the World* (cat. no. 36), itself possibly indebted to Rude's suggested crowning for the Arc de Triomphe. The primary distinction of Bartholdi's *Liberty* was a combination of size and location, which also accounts for its very real success. The sublime grandeur of the statue, on an island at the entrance to New York harbor, answered the poetic

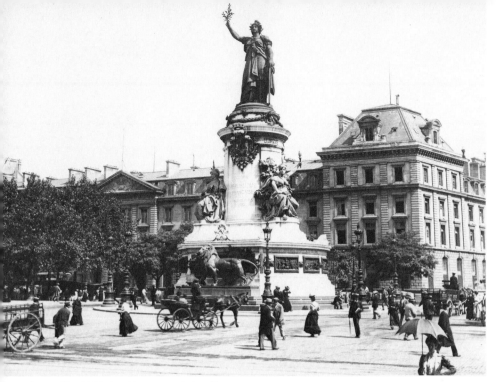

fig. 17. Léopold Morice, *Monument to the Republic*, bronze, 1879–83, Place de la République, Paris.

scale of its meaning. Gustave Eiffel constructed an iron frame for the hammered copper forms, a feat of engineering only feasible in a civilization of technology. In fact the Industrial Revolution, and the resulting affluence, underlie the evolution of the public monument. Without the aid of technology—the science of metallurgy and the facility of transport—as well as economic stimulation, the burgeoning art form would have been stunted. When the *Statue of Liberty* was unveiled in 1886, suffragettes quickly noted that Liberty was a woman.[32] Laboulaye's intended message backfired. The American mind was too direct to associate her with the nuances of French politics, and the towering lady came to symbolize an escape from rather than a debt to the Old World.

Although "the Republic" had tempted sculptors since 1789, nearly a century passed before any project bore monumental fruit. The Third Republic was born out of a power vacuum, not a revolution. Napoleon III's empire crumbled like dry rot at Bismarck's touch, leaving no political party of sufficient strength to seize power. France found herself saddled with a National Assembly made up of rival ideologies, themselves torn by warring factions. Monarchists split between legitimists and Orléanists, with a few Bonapartists tagging along; republicans ranged from far left to a

right that found more in common with the opposition. Consequently, the new government was a compromise—not dedicated to building a new social order, but to preserving the old. How intensely conservative the majority of French were in the 1870s was demonstrated by the savage repression of the Paris Commune. Only after the 1877 senatorial elections squelched the royalist bid for power did the Third Republic function in earnest.

With a securer political climate, Soitoux's marble *Republic* was dusted off, and new versions of the subject timidly emerged at the 1878 Salon.[33] The official nod came for the Trocadero entrance of the 1878 Exposition Universelle, but as Charles Blanc icily observed, "Pacific under her casque, seated and holding an upright sword, Clésinger's *Republic* is better by intention than by style."[34] Little wonder that the city fathers rejected its permanent installation in favor of a competition.[35] The "Château d'Eau" was renamed "Place de la République" in anticipation of a colossal statue that would symbolize the unification of all the French under the Third Republic. The municipal council signed the decree for a monument on March 18, 1879—eight years to the day since the Commune had repudiated the Versailles government.[36]

The council outlined a rigorous program for a monument that specified the requirements of site and iconography and called for a public subscription to finance it. Seventy-eight artists responded, of which three were asked to submit a more polished model for a second round.[37]

One hundred years of imagery were funneled into Léopold Morice's *Monument to the Republic* (fig. 17), inaugurated on Bastille Day of 1883. In collaboration with his brother Charles, an architect, Morice elevated the *Republic* on a mammoth cylindrical pedestal. A laurel crown supplements her Phrygian bonnet. She holds the tablets of law (for order) and extends an olive branch for peace, but the sword at her side intimates her willingness to apply force if necessary. *Liberty, Fraternity,* and *Equality* sit around the base, the visual and philosophical buttresses of the *Republic.* Encircling the lowest platform are twelve reliefs of Revolutionary episodes.[38] A striding lion, reminiscent of Barye's, guards a ballot box in the incongruous shape of an urn. The astrological relevance disappeared, leaving the lion as a heraldic emblem of the people's will. The monument, the standard formula thereafter, "closely conforms to the program and pleases everyone by the nobility of its appearance.[39] The familiar imagery in clear order had a comfortable tidiness about it. Impressive and serene,

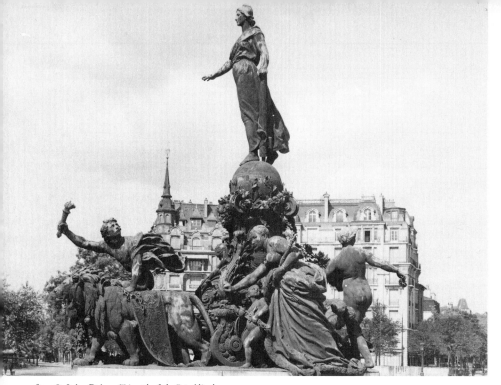

fig. 18. Jules Dalou, *Triumph of the Republic,* bronze, 1879–89, Place de la Nation, Paris.

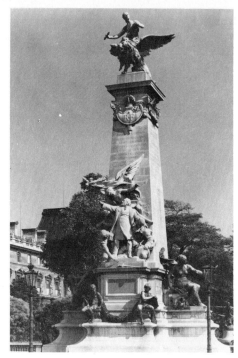

fig. 19. Jean-Paul Aubé, *Monument to Gambetta,* bronze, 1884, formerly Place du Carrousel, Paris (destroyed).

this *Republic* reassured her citizens that all was well.

The conservative committee wanted to avoid, at any cost, a *succès de scandale.* When Jules Dalou's exceptional *Triumph of the Republic* (fig. 18) deviated from the prescription, the committee felt compelled to eliminate it, yet on their recommendation the model was purchased with the Place de la Nation in mind. In departing from the guidelines, Dalou created a monument at once traditional and innovative. He drew on the same iconographical sources as Morice but adapted them to more contemporary and personal circumstances. The Republic dominates the globe in lofty benevolence from her chariot drawn by lions; Liberty seeks direction from her to guide her retinue of peace, abundance, and honest labor. The irrepressible joy of such a utopian world, far from David d'Angers' menacing Hercules, comes across in the playful touches of frisky lions and pudgy putti. Old symbols blend with new, but what ultimately distinguishes Dalou's group is a more modern fusion of form and content. Dalou's *Republic,* which glorified middle-class virtues in a mixture of real and ideal language, would be unthinkable in the aristocratic enclaves of the 16ᵉ arrondissement, but it proved irresistible to the prosperous burgher and aspiring

laborer of the 12ᵉ. To Dalou's supreme gratification, the political implications of his monument brought a hundred thousand "republicans" to the inauguration ceremony of 1899.

War and politics provided the impetus for the majority of monuments to ideas (as opposed to individuals) erected in nineteenth-century France, but the circumstances of military defeat and republican victory reversed the focus of these monuments. War memorials no longer gloated over the fruits of victory; they concentrated on patriotic service. Where once the individual king embodied the institution of monarchy, monuments to the Republic were the collective incarnation of the government. Although the need to compensate and the desire to establish an identity both acted as catalysts to the proliferation of "idea" monuments after 1871, their number was small in proportion to the total quantity of monuments erected.

Competitions and subscriptions, sporadic under the monarchies, became the standard procedure for commissioning and funding public works of art in the last half of the century. As patronage shifted in this way, the monument became truly public

property. This shift not only afforded a fairer opportunity to artists; it also opened the monument to various organizations and informal groups, who were to generate more commissions than the state. A decentralization in the production of public monuments also occurred as more and more provincial centers commissioned them.

Monuments to individuals steadily multiplied. Cultural and humanitarian heroes gradually gained precedence over the political and military figures that had dominated the first half of the century. As subjects diversified, they also filtered down to talents of less extraordinary measure. As if atoning for centuries of neglect, honorific statuary jostled onto parks and avenues across France. The more common the monument became as a form of homage, the more essential it seemed.

When the Second Empire fell, Paris could boast only nine monuments to her illustrious inhabitants, but by the early twentieth century, more than 110 ornamented her public spaces.[40] More eminent subjects called for more exceptional orchestration, and an increase in complexity matched that of quantity. Since one sure way to innovate was to augment, compositions were often embellished to an extreme. Others shunned materialism as a distraction from the individual. No new formats eradicated traditional ones, but the principal

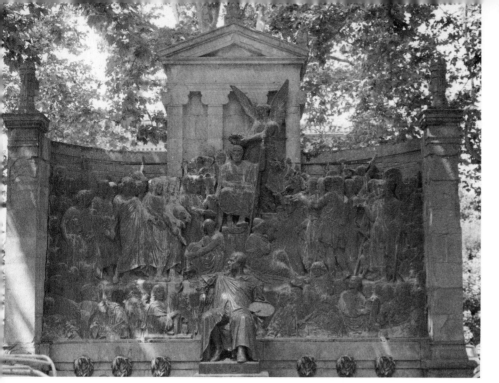

fig. 20. Antoine Etex, *Monument to Ingres,* bronze, 1871, Montauban.

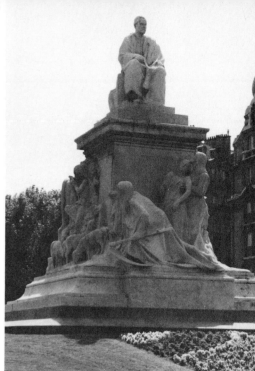

fig. 21. Alexandre Falguière, *Monument to Pasteur,* bronze, 1904, Place de Breteuil, Paris.

types—standing portraits, seated figures, busts, groups—underwent a gamut of permutations.

The standing portrait, the most popular format, remained firmly rooted in the tradition defined by David d'Angers for both historical and contemporary personalities. Dalou developed David's experiments in expressing genius into a more comprehensive approach by investing his *Lafayette* (cat. no. 74) with a forceful simplicity, but the synthesis of creative genius in its corporeal and spiritual form was the accomplishment of Rodin. The Société des Gens de Lettres approached Rodin in 1891 for a *Balzac* to stand on the Place Palais Royal. Rodin abandoned the heroics of the "significant moment" to create a portrait so potent as to render attributes superfluous. After numerous studies exploring a nude figure (cat. no. 205), Rodin wrapped the author of *La Comédie Humaine* in a housecoat—his working attire—which covered the bulk of his frame in one continuous envelope that channels our attention to the rough-hewn head. The phallic silhouette, repeating the *Balzac's* onanistic gesture under the mantle, evokes the surging, vital compulsion of genius. The lack of finish reinforces the raw, molten energy of the man's imagination. By renouncing traditional expressive modes, Rodin appalled the committee who then turned

to the more conservative Falguière (see cat. no. 135).

In contrast to Rodin's *Balzac,* the vital impact of the much-admired *Gambetta Monument* (fig. 19) depends on the apparatus rather than the individual presence. Léon Gambetta had been a problematic force in the republican movement, a man whose charisma exceeded his real abilities of leadership. His early death at forty-four triggered several ornate ensembles that were a catharsis for the widespread grief. Aubé won the 1884 competition for a monument to Gambetta on the prestigious site of the Place du Carrousel with a bronze and marble conglomerate built around a thick obelisk and topped by a figure of the Republic perched on a winged lion. The principal group loosely imitates the *Marseillaise* (fig. 71), with Gambetta's stance echoing that of the old warrior.

Although seated poses were frequently chosen for authors, no ironclad rule ever governed this convention. Julien's seated *Poussin* probably influenced Etex's *Monument to Ingres* (fig. 20) in which the aged doyen of the "official" school, clad in a studio frock-cum-toga, regally surveys the vista. Montauban, Ingres' birthplace, had sponsored a contest in 1868 that nar-

rowed the choices to two, neither of which were deemed worthy of execution by the Institute in Paris. Undaunted, Etex took it upon himself to exhibit a sketch on canvas of his proposal on the town's Promenade des Carmes to solicit the judgment of all. The consensus enabled him to unveil his triumph in 1871.[41] His solution to the composition was hardly less eccentric at the time, for Ingres sits in front of a bronze *Apotheosis of Homer,* embedded in a stone frame that incorporates the painting's temple. Etex had already exploited the replica of a painter's masterpiece in bas-relief on a small scale with the *Raft of the Medusa* for Géricault's tomb (fig. 112). While the notion of illustrating a painting on large scale remained unusual, the custom of providing an architectural backdrop or large relief gained favor.

If the seated pose made Ingres appear enthroned, it gave Falguière's *Pasteur* (fig. 21), completed by 1904, a greater informality. The scientist's vaccine against rabies and process for sterilizing food made his name literally a household word. Falguière referred to these accomplishments through a fusion of common symbols: a scythe representing death, a mother who looks to Pasteur to save her child, the dairy stock which unwittingly transmitted the germs. The continuous relief of the base mitigates the figure's isolated frontality

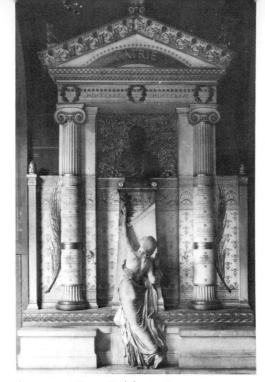

fig. 22. Henri Chapu, *Youth* for the *Monument to Regnault,* marble, bust by Degeorge, architecture by Coquart and Pascal, 1876, Ecole des Beaux-Arts, Paris.

by inviting us to walk around the total sculpture. Despite the high pedestal, Pasteur appears closer and more accessible to us because the breadth of the base links him to the surrounding Place de Breteuil.

Dalou chose to humanize *Lavoisier,* 1890, not with accessories, though some spill across the base, but by stressing his contemplation (cat. no. 77). The tense contortions communicate the stubborn persistence of his mind; Lavoisier practically bites his nails in the agony of concentration. The introspection and personalized vision of the famous chemist parallel Rodin's experiments with *The Thinker* (cat. no. 195), in which the powers of intellect are thrust into a nameless hulk. The antithesis of the "athlete of virtue" where a beautiful body equates with a keen mind, the neolithic *Thinker* struck Rodin's contemporaries as a subhuman, a subversive recognition of the vulgar working class. The glory of battle might be open to all, but the dominant bourgeoisie certainly did not want to accredit the faculty of reason to restless members of the proletariat who were making their aspirations felt.

While *The Thinker* extolled genius through the anonymous, Dalou responded to the growing recognition of all mankind in a more prosaic and palatable way with his *Alphand,* 1889 (fig. 50). Hard work—not

birth, nor wealth, nor even genius—distinguished this comparatively minor civil servant, whose contribution was to make Paris more habitable through parks and gardens. While both Dalou and Rodin channeled their social conscience into unrealized monuments to workers (figs. 54 and 56), Hector Lemaire's monumental vignette *Rescue* was, by comparison, as safe as the woman in the fireman's arms.[42] By the end of the era, race car drivers and mountain climbers vied with scholars and creators for immortal bronzes. The common man had indeed come a long way since Pigalle placed "the citizen" at *Louis XV*'s feet.

The honorific significance of the bust was familiar to the Age of Enlightenment, particularly in engravings, but when the monument ceased to be a government monopoly, the bust offered an economic alternative to life-size portraits. Maindron's simple *Monument to Beethoven* (cat. no. 161) exemplifies the type. The context, however, was extensively amplified after mid-century, as Frémiet's *Corneille* (cat. no. 143) illustrates on small scale. Sculptures of a Muse crowning the honored personage date at least from Desjardin's *Louis XIV,* 1683, in the Place des Victoires, and thereafter the motif was applied to bust monuments.

The *Monument to Regnault* (fig. 22), who with eleven other students of the Ecole des Beaux-Arts was killed in the war, simulates a temple in the highly wrought architectural style cherished by the professors. In simple eloquence, Chapu's personification of *Youth* stretches up to bestow her palm at the base of Regnault's bust. This combination of architecture and figure with a portrait bust was widely imitated.

Dalou transformed the sensuous chastity of Chapu's figure into a Baroque orgy with his subsequent *Monument to Delacroix* (cat. no. 78), 1890, a private commission funded through public subscription. Apollo applauds Time as he lifts Fame, who arches back in ecstatic adulation to place her tribute before Delacroix's bust. Against the straight lines of the pedestal, the complex, interlocking figures form a sweeping arabesque that integrates the parts. American sculptor Lorado Taft chided the "tumultuous acrobatics,"[43] but what more stupendous homage to the neo-Baroque painter could be found?

Achievements of the imagination, a legacy of the Romantics, dominated the public monument at the end of the century. The Romantic forces were spent, but Victor Hugo's towering shadow stretched into the next era. For such a giant, Barrias summoned all his experience as a monument maker to his last great public statement

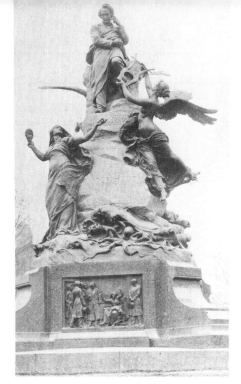

fig. 23. Ernest Barrias, *Monument to Victor Hugo,* bronze, 1902, formerly Place Victor Hugo, Paris (destroyed).

(fig. 23). The poet in exile meditates at the summit of the rock, the Isle of Guernsey, surrounded by crashing waves. Poetry, Drama, and Satire pay tribute, while Literary Fame (fig. 57) raises her trumpet in what was ultimately her own Last Judgment.[44] No one at the 1900 world's fair foresaw Barrias' masterpiece as a harbinger of the monument's decline. Barrias was not insensitive to the new sculptural trends and admired Rodin intensely. With a certain originality, he integrated the base and figures into a three-dimensional composition, but the group's rhetorical opulence culminated the values of a past society without forging a bridge to the new.

There was nothing too alarming in the early maquette (cat. no. 201) that earned Rodin the commission for the *Burghers of Calais* (fig. 72), though the city delegates disapproved of the artist's insistence on representing all six men equally. Calais planned to memorialize the six selfless citizens who offered themselves as hostages to Edward III of England in 1347 to relieve their siege-stricken city. As Rodin studied the six figures individually, in isolation from the conventional pedestal, he began to perceive each as a human being responding to crisis according to his own character. Instead of proudly meeting their fate, as the committee hopefully envisaged, the six men confront their innermost souls

as they prepare to depart. Despair to resignation, their emotions are private and unheroic rather than collective and glamorized. Even a sympathetic mayor was unable to spare Rodin from the scathing criticism. A compromise installed the *Burghers* in front of a garden on a tall base in 1895, a far cry from Rodin's idea of spacing the Burghers singly across the public square, their socles flush with the ground.[45] Exposed in their humanness, these men would have mingled with flesh and blood in a shared space. Unlike the *Louis XV,* they abandoned the pedestal willingly to join us. Rodin resolved one paradox with another; his monument propagated a communal message through subjective emotions. The *Burghers* are not didactic totems, removed and specific; they are existential brethren, immediate and universal. De-sanctifying the Romantic view of heroism, Rodin redefined the monument for the coming century to allow a freedom of interaction between viewer and work of art essential in a diverse society.

Notes

*Two excellent analyses of the public monument in the nineteenth century are R. Butler Mirolli's essay "Monuments for

the Middle Class," in Louisville, 1971, pp. 9–26, and H.W. Janson's *The Rise and Fall of the Public Monument,* for the Andrew W. Mellon Lectures, fall 1976, Tulane University. I am grateful to my colleagues Jeff Ford and Walter Leedy for their comments on my manuscript.

1.
Chateaubriand, *Memoires d'Outre-Tombe,* Paris, 3rd ed., 1957, p. 438.
2.
Réau, 1959, offers a detailed account of the destruction of the monuments throughout French history. Bizardel, 1974, pp. 153–56, documents losses from World War II.
3.
D. Diderot, "Essai sur la peinture," 1765, *Oeuvres complètes,* Paris, 1876, x, pp. 502–4.
4.
Bournon, 1911, p. 170.
5.
During the Restoration, Bosio's *Louis XIV* and Cortot and Dupaty's *Louis XIII* joined Lemot's *Henri IV* in Paris. Cartellier's *Louis XV* claimed Pigalle's pedestal in Reims, respected for its imagery during the Revolution, while Lemot's equestrian *Louis XIV* triumphed in Lyon.
6.
Bart, 1896, pp. 432–37, 443. The Place de la Concorde, which gives the adjacent bridge its name, underwent numerous

changes in title since it was created for Bouchardon's *Louis XV,* from Place Royale (and sometimes Louis XV), to Revolution, Concorde, and Louis XVI, before definitively entitled the Place de la Concorde.

7.
Frémy, 1828, pp. 5–8. See also J. A. Gregoire, *Relevé général des objets d'arts commandés depuis 1816–1830 par la Ville de Paris,* Paris, 1833, pp. 30–35.

8.
Bart, 1896, p. 433, notes that Louis-Philippe added personalities from the First Empire to the series in 1837, when he sent it to the newly decreed museum of Versailles. Bournon, 1911, p. 89, explained that the weight of the marble compromised the bridge's solidity.

9.
Louis XVIII had also planned to modify the Arc, with sculptures glorifying the Duke of Angoulême's Spanish victories in 1823. Under the July Monarchy, Rude had designed reliefs for all four pylons and was disappointed with only one. See R. Butler, "Long Live the Revolution, the Republic, and Especially the Emperor!: The Political Sculpture of Rude," *Art and Architecture in the Service of Politics,* ed., H. Millon and L. Nochlin, Cambridge, Massachusetts, 1978, pp. 92–107. Triumphal arches were not confined to Paris or the nineteenth century. Marseille dedicated one in 1835 on which David d'Angers' *Depart of the Volunteers* was

repeatedly compared to Rude's. The *ancien régime* had erected arches in conjunction with triumphal entries.

10.
T. Silvestre, *Rude,* Paris, 1856, p. 325.

11.
Ibid., p. 315.

12.
D. d'Angers, "Notes de David d'Angers sur la direction des Beaux-Arts de 1830 à 1847," *L'Art,* 1875, III, pp. 405–6.

13.
Cited by G. Chesneau, *Les Oeuvres de David d'Angers,* Angers, 1934, p. 36.

14.
Rochet's composition is similar to Eugène Simonis' *Godefroid de Bouillon,* 1848, Brussels. The recent monograph by A. Rochet, *Louis Rochet,* Paris 1979, has made his career more accessible. The six Norman dukes were added in 1875 according to the original plan. Many of these epic sculptors' reputations have faded because their works are not very collectible.

15.
L. de Fourcaud. "François Rude," *Gazette des beaux-arts,* 1890, IV, p. 338.

16.
R. Butler, "Long Live the Revolution, the Republic, and Especially the Emperor!: The Political Sculpture of Rude," *Art and*

Architecture in the Service of Politics, ed. H. Millon and L. Nochlin, 1978, pp. 92–107.

17.
Lami, 1914–21, I, p. 399; IV, p. 213.

18.
J. Lethève, "Une statue malchanceuse: 'La République,' de Jean-François Soitoux," *Gazette des beaux-arts,* 1963, LXII, pp. 229–40. A similar contest was held for painting.

19.
Bournon, 1911, p. 172. The statue was moved to the opposite side of the Place de l'Observatoire in 1892.

20.
As wary of raising monuments to himself as his uncle had been in his lifetime, Napoleon III sanctioned few monumental portraits of himself, among which were two reliefs on the Louvre, one by Simart, the other by Barye, later replaced by Mercié's *Genius of the Arts* and Clésinger's equestrian statue, now at Chislehurst.

21.
A. Rochet, *Louis Rochet,* Paris, 1979, p. 135.

22.
R. du Merzer, "La Fête du 15 août," *L'Illustration,* 1869, p. 116.

23.
Fear of such controversy led the city of Paris to reject Rochet's gift of the equestrian *Charlemagne,* though the Council later agreed to a qualified acceptance.

24.
F. Masson, "Jeanne d'Arc dans l'Art," *Figaro Illustré,* April 1903, no. 157, pp. 1–25, cites most of the major statues in France. The 1458 bronze may be the first public monument in French history. Mutilated in 1567 by Protestants, it was restored in 1571, destroyed in 1793, and replaced on Bonaparte's command in 1804 with a statue by Gois.

25.
Inventaire générale des oeuvres d'art appartenant à la ville de Paris, Paris, 1877, I, p. 274.

26.
Lami, 1914–21, I, p. 222.

27.
J. Buisson, "Le Salon de 1881," *Gazette des beaux-arts,* 1881, XXIV, p. 226, in reference to Barrias' model.

28.
H. Roseneau, "The Sphere as an Element in the Montgolfier Monuments," *Art Bulletin,* 1968, I, pp. 65–66.

29.
L'Illustration, February 3, 1906, p. 75.

30.
M. Trachtenberg, *Statue of Liberty,* Harmondsworth and New York, 1976, p. 30. Trachtenberg's monograph thoroughly analyzes the statue's extraordinary history.

31.
David d'Angers' "De la proportion en sculpture," reprinted in *L'Artiste,* October, 1879, p. 263, is one of the important early theoretical statements in France. The heaviness and placement of many of the German colossi, for example Ludwig von Schwanthaler's 60-foot *Bavaria,* in Munich, make them foreboding.

32.
Louisville, 1971, p. 36.

33.
Lethève, "Une statue malchanceuse: 'La Republique,' de Jean-Francois Soitoux," *Gazette des beaux-arts,* 1963, LXII, p. 234.

34.
Blanc, Paris, 1878, p. 175. Lethève, op. cit., p. 239, suggests that Clésinger, forever the opportunist, touched up an *Imperial France,* hence the casque, for the occasion.

35.
Inventaire générale des oeuvres d'art appartenant à la ville de Paris, Paris, 1877, II, p. 409.

36.
J. Hunisak, *The Sculptor Jules Dalou: Studies in His Style and Imagery,* New York, 1977, p. 208, points out the monument's significance as a gesture of "reconciliation." The best discussion of the *Republic* competition and the *Triumph of the Republic* is found in this excellent study of Dalou's monumental oeuvre.

37.
L'Arte, 1879, XIX, p. 71.

38.
These reliefs are frequently misattributed to Dalou.

39.
C. Guymon, "Chronique des Beaux-Arts," *l'Illustration,* 1879, p. 254.

40.
Bournon, 1911, p. 169, only cites extant statues in this sum and excludes tombs, architectural structures, and statues, such as the Luxembourg Queens, which are more accurately termed "garden" statues. The French themselves called this phenomenon "statuomanie." M. Schneider's *Denkmaler fur Kunstler in Frankreich: ein Thema der Auftragsplastik im 19 Jahrhundert,* Friedberg, 1977, which I was unable to consult, may shed further light on the problem of monuments to genius.

41.
E. Forestie, *Notice sur le monument d'Ingres ...,* Montauban, 1871, p. 4.

42.
Bournon, 1911, p. 182, described Lemaire's monument *Rescued,* now destroyed, on Square Violet, Paris.

Portrait Sculpture

James Holderbaum

43.
L. Taft, *Modern Tendencies in Sculpture,* Chicago, 1917, p. 31.

44.
For more on the origins of monuments to genius that Barrias may have known, see J. Colton, *The Parnasse François: Titon du Tillet and the Origins of the Monument to Genius,* New Haven, 1979.

45.
C. Judrin, M. Laurent, and D. Vieville, *Auguste Rodin, Le Monument des Bourgeois de Calais,* Paris, 1977, p. 103, describes Rodin's preference for lining the statues one after the other in front of the Hôtel de Ville. A. E. Elsen, *Rodin,* New York, 1963, p. 67. and elsewhere, discusses how Rodin shaped a new definition of public sculpture.

The portrait sculptor in nineteenth-century France inherited an inexhaustible patrimony from the previous century, which expanded and infinitely refined the traditions, purposes, and methods of portraiture developed since antiquity. The eighteenth century put its special stamp on all the familiar varieties of portrait sculpture: the traditional bust, ranging in scale from colossal to miniature and in intent from overt propaganda to intimate portrayal of human essences; the full-figure portrait, standing, seated, equestrian, sometimes in contemporary clothing, sometimes in antique costume, often in unpredictable combinations of the two, now pompous and periwigged, now informal and approachable, sometimes heroically nude.

Many categories of portrait sculpture that had been rare and sporadic before 1700 were codified as norms during the eighteenth century. Both the portrait made primarily on aesthetic impulse and the portrait conceived as a sculptor's intimate personal statement about the subject became frequent and often overlapping phenomena (Bernini's exceptional *Costanza Buonarelli* is an early adumbration of both). They are often an act of homage by the sculptor to his subject (for example, J.-L.

Lemoyne's bust of his master, Coysevox). Another bequest of the eighteenth century was the historical portrait (for example, Caffieri's and Houdon's busts of seventeenth-century playwrights and actors for the Comédie Française), again made with many nuances of overlapping intentions. Especially momentous were the innovations of the Age of Enlightenment in didactic portraiture: the portrait of the national hero for patriotic inspiration (for example, d'Angiviller's precocious series of great men, including Houdon's prophetically cavalier *Tourville* of 1779–81 and Pajou's *Turenne* of 1783); the less specifically political portrait of the great man (a substantial part of Houdon's oeuvre)—of the philosopher, the writer or other artist, of the worthy in any walk of life—made for moral and intellectual edification. Sometimes these verged on another category distinctively nineteenth-century, that of polemic portraiture, in which the sculptor makes a personal manifesto of his interest in or sympathy with controversial ideas and personages (perhaps marginally anticipated by works like Pigalle's *Voltaire* and Houdon's *Cagliostro*).

The forms and media of nineteenth-century portrait sculpture were also inherited. Nothing seems more quintessentially Louis-Philippian than the ornamental full-length portrait statuette (usually less than a half-meter in height, and sometimes tiny), as this exhibition demonstrates. Again these were enormously varied in subject and purpose but functioned especially as a didactic or reassuring presence in the bourgeois household. This usage, too, was passed down from the eighteenth-century (see Rosset's *Voltaire* and his statuettes in Dijon; Dardel's pre-Romantic small bronzes of Condé ancestors in Chantilly). Statuettes, and especially statuette groups, were also ready vehicles for anecdotal material, especially of non-antique inspiration from the ages of chivalry and the cavaliers, much encouraged by "Gothick" and other early Romantic novels. This art was soon dubbed "Troubadour Style," *le style trouvère,* although the term is often loosely extended to picturesque subjects from the Renaissance and early seventeenth century as well, and even to monumental statues (such as Houdon's *Tourville* and others of the d'Angiviller series). The profile portrait medallion (modeled, not minted) that proliferated in nineteenth-century France had not been rare in the previous century. The familiar noble media, marble and bronze, and the more modest terra-

cotta had acquired a humble stepsister, the plaster cast (often carefully reworked and sometimes patinated as bronze or terracotta), frequently produced in specialized ateliers. There was also the unglazed white porcelain (called *biscuit* or Parian ware) produced in State and private ceramic factories. Multiple editions in this medium attested to the increasing commercialization and democratization of even the aristocratic art of sculpture. Except in remote provinces, wood was virtually never used for portraiture until Gauguin.

All this the nineteenth century inherited from the eighteenth, but surely its most precious bequest was the high standard of quality attained in the ultimate distillation of Bernini's portrait tradition. French portraitists of the eighteenth century remain unequaled connoisseurs of the human face. Almost never exploiting their art to probe emotional extremities or overtly tragic implications, they nevertheless could make unexpected adjustments in the equilibrium of objectivity and subjectivity (compare Pigalle's and Houdon's strikingly dissimilar portraits of *Voltaire* or *Diderot*), infinitely increasing the communicative give-and-take in the triple colloquy of sitter, artist, and viewer. It is an art that

compounds wit and wisdom, human understanding, and exquisite yet vigorous technique (although virtuosity is usually explicit only when the occasion demands). It constitutes a definitive apology for the Occidental doctrine of individuality.

The culmination of French eighteenth-century portraiture was in the abundant and incomparable production of Jean-Antoine Houdon (1741–1828), whose activity as portrait sculptor stretched from 1769 to 1814. In his later years, Houdon was still able to teach at the Ecole des Beaux-Arts and to supervise the production of replicas in his atelier. He was therefore both testator and executor of the immense estate inherited by nineteenth-century portrait sculptors—a debt fully acknowledged in word or deed by the greatest portraitists of the three principal phases of French sculpture after his death: David d'Angers during the heyday of High Romanticism just before and during the July Monarchy; Carpeaux during the Second Empire; and Rodin during the Third Republic.[1] One hopes that in the months before his death, the octogenarian relic of the *ancien régime* could take some satisfaction in seeing his eclipsed art reinstated by both critics and sculptors of cresting High Romanticism in Paris.

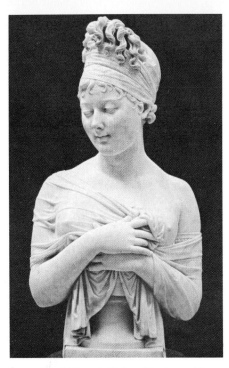

fig. 24. Joseph Chinard, *Madame Récamier,* marble, c. 1802–5, Musée des Beaux-Arts, Lyon.

Eclipsed it surely was, during the first quarter of the new century, by the Neoclassical school of Antonio Canova. The irony is that Houdon himself had intermittently anticipated its antibaroque, antiquarian reforms, and had even sometimes chosen to demonstrate a deeper grasp of Winckelmann's Neoclassical principles than any other sculptor of his lifetime. Still, understandably and rightly, the imperial family chose Canova for its grandest portrait statues, and the result is a group of masterpieces that embody their period as distinctively and vividly as do the portraits of Augustus, Justinian, or Louis XIV. On the other hand, the inescapable presence of Houdon's portraits during the Romanizing interlude of Neoclassicism could hardly be ignored by younger sculptors. Surely it encouraged vitalizing injections of the old French individualization, wit, and pictorial ingenuity; and even the portrait busts by Italian sculptors working in Paris, Bosio and Bartolini for example, have an unmistakably Gallic accent. Indeed, one could speculate that memories of Houdon played an important part in Bartolini's moderation of Neoclassicism, as they did for Bartolini's French admirer, David d'Angers. Again and again, these memories seem to breathe human warmth into the chill marble of such French portrait masters of Neoclassicism as Joseph Chinard (1756–1813) and

A.-D. Chaudet (1763–1810). Chinard rivals Canova in women's portraits, but here he had the advantage of working mainly in Paris, where standards of women's dress, coiffure, and jewelry attained the status of fine art and could inspire Chinard's unique imagination to metamorphose fact and fashion into purely aesthetic configurations, in a way comparable only to Ingres' actually quite different painted portraits of women during the same years (see Ingres' *Madame Rivière,* Louvre, 1805; *Madame Devauçay,* Chantilly, 1807). The old questions of mitigating the truncation of the bust and of unifying truncation and pedestal—questions simply ignored by Canova—occasioned brilliantly inventive and varied propositions by Chinard. In his beloved bust of *Juliette Récamier* (fig. 24), for example, the arms are retained entirely—their contours could well have aroused the envy of any of the great draftsmen of the age—crossed low on the breast and holding the light, clinging shawl so delicately that a happy accident of disclosure is not prevented; but the ends of the shawl then hang down symmetrically, draping the pedestal as formally as the valances and curtains arranged about the palatial windows in Percier and Fontaine interiors of the period. Chinard's many ingenious

variations on this interplay of artifice and reality at the truncation make a more illuminating disquisition on the curious nature of the portrait bust than anything in the literature on the subject. His works are studded with other brilliant but subtle touches—often almost surreptitious—as, on Mme. Récamier's upper left arm, the bracelet nearly hidden by the shawl, the sudden discovery of which is effective beyond explicability.[2] It was probably more Chinard than anyone else who established the lasting currency of the portrait medallion in nineteenth-century France—small round relief profiles for popular editions in plaster or *biscuit,* the prototypes for countless thousands (usually in bronze, however) during the rest of the century.

Other Empire portrait sculptors—Chaudet is one—sometimes asserted their non-Canovan Frenchness in terms of grand and heroic vigor, arguably encouraged by the proximity of the great painter Jacques-Louis David. Military portrait statues and busts were another very French specialty, one that permitted a respite from antiquarian doctrine; yet the splendid Napoleonic uniforms were ideal vehicles for the exquisitely detailed carving of marble, fine as cameo-cutting, that preoccupied many French Neoclassic sculptors. This specialty had a healthy survival through the Restoration (for example, Bosio) and long after.

Some of the older sculptors of the Empire managed enterprising reconciliations of residual pre-revolutionary portraiture and the new Neoclassical art (see J.-B. Stouf's portrait statue of the composer Gretry from the Opéra Comique, 1809, Metropolitan Museum).

Both before and during the hegemony of international Neoclassicism—itself so patently a subsumption of the vaster, multifarious phenomenon of Romanticism that many writers have preferred the term "Romantic Classicism"—there were frequent anticipations of the artistic means that would be used during High Romanticism to oppose the dogmatic antiquarianism of Neoclassicism. Early intimations of the Byronic spirit to come can be sensed in many Parisian portraits—Corbet's dashing bust of the young Napoleon (1798),[3] or even the more restrained busts by Houdon of John Paul Jones (1781) and Robert Fulton (1804).

In all of Europe and in the New World as well, the international Neoclassical portrait style, most characteristically represented by the marble busts of Thorvaldsen, remained paramount throughout the first half of the nineteenth century and even longer in the provinces. It owed much of its longevity to the official academies of art, whose faculties practiced it themselves and preached it to their students. These schools were also in a position to reject experimental heterodoxies from official art exhibitions like the Salons and thus to deny conspicuously independent sculptors the audience indispensable to the receipt of commissions and hence to commercial viability. The decorum to be observed in these busts demanded an imagery declaring allegiance to the norms of antiquity and the usages of Canova's school. Clothing is omitted, or reduced to a suggestion of timeless, vaguely ancient drapery. Recognizable likeness must be carefully reconciled with plausible idealization. Idiosyncrasies of expression, psychological state, and emotion—so marvelously observed in the eighteenth century—ought to be attenuated to unassertiveness; eyes are usually blank, but in the exceptional instances when iris and pupil are carved, they avoid searching communication. Marble is the only serious medium; anything else is to be treated as though it were stone (terracotta, plaster; the rare bronze is chased into a carving). Suave contours assure closed form and keep salience and incursion firmly in check. Hair is usually at least semistylized, locks and curls frequently composing patterns that are executed with gem-carver's precision—a rejection of the picturesque textures of the eighteenth century, which were often sketchy and even atmospheric. In general, surfaces are pumiced to perfect smoothness, often sleekly waxed. This art exalts anonymous impersonality: later Neoclassical busts are almost always unattributable unless there are signatures or other documentation; indeed, the country and even the continent of origin are often uncertain. These rules assured a higher level of competence than has since been generally conceded, but by the 1820s, predictably, more adventurous spirits would find it all intolerably dull and confining.

French critics writing during the second quarter of the nineteenth century correctly averred that the definitive break with international Neoclassicism was made in Paris by Pierre-Jean David d'Angers (1788–1856). The statue usually cited as the decisive harbinger of the French High Romanticism of 1830 is David's four-meter marble colossus of Louis XIV's general, the *Grand Condé*, commissioned in 1816. The huge but half-sized plaster model (2.11 m.) in Angers was conspicuously exhibited in the Salon of 1817; the marble, not completed until 1827, was destroyed at Saint-Cyr in the Second World War. In any case, the work has been photographically promulgated in twentieth-century publications by a small bronze statuette (see cat. no. 92) from a later edition prepared by David

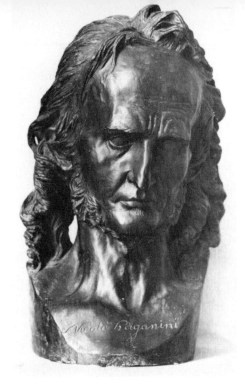

fig. 25. Pierre-Jean David d'Angers, *Bust of Paganini,*
bronze, 1830–33, Musée des Beaux-Arts, Angers.

himself. Both the Restoration government
of Louis XVIII and David himself, a lifelong
fanatic republican who despised it, point-
edly ignored Napoleonic Neoclassicism
and turned to the *ancien régime*'s cavalier
portraits of patriotic inspiration such
as Houdon's *Tourville* of the d'Angiviller
series (1779–81).[4] But David must have
found Houdon's image a bit precious and
dandified, cluttered with distracting liter-
alness in its details: laces, ribbons, plumes,
periwig. David has galvanized the fussy
and decorative historicism of the dashing
cavalier of Romanticism: surely this was
the image that his friend Dumas had in
mind when, some twenty years later, he
invented the Three Musketeers. The noble,
impassioned face of David's *Condé,* made as
outrageously handsome as recognizability
would permit, has only to be compared
with Coysevox's seventeenth-century
portrait documenting the prince's actual
appearance—hyperthyroid, hooknosed,
disdainful—to see at once what Romanti-
cism is all about (admittedly, David is
figuring the 23-year-old Condé; Coysevox's
is decades older). David's portrait of the
military hero—in the costume of his
time, charging fearlessly into battle (Neo-
classical statics almost be damned), yelling
encouragement back to his troops—at
once became an indispensable theme of
nineteenth-century monumental sculpture.

Among its hundreds of progeny is the
greatest masterpiece of the genre, the older
but much less precocious François Rude's
Marshal Ney of 1852–53 (fig. 13); indeed,
these two historical portraits are effective
termini for High Romanticism in
French sculpture.

David's enormous legacy of portraits of his
contemporaries should assure his title to
a far higher reputation than he now seems
to enjoy. Some six hundred portraits may
make him the most prolific of the major
Occidental portraitists. They seem un-
equally successful to us today, but many
are brilliant, and a few are profoundly orig-
inal masterpieces that made critical muta-
tions in the history of sculpture. During
his own lifetime, authoritative critics pro-
nounced him the most representative
sculptor of his age.[5] A flood tide of his un-
ceasing portrait production crested in the
period just before and after 1830. In those
years he turned out dozens of intensely
Romantic busts, including such unforget-
table images as the poet *Lamartine* of 1828,
his thoroughbred head tilted back on a
swanlike neck, his glazed eyes lost in the
clouds, the faintest shadow of a beatific
smile brushing his lips; or the writer and
statesman *Chateaubriand* of 1829 (in Com-

bourg, Brittany), the awe-inspiring elder
high priest of French Romanticism, his
face a readable chart of noble passions and
exalted thought, suggesting both suffering
and invincibility. The hyperbole of some
of these gloriously exaggerated brows and
braincages—truly extreme in the cele-
brated bust of Goethe, modeled in 1829 on
a special trip to Weimar (Goethe Museum)
—reveals a fearless will to unorthodox, ex-
pressive distortion. David's almost obses-
sive faith in the then hardly questioned
sciences of physiognomy, especially of
Lavater, and phrenology, especially of Gall
and Schurtzheim (of whom he made a
portrait medallion), are amply docu-
mented.[6] Yet the extraordinarily expres-
sive liberties David takes with visible
reality cannot be wholly attributed to the
influence of these sciences.

By 1830 his rapidly developing style
reached a peak in the portrait of the violin-
ist Paganini (fig. 25), arguably the greatest
bust of Romanticism. There is increas-
ingly bold modeling in his work, but
now David moved on to a quite sudden and
radical realization of the possibilities of
modeled, of plastic as opposed to glyptic or
hewn, sculpture. Only rarely, in the many
generations since Donatello's late sculpture
in bronze, had there been this kind of abso-
lute congruence of passionate impulse and
impassioned manual execution. The almost

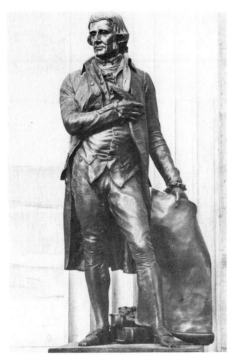

fig. 26a. Pierre-Jean David d'Angers, *Thomas Jefferson*, bronze, 1832–33, Capitol Rotunda, Washington, D.C.

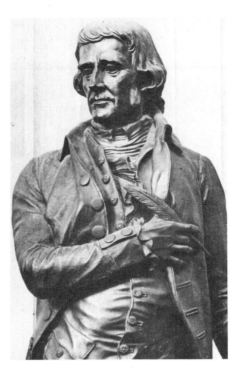

fig. 26b. Detail of fig. 26a.

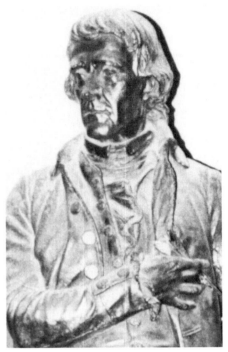

fig. 26c. David d'Angers, *Thomas Jefferson* (detail), patinated plaster, 1832–33, City Hall, New York.

unbearable intensity of David's visual-emotional response to the demoniacal wizardry of Paganini seems in total, irresistible control of the strong fingers and the darting sculptor's tools. The yielding clay is impetuously squeezed and stretched; hollows and distortions and asymmetries are inflicted on the strange shape emerging. Brow and crown are pulled upward, much higher on his right than his left; the nose is ripplingly deflected to his right, but the chin to his left; cheekbones and hollows are completely dissimilar on the two sides; the furious modeling stick whips the hair into turbulent currents. David himself seems to have been perplexed about what he was doing. In 1831 the critic Gustave Planche announced the imminent execution of the *Paganini* in marble,[7] the material into which the boldly clay-modeled *Chateaubriand* and *Goethe* had been magnificently translated; but the graphological uniqueness of execution must have defied any of the standard copying techniques in either marble or sand-cast bronze. There is also reason to believe that David planned to, and eventually did, make later revisions that pushed his rash experiments even further.[8] Meanwhile, in 1832, a most fortunate development solved the dilemma. The accomplished bronze founder Honoré Gonon emerged as a master of a long-neglected technique for monumental

sculpture, bronze casting by the lost-wax process, which can assure that the subtlest touches in the clay model are precisely retained in the metal. In 1833, David seems to have hazarded the decision to sacrifice the probably revised model in order to obtain from Gonon the most exact bronze possible, which he then exhibited in the Salon of 1834. His most ardent and articulate admirers, including Planche, were appalled. This bust, despised in its time, today is considered David's masterpiece; this says much about the extent to which Rodin, fifty years after the *Paganini*, completely changed notions about bronze sculpture; Rodin has taught us to understand the *Paganini*. But it says as much about the importance of David's accomplishment as the reviver of truly modeled sculpture in clay for casting in bronze, that if one compares the *Paganini* with Rodin's early bust of Father Eymard (1863), the sculptural essentials of each pretty well make an equation. One wonders whether the early works of David's sometime student, the hotheaded arch-Romantic Auguste Préault (see cat. no. 185), encouraged David's final exertions, or whether they reflect them.

Hardly less important were David's historical portraits for public monuments; their forms and techniques were also perfected just after 1830. The monumental bronze statue of Jefferson of 1832–33 (fig. 26a) is the first and most characteristic of a type invented by David: the naturalistic but noble figure worthy of public veneration and emulation, in modern costume and with readily intelligible, commonsense attributes rather than abstruse allegorical adjuncts, conceived for bronze and taking full aesthetic advantage of the medium.[9] Today it is difficult to understand the extraordinary originality of this invention in 1830; countless later derivations from it dull our response to the freshness and force of David's prototypes in their own time. The seminality of this type is clear if we compare the *Jefferson* with the still Neoclassical contemporary portrait monuments by Thorvaldsen, and then with characteristic examples of half a century later, such as Saint-Gaudens' *Farragut* or J. Q. A. Ward's *Beecher* in New York—bronzes not in any essential way stylistically developed beyond David's and actually more conservative in facture. Before the *Jefferson*, David's numerous monuments had been realized in marble, but beginning with the *Jefferson* they were planned from the first for bronze —long avoided in grand statues if possible —indeed, a rich and lustrous bronze, as

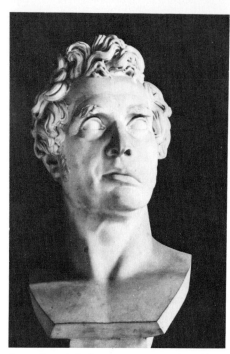

though to provide a refuge of warmth amid the marmoreal chill of later Neoclassicism. These later works exploited fully the aptitude of bronze for conserving both strong and sketchy modeling and picturesque varieties of surface texture. Avoiding the extremes of the more private *Paganini* bust, David seems first to have retouched the wax epidermis prepared for *cire-perdue* casting and then, working with Gonon, to have made greater use of chasing in the final bronze. He thus moderated the harsher realism of many passages in the great plaster model (fig. 26c) which in this case was not sacrificed and still stands, ignored for a century and a half, in the Council Chamber of New York's City Hall. Even so, the coarse roughness of the boldly textured surfaces of the bronze and the very choice of that material shocked the senators in Washington, who rejected it and preferred to wait for Greenough's marble Washington in the guise of a half-naked but peruked Olympian Zeus.[10]

Today David is best known as the overwhelmingly prolific specialist in the portrait medallion; his more than five hundred examples are represented by a selection of twenty-two in this exhibition. Usually they are from about ten to eighteen centimeters in diameter, in profile or occasionally three-quarter view, one-sided, and not minted but modeled for casting in bronze (or plaster). Very few were commissioned or indeed even commercial, for David's altruistic, didactic purpose—unique but symptomatic of the period—was to accumulate a gallery of great and admirable men and women for the edification of his contemporaries, and especially of posterity (see cat. nos. 93–98). Virtually every sculptor after 1825 turned out portrait medallions. Here, too, David reached maturity late in the 1820s and produced many of his best works in the next few years, including most of those in this exhibition. David's oeuvre as a whole presents such unpredictable interminglings of Romantic hyperbole with subjective distortion (cat. no. 97), of bluff realism (for example, the superb terracotta bust of Pierre Boncenne, 1840, Angers[11]) and of occasional vague reminiscences of a moderated late Neoclassicism (in certain marble monuments and busts) that a precise diagnosis and definition of David's historical position has eluded modern scholars. Indeed, his contemporaries registered contradictory colors of the chameleon. While some younger extremists complained of his conservatism, Planche objected to his Romantic distortions and Baudelaire qualified his praise of a statue with the observa-

tion that it was merely naturalism, with no higher purpose.

The liveliest years of French High Romanticism, the 1830s, witnessed an abundance of remarkable portrait sculpture, even by masters not primarily portraitists, such as François Rude (1784–1855) and Antoine-Louis Barye (1796–1875). Rude's two marble busts of the painter Jacques-Louis David (figs. 27–28) provide a striking demonstration of the Romanticization of the portrait bust: the earlier, smaller work, undraped and conventionally truncated, eyes blank, hair and brows semistylized into exquisitely chiseled locks and waves, the unblemished surfaces smoothly polished—in short, a superb example of later Neoclassicism, like a particularly energetic Bosio; the later bust, much magnified in scale and spirit, with a great Byronic mantle flung about its huge shoulders, its alert eyes defiant (sharply incised iris and pupil), the much more picturesquely textured hair and brows (frank drill holes) enlivened especially at the sides of the head, rather like the work of David d'Angers, the flesh surfaces grainier and even with the creases of age crossing the throat. In the course of executing the later bust, the true Rude belatedly emerged in the greatest colossal sculpture of Romanticism, the *Departure* on the Arc de

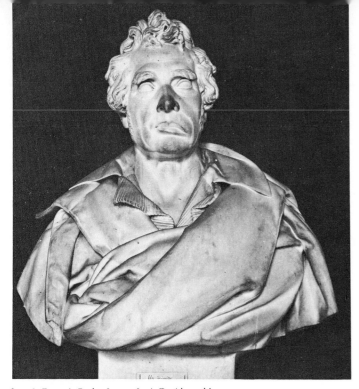

fig. 28. François Rude, *Jacques-Louis David*, marble, 1833–38, Louvre, Paris.

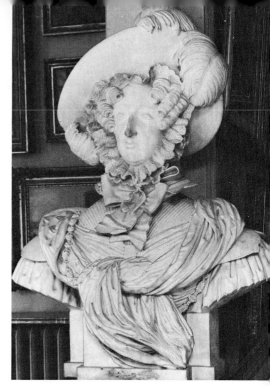

fig. 29. Antonin Moine, *Queen Marie Amélie*, marble, exhibited at the Salon of 1833, Musée Carnavalet, Paris.

Triomphe (fig. 71), and something of its heroic and excitative grandeur has transformed the portrait of David. The late flowering of Rude's genius continued almost to his death. In his sixties he produced the two most stirring masterpieces among Romantic portrait monuments with historical subjects: *Napoleon Awakening to Immortality* (fig. 12), which in its silent woodland setting works an effect not susceptible to photography, and the *Marshal Ney* (fig. 13), the descendant of David's *Condé* but effectively smaller and thus more human, without the hint of operatic posturing emphasized by the colossality of the *Condé* or indeed of Rude's own *Departure*.

Sculpture in the Salons of 1831, 1833, and 1834 demonstrated the extraordinary variety of responses let loose by the emancipation proclamation of French Romanticism, Victor Hugo's *Hernani,* produced early in 1830. Four sculptors in particular gave rise to heated controversy as the extremist fringe of the new Romanticism: Antonin Moine (1796–1849), Henri de Triqueti (1807–1874), Jehan Duseigneur (1808–1866), and Auguste Préault (1809–1879), and, for many critics, David's *Goethe* and certainly his *Paganini* busts thrust the older master into their midst. Actually, Moine is a "little master" whose unique sensibility refused circumscription by a single trademark style. Gautier

and many others adored his extraordinary bust of Queen Marie-Amélie (fig. 29), a spectacularly notorious entry in the Salon of 1833 which ventured exhilaratingly far out on the thin ice of preposterousness. In the set of her head and slightly pursed lips, the placid but proper Italian princess seems a bit taken aback, as though she had just happened unexpectedly upon a mirror, and been quite astonished at the actual effect of her farrago of finery: the immense coils of her coiffure, her lace-lined hat of huge brim and lush ostrich plumes, her great rope of carved ivory beads, her shirred blouse and collars and bows and ribbons and scarves and epaulets. We cannot document whether Moine is flirting with benign parody; but his image of the Queen is an emblem of the middle-class monarchy of Louis-Philippe and its capital, much as Rigaud's *Louis XIV* is a symbol of that reign. A critic as astute as Gustave Planche solemnly praised its modernity, totally free of historical borrowings; yet its sheer quality reminded him of Renaissance art. Moine's unorthodoxy severely reduced his commissions, and in 1849 he took his own life.

In the three Salons just listed, Duseigneur was another conspicuous radical whose sculpture, portraiture included, was found

perplexing. In 1833 he showed a bust of Victor Hugo, wittily dismissed by the critic Jal with a Hugo-like flight of adjectives ("machure, grognon, renfrogne," roughly: "messy, querulous, scowling"),[12] and another of the *Bibliophile Jacob* (Paul Lacroix; Paris, Montmartre cemetery) with a pile of books as a pedestal. Unlike Moine and Préault, by 1836 Duseigneur seems to have decided that more conventional art was less painful than unemployment,[13] and he devoted the rest of his life to often competent but usually less provocative church and portrait sculpture, an example of which is the later bust of Hugo in this exhibition (cat. no. 123). Moine's close friend and sometime student, Auguste Préault—the archetypical Romantic artist—refused to retreat a hairbreadth, resigning himself to penury and to years of total exclusion from the Salons. More than any other sculptor, Préault grasped and intensified the spirit and techniques proposed by the portraiture of his other master, David d'Angers. His busts and statues are always interesting—and like Moine's, sometimes a little mad—but even more remarkable are his reliefs and medallions (cat. nos. 185–187). Their sometimes almost painful realism—the adjective *laid,* meaning "visually ugly," recurs in virtually every sentence of the innumerable volleys fired by Préault's early critics—is redeemed by their impassioned execution and their aura

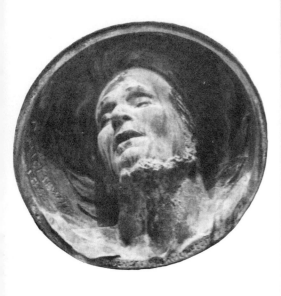

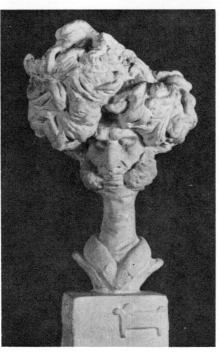

fig. 30. Auguste Préault, *Portrait Medallion of Adam Mickiewicz*, bronze, exhibited at the Salon of 1868, Mickiewicz's tomb, Montmorency Cemetery.

fig. 31. Pierre-Jean Dantan, *Berlioz*, plaster, 1833, Musée Carnavalet, Paris.

of visceral involvement. David's hyperboles of modeling are pushed to even rasher extremes; notice what Préault makes of such structural essentials as the front of the cranium, cheekbones and hollows, and nasal cartilage; ears, strange configurations of erratic tortuosity, become the unlikely vehicles of Romantic expression. The uncertainty of improvisatory sketchiness is preferred to factual definition, as nearly every critic complained. A tailor would go mad trying to copy his collars, lapels, cravats, and shirtfronts. Impulses more of a painter than a sculptor produce flickering highlights and an almost obsessive experimentation with textures, not necessarily even naturalistic ones: the image of Macquet (cat. no. 186) is stamped all over with coarse and conspicuous thumb prints. Especially in more mature works, hair and draperies sometimes undulate about the person like phantom emanations. Here, too, David is the source, in his "gesticulating" hair (see David's medallion of Augustin Dupré, 1833),[14] but the device is sometimes carried so far that it has often been observed as a prophecy of the whiplash patterns of Art Nouveau. A restrained hint of this is seen in the medallion portrait of the Polish poet Adam Mickiewicz in Montmorency, which Préault himself thought his best work (fig. 30).[15] After the Revolution of 1848, Préault became a

culture-hero, exhibited again at the Salons, received important commissions—and happily went right on through his career of half a century as though the 1830s had never stopped.

A distinctive feature of Romantic portraiture was the full-length portrait statuette, often planned only for this size and aesthetically adjusted to small scale, but sometimes based on models for large figures or ingeniously reduced from monumental sculpture by new devices such as the machine of Achille Collas. Nearly every known Romantic sculptor produced portrait statuettes and the result is a vast population of delightful little men and women. Even Barye made an irresistible little equestrian statue of the Duke of Orléans, and Moine, a statuette of the Duke's sister, the Princess Marie. Barre, Chaponnière, Cumberworth, and every other young sculptor hastened to produce figurines of these and the rest of the royal family, and most of the other celebrities of the reign and its capital. The enchanting cabinet of little Louis-Philippians in the Musée des Arts Décoratifs evokes the charm and flavor of these decades. Small and miniature busts also proliferated. Pradier's little standing figures of *Louis-*

Philippe (cat. no. 176) and *Darcet* (cat. no. 178) are thoroughly representative examples of these portrait statuettes. The best known of the little masters of statuettes was Auguste Barre, whose much coveted small bronzes of the great ballerinas of the period (cat. no. 4) are the prettiest objects of nineteenth-century sculpture.

A curious corollary phenomenon of the 1830s flood of statuettes was the sudden fashion for plaster caricature figurines (called *charges*) of celebrities by Pierre-Jean Dantan (cat. no. 83).[16] Critics then, as now, deprecated them as art and ignored their significance in the progressive development of the time, the revival of modeled sculpture. Susse sold Dantan's first *charges* in the early 1830s, the very years when David and Préault were chancing new audacities in modeled sculpture, and surely the wondrously gnarled and fantastic shapes of Dantan's caricature portraits (fig. 31) present analogies useful for critical and historical diagnosis. His inventiveness in image and form is dazzling. The prevailing atmosphere of amiability in these *charges* is occasionally rent by the corrosive malevolence of certain figurines.[17] Honoré Daumier's more profoundly human and poignant *charges* (cat. nos. 86–87) are further evidence of the importance of the revival of modeled sculpture. They were not publically exhibited until 1878, just

before Daumier's death. Years ago, Professor Licht[18] pointed out that this exhibition fell between the Parisian showing of Rodin's *Age of Bronze* (fig. 66) in 1877 and his *Call to Arms* (cat. no. 192) of 1878, with its astonishingly new explosion of reckless modeling. Did Daumier's sculpture exert some catalytic force in the profound change of the nearly forty-year-old Rodin?

During the eighteen years of the July Monarchy (1830–48), numerous other less conspicuous but accomplished portrait sculptors appeared. Francisque Duret, although made famous by his *Dancing Neapolitan Boy* (cat. no. 122), is more characteristically represented by such mature works as his seated portrait figure in marble of the actress Rachel as Racine's Phèdre (Comédie Française), of sober elegance, impeccably composed and realized. Duret's art is distinguished by the suavest formal and technical perfection, by patrician ease and superb taste, and by handsome imagery in which the natural dominates but never compromises the ideal. A host of other sculptors poured forth unprecedented quantities of portrait busts and statues of respectable quality—for example, the more Romantic and individual Hippolyte Maindron (cat. no. 161) the more conservative François Jouffroy (1806–1882) and Jules Cavelier (1814–

1896), and dozens of others—but by the end of the reign, portraiture was pervaded by a new spirit calling for new standards and methods, as is seen in the early works of Clésinger, Aimé Millet (1819–1891), and Eugène Guillaume (1822–1905).

The France of 1850 was much more fragmented than the France of 1830, and so was its art. Clésinger's spirited bust of the painter Thomas Couture (cat. no. 59) has been characterized correctly as Romantic, but the term by now wants some qualification. The intensity of conviction of his master, David d'Angers, had been somewhat relaxed, and purely aesthetic impulses elaborate continuous fluent rhythms over the composition in a way unmistakably studied from later Baroque-Rococo sculpture. It seems much closer to Carpeaux than to David and Rude. Clésinger's bust of the Cardinal Antonelli (Art Institute of Chicago), on the other hand, alludes more to the grandeur of seventeenth-century Baroque; later works experiment with polychromy. Guillaume's fine bust of Msgr. Darboy (Louvre) vaguely recalls Mino da Fiesole, while, somewhat later on, the references of the younger but historically representative Frédéric-Auguste Bartholdi (1834–1905) range impartially

from antiquity and academic through late Gothic, the fifteenth and sixteenth centuries, the most grandiose Baroque, and a pneumatic Romanticism, to something like contemporary realism. In short, the progressive current of sculpture was eclecticism, and its success was so complete and so long-lived that what should be a perfectly neutral adjective, "eclectic," has never since been able to shake off the implications of disdain it acquired from a generation predictably reacting against it. The portraits of 1850 are also the first made by sculptors who had seen photographs by the time they began to produce serious work.

Busts by Cordier and Carrier-Belleuse make further variations on Clésinger's exuberance and eclecticism. These three and Carpeaux magnificently realize in portraiture the luxury and opulence of Paris during the eighteen years of the Second Empire (1852–70). Cordier's first Salon success, the bust of a Sudanese Negro, shown in 1848, established another persistent if minor genre: sculpture which, although it is also portraiture, is an ethnological study, and in the case of Cordier, an increasingly scientific one. Traveling extensively, Cordier accumulated an extensive collection of photographs of racial representatives; he must have been one of the first artists for whom the active prac-

tice of photography was an important part of the process of artistic creation. He has remained famous, and justly so, for his revival of polychromy in sculpture—yet another facet of mid-century eclecticism, the source of which was the long-ignored antique tradition of sculpture in contrasted colored marbles and other stones, sometimes combined with bronze (there are superb examples in the Louvre). His assemblies of onyx, semiprecious colored stones, and varyingly patinated bronze achieve a gorgeous, unabashedly ostentatious splendor (cat. no. 63) that is the hallmark of a principal vein of Second Empire taste most familiarly represented by the interiors of the Opéra.

Carrier-Belleuse is the exemplar of Rococo revival, still another facet of mid-century eclecticism, and of unembarrassed virtuosity in effortlessly brilliant modeling; but today the redolences of his prolific production seem entirely of his own time rather than of the previous century. In his portraiture, eighteenth-century models such as the busts of Caffieri are transformed by injections of a healthy and human nineteenth-century showmanship. His portraits (cat. nos. 52–54) offer a characteristic anthology of Second Empire eclecticism. Historically, Carrier's accomplishment is an important extension of the 1830 revival of truly modeled sculpture;

and if the next generation, including his own invaluable assistant Rodin, saw it as facile brilliance, it was, ironically, a generative force in the shaping of Rodin's own special genius.

This is the fertile soil from which great art, that of Jean-Baptiste Carpeaux, sprang and took constant nourishment. Carpeaux's early bust of a dear, dead friend, Victor Liet (Valenciennes),[19] seems belatedly and conservatively reminiscent of David d'Angers' work, yet its troubled gaze and ambiguously parted heavy lips remain hauntingly fixed in the memory when some greater masterpieces have escaped it. His first great bust was of the French ambassadress to Rome, the Marquise de La Valette (fig. 32). The aging (she was sixty-two) but still handsome and distinguished face seems to have been caught in a poignant moment of private wistfulness. Her weary smile only reinforces the sadness etched about her eyes and the drooping lines of her brows—a sadness the more poetic because it seems remembered rather than acute and because her slightly lowered gaze to her left averts it from us. Yet so delicate and tactful is Carpeaux's understatement that it still functions perfectly as public portraiture. No one can be blamed for questioning whether the subjective-

sounding phrases of our analysis have much to do with the ideas of Carpeaux and his patron at the time the bust was made, but in fact Carpeaux's daughter records a later consultation of the Empress and Prince Imperial with the sculptor over the bust of the Emperor Napoleon III, in which they discuss intensifying the effect of "the remoteness of the gaze, the bitterness about the lips."[20] Indeed at least half of Carpeaux's portraits emanate deeply affecting but elusive and sometimes almost clandestine psychological iridescences. The occasional frankness of these exposures is usually softened and sometimes quite obscured by brilliant execution and by the worldly finery of the subject, as the Marquise's rose-wreathed coiffure, her six ropes of heavy beads, and her lavish gown with its bows, its gathered folds at the bosom, and its frilly tiered ruffles. The ruffles, especially, are dashed off with a sketchy approximation, the results of which are quite unlike earlier anticipations of this kind of unfocused roughness; they suggest flickering light, little tremulous motions, and even the rustle of rich stuffs. In most of his later busts, especially those planned for marble, this brilliant pictorial effect had to be transposed into quivering little leaves and flowers and nervous ripplings of cloth; but Carpeaux's astounding quantities of mercurial sketch models continued to explore every possibility of movement, of

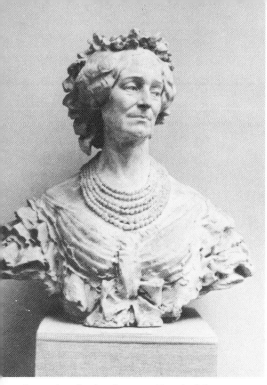

fig. 32. Jean-Baptiste Carpeaux, *Marquise de la Valette,* plaster, 1861, Musée des Beaux-Arts, Valenciennes.

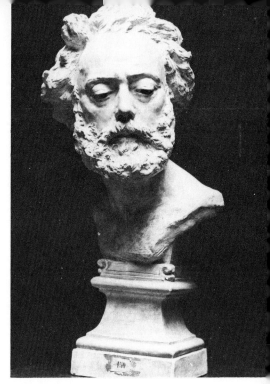

fig. 33. Jean-Baptiste Carpeaux, *Bruno Chérier,* plaster, 1875, Musée des Beaux-Arts, Valenciennes.

transition, of the shaping gesture, of things becoming rather than things become;[21] they set the standard of the new modeling for future masters like Dalou and Rodin. Furthermore, this liveliness of improvisation is in no way inhibited by the fuller elaboration of works like the Roussel relief in this exhibition, (cat. no. 33). Carpeaux's own notions about the importance of his sketch models can be inferred from the fact that he was one of the first sculptors to encourage the manufacture of multiple editions of his maquettes.

The definitive image of Second Empire monarchy, the famous bust of the imperial cousin, the Princess Mathilde, dates from the next year, 1862 (plaster model in Copenhagen; marble in the Louvre; plaster replica in Philadelphia). It is the masterpiece of Baroque revival, its imposing majesty at least rivaling any of the Bourbon busts by French sculptors of the seventeenth or eighteenth centuries. The art reborn here was that of Bernini and Algardi, neither of whose work seems to have occupied Carpeaux very much during his Roman years; at the Salon of 1863 Paul Mantz recognized references to Coysevox and Guillaume Coustou, whose sculpture was a leavened gallicization of the Roman masters.[22]

Carpeaux's unique talents in portraying women have been continuously praised since these first Salon successes—not even his beloved eighteenth-century predecessors equaled him here. Today perhaps some of his secrets can be more readily surmised than before the age of feminism. It would be difficult to think of another portraitist whose women possess the complete human franchise of Carpeaux's (portraits of intrepid old battle-axes hardly count); even Rembrandt's do not quite imply the full equality of women and men as human beings; perhaps Van Dyck's Antwerp ladies more nearly do. The abnormally sensitive Carpeaux seems to have been able to achieve a momentary but total suspension of ego and therefore an extraordinary identity with his feminine subjects: like a completely dedicated actor, he has briefly become them while sculpting them. The inevitable irony is that the least sexist portraits of women ever made by a male artist were the work of a man outrageously sexist in his own life, subjecting his beautiful young wife, a lady of breeding, intelligence, and business acumen, to intolerable rages of jealousy and a variety of cruel abuse.

We can also speculate that Carpeaux's incomparably percipient eye owed something to the experience of photographs, which

have a way of immobilizing things that actually undergo constant change in nature, like posture and expression, at quite different moments from those traditionally chosen by earlier artists. The surprises and revelations of photography must have encouraged him to seek out the unconventional attitudes and nuances of idiosyncratic expression that impart such vivid aliveness to his best portraits. Many of them are less overtly novel or quizzical, such as the handsome bust of Giraud in this exhibition (cat. no. 34), which anticipates later masterpieces like those of the urbane *boulevardiers:* Garnier, the architect, and Gérôme, the painter-sculptor; or the irresistible full-length figure of the Prince Imperial in knickers, with his adoring dog Nero (cat. no. 39), intended by Napoleon III as a heavily silvered bronze pendant to Bosio's famous silver statue of the boy Henry IV. This was imperial propaganda quite unlike the bust of Mathilde but even more cannily calculated for a middle-class constituency, and profitably reproduced in innumerable statuettes of various sizes and materials, even after the fall of the Empire.

Carpeaux somehow managed a final distillation of his portraiture in the deeply moving bust of his beloved and generous friend, the painter Bruno Chérier (fig. 33)

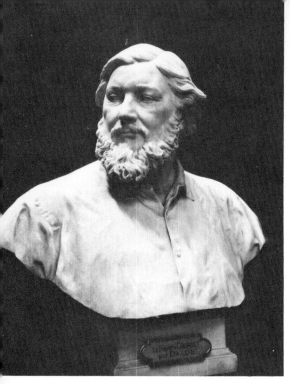

fig. 34. Jules Dalou, *Bust of Gustave Courbet,* marble, 1887–90, Musée des Beaux-Arts, Besançon.

—an artistic last testament produced during the difficult months before Carpeaux's death in 1875. Its verisimilitude is scientifically exact but of magic intensity—as charged with potent feeling as any of David's or Préault's, but modeled with inflections so delicate as to be barely discernible, at once sketchy and precise. As perhaps never before in his brilliant career, the dying man captured life in art.

Although for half a century modern critics have deplored the Second Empire as a nadir of sculpture, in its short span remarkable quantities of highly competent portraiture poured from French ateliers, and many sculptors besides Carpeaux emerged to the acclaim first of Paris and then of educated persons everywhere. They are emerging again today for reappraisal after a half-century's eclipse which was almost total. A ruthlessly exclusive list must include Frémiet, Dubois, Falguière, Chapu, Dalou, Barrias, and Mercié, all of whom were recognized before the fall of the Empire in 1870 and continued to produce interesting portraits for decades afterward. Frémiet, for years strictly an *animalier,* was never a true portraitist (although he turned out admirable busts of the Emperor and of Gabriel Fauré), but during the second half of the century he was the leading specialist in the history-portrait, often in the domestic form of the statuette, a Romantic tradition that

he thoroughly revised in the aftermath of mid-century realism. His trenchant little characterizations (St. Louis, Francis I, Velàzquez) should be the models for modern productions of opera and historical drama of the second half of the nineteenth century. His *Snake Charmer* (cat. no. 144) represents his superb craftsmanship, his scientific yet exotic realism, and his zesty theatrical imagination. It is a true portrait, in this case an ethnological portrait, a genre in which he displaced Cordier.

None of the six other, younger sculptors was primarily a portraitist either, but all made distinguished portraits. Falguière's fine and often lively modeled busts demonstrate the high standards Carpeaux had established in Paris. Although Falguière was famous from his first important Salon success of 1864, he could learn from the innovations of less-rewarded junior sculptors: visitors to this exhibition can assess the debt to his younger friend, Rodin, in Falguière's late marble bust of Balzac (cat. no. 135). In many of his numerous portrait monuments, such as the last, in honor of Alphonse Daudet at Nîmes, Falguière also succeeded in tempering his southern exuberance with certain tinctures of symbolist suggestion and ornament absorbed from younger sculptors of the *fin-de-siècle.*

In their differing ways, Dubois, Chapu, and Mercié upheld more familiar standards of "art as beauty," inherited from such older sculptors as Chapu's master Duret, but revised in the light of new notions about the plausible and the natural. Their goal was sculpture in which nature unmistakably predominates but which can still accommodate aspirations instilled by academic training and fired by the love of Renaissance and antique masterpieces; at its best, theirs is an art of noble, wholesome beauty, of high criteria in form, composition, and execution, and of unexceptionable taste. As such, for cultivated persons the world over, it seemed the finest art of the period. The sober restraint and sincerity of their portraits—such as Chapu's bust of Bonnat from the early 1860s (Louvre) or Dubois' of Saint-Saëns and Pasteur (cat. no. 120)—made them the international touchstone of excellence in portraiture. Their accomplishment was what made young sculptors from all over the world flock to Paris; theirs, essentially, were the ideals that inform the work of such younger Americans as Augustus Saint-Gaudens and Daniel Chester French. Barrias varies this art with heady measures of *fin-de-siècle* exoticism and with a more pictorial craftsmanship, essaying new permutations of Carrier's polychromy, combining colored stones, ivory, gold, and silver, and exquisitely contrasted colored patina-

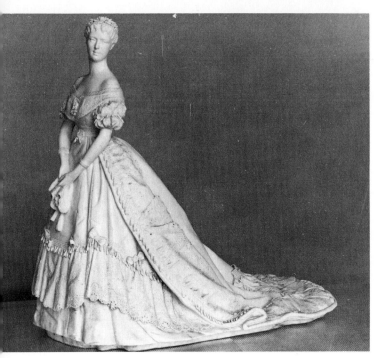

fig. 35. François Willème, *Comtesse Greffuhle*, plaster, c. 1865, Musée des Arts Décoratifs, Paris.

tions of bronze. His more straightforward portraits are much like those of the others. The more vigorous busts by Dalou (fig. 34; cat. nos. 73 and 75) are recognizably indebted to those of his master Carpeaux; they declare a stronger and more extravertedly individual personality than the others of the group and demonstrate extraordinary capacities for more highly inflected modeling, rivaled only by that of Carpeaux and Rodin. Like all of the group, Dalou's respect for prevailing standards in his art precluded the audacities of a genius like Rodin's, and yet for many of his most intelligent contemporaries, what seemed to them an extreme of realism in some of his works was judged bold indeed.

Finally, a word about a characteristic but nearly forgotten phenomenon of nineteenth-century portraiture: Willème's photosculpture (see cat. no. 217), which could turn out busts and portrait figurines such as the charming statuette of the Countess Greffuhle in the Musée des Art Décoratifs (fig. 35). It must be confessed with a little embarrassment that the plaster statuette seems hardly inferior at least to the 1830s portrait figurines, but in any case, at this late date, no sculptor of talent or integrity was interested in miniature portraits unless they could be transformed by *fin-de-siècle* innovations, as in those of Théodore Rivière and Troubetzkoy.

Sculptors of pre-Rodin persuasion continued to emerge long after Rodin. The success of the much older Gérôme as a sculptor actually coincides with Rodin's, but his polychrome bust of Sarah Bernhardt (cat. no. 155)—a quintessential statement of the *fin-de-siècle* in sculpture—is as far from Rodin as Gustave Moreau is from Cézanne.

Nevertheless, the various traditional genres of European portraiture were radically transformed by Rodin during the 1880s and 1890s, after which they could never again be a principal concern of artists in the true vanguard. His early bust of his father (1860) is slightly more daring than the sober contemporary portraits of Dubois and his contemporaries, but that of Father Eymard of 1863 is a masterpiece that seems unthinkable without knowledge of David's *Paganini*, even though there is reason to believe Rodin may not have known it (he certainly knew and admired other works by David).[23]

The fully matured Rodin of the 1880s began to pour forth a series of great portraits. The bronze bust of Maurice Haquette of 1883 (Musée Rodin) presents radically different modeling from the Davidian *Eymard*. in which one sensed especially the pressures of shaping fingers;

now after the extraordinary exploded mass of the *The Call to Arms* (cat. no. 192) the *Haquette* seems modeled more by some kind of eruptive force from within; in Rodin's mature modeling, the intensified alternations of intrusion and protrusion increasingly produce strange blobs and gouges. He does not reproduce appearances but transforms them into expressive equivalents where much is suppressed or distorted, and the goal is to evoke the magnetism of the subject and Rodin's response to it. Especially in his late portrait masterpieces such as the *Clemenceau* (1911) or *Benedict XV* (1915), the sculpture seems the urgent precipitate of the spiritual collision of towering individualities, the subject and the artist. Despite their appearance of extemporization, they were exhaustively pondered, often with much revision.

Two earlier portraits of artists made within months of each other, *Carrier-Belleuse* from 1882 (cat. no. 198) and *Dalou* from 1883 (cat. no. 199), offer some indication of the range of Rodin's response. The marble portraits—the famous *Madame de Morla Vicunbha* is as early as 1884 (Musée Rodin; it is often overlooked that the marble itself is dated 1888)—are mainly of women; they permit Rodin to return to and explore with endless variation the mystery of woman. Rodin's attitude toward the stone is very unlike that of most progressive

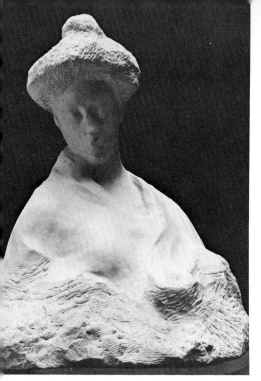

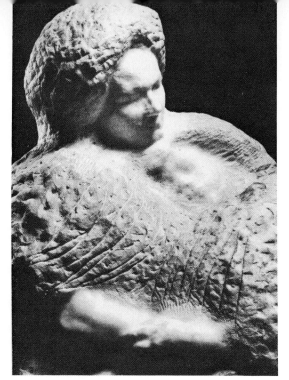

fig. 36. Auguste Rodin, *Madame Fenaille,* marble, 1898, Musée Rodin, Paris.

fig. 37. Auguste Rodin, *Mrs. Thomas Merrill and her daughter,* marble, 1909, Musée Rodin, Paris.

twentieth-century sculptors. Often he chose the most dazzlingly white Carrara marble, for its light-absorptive translucency was the property he needed. When his marbles are installed and illumined effectively, they seem to glow with their own incandescence. The tantalizing mysteries of the unfinished state of many of Michelangelo's marbles inspired Rodin to invent an endless variety of more or less inchoate rough-stone shapes that only in a few passages begin to assume partial, soft-focus readability and in other passages retain the coarse toothing or slashes of the chisels. Michelangelo's had been produced by the direct carving of a truly glyptic, stone-hewing sculptor. By contrast, Rodin worked entirely in clay with frequent trial plaster casts, and then consigned the execution in marble to a *practicien.* Today it is only the incomparably poetic and challenging result that matters: it is an art that can never have a definitive point of arrival, that goes on seeking rather than finding, that asks rather than tells (fig. 36). In one instance, the group of Mrs. Thomas Merrill and her dying daughter (fig. 37), a rough pyramid of marble in which only faces and clasped hands attain hazy representation, the stone was in fact abandoned soon after it was begun; it is a true *non-finito* and one of Rodin's most moving works.

This exhibition reasonably concludes with Rodin and the sculptors of his generation. Innovations in sculpture during the last two decades of the nineteenth century were numerous and eventful, but they relate more to the history of art of our century than of theirs. A less clear-cut case is that of the ceramic sculptor Jean Carriès (1856–1894), whose wild grotesqueries are often in the form of polychrome quasi-portrait busts; they prophesy aspects of Expressionism. The portrait sculpture of Paul Gauguin (1848–1903) occupies an even more central position in the genesis of the sculpture of our century. The early marble portrait of his wife Mette (1877; Courtauld Institute) would have surprised no one had it been exhibited next to a bust by Chapu. But in the bust of Meyer de Haan, (fig. 38) only partially hacked out of an oak log about 1890 (National Gallery, Ottawa), he has rudely rejected all post-Renaissance traditions of representation and execution, and invented a wholly new and idiosyncratic expression, form, and technique. Almost no one could make anything of it then, but soon the grateful, younger artists who would create the art of the twentieth century would build upon its inexhaustible implications.

Notes

1.
Readers should not be misled by David's complaints in his *Carnets* about Houdon's dependence on life-masks, characteristic of the captiousness of private artists' memoirs of the time. He repeatedly includes Houdon on the short list of great sculptors; his own early self-portrait bust (Louisville, 1971, no. 50) seems based on Houdon, perhaps the bust of Dumourier (see G. Chesneau and C. Metzger, *Les Oeuvres de David d'Angers,* Angers, 1934, p. 326, no. 1240) which David eventually owned; this, as well as Houdon's busts of Franklin and Mirabeau, held an important place in his own collection and were left to his native city to be exhibited with his own works. Carpeaux's references to the master sculptors of the French school that culminated in Houdon have been remarked from his earliest Salon entries. Rodin's admiring analyses of Houdon's portraits remain unequalled; see *On Art and Artists,* New York, 1957, pp. 137 ff.

2.
I am indebted to Peter Fusco for his observations on Chinard's portraiture.

3.
Had a characteristically polished marble ever been made of this work, of which the plaster in Lille seems to be the earliest version of many, one wonders whether it

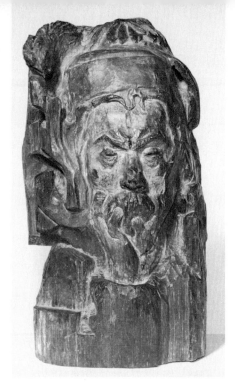

fig. 38. Paul Gauguin, *Portrait Head of Meyer de Haan,* wood, 1890, National Gallery of Canada, Ottawa.

would have seemed quite so pre-Romantic. The handsome bronze casts, such as that in the Birmingham Museum, have the appearance of later foundry and are therefore, not surprisingly, more Romantic-seeming.

4.
See Dowley, 1957, pp. 259–77.

5.
Thoré, 1870, p. 157.

6.
The most complete early statement is by Dr. Bigot, president of the Angevin Société de Médecine, delivered on Nov. 17, 1839; see Jouin, 1878, I, p. 342. A later comment in Blanc, 1876, p. 139. Among many others, Gustave Planche repeatedly mentions this dependence, eventually finding it excessive in an essay of 1850; Planche, 1853, II, pp. 117–18.

7.
Planche, 1855, I, p. 56; this is a reprint of Planche's 1831 review of the Salon of that year.

8.
See A. Bruel, ed., *Les Carnets de David d'Angers,* Paris, 1958, I, pp. 198–99; 201–2; This indicates that David returned to Paganini for later, further sittings, the purpose of which must have been to make revisions. See also ibid., II, p. 215.

9.
Gois' *Joan of Arc* in Orleans (1803–4) and Raggi's *Bayard* in Grenoble (Salon of 1822), both monumental bronzes known to David, are acutally unthinkable in any medium but bronze; but their imagery is characteristically *style trouvère* and their surfaces have been so elaborately chased that they are more carvings than modelings. Neverhteless they are important early steps.

10.
See cat. nos. 26a–c.

11.
H. de Morant, *David d'Angers et son temps,* Angers, 1956, p. 74, pl. X.

12.
A. Jal, *Salon de 1833: Les Causeries du Louvre,* Paris, 1855, II, Salon de 1836 (reprint of article of 1836), p. 323.

13.
Planche, *Salon de 1836,* 1855, II, p. 323.

14.
Reproduced in Paris, Hôtel de la Monnaie, *David d'Angers,* exh. cat. by F. Bergot, 1966, p. 111, no. 132.

15.
Le Figaro, Jan. 15, 1879, and comments, Chesneau, 1880, p. 136.

16.
See J. Seligman, *Figures of Fun,* London, 1957.

17.
Ibid., pl. x.

18.
Conversation with Fred Licht, c. 1955.

19.
Reproduced in N. Jouvenet, *Carpeaux.* Valenciennes, 1974, p. 43.

20.
L. Clement-Carpeaux, *La Verité sur l'oeuvre de J.-B. Carpeaux,* Paris, 1934–35, I, p. 367.

21.
See the illuminating analyses of the sketch-models and the modeling techniques of Carpeaux in J. de Caso, "Jean-Baptiste Carpeaux," *Médecine de France,* 1965, no. 161, pp. 17–32.

22.
P. Mantz, *Salon de 1863,* Paris, 1863. p. 253.

23.
Philadelphia, 1978, p. 240; entry of S. G. Lindsay. Also, A. E. Elsen, *Rodin,* Garden City, 1963, pp. 108–09.

Images of Workers: From Genre Treatment and Heroic Nudity to the Monument to Labor

John M. Hunisak

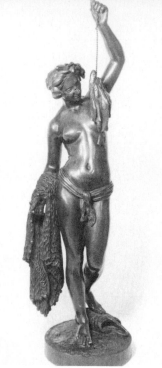

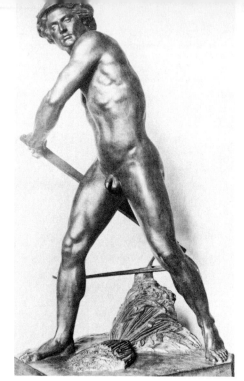

fig. 39. James Pradier, *Allegory of Fishing,* bronze, Musée d'Art et d'Histoire, Geneva, inv. no. 1959-15.

fig. 40. Eugène Guillaume, *Reaper,* bronze, 1849, Louvre, Paris.

Nowhere is the separation between nineteenth-century French sculpture and painting more apparent than in images of workers. If Nochlin was essentially correct when she wrote that "After the 1848 Revolution, the worker becomes the dominant image in Realist art, partaking of both the grandeur of myth and the concreteness of reality,"[1] this generalization holds true only so long as "Realist art" is limited to and equated with painting. Nearly thirty years elapsed before any French sculptor produced a worker as believable as Courbet had created in his *Stonebreakers,* and yet another decade passed before such a worker appeared in the context of a permanently installed public monument.

Given the general lack of familiarity with nineteenth-century sculpture, it is not surprising that this situation has remained unrecognized. In a survey of the titles of sculpture exhibited from the 1840s onward at the Salons, we discover in the *livrets* a certain number that suggest workers of one sort or another. Fishermen and grape gatherers appear with some frequency, as do harvesters. But such "workers" had nothing whatever to do with the contemporary reality of those who labored or with the imagery of Realist painting of the

same period; they are either picturesque genre figures, idealized nudes with an attribute or two who play a masquerade, or perhaps a combination of the two.

Pradier's charming *Allegory of Fishing* (fig. 39) is characteristic of such works. Her classic nudity, as well as her idealized net, fishbag, and prized fish, are at polar extremes from the coarse reality of earning one's living by fishing or selling the day's catch. Like the pleasure-seekers who donned cosmeticized attire of shepherds and shepherdesses to cavort in Marie Antoinette's *petit hameau,* or the endless porcelain figurines that celebrated idyllic rusticity, she is an invented creature who exists only in the realm of fantasy. Strangely enough, even Courbet aligned himself with this tradition when he sculpted. His *Small Fisherboy in the Franche-Comté* is the only three-dimensional work that he ever sent to a Salon. Exhibited in 1863 as a life-size plaster, this figure has no affinity with the workers who appear in Courbet's paintings. Although this adolescent fisherman was identified by his title with a specific region in France, he is no less exotic than the Neapolitan fisherboys of Rude (cat. no. 210) and Duret (cat. no. 122), or their de-

scendants (cat. no. 29). Temporarily abandoning his own Realist aesthetic, Courbet decided that ideal nudity and "fisherboy charm" were appropriate characteristics when he conceived such a figure as a sculpture rather than in two dimensions.

The heroic, adult worker—life-size or larger—entered the history of nineteenth-century French sculpture in the nude and thrived for decades in this unclothed state. The first such figure was created in 1849 by Guillaume while he was a pensioner at the Villa Medici in Rome. After it was shown at the Exposition Universelle in 1855, this *Reaper* (fig. 40) was purchased by the State and put on permanent exhibition at the Musée du Luxembourg, where it inspired many later sculptors. Guillaume himself had been inspired by Bernini's *David,* replacing the sling with a scythe and transforming David's armor into a sheaf of grain. In the process, he imposed a classicist's chill upon the passion of his original model and invented a type that would recur with considerable frequency throughout the century.

Comparable workers often appeared at subsequent Salons. If their labors allowed for an infinite variety of poses, their nudity allied them with the classical tradition of French sculpture and academic training. Ultimately, such workers bore no more re-

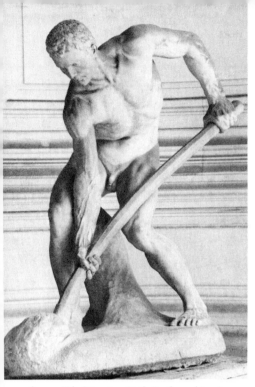

fig. 41. Alfred Boucher, *To the Earth,* marble, 1890, Musée Galiera, Paris.

fig. 42. Laurent Marqueste, *Monument to Waldeck-Rousseau,* marble, 1909, Jardin des Tuileries, Paris.

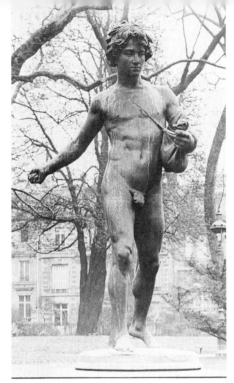

fig. 43. Henri Chapu, *Sower,* bronze, 1865, formerly Parc Monceau, Paris.

lation to contemporary reality than did their predecessors in the genre tradition. Even when descriptive literalness replaced classic idealization, as is true with the fierce concentration and bulging veins of Boucher's figure entitled *To the Earth* (Salon of 1890, fig. 41), the basic conception remained unchallenged. As late as 1909, Marqueste included figures of this sort in his *Monument to Waldeck-Rousseau* (fig. 42). A figure of the Republic escorts two heroic, nude workers before a bust of the great politician. If this particular tradition of worker imagery had always seemed equivocal, Marqueste's monument transcended all bounds of artistic credibility, presaging the afflatus of official sculpture under totalitarian regimes during the twentieth century.

Some indication of various possible interpretations of a single subject can be seen if we compare two works created some thirty years apart: Chapu's *Sower* of 1865 (fig. 43) and another sower, one of Dalou's projects, c. 1896, for a monument to labor (fig. 44). Chapu's life-size figure belongs to the tradition of Guillaume's *Reaper,* idealized in conception and heroic in his state of perfect nudity. Although only a sketch, Dalou's figure clearly belongs to the same race as his prototype in the French countryside, believable in pose and

clothed in the heavy, coarse cloth actually worn by peasants. While both are derived from the pose of Millet's *Sower* exhibited at the Salon of 1850, neither evoked—or could have evoked—a comparably hostile reaction. For Chapu's work, it was fundamental conception that vitiated any inappropriate or threatening associations; the climate in which Dalou's image was created, as well as the frame of mind of its potential audience, had been noticeably transformed by the passage of time.

Not only did Chapu locate his *Sower* in the timeless realm of ideal nudity; he also made fundamental corrections that obliterated all but the most superficial associations with Millet. Every hint of awkwardness was eliminated from the body; the right arm is characterized by a graceful curve, making it harmonious with the perfectly developed torso; the position of the legs has been adjusted to a state of balletic refinement; the hair and face are those of an antique god. Indeed, Chapu at first called the figure *Triptolème,* a mythological hero in the agricultural realm, when he sent it as his *envoi* from Rome to Paris in 1859. Only slight modifications were made before the work appeared as *The Sower* at the Salon of 1865 and Exposition Univer-

selle of 1867, was purchased by the State, and subsequently installed in the Parc Monceau.[2]

Dalou, on the other hand, took every occasion to emphasize affinities between his sower and Millet's famous image. Dalou's clothed figure is comparably coarse and ungainly; he advances with the same aggressive stride, and his arm is at its maximum extension, avoiding any refined formal relationship with his body; his face —or as much of it as we can perceive— reveals crudeness and determination. From the nineteenth century onward, it has been noted that Millet's peasant figures seem to be made of the same substance as the earth upon which they labor, and this observation remains appropriate if applied to Dalou's *Sower.* Indeed, the relief on the socle shows a peasant on hands and knees in direct contact with the earth, working alongside a plow horse. It might be argued that this reading is possible only because we are looking at a sketch and not a finished work, but even Dalou's completed figures of peasants are comparable to those of Millet in this respect. One of Dalou's last works, a life-size figure known as the *Grand paysan (Great Peasant,* fig. 45), is illustrative. The completed plaster was in Dalou's studio at the time of his death. When it became known that he had re-

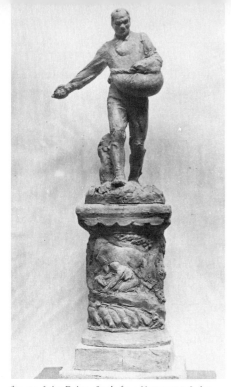

fig. 44. Jules Dalou, *Study for a Monument to Labor,* terracotta, c. 1896, Musée du Petit Palais, Paris.

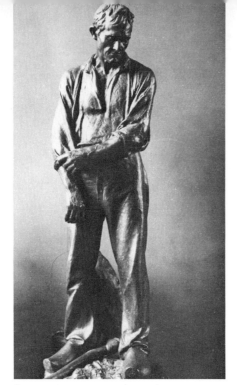

fig. 45. Jules Dalou, *Great Peasant,* bronze, c. 1900, Louvre, Paris.

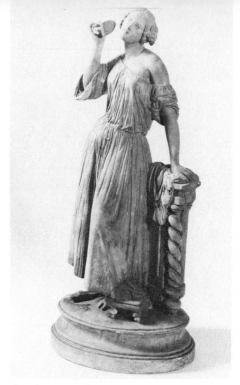

fig. 46. James Pradier, *Ironing Woman,* plaster, c. 1850, Musée d'Art et d'Histoire, Geneva, inv. no. 1910—222.

garded the figure as his legacy to future sculptors, it was cast in bronze and placed in the Musée du Luxembourg.[3] With absolute simplicity and unselfconsciousness, this peasant-worker pauses from his labor in order to roll up his sleeve. This moment of repose contrasts noticeably with the vigor of Dalou's *Sower,* but their underlying affinity cannot be questioned. They are both men of intrinsic dignity, as basic and uncomplicated as the cloth from which their garments have been fashioned. They belong to the earth, which supplies a livelihood in return for their unceasing labor, just as surely as gravity holds them in place and creates a downward pull on their coarse clothing.

Reasons for the contemporary success of Chapu's *Sower* are easily understood. With so many past associations to obscure the fact that this is a worker, there was no danger that any critic or viewer might associate this figure with the present or, by implication, with social and political problems of the present, as had occurred with paintings by Courbet or Millet. Who could be outraged or even mildly threatened by such a civilized worker, an ideal nude figure with an implied provenance that stretched back to antiquity? Indeed, this sort of worker image was acceptable enough to receive imperial patronage. At the Salon of 1866, Iguel ex-

hibited a plaster model of his figure *The Laborer,* commissioned for the Tuileries Palace, and we can be sure that this statue belonged to the tradition of workers in the manner of Guillaume and Chapu.

Exactly what response would have greeted a work like Dalou's *Sower* had it appeared during the 1850s or 1860s is by no means certain. In its capacity as image there is surely no implied anger or savagery in this or any other work by Dalou, and these are precisely the implications which disturbed critics when Millet's *Sower* appeared at the Salon of 1850. At the same time, Dalou's workers are closer to the Realist objectivity of Courbet's *Stonebreakers* than any other figures that occur in nineteenth-century French sculpture, and they might well have been received with comparable hostility.

Whether such subjects would have been considered fitting for the medium of sculpture is less a matter of conjecture. During the 1850s and 1860s, Dalou's *Sower* would surely have been regarded as an affront to the inherent dignity of sculpture. Concentrating on the tangible present in its mundane forms was, after all, something which even Courbet had avoided in his *Small Fisherboy.* The prevailing belief in the gravity implied by the medium was

aptly summarized by Charles Blanc's dictum that "sculpture's creations externalize among men the presence of a superior beauty in visible and tangible forms which manifest the spirit."[4] Dalou's *Sower* contradicts all such notions of "superior beauty" and "manifestation of the spirit." For him, tangible reality was the basis for all art, and the power of his workers as both image and sculpture implies that modern labor was the most worthy aspect of contemporary reality.

The truth of the matter is that, given the climate of the 1850s and 1860s, nothing vaguely comparable to Dalou's workers was created in the art of sculpture. A figure like Pradier's *Ironing Woman* (fig. 46) stands as an anomaly, even as a statuette not made for public exhibition. If her dress, casually cast-aside shoe, and iron are believable enough for a laundress, her coiffure, expression, and pose suggest a classical goddess lost in mid-century Paris and afflicted with an earache. Daumier's terracotta *The Burden* (c. 1852)—a woman who struggles with her heavy load and is accompanied by a child—is another statuette created in a private situation, probably as a three-dimensional study to aid in the execution of paintings with the same subject. The small, undated sketch of a butcher which has been tentatively associated with Daumier might be placed in

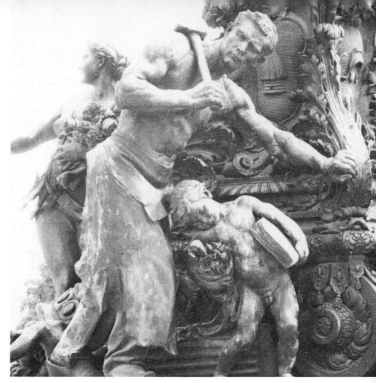

fig. 47. Jules Dalou, *Blacksmith and Child,* from the *Triumph of the Republic,* bronze, 1879–99, Place de la Nation, Paris.

the same category of nonpublic works which experiment with imagery that had not yet become the domain of "serious" sculpture.

With Dalou's competition sketch of 1879 for a monument to the Republic, a new kind of worker was introduced into French sculpture. This blacksmith, accompanied by a child who carries attributes of labor (fig. 47), helps propel the Republic's chariot forward. Here we encounter a modern workman who wears the traditional apron and *sabots,* has a certain forceful dignity, and assumes an unmistakable role in present-day social and political circumstances. But by 1879, such an image no longer implied any social threat or artistic impropriety. A major and unmistakable transformation in attitudes had taken place, and sculptors became free to celebrate without opposition—indeed, with encouragement from all sides—the same kinds of workers who had once provoked intense opposition. Throughout the twenty-year history of this monument's genesis, including the competition of 1879 and inaugurations in 1889 and 1899, occasional objections were expressed about the Rubensian exuberance of the entire ensemble, but not a single voice was raised in opposition to Dalou's blacksmith.

Dalou, the greatest *imagier* of contemporary labor in nineteenth-century French sculpture, was an artist whose personal convictions, as well as social and political sympathies, coincided with the sensibility of an age at the time of his artistic maturity. One wonders what the content of David d'Angers' sculpture might have been had he lived in an age when there were numerous commissions amenable to his political convictions. Happily for Dalou, who was a socialist, republican, and believer in the moral efficacy of manual labor, no such speculation is necessary. The fundamental conservatism of sculpture as an art form dependent on commissions never stood between him and his convictions. After 1879, the political, governmental, and artistic realities of France began to accommodate imagery that had once been anathema. The worker, who had been introduced to nineteenth-century French art by painters, had become so commonplace that the radical implications of his presence in art had become thoroughly diffused. If Realist painters of the 1840s and 1850s could look to the Le Nains as a source of inspiration and legitimacy within the French tradition, Dalou had no comparable

predecessors in the history of French sculpture. The medieval cathedral reliefs depicting labors of the months were hardly adequate in this respect. This great sculptor of modern labor had to look to other sources, including workers themselves.

On the far left side of Dalou's enormous relief, *Estates General, Meeting of June 23, 1789 (Mirabeau Responding to Dreux-Brézé),* we encounter the second major image of a worker by Dalou (fig. 70). He modeled this relief after the announcement of a competition for a colossal monument to the Constituent Assembly of 1789, the program of which included a relief devoted to this subject from revolutionary history.[5] Although the monument was never constructed, the State nevertheless purchased Dalou's plaster relief, had it cast in bronze by Gonon, and installed it in the main entrance hall of the Palais Bourbon. While the fateful confrontation takes place between Mirabeau and Dreux-Brézé (Mirabeau's statement to Louis XVI's representative: "We are here by the will of the people; only bayonets will remove us."), an anonymous workman is busy moving a heavy bench. His presence can be interpreted in a number of ways. While the great men who are recorded by history make fateful utterances which shape the course of events, the manual worker is a constant factor, one who cease-

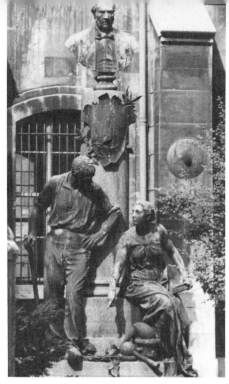

fig. 48. Jules Dalou, *Monument to Boussingault*, bronze, inaugurated July 7, 1895, Conservatoire des Arts et Métiers, Paris.

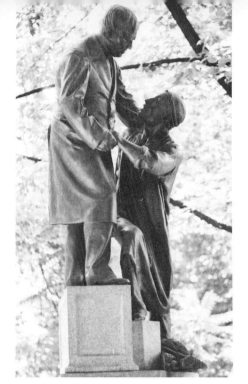

fig. 49. Jules Dalou, *Monument to Jean-Edme Leclaire*, bronze, inaugurated November 1, 1896, Square des Epinettes, Belleville.

lessly tends to mundane needs. Expanding the meaning of Mirabeau's words "the will of the people" beyond what was originally intended, Dalou might have wished to draw attention to the actualities of his own historical present: in the aftermath of the 1848 Revolution, universal suffrage did come into existence, and this workman may symbolize the "will of the people" in some broader sense of that ambiguous term.

When this relief appeared in the Salon of 1883, it was endlessly discussed in the press, but what went unnoticed at that time was the fact that, in basic narrative and formal organization, it reproduced a popular print by Raffet. Henry Jouin, the one critic who noted this similarity, accused Dalou of plagiarism and did not pursue the matter further.[6] Dalou did have problems in dealing with large-scale composition, and the charge should not be dismissed out of hand. At the same time, another possibility must be given due consideration. In basing a relief of major significance upon a popular print, Dalou may have wished to aggrandize the art of the people in a manner comparable to that of the Realist painters and writers of the 1840s and 1850s. If so, the meanings suggested by this worker's presence lose none of their poignancy, but the added dimension of popular reference places Dalou's

intentions within a well-established Realist tradition.

During the 1880s there was a considerable strengthening of the bond between the art of sculpture and the imagery of labor, both in France and elsewhere. There is strong probability that such powerful works of modern Italian sculpture as Orsi's *Proximus Tuus* (1880) and Vela's *The Victims of Labor* (c. 1882) came to the attention of sculptors in France. The Belgian artist Constantin Meunier, who had already exhibited a major painting devoted to modern labor, *The Pouring of Steel in the Seraing Factory (Belgium)*, at the Paris Salon of 1881, sent his first worker in three dimensions to the Salon of 1886. This was an event of major importance for the imagery of labor in France. From then until his death in 1905, Meunier exhibited variations on worker themes in sculpture almost every year at the Salon. These works were received with critical acclaim and much admired by members of the French artistic community.

Three monuments by Dalou that were unveiled in the later 1890s placed images of dignified and believable modern workers in the public spaces of Paris. In each instance, the monument celebrates a famous individual, and workers appear as bene-

ficiaries of that individual's career. These monuments are not well known, but their importance is central to the history of worker imagery in nineteenth-century French sculpture. The role of public monuments had always been to express ideas that had achieved the status of consensus, and these monuments are tangible witness to the place that labor had come to occupy in French society. From 1892 until 1906 was the era of legislation in France that established maximum hours for the working day and a compulsory day of rest each week, as well as regulation of child labor. In 1891, Pope Leo XIII issued his encyclical, *Rerum Novarum*, concerning workers in modern society and the mutual obligations between labor and capital. When the Vatican and the monument makers are concerned with a common issue, it is undoubtedly an idea whose time has come.

Dalou's *Monument to Jean-Baptiste Boussingault* (fig. 48) was inaugurated on July 7, 1895, in the courtyard of the Conservatoire des Arts et Métiers, and it has since been moved to a garden of that same institution. If the format of this monument, with Boussingault's bust atop a pedestal and symbolic figures beneath, is traditional, these figures are new in terms of both imagery and content. The peasant, one of the few works which still pleased its creator

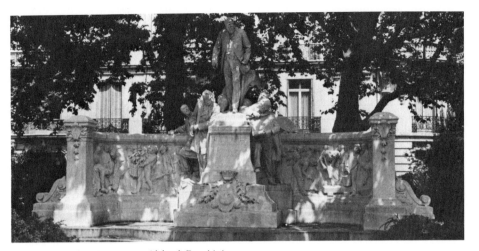

fig. 50. Jules Dalou, *Monument to Alphand,* Dauphiné stone, inaugurated December 14, 1899, Avenue Foch, Paris.

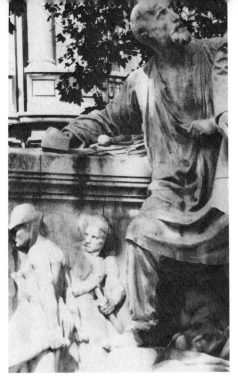

fig. 51. Detail of fig. 50: Dalou's self-portrait as "the sculptor."

after it was completed, is recognizable as a companion to other figures in Dalou's oeuvre: the blacksmith from the *Triumph of the Republic,* the worker of the Mirabeau relief, the *Sower,* the *Grand paysan.* Furthermore, his presence is wholly reasonable in terms of Boussingault's accomplishment as an agronomist whose systematic application of chemistry to agriculture helped transform farming into a modern scientific activity. Dalou's implications are clear: Boussingault's discoveries have improved and will continue to improve the peasant's lot. The seated female figure, whose identity is unclear, might be seen as a modern Demeter who points out to the peasant not only the branch of a plant, but the chemical apparatus which Boussingault used to improve the means by which that plant is grown. A sense of optimism and a belief in progress pervade this monument as it celebrates a wholly modern hero whose accomplishment resulted in significant materialistic improvement.

The *Monument to Jean-Edme Leclaire* (fig. 49) was inaugurated November 1, 1896, on the Square des Epinettes (Belleville). When Dalou learned about the life and actions of the entrepreneur, he developed a strong interest in this self-made individual whose business activity had been house painting. Leclaire's concern for the workers in his employ had led him to share profits

with them and establish a benefit society on their behalf. Those same workers erected this monument in his honor after Leclaire's death.

Rather than the traditional bust and symbolic figures which Dalou had used for the *Boussingault Monument,* here we find a new format. Leclaire is present as a full, life-size figure who plays an active role in conjunction with one of his house painters. This painter wears the traditional smock of urban workers, while Leclaire is dressed in the clothing of a successful bourgeois, including top coat. Reaching out to clasp the worker's left hand and placing a reassuring hand on his right shoulder, Leclaire assists him in taking a step upward. Once again, Dalou's meaning is absolutely clear: the worker's step does not merely indicate an increase in physical altitude, but also a metaphoric advance in status and dignity, aided by Leclaire's philanthropy. On the same level as the worker's left foot, Dalou included a still life of attributes: a sponge, a scraper, and various brushes—the tools of a house painter's profession. Just as the worker and Leclaire stand for themselves, without external reference or formula, so too do these tools exist in their own right, modern equivalents to the traditional

attributes of saintly martyrdom or the historic accomplishments of political and intellectual heroes of the past.

On December 14, 1899, Dalou's *Monument to J.-C.-Adolphe Alphand* (fig. 50) was inaugurated on the Avenue du Bois-de-Boulogne (subsequently renamed Avenue Foch). So great was Dalou's admiration for this Director of Public Works for the City of Paris that he refused remuneration for the six years of labor that went into creating this monument. Alphand, the supervisor of so many projects which gave modern Paris its particular personality, especially its parks and squares, stands above four professional men who surround his pedestal and two friezes of the workers who executed his plans. At the inauguration, Alphand was praised as the one who had transformed the Paris of kings and nobility into the Paris of French democracy.[7] Dalou's reliefs celebrate the workers who physically created modern Paris under Alphand's aegis. Every one of their gestures or stances of repose indicates Dalou's loving study of these men at their labor and his belief in common workmen as unsung heroes of the modern era.

When Dalou chose to include professional men who collaborated with Alphand, he decided that specific individuals would become appropriate personifications of their professions. The architect Bouvard, the

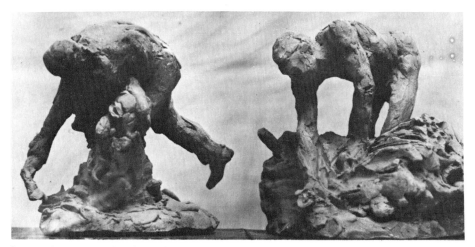

fig. 52. Jules Dalou, *Wood Gatherer* and *Binder of Grain*, terracotta, c. 1894, Musée du Petit Palais, Paris.

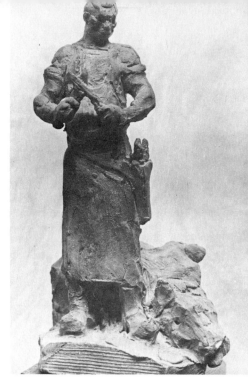

fig. 53. Jules Dalou, *Slaughterer Sharpening his Knife*, terracotta, 1891–95, Musée du Petit Palais, Paris.

painter Roll, and the engineer Huet represent their respective fields of activity; Dalou included himself as "the sculptor" (fig. 51). His personal sense of identity is clearly indicated in this portrait. Wearing a worker's smock and holding a mallet and chisel, Dalou extends his right arm across other tools used by a sculptor in a gesture which can be read as a protective and affectionate embrace. His self-image is as assertive as it is straightforward: Dalou regarded himself as the artist-worker *par excellence* and petrified that image for all time on the *Monument to Alphand*.

Even if Dalou granted unprecedented importance to modern workers on each of these monuments, those workers nevertheless remained subsidiary characters. Their presence must properly be seen in the larger context of commemorating the Republic, Mirabeau, Alphand, Leclaire, or Boussingault. But while Dalou worked on these commissions, he also was planning a more visionary monument that would promote workers from this secondary role to the status of protagonists. The sketch of the *Sower* (fig. 44) is one of many studies for that monument.

According to Dalou's own account, this project dates from the time when his *Triumph of the Republic* was first inaugurated

on September 21, 1889. He came away from that inauguration feeling dismay at the makeup of the attending crowd and later confessed his feelings on that day: "Where was the army of labor hiding during this old-fashioned gala? Where were my *practiciens,* my *adjusteurs,* my casters, and my plaster workers? or the millions of arms which create? or those who labor on the soil? I saw guns and sabres, but not a work tool."[8] As a result of this experience, Dalou resolved to create a monument to those workers who had not been present and who, even on his own monuments, were relegated to subordinate status.

Dalou's fundamental dependence on contemporary, tangible reality as a source for his art is nowhere more apparent than in his gathering of visual data for this monument. Urban workers of his native Paris were always present for firsthand study, but Dalou needed to travel in order to encounter other workers and observe them at their labors. Study trips took him to factories, countryside, and seashore where he made rapid drawings of the workers he saw. These images were subsequently transformed into brilliant clay sketches which

capture not only the appearance of the workers Dalou observed, but their essence as well. Two peasants—one gathering wood and another binding a sheaf of grain (fig. 52)—and a slaughterer—most likely a professional from an urban slaughterhouse (fig. 53)—serve to indicate the extraordinary vitality and animation of these sketches.

Unfortunately, Dalou never found a satisfactory format for incorporating these superb sketches into a single monument. His final plan was for a large column covered with garlands of work tools in relief, beneath which would be workers standing in niches (fig. 54). Various studies for this area of the monument suggest the gravity of medieval niche sculptures, while also evoking the personalities of contemporary laborers. In a series of three rough sketches —a worker with a jack, a slaughterer, and a puddler (fig. 55)—we see the wide variety of workers whom Dalou planned to include on his monument; virtually every aspect of labor in modern French society would have been represented.

Dalou was not the only sculptor to envision a monument to labor in the last years of the nineteenth century.[9] In Belgium, Meunier's monument was actually constructed in more than one version. From 1898 until the end of the first decade of

fig. 54. Jules Dalou, final maquette for the *Monument to Workers,* plaster, c. 1898, Musée du Petit Palais, Paris.

fig. 55. Jules Dalou, *Three Workers in Niches,* terra-cotta, c. 1895, Musée du Petit Palais, Paris.

the twentieth century, Rodin planned a colossal *Tower of Labor* (fig. 56) which, like Dalou's *Monument to Workers,* never got beyond the stage of an elaborate maquette. Whereas Dalou's proposed monument was limited to the glorification of manual workers, Rodin's conception was more universal in scope. As one ascended Rodin's spiral staircase wrapped about a column on which workers would be represented in relief, the kind of labor depicted would change. A crypt beneath the column would be the realm of underground workers like divers and miners. On the column itself, there would be a transformation from manual to mental labor, "from hammers to the brain," as Rilke explained the symbolic pilgrimage of ascending this monument.

Both Dalou and Rodin conceived and designed their monuments to labor in the context of an age and a culture that believed in the efficacy of such an undertaking. Dalou claimed that the concept of such a monument was "in the air,"[10] and the efforts of historian, critic, and fine arts inspector Armand Dayot to have such a monument constructed in Paris by the time of the Exposition Universelle of 1900 corroborated Dalou's perception. At the same time, both sculptors designed their monuments out of a sense of conviction.

They placed physical labor among the highest of human activities and believed in the necessity of building such a monument. Furthermore, both Dalou and Rodin cultivated images of themselves as artist-workers and often spoke about this aspect of their self-perceptions to reporters.

Because work was "the cult called forth to replace past mythologies,"[11] Dalou was convinced that the construction of a monument to labor was particularly urgent in the modern era. Such a monument would serve not only to glorify manual labor: it would also function as a reassuring and didactic symbol, just as monuments had traditionally done. Dalou's feelings about the practical effect of symbols and symbolic gestures were made clear when he spoke about the popular fête planned for the final inauguration of the *Triumph of the Republic* on November 19, 1899. The specific issue at hand was the proposed filing of thousands of workers past his monument. With considerable emotion, Dalou told a journalist, "perhaps [the man who works with his hands] will then better understand that a tool is not merely something made of wood and iron, but that it is

the true force of the country, and that the real heart [of France] beats beneath smocks made of coarse cloth."[12]

Rodin's pronouncements on the subject of work are no less serious but are far more extensive: they have aptly been called "a gospel of labor."[13] Never was he more insistent on the message of that "gospel" than when he spoke to a reporter in 1908 about his *Tower of Labor:*

*The Middle Ages had their cathedrals. The soul of the populace was expressed through them, their stones were like the phrases of a canticle; they sang the enthusiasms of popular faith....
Today, the people believe above all else in work; almost everyone puts his faith in it. Thus it is to work, to work-the-king, that I wish to raise a monument which would be at once architectural and sculptural.*[14]

A half-century before Rodin and Dalou designed their monuments to labor, the theme of workers as modern and believable human beings was rare in French painting and unknown in French sculpture; and yet by 1900 the two great living sculptors of that same nation had invested untold effort in ill-fated monuments meant to celebrate the probity and efficacy of work. With this theme, the art of sculpture achieved a partial detachment from strictures that had often proved stultifying during the preced-

fig. 56. Auguste Rodin, *Tower of Labor,* plaster, 1898, Musée Rodin, Meudon.

ing century. If this union between sculpture and the imagery of labor produced a number of memorable art works, it was also short-lived. The future of sculpture lay elsewhere, but the imagery of workers contributed to the energetic culmination of traditional sculpture before the inherent importance of subject matter gave way to the formal and expressive concerns of early modernism.

Notes

1.
L. Nochlin, *Realism,* Baltimore, 1971, p. 113.
2.
O. Fidière, *Chapu, sa vie et son oeuvre,* Paris, 1894, p. 32.
3.
Official letter explaining why this figure was chosen, dated March 1, 1904. Archives du Louvre, S 30.
4.
From the title of Blanc's "Grammaire historique des arts du dessin," chap. II, *Gazette des beaux-arts,* 1864, XVI, p. 484.
5.
See cat. no. 74 for further details.
6.
Jouin, 1884, p. 96. Raffet's print is illustrated in J. M. Hunisak, *The Sculptor Jules Dalou,* New York and London, 1977, fig. 56.

7.
G. Larroumet, *Discours: Inauguration du monument élevé à la memoire de J.-D.-A. Alphand à Paris le 14 décembre 1899,* Paris, 1899, p. 5.
8.
J. Tild, "Dalou: La genèse d'une oeuvre," *La Renaissance de l'art français et des industries de luxe,* 1920, p. 182.
9.
See especially J. A. Schmoll, "Denkmäler der Arbeit: Entwürfe und Planungen," *Studien zur Kunst 19 Jahrhunderts,* XX, 1972, pp. 253–81, and J. M. Hunisak, "Rodin, Dalou and the Monument to Labor," in the forthcoming *festschrift* for H. W. Janson (Abrams, 1980).
10.
Journal notation by Dalou on April 28, 1897, quoted by M. Dreyfous, *Dalou: Sa vie et son oeuvre,* Paris, 1903, p. 249.
11.
Ibid., p. 249.
12.
P. Forthuny, "J. Dalou," *Revue d'art,* November 11, 1899, p. 22.
13.
A. Elsen, *The Gates of Hell,* Minneapolis, 1960, p. 90.
14.
Le Bâtiment, April 30, 1908.

Allegorical Sculpture

Peter Fusco

Allegorical sculpture entered the nineteenth century as part of an academic tradition of moral and propagandistic expression that for centuries had been vital to civic, court, and sacred life. With varying degrees of consistency and precision, nineteenth-century artists drew upon early source books such as Ripa's *Iconologia,*[1] Boudard's *Iconologie,*[2] and Wincklemann's *Versuch Einer Allegorie;*[3] they also consulted more recent texts such as Chompré's *Dictionnaire*[4] and Huet's *Le trésor des artistes;*[5] and, of course, they were guided by earlier works of art.

In addition to the specific attributes and images adopted from these sources, the nineteenth-century artist inherited a number of attitudes or presumptions about allegory in general. The standard prerequisite for an allegorical sculpture was a human figure (most often female) wearing or bearing attributes which occasionally were secondary figures (e.g., the children suckled by Charity). It was generally understood that allegory encompassed mythological figures commonly regarded as personifications of those traits, situations, spheres, and elements with which they were associated in classical myth (e.g., Venus as Beauty). It was common to employ allegorical sculptures as elements in a series (e.g., the Cardinal Virtues or the Four Seasons). Whether as a series or as

individual figures, when allegorical sculptures appeared in conjunction with the image of a ruler or patron for whom they were created, they played a compositionally subordinate role (e.g., flanking Virtues). There was a tacit understanding that allegorical sculpture should be morally edifying. And, of course, an allegory was intended to be read and understood by the public, however limited, to which it was addressed. All of these presumptions persisted throughout the century and were reflected in the more or less continuous production of traditional allegorical sculpture such as the *Fame* placed at the back of Barrias' *Monument to Victor Hugo* (fig. 57). Works of this type not only remained common but were proliferated through reproductions, usually reduced in size, totally divorced from their original context: allegory for allegory's sake in the form of the independent statuette (see cat. no. 11). Such traditional allegorical sculptures provide the standard against which changes may be observed.

Neoclassical aesthetics, as embodied in the theoretical writings of the late eighteenth and early nineteenth centuries, endorsed Socrates' maxim that "Nothing is beautiful but that which is good;"[6] it followed that allegorical sculpture should, ideally, represent noble concepts. Wincklemann advo-

cated the emulation of antique art which, in his view, "did not present images of vice" and "should employ noble images in its presentations and give to them ideally beautiful forms."[7] These sentiments continued to echo throughout the nineteenth century, perhaps most influentially in Eméric-David's sculpture manual from which the Socrates maxim above is cited. David d'Angers wrote in 1842: "Allegory, when it is very clear, can serve ... by elevating thought toward the high regions of the imagination" and "it aids to render moral sentiments."[8] Henry Jouin, discussing allegory in his survey of the European sculpture scene in 1878, preached that "only noble passions belong to the serious and sincere sculptor because a primordial law demands that marble always be dignified."[9] Sculptor Jules Salmson wrote in 1892 that "Allegory ... will remain the eternal resource of monumental art for translating, by condensing them, the grand thoughts worthy of characterizing a century, its aspirations, progress, beliefs, and its particular genius."[10] For the most part sculptors and patrons adhered to these precepts, thus assuring the continuous production of allegorical sculpture that was presumably noble or ennobling. It is perhaps

best represented in the present exhibition by Chapu's *Truth* (cat. no. 57) and Dubois' *Charity* (cat. no. 118) and *Military Courage* (cat. no. 119). Notably, all three of these bronzes are reductions of works which, like Barrias' *Fame,* originally functioned as adjuncts to the portraits of famous men.

In practice, the tradition of what one is tempted to call "goody-goody" allegorical sculpture held little interest for the Romantics working in the 1830s and 1840s. Rather, they were fascinated with all that was evil, sinister, deviant, deformed, and ugly. Feuchère's *Satan* (cat. no. 137) —strictly speaking not an allegorical work— is typical of these interests as a personification of melancholy evil. David d'Angers, although he expressed a positive correlation of allegory with moral sentiment, executed relatively little allegorical sculpture, generally preferring to render the characteristics of famous men through physiognomic devices and expressive modeling rather than by means of an adjunct virtue. And when he mused about various allegories, as he often did in his writings, those he fantasized tended to be rather dire concepts such as "Adversity without Hope."[11] The oeuvre of the arch-Romantic sculptor Auguste Préault provides perhaps the best indication of the leanings of Romantic allegorical sculpture. Following are the titles of his allegorical,

fig. 58. Auguste Préault, *Tuerie,* bronze, modeled 1834, Musée des Beaux-Arts, Chartres.

or allegorical-sounding, works: *Outcasts, Silence, Grief, Melancholy, Fate, Shame,* and *Misery.*[12] Many of these are lost. None, so far as we know, were commissioned; thus they may be taken as indicative of the artist's personal interests. His most famous work in this vein is entitled *Tuerie,* which translates as *slaughter* or *carnage* (as distinguished from *massacre,* with its Biblical associations). This extraordinary relief (fig. 58) was radically unconventional not only in subject but also in style: the tormented, fragmented figures contrast markedly with the clear, complete, ideal forms of Neoclassicism. A curious detail—much like the titles above illustrations in iconographical handbooks—is the inclusion of the word "TUERIE." On the one hand this seems an unexpectedly prosaic gesture, as if the artist realized that his work was unreadable and he wished to provide it with a built-in label; at the same time, the floating isolated word (without the requisite article "la" preceding it) foreshadows the fragmented verbal imagery of Cubism, Dada, and Surrealism.

Préault represents an extreme case, and the Romantics' penchant for "ignoble" allegory was a relatively sporadic phenomenon. Préault himself, when provided with a commission for two statues on the new wing of the Louvre, was to execute relatively conventional figures of *War* and *Peace* (1855).

The disturbed, enigmatic, dreamlike quality of *Tuerie* was prophetic of many late nineteenth-century works that rejected allegory for symbolism, but it had few immediate progeny. It is even debatable whether one ought to consider Préault's *Tuerie* as an allegorical sculpture at all. Its intensely personal quality not only set it apart from, but also made it antipathetic to, traditional allegorical sculpture which purposely employed stock attributes and depended upon conventions to produce works that could be readily understood. If followed to its ultimate, logical extreme would the Romantic aesthetic—with the value it placed on the unique, the irrational, and the ineffable—have excluded allegory? Was the ultimate Romantic allegorical sculpture a totally private allegory and, thus, a contradiction in terms? Such questions can only be answered by recourse to definitions of "Romanticism" and "allegory" which this essay will not attempt to provide. In any case, it would seem that most allegorical sculpture with themes central to Romantic imagery was realized in relatively small uncommissioned works. It is difficult to imagine a major public monument erected to *Slaughter* (as distinguished from a monument commemorating

a person or persons who were slaughtered) or to *The Genius of Suicide*—the title of a sculpture exhibited by Louis-Victor Bougron at the Salon of 1836.

Public allegorical sculpture was affected, above all else, by political change. In the hundred years following the Revolution of 1793, France saw two empires, two monarchies, and three republics. With each new government there arose the need for monuments which would embody the new political ideals. The result was a proliferation of allegorical sculpture that—in varying degrees and, to a certain extent, regardless of the particular government in power—reflected certain pervasive sociopolitical changes: the separation of Church and State, and the end of absolutism and rule by divine right.

The most obvious expression of these changes is the usurping of the ruler's portrait in public monuments by the allegorical statue. For example, while the pre-1793 plan for a monument in the Place de la Bastille called for a column surmounted by a figure of Louis XVI, when Louis-Philippe later erected a column on the same site (to commemorate the 1830 revolution which brought him to power), he crowned it with a *Genius of Liberty* rather than with his own image. Contemporary critics recognized this as a break

fig. 59. Auguste Dumont, *Genius of Liberty*, bronze, (model for the July Column, Place de la Bastille), c. 1836–40, Louvre, Paris.

with tradition. The *Genius of Liberty* (fig. 59), sculpted by Auguste Dumont, appeared at the Salon of 1836, and one reviewer wrote: "This statue is destined for the July column. We don't know why the government has judged it appropriate to place at the summit of this monument one of these banal mythological [sic] allegories instead of a colossal statue of one of the great men of our revolutionary history."[13] Implicit in this criticism is the assumption that allegory was not as elevated, in the hierarchy of sculpture types, as was the portrait of a great man. In 1892, the sculptor Salmson could still write: "A . . . grave mistake of the Romantics was to place portraits in monumental allegories, instead of [keeping] these latter elements in the secondary divisions of the monument."[14] Nevertheless, Dumont's *Liberty* was erected in 1840, thus symbolizing not only the new political ideals but also the new role that allegory was to play. From its position at the base of the public monument, allegory had been raised and placed on a pedestal. In a world without absolute rule by divine right, it was no longer always possible to embody political beliefs in the image of an individual ruler. One turned instead to allegorical images. A comparable change occurred in the names of city streets and squares; thus, the Place Louis XVI was to become Place de la Con-

corde. As the century moved on, France was covered with a profusion of figures and busts representing Republic, Liberty, Revolution, and France.

Today most of these works appear remarkably bland in relation to the intensity of the political turmoils which spawned them. The elaborate competitions organized in 1848 and 1879 for statues of the Second and Third Republics resulted in unremarkable statues by Soitoux and Morice (fig. 17). Of the more than one hundred paintings and sculptures of Revolution commissioned by the Third Republic during the 1880s and 1890s, hardly any are remembered today. The necessities of expressing an abstract governmental ideal, satisfying a committee in charge of the commission, pleasing an informed and politically diverse press, and communicating with a fickle general public combined to create a process of "banalization" that left few works untouched. Falguière's *Revolution,* commissioned for the Panthéon in 1890, is a case in point. Over the course of ten years, the artist produced four different projects, all of which were eventually abandoned. The most interesting of these, preserved in a bronze cast (cat. no. 134), was found unacceptable; in the end, as his

final project, Falguière produced not a *Revolution* but a *Liberty,* so totally homogenized and lacking in distinctiveness that she might just as easily be read as Joan of Arc, France, a Christian martyr saint, Peace, Victory, or Liberty.[15] The century's most famous figure of Liberty, by Bartholdi (cat. no. 13), is by no means the least banal; it is remembered most of all for its size, location, and the sheer fact that it was completed—this, in itself, an extraordinary socio-political achievement. It would seem that the lack of aesthetic distinction and the potential for realization were two sides of the same coin. In an age without a consensus of faith in absolutes—temporal or spiritual—those images that could express national ideals were iconographic composites that conveyed political compromises. In such a highly politicized arena there was little room for daring or uncompromising reactions. When Rodin participated in the 1879 competitions for a group to represent the Defense of Paris and a bust of Republic, his entries, respectively *The Call to Arms* (cat. no. 192) and *Bellona* (cat. no. 193), received some notice from the press, but they failed even to place among the final projects considered.

Just as civic allegories began to displace images of rulers, so too, with the separa-

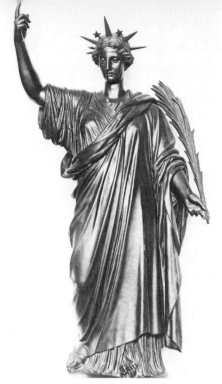

fig. 60. Jean-Pierre Cortot, *Immortality*, bronze, modeled c. 1835, Louvre, Paris.

tion of Church and State, they began to displace a number of religious images. At the Salon of 1831 Antoine Desboeufs exhibited a plaster *Genius of Liberty Breaking the Sword of Despotism* which met with the following critique: "Before the July revolution this statue was a *Saint Michael Overcoming a Demon;* the metamorphosis was brought about cheaply; it sufficed, so it appears, to add a flame on the head of the archangel to make of him a genius."[16] Desboeufs probably believed that with a secular theme his statue would have a better chance of being commissioned in marble or bronze by the new government. The July Revolution of 1830 brought about the secularization of a number of formerly religious buildings, most notably the Panthéon (perhaps the location Desboeufs had in mind for his *Genius of Liberty*).

To replace the cross on top of the Panthéon's dome, the new Ministry of the Interior commissioned Cortot to execute a figure of *Immortality.* The composition of Cortot's work is preserved in a bronze cast from a sketch for the figure (cat. no. 64) and in a bronze reduction of the completed model (fig. 60). Cortot's full-scale plaster model was completed in 1836 and placed in the apse of the Panthéon where it remained until it was destroyed during the

uprising in June 1848. The political passions that had instigated it cooled, delaying its casting, until finally it no longer suited the government in power. Fifty years later a similar fate was met by Falguière's final plaster model of *Revolution,* also commissioned for the Panthéon. But the Panthéon was a site particularly sensitive to political shifts, as the most spotlighted showcase for changing values. Elsewhere, secular allegories would more quietly displace, or appear alongside, religious works. Throughout the provinces, on the facades of the Hôtels de Ville, or in the meeting rooms of the Palais de Justice, the image of the Virgin Mary found a civic counterpart in Marianne, symbol of the Republic; and allegories of civic virtues began to infringe upon the territory formerly reserved for the statue of a city's patron saint.[17] With the separation of Church and State, communal social values, no longer necessarily identified with religious ones, came to be expressed through allegories of civic and patriotic virtues such as heroism, valor, sacrifice, aid, and fortitude. These are the concepts extolled in numerous public monuments symbolizing

Defense or Resistance which, for lack of a victory over the Prussians in 1870, were erected throughout France during the Third Republic (see essay on "The Public Monument"). With increased secularization, one assumes that certain changes also occurred in the depiction of traditional religious allegories, such as the cardinal virtues, but religious sculpture of this period is as yet too little known to draw many generalizations. Perhaps one ought to begin with a study of images of Charity, a traditional religious virtue, eminently laudable from a civic standpoint, one which appealed to social-realist sentiments and was both a symbol of motherhood and a potential secular equivalent to the image of the Madonna and Child.

Cortot's *Immortality* (fig. 60) is symptomatic of a phenomenon that occurred with increasing frequency in public allegorical sculpture of the nineteenth century. It is an allegory arrived at by the conflation of elements borrowed from several other traditional allegories. Except for being female, Cortot's figure has little in common with traditional representations of Immortality, prescribed by Ripa and Boudard[18] as a winged figure dressed in gold or carrying a gold ring and a phoenix.

Cortot's figure bears the martyr's palm, often associated with Victory, and is crowned by a nimbus, the attribute of the sun god Helios and one often associated with Truth. Although Cortot's adoption of these elements for his *Immortality* does not seem particularly incongruous, one is much more likely to identify her as Peace or, as she has been cataloged in the Louvre since the nineteenth century, as Victory. The combining of attributes and their associations is nothing new, but it appears to have become more frequent, almost standard practice for allegorical figures once they had become the center of the public monument. Bartholdi's *Liberty* (cat. no. 13) —a work which probably owes some debt to Cortot's *Immortality*—is a prime example of this syncretistic process, as it has recently been termed,[19] combining attributes or elements from traditional representations of Faith, Truth, Martyr Saint, Prophetess, and Romantic Heroine.[20]

The increased appearance of the conflated or syncretistic allegory is probably the result of the need to compromise and satisfy several conflicting demands which, as we have seen, were placed upon politically motivated allegorical sculptures. In the syncretistic allegory there is a breakdown in the significance of conventional attributes. Their potential for conveying mean-

ing becomes larger in scope and more flexible, but at the same time they are less immediate and vivid. Flexibility breeds blandness.

Even in cases where allegory is not politically motivated, we find repeated complaints in the reviews of the annual Salons about the lack of distinctiveness of one figure or another and about the inappropriateness of a work's title. When Clésinger exhibited his *Melancholy* at the Salon of 1846, Pierre Malitourne noted, "M. Clésinger has chosen for the subject of a statue a metaphysical entity, the personification of one of the most subtle sentiments of the human soul . . . the *livret* calls it *Melancholy;* it would have been able to print, without any inconvenience, *Reverie* or *Meditation*."[21] Two years later when Jouffroy exhibited a *Reverie,* the same reviewer classified it as one of "these motifs that only the moderns have . . . a little artificially made part of their domain."[22] Although Malitourne appreciated both Clésinger's *Melancholy* and Jouffroy's *Reverie* for their beauty and technical accomplishment, he found their intended meaning and their titles or subjects suspect. Théophile Gautier, reviewing the Salon of 1857, suggested of

the sculptor Grabowski's pretentious sounding *Thought and Instinct:* "Perhaps this group was at first only a dreaming young girl accompanied by a dog."[23] Falguière's *Diana* (cat. no. 130), which he might well have called *Hunting,* although much admired by contemporary critics as a statue of a nude, was found unconvincing either as goddess or as huntress. The artist's blasé attitude toward the iconography of his figure is revealed by the fact that, although he posed her as if holding a bow and withdrawing an arrow from a quiver, these traditional attributes were omitted.

It seems clear, both from the works themselves and from contemporary reactions to them, that most of the allegorical Salon sculptures—those not the result of a government or private commission and not intended to fulfill a specific public function—were, if not allegory for allegory's sake, then allegory as pretext, excuse, or simply afterthought. Such allegorical pretexts were employed most often to sanction a display of the female nude. As noted earlier, female figures had always predominated in visual allegory. For example, among the 202 illustrations to the 1611 edition of Ripa's *Iconologia,* 150 depict woman; but only 7 of these—Beauty, Clarity, Grace of God, Heresy, Nature,

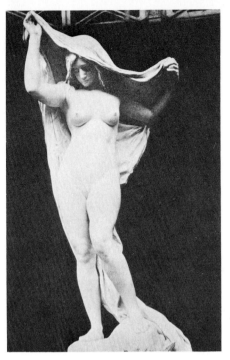

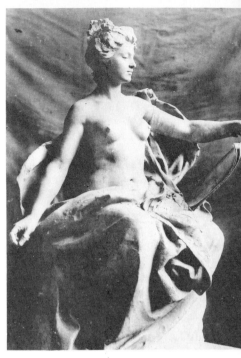

fig. 61. Ernest Barrias, *Nature Unveiling Herself Before Science*, marble, 1893, Ecole de Médecine, Bordeaux (reproduced from *La Sculpture Moderne*, 1896, I, pl. 100).

fig. 62. Félix Charpentier, *Contemporary Art*, terracotta, c. 1895–1900, location unknown (reproduced from *La Sculpture Moderne*, 1901, II, pl. 64).

Pleasure, and Truth—can reasonably be classified as nude. If nineteenth-century artists played free and loose with the attributes borne by allegories, they took even further liberties with the draperies that traditionally covered these figures. By the end of the century, the nude or partially draped female could serve as an allegory of practically anything, including Art, Music, Poetry, Youth or Old Age, Joy or Misery, Innocence or Voluptuousness, Victory, Defense, Gas, Steam, The Bicycle, The History of Philosophy, or Compulsory Non-Denominational Education. Even Gautier, for whom nudity was an essential condition of sculpture, noted in his 1857 Salon review the artificiality of female nude subjects: "how embarrassed statuaries must be to imagine a pretext for the nude without recourse to classical Olympia and to Chompré's *Dictionary.* Bathers, huntresses, young girls removing the petals from flowers, more or less happy personifications, old and renovated allegories, what subterfuges will one not employ with the aim to motivate a bit of torso and to render plausible the small of the back!"[24] Twenty years later the same sentiments were still being repeated in the Salon reviews: "One sees [the public] astonished by the large number of young females, falling out of

their clothes, that the artists march before them each year.... The artists deceive themselves, in our opinion, when they imagine that they seduce the crowd and even their colleagues...in devoting themselves every year to an obvious display of eternal female charms."[25]

The increased frequency of nude female sculpture at the annual Salons was by no means restricted to allegorical works. In general, however, it seems that the nude or partially draped female sculpture, more often a mythological figure during the first half of the century, appears by mid-century most frequently under an allegorical title. Throughout the century, what would seem to be the most popular single female figure from the Bible is the nude Eve (see the essay "Religious Sculpture in Post-Christian France") whom we may view as an allegory of Seduction or Temptation. In a sense the female Salon nude, whatever her purported subject, often intentionally became an allegory of feminine beauty or, even more frequently, of voluptuousness. The latter quality was, in effect, the subject of the notorious work Clésinger exhibited at the Salon of 1847 and to which

as afterthoughts he added a snake and the title *Woman Bitten by a Snake* (cat. no. 58). It was undoubtedly with this work in mind that the following year one critic wrote:

Such astounding successes have been obtained, especially in recent years, with figures of nude women, baptized with one poetic name or another, that nearly all the sculptors have wished to try this route, have believed it easy, and have promised themselves marvels. Each one in his turn has believed himself called to translate the poetry of beauty...each one secretly made too much of the chosen subject.... To attack this inexhaustible subject, feminine beauty, the ancients had one given which belonged to all, an infinite ideal...their eternal Aphrodite.[26]

In the nineteenth century, Aphrodite or Beauty is relatively rare, but the sexy female nude is everywhere. Nature, traditionally the multi-breasted aberrant mother of us all, becomes a voluptuous woman who provides not the milk of life but entertainment in the form of a striptease (fig. 61). *Contemporary Art* is a barebreasted young woman (fig. 62).

During the second half of the century many new subjects entered the domain of allegorical sculpture, but rather than

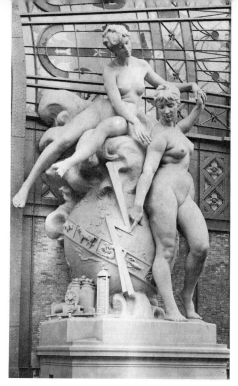

revitalize it, by their very newness they tended to point up its sterility. At the Salon of 1878 Aimé Perrey exhibited a female figure representing *Commercial Loyalty* which was intended, in reductions, to sit upon the counters and cash registers of the Bon Marché department store. Not surprisingly, it was rebuffed by Salon critics who questioned whether such a subject was worth being sculpted.[27] Perhaps the greatest number of new subjects were generated by the Industrial Revolution. At the end of the century one little-studied commercial bronze maker, Picault, seems to have specialized in industrial allegories and personifications of new crafts and métiers. New subjects also entered the mainstream of French sculpture as evidenced by Etex's *Genius of the Nineteenth Century Having Vanquished the Elements by Steam and Electricity* (Salon of 1861) and Carrier-Belleuse's *Industry Bringing Light, Bread, and Abundance to the World* (commissioned in 1865). Allegories of *Steam* and *Electricity* were executed, respectively, by Chapu and Barrias for the Galerie des Machines at the Exposition Universelle of 1889. Such works engendered few typological changes. Barrias' *Electricity* (fig. 63, cat. no. 7) combines old symbols and new—a zodiac-encircled globe and a minature generator—with

the by now familiar voluptuous females who, much like the pretty girls of modern advertising, draw our attention to the wonders of the new product. Commercial allegory at its best, *Electricity* gives us two voluptuous females for the price of one.

Stylistically, within the oeuvre of an artist, the figure types employed to personify a given concept rarely differ. Thus, either of the figures in Barrias' *Electricity* might easily have posed for his *Nature* (fig. 61). Similarly, the same physical type in Chapu's *Steam* is to be found in the artist's *Truth* (cat. no. 57) or his *Christian France* on the tomb of Msgr. de Bonnechose in Rouen. In this respect, these works recall Mannerist allegorical sculpture such as Giambologna's idealized and purposely stereotyped figures, which are pure attribute bearers. It was for Rodin to take advantage of the other great legacy of sixteenth-century Italian sculpture and to follow Michelangelo's search for an expressive figure type that without attributes would incarnate the concept it was to represent.

The counterpart of the voluptuous female in nineteenth-century allegory is the androgynous male nude in the form of a *génie* —a spirit or motivating force that according to antiquity inhabited (sometimes in pairs, one good and one bad) all men.[28] Traditionally the *génie* had been most familiar as a funerary genius, a torchbearing, mourning figure on a tomb (fig. 95). In the nineteenth century he frequently materialized in other contexts. He could appear as an infant and as such would relieve the attribute-bearing putto of his burden, as with the series of *génies* crowning the pediment of the new wing of the Louvre (cat. no. 215). In addition to playing secondary roles on tombs and appearing as part of a series, he could also be the major protagonist in a public monument, as with Dumont's *Genius of Liberty* (fig. 59). In such starring roles and as the center of a group he is most often depicted as a beautiful adolescent like Carpeaux's *Genius of the Dance* (cat. no. 40). Along with these joyous, civic appearances the *génie* continued to be associated with death and dying: René de Saint-Marceaux's *Genius Guarding the Secret of the Tomb* (Salon of 1879); Emile-André Boisseau's *Genius of*

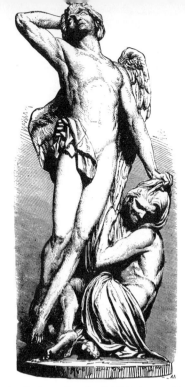

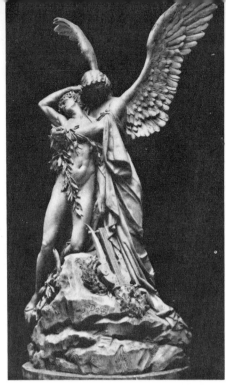

fig. 64. Engraving after Frédéric-Auguste Bartholdi, *Genius in the Clutches of Misery,* plaster exhibited at the Salon of 1859, location unknown (reproduced from *L'Illustration,* 1859, XXXIV, p. 116).

fig. 65. Gustave Doré, *Glory,* plaster, exhibited at the Salon of 1878, location unknown.

Evil (Salon of 1880); and Horace Daillion's *Genius of Eternal Sleep* (Montparnasse cemetery, 1889). In addition to personifying various human endeavors and the essential nature of a person, place, age, or object, the *genie* could represent genius in the sense of the specially gifted or creative person. This would seem to be the case with Bartholdi's *Genius in the Clutches of Misery* (fig. 64) exhibited at the Salon of 1857. Neither contemporary critics nor the artist's biographers provide clues to its meaning, but it is tempting to see it as a Romantic allegory of the misery that every genius is fated to endure because of his special gifts and sensitive nature. Bartholdi's genius may have influenced the later and even more opaque allegory *Glory* exhibited by Gustave Doré at the Salon of 1878 (fig. 65). Here the dying adolescent has neither wings nor a flame on top of his head, so it is uncertain whether or not he is a *génie* proper; but, since he is simultaneously draped in laurel and stabbed to death by Fame, we may view him as a symbol of the genius' plight.

If critics complained, as they did, that Doré's *Glory* was "difficult to decipher," it is little wonder that they were puzzled by Rodin's figure now commonly called *The Age of Bronze* (fig. 66). At least Doré's *Glory* had attributes and it had a title. Rodin first exhibited his work without either of these elements.[29] It was only later that it was given various titles, including *Man Awakening to Nature, The Wounded Soldier. Primitive Man, The Awakening of Humanity.* and *The Age of Bronze.* Unlike traditional allegory, it probably was never intended to represent a single specific subject, nor did Rodin feel the need to justify it with a title. Rodin himself said, "there are at least four figures in it."[30] In Rodin's early works such as *The Age of Bronze,* more than any stylistic innovation it was his attitude to subject matter that was new and different.[31] The subject per se was no longer inherently important or specific, and it could change as the work evolved. This was the beginning of the end of traditional allegory. Eventually Rodin's search to represent human passions through expressive human forms led him to a fragmentation of the human figure. The academic figure and the conventional attribute were, in a sense, twisted and melded into one, resulting in romantically charged symbolic human fragments (see cat. no. 207), the modern extensions of Préault's *Tuerie.* Alongside

Rodin's works traditional allegory did not, as we might wish, go out in a blaze of glory; rather, looking backward, it unmindfully pedaled into the sunset (fig. 67), persisting as a common but *retardataire* idiom of expression.

Notes

1.
First published, without illustrations, in Rome, 1593; for this essay, the following editions have been consulted: C. Ripa, *Iconologia,* Rome, 1603, and Padua, 1611; *Iconologie,* Paris, 1644 (trans. J. Baudoin).
2.
J. B. Boudard, *Iconologie,* Vienna, 1766.
3.
J. J. Winckelmann, *Versuch einer Allegorie,* Dresden, 1766; translated as *De l'Allegorie,* Paris, An. VII (1799).
4.
Chompré, *Dictionnaire portatif de la fable,* Paris, 1801.
5.
J. B. Huet, *Le trésor des artistes,* Paris, 1810.
6.
J. B. Eméric-David, *Recherches sur l'art statuaire,* Paris, 1805; ed. consulted, Paris, 1863, p. 40.
7.
J. J. Winckelmann, *De l'Allegorie,* Paris, An. VII (1799), pp. 51–52.

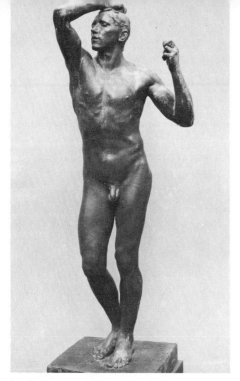

fig. 66. Auguste Rodin, *The Age of Bronze,* bronze, 1875–76, Ny Carlsberg Glyptotek, Copenhagen.

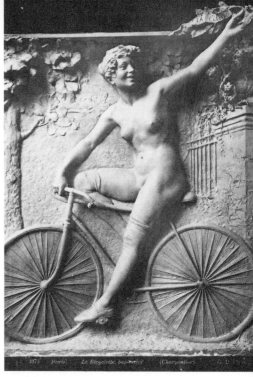

fig. 67. Félix Charpentier, *The Bicycle,* terracotta, c. 1895–1900, location unknown (reproduced from *La Sculpture Moderne,* Paris, 1901, II, pl. 61).

8.
A. Bruel, ed., *Les carnets de David d'Angers,* Paris, 1958, II, p. 124.
9.
H. Jouin, *La sculpture en Europe,* Paris, 1879, p. 198.
10.
J. Salmson, *Entre deux coups de ciseau,* Paris, 1892, p. 348.
11.
A. Bruel, ed., *Les Carnets de David d'Angers,* Paris, 1958, II, p. 230.
12.
All of these works are listed by Lami, 1914–21, II, pp. 114-17, except for *Misery* which is cited by C. Pelletan, "A. Préault," *L'Artiste,* 1879, XXXIX, p. 97.
13.
Unsigned author, "Beaux-arts, Salon de 1836, sculpture," *L'Artiste,* 1836, XI, p. 123.
14.
J. Salmson, *Entre deux coups de ciseau,* Paris, 1892, p. 349.
15.
Falguière's *Liberty* is illustrated in Y. Rambusson, "Quelques oeuvres peu connues de Alexandre Falguière," *Les arts,* 1902, no. 2, pp. 28–32.
16.
Unsigned author, "Beaux-arts, Salon de 1831, sculpture," *L'Artiste,* I, p. 246.

17.
The most perceptive and statistically sound studies of the new imagery and new urban locations of allegorical sculpture are to be found in M. Agulhon's recent publications; see the bibliography at the back of this catalog.
18.
C. Ripa, *Iconologia,* Rome, 1603, p. 223; J. B. Boudard, *Iconologie,* Vienna, 1766, p. 107.
19.
M. Trachtenberg, *The Statue of Liberty,* Harmondsworth and New York, 1976, p. 65.
20.
Ibid., p. 79.
21.
P. Malitourne, "Le Salon, La sculpture en 1846," *L'Artiste,* 1846, VI, p. 187.
22.
P. Malitourne, "La sculpture en 1848," *L'Artiste,* 1848, I, p. 142.
23.
T. Gautier, "Salon de 1857," *L'Artiste,* 1857, II, p. 183.

24.
Ibid., p. 161.
25.
C. Timbal, "La sculpture au salon," *Gazette des beaux-arts,* 1877, XVI, p. 32.
26.
P. Malitourne, "La sculpture en 1848," *L'Artiste,* 1848, I, p. 142.
27.
P. de Saint-Victor, "La sculpture en 1878," *L'Artiste,* 1878, XXXVIII, pp. 226–27.
28.
This definition is taken from Chompré, *Dictionnaire portatif de la fable,* Paris, 1801, II, pp. 454–55.
29.
On *The Age of Bronze,* see especially A. E. Elsen, *Rodin,* New York, 1963, pp. 21–26; J. L. Tancock, *The Sculpture of Auguste Rodin,* Philadelphia, 1976, pp. 342–56; J. de Caso and P. Sanders, *Rodin's Sculpture,* San Francisco, 1977, p. 39–47.
30.
Cited in ibid., p. 31.
31.
This observation is taken from R. Butler Mirolli, *The Early Work of Rodin and its Background,* Ph.D. diss., New York University, 1966, p. 245.

Historical and Literary Themes

H. W. Janson

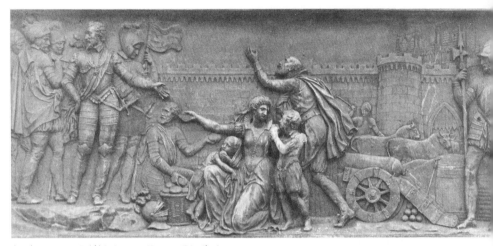

fig. 68. François-Frédéric Lemot, *Henry IV Distributing Bread to the People of Paris,* bronze, 1816–18, bas-relief on the base of the equestrian monument to Henry IV, Pont Neuf, Paris.

This essay must begin with a set of definitions and exclusions. Subjects taken from Scripture or pious texts such as the *Golden Legend* must be classed as religious rather than literary. Those derived, directly or indirectly, from classical Greek or Roman literature have a hallowed aura of their own as exemplars of nobility or tragedy, and hence demand to be categorized as mythological. The Bible, the lives of saints, the *Iliad* and *Odyssey* are all, on some level, records of historic events, however embroidered or disguised; they are also literary works of a high order. Still, we find it difficult to think of them in these terms, and for earlier times, including the nineteenth century, they embodied the authority of revealed truth or profound moral insight. Even subjects from ancient history untainted by mythology and vouched for by Plato or Plutarch, such as the death of Socrates or the death of Germanicus, entered the visual arts as timeless—or timely—moral paradigms, not under the rubrics of history or literature.

What concerns us, then, in speaking of historical and literary themes in nineteenth-century sculpture is secular and postclassical history and literature; yet our field of discussion needs to be narrowed still further in order to set it apart from other categories. We must, first of all,

acknowledge the inherent limitations of sculpture in rendering narrative of any kind. With few exceptions, such scenes are confined to reliefs, which borrow heavily from their counterparts in painting and thus tend to be among the least significant productions of their authors. This is no less true of Lemot's *Henri IV Distributing Bread to the People of Paris* (fig. 68) on the base of the bronze equestrian monument to that monarch on the Pont Neuf (1816–18) than of Carpeaux's *Napoleon III Receiving Abd-el-Kader at Saint Cloud* (1853, fig. 69) or of *Estates General, Meeting of June 23, 1789* (fig. 70), a huge panel more than twenty feet long by Dalou (1883), the most ambitious effort of its kind. Largest of all is the spiral relief of Napoleon's victories covering the column in the Place Vendôme, but the scenes are all but impossible to view even with the aid of binoculars. The motivation behind these works is as varied as the choice of themes: Lemot's *Henri IV* was commissioned by Louis XVIII to replace an earlier equestrian statue destroyed during the Revolution, and the relief on the base was added in order to emphasize the beneficence of that popular monarch and thus to propagandize for the newly restored *ancien régime.* Carpeaux picked his subject

in the hope of attracting the Emperor's attention and patronage. Dalou's relief is a statement of political faith, suitably placed in the Chamber of Deputies, while the column on the Place Vendôme, crowned by Napoleon's statue in Roman Imperial guise, seeks to immortalize his campaigns by proclaiming them analogous to the triumphs of Trajan and Marcus Aurelius.

What these examples have in common—and what makes them representative of their kind—is their goal of converting historic events into enduring myths, notwithstanding the use of meticulously authentic costume. Two of them are outdoor monuments, accessible to all; Dalou's relief is as public as a church altar; and even Carpeaux must have visualized his panel as destined for an important place in one of the public rooms at Compiègne or the Tuileries: his composition clearly reflects the classic surrender scenes familiar from Greco-Roman art. None of the four, however, succeeds in raising its subject to the level of heroic grandeur demanded by artist and patron alike. To achieve this, historic accuracy had to give way to an approach best exemplified by the large sculptural groups on the Arc de Triomphe, among which Rude's *Marseillaise,* (1833–36, fig. 71) is by far the most famous. Its ostensible subject, the departure of the volunteers of

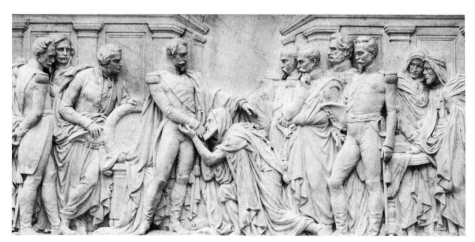

fig. 69. Jean-Baptiste Carpeaux, *Napoleon III Receiving Abd-el-Kader at Saint-Cloud,* marble, 1853, Musée des Beaux-Arts, Valenciennes.

1792 to defend the young French Republic, here becomes a timeless event of mythic splendor: the volunteers, some nude, others in classic armor, surge forward inspired by the winged Genius of Liberty above them, challenging all future generations of Frenchmen to join their ranks. The two heads in this exhibition (cat. nos. 211, 212) convey something of the tremendous *élan* of Rude's masterpiece, helping us understand why it engenders an emotional response in France second only to that of the national anthem itself. The group explodes the limits of relief as much as it does those of historical narrative, and not merely because of its huge scale (it is over forty feet tall); in reality, it consists of figures in the round arranged to form a cohesive entity against the background of a wall. A generation later, Carpeaux was to employ the same mode for his famous group, *The Dance,* on the facade of the Paris Opéra, which is, however, beyond the scope of this essay. (For the central figure, see cat. no. 40 of this exhibition.) Rude's daring becomes strikingly evident by comparison with the other three monumental groups on the Arc de Triomphe. They, too, deal with recent historic events and are constructed like his, but the vital spark is lacking—in part, surely, because

the subjects chosen did not lend themselves to an equally happy solution. The contrast, noted immediately by both critics and the general public, may have served as a warning against further commissions of the same kind. Historic events as subjects of monumental sculpture are indeed extremely rare after the 1830s.

One of the last, and certainly the most fascinating, of these projects is Rodin's *Burghers of Calais* (fig. 72), a monument in honor of six prominent citizens who had delivered themselves into the hands of the English as hostages to lift the siege of the city in 1347. Rodin chose to show them barefoot and in sackcloth, with ropes around their necks, in accordance with the humiliating conditions laid down by the enemy, a decision that offered three advantages: it was historically accurate, it stressed the sacrificial spirit of these civic martyrs, and it circumvented the problem of period costume. There remained, however, the far greater difficulty of how to shape the six figures into a coherent group; what kind of common action could they be made to perform? Rodin's first sketch evokes memories of Rude's *Marseillaise:* on a tall base (lacking in cat. no. 201) suggesting a triumphal arch, the hostages move forward defiantly, only one of them turning aside and clutching his head in

terror.[1] This solution must have struck the artist as too conventionally rhetorical and psychologically implausible. He soon abandoned it, along with the tall base, and concentrated on the character and the individual response of each member of the group. In the final form of the monument, they no longer present themselves as a phalanx; they seem, in fact, hardly aware of each other's presence. What unites them is only their common condition and the low rectangle of ground on which they stand. The beholder, confronting them almost at his own level, is urged to focus his attention on the self-absorbed quality of the figures—unheroic, complex human beings like ourselves. Little wonder the city fathers of Calais, who had wanted a civic-patriotic public monument, thought the *Burghers* a failure. They would have been far happier with Rodin's first design. What Rodin gave them no longer shows a specific event writ large enough to become an exemplary act of heroic sacrifice. It is a monument to humanity in crisis, strangely prophetic of our own twentieth-century experience.

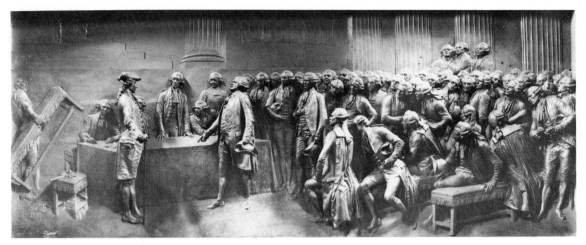

fig. 70. Jules Dalou, *Estates General, Meeting of June 23, 1789 (Mirabeau Responding to Dreux-Brézé)*, bronze, 1883, Salle Casimir-Perier, Chambre des Deputés, Paris.

In contrast to historic narrative, the portrayal of historic personalities was one of the major fields of nineteenth-century sculpture. Portraiture as such had been a firmly established sculptural task ever since the days of ancient Egypt and, in more recent times, had achieved new importance because of the interest of the Renaissance in individual likeness. Yet, from the Quattrocento until the late eighteenth century, portrait sculpture was almost wholly devoted to the living (or, in the case of tombs, the very recently deceased). Apart from ancient rulers and classical philosophers or poets, the memorable personalities of the past hardly ever appear in Renaissance and Baroque sculpture; when they do, as in the bronze statues of ancestors surrounding the Emperor Maximilian's tomb in Innsbruck, they evince no concern with historic accuracy. There are occasional exceptions to this rule (for example, Renaissance busts of Dante and the bronze statue of 1622 honoring Erasmus in Rotterdam) but they are rare enough to be counted on the fingers of one hand. Nor were there any professional portrait sculptors—that is, sculptors who built their careers on portraiture, or *bustiers,* as the French Royal Academy contemptuously called them—before the mid-eighteenth century: the earliest, Houdon in France

and Nollekens in England, were born around 1740.

The expanding demand for portrait sculpture at that time coincides with the growing paucity of large-scale commissions from State and Church. It also reflects two essential aspects of the Enlightenment: the cult of individual genius embodied in the "culture-hero" and a new historic consciousness. These gave rise, in 1776, to an ambitious venture conceived by Count d'Angiviller, the head of the Royal Academy, that was to place the sculptured portrayal of historic personalities on a new basis: the series of marble statues of the *Great Men of France* for the Louvre, which was then being turned into a museum (they are now in the Palace of Versailles). Their purpose, characteristically, was to "reawaken virtue and patriotism" among the people. Four statues were commissioned every two years. In keeping with the aim of the project, the sculptors provided small-scale replicas for reproduction in porcelain to make the series accessible to the general public. Count d'Angiviller not only chose the subjects but laid down two rules: each Great Man must be shown in correct historical costume and "at

the most significant moment of his life." The selection, significantly enough, honored "culture-heroes" of the past and civilians noted for courage or honesty along with military men. Since the series did not include semi-legendary figures from the distant past of the nation such as Vercingetorix (the earliest members are late medieval), the requirement of authentic costume posed no difficulty. The "significant moment," on the other hand, proved a mixed blessing: in demanding active poses, it avoided the deadening dullness of a series of standing figures, but the significance of the action was apt to elude the beholder unless he knew the moment in question and could, as it were, supply the missing actors involved in the dramatic situation. Nor was it always possible, especially in the case of "culture heroes," to locate *the* most significant moment of a lifetime. As a consequence, the requirement came to be interpreted more and more loosely among the countless nineteenth-century successors of the *Great Men:* the most significant moment became a significant moment or simply a significant or characteristic activity. What remained, however, was the demand for action, for authentic costume, and, whenever possible, for authentic likeness (see the essay on "Portrait Sculpture").

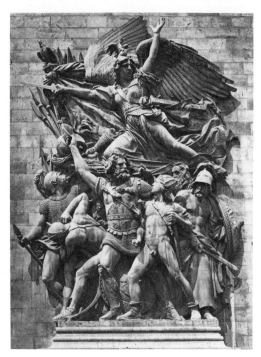

fig. 71. François Rude, *The Departure of the Volunteers (The Marseillaise)*, stone, 1833–36, Arc de Triomphe, Paris.

The *Great Men* series became the model for innumerable public monuments honoring historic figures of every sort throughout the nineteenth century. The category "public monument," however, embraces a wide variety of other subjects as well and thus falls outside the scope of this essay (for its evolution and typology, see the essay on "The Public Monument"). Programmatically, the only direct descendant of the *Great Men* is the cycle of *Famous Women of France* planned and executed in 1846–50 for the Luxembourg Gardens; the twenty marble statues, most of them of rather modest quality, demand to be classed as garden sculpture rather than public monuments. There are no "most significant moments" here, and barely a hint at characteristic activity. Perhaps the causes of their fame did not lend themselves to visual display or, if they did, would have been viewed as "unwomanly." The cycle was intended to include Joan of Arc (by François Rude, 1852, Louvre, Paris), whose triple role as folk heroine, saint, and political symbol exempted her from such inhibitions. She represents a special and unique category in French sculpture (see cat. nos. 8, 9, 121, 141, 168, 173). The other Luxembourg ladies, an unduly con-

servative and timidly chosen lot, reflect all the failings of the last years of Louis-Philippe's reign.

The male descendants of the *Great Men* fared somewhat better, although individually rather than as members of series. What interests us here is not their function as public monuments but the public's seemingly limitless demand for small-scale replicas in bronze, terracotta, or plaster, continuing the tradition of the miniature porcelain versions of the *Great Men*. These "reductions" could be produced with great precision from the full-size model by various mechanical devices such as the patented "procès Colas," or the artist might provide them directly, using his own maquette. While their popularity can be explained by the Romantic fascination with the past and especially with great men as the makers of history, some share will also have to be assigned to the fact that most of these statues are alive with "significant action," which often makes them visually more effective at close range and on a small scale than they are when viewed at a distance as public monuments. This is as true of David d'Angers' *Grand Condé* (cat. no. 92), an early work commissioned by the State in 1816 and closely akin to the military heroes of the *Great*

Men series, as it is of his *Gutenberg* (cat. no. 102), done for Strasbourg more than twenty years later. The great printer in his painstakingly detailed costume, displaying a sheet with the words *Et la lumière fut* (And there was light), which he has just extracted from the press behind him, can hardly be called a monumental figure; he projects poorly at a distance but is a delight as a statuette.[2] Much the same may be said of Dalou's theatrically proud *Lafayette* (cat. no. 74) and of his brooding *Lavoisier* (cat. no. 77), occasioned by the centenary of the great scientist's execution and memorably evocative even today. Lavoisier's mental anguish may relate to the pangs of intellectual labor as much as to his imprisonment.[3]

In the wake of these reductions there arose, from the 1830s on, what might be called "mini-monuments," statuettes of historic figures that were never meant to be public monuments but were intended from the start for the table top or mantelpiece of the private collector. Barye did several, including the equestrian *Charles VII Victorious* (cat. no. 20), echoing Verrocchio's *Colleoni* and historically accurate except for the horse, a modern breed of Arabic ancestry

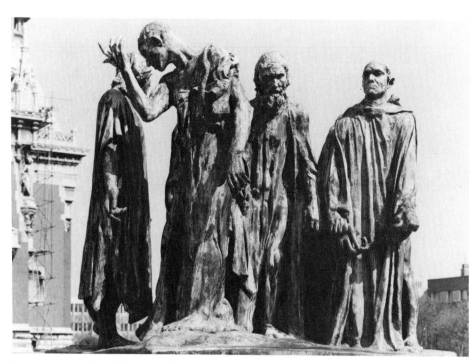

fig. 72. Auguste Rodin, *The Burghers of Calais*,
bronze, 1884–86, in front of the Town Hall, Calais.

too lightly built to carry a man in full armor. These mini-monuments often come in pairs: Carrier-Belleuse's *Raphael* (cat. no. 45), pausing on a flight of steps, has a companion, *Michelangelo,* in the Staatliche Museen, Berlin-Dahlem. Feuchère's *Cellini* (cat. no. 138) is meant to gaze at a thoughtful *Palissy.* Such statuettes have the self-contained dignity of large-scale statues; they demand a pedestal, as it were. Meissonnier's *Marshal Ney* (cat. no. 164), in contrast, grimly battling an icy wind, evokes the horrors of Napoleon's retreat from Russia, so often depicted by Meissonnier himself and many others before him. We are expected to visualize him at the head of an army in desperate straits, against the background of an endless wintry plain. It is a monument-without-a-pedestal, like the *Burghers of Calais,* devoid of drama or rhetoric. What it celebrates is not military glory but the determination to survive in the midst of catastrophe—a far more subtle tribute to Ney's greatness as a military hero than any of the monuments in the "significant moment" tradition.

The new importance of portrait sculpture during the last third of the eighteenth century is most strikingly evident in the vogue for busts of the leading figures of the Enlightenment, displaying "the physiognomy of genius." Houdon's busts of

Diderot, Voltaire, and Rousseau generated such a demand for replicas that their number, in marble, bronze, terracotta, and plaster, must be in the hundreds, not to mention variants and reductions. His portraits of the harbingers of the American Revolution, Benjamin Franklin and John Paul Jones, enjoyed a similar success. This fascination with "the physiognomy of genius" soon extended to the culture-heroes of the past and gave rise to reconstructions of their "living presence" based on whatever visual sources were available. The busts of the three great French playwrights of the seventeenth century—Corneille, Racine, and Molière—in the foyer of the Théâtre Français do not date from their lifetime (none was made then) but were done by Houdon and his contemporaries. They are the forebears of what was to become a veritable flood of such busts in the Romantic era. Carrier-Belleuse produced a greater variety of subjects than any other sculptor to feed this appetite, by no means limited to French culture-heroes, as evidenced by his busts of *Milton* (cat. no. 54) and *Murillo* (cat. no. 52).[4] They offer an interesting contrast: *Murillo,* derived from reliable visual sources, looks like a courtier rather than a painter, while

Milton, for whom such sources were not available, is in essence an imaginary portrait, the blind genius absorbed in listening to his inner voices. Whether Falguière's *Balzac* of 1899 (cat. no. 135) belongs in the category of historic portraits seems doubtful, even though it was made forty-nine years after the great writer's death. The features of Balzac were known from an abundance of earlier portraits, including photographs, so that the bust is more accurately described as the posthumous portrait of a near-contemporary (the lives of artist and sitter overlapped by nineteen years). In 1891 Rodin had been commissioned by the Société des Gens de Lettres to design a monument to Balzac (see cat. no. 205 for one of his studies) but his model, exhibited in 1898, created a scandal and was rejected. The Société then transferred the assignment to Falguière, who produced a more conventional monument while retaining some important aspects of Rodin's. Our bust is an "excerpt" from Falguière's monument, a modified version of his model for the head of the figure; the rough, "unfinished" treatment of the truncation juxtaposed to the soft, "veiled" carving of the face reflect the influence of Rodin, whom Falguière admired. Such "excerpts" had the same purpose as reductions—to make public sculpture accessible to the private collec-

tor. Both practices originated in the late eighteenth century and died out in the early twentieth. Falguière's *Balzac* is among the last examples (for earlier ones, see the two heads from Rude's *Marseillaise* (cat. nos. 211, 212).

The posthumous portraiture of near-contemporaries, although not unknown in sculpture before 1800, achieved a new significance in the portrait medallions of David d'Angers. There are more than five hundred of them, ranging in date from the early 1820s to 1854; David called them his "gallery of great men" (he also included a number of women). The choice of subject was indeed entirely his own, determined by personal admiration and reflecting a characteristically Romantic perception of history. Victor Hugo told David that these medallions were "the bronze coins that will pay your entry to posterity." To David himself, profoundly convinced that physical appearance mirrors the soul, they were a new kind of monument, accessible to all, and destined to "moralizer le peuple" by perpetuating exemplars of greatness. Hero worship was not only his passion but also a moral and aesthetic command. If the great majority of his subjects were the artists and thinkers of his own time (see cat. nos. 93–97), he reserved a special niche in his pantheon of genius for the makers of the

French Revolution, from Marat to the young Napoleon. Those few who were still alive in the 1830s he went to great lengths to seek out (such as Rouget de l'Isle, the author of the Marseillaise, whom he found living in poverty), but most of them were long dead, so that he had to reconstruct their features from whatever visual sources he could find. His medallions are almost invariably much superior to these. There is no little irony in the fact that so many of the great names of the 1790s owe their most memorable portraits to David's sense of mission during the reign of Louis-Philippe and the short-lived Second Republic.

Horace's famous dictum, *ut pictura poesis,* proclaiming the fundamental kinship of painting and poetry, was never extended to sculpture until the Romantic era. Victor Hugo could address David d'Angers as the "Poète du marbre," and David, in turn, admired and befriended the writers of his day far more often than he did the painters and sculptors. In his "gallery of great men," authors form by far the largest group; those whom he revered as truly major figures (Goethe, Tieck, Victor Hugo, Balzac, Chateaubriand, Lamartine, Béranger) he honored with over-life-size

marble busts which he presented to the sitters—a generous form of homage unparalleled in the history of sculpture. Despite his deep attachment to literature, however, David never chose a literary theme for any of his works. On the other hand, he himself and his art could, on occasion, become literary themes: in 1828, Victor Hugo wrote an "Ode to David," and Marceline Desbordes-Valmore expressed her admiration for his *Young Greek Girl on the Tomb of Marco Botzaris* in a poem inspired by the statue. Two other examples are "Le Masque" and "Danse macabre," in *Les Fleurs du Mal,* each based on a maquette by Ernest Christophe (1827–1892). Both are described at length in Baudelaire's *Salon de 1859* (section IX, "Sculpture"), which also cites large portions of "Danse macabre," inspired by the figure of a female skeleton in festive dress. This sketch never grew into a statue, and the maquette (which Baudelaire is said to have owned) is lost. "Le Masque" reflects a maquette for *La Comédie humaine.* Fifteen years later, Christophe developed it into a large statue. When he showed the marble version in the Salon of 1876, he adopted Baudelaire's title for it (the statue is in the Jardin des Tuileries). How closely it corresponds to the maquette admired by Baudelaire in the late 1850s is difficult to say, since this maquette, too, has not sur-

vived. Both poems suggest that Baudelaire was inspired by the idea rather than the visible reality of the maquettes.

The use of themes from postclassical literature in nineteenth-century sculpture is a good deal less rare, but it is subject to various limitations that need to be examined. As we have seen, subjects drawn from national or local history could be commissions financed by the public purse; literary subjects, with few exceptions, were not. The Ecole des Beaux-Arts, guardian of the academic tradition, actively discouraged them. They might be admitted to the Salon, but the Prix de Rome, coveted by every aspiring young sculptor, was gained by treating assigned subjects from ancient history, mythology, and, more rarely, religion (see the essay "Learning to Sculpt"). Until the middle of the century the State hardly ever purchased sculpture with modern literary themes. Little wonder, then, that Dante, Ariosto, Shakespeare, Milton, and Tasso, who had provided a wealth of motifs for painters from the later eighteenth century on, did not begin to make their appearance in sculpture until the 1820s. Unfortunately, the earliest examples have not survived; we know them mainly through listings in Salon catalogs, which vary greatly in the amount of information they convey, often omitting the

material and failing to state whether the work in question was a relief or a piece of sculpture in the round. We do learn from them, however, that these older authors, who by then had the status of classics, entered the repertory of French sculpture a full generation later than very recent or contemporary writers. The first hint that sculptors were addressing the reading public is to be found in the Salon of 1787: a relief roundel three feet in diameter by LeComte, *The Unhappy Reader,* described as showing him "furiously turning the pages of a book." Two years later we encounter a scene (obviously also a relief) by Fortin whose description reads like the summary of a rather gruesome novella: a group of travelers has entered the catacombs of Egypt, where they come across two corpses, one of which holds a written message informing the visitors that the two had been robbed by their guides and then locked into the catacombs to die of hunger; as they read these words, the travelers hear their own guides locking the door behind them. The subject surely has a literary source, although I have been unable so far to discover it. Since the "plot" of this Near Eastern "Gothick" tale had to be printed in the Salon catalog, we may

assume that it was not widely known. The relief itself would have been a complete puzzle without the verbal commentary. Intriguingly, there is no title, suggesting that the story is an episode in some larger work of fiction. Another Oriental subject, taken from *The Thousand and One Nights* (which had been available for some time in French translation) was shown by Clodion in the Salon of 1801, again accompanied by a lengthy description, but this time in the form of a freestanding group of figures: a fairy tale about a beauty contest between a Chinese princess and a Persian prince. Meanwhile, however, in 1795 Jean-Jacques Rousseau had invaded the sculpture section of the Salon. Dumont entered two terracotta reliefs, an episode from *Emile,* precisely defined in the catalog, and a scene from *Paul and Virginia,* the immensely popular primitivist romance by Rousseau's disciple Bernardin de Saint-Pierre, showing the two lovers running toward their hut in a rainstorm. A younger sculptor, Chaudet, chose a simpler theme, *Paul and Virginia in Their Cradle.* The persistent popularity of the pair is attested by Charles Cumberworth's plaster group exhibited in the Salon of 1844 (see cat. no. 65). Two years later, the same artist showed a statuette of Marie, another character from *Paul and Virginia;* the plaster model and a bronze cast were acquired by the State, one of the

fig. 73. Félicie de Fauveau, *Monument to Dante,*
marble, 1834, monument destroyed, marble groups
in the Cuvillier Collection, Paris.

earliest purchases of its kind. The bronze group does not represent any specific moment in the story of the two lovers but simply their idyllic "togetherness." Because of their near-nudity, they might well be mistaken for Daphnis and Chloë, their classical ancestors. All that identifies them is a few telltale accessories.

Except for the scene from *Emile,* the earliest examples of literary themes share one common feature, their exotic locale—an Egyptian catacomb, the Arabian Fantasy of *The Thousand and One Nights,* the South Sea island of *Paul and Virginia.* When literary subjects reappeared in the sculpture section of the Salon after a twenty-five-year lapse coinciding with the reigns of Napoleon and Louis XVIII,[5] this Romantic preference for the geographically or culturally remote continued to be a conspicuous trend. In 1827 Félicie de Fauveau exhibited a *sujet tiré du roman de l'Abbé, par Walter Scott,* presumably a medieval scene from one of the Waverley novels. Since the catalog fails to describe the subject, it could have held little meaning for the Parisian public but probably appealed to those attuned to the newly fashionable *style troubadour.* Soon after her self-exile to Florence in 1834, the same artist created a *Monument to Dante* (fig. 73) in the shape of a Gothic tabernacle

showing the tragic lovers, Paolo and Francesca, twice: as an amorous couple on earth and as floating spirits in hell.[6] About the same time, in 1835, Etex displayed a marble relief, *Francesca da Rimini,* in the Salon. The panel, at present untraceable, included Paolo as well; the use of her name alone to identify the subject was not unusual, since she bore the greater burden of guilt, having broken her marriage vows, and hence occupied a more important place in the Romantic imagination. We may assume that Etex showed the illicit lovers' sin rather than their punishment. Of all the sculptors who had depicted the theme since the late eighteenth century, Félicie de Fauveau seems to have been the only one to include the suffering of the pair in the Inferno until we meet them again, half a century later, in Rodin's *Gates of Hell.*

Still more gruesome, but also far more difficult to visualize, was Dante's tale of Count Ugolino and his sons, immured in a tower to die of starvation. Before he died, the father devoured his children. When Carpeaux chose it as the theme of his final project during his residence at the French Academy in Rome, he created not only a great work of art but the most impressive

piece of French nineteenth-century sculpture based on a literary source. Our exhibition shows three stages in the evolution of Carpeaux's design: a sheet of sketches of 1858, a bronze cast after an early maquette, and a bronze reduction of the completed group of 1861 (cat. nos. 30–32). We do not know what moved him to undertake this challenging task. If he was acquainted with any of the pictorial illustrations of the story (there were only a few, none of them at all memorable), he disregarded them; the visual antecedents of his group are to be found almost entirely in the realm of recent French sculpture. The most important of these, Etex's *Cain and His Race,* is an over-life-size group of nudes like Carpeaux's. It too was executed in Rome, in 1832. The plaster model entered the Salon a year later, and in 1839 the State ordered the marble version (Lyons, Musée des Beaux-Arts), which was shown in the Exposition Universelle of 1855, where Carpeaux must have seen it shortly before his departure for Rome. Its mood of utter dejection makes *Cain and His Race* a far less dramatic work than the tense *Ugolino,* but it is a landmark in its own right, the most ambitious monument to the Romantic fascination with evil (see cat. nos. 124–125). Another such monument, the *Satan* by Feuchère, a contemporary of Etex, has left strong traces in the central figure of Car-

peaux's group. Our artist probably knew it from bronze casts such as cat. no. 137, dated 1850, rather than from the original plaster of 1834. Although the Salon catalog entry does not say so, there is strong reason to think that what Feuchère had in mind was the Satan of Milton's *Paradise Lost.* Some years before, in 1827, an older and now-forgotten sculptor, Jean-Jacques Flatters, had exhibited *Le Satan de Milton,* described in the Salon catalog as "the rebellious angel falling into the abyss." The piece (we cannot tell from the catalog entry whether it was a relief or in the round) was destroyed soon after, but some notion of its appearance may be gained from the same artist's illustrations of *Paradise Lost,* posthumously published in London in 1851. Be that as it may, Feuchère's *Satan,* despite his huge bat's wings, is not a grotesque monster but is so close to being human as to arouse a measure of sympathy, even compassion; clearly, he is Satan Defeated suffering the consequences of his revolt, rather than the rebellious angel plotting against the Lord. It is this aspect of the figure that links it with Carpeaux's *Ugolino.*

For Satan as well as for Cain and his race, nudity is "natural." Dante's sinners, in contrast, demand historic costume if they are represented as alive on this earth; it would be absurd to show Paolo and Fran-

cesca in Rimini nude, and no artist ever thought of doing so. The same rule ought to hold for Ugolino and his sons in their tower, yet Carpeaux visualized them as nude from the very start. His reason—if indeed he consciously weighed the alternative—was the deeply held conviction shared with his academic teachers that the nude human body is the sculptor's noblest task, reinforced in his case by a passionate admiration for Michelangelo. On one level the *Ugolino* group can be viewed as a virtuoso academic exercise; the carefully studied expressions of the five heads recall the *têtes d'expression* that were part of every student's experience at the Ecole des Beaux-Arts. One shudders to think what less able hands would have done with the theme. It is a tribute to Carpeaux's genius that we are not tempted to take the group apart, that the tortured Count and his dying sons form a single, breathtaking whole. Still, even he could not have deprived Paolo and Francesca of their costumes without depriving them of their identity as well; there simply were too many competing pairs of young lovers in classical poetry and mythology. Ugolino had no such rivals; hence the well-known subject was not endangered by the nudity

of the figures. Indeed, by removing it from its historic context, Carpeaux endowed his group with a universality he could not have achieved otherwise. It speaks to us as an enduring vision of hell-on-earth, whether or not we happen to know its literary source. Rodin admired it immensely—there are multiple echoes of it in his *Gates of Hell.* Yet the Dantesque motifs in that cauldron of images (*Ugolino* as well as *Paolo and Francesca*) keep such strange company that we would be quite unable to find them if Rodin himself had not singled them out in separate, later works derived from the *Gates.*

The examples discussed so far suggest that the inherent limitations of sculpture in rendering narrative, noted in relation to historic subjects, proved even more troublesome for literary themes. Specific scenes from novels, plays, or epic poems almost invariably appear in the form of small-scale pictorial reliefs, Carpeaux's *Ugolino* being the one triumphant exception, and many of them, as we have seen, needed lengthy quotations or "plot summaries" to be understandable. The problem of identifiability they pose is well illustrated by Préault's *Hamlet Recoiling Before the Ghost* (cat. no. 188): the costumes, the bit of architecture on the right, and the presence of the moon tell us that this is a medieval nighttime scene, but even Pré-

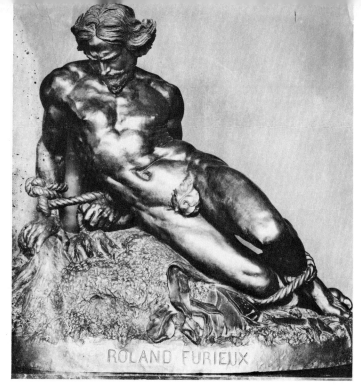

fig. 74. Jean-Bernard Duseigneur, *Roland Furieux,*
bronze, 1867, model exhibited at the Salon of 1831,
Louvre, Paris.

ault, the most resourceful master of relief among nineteenth-century sculptors, could not communicate to the beholder that the figure on the left is an apparition. The intended meaning of the panel becomes clear only if we view it in its original context, on the tomb of the actor Philibert Rouvière, whose most famous role was that of Hamlet; it shows a moment from an actual production of Shakespeare's play, with Rouvière in the title role.

The alternative to narration, far more compatible with the nature of the medium, was to represent a single character such as Milton's *Satan.* The earliest instance of this practice that has come to my attention is the impressive life-size bronze figure of *Roland Furieux* (fig. 74) by Duseigneur in the Salon of 1831, showing the hero of Ariosto's *Orlando Furioso* nude and bound with ropes, in accordance with an incident described in canto 39, of which the catalog provides a lengthy summary. Since the protagonist of Ariosto's poem, although always on the verge of madness, did not remain fettered for long, the summary was necessary to distinguish him from other nude captives that had been part of the sculptural tradition ever since Michelangelo. Duseigneur's figure draws its strength from this tradition. Still,

the danger of confusing one subject with another could prove difficult to evade: Carrier-Belleuse's coquettish female nude bound to a rock (cat. no. 49) might be either Andromeda waiting to be liberated by Perseus or Ariosto's Angelica, who was similarly rescued by Roger. Only the title of the marble statue (of which ours is a terracotta reduction) in the Salon catalog of 1866 informs us that it is in fact Angelica. The Roger-and-Angelica episode in *Orlando Furioso* is, of course, a Renaissance echo of Perseus and Andromeda except for Roger's steed, the miraculously speedy compound animal Ariosto called a hippogriff. Barye's bronze group showing that strange beast with Roger and Angelica on its back (cat. no. 23) would be hard to distinguish from any number of abduction scenes of song and story if the two were on a horse. There are nevertheless a number of unmistakable literary characters, such as the Mephistopheles of Goethe's *Faust,* who seems to have succeeded the Miltonian Satan as a sculptural subject at midcentury. The Salon of 1853 included two, both of them statuettes soon to be cast in bronze. One of these, Gautier's oddly haggard and elongated figure (cat. no. 149), is immediately recognizable by his cloven

hoof, his sly, conspiratorial pose, and his medieval costume. Faust himself and his beloved Gretchen, on the other hand, hardly ever appear in sculpture;[7] although familiar enough to the French public, especially from Gounod's opera of 1859, they were not clearly identifiable in isolation. The same may be said of most of Shakespeare's characters: I have looked in vain for Hamlet contemplating the skull of Yorick, which would seem to be a feasible subject for sculpture. There exist, however, some Ophelias; the most important is the life-size bronze relief by Préault (fig. 75) in the Musée des Beaux-Arts, Marseilles, from the plaster model of 1850, that shows her floating in her watery grave.[8] Dante, as both author and protagonist of *The Divine Comedy,* enjoyed a unique position; the Trecento poet was honored in portrait busts and statues while Dante and Virgil combined, as in Triqueti's bronze group (cat. no. 216), show the fictional hero of *The Divine Comedy* with his guide.

The most puzzling and complex aspect of our topic, explained only in part by the identifiability problem, is the almost total absence of themes or characters from nineteenth-century literature in the sculpture of the time. (Goethe's *Faust,* conceived as early as 1775, still belongs to the late eighteenth century.) That Stendhal,

fig. 75. Auguste Préault, *Ophelia,* bronze, 1876, model exhibited at the Salon of 1850, Musée des Beaux-Arts, Marseille.

Balzac, and Zola yielded no subjects for sculptors is understandable enough, but why does the same hold true for the great Romantics, from Byron and Victor Hugo to Dumas *père et fils?* Could we not, at the very least, expect to find a Childe Harold or the Three Musketeers?[9] Even Chateaubriand's *Atala,* published in 1801 and reissued in countless editions in France and abroad during the next half-century, inspired only one piece of sculpture of any significance: Duret's life-size bronze, *Chactas Mourning at the Grave of Atala* (fig. 76). The burial of the heroine, depicted in Girodet's famous painting and several less well known ones, attracted not a single sculptor, it seems. Neither did the love idyll of the Indian brave and maiden during their wanderings in the forest, probably because the subject had been preempted by *Paul and Virginia* groups such as Cumberworth's (see cat. no. 65).[10] Duret's pensive *Chactas,* nearly nude but with only minimal indications of his ethnic identity, belongs among the early ancestors of Rodin's *Thinker.* In another work of fiction, the novel *Les Martyrs* (1809), Chateaubriand invented a character even more appealing to the Romantic temper than Chactas and Atala: Velléda, "arch-druidess" of ancient Gaul, beautiful and mysterious, who fascinates but does not respond to the love of the narrator. Main-

dron, perhaps stimulated by the success of Duret's *Chactas,* made a charming statue of her for the Salon of 1839; soon after, the State commissioned a marble copy for the Luxembourg Gardens (fig. 77), which was shown in the Salon of 1844. The catalogs of both exhibitions cite Chateaubriand's description of Velléda at some length as an aid to the beholder. The author, however, says nothing of her costume, which Maindron had to invent without any precedent to guide him except the requirement that she must not be made to look either classical or modern. What he produced might well be mistaken for a lightly clad American Indian maiden.

We conclude our survey with a sampling of borderline cases. The earliest I know of is a "finished sketch" (for a relief) by Bridan in the Salon of 1827, which also contained Flatters' *Satan de Milton* and Fauveau's scene from a novel by Sir Walter Scott. Bridan's panel, now lost, is described in the catalog as showing "Michelangelo, old and blind, who has asked to be taken to the *Torso Belvedere* so that, by touching it, he can once more experience its beauty." No source is cited, yet the event, clearly a legendary one, could hardly have been invented by Bridan. Where did he find it?[11]

Our problem, however, is how to classify the subject rather than to pin down Bridan's source. For him, the scene must have represented historical truth, while to us it is fiction. An analogous case is Legendre-Héral's life-size bronze, *Giotto Tracing the Head of a Ram in the Sand* (fig. 78). The catalog of the Salon of 1841, where the plaster model was shown, gives no source perhaps because the story of Giotto the shepherd boy demonstrating his god-given talent was well known from Vasari. Backed by so authoritative a source, the incident was surely accepted at face value by both the sculptor and his audience. We, on the other hand, know that the same (or a very similar) anecdote has been told of several other famous artists and hence belongs in the realm of legend.

Far more complicated, and so far unresolved, are the questions raised by Hébert's group, *Toujours et Jamais* (cat. no. 159), surely the most original piece of sculpture in the Salons of 1859 and 1863, when the plaster model and the bronze cast, respectively, were exhibited there. The catalogs of both years list it simply by the title given above, without further ado; as inscribed on the piece itself, however, the title reads *Et Toujours! Et Jamais!,* which has the ring of a quotation from some recent poem. It means "always and never"; its relation to the subject remains

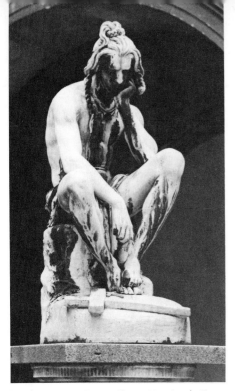

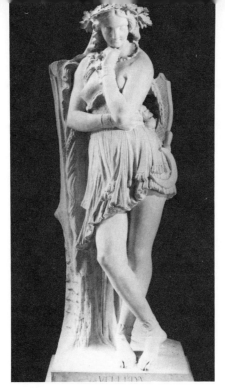

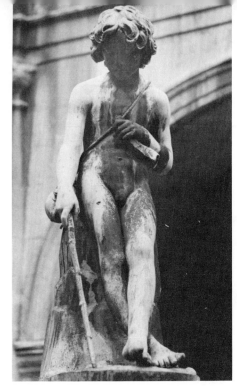

fig. 76. Francisque Duret, *Chactas Mourning the Grave of Atala*, bronze, 1836, Musée des Beaux-Arts, Lyons.

fig. 77. Etienne-Hippolyte Maindron, *Velléda*, marble, Salon of 1844, Luxembourg Gardens, Paris.

fig. 78. Jean-François Legendre-Héral, *Giotto Tracing the Head of a Ram in the Sand*, bronze, 1842, Musée des Beaux-Arts, Lyons.

obscure—unless we can locate the rest of the poem. What we see is a decaying, shrouded corpse that has risen from its tomb and is embracing (and carrying) a nude young woman who offers no resistance, perhaps because she, too, is dead. To what extent, we wonder, is this a latter-day version of the venerable theme of "Death and the Maiden"? Originally—that is, in the Late Middle Ages and the Renaissance —the nudity of the woman denoted lustfulness, and she struggled vainly against the advances of the "living skeleton" representing Death. Romanticism reversed the values implicit in the image: the maiden became Innocence, or Life tragically severed before it has been fully experienced. In no previous instance, however, does Death rise from the grave as in Hébert's group. The sculptor, or his as yet unknown literary source, apparently depicts a pair of lovers reunited in death, so that the corpse represents the male partner in a relationship of long standing, rather than Death as such. This reading would seem to do justice to the visual evidence but must be advanced with caution until the discovery of Hébert's source puts us on safer ground. We cannot, of course, entirely exclude the possibility that he invented both the title and the content of the group independently. But suppose he did borrow the title

from a poem. Might he not have done so because the words seemed to fit what he had already done? In that event, the content of the poem would provide little guidance for our interpretation of the group. Whichever of these various alternatives turns out to be the correct one, we need not wait for the answer in order to be moved by the haunting beauty of Hébert's work.

The ex post facto adoption of a literary title would stretch the relationship between a piece of sculpture and its literary theme to the breaking point. Not surprisingly, that point is reached in the work of Rodin. The most striking instance is the pathetic figure of a nude old woman (cat. no. 200) known as *La Belle Heaulmière*, "The Helmet Maker's Beautiful Wife" or, more fully, "She Who Used to Be the Helmet Maker's Beautiful Wife." The title is taken from a lament regretting the brevity of life and the passing of its pleasures by the fifteenth-century poet François Villon, and the older Rodin literature maintains that the poem inspired the statue. In actual fact, however, Rodin's starting point was the shocking sight of a nude old woman posing for one of his assis-

tants, Jules Desbois, who portrayed her in a work entitled *Misery* (fig. 79).[12] Rodin became fascinated with the aesthetic challenge implicit in such a model, asked her to pose for him, too, and positioned her in a way more fully expressive of the pitiful frailty of old age. Villon's poem did not tell Rodin what to do; rather, he picked the title afterwards because of its bitter irony when applied to this statue. In later years, he himself began to doubt whether the public would understand the title, and initiated, or agreed to, other names for the work. On another occasion, he adopted part of a poem by Baudelaire in the same way, by hindsight, as it were. This conviction that shapes come before words, this declaration of independence from "meaning" in the accepted sense, is the essence of Rodin's modernity.

Notes

1.
Rodin's earlier *Call to Arms* (cat. no. 192) shows an even closer relationship to *La Marseillaise*.

2.
Compare also David's statuette of Jefferson (cat. no. 99) with his statue of Jefferson in the Rotunda of the U.S. Capitol (fig. 26a), and *General Foy* (cat. no. 111) by Louis Desprez, a reduction of the marble statue in the Chamber of Deputies (1833–37).

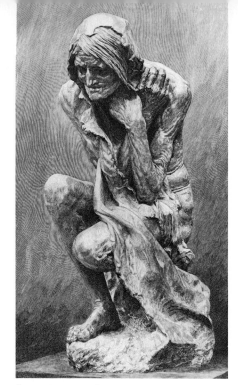

fig. 79. Engraving after Jules Desbois, *Misery,* wood, Salon of 1896 (reproduced in the *Gazette des beaux-arts,* 1896, XVI, plate facing p. 8).

3.
The marble monument, almost ten feet tall, is in the Large Amphitheater of the Sorbonne.
4.
He also did Shakespeare, Michelangelo, and Dürer, among many others.
5.
The only exception known to me is a group by Petitot *père* shown at the Salon of 1819, *Childeric et Mélissa,* from *La Gaule poétique* by Marchangy, according to the catalog; apparently a borderline case between history and literature.
6.
The tabernacle is known only from old photographs, but the sculpture survives in a private collection. The most recent, and easily overlooked, discussion of the theme of Paolo and Francesca in painting, where it occurs earlier and far more frequently than in sculpture, is by Wolfgang Hartmann, *Jahrbuch 1968/69,* Schweizerisches Institut für Kunstwissenschaft, Zurich, pp. 7–24 (with references to all the earlier literature).
7.
Among the rare examples is Falguière's marble statuette *Marguerite à l'église* (before 1887, present location unknown).

8.
Another aquatic heroine, *Ondine,* derived from the poem by Auguste Barbier, was the subject of a statue by Préault which the Salon jury of 1835 rejected; two dozen years later, the State ordered a bronze cast —a telling commentary on Préault's belated recognition and the changing standards of State patronage. Other *Ondines* followed quickly (by Klagmann, 1859, and Carrier-Belleuse, 1864).
9.
The only piece of sculpture inspired by a character from mid-nineteenth-century literature that I have been able to find is Pradier's marble statue of *Nyssia* (Salon of 1848), taken from Théophile Gautier's *Le Roi Candaule,* first published the previous year. Since Nyssia is a beautiful nude woman, the task was an easy one for Pradier—so easy, in fact, that he could have adopted the name for almost any of his female nudes. I suspect that Pradier did exactly that, in order to court the favor of Gautier, who was not only an important writer but an influential art critic whose attention Pradier had sought in a most respectful letter in 1844 (published in Lami,

1914–21, IV, p. 107). The entry in the Salon catalog includes a lengthy quotation from *Le Roi Candaule* to identify the unfamiliar subject.
10.
It remained for an American sculptor, Randolph Rogers, to represent Chactas and Atala as lovers in the wilderness.
11.
The earliest source for the anecdote would seem to be J. von Sandrart, *Academie der Bau- Bild- und Mahlerey-Künste,* Nuremberg, 1675, I, 2, f.33b. (I owe my acquaintance with the passage to the kindness of Dr. Ulrich Middeldorf.) Sandrart does not specify the *Torso Belvedere;* he speaks of "antique figures" in general. Presumably, Bridan chose the *Torso* as the most famous single object within that class. But he could hardly have been familiar with the original German edition (or its reprint, under the title, *Teutsche Academie…*). Sandrart himself issued a condensed Latin translation of his work for the international market in 1683 that might have been accessible to Bridan (or to the French author from whom he took the subject). Since that edition has not been accessible to me, I am not sure whether it contains the anecdote in question. Its appeal to an age that introduced the blind Homer and the blind

Religious Sculpture in Post-Christian France*

Ruth Butler

Belisarius into art is easily understandable. For the French view of Michelangelo around 1800, see E. Dörken, *Geschichte des französischen Michelangelobildes von der Renaissance bis zu Rodin,* Bochum, 1936 (Ph.D. diss., Bonn, 1933), pp. 15–78. Dörken, however, is unfamiliar with our anecdote and cites no French sources for it.
12.
Desbois exhibited his work under the title *La Misère* in the Salon of 1896. Remarkably enough, it is of wood, a material rarely used in nineteenth-century sculpture. Desbois may have thought of Donatello's wooden *Mary Magdalen* when he asked the old crone to pose for him, and his choice of material would seem to be another homage to the Florentine master. According to Thieme and Becker's *Allgemeines Künstlerlexikon,* under "Desbois," the plaster model of *La Misère,* dated 1894, is in the Musée des Beaux-Arts, Angers, while the wooden figure is at Nancy.

I was angry on the day of my First Communion; I gave myself to the Church solely in order to obey my mother. I went to find my confessor and told him that even that morning I had been angry, and that I was not worthy to receive the Sacrament. He gave me absolution, but still I couldn't decide to take Communion. They had to carry me to the altar; there I took Communion with God all alone.[1]

Antoine Etex

In the early period of faith the despotism of religion imposed a constrained and timid nature upon art. We can see it in the tight clothes in the sculptures, and in the rigid limbs held close to bodies like a timid man standing before an unyielding master. In our own age faith is no longer so alive, and we see draperies on statues that are full, we see figures with freedom of gesture, but because conviction no longer exists, these saints give the impression that they have sworn to honor something they no longer believe. Saints, as we know them, are like people who have acquired a social position which they wish to keep, just like the bourgeoisie of today. Earlier religious figures appeared totally absorbed in meditation. That was the reason for their existence. Now they are actors posing before the public, actors certain to have the esteem and approbation of the people. Once the expression on the faces of the saints bore the imprint of the roughness which man had acquired in the

course of intense struggles. Now they walk gravely and securely in the midst of an abundant harvest, which they have planted and which they intend to reap.[2]

David d'Angers

With my elbows on the window sill of my hotel room, I gaze far and wide over the world and, like God the Father, I judge it.[3]

Auguste Rodin

These thoughts of three nineteenth-century French sculptors about the experience of religion can help to orient us within a complicated subject.

Antoine Etex remembered the day he took First Communion, thus becoming a practicing member of the Church. We should keep in mind that most of the artists represented in this exhibition (with the exception of a few, such as James Pradier who was Protestant) were Catholic, and that at some point in their lives they took Communion and went to church. David d'Angers' remarks emphasize for us something we know all too well—that modern religious sculpture as we see it in the churches, though lifelike in gesture and appearance, is shallow, especially when

compared to the great works of the Middle Ages. Finally, Rodin, sitting by himself in his hotel room in a tiny town in the Loire Valley, gives clear evidence that, for all his Christian education—so intense that as a young man he briefly became a member of a religious order—he, like his *Thinker* in *The Gates of Hell,* took his place in a world that was post-Christian.

Religion was a very complex question for French people during the nineteenth century. Sculptors as a group, experienced the various issues with particular intensity. These issues were political, economic, and social, not to mention more personal questions of faith and feelings associated with religion.

Anticlericalism in nineteenth-century France was primarily a political matter. The Church had been second only to the monarchy as a focus of the wrath of the Revolution. By the decree of the 11th Prairial (May 30, 1795) only those persons who had taken the oath to submit to the laws of the Republic were entitled to use Church property. And so began the fundamental split between Church and State in France which extended down through the nineteenth century, though the nature of the cleavage was constantly altering. Napoleon moved to stabilize the relationship through the Concordat of 1802. By this

agreement the Church accepted the permanent loss of its property, while Napoleon committed the State to pay clerical salaries; so the role of the clergyman was similar to that of a public functionary, not exactly a change that strengthened the view of the Church's spiritual mission in the eyes of the French people.

Historians have noted that when Catholicism was recognized again in France, artists and writers began to exhibit a nostalgia for the Middle Ages. Chateaubriand's *Génie du Christianisme* was the most prominent example of this in literature. Painters, too, began to work with subjects that could lead their audience into reflecting upon the lost medieval world, a world when Christianity was truly great in spirit and in reality.[4] There was nothing quite like this in sculpture, however. In the early nineteenth century, before the fall of Napoleon in 1814, we find but a single sculptural work in the Salons on a Christian subject: *The Death of the Virgin* by Cyprien (Salon of 1802). What did fill the imperial Salons were busts and statues, primarily of the imperial family and the military geniuses of Napoleon's army, and the mythological figures favored by Neo-classical sculptors. The only serious

reference to religion in an imperial Salon occurred in a group by François-Joseph Duret showing *Religion and France under the Protection of Napoleon.* That sums up the situation quite nicely.

Louis XVIII was in exile for twenty-three years. During that time it is safe to assume he never doubted the principle of divine right for a moment. When he returned to France one of his major goals was to re-establish the Church as preeminent in French society. In 1822 he promulgated two new press laws: one forbidding the publication of views critical of the divine right of kings, the other forbidding any published outrages against religion. Another factor to be taken into consideration is that the return of the Bourbon coincided with a religious revival that was already gaining momentum in France. Between 1814 and 1830 more than a thousand new religious houses for women came into existence in France, and almost seven hundred new churches were begun. For writers, the restoration of the monarchy had been a breath of freedom. Not only Chateaubriand, but also Lamartine and Hugo were good Catholics and good royalists. In the period of the Restoration, Victor Hugo found in poetry the natural daughter of religion: "The desire to thank a bountiful God in language worthy of Him begat

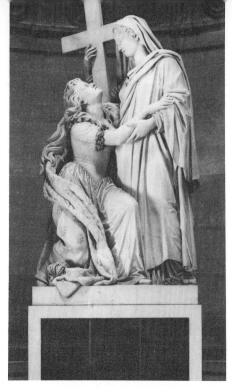

fig. 80. Jean-Pierre Cortot, *Marie-Antoinette Supported by Religion,* marble, 1820s, Chapelle Expiatoire, Paris.

poetry. From its birth it shared in the triumphs of religion, which united the earliest societies and began the civilization of the world."[5]

We can look at a single commission in sculpture to consider the new order of things: the works executed for the Chapelle Expiatoire. The chapel was built between 1815 and 1826 in the middle of Paris on the spot where Louis XVI, Marie-Antoinette, and Mme. Elizabeth, sister of Louis XVI and Louis XVIII, were buried in a common grave along with hundreds of Swiss Guards who had been slaughtered in the Tuileries in 1792. The chapel was to expiate the sin that lay upon the souls of Frenchmen for having murdered their king. For the interior, Louis XVIII asked his first sculptor, François-Joseph Bosio, to execute the group of Louis XVI. The complementary group, showing Marie-Antoinette, he gave to Jean-Pierre Cortot. Bosio depicted Louis XVI kneeling in ecstasy, while an angel takes him by the arm to show him the way to paradise. The king preceded his wife to the guillotine, and she is shown still alive (fig. 80). It is the last day of her life, October 16, 1793, and she turns to religion for support and comfort: "I die in the Catholic apostolic

and Roman religion, that of my fathers, in which I have been brought up, and which I have always professed; having no spiritual consolation to expect, not knowing whether there still exists here any priests of that religion." (from Marie-Antoinette's letter to Mme. Elizabeth). When we first look at the figure of Religion, seen as a Roman matron in heavy classical robes (by tradition her features are those of Mme. Elizabeth), we recognize the Neoclassical element in the style, but the dramatic figure of Marie-Antoinette, full, turning, with heavy hair falling loosely over her ermine cape, as she looks imploringly at Religion, is not Neoclassical. Nor is the subject an ideal and generalized statement about the relationship of royalty and religion; rather it is a specific depiction of the queen on the last day of her life. This is made clear by the letter she wrote to her sister-in-law on the morning of her execution, that is reproduced on the pedestal of the group. In spite of some Neoclassical drapery, Cortot's work is a highly charged Romantic work.

The nineteenth-century sculptor had an infinitely more traditional role to play with regard to Christian subject matter than did his contemporaries in poetry and painting. During the Restoration, Christian themes in sculpture slowly began to reappear in the Salons. In 1817, the first Salon held since Louis XVIII had returned to the throne, there was a *Virgin Holding the Christ Child* by François-Nicolas Delaistre. When exhibited, the group was already in the king's own collection. Jean-Baptiste Stouf showed statues of Abbot Suger and St. Vincent de Paul, both commissions from the Minister of the Interior. That was all. The sculptors had been too long out of the habit of doing religious work. In the Salon of 1819 we find eight works with Christian themes; in 1822 there were ten, plus a *Samson* by Gaurard; in 1824, fifteen; and in the Salon of 1827, the last Bourbon Salon, there were twenty-one.[6] The statues and groups shown in these exhibitions were by such sculptors as Cortot, Bosio, Bra, Dieudonné, Rude, and David d'Angers, and they represented the great Christian subjects and saints: *The Descent from the Cross,* the *Virgin and Christ,* the *Flagellation,* the *Immaculate Conception, St. John the Baptist, St. Catherine, St. John the Evangelist, Mary Magdalen,* and *St. Cecilia.* Except for *Samson* there were no figures

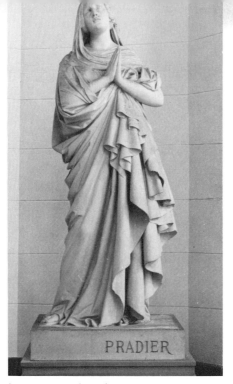

fig. 81. James Pradier, *The Virgin,* plaster model, 1830s, Parish Church, Ville d'Avray.

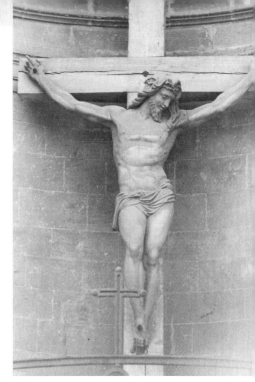

fig. 82. David d'Angers, *The Crucifixion from the Calvary of Angers,* zinc, begun 1819, Cathedral of Saint-Maurice, Angers.

from the Old Testament. Most of these works left the Salons to be sent to various churches in Paris and in the provinces. Sometimes the catalogs even indicated where they were to go: Cortot's *Virgin with the Infant Jesus* (in silver) would leave the Salon of 1827 for the new basilica of Nôtre-Dame de la Garde in Marseille, and Cortot's *Ecce Homo* in the Salon of 1819, as well as Rude's *Immaculate Conception* in the Salon of 1827, were to be placed in Saint-Gervais-Saint-Protais in Paris. David d'Angers' *St. Cecilia* (Salon of 1822) was destined for the church of St. Roch.

The Revolution of 1830, like the Great Revolution, was strongly anticlerical. The Bourgeois Monarchy began its reign on unfriendly terms with the Church, a condition sharply punctuated when rioters interrupted a mass on the eleventh anniversary of the assassination of the Duke of Berry in Saint-Germain l'Auxerrois in 1831, destroying images and crucifixes in the process of their protest. In time, the intensity of this hostility diminished and we find that, in fact, three thousand churches were erected in France during the July Monarchy. Many were furnished with new and impressive sculptures, all financed by the State. The most important work in Paris was for the new churches of the Madeleine, Nôtre-Dame de Lorette, and Saint-Vincent de

Paul, and for older churches that had been transformed into temples following the Revolution, particularly Saint-Gervais-Saint-Protais (formerly the Temple of Youth) and Saint-Sulpice (formerly the Temple of Victory). These projects involved the participation of Barye (*St. Clotilde* for the Madeleine), Clésinger (*Christ* and a *Pietà,* both for Saint-Sulpice), Duseigneur (*St. Agnes* for Saint-Sulpice), Etex (*St. Augustin* for the Madeleine), Feuchère (*St. Teresa* for the Madeleine), Maindron (*Christ on the Cross* for Saint-Sulpice), Pradier (*St. Peter* for Saint-Sulpice and the *Marriage of the Virgin* for the Madeleine), Préault (*St. Geneviève* for Saint-Gervais-Saint-Protais), and Rude (*The Baptism of Christ* for the Madeleine and the *Crucifixion* for Saint-Vincent de Paul). As we can readily see, all the best Romantic sculptors executed traditional Christian sculptures for Catholic churches. Often these works provided them with an income when there were few other commissions to be had. This body of work is the most overlooked in the repertory of the Romantic sculptors, for the sculptures are located in the least-visited churches of France. Also they are usually not among the best works

of the artists and offer little incentive to seek them out.

We can look at one example to see the kind of figure being fashioned for ecclesiastical decoration during the July Monarchy. In 1837 the State ordered from Pradier a marble of a figure of the Virgin that he had already finished in plaster (fig. 81). The marble was in the Salon of 1838 and then placed in the Cathedral of Avignon. Pradier was best known for his mythological figures; he truly excelled in creating Psyches, Venuses, and Graces. When he did his *Virgin* he took the basic figure type of a Grace or a Venus and wrapped her in a late Gothic gown used to show off his celebrated virtuosity through the skillful rendering of rich linear edges and vigorous plastic folds. It did not win over the critic for *L'Artiste,* however, for he found it to be "one of those works in which we see the skill for which this academic artist is so well known. But besides that, it shows complete absence of originality."[7] More interesting, and surely also of the 1830s, is the unattributed *Saint Theresa* in the present exhibition (cat. no. 218). Appropriately this sculptor chose a style inspired by Spanish Baroque sculpture. We recognize this in the attitude of ecstasy, the framing of the head by the cowl in

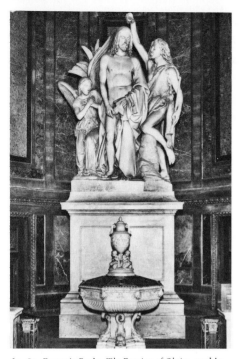

fig. 83. François Rude, *The Baptism of Christ,* marble, 1835–43, Madeleine, Paris.

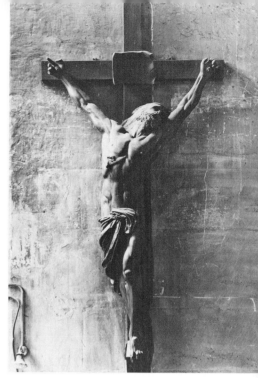

fig. 84. Antoine Préault, *Crucifix,* wood, 1840, Saint-Gervais-Saint-Protais, Paris.

an aureole of space, and in the long simple folds of the heavy drapery.

A broad examination of nineteenth-century religious sculpture reveals that there was no intrinsic vocabulary, as there was in portraiture or in animal sculpture, for instance. When a sculptor took a commission or chose to create a saint or an episode from the New Testament, he looked to the past for the manner and the phrasing that would be most suitable, and usually his references were fairly obvious. Perhaps the favorite period for sources used by sculptors working during the July Monarchy was the sixteenth century. It provided them with solidly constructed figures in a style that was fully comprehensible to a group of artists who had been trained in Neoclassicism. Rude and David d'Angers turned to the sixteenth century when they were faced with such commissions. David began his *Calvary* for Angers in 1819. If we look at the figure of Christ (fig. 82), we find a highly traditional figure, perhaps a bit more athletic than the sixteenth-century prototypes, but totally phrased according to the art of the past. Between 1835 and 1843 Rude created a *Baptism of Christ* for the Madeleine (fig. 83). In this limp and unimaginative work he combined the basic iconography found

in Renaissance paintings; St. John is to Christ's left with his right hand raised, and the angel is to Christ's right. There is even a bit of rocky landscape underneath St. John's knee. Christ's body is strong, yet he is strangely withholding, weightless, and abstract. The figure can be compared to works by such sixteenth-century post-Michelangelo sculptors as Montorsoli, as we see his style in the *Risen Christ* in the Church of the Servi in Bologna. Louis de Fourcaud, Rude's great admirer and major nineteenth-century biographer, found that "No one was less apt than the sculptor of the great Arc de Triomphe relief at working with sacred subjects, for they did not touch him and he had no imagination for them . . . we can hardly find anything so lacking in spontaneity and humanity as his *Baptism,* a work in which his exceptional skill was totally wasted."[8]

Pradier and Rude both took on such projects as the *Virgin* and the *Baptism of Christ* in order to pay their bills. Rude received forty thousand francs from the Ministry of the Interior for his group in the Madeleine. The State contributed only two thousand francs toward the purchase of Pradier's *Virgin* for the Cathedral of Avignon, but

funds were being secured through public subscription and he must have received considerably more.

The financial difficulties of being a sculptor during the July Monarchy were extreme, and commissions for religious sculpture helped artists to survive. Auguste Préault wrote a letter to David d'Angers in which he put the problem into sharp relief: "I don't feel like committing suicide, nor do I want to go crazy. I pray you to let me know if you can get me some work."[9] The artistic climate of the conservative July Monarchy was particularly hard on sculptors like Préault who made their reputation on the basis of a bold new style and themes unknown in the history of sculpture. Within a few years after writing this letter, Préault was hard at work on an enormous bas-relief depicting *The Adoration of the Magi* (1839, now destroyed), and soon after he began the first of his famous *Crucifixions* (fig. 84). Here we see an example of traditional religious imagery in which the artist has not turned to available prototypes in a perfunctory fashion. Instead he created an incredibly expressive and original figure. He carved his great athlete out of wood, showing Christ in agony, with head thrown back; a cry bursts from his lips into the surrounding space. His bristling hands are caught between the

wood and iron, and blood spurts from the wound in his side. Préault's *Christ* does not die in humble resignation. Instead His mien is a rebellious one in a way that connects Him with the darker side of Romantic religious imagery. This does much to explain why the clergymen who saw the *Crucifix* were so reluctant to take it for the walls of their churches. The State paid Préault a thousand francs for his *Crucifix* and offered it to the church of Saint-Germain-l'Auxerrois. The clergy said they did not want it. Neither did the priests of St. Paul's. Finally they accepted it at Saint-Gervais-Saint-Protais after Préault had lamented to the curé: "Monsieur, twice your fellow priests have turned our Lord away. I beg you to take Him; if not I shall convert to Mohammedanism."[10] Christian image-making was not an easy matter for Romantic sculptors.

State funding for church furnishings, a practice born of Napoleon's Concordat, continued right into the Third Republic, becoming ever more anachronistic. In a very fundamental way the Church had failed the common man in nineteenth-century France, and we find republicanism firmly anchored in anticlerical sentiments. Courbet's old friend Castagnary, when writing about the Salons of the early Third Republic, complained bitterly about the enormous saints in marble being commissioned for the Panthéon:

Here is a Saint John of Matha *by M. Hoille that is destined for the Panthéon. I have nothing to say about the statue itself. M. Hoille is an excellent sculptor who knows very well how to work. But when we think about ten statues, twenty statues, all representing saints and all realized in the same traditional mold? It is not possible to continue like this; it is not possible that under a republic State funds are being used to pay for such conceptions as these that are taken from the moral order. We have said it before, and we shall say it again: "The Panthéon is a monument that was reclaimed by the Revolution and we must not cease to claim it."*[11]

The best sculptors of the Republic made no images for churches — not Barrias, nor Bartholdi; Dalou would never have done such a thing, and even Mercié did so only once, when he made *St. Eloi* for the Panthéon. And Rodin made no statues for churches. With the name of Rodin we come to the most interesting thought of all, for it is clear that of all the artists represented in the present exhibition he is the one who was most attentive to religious issues. We find here his statues of *St. John the Baptist Preaching* (cat. no. 191) and *Eve* (cat. no. 196), his groups of *The Hand of God* (cat. no. 208) and *The First Funeral* (cat. no. 209). But these are works that could be placed in no church. Even Rodin's representation of St. John the Baptist, who had been one of the most popular saints in French churches throughout the nineteenth century, would be unimaginable in such a setting.

Rodin is the best sculptor to lead us into viewing the dichotomy of the religious situation at the end of the century. His inclination toward personal religious feelings was genuine. If it had not been, we can hardly imagine that his response to the crisis brought on by his sister's death would have been to enter religious life. Rodin's stay in the order of the Society of the Blessed Sacrament was brief, perhaps no more than six months (probably December 1862 to May 1863), but he must have been moved by this unusual order with its double mission of making possible the most intense aesthetic experience of the Eucharist and making it accessible to the working-class families of the city. The head of the order, Pierre-Julien Eymard, a truly extraordinary individual, recognized in the twentieth century as a saint by the

Catholic Church, must have perceptively inspired Rodin's thoughts. Rodin's experiences in the spiritual realm continued to manifest themselves long after he had left the order. This can best be understood in his lifelong devotion to the cathedrals of France and to what they meant, even for modern man: "The heavens declare the glory of God: the Cathedrals join to that the glory of man. They offer all men a splendid, comforting, and exalting spectacle; the spectacle of ourselves, the eternalized image of our soul, of our country, of that by opening our eyes, we have learned to love."[12]

By the time Rodin began making mature choices about his sculpture, the Church was not a significant force in the lives of most people living in France. It would have been unthinkable for the most original sculptor at the end of the century to have created statues for churches in the manner of the Romantic sculptors, or even in the manner of his immediate predecessors who worked during the Second Empire. Both Carpeaux and Carrier-Belleuse contributed statues to church decoration. It is equally clear, however, that religious interests and moral issues played a profound role throughout most of Rodin's creative life. *The Gates of Hell* with the

figures of *Adam* and *Eve* which were to have stood on either side, *The First Funeral,* and *The Hand of God* all reveal associations with religious ideas, but they are not taken from traditional Catholicism. We must look to the Romantic movement, and particularly to the work of the writers, in order to understand the background for these works. The majority of creative people in the nineteenth century found their only hope of experiencing true spirituality was to relinquish official religion and to search elsewhere for ways to penetrate the mystery of human existence. As early as the 1850s, while at the Petite Ecole, Rodin plunged himself into a program of reading—Lamartine, Musset, Hugo, and later, Baudelaire. Lamartine and Hugo as young men were quite orthodox, but in their mature work, as in the work of Musset and Baudelaire, they made the most personal and fragmentary choices from traditional religion in order to reveal their ideas about man in his universe. They shared a common pessimism, as well as a taste for the darkly seen drama in view of man's fate. In the course of the nineteenth century, the poets of France developed a dramatic theology of evil in which Satan

assumed a mythic role. Their ideal Satan was the one whom they had met through Milton. As one author has pointed out, Milton's Satan "oriented their minds toward supernatural forms that were capable of explaining the agony of the individual in the modern world, the man who was estranged from God, and the hopes and doubts of a humanity that wished to understand the origin of evil at the same time they wanted to find it not eternal."[13]

During the July Monarchy a body of work by sculptors came into being that parallels the work of the writers. As long as we do not expect orthodoxy, we may view it as religious sculpture. This work, too, was found in the annual Salons, but instead of going to churches, it was purchased by the State for museums, or it was bought by private collectors. The subjects were not Madonnas or Crucifixions, Christian images of hope and salvation; rather they were those of sin, guilt, punishment, and damnation. The first such image to appear in a Salon catalog of the nineteenth century was the *Satan of Milton* by Jean-Jacques Flatters in the Salon of 1827. Flatters had begun illustrating *Paradise Lost* during the same period. We do not know what this statue looked like because it was destroyed before 1840, but we do have the *Satan* by Feuchère (cat. no. 137) showing a

fig. 85. J. E. Chaponnière, *David and Goliath,* model 1831–34, bronze cast 1837, Geneva.

fig. 86. Vincent-Emile Feugère des Forts, *Dead Abel,* plaster, 1864, Musée de l'Ancien Palais Episcopal, Chartres.

humanized figure with a powerful body enclosed in giant wings. The expression on his face and the gesture of his left hand imply feelings of doubt and suggest that Feuchère could have been thinking of the famous passage in Book IV of *Paradise Lost* when Milton portrayed Satan beset by doubts at the moment he first looked upon Eden:

> *...horrour and doubt distract*
> *His troubled thoughts, and from the bottom stir*
> *The Hell within him: for within him Hell*
> *He brings, and round about him, nor from Hell*
> *One step, no more than from himself, can fly*
> *By change of place: now conscience wakes despair,*
> *That slumbered; wakes the bitter memory*
> *Of what he was, what is, and what must be*
> *Worse; of worse deeds worse sufferings must ensue.*

The reviewer for *L'Artiste* found the appearance of Feuchère's *Satan* to be not quite human enough for his taste, suggesting that "the artist should not have exaggerated the forms of his figure in a fashion that is so removed from nature."[14] But the figure became well known and highly appreciated by later artists. It is part of the heritage from which Carpeaux drew when he created his *Ugolino* (cat. no. 32) and Rodin when he made his *Thinker* (cat. no. 195). To understand both of the later fig-

ures and the nature of the guilt they bear within them, we must remember that part of their ancestry lies in Feuchère's *Satan.*

Another figure in the present exhibition that gives evidence of a fascination with the great tempters, with those who sought to provoke the human weakness of thirsting for a knowledge that could bring damnation with it, is *Mephistopheles* by Jacques-Louis Gautier (cat. no. 149). This figure so pleased Napoleon III that he acquired a cast of it as soon as he saw it in the Exposition Universelle of 1855.

The Old Testament provided the richest source for sculptors in their desire to explore the eternal dualism of man's encounter with good and evil. It provided narratives and characters with mythical status that were comprehensible to almost everyone, but that were not limited by associations with Catholicism. France was not much burdened with the debate over literalness that was taking place in Protestant countries where the Bible had been the specific — at times the exclusive — source of Christian belief, and so there was a certain freedom in treating these subjects. Following the Revolution of 1830, unorthodox subjects in sculpture were immediately more acceptable; we find this

freedom in the enthusiasm for figures and events from the Old Testament: David portrayed in various aspects (but always young) by Feuchère (1831), Barre (1834), Chaponnière (1835, fig. 85),[15] Bonnassieux (1844); Judith by Feuchère (1831) and by Félicie de Fauveau (1842); Sarah by Elshoecht (1831); and Hagar created by Lescorne (1833) and Schoenewerk (1841). But by far the most interesting subjects provided by the Old Testament were those dealing with the First Family, and most especially Eve and her sons. Although artists in other fields were drawn to the early chapters of Genesis during the nineteenth century, it is not unfair to say that it became the special prerogative of sculptors to work out their sense of religious issues, of the origin of man and the nature of guilt, through the figures of Adam and Eve, and Cain and Abel. These subjects first appeared in the Salon of 1833. Flatters showed *Eve,* and Etex showed the plaster of *Cain and His Family, Accursed of God* (cat. no. 124).

Etex was only twenty-four when he decided to make *Cain.* It became his most celebrated work and one of the great images of Romantic sculpture. Eventually he realized it as a marble over six feet in height, presented at the Salon of 1839 and at the Exposition Universelle of 1855.

fig. 87. Antonin-Jean-Paul Carlès, *Death of Abel*, marble, 1887, formerly in the Musée du Luxembourg, Paris.

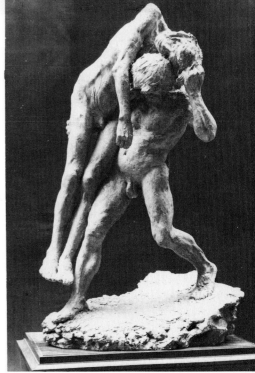

fig. 88. Alexandre Falguière, *Cain and Abel*, plaster, 1880s, Sculpture Deposit, Ivry.

Etex created *Cain* in Rome. He began it in 1832, a few months after his arrival in the Eternal City. Since he had failed to win a Prix de Rome and was not at the Villa Medici, he found himself very isolated. He recorded in his autobiography that he was "profoundly despondent and entertained the horrible thought of committing suicide." In such a state of mind he made the acquaintance of Berlioz, also "sad and discouraged," and the two young Frenchmen considered the possibility of becoming monks.[16] Etex's depressed mental state while working on his group helps to explain his success in capturing the gloomy nature of the subject, but it does not explain the subject itself, which was already in the storehouse of sculpture subjects. Barye had won a second prize in the Prix de Rome contest of 1820 with his *Cain Accursed of God after the Murder of Abel* (destroyed). But even more than that, Etex was probably inspired by Byron's drama *Cain* (1821). Although Etex never mentioned Byron's work in his autobiography, we can be sure that he read this well-known work by the man who was widely regarded on the Continent as the greatest modern English poet.[17] Byron, along with Shelley, continued what Milton had done in *Paradise Lost:* he expanded upon the biblical episodes of the story of Eden. In

Cain, Byron explored man's propensity for violence, his torment under the burden of guilt, and the horrible realization that evil is a hereditary curse.[18] As the play ends, Adam tells Cain "we dwell no more together," and Cain, cast out, goes "eastward from Eden." His last words are of Abel:

And he who lieth there was childless. I
Have dried the fountain of a gentle race,
Which might have graced his recent marriage
* couch,*
And might have temper'd this stern blood of
* mine,*
Uniting with our children Abel's offspring!
O Abel![19]

When Etex sent home this group showing our despondent forebear with those he took with him, his wife-sister and their two children, the reception was clearly positive. Etex was barely known in Paris, but the reviewers looked at the group and pronounced it "grandly conceived," strong praise for a young sculptor who had not even enjoyed the prestige of a Prix de Rome. When the reviewer for *L'Artiste* developed his discussion of the work in his "Salon of 1833," it was clear that he, too, was thoroughly imbued with the story according to Byron: "To Cain's right we see

his son leaning on his shoulder. He looks at his father and with that look he questions. Cain is shown with his hands spread wide, as if not to touch his family and thus communicate to them the curse that lay upon him. Then he hides his right hand, the one with which he had committed the murder."[20]

In 1834, Arthur Guillot exhibited *The Body of Abel.* François Jouffroy showed *Cain Accursed* in the Salon of 1838, created some years earlier, however, since Louis-Philippe purchased it in 1831. The Salon of 1845 had Auguste-Hyacinthe De Bay's *First Cradle* and Gabriel-Joseph Garraud's *First Family on the Earth.* The latter was acquired by the State and placed in the Luxembourg Gardens on a pedestal showing the beginning of the world.[21] The group by De Bay (cat. no. 103) shows Eve cradling her sons with her first-born sleeping on her right arm. We know him by his size and gesture—even as an infant he pushes a fat hand into his brother's chest. The bas-reliefs on the base provide the symbols of the drama: the tree of life, the altars of sacrifice, and the scene of the murder itself. Arsène Houssaye commented on both groups in his review of the Salon of 1845, criticizing them in a way that was common for critics of sculpture during the nineteenth century. He found *The First Cradle* not serious enough in view of its

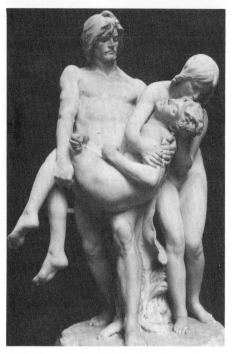

fig. 89. Ernest Barrias, *The First Funeral,* marble, 1878–83, Parc de l'Hôpital Sainte-Anne, Paris.

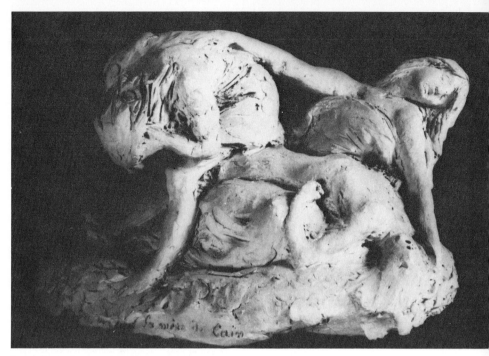

fig. 90. Ernest Barrias, *The Mother of Cain,* terracotta, 1880s (?), Musée du Petit Palais, Paris.

important subject: "De Bay's Eve is more coquettish than she is beautiful, which we see in her attitude and in her expression." He described *The First Family:* "Adam wipes the sweat from his brow, with Eve at his side; to her left Abel sleeps the sleep of innocence, while Cain is wide awake and full of Envy, looking at Abel with his scornful eye. Sculpture is an art that can explain many things, but it cannot be painting, and it should leave to painting what belongs to painting."[22] This was a commonly held view in the nineteenth century: sculpture was to give the potent symbol for the substance of an idea, not the narrative sequence of the story. That was the business of painting.

When Byron wrote his drama he wanted us to respect Cain, a man who longed for knowledge, who wanted more than anything to solve the mystery of being, of life and of death. This view of Cain set the tone for the whole century, and writers and artists identified with Eve's first-born. Like Satan and Faust, he was a rebel. He was angered by the way God had placed the forbidden tree in Eden, thus arranging for the Fall. And how could the desire for knowledge be wrong? Cain was the ideal symbol for rebellion against a father and against a societal system that was basically unfair.

But Abel, the innocent one, whose sacrifices are always acceptable — with him the Romantic artists could not identify. Instead, he became the symbol of unconsummated love, endlessly and hopelessly an object of desire. As Cain was the symbol of a permanent heritage of evil, Abel was the symbol of the eternal loss of love and innocence. Two examples of the solitary figure of Abel, of he who might have been the "fountain of a gentle race" had he not been "dried" by Cain, are by Vincent-Emile Feugère des Forts, *Dead Abel* (fig. 86), first shown in the Salon of 1865, and Antonin Jean Paul Carlès, *Death of Abel* of 1887 (fig. 87). They are virtually the same figure with their slender adolescent bodies shown in gentle torsion, legs crossed and hips raised.[23] The most obvious difference is that Carlès chose not to cover Abel's genitals with a sheepskin. We cannot fail to recognize in these beautiful pubescent corpses the Romantic predilection for necrophilia. We can also see in them examples of works that made the critics cry out in objection when they felt the sculptors straying too far from "true biblical feeling."

The sculptors' interest in Cain and Abel as a subject continued into the last part of the century, with the corpse of Abel remaining the focus of the emotional content and the compositions of their works. Alexandre Falguière was responsible for one of the most innovative and probing views of primal fratricide done in the latter part of the century. First he worked it out in painting, exhibiting the canvas at the Salon of 1876. When Castagnary saw it he commented, "the subject of *Cain and Abel,* like that of the *Dead Christ,* is a place where the generations transmit to one another their common heritage, and it is one in which it is extremely difficult to innovate. By taking his inspiration from reality, Falguière has rejuvenated the subject. He shows Cain at the moment when, terrified by his act, he tries to hide the body of Abel."[24] It was probably in the 1880s that Falguière transferred the subject into sculpture (fig. 88), making it into an over-life-size group of enormous power. It exists only in plaster, and Falguière never showed it during his lifetime.

The group dealing with the death of Abel which achieved most fame during the Third Republic was *The First Funeral* by Barrias (fig. 89 and cat. no. 6). His plaster model was ready for the Salon of 1878, and the final version in marble was in the Salon of 1883. From there it went to the newly-rebuilt Hôtel de Ville in Paris, a place of high honor for the exhibition of any work

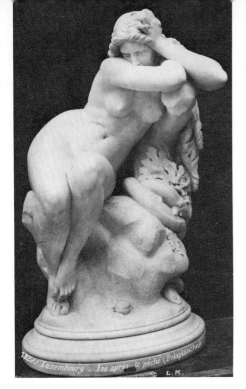

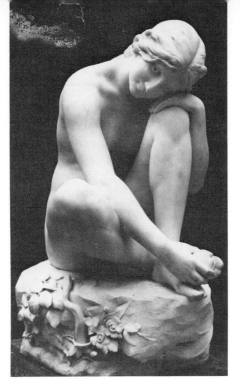

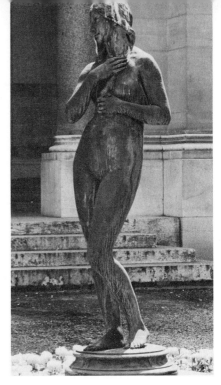

fig. 91. Eugène Delaplanche, *Eve in the State of Sin*, marble, 1869, Paris, formerly Jardin des Tuileries, present location unknown.

fig. 92. Eugène Delaplanche, *Eve Before Committing the Sin*, marble, 1890, formerly in the Musée du Luxembourg, Paris.

fig. 93. Paul Dubois, *Eve*, bronze, 1873, Musée du Petit Palais, Paris.

of art in the years of the young republic. Barrias showed Adam and Eve holding the body of their younger son. The feeling is particularly lyrical and tender, and it was this quality that was most admired when the public and the critics first saw it: "Abel, sweet Abel, the first lamb of God, the first innocent one to be killed, even so because of his very innocence, Abel, the most ancient symbol to announce the coming of the Savior."[25] Any reservations expressed were in relationship to Barrias' choice of models, who seemed common and, to some critics, not majestic enough. Paul de Saint-Victor looked at the head of Adam and pronounced it to be "common and modern, that of a fisherman who has just dredged up a drowned man."[26]

Barrias had another and even more interesting idea about the subject, one that he probably hesitated to execute because it was so radical in conception. We see the group in a small sketch (fig. 90). Its disparate composition is charged with emotion, not simply that of the grief felt by parents for their son, but that of the terror they experienced for understanding that "Death is in the World!" Although there is no specific relationship between this group and Rodin's *First Funeral* (cat. no. 209), they share similarly complex compositional

elements through which both artists expressed their idea of the burden injected into life by death.

Barrias inscribed the words "La mère de Cain" into his clay sketch. For the nineteenth century it was Eve, not Adam, who played the critical role in the drama of the opening of Genesis. Again we come back to the fact that the modern religious experience was more attuned to the evil in the world than to the promise of future blessedness, and Eve was the major symbol of that awareness. The Salons of the late nineteenth century abounded in sculptural images of Eve. Among the best known are those by Eugène Delaplanche, *Eve in the State of Sin* (Salon of 1870, fig. 91) and *Eve Before Committing the Sin* (Salon of 1891, fig. 92); Paul Dubois, *The New-Born Eve* (Salon of 1873, fig. 93); Gaston Guitton, *Eve* (Salon of 1875); Falguière, *Eve* (Salon of 1880, fig. 94); and Ernest-Eugène Hiolle, *Eve* (Salon of 1883). With the exception of Dubois' figure they all indicate Eve's transgression and include the serpent as a symbol of her fall from grace. A more important issue for all these sculptors, however, was to portray Eve as the prototypical woman, the figure through which

they could demonstrate their ability to create their ideal of woman's body. Late nineteenth-century sculptors represented Eve as Neoclassical sculptors had fashioned Venus. Dubois said so explicitly when he worked on his *Eve* long and in secret, hoping that she would reveal to the world the perfect image of feminine beauty.[27] When Falguière's *Eve* appeared in the Salon of 1880, Henry Harvard recognized in her a new direction for the sculptor, and though he found her "a little fragile for the mother of all humanity," he nevertheless saw her to be the most "exquisite of curving forms, very feminine, very elegant, and extremely personal. . . . The body is supple, the pose gracious, and the execution irreproachable."[28]

By the early Third Republic, when these figures appeared in the Salons, archaeology and anthropology had taken over the serious task of trying to understand who were the first human beings. The myth of Adam and Eve had passed into folklore, and we find we have left the subject of religious sculpture behind. But one last observation: of all the Eves made by sculptors of the Third Republic, the most powerful was surely that of Rodin (cat. no. 196). He conceived of her in 1880, but he did not exhibit her as a life-size figure until the last year of the century, in 1899. She is not

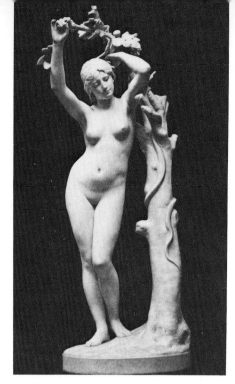

fig. 94. Alexandre Falguière, *Eve,* marble, 1880, Ny Carlsberg Glyptotek, Copenhagen.

sensuous as are her contemporaries, she is not accompanied by the tired symbol of the serpent, but she makes us believe in her guilt through gesture, bearing, and expression. Perhaps Rodin held back, not entering her in a Salon (he did exhibit the 30-inch version, however, at the Rodin/Monet show of 1889) because he wanted the public to apprehend her for the first time in the context for which she was conceived. Rodin had planned on placing statues of Adam and Eve on either side of *The Gates of Hell.* Let us consider what the experience of these works would have been if the Third Republic had actually built the new Musée des Arts Décoratifs, and if Rodin had been able to carry out his conception. We would have walked between the life-size images of our first parents, whose legacy to us was their sin, through the doors depicting human suffering resulting from transgressions old and new, and beneath a judge, *The Thinker,* who was one of us. We would then have entered into the temple of art where we might have found salvation through beauty and the expressive power of the creative spirit. It would have been an experience parallel to that of medieval man when he entered the cathedral, hoping against hope, that he might find redemption there. Rodin wanted to make a religious experience possible once again through the sculpted image, but it was to be an experience found within a secular world.

Notes

*I wrote my sections for this catalog while I was a Fellow at the Mary Ingrahm Bunting Institute of Radcliffe College. I should like to express my gratitude for the privilege of being an Institute Fellow, for it facilitated my work in every way.

1.
A. Etex, *Les Souvenirs d'un artiste,* Paris, [1877], p. 20.
2.
A. Bruel, ed., *Les Carnets de David d'Angers,* Paris, 1958, II, pp. 174–75, notes of 1844.
3.
Rodin, 1950, p. 37.
4.
R. Rosenblum, "Painting Under Napoleon, 1800–1814," *French Painting 1774–1830: The Age of Revolution,* Detroit, 1975, pp. 169–70.
5.
These are Hugo's thoughts from the period of the 1820s, quoted in G. Brades, *Revolution and Reaction in Nineteenth Century French Literature,* New York, n.d., p. 216.
6.
I have taken these figures from the Salon catalog; therefore they are approximations, as it was always possible that works were shown and not mentioned in the catalogs.
7.
"Salon de 1838," *L'Artiste,* 1838, I, nos. 14–15, p. 173.
8.
L. de Fourcaud, *François Rude, sculpteur, ses oeuvres et son temps,* Paris, 1904, p. 256.
9.
Lami, 1914–21, IV, p. 113.
10.
Ibid., p. 115.
11.
Castagnary, 1892, II, p. 277.
12.
Rodin, 1950, p. 73.
13.
M. Milner, "Le Satan de Milton et l'Epopée Romantique Française," *Le Paradis Perdu,* 1667–1967, ed. J. Blondel, Paris, 1967, p. 240.

14.

"Salon de 1834," *L'Artiste*, 1834, I, no. 7, pp. 148–50.

15.

H. W. Janson noticed that Chaponnière took the *Praying Boy* of Pompeii as a classical prototype for *David*.

16.

A. Etex, *Les Souvenirs d'un artiste*, Paris, [1877], pp. 119–20.

17.

E. Partridge, *The French Romantics' Knowledge of English Literature, 1820–1848*, Geneva, 1974 (originally published in 1924), pp. 110–11.

18.

My understanding of Byron's *Cain* has been greatly assisted by T. G. Steffan, *Lord Byron's Cain*, Austin, Texas, and London, 1968.

19.

Lord Byron, *Cain, A Mystery*, London, 1824, pp. 79–85.

20.

"Salon de 1833," *L'Artiste*, 1833, I, no. 5, p. 143.

21.

The composers of the catalog of the Salon of 1845 included the appropriate quotation from Genesis underneath Garraud's name and the title of his work: "In the sweat of thy face shalt thou eat bread till thou return to the earth out of which thou wast taken: for dust thou art, and into dust thou shalt return" (Genesis 3:19). It is Lami, 1914–21, III, pp. 6–8, who mentions its acquisition for the Luxembourg Gardens. It has since disappeared from the gardens.

22.

Houssaye, 1845, IV, p. 4.

23.

The figure of Abel was already a subject for sculpture in the eighteenth century, as we see in Jean-Baptiste Stouf's *Abel* in the Louvre. There are two other important sources for these figures: one is the figure who has been murdered in Prudhon's *Vengeance and Justice Pursuing Crime* (Louvre). Prudhon's inspiration was to have been a sentence from Horace ("Raro antecedentem scelestum deservit poena"), W. Friedlaender, *David to Delacroix*, Cambridge, Massachusetts, 1966, p. 57; but in the nineteenth century, the painting came to be interpreted as a Cain and Abel. The other source is David d'Angers' *Young Barra*, which was in the Salon of 1839. The two sculptures of Abel are actually closest to the figure in Prudhon's painting, which shows the corpse with his arms flung wide, his legs delicately crossed, and his naked hips raised up.

24.

Castagnary, 1892, p. 219.

25.

Peladan, 1883, p. 20.

26.

Saint-Victor, 1878, p. 223.

27.

Expressed in a letter of March 7, 1873, and quoted in the thesis of J. M. Delahaye, *Paul Dubois, Statuaire*, Ecole du Louvre, Paris, p. 97.

28.

H. Harvard, "Salon of 1880," *Le Siècle* (1880), quoted in the special edition of *La Plume: Alexandre Falguière, sculpteur et peintre*, 1898, p. 90.

Tomb Sculpture

Fred Licht

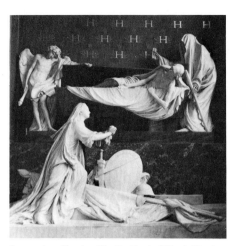

fig. 95. Jean-Baptiste Pigalle, *Tomb of Claude-Henri d'Harcourt, Lieutenant-General of the Armies of the King,* marble, 1771–76, Nôtre-Dame, Paris.

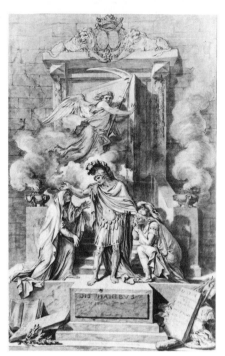

fig. 96. Augustin Pajou, *Project for Tomb of Marshal Charles-Louis-Auguste Fouquet, Duke of Belle-Isle,* pencil, pen and black ink, watercolor and white gouache, 1761, Cooper-Hewitt Museum of Design, Smithsonian Institution, New York.

Le lieu commun où leurs cendres reposeront sera isolé de toute habitation planté d'arbres sous l'ombre desquels s'élevera une statue représentant le Sommeil. Tous les autres signes seront détruits.
 Arrêté sur le culte et sur les cimitières, [signed by] Fouché, Nevers 19 Sept. 1793

L'espoir ferme après moi les portes du néant,
Et rouvrant l'horizon à mon âme ravie,
M'explique par la mort l'enigme de la vie.
 Lamartine, "La foi"

O Mort, vieux capitaine, il est temps! levons
 l'ancre!
Ce pays nous ennuie, ô Mort! Appareillons!
Si le ciel et la mer sont noirs comme de l'encre
Nos coeurs que tu connais sont remplis de
 rayons!

Verse-nous ton poison pour qu'il nous réconforte!
Nous voulons, tant ce feu nous brûle le cerveau,
Plonger au fond du gouffre, Enfer ou Ciel,
 qu'importe?
Au fond de l'Inconnu pour trouver du nouveau!
 Baudelaire, "Le Voyage"

Due to the Terror and then to the exhausting massacres of the Napoleonic wars, France was the first Western nation to experience and understand the modern inflation of death and its consequent devaluation of sentiment and respect. There had been plagues, famines, and wars before this time that had demanded vast hecatombs of human lives, but all earlier cataclysms had been understandable in the light of God's justifiable wrath. The lives snuffed out by the Terror and by the military campaigns of the subsequent fifteen years were sacrifices to human cruelty, to human vanity, or to human madness.[1]

The representation of noble and pious death which still maintained a certain degree of sincerity in Italy, England, and Austria could not be maintained with equal assurance in a land such as France that had witnessed the ravages of violence on a modern scale and in a modern, secular spirit.

For this reason and for others which still remain to be investigated, French funerary sculpture of the nineteenth century is quantitatively negligible when compared to the output of Italy or England. In France, just because the funeral monument represents an exception and not the rule, it was generally the domain of true artists and not of hacks and commercial specialists as was the case in Italy. It was also generally the result of extraordinary circumstances and therefore enormously revealing of the tenor of the times, since it usually represented a great artist's interpretation of human destiny made manifest by concrete events.

The convulsive succession of political events, the constant changes of regime that led from the beginning of the French Revolution to the explosion of 1848, are not reflected in the funerary sculpture of the time. The epoch militated against the creation of monuments to individuals. For one thing, the democratic ideals of the Revolution did not permit the continuation of a tradition that had been strongly if not exclusively associated with the *ancien régime.* For another, there was a fundamental lack of stability and of commonly held standards which are so essential to singling out those individuals deemed worthy of permanent memorials. It was only after the bourgeoisie had accustomed itself to its new position of power that there was a true upswing in the commissioning and execution of funerary monuments on a large scale.

The symptoms of such drastic reorientations, however, became visible in funerary art long before the Revolution swept away the *ancien régime.* Pigalle, though he was the greatest exponent of the late Baroque phase of French eighteenth-century sculpture, was perhaps the first artist to signal new themes and new attitudes towards the ultimate enigma of human existence.

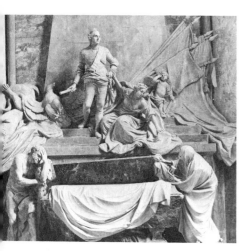

fig. 97. Jean-Baptiste Pigalle, *Tomb of Marshall de Saxe*, marble, 1777, St. Thomas Church, Strasbourg.

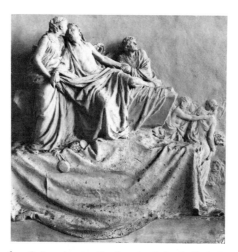

fig. 98. Jean-Antoine Houdon, sketch for the *Tomb of Prince Alexander Mikhailovitch Galitzin*, terracotta, 1777, Louvre, Paris.

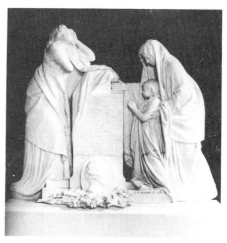

fig. 99. Jean-Antoine Houdon, *Tomb of Victor Charpentier, Count of Ennery*, marble, 1781, Louvre, Paris.

His *Tomb of d'Harcourt* in Nôtre-Dame introduced a note of new domestic realism (fig. 95). Never before had a funerary monument dealt with such a peculiar narrative theme. Funerary sculpture, since it is always meant to imply the eternal glory to which the deceased has ascended, is generally shy of narrative because narrative implies a beginning, a middle, and an end. No matter how active the flanking virtues are in Baroque funerary monuments, their primary function is to exist in all eternity and to guarantee salvation (a timeless state of existence) to the faithful Christian soul. Pigalle for the first time places his allegorical figures in a secondary position and emphasizes the hallucinatory anguish of d'Harcourt's widow as she watches the corpse of her husband subside into its coffin. Considered from the point of view of narrative action, there is a strong element of temporality here because what is happening cannot be suspended in this manner for all time. It must come to an end one way or another.

Just as remarkable is the fact that this tomb does not address an audience but is played out between husband and wife; the tradition of tomb sculptures as purveyors of theological or moral encouragement for the living is bypassed. This is not the place to decide whether the story of Mme.

d'Harcourt's supposed vision of her husband is true or apocryphal, nor need one have recourse to such an explanation to see the monument, in spite of its novel aspects, within the framework of Baroque iconography. Essentially, the motivating force behind it is the Christian widow's piety and her longing to join her husband in the world beyond the tomb. Looked at from this vantage point, the tomb remains thoroughly Christian in its admonition to piety for the dead and in its appeal to face death, as Mme. d'Harcourt does, with Christian courage and confidence.

It is also the otherworldly, visionary content of the scene that links it to traditional monuments such as the one to Molière in St. Roch where a *pleureuse,* or mourner, has come to grieve at the bust of her idol.[2] The idea of incorporating into the composition a figure of a woman who is only visiting the tomb and is not actually a part of the monument is utterly new and prophetic. It will be taken up again by Canova in his monument to Maria Christina, and from then on the theme remains one of the most symptomatic constants of modern funerary sculpture.

Still more astonishing (because there is no visionary explanation) is Pajou's projected monument to the Marshall Charles-Louise-Auguste Fouquet, Duke of Belle-Isle, which was never carved but has come down to us in the form of a very elaborate drawing (fig. 96).

At first sight, the tomb seems to be of the usual operatic cast not unlike Pigalle's Marshall Maurice de Saxe monument (fig. 97). In both cases the warrior stoically strides to his last abode, accompanied by grieving allegorical figures. In Pigalle's monument the costume is vaguely contemporary; in the slightly more classicizing Pajou, Roman costume is given preference. On closer inspection, however, it becomes evident that there is an immense and decisive difference. Whereas Maurice de Saxe descends to the open sarcophagus in front of him, Marshall Fouquet is already inside his sepulcher. Since he was the last member of his family, the allegory of Time closes the heavy door to the grave through which no further illustrious kin will pass. For all the grandiose effects of burning incense, theatrical gestures, and noble architecture, what we are allowed to witness must forever be invisible to the eyes of the survivors. The scene is even more hermetic

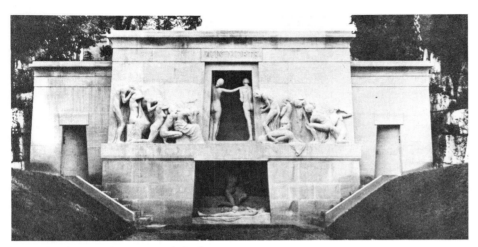

fig. 100. Paul Bartholomé, *Monument to the Dead*, limestone, 1899, Père-Lachaise cemetery, Paris.

than in the d'Harcourt monument, and the narrative, instead of pointing to life everlasting, emphasizes the finality of all things by dwelling not only on the death of one man but on the extinction of a whole family line. In sentiment, too, we are here a considerable step closer to the deliciously horripilating "Gothick" concept of the frightful interior of the charnel house than to the equally dramatic but moralizing, and therefore religiously meaningful, skeletons which so often surmount Baroque tombs.

Houdon's tombs of Prince Alexander Mikhailovitch Galitzin (fig. 98) and the Count d'Ennery (fig. 99) represent a hesitant halfway point between the old and the new.[3] The extraordinary drama of the late Baroque is decisively rejected by him, as is the desire to find a fresh content such as we saw in Pigalle and Pajou. What does suggest the future is Houdon's restrained sentiment and the temporal, narrative element that can also be found in contemporary tombs in Austria, Germany, and England.[4] Both tombs deal with the theme of visitors mourning at the tomb of the departed and thus reject the atemporal idea of integrating the flanking figures with the sarcophagus as part of the monument. Here we deal with two separate entities: the tomb itself and the visitors who will eventually leave the tomb.

Though these examples show some signs of the changes to come, they do so only by implication. Far more decisive for the development of modern funerary sculpture in France are the attitudes toward burial developed during the Revolution, attitudes which retain their power throughout modern times.[5] There can be absolutely no ambiguity on this score: the French Revolution execrated, on moral and political grounds, all thought of funerary decoration. Though a certain minor hero-cult involving small busts of the most illustrious personalities of revolutionary events was permitted, public funeral monuments were everywhere proscribed. The Panthéon in Paris, dedicated "Aux grands hommes de la patrie" in the manner of Santa Croce in Florence and Westminster Abbey in London, is exemplary in this respect. The idea of honoring illustrious cultural and political heroes of the nation was retained from the Italian and English prototypes. Yet the idea of celebrating these heroes with effigies was rejected. The tombs of the crypt in which the *grands hommes* are buried are stark and without any sign that might call to mind the semblance of the men who lie here. The communal aura, the anonymous quality which the Revolution exalted

as proper for this sphere of human emotion, reigns supreme.[6]

Most indicative of revolutionary speculation is a fantastic scheme devised by Giraud for a monumental civic graveyard outside Paris.[7] Though clearly unrealizable because of the curious alchemy involved, this scheme nevertheless brings home every aspect of modern French thought and sentiment regarding burial. The graveyard was to be a large formal park enclosed by a vast, columned portico which in turn was surrounded by forests. The columns of the portico were to be made of a crystalline transparent substance derived from the bones of human cadavers. Faith in science was so complete that the author saw no difficulty in obtaining a vitreous material capable of withstanding architectural pressures. This scheme was seen to have great moral and aesthetic advantages: it would eliminate individual vanity after death and also serve as a lesson to those who might be tempted to be vain while alive. It illustrated the strength and beauty of anonymous communality, the total being more impressive than the individual parts. It would also illustrate the beauty of human Reason which is capable of transforming putrifying corpses into a shining architecture of dignified purity. The final monument would be a perpetual hymn to

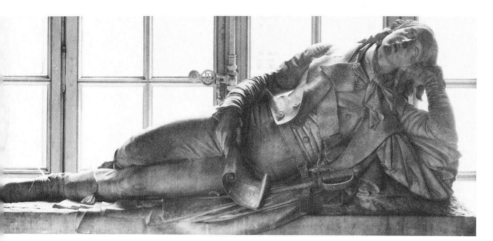

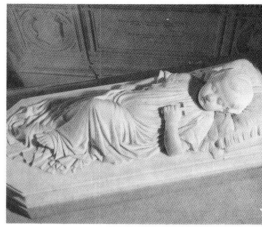

fig. 101. James Pradier, *Tomb of Louis-Charles d'Orléans, Count of Beaujolais,* marble, 1839, Musée de Versailles.

fig. 102. James Pradier, *Tomb of Princess Françoise d'Orléans,* marble, 1847, Royal Chapel, Saint-Louis, Dreux.

humanity instead of inducing melancholy thoughts on the passing of negligible individual lives.

This communal ideal, presented in its most extreme form in Giraud's project, casts its shadow far into the century, and it is no accident that the most impressive and influential funerary sculpture at the very end of the nineteenth century should once again be a communal monument: Bartholomé's *To the Dead* at Père-Lachaise (fig. 100).

Between these two terminal points of French nineteenth-century funerary art there appear two major variants which exemplify the two main trends of French public life. One is best represented by the royal tombs of Dreux and the ecclesiastic tombs of Nôtre-Dame. The other, far more difficult to grasp in its import and implications, is a disconnected series of highly individualized masterpieces created by the greatest talents of modern sculpture in France. Their freedom of conception and execution, their total dedication to a specific death and a specific life make it difficult to discern any kind of tradition here. One cannot even maintain that they represent the most progressive and libertarian spirit of French civilization during the century—just as it would be foolish

to identify the painting of Degas and Cézanne with progressive and libertarian movements. Nevertheless, they do represent some of the highest achievements in sculpture of this century.

Dreux and Nôtre-Dame

The first activity in the field of funerary sculpture on the part of the restored Bourbons concerned the two statues of the Chapelle Expiatoire and the far more modest tomb of Louis XVI and Marie Antoinette in the Cathedral of St. Denis. There is little else in the way of official commemorative statuary at this time. The Orléans dynasty, eager to establish its own traditions, attempted to raise the originally rather modest chapel at Dreux to the rank of a dynastic shrine. Surrounding the main apse of the new, sumptuous chapel, an ambulatory was built which repeats *mutatis mutandis* the arrangement of tombs in St. Denis, except that the ambulatory of St. Denis is raised above the floor level of the church whereas in Dreux the ambulatory is lowered so that it remains invisible for anyone standing within the church proper.

Although the first burial took place in the chapel as early as 1818, the ambulatory was

dedicated only in 1844. The ashes of members of the royal household who had died earlier were translated to Dreux and a large number of sculptural monuments were commissioned. Pradier, who had already proved his ability in this genre with his *Count of Beaujolais* (fig. 101), was given the lion's share of these first commissions. His tomb for Princess Françoise d'Orléans (fig. 102) is typical of the strong Italianate influence which reigned in the field of official sculpture well into the middle of the century. The strong predilection for virtuoso carving comes out particularly in the transparent treatment of the drapery. There is also an attempt, which typifies almost all official funerary sculpture of the century, to avoid the suggestion of death and substitute an impression of sleep. The infant's left leg is drawn up, the left hand clutches a tiny crucifix, and the head is turned out of the rigid frontal axis to emphasize the gentle movements of a sleeping child.

The same unwillingness to deal directly with corpses and the same desire to gloss over the appearance of death speaks from Barre's tomb for Louis-Philippe's mother, the Duchess of Orléans-Penthièvre (fig. 103). Realistic virtuoso renditions are lavished on minor details so that the eye and the mind are not allowed to dwell on the one reality that is so overwhelming:

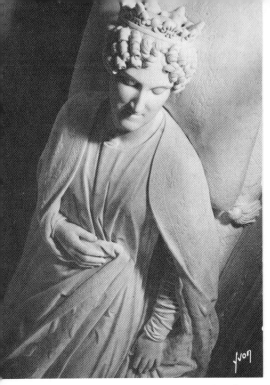

fig. 103. Jean-Auguste Barre, *Tomb of Duchess of Orléans-Penthièvre*, marble, 1846–47, Royal Chapel, Saint-Louis, Dreux.

fig. 104. Aimé Millet, *Tomb of Adelaide d'Orléans*, marble, 1876, Royal Chapel, Saint-Louis, Dreux.

the reality of death. This tendency comes to its fullest expression in the 1876 tomb of Louis-Philippe's sister, Adelaide d'Orléans, by Aimé Millet (fig. 104). Here the transcription of curls, *ajour* (or open-work embroidery), and carefully arranged dress folds keeps us occupied by sheer liveliness of handling. Again, the pose is that of sleep rather than death so that there is a certain incongruity in finding an elegant and dignified lady asleep with all her clothes on.

By far the most moving tomb in which the earlier avoidance of explicit death is converted into a great virtue is the tomb dedicated to Princess Ferdinand d'Orléans by Chapu (first exhibited in plaster in the Salon of 1885; fig. 105). Because the princess was of the Protestant faith and could not be buried within the precincts of the royal chapel, an additional chapel was built to the right of her husband's tomb. The figure of the princess turns slightly to the right, and her right arm extends past the architectural balustrade which separates her chapel from the rest of the church. Seen in conjunction with the slightly earlier tomb of Prince Ferdinand by Loison, this gesture of wifely tenderness cut short by the rigid

lying-in-state attitude of her husband becomes extraordinarily touching.

Dating from the very end of the century is the tomb of Princess Marie d'Orléans by Lemaire (1892; fig. 106). Here we are dealing with a typical example of *fin-de-siècle* perplexity when faced with the subject of death. While there was still a certain discipline and probity of observation in the earlier tombs at Dreux, here we have a conglomeration of objects and effects; the sculptor doesn't even shrink from letting the feet of the princess extend beyond the limits of the tomb; the silhouette must be enlivened at any cost. There is one episode in this sculpture which does make it worthy of note: partly to add compositional variety, partly to say something definite about the life and virtue of the departed princess, two statues—one miniature, one life-size—were added to the tomb, for Marie d'Orléans was herself a sculptress (see cat. no. 173). The angel at the head of the sepulcher is her work and the tiny St. Joan standing next to her pillow is a reduced copy of yet another

sculpture that she executed. There is something at once ingenuous and prophetic in this mixing of different levels of reality and disparate iconographies.

Even in the world of official sculpture, the need for stylistic unity, once so strongly felt, was beginning to break down. Casual juxtapositions of various fragments belonging to different conceptual realms are permissible if they lend added interest and significance to a sculptural monument. Although it begins from totally different premises, the situation is analogous to that which led to the assemblage of objects belonging to disparate realities in the work of Severini and Picasso about 1910.

The centerpiece of the funerary ambulatory at Dreux, Mercié's slightly over-life-size statue of Louis-Philippe and his wife Marie-Amélie, is almost unrecognizable as a tomb sculpture (fig. 107). The contradictory attitudes of the two figures—she kneeling, he standing—the equally disparate activity implied by these attitudes—she praying, he passive, as if he had simply accompanied her on her way to church—obviate all thought of death. The artist and his sponsors apparently wanted to point to the tradition of tombs in which the de-

fig. 105. Pierre Loison, *Tomb of Prince Ferdinand d'Orléans,* marble, 1840s; Henri Chapu, *Tomb of the Princess of Orléans,* marble, 1885, Royal Chapel, Saint-Louis Dreux.

fig. 106. Henri Lemaire, *Tomb of Princess Marie d'Orléans, Duchess of Württemberg,* marble, 1892, Royal Chapel, Saint-Louis, Dreux.

parted are seen absorbed in prayer for the salvation of their souls, but the king's corpulent figure, looming over his kneeling wife, gives the scene an air of domesticity that robs it of all connection with the nobility and faith of medieval and Renaissance tombs.

Equally part of the official trend in funerary sculpture as the dynastic tombs at Dreux are the tombs dedicated to the clergy. Though there are hundreds of such tombs scattered all over France, it is permissible to focus on the group in Nôtre-Dame in Paris. These can be considered as exemplary, standing as they do in the most famous church of the capital. Traditions are stronger in this sector, and both the artist and his sponsors could rely on earlier funerary sculpture simply because the institution to be celebrated in these monuments was far more intact than that of the monarchy. Even here, however, where we would be justified in looking for continuity of content and form, we find all sorts of drastic changes indicative of modern circumstances.

The series begins with the tomb of Cardinal de Belloy by Louis Pierre Deseine (1819, fig. 108). In general composition the monument resembles standard Baroque tombs: the deceased prelate is enthroned on a raised central block, flanked by figures to either side. The influence of Canova and especially of Thorvaldsen is evident in the severe draperies and in the distinct separation of levels by means of stereometric blocks on which the figures stand. Deseine has tried to return to a certain Baroque linking of the figures by means of connecting gestures, instead of compartmentalizing them as Thorvaldsen and his followers had done. The gestures themselves, however, lack the convincing aplomb of earlier tombs and are clearly incongruous with the somewhat rigid handling of the drapery. It is also typical of contemporary lack of faith in allegorical interpretation that Charity is no longer impersonated by a female figure with two infants but is represented instead by a little drama that turns a theological virtue into a financial transaction.

Expressive of the general trend in the Church to present the priesthood in modern guise without sacrificing the traditional idiom are the tombs of Archbishop Affre by De Bay (fig. 109) and Msgr. Darboy by Bonassieux (fig. 110). Both prelates died amid great political and social upheaval: Affre was shot in 1848 just as he was negotiating a truce at the barricades, while Darboy was shot as a hostage in 1871. There was good reason, therefore, for the Church to present these men as heroes who had given their lives to bringing Church and people together again. The Affre monument, judging from a number of small-scale bronze versions, must have been fairly popular and is certainly the more successful of the two. The relief, even though crowded and somewhat unclear, tells of the archbishop's last moments on the barricades while his effigy, holding aloft the branch of martyrdom and pointing to his last words, is not lacking in dignity.[8] In contrast, the later Darboy monument is strangely haphazard. There is no telling why he sinks to the ground, and the drama of his death as well as of his involvement in one of the most decisive

fig. 107. Antonin Mercié, *Tomb of Louis-Philippe and Marie-Amélie*, marble, 1886, Royal Chapel, Saint-Louis, Dreux.

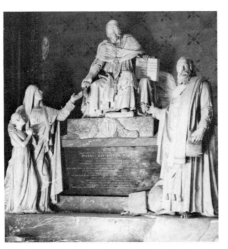

fig. 108. Louis-Pierre Deseine, *Tomb of Cardinal de Belloy*, marble, 1819, Nôtre-Dame, Paris.

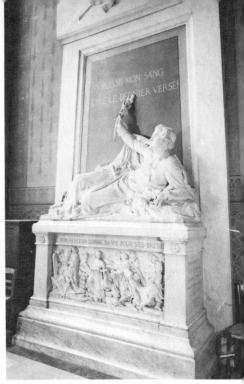

fig. 109. Auguste-Hyacinthe De Bay, *Tomb of Msgr. Affre*, marble, commissioned 1849, delivered 1860, Nôtre-Dame, Paris.

events in French history is completely ignored. What little impetus there had been during the middle decades of the nineteenth century to find an idiom that would be both realistically contemporary and yet eloquent of the history and tradition of the church seems to have been sapped completely during the 1890s. The last of the monuments in Nôtre-Dame, that of Msgr. Quelen by Geoffroy-Dechaume, is dated 1892. Quelen, who had actually died in 1839, is shown very much in the guise of a Baroque tomb effigy. Except for the technically very dry handling of surfaces and the dull massing of drapery, there is very little in this statue that speaks of the desire to create a new typology of modern ecclesiastic sculpture.[9]

The Independent Tradition

Although it is true that the funerary sculpture of both official and independent artists comes to sterility towards the end of the century, it is equally true that those tombs commissioned for nonofficial occasions show a great deal more vitality and are aesthetically far more viable. Unlike Italy, where the tomb during the nineteenth century is not really considered on its artistic merits but purely on craftsmanlike ability to represent certain scenes associated with death, France and especially

Paris made high demands of the artist. There is an urge here on the parts of both artist and sponsor to create work that will be remarkable and successful even when divorced from its private and mournful circumstances.[10]

Bridging the categories of dynastic and private tomb is Pradier's tomb of the Count of Beaujolais (fig. 101). Although dedicated to a prince of the ruling house of Bourbon, it is endowed with a highly personal note that goes beyond the official expression of dignity to express the artist's own sentiments associated with youth, grief, and beauty.

Justifiably the most famous French tomb of the epoch is Rude's *Godefroy de Cavaignac* of 1845 (fig. 111). It is also a perfect example for studying nineteenth-century approaches to the art of the past. It represents one of the most successful attempts at translating the religious values of the past into a secular morality suitable for the modern temper.

The direct sources for this haunting figure are medieval and Renaissance representations of the dead Christ. Sculpturally, the

origins of the conception lie with the tradition of entombment groups which combine a vigorous realism with serene dignity. In Italy, too, this type is popular—especially in Emilia—and finds its highest expression in Bandini's *Dead Christ* in the crypt of Urbino Cathedral. Rude's realism, in comparison with these earlier examples, is more radical. The isolation of the corpse, the sense of exhaustion are taken to a point that has only one prototype in earlier art: Holbein's *Entombed Christ*, a painting which held special meaning for the nineteenth century. Rude captures all the dignity of such earlier imagery but avoids the suggestion of heroic nudity by disposing the drapery in such a way as to suggest the morgue rather than Golgotha. By the same token, the unadorned, neutral ground of the sculpture, so different from the landscape mounds of the Pietà groups, gives the body a startling proximity in time and place to the visitor who comes upon this sculpture. The very absence of the expected mourning figures adds to the immediacy of effect. As one approaches the tomb, one is forced to make one's own peace with this startling representation of death. Rude has deprived us of the intercession of attendant saints who are usually associated with the dead Christ. The saints who formerly

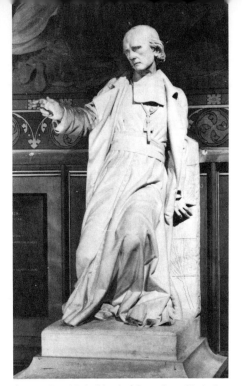

fig. 110. Jean-Marie-Bienaimé Bonassieux, *Tomb of Msgr. Darboy*, marble, 1876, Nôtre-Dame, Paris.

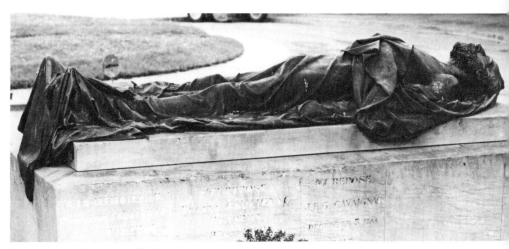

fig. 111. François Rude, *Tomb of Godefroy Cavaignac*, bronze, 1845–47, Père-Lachaise cemetery, Paris.

mourned Christ gave understandable and higher meaning to death. Now the burden of deciphering the mystery involved in the cessation of life suddenly shifts to our shoulders. We must make our own way through the tangled emotions of grief and repulsion evinced by the sight of Cavaignac's corpse.

Stylistic categories that are valid and useful for the study of nineteenth-century painting break down completely when one tries to transfer them to sculpture. This is particularly true of funerary sculpture. After 1830 the characteristics of style become confused and unrecognizable. The concepts of Romanticism, Realism, and Naturalism cannot be applied to sculpture. It is here, perhaps, that we finally arrive at the purest form of styleless art which has intrigued artists and critics ever since Baudelaire's time. Certainly such sculptures as Etex's tomb of Géricault (fig. 112) cannot be inserted under any stylistic rubric. The idea of showing the artist abed while painting is as Realistic as it is Romantic since Géricault did in fact paint his last works while confined to bed by the complicated wounds and fractures suffered in an accident.[11] Just as difficult to seize, on stylistic

grounds, is the tomb of Madame de Staël at Coppet. The severely unadorned black basalt sarcophagus which holds her body preserved in vinegar might be thought of as classical in its restraint. The total effect, however, in its lugubrious setting and massive presence, is highly emotional and anticlassical. Much the same can be said of the tombs carved by the most eccentric of Romantic artists, the sculptress Félicie de Fauveau. Her mother's tomb in the cloister of the Carmine in Florence is a masterpiece of realistic portraiture.[12] Her most elaborate work, the tomb of Favreau in Santa Croce (fig. 113), for all its Troubadour Style framework and for all the full-blooded Baroque modeling of the central figure, has a peculiarly realistic cast to it because the flight of the soaring soul is not set against the supernatural heavens but against a carefully developed view of Florence. Transcendental flight is turned into a feat of aerodynamics.

Even where one would expect the most Romantic outbursts, in Préault's tomb of the Abbé l'Epée in Saint Roch (fig. 114),

one comes up against an astonishing sobriety of style and composition. As in Thorvaldsen's most classicizing tombs, the degree of interaction between the central and the flanking figures is kept to an absolute minimum and the great achievement of the deceased is celebrated and explained to us in the weirdly illustrational base relief where the gestures of severed hands spell out the sign alphabet invented by the good Abbé for his deaf and dumb patients.[13]

Sober and *bienséant* modesty are the essential characteristics demanded of sculptors by the upper reaches of French society in the first half of the century. Marochetti met this taste in the unassuming tomb of the Countess de la Riboisière in the Parisian hospital that still bears her name. Unassuming and free of rhetoric, Marochetti's work is somewhat influenced by Bartolini's tomb of Princess Zamoyska in Florence. The still rather religious serenity of Bartolini's tomb is deflected toward a more secular mood by Marochetti. Decorum is stressed more emphatically than faith, and appearances are rendered with impeccable but never showy realism. With such —to modern eyes—rather slight gifts, Marochetti was the successful exponent of the dominant and highly circumspect core of the upper French bourgeoisie.

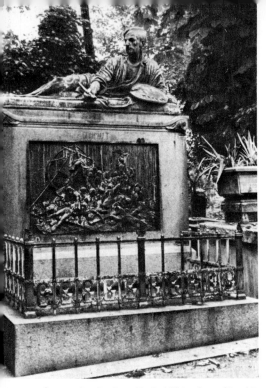

fig. 112. Antoine Etex, *Tomb of Géricault*, marble with bronze bas-reliefs, 1841, Père-Lachaise cemetery, Paris.

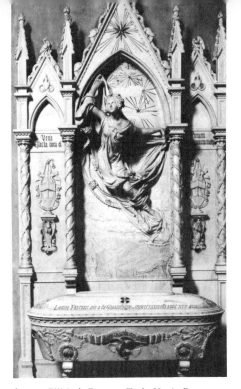

fig. 113. Félicie de Fauveau, *Tomb of Louise Favreau*, 1858, marble, Santa Croce, Florence.

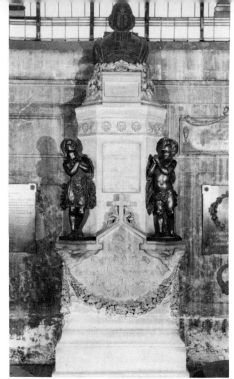

fig. 114. Auguste Préault, *Tomb of Abbé l'Epée*, stone, 1844, formerly Saint-Roch, Paris (destroyed 1871).

The French upper middle class, unlike its Italian counterpart, was very sure of itself and of its values and rejected all the eccentricities that were possible in Italy, where the bourgeoisie felt itself isolated and without tradition. It is only in the provinces that we sometimes find startling exceptions to the reportorial realism of the standards set by Parisian funerary sculpture. It is therefore in the provinces that we sometimes come upon tombs that make up for their relatively mediocre quality by means of audacious freedom of style or expression. Standing to one side of the major development of modern sculpture in France, they nevertheless compel interest and admiration.

The best example of this highly imaginative category of funerary sculpture in France is Bartholdi's monument in Colmar to the French soldiers who fell during the Franco-Prussian war (fig. 115). Without any reference to a specific time and place, this monument achieves a startling universality. The very ambiguity of the action is breathtaking. Is the warrior about to rise from the tomb to grasp the sword and wreak vengeance, or has he just relinquished his weapon as the tomb closes on him inexorably? In either case, the sense of horror is immediate and lasting. Rarely has

the nineteenth century produced anything that evokes all our animal fears of death with such incontrovertible power.

Only toward the very end of the century do we find two works that in their originality and dignity are worthy of the great tradition of French sculpture. Significantly, it is not Rodin who brings the chapter of French funerary sculpture to a close. His whole character causes him to avoid the sense of finality that a secular attitude towards death must necessarily have. Nor was he interested in achieving that subordination of style to content which is so important for the whole genre. It is to Bartholomé and Dalou that we must look for the final and moving end to a great tradition of Western sculpture.

In his *Monument to the Dead*, (fig. 100) Bartholomé closes the parenthesis that was opened by Giraud's concept of a communal grave. Bartholomé had already distinguished himself in the touching grave of his wife in which he experimented with what was to become an important new idea: the fragment. Something ephemeral

and intimate is expressed by showing only the busts of husband and wife at the moment of their last kiss.

The *Monument to the Dead* has often been discussed as a sign of revolt against the two dominant factions of sculpture at that time, and certainly the composition negates both the narrowly realistic, decorative dispersion of form of the official Salon artists as well as the dynamic, restlessly shifting fluidity of Rodin. In that respect it can be seen as part of an international urge to reestablish an architectural, tranquil order. The monument can be understood as a French and independent counterpart of Adolf von Hildebrandt's demand for a new formal and moral order.[14]

To understand the artist's goal fully, the monument must be viewed *in situ* as the vanishing point of the great central avenue of the cemetery so that all the *enfilades*, those of the dead who lie buried to either side and those of the living who ascend the slope of the park, are funneled to the central entrance toward which all the figures converge. Formally, the steadfast procession away from the visitor was first invented by Canova in his Maria Christina tomb in Vienna. Morally, it is the expression of a modern and secular, egalitarian consciousness. The anonymity, the impartial nature

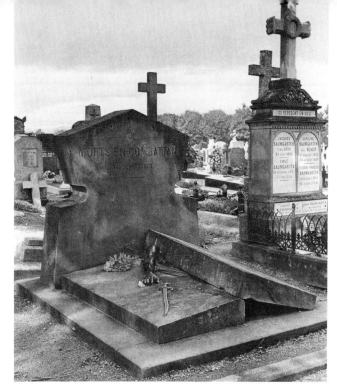

fig. 115. Frédéric-Auguste Bartholdi, *Tomb of the National Guard,* stone and bronze, 1898, municipal cemetery, Colmar.

fig. 116. Jules Dalou, *Tomb of Victor Noir,* bronze, 1890, Père-Lachaise cemetery, Paris.

of modern death are expressed here. This is in sharp contradistinction to the highly religious experience of the medieval *Danse Macabre* tradition in which Death has a defined character, metes out a just death to each of his victims, and gives an individual destiny to the end of each life that he snuffs out. Death, in the modern monument, is no longer capable of taking on any guise whatsoever. He has neither character nor action left to him, and certainly he is no longer the instrument of divine law. Instead, Death is simply the cessation of life.[15] It has no meaning or logic or describable features. If it teaches anything, it is resignation to a biological fact.

If Bartholomé's *To the Dead* can be thought of as the ultimate nineteenth-century speculation on death as it regards all of humanity, Dalou's tomb of Victor Noir (fig. 116) exemplifies the ultimate expression of modern attitudes towards individual death. Brancusi's *Kiss* notwithstanding, it is the last aesthetically viable sculpture that also belongs to the tradition of public commemoration of an individual.

Victor Noir, an audacious republican journalist, was shot to death by Prince Pierre Bonaparte in 1870. His funeral nearly ended in a pitched battle between gendarmes and mourners. Thousands of Parisians had come to do Noir homage even though public funeral honors had been for-

bidden by the regime. The "affaire Noir" made such a lasting impression and aroused such high feelings that Dalou's monument was not installed until 1891. Noir and his associates on the journal *La Marseillaise* had been publicly insulted by Prince Bonaparte, and Noir had been appointed witness for a duel to which the prince had been challenged by the offended party. It was in this official guise as second that Noir went to Prince Bonaparte's house to settle the customary details. Bonaparte, enraged at having been challenged, met him at the door and shot him dead. A subsequent trial cleared him of guilt and further infuriated the liberals chafing under the regime of the Second Empire.

In an earlier tomb, that of Auguste Blanqui, Dalou had already continued the tradition of the medieval and Renaissance *gisant* tombs, much as Rude had done in his Godefroy de Cavaignac monument. The emblematic bouquet of thorns and thistles adds a slight moralizing tone that Rude avoided. With the Noir monument, Dalou went much further along the path of sober, thoroughly modern and impartial reportage, and it is this very sobriety and detachment from any overt sentiment that makes the tomb of Victor Noir one of the perpetual and justifiable favorites of all

visitors to Père-Lachaise. During his life, Noir had been notorious for his slipshod way of dressing, but for the sake of propriety he had gone to the trouble of wearing all the haberdashery that his position as second in a duel involving an "Altesse Imperiale" required. Gloves, top hat, and severely buttoned redingote were all donned for the special occasion. The scattered, limp gloves, the pathetic finery which he had forced himself to wear out of respect for his socially exalted adversary—all these details were not lost on Dalou's public even though we, today, must reconstruct some of the sentiment they aroused. But even if we deny ourselves the right to evoke sentiments that are no longer directly inspired in us, the effectiveness of the tomb is still incontrovertible in its power and its haunting immediacy and modern flavor.

Dalou's concern for a style that would incorporate all the most advanced political and ethical ideals of his time inspired him to invent monuments on modern themes such as his projected *Monument to Labor* (fig. 54). This gigantic plan was too far ahead of the political realities of his day to find the necessary backing. It is only in his tomb of Victor Noir that he realized, in lesser dimensions, all his hopes for a fully modern expression. He must have been conscious of challenging comparison with Rude's *Godefroy de Cavaignac* (fig. 111), also

in Père-Lachaise; both were devoted to heroes of liberal struggles, both compositionally related to the ancient French tradition of *gisant* tombs. Whereas Rude, however, still intends to carry into modern times some of the dignity of earlier French tombs by means of the noble draping of the shroud and the emphasis on a serene and impressive silhouette, Dalou has transposed the whole concept of the tomb to the journalistic chronicle of a news item. He may have been inspired by Gérôme's very popular painting of the *Death of Marshall Ney*.[16] Instead of hinting at the solemn lying-in-state which Rude still suggests (in spite of his trenchant realism), Dalou presents the figure of Victor Noir as if we had happened upon the corpse inadvertently as it lay in the street in front of Prince Bonaparte's doorstep.

A revealing early sketch for this tomb figure (cat. no. 80) proves that Dalou was preoccupied in avoiding the exaltation of Rude's *Cavaignac* by giving preference to the odd angle of vision. Still more importantly, he calculates a sharp sighting downwards so that the notion of witnessing a street accident becomes almost automatic. The scattered still-life elements, the detached description of fashionable, contemporary clothes, rob the figure of the timelessness that Rude had insisted on by

showing us his *Cavaignac* raised on a high pedestal and draped in a shroud. The finite nature of individuality and of life is thus brought home by Dalou as no funerary effigy had ever done. Once Dalou established that death and individuality are both accidental instead of being matters that involve a specific destiny, the possibility of celebrating an individual on his tomb was destroyed. In spite of rare instances in which funerary effigies are still attempted, the future of funerary monuments lay with the path indicated by Bartholomé's *Monument to the Dead*.

The celebration of anonymous death and of mass death is the true preoccupation of those artists who are still concerned with expressing ideas regarding each man's moment of truth. Until now no sculptor has been adequate to the task of creating a monument to the dead of Hiroshima, of Dresden, of Auschwitz; the attitude expressed in Dalou's *Victor Noir*—and it is perhaps the only attitude one can maintain with honesty in modern times—blocked the road to commemoration. The newspaper item that rouses our still-primitive curiosity about death is ephemeral. We can only conceive of the future as a terrestrial, finite future and not a timeless "beyond."

The automatic association of death with sanctity has gone from us. Dalou's tomb of Victor Noir is really the tombstone of a human tradition and a human urge that began when the Pyramids were built.

Although we still feel grief and melancholy when we participate in a funeral, our urge to transmit this mourning to future generations has been sapped. Our belief in the sanctity of the individual life, our will to emulate those who have gone from us, no longer nurtures those human energies that raised monuments to the dead for the past five thousand years.[17]

Notes

1.
Voltaire's famous description of rape, pillage, and murder perpetrated by the Bulgarian troops in *Candide* foreshadows later nineteenth-century attitudes towards similar catastrophes. His sarcastic wrath at such events and especially at the notion of such events taking place because they were willed by God was intelligible only to a relatively small elite. Besides, as always with Voltaire, it is difficult to tell whether he rails at the institutions of the *ancien régime* or against the perversion of the institutions.

2.
This monument, it must be remembered, is not a tomb but a *memoria*.

3.
In Houdon's *Tomb of Mikhail Mikhailovitch Galitzin* (marble, 1774, Donskoy Monastery, Moscow), a winged genius leans mournfully and protectively against the cinerary urn of the departed. The allegorical figure, instead of being part of the monument, only visits the tomb. In the unexecuted tomb of Prince Alexander Mikhailovitch Galitzin (fig. 98), the allegorical figures gather around the wounded prince as he lies on what might be either his deathbed or his coffin. In both cases the allegorical figures are not timeless representatives of virtue but also active, and therefore temporal actors in a narrative. Only in the d'Ennery tomb (fig. 99) does Houdon resolutely turn to unequivocal narrative by representing the actual scene of the family gathering around the tomb to do homage to their illustrious forebear.
4.
For sepulchral sculpture in German-speaking countries see H. T. Beenken, *Das neunzehnte Jahrhundert in der Deutschen Kunst,* Munich, 1944 and H. W. Janson, "German Neoclassic Sculpture in International Perspective," *Yale University Art Gallery Bulletin,* 1972, XXXIII, p. 4. For England see N. Penny, *Church Monuments in Romantic England,* New Haven, 1977.

5.
Also of interest in regard to the changes that take place in funerary sentiment where funeral practices are concerned is the comparison between Jacque Saly's maquette for the tomb of Guy Valori (Louvre) and Chinard's *Jeune femme appuyée sur un cippe* in the same museum. The former is an actual tomb project. The latter, which for all intents and purposes looks exactly the same, is a model for a *pendule.* Similar evidence of interchangeability between tomb, monument, and clock-ornament can be found in H. W. Janson, "German Neoclassic Sculpture," p. 4.
6.
The statue of Voltaire in the vestibule of the Panthéon's crypt is an isolated afterthought. It is also not associated directly with Voltaire's tomb but stands as an independent ornament of the central corridor.
7.
See W. Messerer, "Zu extremen Gedanken ueber Bestattung und Grabmal um 1880," *Probleme der Kunstwissenschaft,* 1, Berlin, 1963, p. 172.
8.
For a complete bibliography on Msgr. Affre, see C. C. Hungerford, "Meissonier's Souvenir de guerre civile," *Art Bulletin,* June 1979, p. 283, footnote 21.

9.
Hyacinthe-Louis Quelen (1778–1839) was one of the most prominent and influential ecclesiastics during the Bourbon Restauration. For the art historian, his reception address at the Academie Française (November 25, 1824) on "L'alliance de la religion avec les lettres, les sciences et les arts" is an important document for determining Church policy towards the arts.
10.
The twentieth-century notion of placing works of art on tombs that originally had no connection with funerary sculpture has its roots in this prototype. Maillol's *Pomona* in the Hoernli Cemetery at Basel and Pomodoro's *Sfera* in the Cimitero Monumentale in Milan are examples of this modern trend. Even Brancusi's *The Kiss* is fairly traditional; both sculptures declare themselves first and foremost as detached and independent pieces of sculpture that are only very tenuously connected with the individuals who are buried beneath the stones. The funerary nature of these sculptures arises only in a second phase of contemplation.

11.
The idea of celebrating a famous painter by translating one of his most famous works into a relief as happens here with the *Raft of the Medusa* has anterior prototypes. Chateaubriand had Poussin's *Et in Arcadia Ego* reproduced in marble for Poussin's tomb in San Lorenzo in Lucina. The idea behind such a practice is of interest. Where virtuous deeds *ad majorem Dei gloria* are stressed in late Baroque tombs, the nineteenth century stresses success and achievement.

12.
Illustrated in Licht, 1967, plate 66.

13.
Préault's better known and more successful tomb sculptures are all relatively small relief heads such as the tomb of Rouvière (cat. no. 188) and the still more famous *Le Silence.* Both display an astonishing ability to suggest an aura of the macabre in spite of the vigorously realistic modeling. See E. Chesnau, *Peintres et statuaires romantiques,* Paris, 1880, and T. Reff, "Redon's *Le silence:* an iconographic interpretation, *Gazette des beaux-arts* 1967, LXX, p. 365.

14.
The double-storied composition is also reminiscent of contemporary stage sets for Verdi's *Aïda.*

15.
"Der Tod ist der Zustand der Ruhe und der Bewegungslosigkeit." G. E. Lessing, *Wie die Alten den Tod gebildet.*

16.
See G. Ackerman, "Gérôme and Manet," *Gazette des beaux-arts,* 1967, LXX, p. 163.

17.
Dalou was also the author of far more and far more ambitious tombs than I have been able to deal with here. Particularly his tombs and related funerary sculpture at Windsor merit a great deal of study in this context. In the same manner, I have slighted a great number of fascinating funerary monuments in the provinces, in the colonies, and, especially important, in the French national churches of San Luigi de' Francesi and Santa Maria in Via Lata in Rome as well as the tombs of exiled Bonapartists which are scattered all the way from Santa Croce in Florence to Tallahassee in Florida. For French tombs in Rome, see A. Le Normand, "Paul Lemoyne, un sculpteur français à Rome au XIX siècle," *Revue de l'Art,* 1977, no. 36, p. 27. Still another category that has been slighted in this short essay is the group of tombs that resemble civic monuments. David d'Angers' great tomb of General Gobert in Père-Lachaise is the best early example of this class of sculptures.

LOUISE ABBEMA
1858 Etampes–Paris 1927

Great-granddaughter of Comte Louis de Narbonne and the actress Mlle. Contat, Louise Abbema was exposed from an early age to high society and the arts. Reminiscing in 1903 she wrote that it was the example of Rosa Bonheur that "while a little girl...decided me to become an artist."[1] Abbema first studied drawing under the direction of a family friend, M. Devedeux, and by 1870 she had begun painting. In 1873 she entered the studio of Chaplin, and in 1874 she worked with Carolus-Duran who encouraged her to exhibit at the Salon of that year. Some time later she also studied with Henner.

Abbema's first major success came when she exhibited a painting, *Portrait of Sarah Bernhardt,* at the Salon of 1876. She continued exhibiting regularly at the Salons until 1926, winning an honorable mention in 1881. She also exhibited in the Woman's Building at the 1893 Chicago World's Fair[2] and at the 1900 Exposition Universelle in Paris where she won a bronze medal. In 1906 she was awarded the Legion of Honor.

Abbema worked in pastel, watercolor, and oil, producing numerous flower pictures, still lifes, landscapes, and portraits. She executed several ceilings and decorative panels for private homes and public buildings in Paris, including the town halls of the VIIᵉ, Xᵉ, and XXᵉ arrondissements, the Hôtel de Ville, the Museé de l'Armée, and the Théâtre Sarah Bernhardt. Abbema also made illustrations for René Maizeroy's novel *La Mer* and for several other publications. Only one sculpture by her is known (cat. no. 1). P.F. & G.S.

1.
Portrait of Sarah Bernhardt (1844–1923)
Bronze
diam: 6¼ in. (15.9 cm.)
1875
Signed and dated: Louise Abbema 75
No foundry mark
Provenance: Shepherd Gallery, Associates, New York
Lender: Ellen Burstyn

Abbema first met Sarah Bernhardt in 1871,[3] and it was apparently soon thereafter that she thought of portraying the famous actress. A version of Abbema's medallion, executed in 1875, was exhibited at the Salon of 1878. In this same Salon, Bernhardt, also a part-time sculptor, exhibited a marble bust of Abbema.[4] Abbema made drawings after both of these works,[5] and throughout her career she continued to produce paintings of and for Sarah Bernhardt. It seems likely that the 1875 medallion was made by Abbema from one of her studies for the painted portrait of Bernhardt exhibited at the Salon of 1876. After the medallion, Abbema apparently abandoned sculpture.

From the 1870s, the two female artists remained close friends.[6] Abbema was a regular visitor to the informal gatherings of artists, writers, and actors that took place in Bernhardt's studio on the Boulevard de Clichy, and from 1886 until 1922 she was a favored guest at Bernhardt's castle retreat on Belle-Isle. Abbema owned an extensive series of photographs of Sarah Bernhardt in various poses and costumes, nearly all of which bore the mock dedication: "A Louise Abbema, la plus grande artiste, Sarah Bernhardt, l'autre plus grande artiste."[7] P.F.

1.

ZACHARIE ASTRUC
1835 Angers—Paris 1907

Notes

1.
T. Stanton, *Reminiscences of Rosa Bonheur,*
London, 1910, p. 140.

2.
M. H. Elliot, ed., *Art and Handicraft in
the Woman's Building of the World's Colum-
bian Exposition,* Chicago, 1893, pp. 53,
124, 179, 181.

3.
Lecocq, 1879, p. 13.

4.
This may be identical with the marble
bust, signed and dated 1878, which re-
cently sold at auction in Paris, Drouot-
Rive Gauche, Salle no. 8, *Art 1900,* March
21, 1978, lot no. 83 (illustrated).

5.
Reproduced in and apparently done to
illustrate Lecocq, 1879, frontispiece and
p. 9.

6.
On their relationship see G. G. Geller,
Sarah Bernhardt, London, 1933, pp. 121–
22, 252, 267; L. Verneuil, *La Vie Merveil-
leuse de Sarah Bernhardt,* New York, 1942,
pp. 25–29, 106, 114, 133, 148, 199, 235,
273; S. Rueff, *I Knew Sarah Bernhardt,*
London, 1951, p. 128; C. O. Skinner,
Madame Sarah, Boston, 1967, pp. 95–97,
111, 135, 197, 238, 262, 276, 315.

7.
Lecocq, 1879, pp. 8–9.

Selected Bibliography

Lecocq, G., *Louise Abbema,* Peintres et
sculpteurs, I, Paris, 1879.

Levasseur, A., *Croquis contemporains,* 1ère
livraison, Paris, 1880.

Bellier and Auvray, 1882–87, II, supple-
ment, pp. 1–2.

Lasinio, P., "Luisa Abbema," *Natura ed arte,*
February 15, 1892, fasc. 6, pp. 424–28.

Clement, C. E., *Women in the Fine Arts,*
New York, 1904, pp. 1–2.

Sparrow, W., *Women Painters of the World,*
London, 1905, pp. 182–83.

Thieme and Becker, 1907–50, I, p. 12.

Poet, playwright, musician, art critic,
painter, and sculptor, Zacharie Astruc was
one of the most versatile artistic talents in
the nineteenth century. Gifted with both
genius and charisma, he mingled at ease
with the leading artistic and political figures
of the period including Manet, Monet,
Whistler, Léon Gambetta, Léon Bloy,
Barbey d'Aurevilly, and Alphonse Daudet.
Today he is remembered for his contribu-
tions to two of the major aesthetic currents
of the era, Hispanisme and Japonisme, and
for his staunch support of Manet and the
Impressionists. As the spokesman for the
new movement, Astruc was given a promi-
nent position, seated next to Manet, in
Fantin-Latour's famous group portrait of
the Impressionist circle, *A Studio in the
Batignolles Quarter* (1870). Astruc began his
career as an art critic in 1859 with his first
Salon review, *Les 14 Stations du Salon.* He
wrote regularly for the daily newspaper
L'Etendard between 1866 and 1868, and
remained active as a critic until 1872.

During the 1870s and 1880s he turned
more to the practice of painting and
sculpture. A self-taught artist, he proved
to be equally adept in both but expressed a
preference for sculpture in 1862: "Sculp-
ture is my passion: marble gives me a sort
of enthusiasm; I cannot see the human
form develop without being moved."[1]
Although his first sculptures, busts of
his friends Mario Proth and Charles
Jouffroy, date from 1856, he did not
make his Salon debut until 1869, when
he exhibited a medallion of his father read-
ing and a bas-relief entitled *The Monk,*
later purchased by the State. Unlike his
paintings, which focused on still life and
genre, Astruc's sculptures were primarily
portrait busts and medallions of his family
and friends. Only occasionally did he exe-
cute works inspired by literature (*Hamlet,*
1887), mythology (*King Midas,* 1889, and
The Repose of Prometheus, 1891), or history
(*Blanche de Castille*). His most highly
acclaimed sculptures were a copy of Alonzo
Cano's *St. Francis* (1873–74) and the *Mask
Merchant* (see cat. no. 2). Several of his
paintings and sculptures were acquired by
the government. In addition to earning
honorable mentions at the Salons of 1882,
1883, 1885, and 1886, Astruc was elected
to the Legion of Honor in 1890 and won a
bronze medal at the Exposition Universelle
of 1900. M.B.

2.

Mask of Alexandre Dumas fils (1824–1895)
Bronze
h: 10 in. (25.4 cm.); w: 7¾ in. (19.7 cm.)
After 1883
No marks
Lender: Private Collection

Astruc's portrait of Dumas *fils,* the cele-
brated novelist and dramatist, is a replica
of a mask originally produced for a bronze
group entitled the *Mask Merchant.* Ex-
hibited in 1883 at the Salon and at the Ex-
position Universelle in Nice, the sculpture
was purchased by the State and placed in
the Luxembourg Gardens in 1886. The
Mask Merchant represents a partially clad
youth carrying portrait masks of eminent
living artistic and political personalities—
Gambetta, Victor Hugo, Gounod, and
Théodore de Banville. In addition to that
of Alexandre Dumas, masks of Balzac,
Carpeaux, Delacroix, Corot, Berlioz,
Faure, and Barbey d'Aurevilly decorate the
base. A medallion mask of James de Roths-
child once hung from the boy's neck but
has since disappeared.

2.

JEAN-AUGUSTE BARRE
1811 Paris 1896

Clearly Astruc intended the figure to portray a *gavroche,* or street urchin, peddling his wares.[2] Although this treatment of the subject is a fantasy, unprecedented in art, the representation of figures holding masks is not uncommon in sculpture; they can be found in antique bas-reliefs that depict playwrights holding dramatic character masks.[3] During the late nineteenth century, masks appeared frequently in Symbolist art, but unlike those in the works of James Ensor and his contemporary Félicien Rops, Astruc's masks are straightforward, naturalistic portraits without mysterious or sinister overtones.[4] Life masks were apparently a popular form of portraiture beginning in the middle of the century. In 1863, Philippe Burty wrote that "casting faces (*moulé le visage*) was at that time the fad of Meissonier, Steinheil, and Geoffroy [Dechaune]."[5] As a result of the success of the *Mask Merchant,* Astruc executed a series of individual portrait masks of contemporary personalities, some of which were displayed at the Salon of 1889. Astruc's engaging street urchin may have inspired Barrias' playful allegorical figure holding a mask of Goi for his monument to the playwright Emile Augier (1895).[6] M.B.

Notes
1.
Flescher, 1977, p. 436.
2.
Ibid., p. 456.
3.
Ibid., p. 456.
4.
Ibid., p. 458.
5.
Cited in Cambridge, Massachusetts, 1969, p. 195.
6.
Illustrated in G. Lafenestre, "Ernest Barrias," *Revue de l'art ancien et moderne,* 1908, XXIII, p. 337.

Selected Bibliography

Lami, 1914–21, I, pp. 24–26.

Flescher, S., "Zacharie Astruc: Critic and Artist (1833–1902)," Ph.D. diss., Columbia University, New York, 1977.

Son of *ciseleur* and medalist Jean-Jacques Barre, Jean-Auguste first studied with his father and then in the studio of Cortot. He was admitted to the Ecole des Beaux-Arts in 1826. In 1829, at age eighteen, he executed a group entitled *Gymnastics,* his first recorded work.[1] This statue was commissioned by an exiled Spanish Colonel Amoros (1770–1848) whose bust portrait (on the tomb of Amoros in the Montparnasse Cemetery) Barre also sculpted in 1830. Barre made his Salon debut in 1831 and continued to exhibit regularly until 1886. At the Salon of 1834 he won a second-class medal for his marble *Ulysses Recognized by His Dog* (Château de Compiègne gardens), and at the Salon of 1840 he won a first-class medal for a plaster statue of *François de Lorraine, Duc de Guise* (Musée de Versailles). In 1852 he was elected to the Legion of Honor.

Throughout his long and active career, Barre seems to have remained in constant good favor despite changes in government. Louis-Philippe both acquired and commissioned several works from Barre including the tomb of his mother, the Dowager Duchess of Orléans, Louise-Marie-Adelaide de Bourbon (executed 1844–47 for the royal chapel at Dreux, Eure-et-Loir; see fig. 103). Under the provisional government of the Second Republic, Barre was one of the sculptors commissioned by the Ministry of the Interior to execute a plaster statue in the competition for a symbolic figure of *The Republic.* Under Napoleon III, Barre was the favorite court portrait sculptor of the 1850s and shared the same role with Carpeaux in the 1860s. At the age of sixty-eight in 1879, Barre received his last government commission, a marble bust of *Berryer* (Musée de Versailles) executed for the Ministry of Public Instruction and Fine Arts.

Barre's oeuvre includes a number of mythological and allegorical works, among which are figures of *Bacchia* (1853), *The Renaissance* (1855), and *Fame* (1859, executed for the interior courtyard of Lefuel's new wing of the Louvre). He made a few religious sculptures for Paris churches: *Saint Luc* (1844) for Saint-Vincent-de-Paul and *Twelve Apostles* (1851) for the main altar of Sainte Clotilde. He also produced decorative figures such as those for the *surtout de table* which Roussigneux designed for the Prince Imperial. Above all, however, Barre

made portraits—medallions, busts, statuettes, and statues—which range in style from the vigorous Romantic realism of some early works (cat. no. 3) and the decorative charm of certain statuettes (cat. no. 4) to the academic classicism of official commands, as in his busts of Napoleon III (cat. no. 5). Little of Barre's work has been illustrated, let alone studied. Recently one of his descendants, M. Regnoul-Barre, announced to the *Club Français de Médaille* that he possesses extensive documentary material relating to Barre, his father, and his younger brother, the medallist and painter Albert-Desiré. P.F.

3.
Portrait of a Man
Bronze
diam: 8⅝ in. (21.9 cm.)
Signed and dated: AUG BARRE 1830
No foundry mark
Provenance: Heim Gallery, London
Lender: The Cleveland Museum of Art, Norman O. Stone and Ella A. Stone Memorial Fund

Although the sitter of this portrait is unknown, one may assume that he was an artist. Portraits *en negligé,* or in casual dress with open shirt, first became common in French sculpture with the busts of artists produced by Antoine Coysevox (1640–1720) in the early eighteenth century. The open-at-the-neck work shirt became not only a symbol of the artist-craftsman but also of one who opens up or reveals his soul through art. This purposely casual manner of portraiture was especially popular during the Romantic period when artists often chose to see themselves as bohemians, forced to live outside the norms of society by the special talents with which they had been blessed or cursed.

At his Salon debut in 1831 Barre exhibited both a group of medallions in a frame and a single medallion; the subjects of these works are unrecorded, but it is possible that one of them was identical with the work in the present exhibition. The Cleveland medallion is particularly beautiful, with the sitter rendered in a rugged, sketchy fashion and in unusually deep relief (as compared with other portrait medallions of the period such as those by David d'Angers and Préault). Barre's

early medallions were singled out for special praise by the Salon reviewers of the 1830s.[2] P.F.

4.
Fanny Elssler (1810–1884)
Silvered bronze
h: 16⅞ in. (42.9 cm.)
1837
Signed and dated: A. Barre fct 1837 (on top of base)
Inscribed: FANNY ELSSLER (on front of base)
Foundry mark: Eck et Durand Fdeur Fcant (on top of base)
Lender: The Fine Arts Museums of San Francisco, Gift of Mrs. A. B. Speckels, Museum of Theater and Dance

Among Barre's most popular works were his portrait statuettes of famous theatrical personalities.[3] He first exhibited a statuette, of an unspecified sitter, at the Salon of 1836; Lami suggested that this may have been the model for the *Fanny Elssler*.[4] A reviewer for *L'Artiste*[5] implied

that Barre exhibited both the *Fanny Elssler* and a statuette of another dancer, *Marie Taglioni*,[6] at the Salon of 1837 although these works are not listed in the Salon *livret* of that year. The original plaster model for the *Fanny Elssler* was supposedly in the collection of H. Rouart earlier in this century.[7] A bronze version once belonged to M. Metman[8] and may be identical with the example now in the Musée des Arts Decoratifs in Paris. Another bronze of *Fanny Elssler* was sold at auction in Paris in 1962.[9]

The figure of *Fanny Elssler* depicts the Austrian ballerina at the age of twenty-seven in the costume of a Spanish dance, the Cachucha. In 1836 she danced the Cachucha at the Paris Opéra in the role of

3.

the dancer Florinda, adopted from Le Sage's novel *Le Diable boiteux* (*The Lame Devil*). It was in this ballet that Fanny aroused the admiration of critics, including Théophile Gautier who wrote in *La Presse* of 1837: "Fanny Elssler, that German [sic] girl who has transformed herself into a Spaniard; Fanny Elssler, the 'cachucha' incarnate . . . raised to a state of a classical model; Fanny Elssler, the most spirited, precise, intelligent dancer who ever skimmed the boards with the tip of her steely toe."[10]

It was amid such praise that Barre produced his statuette, presumably at the request of one of Fanny's admirers or in order to exploit her popularity. A lithograph by Lafosse after a drawing by Deveria,[11] also executed at this time, depicts Fanny in a manner that is strikingly similar, in pose and costume, to Barre's work.

A tradition of portraying theatrical personalities existed in French sculpture during the second half of the eighteenth century, notably in the works of Boizot, Caffieri, Houdon, and Merchi.[12] The last, in fact, seems to have produced statuettes that he attempted to sell in the form of commercial reproductions;[13] however, the genre of the portrait statuette first became firmly established in the early 1830s. Two contemporary sources credit the "invention" of this type to a little-known, short-lived artist, J.-E. Chaponnière (1805–1835),[14] who at the Salon of 1833 exhibited small plaster statuettes of a dramatic artist, Mlle. Juliette, and of the sculptors Tiolier and Pradier (Chaponnière's teacher). A reviewer of the Salon of 1835 noted that at this date Barre was already making charming statuettes "à l'exemple de M. Chaponières [sic]."[15]

If the genre of the portrait statuette began with the depiction of famous contemporary artistic personalities and artists, its sphere was soon expanded to include artists of the past and other historical personages as well as simple bourgeois patrons. The realistic, detailed style of these works had mass appeal, and their small size and often inexpensive medium made them affordable. Anecdotal and picturesque, they satisfied a desire to possess a lifelike and complete image of the famous, the fashionable, or

the familiar; as such they played a role that was eventually to be taken over by photography. By the mid-nineteenth century, these small sculptures—catering simultaneously to demands for portraits and figurines—had become so popular as to evoke a critical outcry against the "deluge of statuettes."[16] Despite the popular acceptance of Barre's works when they first appeared in the mid-1830s, four of the artist's pieces—*Indian Dancer, Queen Victoria, Napoleon,* and *Mme. Paul Delaroche*—were rejected by the Salon jury of 1839.[17] In 1840 a Salon reviewer remarked that Barre's statuettes had grown old like their models, and the writer quipped that by now Fanny Elssler "must be bored with eternally playing her castanets."[18] Barre continued to make works of this type until at least 1848, the date of his ivory statuette, *Mlle. Rachel* (Louvre). P.F.

5.
Napoleon III
Marble
h: 28 in. (71.1 cm.)
Signed and dated: A. Barre 1852 (on lower right)
Lender: Christopher Forbes, Far Hills, New Jersey

Because so many sculptors—Lequien, Iselin, Prosper d'Epinay, Hébert, to name only a few—executed busts of Napoleon III, it might appear that the Emperor did not prefer one artist over another or that he sought to be democratic in the distribution of commissions.[19] It seems, however, that Barre produced more portrait busts of Napoleon III than any other sculptor did. Between 1852 and 1865, he created no less than eleven bust-length portraits of the ruler,[20] and many of them were produced in several versions. They employ various formats, including a classicizing, bare-chested presentation of the sitter,[21] but most show him in contemporary military dress or imperial regalia. Our bust was executed in 1850 shortly before Louis-Napoleon was proclaimed emperor in December of that year. It depicts the sitter in dress uniform as president of the Republic. It may be identical with the work exhibited in the Salon of 1852, which was described by one contemporary critic as

5.

"resembling and treated in that slightly cold manner, careful and avid for precision."[22] Another marble version of the work, also signed and dated 1852, is in the collection of the current Prince Napoleon; a third version recently sold at auction,[23] and a plaster version with simplified socle is in the collection of Christopher Forbes. The National Archives, Paris, possess two bronze replicas of the work, and apparently two other marble versions not yet located were executed.[24] M.B. & P.F.

Notes

1.
Jouin, 1900, pp. 133–34.
2.
L'Artiste, 1831, II, p. 4; *L'Artiste,* 1834, VII, p. 90; *L'Artiste,* 1835, IX, p. 136: "M. Barre se tire à merveille de la statuette; mais c'est surtout dans le medallion qu'il excelle: le medallion est encore une manière ingenieuse de faire faire son portrait sans être ridicule. Ceux de M. Barre sont très-finis, très gracieux, très-fins, très-ressemblans."
3.
On works of this type in general see Benoist, (1928), pp. 134–36; Lièvre, 1935, pp. 107–16; Metman, 1948, pp. 39–40.
4.
Lami, 1914–21, I, p. 47.
5.
"Salon de 1837. Sculpture," *L'Artiste,* 1837, XIII, p. 181.
6.
Illustrated in Rheims, 1972, p. 387, fig. 16N.
7.
Benoist, (1928), p. 170; P.-A. Lemoisne, "Collection de M. Alexis Rouart," *Les Arts,* March 1908, VII, no. 75, p. 24, states that Rouart owned a bronze version of *Fanny Elssler,* dated 1836, but makes no mention of a plaster.
8.
Ibid., p. 170.
9.
Bénézit, 1966, I, p. 462.
10.
Quoted from I. Guest, *Fanny Elssler, The Pagan Ballerina,* London, 1970, p. 75.
11.
Illustrated in Kochno and Luz, *Le Ballet,* Paris, 1954, p. 101. A version of Barre's statuette appears on the

mantelpiece in an 1840 illustration by J. J. Grandville (see G. Sello, ed., *Grandville: Das Gesamte Werke,* Munich, 1972, I, fig. 286).
12.
M. Beaulieu, "Le Théâtre et la sculpture française au XVIIIe siècle," *Le Jardin des arts,* 1956, pp. 165–72.
13.
Hubert, *Les sculpteurs...,* 1964, p. 4.
14.
"Salon de 1835 (VIIe article) La sculpture," *L'Artiste,* IX, 1835, p. 136; J. Janin, *Notice sur J. Feuchère,* Paris, 1853, p. 4.
15.
"Salon de 1837 (IXe article) Sculpture," *L'Artiste,* 1837, XIII, p. 136.
16.
A vehement attack appeared in *Paris comique..,* Paris, 1845 (cited at length in J. Seligman, *Figures of Fun,* London, 1957, p. 13). Other artists who produced portrait statuettes were Boitel, Cavelier, Cumberworth, Dantan, Feuchère, Grootaers, Klagmann, Maindron, Petit, and Pradier.
17.
Janin, 1839, p. 309.
18.
Janin, 1840, p. 270.
19.
Philadelphia, 1978, p. 231.
20.
Lami, 1914–21, I, pp. 49–51.
21.
For an example of this type, see London, 1978, cat. no. 37.
22.
P. Malitourne, "Salon de 1850. La Sculpture," *L'Artiste,* 1852, VIII, p. 166.
23.
Paris, Hôtel Drouot, June 9, 1978, cat. no. 95.
24.
New York, 1973, Appendix III.

Selected Bibliography

Beauvoir, R. de, "Les statuettes de Barre," *La Mode,* 1837, pp. 9–12.

G..., E., *Sur la statue de Guttenberg par M. Barre,* Rennes, 1861.

Lami, 1914–21, I, pp. 45–53.

Lièvre, 1935, pp. 107–16.

Metman, 1948, pp. 39–41.

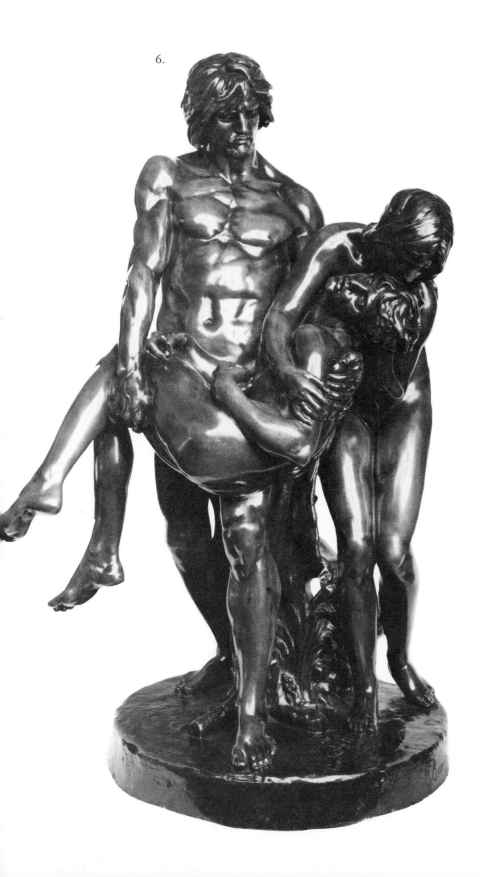

6.

LOUIS-ERNEST BARRIAS
1841 Paris 1905

Born to a humble family, the son of a porcelain and fabric painter, Barrias' early life was predominantly unhappy due to the incompatibility of his parents. His brother Felix, nineteen years his elder, was an established history painter who won the Prix de Rome in 1844. After his parents separated, young Ernest was required to care for his ailing mother instead of attending school. Only through the generous financial assistance of a family friend was he able to study art under Felix's former teacher, Léon Cogniet. Demonstrating more interest in modeling clay than in drawing, at age thirteen Barrias was apprenticed to the sculptor Pierre-Jules Cavelier; four years later he entered the Ecole des Beaux-Arts as a student of François Jouffroy. In 1861 he made his Salon debut with portrait busts of his father and the engraver Jazet, and he placed second in the Prix de Rome. He won first prize in the competition in 1865 with his version of *The Founding of Marseille*. During these years he worked on various decorative projects, notably the facade of the new Opéra and figures of *Virgil* and *Spring* for the Hôtel de Paiva.

One of the marble sculptures he created in Rome, the *Spinning Girl of Megara*, earned him a medal at the Salon of 1870 and was immediately purchased by the State. A few months later, Barrias fought in the Franco-Prussian War; exposed continually to chilling night air, he contracted bronchitis which would plague him for the rest of his life. After his return from the war, he won a first-class medal at the Salon of 1872 for his highly acclaimed marble sculpture, *The Oath of Spartacus,* a work which was seen as extolling the stoicism of the nation after its recent defeat by the Prussians. As a result of the success of the plaster model of his *First Funeral* (fig. 89 and cat. no. 6), exhibited in 1881, Barrias gained considerable esteem. From this time on, despite continual poor health, he created several major monuments in bronze and marble. These include commemorative sculptures of *Bernard Palissy* (1881, in the square of Saint-Germain-des-Près, Paris), the *Defense of Saint-Quentin* (1881), *The Defense of Paris* (1883), *Joan of Arc* (1892, see cat. nos. 8, 9), *Victor Schoelcher* (1895, Cayenne, French Guiana, dismantled 1960), and *Victor Hugo* (1902, fig. 23). In addition, he received numerous

commissions for portraits and decorative sculptures. His most popular and best-known work is a *Portrait of the Young Mozart*.

An exemplary French academician, Barrias succeeded his instructor Cavelier as professor at the Ecole des Beaux-Arts and was designated a *commandeur* in the Legion of Honor in 1900. Among his many appointments, he was a member of the Society of French Artists, the Commission of National Museums, and the Superior Council of Fine Arts. M.B. & P.F.

6.
The First Funeral
Bronze
h: 20 in. (50.8 cm.)
After 1878
Signed: E. Barrias (on left side of base)
Foundry mark: THIEBAUT FRERES FONDEURS PARIS (on base)
Lender: David Daniels, New York

Among the many sculptures of Adam and Eve created in the nineteenth century, few are more poignant than Barrias' *First Funeral*.[1] The parents are represented mourning the death of their young son whom they carry to a final resting place. This incident is not recorded in Genesis, but medieval commentaries on the Bible state that because of their great bereavement, Adam and Eve lamented Abel's death for a hundred years.[2] Few artists have treated the plight of the first parents in such sympathetic terms. Barrias contrasted what he considered to be masculine and feminine responses to death. Eve is an emotionally demonstrative figure who embraces her child and tenderly caresses his head. The sculptor stressed her compassionate, maternal side rather than depicting—as was more common—a sensual, fallen seductress.[3] More stoical in nature, Adam gazes at the lifeless body of his son with thoughtful resignation.

The First Funeral followed Barrias' highly successful *Oath of Spartacus* (1872). While the latter may be viewed compositionally as the pagan equivalent to a Deposition, *The First Funeral* recalls representations of the Lamentation. The earlier work dealt with two figures, one supporting the weight of the other; the *Funeral* treats similar relationships, complicated by the addition of a third figure. Life-size groups fully in the round and composed of three equally important figures pose particularly difficult formal problems and are relatively

rare in the history of sculpture; thus *The First Funeral* was an ambitious undertaking. The artist may have intended it as his answer to the two most admired groups from earlier in the century—Etex's *Cain and His Race* (cat. no. 124) and Carpeaux's *Ugolino* (cat. no. 32)—both of which also deal with tragic parent-children themes. Unlike these earlier works, however, *The First Funeral* does not have a compositionally dominant figure, nor is it completely successful. As one contemporary critic remarked, "One cannot walk around the figures without completely losing view of the composition and the rendering of the work, and the eye then sees nothing more than a series of nearly parallel legs that make a poor and meager effect under the general mass."[4]

Most contemporary critics had mixed praise for *The First Funeral*,[5] but Roger-Ballu hailed it as "the highest manifestation of the sentiments that sculpture can express,"[6] and the plaster model was a triumph at the Salon of 1878, earning Barrias a Medal of Honor. The work must also have played some role in his admission to the Legion of Honor in the same year. The marble version, exhibited at the Salon of 1883 and the Exposition Universelle of 1889, was acquired by the city of Paris (fig. 89). Its popularity is also reflected in the copies by Marmontel (1886), Munkacsy (1887), and Jacobin (1891). During the early 1880s Rodin produced a more impassioned rendering of the same tragic subject for the *Gates of Hell* (cat. no. 209).
 M.B. & P.F.

7.

7.
Allegory of Electricity
Plaster
h: 12¾ in. (32.3 cm.)
1889
Inscribed and signed: a mon ami Dutert/ E. Barrias/1889 (on right side of base)
Lender: Private Collection, New York

The *Allegory of Electricity* is one of the most unusual and intriguing examples of nineteenth-century French sculpture. The work exhibited here is a *maquette* for the monumental thirty-foot-high sculpture (fig. 63) executed for the *Galerie des Machines* at the Exposition Universelle of 1889. The large statue is now destroyed; a

8.

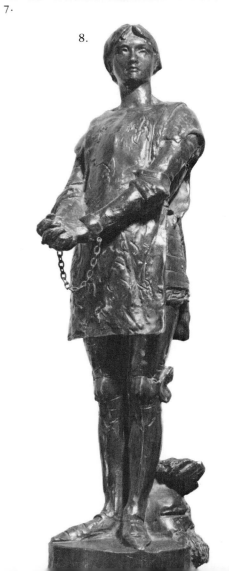

model is preserved in the Carl Jacobsen Collection at the Ny Carlsberg Glyptotek, Copenhagen.

From the maquette we can hardly sense the full impact of Barrias' finished sculpture. A sketchy zigzag bolt on the globe later became a bold spark of electricity. The small separate forms at the base of the globe developed into a tiny geometric engine. In the final work, a frieze ran diagonally across the globe, depicting the signs of the zodiac. The figures of the women, here summarily indicated, took on richer detail, more defined sensuousness, and an interrelated grace. The standing woman, with a gesture at once didactic and erotic, pointed downward to the electric bolt.

Electricity was intended as an *hommage* to the modern world—to the spirit of invention, progress, science, and technology. At the 1889 Exposition it was paired with Henri Chapu's *Allegory of Steam* in the *Galerie des Machines*. For his work Barrias juxtaposed traditional allegorical devices, such as the voluptuous female nudes and the signs of the zodiac, with a realistically rendered engine in an uncomfortable union of the old and the new. If he intended to elevate the new energy force—to endow it with a "rightness" in the cosmos—the allegory he presents is not completely intelligible. The coy gestures of the two fleshy women strike a frivolous note in the work, their abundant, curved forms overly emphasized by the contrast with the sharp, jagged edges of the lightning bolt. As in many sculptures of the period, a seriously intended subject was treated with such a high degree of sensualism that the result was wonderfully ludicrous. The *Allegory of Electricity* demonstrates the dilemma of academic artists attempting to cope with modern technology in a traditional, outmoded vocabulary of visual expression.

M.B. & P.F.

8.
Joan of Arc in Tunic and Chains
Bronze
h: 14¼ in. (36.9 cm.)
c. 1892
Signed: E. Barrias (on top of base)
Foundry mark: Alexis Rudier Foundeur Paris (on base)
Lender: Allen Memorial Art Museum, Oberlin College, Gift of Michael Hall

9.

9.
Joan of Arc in Helmet and Armor
Silvered and gilded bronze and ivory
h: 21⅝ in. (54.9 cm.), including 1⅜ in. (3.5 cm.) marble base
After 1892
Signed: E. Barrias (on top of bronze base)
Inscribed: Vous avez pu m'echainez/ Vous n'enchainerez jamais la Fortune de la France Jeanne d'Arc (on front of bronze base)
Foundry mark: Susse F^res Ed^tr (on top of base)
Lender: Allen Memorial Art Museum, Oberlin College, Gift of John N. Stern

To the French public of the nineteenth century, Joan of Arc (1412?–1431) was the national spirit incarnate. Many considered her life exemplary in its single-minded dedication to a patriotic cause; yet the Maid was not always revered as a national heroine.[7] Before 1800 her popularity was limited to Domrémy, her birthplace, and Orléans, the site of her greatest military victory. In general she was regarded as a mysterious, legendary curiosity, rather than as a distinct historical personality. Interest in her life began to grow in the mid-eighteenth century and rose rapidly in the opening years of the following century. Recognizing her as a symbol of French resistance to foreign—particularly English—domination, Napoleon, as First Consul, was the first major government leader to honor Joan of Arc as a heroine of national consequence. In 1803 he not only revived her yearly feast in Orléans (discontinued during the Reign of Terror), but also authorized the erection of a new monument to her in the city.[8] Although he initiated a revival of interest in Joan, Napoleon could not have anticipated the outpouring of admiration for her that occurred during the Bourbon Restoration (1814–30), when she was celebrated in several new monographs, plays, and paintings.[9] The increase in her popularity can be attributed directly to the return of the monarchy, which sought to reaffirm its origins in the medieval past. Joan, because of her efforts in elevating Charles VII to the throne, was regarded as a savior of the French monarchy.

In the following decades, the beloved heroine became the subject of widespread fascination. Her brief life inspired hundreds of historical studies, novels, plays, poems, paintings, and sculptures. It is not surprising that Joan played an important

10.

role after the dual disasters of the Franco-Prussian War and the Commune. In those dark days she provided a consoling and inspiring memory to the defeated people. Her commemoration was more poignant at this time since her native province, Lorraine, was annexed with Alsace to Germany. Hundreds of Joan of Arc monuments were raised to bolster flagging morale. These and similar works honoring other heroes were authorized by the Third Republic to fortify patriotism and nationalism.

The memory of Joan stirred religious as well as patriotic sentiments. Because she based her mission on divine inspiration, Catholic leaders viewed her as a symbol of unity between Church and State. In their sermons the clergy hailed Joan as an exemplar of Christian faith and virtue. The movement for her canonization, launched in 1869, stimulated further investigation into her character and career, and in 1920 Pope Benedict XV declared her a saint.

One of the largest and most impressive of the monuments commemorating Joan was a shrine raised on the Plateau des Aigles, Bonsecours, near Rouen, between 1889 and 1892. Although Rouen, the site of her imprisonment and death, already possessed at least two sculptures of the Maid, these were not enough to satisfy the intensified fervor for her that developed after 1871.[10] The plea for a new expiatory monument to Joan was initiated by the spiritual leader of the community, Msgr. Bonnechose, and his successor, Msgr. Thomas, who instituted a subscription for the project in 1888. Thomas carefully supervised the construction of the monument, selecting both the architect, Jules Lisch, and the sculptors, including Barrias.[11] The shrine, completed in 1892, consists of three pavilions, elaborately decorated with Gothic and Renaissance motifs. The largest, central hexagonal building building contains a marble sculpture of Joan by Barrias. Sculptures of St. Catherine by Verlet and St. Margaret by Pépin are set in the two flanking pavilions.

The *Joan* by Barrias celebrates not the tragic victim burned at the stake, but the heroine as her supporters preferred to remember her, noble and steadfast. Represented as a prisoner in armor, with her hands bound, her hair is cropped *en ronde,* a common male hairstyle of the fifteenth

century that she is known to have adopted. The sculptor's interpretation of Joan as a defiant prisoner corresponds to descriptions of her attitude and behavior at the beginning of her imprisonment and trial. Charged with heresy, witchcraft, and idolatry, she calmly replied to the judges' questions with intelligence and wit. She did not accept her imprisonment with resignation, but attempted to escape twice, suffering physical injury each time. Barrias' conception of the statue may have been influenced by Msgr. Thomas, who had specific plans for the shrine even before he appointed the sculptor to the project.[12] As work on the monument progressed, Thomas decided that it should be dedicated not only to Joan, but in memory of all French soldiers;[13] thus the shrine serves both as an expiatory monument and as a memorial to military valor.

The two statuettes in the exhibition are reduced variations of Barrias' sculpture at Bonsecours. In cat. no. 8, Joan wears a tunic over her armor. Cast entirely in bronze, it is characterized by rugged surface texture, and it may reflect one of the artist's sketches for the monument. In cat. no. 9, the sculptor transformed the heroic sculpture into a purely decorative object. Joan is represented in gilt and silvered bronze armor. Her head and hands are carved from ivory, the tonality of which enhances the statue's lifelike qualities and serves as a foil to the shiny, reflective surface of her brilliant armor. Every detail of her suit is clearly articulated as if to suggest the impression of real, albeit miniature, armor. Statuettes such as this, made from precious materials, satisfied late nineteenth-century popular taste for ornamental objects to decorate curio cabinets and mantelpieces. M.B. & P.F.

10.
Nature Unveiling Herself before Science
Ivory, gilded and silvered bronze, emerald, and lapis lazuli
h: 9⅛ in. (24.1 cm.); w: 4¼ in. (10.8 cm.); d: 2⅝ in. (6.7 cm.)
c. 1899
Signed: E. BARRIAS (on back of left foot)
Foundry Mark: Susse Fres Ed (behind right leg)
Lender: Private Collection

Barrias' earliest version of this allegorical sculpture, entitled *Mysterious and Veiled Nature Uncovers Herself before Science,* was

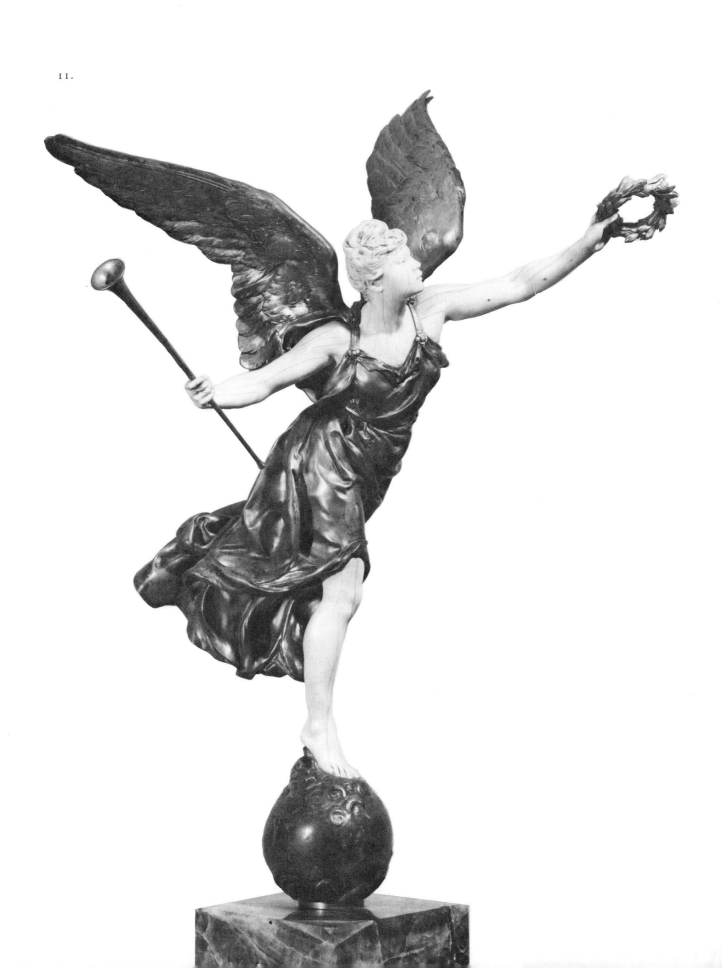

exhibited at the Salon of 1893 and later acquired by the Ecole de Médecine in Bordeaux. Executed in marble, the female personification of Nature was nude, except for a long veil that covered her back from head to toe.[14] A marble replica of this work, produced for Carl Jacobsen in 1896, is in his collection at the Ny Carlsberg Glyptotek, Copenhagen. Barrias displayed a reduction of the statue in tinted marble, onyx, red Pyrenees stone, and malachite at the Salon of 1899. The sculpture exhibited here, as well as numerous other polychrome versions,[15] appear to be variations of the 1899 statue, now in the Louvre. The sculptor returned to the subject in 1902, when he created an entirely white marble version for the Ecole de Médecine in Paris.[16]

Barrias represented Nature as a voluptuous young woman. Lifting the top portion of her sumptuous cocoon, she begins to reveal her figure—ostensibly for the benefit of scientific investigation. In contrast to the *Allegory of Electricity* (cat. no. 7), for the *Nature* Barrias was able to draw upon certain allegorical themes common in Renaissance and Baroque sculpture. Didactic subjects such as "Time Unveiling Truth," symbolized by a female figure disrobing, provided precedents for a "striptease" within the framework of moral instruction. Noting the obvious sexual overtones of Barrias' *Nature,* the critic Paul Desjardins described the figure as a "coquette" whose coy gesture lacked the grandeur appropriate to the serious subject.[17] In the version of the work exhibited here, the use of precious materials—ivory, emeralds, and lapis lazuli—enrich its sensual appeal as well as its decorative quality. Ultimately inspired by antique literary references to chryselephantine sculpture, the multicolored mixed-media technique became increasingly popular at the end of the nineteenth century and was particularly effective when employed in semi-erotic works such as the *Nature* or Gérôme's sculptures of the female nude (cat. no. 157). The variety of chromatic and textural effects in the *Nature* reflect the opulent *fin-de-siècle* taste and parallel developments in contemporary, Symbolist painting. *Nature's* predominately curvilinear silhouette and undulating drapery folds are also suggestive of the organic forms found in Art Nouveau.

M.B. & P.F.

11.
Allegory of Fame
Ivory, bronze, and gilded bronze
h: 29½ in. (74.9 cm.), including base
c. 1893–1902
Signed: E. Barrias (on the globe)
Foundry mark: SUSSE FRERES EDITEURS/
PARIS (on globe near base)
Lender: David Daniels, New York

Since antiquity, Fame has been personified as a winged female, although her best-known attribute, a long trumpet, did not appear in art until the Renaissance. Barrias' *Fame* is a graceful figure, delicately balanced on a globe, symbolic of her ubiquity; she carries a laurel crown, one of Apollo's attributes which generally denotes victory or artistic accomplishment.

The pose of the figure, balanced on one foot atop a spherical element, is adopted from Giambologna's famous sixteenth-century *Mercury*. Similar echoes of the *Mercury* appear in other French sculptures from the second half of the nineteenth century (cat. no. 132), and Barrias himself had employed its pose in a *Bacchante* exhibited at the Salon of 1890. In contrast to this work, however, the flying pose of the *Fame* has maintained much of its original iconographic significance, since *Fame*—who spreads the renown that makes people immortal—is, in a sense, like *Mercury,* a messenger of the gods.

Figures of Fame commonly appear on funerary sculpture, triumphal monuments, and memorials to illustrious persons. The exhibited work is, in fact, a variation of a statue of Literary Fame that adorned the back of Barrias' *Monument to Victor Hugo* (fig. 23, completed 1902, destroyed 1942);[18] it was probably while working on this monument that Barrias created his independent statuette of Fame. Although the exact date that it was first modeled is uncertain, by 1893 the Susse foundry had issued an edition of *Fame. (La Renomée).*[19] At the Salon of 1902 Barrias exhibited a silver and ivory *Fame* which was, presumably, identical in composition to the work in the Daniels collection.[20]

M.B.& P.F.

Notes
1.
For other notable sculptures of Adam, Eve, and their children, see Ruth Butler's essay on "Religious Sculpture in Post-Christian France."
2.
S. and R. Bernen, *A Guide to Myth and Religion in European Painting, 1270–1700,* New York, 1973, p. 9.
3.
See the sculptures of Eve by Eugene Delaplanche and Alfred Boucher illustrated in Tancock, 1976, pp. 152–53, nos. 8-1 and 8-2.
4.
"Les médailles et les médaillés," *L'Artiste,* 1878, XXXVIII, p. 60.
5.
Saint-Victor, 1878, p. 223; Jouin, 1883, p. 71.
6.
Roger-Ballu, 1878, p. 190.
7.
For a discussion on changing attitudes toward Joan of Arc, see C.W. Lightbody, *The Judgments of Joan,* Cambridge, Massachusetts, 1961.
8.
For information on the new monument to Joan of Arc by Gois *fils,* see H. Herluison and P. Leroi, "Le sculpteur Gois fils et sa statue de Jeanne d'Arc," *Mémoires de la société historique de l'Orléanais,* 1905, XXIX, pp. 515–44.
9.
N.D. Ziff, "Jeanne d'Arc and French Restoration Art," *Gazette des beaux-arts,* 1979, XCIII, pp. 37–48.
10.
Paul-Ambroise Slodtz's eighteenth-century sculpture of Joan crowning a fountain in the Old Market depicts her as an allegorical figure in the guise of Bellona. Feuchère's statue in the city hall, *Joan of Arc at the Stake* (1845), commemorates a tragic rather than heroic figure.
11.
For details on the construction of this monument, see L'Abbé Sauvage, *Le monument de Jeanne d'Arc à Bonsecours,* Rouen, 1892. Also see Paris, Hôtel de la Monnaie, 1979, p. 257, for photographs of the central portion of the monument and of Barrias' sculpture.
12.
Sauvage, 1892, p. 91.

FRÉDÉRIC-AUGUSTE BARTHOLDI
1834 Colmar—Paris 1904

13.
Ibid., p. 29.
14.
Illustrated in Lafenestre, *Revue de l'art ancien et moderne*, 1908, p. 333.
15.
Examples are in the Museum of Fine Arts, Boston (*Boston Museum Bulletin*, LXXI, no. 363, 1973, p. 38) and the Stanford University Museum of Art (Louisville, 1971, no. 1, pp. 31–32).
16.
A polychrome marble reduction of the third version, executed by M. Wattel, is listed in Lami, 1914–21, I, p. 60.
17.
Desjardins, 1899, p. 288.
18.
Illustrated in Tancock, 1976, p. 414.
19.
Lami, 1914–21, I, p. 59.
20.
A bronze version of *Fame* is in the collection of the Wellesley College Museum; two versions are illustrated in Berman, 1974–77, II, p. 612.

Selected Bibliography

Mourey, G., "Ernest Barrias," *Les Arts*, 1905, no. 40, pp. 29–32.

Souries, A., *L.–E. Barrias (1841–1905): Notes biographiques*, Paris, 1905.

Puech, D., *Notice sur la vie et les oeuvres de M. Ernest Barrias lué dans la séance de l'Académie de Beaux-Arts du 24 nov. 1906*, Paris, 1906.

Lafenestre, G., "Ernest Barrias," *Revue de l'art ancien et moderne*, 1908, XXIII, pp. 321–40.

————, *L'Oeuvre de Barrias*, Paris, 1908.

Lami, 1914–21, I, pp. 53–61.

Bartholdi's secure middle-class origins were well suited to his future role as a maker of public monuments. After the death of the sculptor's father, a civil servant, Mme. Bartholdi moved Auguste, age two, and his elder brother Charles to Paris, where they lived in comfort on the substantial income from their property in Colmar. Both children pursued artistic careers; but Charles, later plagued with mental illness, never achieved public recognition. Auguste studied architecture and then painting with Ary Scheffer, who encouraged him to undertake sculpture. With this aim he sought training in the studios of Soitoux and Etex. In 1853 he submitted his first work to the Salon, a sculpture of the *Good Samaritan*. (In later years he would rarely execute religious sculptures.) His next major piece, a large bronze monument to a former native of Colmar, General Jean Rapp (1855), reveals his two ruling passions: his emotional ties to his homeland and his preference for gigantic sculpture. His trip with Gérôme to Egypt in the following year nurtured his fascination for the colossal mode and inspired a bronze group, *The Lyre among the Berbers, Souvenir of the Nile*, exhibited at the Salon of 1857. He returned to the Nile in 1869 hoping to obtain a commission for a mammoth female figure upholding a light at the entry of the Suez Canal, which opened in November of the same year.

During the 1860s he was occupied with several patriotic monuments for Colmar. In 1870, during the Franco-Prussian War, he became an officer. France's defeat was particularly poignant for him since his beloved Alsace was annexed to Germany. In the aftermath of the war he traveled to the United States, where he discussed his intentions of building a colossal statue on an island in New York harbor with several distinguished Americans, including President Ulysses S. Grant and Henry Wadsworth Longfellow. The groundwork for the *Statue of Liberty* (cat. no. 13), France's gift to the United States, was laid at this time, but a fund-raising campaign for the project was not organized in France until 1874. *Liberty* was completed ten years later, dismantled, transported, and unveiled on Bedloe's (now Liberty) Island on October 26, 1886.

Although a great deal of Bartholdi's energies were devoted to this extraordinary enterprise during the 1870s and 1880s, he found time to execute several monuments on a subject close to his heart: French heroism during the Prussian conflict. In addition to the colossal *Lion of Belfort* (cat. no. 12), these memorials include *The Curse of Alsace* (1872), *Tomb of the National Guard of Colmar* (1872, model exhibited 1898) and the *Monument to the Victims of the Siege of Brisach* (1873). Similar themes would preoccupy the sculptor until the end of his life. These monuments eclipse his other works, primarily portrait busts and sculptures of historical personalities such as *Washington and Lafayette* (Paris, New York, 1892) and *Diderot* (Langres, 1884). An artist of meager talents who conformed to academic tradition, Bartholdi led a productive, successful career due predominantly to the vogue for civic monuments in the late nineteenth century. M.B.

12.
Lion of Belfort
Terracotta
h: 10⅛ in. (25.7 cm.); w: 14 in. (35.6 cm.); d: 5⅜ in. (13.7 cm.)
After c. 1875–80
Signed: Bartholdi (at upper left)
Lender: Dr. and Mrs. Herman G. Sturman, Los Angeles

Although Bartholdi moved to Paris at the age of two, he returned to his birthplace, Colmar, for extended visits throughout his life. His enduring devotion to his native Alsace is reflected in the numerous monuments he created for that province.[1] In 1871 the municipal council of Belfort awarded him the commission for a colossal statue to honor the townspeople's recent heroic defense of the city against the Prussian invasion. The thirty-eight-foot-high, seventy-foot-long *Lion of Belfort* was not completed until 1880, due to the lack of available funds.[2] Carved from enormous blocks of red granite, Bartholdi's majestic lion is embedded in the rugged cliffs below the fortress overlooking the city.

The sculptor's choice of a lion to represent the valiant citizens of Belfort was meaningful, since lions as symbols of strength and courage have long appeared in sculpture as civic guardians. The employment of a lion alone for a monument, without accompanying allegorical figures, is rare but not

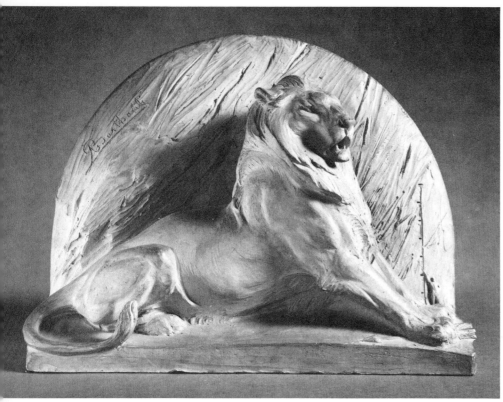

12.

unknown in nineteenth-century sculpture. Bartholdi may have been inspired by Thorvaldsen's famous *Lion of Lucerne* (1819–21), which also commemorates military valor and similarly exploits the grandeur of the surrounding natural setting; but unlike Thorvaldsen's mournful, wounded creature, Bartholdi's *Lion* is alert and fiercely defiant. With his unyielding pose and ferocious snarl, he threatens any enemy who dares to venture in his shadow.

The small reddish terracotta exhibited here is one of several reduced variants of Bartholdi's imposing monument. In addition to this relief, freestanding bronze statuettes of the *Lion* were issued by Thiébaut Frères in a variety of sizes in the early twentieth century. In our version, a tiny human figure on the lower right indicates the original stone sculpture's gigantic proportions. Striations sketched on the curved background suggest the rock environment it inhabits. The *Lion*'s generalized anatomy, necessitated by the sheer enormity of the project, is in keeping with Bartholdi's idealized, classicizing style epitomized in the *Statue of Liberty* (cat. no. 13). Rather than reproduce a lion from nature, the sculptor

wished to create a potent symbol of resistance to foreign invasion, a recurrent theme of public monuments after France's humiliating defeat by the Prussians in 1870. M.B.

13.
Liberty Enlightening the World
Bronze
h: 34 in. (86.4 cm.); w: 10⅝ in. (27 cm.); d: 10⅝ in. (27 cm.)
After 1884
Signed: A. Bartholdi (on right side of base)
Foundry mark: Thiebaut Freres Fondeurs Paris (on back side of base)
Lender: American Museum of Immigration, New York

Because the *Statue of Liberty* is recognized throughout the world as a personification of the United States, the monument's French origins are often overlooked. Bartholdi, its creator, claimed that *Liberty* was the brainchild of Edouard-René Lefebvre de Laboulaye (1811–1883), a distinguished legal scholar who specialized in American political history. Laboulaye headed a circle of moderate republican intellectuals who hoped one day to exercise influence over the government. In 1865 several of these men, including Bartholdi, attended a dinner party at Laboulaye's estate during which the professor proposed to present a monument to the United States in memory of French assistance during the American War of Independence.[3] Although Laboulaye encouraged Bartholdi to undertake the project at this time, work on the monument did not begin until several years later. An early maquette, signed and dated 1870, already depicts the basic form of the final sculpture—a classically draped female figure holding aloft a lamp—clearly adapted from Bartholdi's unrealized project for a lighthouse at the Suez Canal. Several months later, in the summer of 1871, the sculptor sailed to the United States to gain American approval for the monument. Desolate at the tragic outcome of the Franco-Prussian War, he wrote to Laboulaye shortly before his departure: "I will try to glorify the Republic and Liberty over there, in hope that someday I will find it again here."[4] The subject appears to have met with enthusiasm, but the sculptor may

have exaggerated America's positive response in order to retain his financial backers in France.[5] During his visit, Bartholdi selected Bedloe's Island in New York Harbor as the future site for his colossus. A fund-raising campaign to obtain the $400,000 needed to construct the monument was instituted in 1875. Laboulaye and Bartholdi's project received a great deal of public interest at this time, due undoubtedly to the ascension of moderate republicans in the government during that year.

Bartholdi's conception of the monument began to crystallize as he toured the United States. The theme of the memorial, which would serve as a lighthouse, would be "Liberty Enlightening the World." Several drawings and models in the Bartholdi Museum in Colmar mark the different stages in its development. Appropriate to the theme, a terracotta *bozzetto* shows *Liberty* wearing an early variation of her radiant diadem, long an attribute of Helios, the sun god. In a later plaster model she appears as in the final monument: a stately, austere woman who holds the torch of freedom in her right hand, a tablet that would be inscribed "JULY IV MDCCLXXVI" in her left, and who treads on the broken shackles of tyranny.[6]

After Bartholdi arrived at his final design in 1875, the model was enlarged section by section four times in plaster. Because the construction of the 151-foot sculpture presented unique technical problems, the artist sought expertise from his friend, the archaeologist-architect Viollet-le-Duc; after the death of the latter in 1879, Gustave Eiffel (who had not yet erected his tower) took over the design of the armature. Sheets of copper 3/32 of an inch thick were painstakingly hammered onto wooden patterns and attached to the iron and steel framework. Although the right hand and torch were exhibited at the Centennial Exposition in Philadelphia in 1876 and were shown again with the head at the 1878 Exposition Universelle in Paris, all of the individual sections were not ready for assemblage until 1883. Throughout the year Parisians had the unique opportunity of seeing *Liberty* rise to her full height for the first time. On July 4, 1884, the finished monument was presented to the American ambassador in Paris. It was then dismantled, shipped to the United States, and reconstructed on Bedloe's Island atop a pedestal provided by funds raised by the American public. The *Statue of Liberty* was embraced as a symbol of the nation almost from the moment of its inauguration on October 26, 1886. The bronze displayed in the current exhibition is one of the finest reductions cast after the monument.

M.B.

Notes

1.
Bartholdi's principal monuments in Colmar include the memorials to Jean Rapp (1856), Martin Schongauer (1861), and Admiral Bruat (1863); the *Young Alsatian Vinedresser* (1869); and the *Tomb of the National Guard* (1872).
2.
Gschaedler, 1966, p. 36.
3.
For information on *Liberty*'s timely political significance, see Trachtenberg, 1977, pp. 26–30.
4.
Ibid., p. 31.
5.
Ibid.
6.
For a detailed analysis of the monument's iconography, see ibid., pp. 63–83.

Selected Bibliography

Lami, 1914–21, I, pp. 63–69.

J. Betz, *Bartholdi,* Paris, 1954.

G. Gschaedler, *True Light on the Statue of Liberty and Its Creator,* Narberth, Pennsylvania, 1966.

Louisville, 1971, pp. 33–37.

M. Trachtenberg, *The Statue of Liberty,* Harmondsworth and New York, 1977.

13.

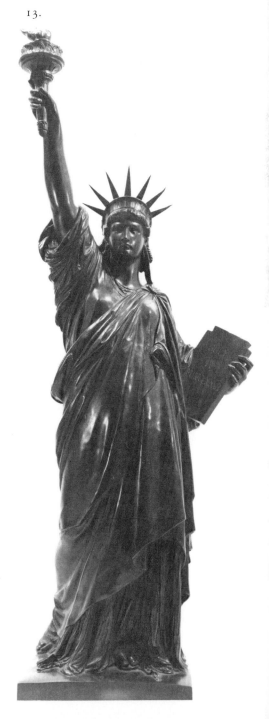

ANTOINE-LOUIS BARYE
1796 Paris 1875

The full life story of Antoine-Louis Barye as an artist and intellectual will probably never be known, for he wrote few letters and kept no elaborate diaries. Barye's friends, in fact, thought of him as a man of few words, but a good listener. Nonetheless, it is possible to reconstruct a fairly clear outline of the major events of Barye's career, based on the notations and imagery of his drawings and on his sculptural oeuvre.

The son of a goldsmith from Lyon, Barye was exposed to the discipline of his father's craft at an early age. Many of its values carried over into his mature sculpture: lucidity of form, love of detail, and delight in imagery in miniature. At the age of thirteen, Barye found employment as an apprentice to a metal engraver who worked with military equipment in the Fourier establishment at Paris. He also fashioned iron dies for metal-stamping in the workshop of Guillaume Biennais, master goldsmith to both Napoleon and the French crown. There Barye saw the most sophisticated technical practices current among Parisian goldsmiths and encountered Neoclassical and antique models that would remain significant for him throughout his career. Among these were the albums of engraved illustrations of antiquities in Italian collections, by Bartoli and Roccheggiani,[1] and those of antiquities in Paris itself, such as the catalog of the collection of the Comte de Caylus.[2]

Drafted by the military in 1812, Barye first served in a topographical brigade, possibly modeling relief maps as he was by then a skilled artisan, and later in the Second Battalion of sappers and miners. At the surrender of Paris in 1814, he was released not far from his father's house.

Returning to the engraver's craft following the war, Barye soon became intrigued with the arts of sculpture and painting. He studied briefly in 1816 with the Neoclassical sculptor Bosio, and then with the painter Gros, a Romantic colorist who had been the official battle painter during Napoleon's Egyptian campaign. The dichotomy between these two teachers — one classical, one Romantic — would be reflected in the art of Barye, both positively and negatively. He turned against Bosio's abstractness and smoothly polished marble toward the richly worked surfaces of realistic bronzes. He set aside the brilliant color and Leonardesque *sfumato* effects of Gros in favor of a subdued palette for his watercolors and oils, of the sort later popular with the Barbizon painters and Gustave Courbet.

A student in the Ecole des Beaux-Arts from 1818 to 1823, Barye's best efforts never won the coveted Prix de Rome. His predilection for three-dimensional forms is clear in his avoidance of the painting competitions and in the character of his surviving works. In 1819 his miniature medallion, *Milo of Crotona Devoured by a Lion* (cat. no. 14), was awarded an honorable mention. In 1820 a second grand prize for sculpture was bestowed upon his *Cain Admonished by God,* a work now lost. He entered a relief sketch in plaster, *Hector Reproaching Paris,* a design derived from John Flaxman's engravings for the *Iliad,*[3] in the competition of 1823.

By the time of his departure from the Ecole in 1824, Barye had studied a considerable body of artistic sources new to him, encompassing works from antiquity, the Renaissance, the Baroque, and the Neoclassical periods. Even the recent theoretical and archaeological writings of men such as Falconet, the Comte de Caylus, Emeric-David, Quatremère de Quincy, and Flaxman were accessible to him. In the Ecole des Beaux-Arts, the basis of Barye's commitment to the European classical artistic tradition was formed. Even the most Romantic, realistic bronzes of animals of his later career reflect his thorough assimilation of classical prototypes.

From 1823 until 1831, Barye worked as an artisan for the goldsmith Fauconnier, perhaps creating for him Barye's first tiny sculptures of animals as independent images. He studied living animals in the menagerie of the Jardin des Plantes and preserved specimens and skeletons in the Musée d'Anatomie Comparée. Notations in his sketchbooks show that he observed dissections of animals and read recent scholarly papers on the species he depicted.

At the Salon of 1831, Barye's satanic animal combat, the *Tiger Devouring a Gavial of the Ganges* (cat. no. 16), launched his reputation in Paris as a mature, daring, and gifted sculptor. Benefit-ing from critical acclaim and a touch of notoriety, he was quickly taken up by the royal house of Orléans. For that circle he created his triumphal allegory, *Lion Crushing a Serpent* (cat. no. 17), shown in the Salon of 1833 with his plaster bust of the Duke of Orléans. Royal support for Barye was apparent when he was created a *chevalier* of the Legion of Honor in May 1833. The *Lion and Serpent* was formally purchased by the State in 1834. It was cast in bronze in 1835 by the same master founder, Honoré Gonon, engaged to cast the larger part of the masterpiece in miniature scale as a *surtout de table.* The *surtout* was an ensemble of five hunting compositions and four combats of predator and prey (see cat. nos. 18 and 19), intended for a vast banquet-table decoration. Strangely enough, the models for this ensemble were rejected from the Salon of 1837 by a hostile jury, probably for political rather than artistic reasons, amid epithets such as "mere paper weights," although one wonders at the appropriateness of that barb to an exquisite design like the *Tiger Hunt* (1836, Walters Art Gallery, Baltimore), a bronze more than two feet high and weighing more than a hundred pounds.

Toward 1834 the political circle of Thiers considered Barye the appropriate sculptor for a projected (but never executed) giant eagle, intended to crown the Arc de Triomphe. The *Lion of the Zodiac* relief, a monumental work in bronze for the cenotaph of the July Column in the Place de la Bastille was created by Barye for the Orléanists from 1836 to 1840; its design reflected ancient sources in both miniature and monumental scale. From 1840 to 1843, he carved a large marble, *Saint Clotilde,* for a chapel in the Madeleine, echoing both an ancient Roman marble in the Louvre and the latest painted portraits of J.A.D. Ingres.

Orléanist patronage fell slowly into decline, and the telling date of 1847–48 appears on the masthead of Barye's first printed sale catalog of his small bronzes, a list of some 107 works. To produce and market his bronzes, he formed a partnership in 1845 — Barye and Company — with the entrepreneur Emile Martin, an arrangement that continued for twelve years.[4] It was in Barye's workshop that the modern phenomenon of the serial production of an artist's designs first arose, a momentous sign of the rise of the middle

class as a major source of artistic patronage in Europe. His last monumental work for the house of Orléans was the *Seated Lion* of 1846, first placed in the Tuileries garden as a mate to the *Lion and Serpent* but shown today as one of a pair with a mechanically made reversal of its design (complete with a mirror-image of the artist's signature),[5] flanking the quai-side portal of the Flora pavilion of the Louvre palace.

In 1849 Barye carved in stone a series of eight colossal *Eagle Reliefs* for piers of the Jena Bridge over the Seine, eagles inspired by ancient sources in miniature scale and perhaps reminiscent of his project for the Arc de Triomphe. For the Pont Neuf he created some ninety-seven *Decorative Masks,* in about 1851. These are placed at regular intervals along the cornice and are highly inventive explorations of moods, styles, and types.

Various official positions were his from the late forties onward. In 1848 he was made director of plaster casting in the Louvre and curator of the gallery of plaster casts. During 1850 he taught drawing for natural history in the agriculture school at Versailles. From October 14, 1854, the date of his four personifications for the New Louvre palace, he was master of zoological drawing in the Musée d'Histoire Naturelle of Paris, a position he held until his death. Among his pupils was Auguste Rodin, in 1863. On November 15, 1855, he received the Cross of the Legion of Honor. He was named a member of the prestigious Institut de France, on May 30, 1868.

Encouraged by the creation, after 1848, of a jury of artists for the Salon, Barye again exhibited in 1850. This time he showed a carefully balanced pair of entries, both monumental in scale: the classically academic *Theseus Combating the Centaur* and the Romantic-realist *Jaguar Devouring a Hare.* The thematic parallel of these works was probably intended to disprove the notion that animal images belonged to the realm of mere popular art rather than to the official hierarchy of subjects. To the latter work Théophile Gautier paid his famous compliment, terming Barye the "Michelangelo of the menagerie."[6]

The Exposition Universelle of 1855 found Barye exhibiting a bronze cast of *Jaguar Devouring a Hare* in the fine arts section and, in the section for industrial bronzes, a group of his serially cast proofs, awarded a grand gold medal for technical excellence.

For Napoleon III's vast project to unite the Louvre and Tuileries palaces, Barye created four stone figures, based on the ancient Seated Hercules type—*Strength, Order, War,* and *Peace* (cat. no. 27)—in 1854 and 1855. Executed at a height of three meters, the figures are still intact, high on facades of the Denon and Richelieu pavilions of the great court. Central to the program of the courtyard is Barye's stone pedimental relief, *Napoleon I Crowned by History and the Fine Arts,* finished in less than four months' time, for the celebrations attending the opening of the New Louvre, in August 1857. It is an apotheosis of Napoleon Bonaparte, intended to enhance the aura of the Second Empire by calling up its connections with the Napoleonic legend, a body of associations enormously moving for the French. Napoleon III preserved a sort of hierarchy of honor, reserving the position on the central axis of the great court, for his illustrious forebear, and having himself placed almost whimsically on the facade of the Riding Academy, a token of his love for horsemanship. The latter was a relief in bronze, dated about 1862, showing Napoleon III in the garb of a Roman emperor. Unfortunately it was destroyed during the Franco-Prussian War and the Commune. Barye created another bronze equestrian, this one freestanding, for the Bonaparte family monument at Ajaccio, Corsica, a work erected in 1865.

Barye restated his early theme of the feline predator with its prey in the four monumental stone groups of 1869 that flank the double staircase of the Palais de Longchamps at Marseille, two designs with lions and two with tigers.

Barye's health began to fail late in 1874, and he died at his home on June 25, 1875. He was buried at Père-Lachaise cemetery in Paris, following a funeral with military and civil honors befitting a *chevalier* of the Legion of Honor and a member of the Institut de France.　　　　G.B.

14.
Milo of Crotona Devoured by a Lion

Bronze
diam: 3¼ in. (8.3 cm.)
Signed and dated: Barye 1819
No foundry mark
Lender: The Walters Art Gallery, Baltimore

Treating the proscribed theme for the medallion competition of 1819 at the Ecole des Beaux-Arts, Barye won an honorable mention with his *Milo of Crotona Devoured by a Lion.* This is the earliest dated work by Barye extant, and its exquisite detail, precision, and miniature scale reflect well the art of the French master goldsmiths, so important in his early experience.

According to the ancient moralizing story of the prideful athlete punished, Milo of Crotona attempts to split open a tree stump with his bare hands in a display of his strength. He manages only to get his hand clamped irretrievably in the cleft tree. Thus trapped and helpless, alone in the wilderness, he is devoured alive by a lion (or by wolves, in some versions). The appealing aspects of this theme, for an audience of 1819, were its Romantic pathos and ghastliness in the service of a moralizing point. Also significant was the example of Pierre Puget's splendid marble sculpture on the same theme (Louvre).

Barye's figure of Milo is conceived in the ideal mode of Neoclassical artists such as John Flaxman and Henry Fuseli. Milo takes an unreal, balletic stance as he tugs at his caught hand, twisting around and dipping slightly under the impact of the lion that bites deeply into his left thigh. Milo's right leg is seen in profile and flexion, while the left is shown frontally and extended, a favorite classicistic motif of the era, ultimately derived from archaic Greek art. A long, curving contour line, like the drawn bow of an archer, dominates the right side of Milo's form, with a tension suited to the dramatic action and a curvature that harmonizes with the circular field of the medallion and the calligraphic accent of the lion's curled tail. The control of spatial depth in the lion is deftly managed, even atmospheric, as in the subtly differentiated near plane of the lion's mask and

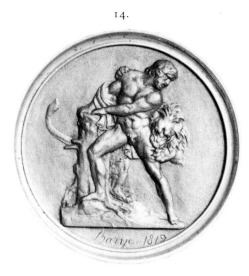

14.

the farther plane of its belly and left hind leg, seen just behind the tree stump. The base resembles the plinth of a freestanding sculpture, with an abbreviated landscape in the Hellenistic mode. Thus Barye's design is a relief depiction of a work of sculpture in-the-round, rather than a paintinglike essay in illusionism. The distinct base of the Milo group suggests the plinth conventions of the images on ancient coins and cameos, of the sort Bayre studied often and admiringly.

In two drawings on an album page (Louvre, RF 6073, p. 72), Barye recorded and made variations on Puget's famous marble of *Milo and the Lion.* A light and elegant sketch of the Puget group appears at the right of his page, emphasizing— even exaggerating—the attenuated proportions of the Baroque marble. Barye rigorously revised these proportions, in accord with classical canons, in the large and powerfully emotional drawing at the center of his page, as well as in the Milo of his medallion relief. The drawing is more extravagant in tone than is the understated mood of the medallion, but it does establish the key motifs of Milo's extended leg and his extended arms pulling at the

caught hand. Barye reversed the upper body of the drawing of Milo for the figure in this medallion.

While the Milo medallion is a somewhat stiff and slightly academic work, it reveals a directness in focusing upon struggle and death that was to characterize many of the artist's later works.　　　　　　G.B.

15.

Hercules and the Erymanthean Boar
Bronze
h: 4¾ in. (12.1 cm.); h. of base: 2½ in.
(6.4 cm.); w: 3½ in. (8.9 cm.)
c. 1820–23
No marks
Lender: The Metropolitan Museum of Art,
New York, Bequest of George Blumenthal,
1941

The third labor of Hercules was to capture alive the ferocious wild boar that lived on Mount Erymanthos in the northwest Peloponnesos. Barye's Hercules strides boldly forward with the subdued and giant boar resting upon his shoulders. The boar's legs are in the air and its head juts forward above the face of Hercules, like the ornate visor of a Renaissance helmet. Two long arcs dominate this vigorous, early design: those of the boar and of the back and extended leg of Hercules. Against these curves are played the angles of the hero's flexed arms and right leg. In fact, the motif of the contrast of the flexed and extended legs of Hercules is twice repeated, in the forelegs and hind legs of the boar. A textural play enriches this design in the smooth muscle of the hero against the richly tufted pelt of the boar, the sort of contrast also present in the slightly earlier *Milo of Crotona* medallion (cat. no. 14).

The rather lightly muscled physique of Barye's Hercules is conceived in the Quattrocento mode of the slender types of Antonio Pollaiuolo. Barye's model was not the thick-set, wide-torsoed portrayal of Hercules in Hellenistic sculpture, such as the *Torso Belvedere* (Vatican Museum, Rome), the type preferred by Michelangelo and by Barye himself, later in his career.

A drawing for this bronze (Walters Art Gallery, Baltimore) treats Hercules with the rigid planarity one might expect in an archaic Greek vase painting. Barye's actual source, however, was very different: a figure in a Bacchic sarcophagus relief, a

Faun Carrying a Sacrificial Ox. He knew this image from an engraving in Visconti, *Musée Pie-Clémentin,* Milan, 1820 (vol. 5, tav. vii), one of the illustrated catalogs of antiquities he studied while a student in the Ecole des Beaux-Arts. In fact, the date of Visconti's publication provides a *terminus post quem* for the bronze. Barye's drawing notably omits the areas of the faun's legs which are obscured behind other images in the relief, confirming this very figure as his source. Unlike this drawing, however, the diminutive bronze alters the relation of animal and hero in placing the two head to head, as well as back to back. The relative mass of the bronze boar is increased over that of the ox in the engraving, yet the bronze retains the ancient motif of the animal's legs shown in flexion and extension. The bronze boar appears to be still alive and is filled with a romantically vicious potential, while the limp creature of the drawing is already dead. An energy-charged adversary is typical of Barye. The hips and shoulders of the faun in the drawing have an archaic frontality of presentation, very like that of the related *Milo of Crotona* medallion. Barye alters this in the bronze to achieve a more naturalistic sense of the hero's vigorous, striding motion as he carries the boar.　　　G.B.

16.

Tiger Devouring a Gavial of the Ganges
Bronze
h: 4¼ in. (10.8 cm.); l: 10¾ in. (27.3 cm.)
Signed and dated: Barye 1831 (on base)
No foundry mark
Lender: George A. Lucas Collection,
Maryland Institute College of Art,
Courtesy of the Baltimore Museum of Art

The monumental plaster original of this work received a second-class medal when it was first exhibited in the Salon of 1831. It was cast in bronze in 1832 by Honoré Gonon and Sons, the masters of lost-wax casting then active in Paris, who continued to work closely with Barye through about 1838. An agonized moment in the death struggle of two satanic creatures is caught in this monumental work. A lordly yet sinister tiger, notorious in India as a nocturnal hunter and a killer of men, bites slowly and deeply into the flesh and genitalia of the writhing crocodile. Almost as a maddened human assailant might do,

the tiger glares viciously into the eyes of its victim. A sense of muscular tension in the tiger, that of muscle pulling against bone, contrasts with the oily, slithering, snakelike motion of the gavial. The wrinkled contours about the bridge of the nose and the eyes of the tiger are superbly expressive—an invention conveying an almost human mood, and one built upon an unerring mastery of anatomy.

The anatomical correctness of these creatures is dazzling in its extent and precision; yet the vivid action and the almost ritual formality of the sphinxlike tiger forcibly remove the image from the realm of mere imitation of nature and stamp it as an expressive symbol, an artful invention. Barye's tiger is somehow more perfect, more heroic than nature; his gavial is more sinister; the moment is both eternal and an instant. In his *Salon de 1831,* the eminent critic Gustave Planche wrote of the *Tiger and Gavial:*

There is a rage in this voracious tiger, and suffering in the crocodile that feels its fangs. Yet I would reproach Barye for smothering the life of these animals beneath a multitude of details minutely reproduced. I would like it a hundred times better were its details fewer. ... The complication of the ... execution gives the work an inevitably dry and hard character.[7]

It is likely that these observations led Barye to work in a distinctly less detailed style almost immediately, as in his two miniature relief plaques also dated 1831, the *Walking Panther* and the *Walking Leopard* (Walters Art Gallery, Baltimore). This simplifying tendency of his style reached a superb culmination in the monumental *Lion of the Zodiac Relief* for the July Column, dated 1835–40. Planche's remarks, however, did not dissuade Barye from continuing to work on other small bronzes of the 1830s in an alternative, decoratively elaborate style.

The bronze *Tiger Devouring a Gavial* was a sensation of the Salon of 1831. For Delacroix, as he would later record in his *Journal,* the mere sight of such exotic creatures could engender a sense of emotional transport.[8] Also intrinsic to the *Tiger Devouring a Gavial* was a moral level of interpretation, a reading of it as an image of the awesome animal violence possible in nature. It calls up Bernardin de Saint-Pierre's moral notion that carnivorous beasts, de-

vouring their prey alive, thus commit a sin against their own nature.[9] Mme. de Staël, the arch-Romantic, spoke of an ideal Romantic art that would provoke "the tears that move to virtue."[10] Victor Hugo's conception of the "grotesque" also applies,[11] for this work exploits the irresistible fascination and the infinite variety of evil. Evil is thus the necessary foil to the monotony of the good and the beautiful. Hence, from the point of view of Romantic morality, Barye's predators were a spectacle of the machinations of evil in the world, a spectacle inherently fascinating and moving, yet with an ultimately positive moral lesson.

Predictably, perhaps, the classical critic Etienne Delécluse voiced the typical academic rejection of Barye's animal protagonists in his review of the Salon of 1831.[12] For Delécluse, the *Tiger and Gavial* existed in a "less elevated mode" than imagery of the human figure. His was simply the traditional notion of the relative merits of various subjects in art, whereby animals rank low on the scale, along with still-life painting, as presumably the least challenging to an artist. Nonetheless, the sheer excellence of Barye's *Tiger and Gavial* also led Delécluse to call it the "strongest and most significant work of the entire Salon." The vigorous responses of the Salon reviewers thrust Barye into the limelight of the Parisian art world, launching his official career as an artist supported by the young Duke of Orléans and his father, King Louis-Philippe, the Bourgeois Monarch. To reap the full benefit of the Salon publicity accorded his work and to appeal to the new middle-class market for his art, Barye devised small bronze versions in two sizes, one 20 inches long, and one, represented in this exhibition, of 10¾ inches.

Barye's drawings allow a glimpse of his elaborate preparatory method of about 1830. He took a classical approach like that of Leonardo or Michelangelo, with the final image based upon many preliminary studies of isolated motifs or anatomical

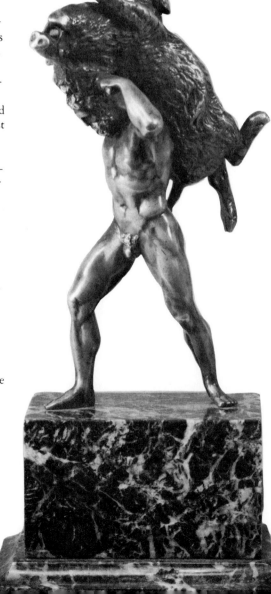

15.

details, and many compositional sketches. No doubt this very elaborateness of method reflected Barye's desire to create a Salon masterpiece of this work. There is even an aspect of scientific pedantry about Barye's method, a distinctly academic tendency toward an ostentatious display of knowledge. His approach sustained the tradition of eighteenth-century empiricism but gave his forms an even greater degree of precision, an unmistakably nineteenth-century, positivistic quality of emphasis. The scholarly dimension of Barye's study of the unusual gavial crocodile, a creature he would never again include in his sculptures, is documented by the partial references to zoological works that the artist wrote in the album now in the Baltimore Museum of Art (Lucas Collection).[13] The heading, "dimensions du petit gavial," accompanies a measured drawing copied directly from Daudin's *Histoire naturelle... des reptiles.* There are references to an "histoire des reptiles par Daudin," and to a "mémoire de Cuvier sur les crocodiles... cahier des annales du musée d'histoire naturelle," which may refer to either of two of Cuvier's scholarly works of 1807 and 1808. Geoffroy Saint-Hilaire's essay of 1825 on the gavial also may have been known to Barye.[14] G.B.

16.

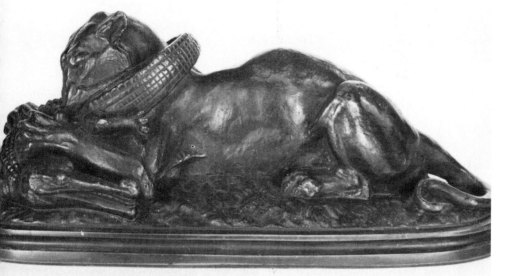

17.
Lion Crushing a Serpent
Bronze model in five sections
h: 5⅜ in. (13.7 cm.); l: 7 in. (17.8 cm.);
w: 4½ in. (11.4 cm.)
1832
Signed: O BARYE 12 (on base behind right haunch)
Inscribed: LION AU/SERPENT/ MODELE (beneath the base)
No foundry mark
Lender: The Walters Art Gallery, Baltimore

This model played an important role in the development of Barye's famous monumental bronze, *Lion Crushing a Serpent,* shown in the Salon of 1833 (Louvre). In this work an awesome, snarling lion pins a serpent beneath the claw of its forepaw. The head of the serpent is drawn back, its jaws opened in challenge. This encounter captures a charged moment, an instant of nearly human analysis and reflection. The scene is rendered dramatic by its very contrast with the irrational rush and frenzy of the struggle one imagines will follow. The energy and tension of the coiled serpent echo in the folds and whorls of the lion's pelt.

The monumental lion is essentially relaxed in its seated position, confident in mood, as though merely toying with the serpent, eyeing it with a sideward glance. In a curious way, this very glance indulges the grotesque, dramatizing the vulnerability of the lion's eye itself: one shudders at the thought of the serpent striking that eye, piercing it with its fangs in one flashing thrust.

Lion Crushing a Serpent was intended from the outset as a flattery of the July Monarchy.[15] Toward 1832 and 1833, a climate of widespread discontent with life under the Monarchy had arisen, a mood of dissatisfaction with the very government the Romantic Revolution had aided to power. In this negative context, the supporters of Louis-Philippe sought to promote Barye's unusual sculptural imagery, which could be understood as flattery of the government. The lion is a symbol of strength, courage, and fortitude in the French commonality of meaning.

The imagery of the bronze is also tied to astrology. Leo and Hydra were the constellations said to rule the heavens during the Revolutionary Days of July 27, 28, and 29, 1830. Barye's *Lion Crushing a Serpent* thus symbolized celestial sanction of the triumphant struggle of the July Revolution and, hence, of the rise of Louis-Philippe. The dynastic, Orléanist references would have been understood easily by a contemporary French audience. Barye's innovative handling of the rather colorless image of two adjacent constellations, as they appear in the star charts, was transformed into a romantically stirring combat of wild animals.

The crown purchased this work from the Salon of 1833 and had it cast in bronze. This cast was exhibited at the Salon of 1836 and placed in the garden of the Tuileries palace. These were fateful events in Barye's career, for they symbolized official acceptance of animal sculpture as a major artistic mode. These events angered the critics and provoked the jealousy of Barye's artistic competitors, providing a target for the barbs of Louis-Philippe's political opponents. The vicious criticsm leveled at this bronze established Barye's notoriety in the Parisian art world.[16] Gustave Planche asked sarcastically, "How is it possible that the Tuileries has been transformed into a zoo?" An anonymous writer said, "Imagine using the gardens for a menagerie!—Only the cage is missing!" Victor Schoelcher noted an "odor of the menagerie." Perhaps the most vicious and mindless thrust of all was aimed by a safely anonymous scribe who said that Barye's type of sculpture had developed because it was "so easy and so popular."

With an eye to Barye's decoratively elaborate realism, the critic Charles Lenormant objected to an "overworked impression" in the *Lion Crushing a Serpent* and said that while he admired the artist's laborious attention to "all the details of the hide and fur," he nonetheless found himself "continuously distracted by minutiae."

The work in the present exhibition is fascinating from a technical point of view.[17] A virtually solid bronze, it was cast by the *cire-perdue* method but is a proof of a rather porous fabric, and one which betrays the hazard involved in casting a solid bronze form having projecting elements of greatly differing thickness. The dissimilar rates of expansion and contraction—in the large mass of the lion's body, as opposed to the lion's slender foreleg, for example—created sufficient stress during the cooling of the bronze to cause the foreleg to crack completely in half. It has been reattached rather crudely, with a pegged joint, but the original, granular fissure remains clearly visible.

The model has been cut into five elements which could be disassembled to facilitate the making of sand molds: (1) the lion's body, (2) the lion's right foreleg and paw, (3) the lion's tail, (4) the serpent's head, and (5) the plinth. An unusual inscription in letters about 3 mm. high is cold-stamped beside the lion's left haunch: O BARYE 12. It is impossible to determine whether this marking identified an artisan or a founder, or whether it indicated that this model served as the master for a particular edition of *surmoulage* casts. The term "modèle" is written in ink or paint inside of the base of the proof, confirming, of course, the point of its five-piece structure. A bronze made from this model is in the collection of the Metropolitan Museum of Art.

The scientific basis of Barye's masterful command of the lion's anatomy is well documented. Joubin cites a brief note written by Delacroix to Barye in October 1828, in which the painter said, "The lion is dead! Come at a gallop! It is time for us to set to work."[18] Evidently the two artists took part in the dissection of a recently dead lion. Another instance of scientific study is the inscription, "lion du cabinet," on an exquisite measured contour drawing of the *Skeleton of a Lioness* (Walters Art Gallery, 37.2167). This indicates that Barye studied in the Cabinet d'Anatomie Comparée, established in Paris in the late eighteenth century by Baron Georges Cuvier. A suite of at least eight dissection drawings of a lioness, apparently donated by an Admiral Rigney, can be reconstructed from various sheets now in the Walters Art Gallery and the Louvre, and from reproductions published by Roger-Ballu in his 1890 monograph on Barye. These drawings are basic to the extensive lion imagery created by Barye during the 1830s.

Two measured drawings of a *Snake's Head* (Walters Art Gallery, 37.2125B) record lateral and dorsal views directly connected with the snake of the monumental bronze, and with this small predecessor of it. Various details in the lateral view are faithfully reproduced in the monumental version: the angle of the opened jaws, the triangular web of tissue at the hinge of the jaw, the undulating line of the tongue, the number and spacing of the teeth, and the size, contour, and placement of the eye. The dorsal view shows the distinctive long ridges linking the eyes and nostrils, the narrowing of the throat behind the hinge of the jaw, as well as the tapered shape of the head. G.B.

18.
Antelope Overthrown by a Tiger

Bronze on wood base
h: 9¼ in. (20.9 cm.); l: 11½ in. (29.2 cm.); w: 9 in. (22.9 cm.), without base
Base h: 6¾ in. (17.1 cm.); w: 12¾ in. (32.4 cm.); d: 11⅛ in. (28.3 cm.)
1834–35
No marks
Lender: The Detroit Institute of Arts, Founders Society Purchase, Robert H. Tannahill Foundation Fund

The *Antelope Overthrown by a Tiger* was once part of an elaborate ensemble intended as a banquet-table decoration, or *surtout de table,* created by Barye for the Duke of Orléans. Begun about 1834 the *surtout* comprised some nine compositions—four animal combats and five hunting scenes—doubtless inspired by table ensembles of French master goldsmiths of the Rococo era, of which the house of Orléans owned several fine examples. Barye's departure from those prototypes was to change the ancillary role of such animal groups—which might appear, for example, as a finial atop a silver soup tureen—and to make them into larger freestanding sculptures.

The five hunting scenes embody the tradition of the hunt as an aristocratic amusement and manifest a kind of world-symbolism, perhaps suggesting the vastness of the French empire. The hunts of wild bull and lion would signify Africa; the *Tiger Hunt* would denote Asia, as would the Mongolian entourage of the *Elk Hunt;* and the *Bear Hunt* would represent Europe. The tallest of these groups, the *Tiger Hunt* (1836, Walters Art Gallery,

Baltimore), was placed at the center of the table, with the other four arranged about it on the arms of a cruciform plan.

Outside the cluster of hunts, at the ends of the cross-plan, were four combats of predator and prey. The predator perhaps symbolized not only the continents, as did the hunts, but also the traditional realms of existence. The *Python Killing a Gnu* (cat. no. 19) calls up Africa, and the two creatures might signify the subterranean and earthly realms, respectively. The *Lion Devouring a Boar* (Louvre) would symbolize Africa, and the earth. The *Eagle and Ibex* (lost) would symbolize Africa, the mountain tops, and the heavens. Finally our *Antelope Overthrown by a Tiger* connotes Asia, and the earth.

Barye himself probably cast the four smaller groups of predator and prey in 1834 and 1835, despite the old description of them as cast by Honoré Gonon and

Sons, cited in the Duchess of Orléans sale catalog of January, 1853.[18] In fact, no evidence exists for such an attribution to the founder Gonon: there is no founder's inscription on the proofs themselves, and their quality is simply too crude to be the work of Gonon. Nor have cast-plaster positives of them appeared.[19] This is further evidence that Gonon's shop was not involved in their execution.

Antelope Overthrown by a Tiger captures perfectly the sense of a dramatic instant. We can almost feel the predator's fangs penetrating deeply into the flesh of its prey. Seen from above, the nearly perfect right angle described by the antelope's neck and body suggests that the animal's neck has been broken. The tiger's left forepaw is exaggeratedly large and pins down the antelope with great force. An oddly sexual touch is evident in the way the tiger's tail brushes the antelope's genitalia.

Barye's underlying classicism of taste would not allow the blurring of the boundaries and contours of these protagonists in a painterly treatment of adjacent edges. The forms are always crisp and distinct, as in the deeply engraved contour of the tiger's left forepaw. Two striking motifs in *Antelope Overthrown by a Tiger* link it with other works of the period by Barye, that of the tiger biting into the throat of its prey, and that of the predator scrambling onto and appearing to embrace its prey.

A variation of this autograph design was produced for the art market.[20] In later years, as a full partner in the firm Barye and Company from 1845 to 1857, Barye gained sophistication as a founder, enabling him to win the Grand Gold Medal

17.

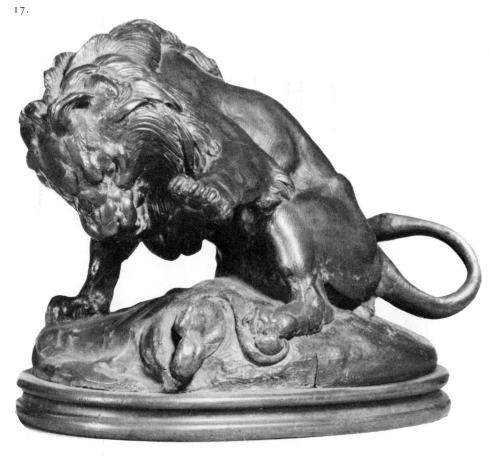

for serially produced bronzes in the 1855 Exposition Universelle. One senses that in 1834 and 1835 the image formulation and expressive aspects of the *Antelope Overthrown by a Tiger* were of greater interest to Barye than the founder's craft, though the piece surely represents his best effort at that time.

The ad hoc character of the work's base is very distinctive. Two vertical edges of the plinth were cast successfully, while the other two were finished with vertical facings of bronze sheet, each fastened with four bronze rivets. These faced edges of the shallow plinth, together with its squarish format and small size relative to the animals upon it, are unmistakable signs of both the autograph nature of the cast and its exact contemporaneity with its table mates with similar bases, the *Python and Gnu* and the *Lion and Boar.* This almost ostentatiously primitive technique, though acceptable to Barye in 1834–35, would never be seen in his oeuvre again. G.B.

19.
Python Killing a Gnu
Bronze
h: 8⅜ in. (21.3 cm.); l: 9½ in. (24.1 cm.); w: 10 in. (25.4 cm.)
c. 1834–35
Signed: BARYE (on base beneath gnu)
No foundry mark
Lender: The Walters Art Gallery, Baltimore

Simply in terms of pure design, this is one of Barye's most exciting works. The African gnu is struck by the python's coils, its head tilting sharply backward under the impact, its tongue lolling but curved as though in an involuntary action. The fallen gnu is held immobile by the awesome pressure of the constrictor coiled about its

18.

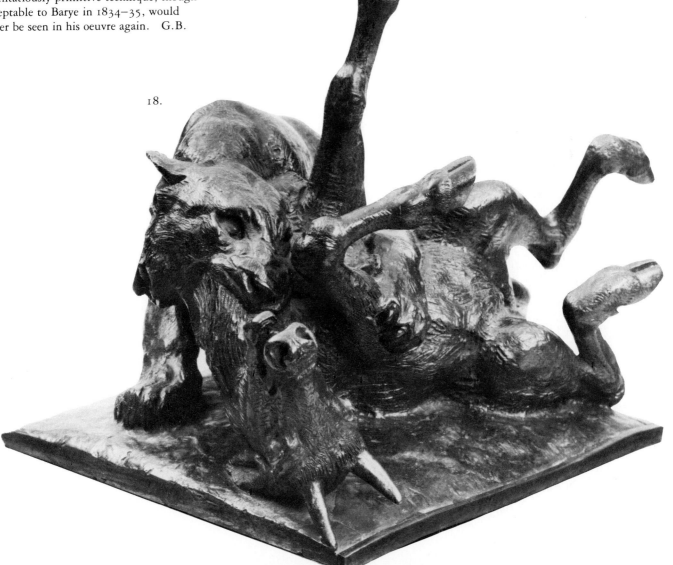

body. The attacking serpent arches in a bold silhouette before the neck of the gnu. This freely undulating, striking segment moves through space in a way that contrasts with the more compact form of the coil crushing the body of the gnu. Another expressive contrast is that of the planar, even cubic, masses of the body and hindquarters of the bovine gnu with the tubular forms of the serpent. A unifying parallel is seen in the arched lines of the gnu's horns, as accents, and the looped arabesques of the constrictor. The incised pattern of the serpent's scales is echoed in the freer passages of cross-hatching that play over the surfaces of the gnu.

The *Python Killing a Gnu* was once a part of the *surtout de table* created by Barye for the Duke of Orléans from 1834 to 1838. It is a mate to the bronze *Antelope Overthrown by a Tiger* (cat. no. 18), and like that work it is an instructive example of Barye's craft of bronze casting, about 1834 or 1835. A splendid crispness of detail, a waxy freshness of surface quality, a razor-sharp record

of incisions on the model, and the ad hoc look of the repair to the edges of the slightly undersize base, by means of riveted plates along all four of its faces, mark this as an exceptional, autograph bronze. It was probably cast directly from a solid wax model, to judge from its heaviness and surface quality. The incised diamond pattern of the snake's scales faithfully captures even the burr left in the wax model by the incising tool. A spontaneous quality is apparent in Barye's decision to omit the diamond pattern completely from the lower part of the serpent, held between the gnu's forelegs.

The base of the proof has a similarly improvised quality, in that the integrally cast base was cut down in size, no doubt to correct a flawed casting. To dress it into a strict rectangle, flat planes of bronze have been riveted and soldered along all four sides of the trimmed plinth. The seam has opened along much of this attachment. The expressive effect of the slightly undersize base is that the animals appear to burst dynamically out of their allotted space at the focal moment of their struggle.

A variant of our bronze made for the general market was cast by Barbedienne.[21] G.B.

20.
Charles VII Victorious
Bronze
h: 19¼ in. (48.9 cm.); without pedestal: 11⅞ in. (30.2 cm.); l. at base: 8 in. (20.3 cm.); w. at base: 3 in. (7.6 cm.)
Before 1836
Signed: BARYE (on base behind left foreleg of horse)
No foundry mark
Lender: Wadsworth Atheneum, Hartford, Gift of Samuel P. Avery

Barye's Charles VII (1403–1461) rides in stately pride, wearing full armor, a great broadsword, and a crown of laurel. A

19.

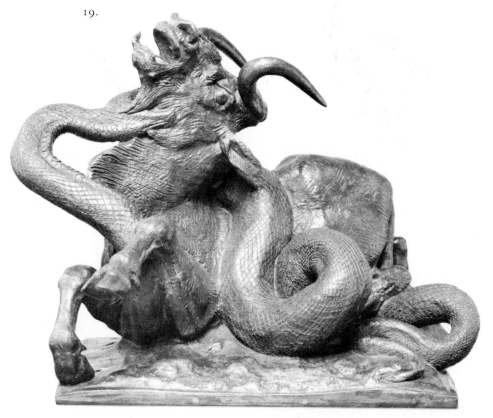

fairy-tale quality of elegance and delicacy pervades the work. Although lacking in the present work, the base Barye designed for this statuette is both architecture and jewel box in one, with elaborate interlaced patterns in low relief like those of Celtic manuscripts. The elegant steed's mane is stretched into long tresses that disappear beneath its trappings; instead it wears light parade trappings. Charles VII is very tall in comparison with the size of his mount. At first glance this would seem to follow the ancient convention of proportional relation evident in two examples that must have been familiar to Barye: the Phidian *Frieze of Riders* from the Parthenon, which Barye had sketched, and the *Marcus Aurelius* equestrian in Rome. Barye, however, seeks to convey the idea of the extreme youth of the king by having him ride a pony rather than a horse. Charles VII, in fact, was Dauphin at fourteen years, was crowned king at twenty-one, and battled the English at the age of twenty-five, assisted by Joan of Arc.

A definite *terminus ante quem* for the design of this work is provided by a proof in gilt bronze, signed and dated 1836 (Musée des Beaux-Arts, Bordeaux). It carries the inscription, "Les membres du Comité d'adm. de la Societé des Amis des Arts de Bordeaux à Mr T.B.G. Scott," and, "Fondu par Honoré Gonon et ses deux fils." This proof was evidently a special commission of Barye, actually patinated by the sculptor himself and presented to the former Consul of Great Britian and founder of the Societé des Amis des Arts de Bordeaux in 1865.[22] It has been suggested that the plaster model of this design was exhibited in the Salon of 1833 under a different title, as no. 5237, "Cavalier du 15ᵉ siècle," the title that appears in the official *livret*,[23] but this assertion must remain speculative without further confirming evidence.

There are several possible artistic sources for this statue. Barye made a sketch (acc. no. 37.2298, Walters Art Gallery, Baltimore) of the Louvre's equestrian *Robert Malatesta, Duke of Rimini.* The slightly backward tilt of the Duke, his rigid leg supported in the stirrup, and certain details of his armor are clearly repeated in *Charles VII.* The

Dauphin's laurel crown may have been adapted from that worn by Lemot's *Henry IV Equestrian* on the Pont Neuf. Barye's drawing of *Horse Trappings* (Louvre, RF 8480, folio 20v) contains the essentials of the design for the trappings over the hindquarters of *Charles VII*'s pony. For example, in both that drawing and our bronze, the narrow, suspenderlike straps that cross the animal's rump converge at a single point marked with a cluster of domical studs.

G.B.

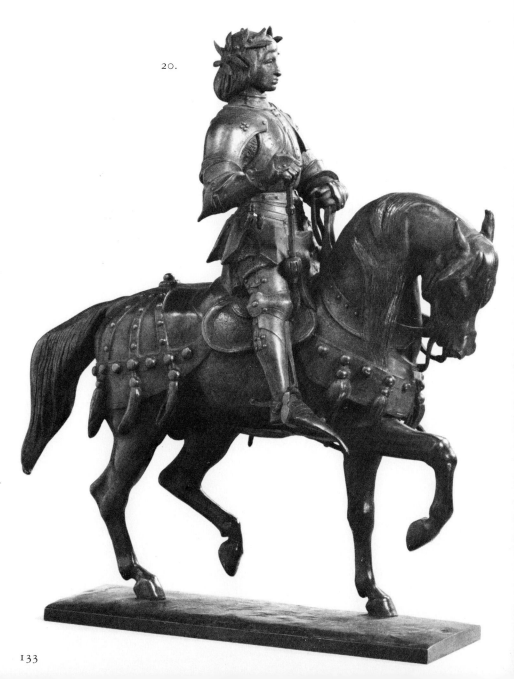

20.

21.
Python Crushing an African Horseman
Bronze
h: 9 in. (22.9 cm.); l: 10¾ in. (27.3 cm.)
c. 1835–40
Signed: BARYE (on base)
Inscribed: Cavalier Arabe surpris par un
serpent (on bottom, by George Lucas)
No foundry mark
Lender: George A. Lucas Collection,
Maryland Institute College of Arts,
Courtesy of the Baltimore Museum of Art

The African horseman reels backward at
the impact of the python's strike for his
throat, his arms flailing in the air. A thick
coil of the serpent pins the horse and rider
to a tree, crushing them against it. The
horse has fallen, hindquarters turned side-
ward and right hind leg flexed as though
in an involuntary response to the terrible
pressure of the python's grip. Even the
rider's waist is locked in the vice of the
serpent's coil. An improbable wind lifts the
horse's mane into a high ridge to interrupt
the silhouette and to relieve the excess of
serpentine movement in both the python
and the arched neck of the horse.

A very likely source for this romantically
grotesque theme of a horse and rider seized
by a giant python is the oeuvre of the
English Romantic painter Henry Fuseli,

21.

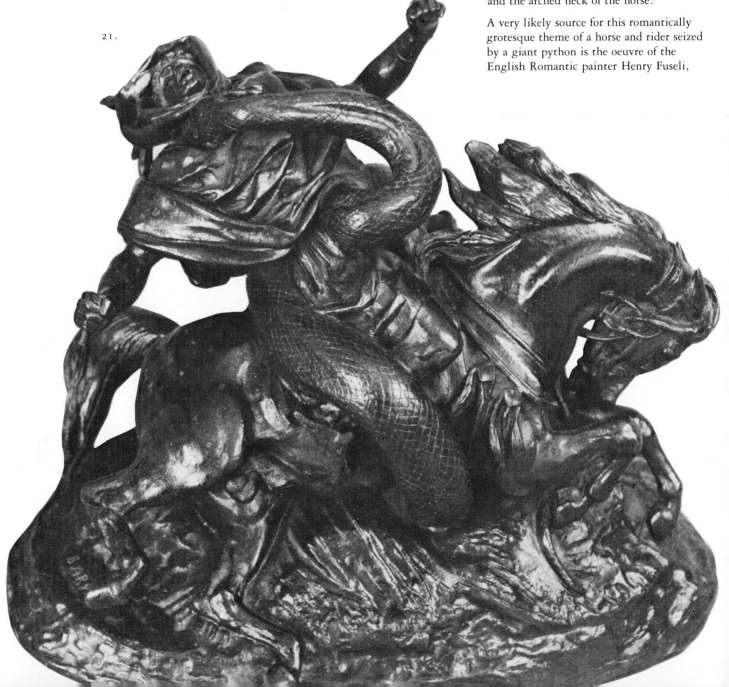

who made several variations of the idea. A watercolor by Fuseli of about 1800–1810, now in Zurich, shows a giant constrictor suspended in a tree above the rider it attacks, a design Barye renders more compactly sculptural in his work. Our sculptor's awareness of Fuseli is fairly certain, in light of his documented attention to motifs in the art of such Englishmen as Flaxman and Landseer.

This bronze is related to a larger sculpture by the artist, *Greek Rider Seized by a Python* (Louvre), and to a drawing in the Baltimore Museum of Art (Lucas Collection, Barye album, folio 9r). G.B.

22.
Theseus Combating the Minotaur
Bronze
h: 18 in. (45.7 cm.); w: 11¾ in. (30 cm.); d: 6½ in. (16.5 cm.)
c. 1840
Signed: BARYE (on base by right foot)
No foundry mark
Lender: San Diego Museum of Art

According to myth, the great hero Theseus journeyed to Crete and slew the Minotaur in the labyrinth, thus freeing the seven youths and seven maidens of Athens who were to be living sacrifices to the Minotaur.

In Barye's bronze, Theseus stands boldly upright, his legs rigidly braced. He does not feel the pain of the Minotaur's claws tearing into his back, nor does he recoil at the monstrousness of his adversary, half bull and half man. The Minotaur's body is herculean and bulky, whereas Theseus is more lightly muscled. Theseus is stoically rigid and strictly planar, in bold contrast to the serpentine flow and imbalance of the Minotaur still clinging to Theseus as it falls in defeat. This same formal contrast, of the rectilinear and the serpentine, was often present in Barye's animal combat designs of the 1830s and is characteristic of his style at this time.

A ritual, frozen quality infuses this ornamental, rather mannered combat. A potential for action, rather than action in progress, is expressed, as are the primordial roles of dominance and submission. The horns of the Minotaur threaten, suggesting its capacity to rip Theseus to shreds, just as the sword of Theseus poised before the forehead of the monster symbolizes the hero's inevitable victory. The motif of the sword before the monster's brain points up the notion of what the monster lacks—

namely, human intellect—and thus restates the moral idea of the triumph of the hero Theseus over the bestial Minotaur.

The strange, groin-to-groin pressure of the embrace of Barye's combatants carries an oddly sexual overtone. The pose may simply amplify the moralizing point of Theseus triumphant over the bestial Minotaur, of his conquest over that monster, understood at one level as a symbol of animal, masculine sexuality. Apart from any erotic overtones, their face-to-face stance is wholly unlike the ancient images of this combat, in which both protagonists always face the viewer. When he designed the sculpture, Barye may have been inspired by Géricault's drawings of boxers, some of which he is known to have copied.[24] G.B. 22.

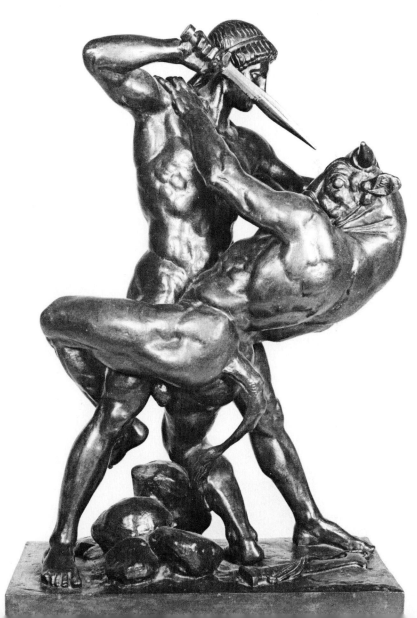

23.
Roger Abducting Angelica
Bronze
h: 20 in. (50.8 cm.); l: 27 in. (68.6 cm.);
w: 9½ in. (24.1 cm.)
c. 1840
Signed: BARYE (in water under hooves)
No foundry mark
Lender: Corcoran Gallery of Art,
Washington, D.C.

Roger's heroic rescue of Angelica, a well-known episode from Ariosto's epic poem *Orlando Furioso* (1532, Canto X, stanzas xcii ff.), was a popular subject among Romantic artists. According to the poem, Angelica, the Princess of Cathay, has been abandoned, naked and chained to a rock, on the *Isola del Pianto* (Isle of Tears), the victim of the sea monster Orc (see cat. no.

49). In a scene immortalized by Ingres in two nearly identical paintings (1819, Louvre; c. 1839, National Gallery, London), the knight Roger arrives flying on a hippogriff (a mythological winged horse with the talons and beak of a hawk) and saves the princess from the horrific monster.

Barye's sculpture depicts the subsequent moment when Roger and Angelica tenderly cling to each other in their flight to safety across the sea.[25] The two look backward, perhaps fearfully, as they brace against the wind in their rapid journey. The long, soaring lines of the hippogriff's wings, tail, legs, and neck dominate the

design, creating a powerful sense of movement, and even suggesting that the creature is slowly alighting. Quite in the spirit of sixteenth-century Mannerist taste, a deliberate dichotomy is created between the quickly gliding hippogriff and the coiled but static dolphin beneath it. In addition, the pose of the embracing couple reflects Mannerist design principles found, for example, in the sculptural groups of Giambologna.

Apparent throughout is a fairy-tale exquisiteness of decorative detail, the elaborate stylistic mode of the hunt groups for the Duke of Orléans' *surtout de table.* There is a glittering play of textures in the pocked coral-reef pedestal, the crisp armor, the smooth flesh of the nude, and the rippled

23.

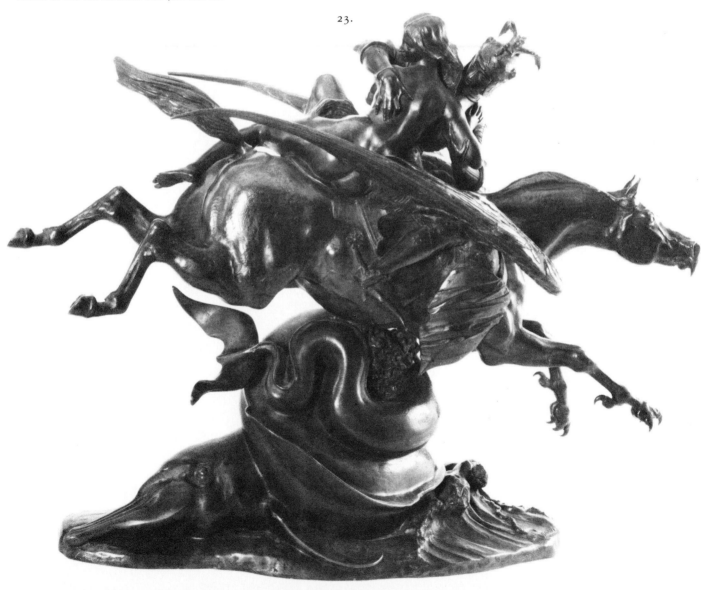

24.

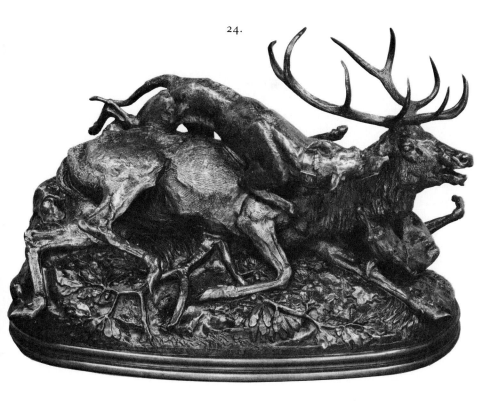

A great stag of ten points has fallen heavily to the earth, totally exhausted by its flight from the two huge greyhounds that have brought it down. One hound bites deeply into the stag's throat, while the other surges across its back and tears at the stag's right ear. The awesome greyhounds have long, tapering heads nearly as large as that of the stag. The collapsing stag has fallen across the leafy and acorn-filled branches of the stump of a gnarled oak tree, a touch that adds to the vivid sense of momentary action, and introduces a realm of decorative elaboration.

The system of curved lines moving in three-dimensional space, apparent in the focal motif of the antlers, is echoed in the arabesques of the dogs' tails and contrasts with the more angular lines of the legs of the stag and dogs. In a subtle way, the play of the meandering lines and volumes of the oak tree is adjusted to the volumes and lines of the creatures. The attention to detail evident in the rocky, fissured, plant-strewn base is carried into the beautifully delineated dogs' collars. The large, square buckles of the collars amplify the narrative sense, alluding to an unseen, human hunter, the ultimate adversary of the stag.

The motif of the uppermost hound, its forelegs drawn in tightly against its body as it leaps for the stag's ear, appears in no fewer than three related drawings. One is the study of *Tumbling Hounds, after Rubens* (Walters Art Gallery, 37.2177A), and the other two are compositional drawings related to several of Barye's contemporaneous stag designs. The uppermost hound of the bronze appears in a virtually identical position in two of the related drawings (Louvre, RF 4661, folio 16r, and Walters Art Gallery, 37.2244, *Two Stags Pursued by Hounds),* leaping upward from a location below and to the right of the stag. A third drawing, the *Single Stag Brought Down by Hounds* (Walters Art Gallery, 37.2245B), shows the ear-biting hound in a different position, very like that of its counterpart in bronze—as crossing over the stag's back, to tear at its right ear. The stag's position in the drawing is altered, in that both the stag's body and its head are over on their sides, as though it were totally incapable of

cloth over Roger's shield. This design might have been commissioned by the elder brother of the Duke of Orléans, the Duke of Montpensier, as a counterpart to the younger duke's table decoration and a mate to the twin casts of the *Candelabrum of Nine Lights* (cat. nos. 25–26), created as a mantel-top decoration for him about 1840.[26]

Barye's drawing of a frenzied horse (Baltimore Museum of Art, Lucas Collection, Barye Album, folio 16v), which shows the animal's mane tossed by the wind, its eye romantically enlarged with agitation, may be a source for the same elements in the hippogriff. It also provides a link with Barye's contemporaneous half-blood and Turkish horse designs.[27] G.B.

24.
Stag Brought Down by Scotch Hounds
Bronze
h: 15 in. (38.1 cm.); w: 21 in. (53.3 cm.); d: 12 in. (30.5 cm.)
Model first exhibited Salon of 1833, this cast c. 1847
Signed: BARYE
Stamped: BARYE 6
No foundry mark
Lender: Los Angeles County Museum of Art, Gift of Mrs. Leona Cantor

25. 26.

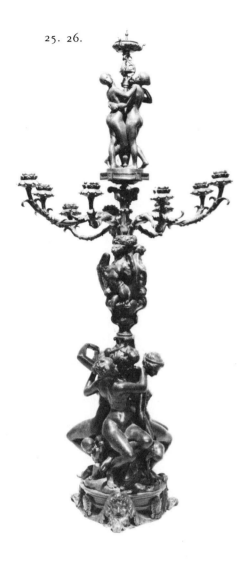

further resistance to the onslaught of the hounds. The bronze stag, however, still holds its head erect, as though to offer an heroic last struggle against the hounds, even as it senses its imminent doom, well portrayed in its nearly human expression of pain.

The image of a hound peering over the top of another animal's back, with chin and forepaws resting upon the quarry as though about to scramble over it, seen at the right edge of *Tumbling Hounds, after Rubens,* is reused for the dog that has leaped onto the right flank of the fallen stag in the compositional study of a *Single Stag Brought Down by Hounds.*

As an undated work, our group poses an interesting question about its position in Barye's developing series of some eight stag designs of the 1830s. Both the intricately realistic base treatment and the rather large scale of this group offer internal evidence for a date of about 1833. Monumental scale had interested Barye greatly from 1830, as in the *Tiger Devouring a Stag,* signed and dated 1830 (Walters Art Gallery); the *Tiger Devouring a Gavial,* Salon of 1831 (Louvre); and the *Lion Crushing a Serpent,* signed and dated 1832 (Louvre). His interest in larger forms doubtless led to the particular size of our group, roughly half again larger than Barye's usual small bronze designs. As for the intricate base treatment, a closely related design, *Stag Brought Down by Two Large Greyhounds,* signed and dated 1832 (Ashmolean Museum, Oxford),[28] has a smooth, domical type of base, intended to contrast expressively with the detailed surfaces of the animals. The disjunctive abstractness of this unreal base, however, apparently led Barye to explore the literal realism of the base of our group, with its fallen tree and oak leaves, a detailed treatment consistent with that of the struggling creatures mounted upon it. The monumental prototype for this style of base was surely the *Tiger Devouring a Gavial,* signed and dated 1831 (cat. no. 16).

A model of our design, in cast plaster touched with wax, is in the Walters Art Gallery. Compositional changes on the model are due mainly to the vicissitudes of the customary procedure of cutting the model into smaller, easily cast elements, and then reassembling it into a salable entity after bronze production had ceased. Breakage of certain details is evident, as is the omission of entire motifs. Barye offered variants of this sculpture in his sales catalogs. G.B.

25–26.
Pair of Nine-Light Candelabra
Bronze
h: 36⅜ in. (92.4 cm.); diam. at base: 6 in. (15.2 cm.); w: 16½ in. (41.9 cm.); d: 16½ in. (41.9 cm.)
c. 1840
Signed: BARYE (on top of base between dolphin and peacock); also,
BARYE (on base of Three Graces)
No foundry mark
Lender: Stuart Pivar, New York

These candelabra, though first offered in Barye's sale catalog of 1847, sustain the taste of the decade of the thirties for an intricately embellished style. An undocumented story often recounted in the earlier literature holds that the Duke of Montpensier, a brother of the Duke of Orléans, commissioned a pair of these candelabra to frame the group of *Roger Abducting Angelica* (cat. no. 23) on his mantel-top, after being impressed with his brother's table decoration ensemble (see cat. nos. 18–19).[29]

The base of each candelabrum has three decorative human masks, like those seen at the corners of the lids of certain Roman sarcophagi. They are placed at intervals of 120 degrees, directly beneath each of the seated goddesses of the first register. The masks provide a kind of grotesque foil to the ideal beauty of the nude goddesses, a thematic contrast restated by the chimeras in the register above the nudes and below the Three Graces uppermost in the design. The masks also support garlands of acanthus leaves suspended between them below Greek palmette motifs. At the level between the Three Graces and chimeras, three branches project; each holds three more branches for the nine candles. The candleholders are like blossoms upon stems, forms that look back to Rococo precedents and forward to the arabesques of Art Nouveau.

With these candelabra, the female nude enters Barye's oeuvre as a significant new theme, a late complement to the heroic male nudes Barye had created toward 1820, in the *Milo of Crotona* medallion (cat. no. 14) and the *Hercules and the Erymanthean Boar* (cat. no. 15). The Three Graces, who turn their backs to the viewer, complement the frontal presentation of the goddesses — Juno (with a peacock), Venus (with Cupid), and Minerva (with a helmet, sword, and owl) — in the lower register. These goddesses reflect the exaggerated, spiraling forms of late Mannerist sculptures such as the bronzes created about 1570 for the *Studiolo* of Francesco I de Medici. Of the three figures, Minerva is the most classically composed. Both groups, Graces and goddesses, were sold independently of the candelabra in Barye's 1855 sales catalog. G.B.

27.

Allegory of Peace

Bronze

h: 39 in. (99.1 cm.); w: 32¾ in. (83.1
cm.); d: 25⅞ in. (65.7 cm.)

Model 1855

Signed: BARYE (on front of self base)

Foundry mark: F. BARBEDIENNE FONDEUR
(on back)

Lender: Museum of Fine Arts, St. Peters-
burg, Florida, Gift of Mr. and Mrs. William
R. Hough of St. Petersburg, Florida

The personification of *Peace* is one figure in
an ensemble of five works created by Barye
between 1854 and 1857 for the Cour du
Carrousel (also called the Place Napoléon
III), of the New Louvre palace.[30] The entire
program consists of four personifications:
Strength and *Order,* paired on the facade of

the Denon pavilion, and *War* and *Peace,*
facing them across the courtyard from the
Richelieu pavilion facade. The focus of the
ensemble is the fifth design, a pedimental
relief on the Sully pavilion, *Napoleon I
Crowned by History and the Fine Arts,* with
its theme of the apotheosis of Napoleon
Bonaparte, an embellishment of the Napo-
leonic legend, intended to enhance the aura
of the Second Empire of Napoleon III.[31]

Strength and *Order* were commissioned on
December 18, 1854; *Peace* and *War* were
commissioned a few weeks later, on
January 17, 1855. All four figures were in-
stalled by January 13, 1856. The apotheosis
relief was executed and installed in the
very brief span of time between March 2,
1857, and June 11, 1857. The contracts for
the four personification figures specified
that Barye would receive 5,000 francs for
each related pair of models, executed at
one-third scale — in fact, the very presenta-
tion models (Louvre) used for casts of the
type of our *Peace* — and would receive
15,000 francs for each pair of full-size
stone groups.

The subjects of the four personifications
represent the great duties of the State, the
government, and the citizen, in a way not
unlike the program of personification
figures devised for the porch of the Pan-
théon by Quatremère de Quincy about
1792.[32] A thematic parallel with Quatre-
mère's concept of the Napoleonic period
would be perfectly in keeping with the
wish of Napoleon III to evoke the
Napoleonic legend, thereby enhancing his
own reign.

Barye conceived the four sculptures as
variations on the ancient theme of Hercules
Resting. In spirit, however, *Peace* suggests
the more lyrical figure of an arcadian
shepherd as he sits upon the back of a re-
cumbent ox, a traditional attribute of
peace, listening to the music of the putto
flautist. The stable, pyramidal composition
of the piece enhances the mood of harmony
and idyllic reverie. The putto suggests an
image of a satyr, playing the ancient
double pipe. In fact, a comparison with a
plaster sketch for the figure (Louvre),
which more clearly reflects Barye's artistic
sources, reveals that this putto is based
upon the putto-satyr standing beside
Michelangelo's *Bacchus,* c. 1496 (Bargello,

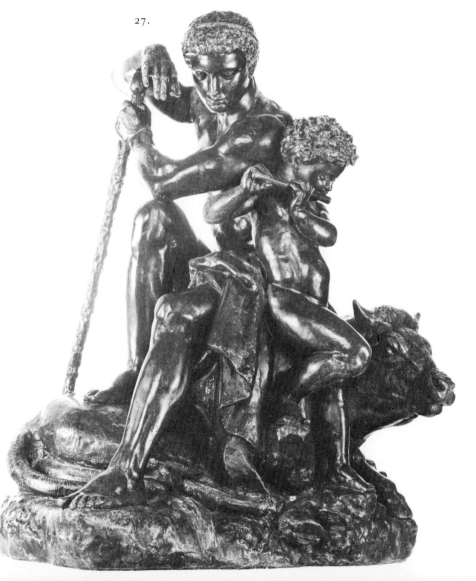

27.

Florence), a figure munching grapes rather than playing the pipes. One sees the resemblance in the placement of the legs, the strong rightward twist of the torso, and the placement of the arms that hold the flute. Details of the figure of *Peace*, such as the arrangement of the fingers on the right hand, suggest the preciousness and overrefined elegance of *maniera* designs of sixteenth-century Italy.

Casts of Barye's *Peace* were offered by the founder Barbedienne in a catalog of 1893, in three different sizes. A bronze identical to the one exhibited here is in Mount Vernon Square, Baltimore. G.B.

Notes

1.
Pietro Santi Bartoli, *Admiranda romanorum antiquitatum...*, Rome, 1693, and *Le antiche Lucerne sepolchrali figurate,* Rome, 1729; Lorenzo Roccheggiani, *Raccolta di cento tavole...*, 1804; idem, *Nuova raccolta di centro tavole,* Rome, 1805–1809; idem, *Raccolta di sessante tavole...*, Rome, 1806.

2.
A. C. P, Comte de Caylus, *Recueil d'antiquités égyptiennes, étrusques, grecques, romains, et gauloises,* 7 vols., Paris, 1752–73.

3.
See *La Divina Comedia di Dante Alighieri Cioé l'Inferno, il Purgatorio, ed il Paradiso. Composto da Giovanni Flaxman Scultore Inglese ed inciso da Tommaso Piroli,* Rome, 1802.

4.
See the discussion of Barye and Company in Cambridge, 1975, pp. 79–88.

5.
This detail was first reported to me by Stuart Pivar.

6.
For a summary of critical reactions to Barye, see Hubert, 1956, pp. 223–30; Gautier's remark is cited p. 227.

7.
G. Planche, *Salon de 1831,* Paris, 1831, p. 105.

8.
The Journal of Eugène Delacroix, trans. Walter Pach, New York, 1948, cited in E. G. Holt, *From the Classicists to the Impressionists,* Garden City, N.Y., 1966. p. 157.

9.
J. H. Bernardin de Saint-Pierre, "Etude Seizième," *Oeuvres complètes,* Paris, 1834, pp. 263–64.

10.
Mme. de Staël, paraphrased in R. Wellek, *A History of Modern Criticism: 1750–1950, II, The Romantic Age,* New Haven, Conn., 1955, p. 220.

11.
The primary text for his notion of the "grotesque" is the "Preface" to the drama *Cromwell* of 1827. See V. Hugo, *Cromwell, Hernani, Oeuvres complètes,* Paris, 1912, I, pp. 7–51.

12.
Cited in Hubert, 1956, p. 224.

13.
Baltimore Museum of Art, Lucas Collection, Barye Album, folio 26v; Louvre, Barye Album, RF 8480, fols. 1r, 1v, 2r, 2v, 3v, 4r, 5r, 6r, 6v, 23v.

14.
Hamilton, 1936, pp. 250–53.

15.
Benge, 1974, pp. 30–35, 344–45.

16.
For a recent summary of the critical literature, see Hubert, 1956, pp. 223–230.

17.
For a full discussion of the relation of the monumental work to both the free versions and the mechanical reductions in smaller scale, see Cambridge, 1975, pp. 76–107.

18.
A facsimile of the catalog is reproduced in Pivar, 1974, p. 272.

19.
See Cambridge, 1975, pp. 76–107.

20.
A cast of this commercial type is illustrated in Pivar, 1974, p. 145. However, that proof is distinctly problematical for it is obviously not an autograph bronze; the title given for it, "Tigre renversant un antilope," does not appear in any of the Bayre or Barbedienne catalogs.

21.
See the discussion and illustrations cited in Cambridge, 1975, pp. 83–85.

22.
Musée du Louvre, *Barye: Sculptures, peintures et aquarelles des collections publiques françaises,* October, 1956–February, 1957, Paris, Editions des Musées Nationaux, 1956, p. 43.

23.
Ibid., p. 43.

24.
See Benge, 1971, pp. 13–27.

25.
A minor Romantic painter, Louis Rioult was one of several artists to portray the same scene (1824, Louvre). See R. Rosenblum, *Ingres,* London, 1967, p. 141, fig. 124.

26.
Lami, 1914–21, I, p. 76.

27.
Barye's *Half-Blood Horse* and *Turkish Horse* are illustrated in Pivar, 1974, pp. 203–6.

28.
I am indebted to Mrs. Jane Horswell of the Sladmore Gallery, London, for bringing this work to my attention.

29.
Lami, 1914–21, I, p. 76.

30.
The standard reference for the history of the Louvre is C. Aulanier, *Histoire du Palais et du Musée du Louvre. Le Nouveau Louvre de Napoléon III,* Paris, 1946.

31.
Benge, 1979, pp. 164–70.

32.
See F. H. Dowley, "A Neo-classic Hercules," *Art Quarterly,* Spring, 1952, pp. 73–76.

Selected Bibliography

Musset, A. de, "Salon de 1836," *Revue des Deux Mondes,* 1836, VI, pp. 144–76.

Delteil, L., *Barye: Le peintre-graveur illustré,* VI, Paris, 1851.

Planche, G., "Barye," *Revue des Deux Mondes,* July 1, 1851, XX, pp. 47–75.

Paris, Hôtel des ventes mobilières, *Catalogue des tableaux modernes...,* January 16–20, 1853.

Lamé, E., "Les Sculpteurs d'animaux, M. Barye," *Revue de Paris,* February 15, 1856, pp. 204–19.

Henriet, C. d', "L'Art Contemporain. Barye et son oeuvre," *Revue des Deux Mondes,* February 1, 1860, XXV, pp. 758–78.

Mantz, P., "Artistes contemporains, M. Barye," *Gazette des beaux-arts,* 1867, I, pp. 107–26.

Paris, Hôtel Drouot, *Catalogue des Oeuvres de feu Barye...,* February 5–12, 1876.

Eckford, H., "Antoine-Louis Barye," *The Century Magazine,* XXXI, 1885–86, pp. 483–500.

Alexandre, A., *Antoine-Louis Barye,* Paris, 1889.

DeKay, C., *Barye, Life and Works,* New York, 1889.

Guillaume, J.J., "Exposition des oeuvres de Barye à l'Ecole des Beaux-Arts," *Nouvelles archives de l'art français,* 1889, V, pp. 178–81.

Ballu, R., *L'Oeuvre de Barye,* Paris, 1890.

Barbedienne, F., *Bronzes de A.-L Barye. Boulevard Poissoniere,* no. 30, Paris, 1893.

Smith, C.S., *Barbizon Days: Millet, Corot, Rousseau, Barye,* New York, 1902.

"Antoine-Louis Barye," *Archives de l'art français,* 1910, IV, pp. 180–81.

Reboussin, R., "Barye peintre," *L'Art et les artistes,* 1913, XVI, pp. 195–210.

Saunier, C., *Barye,* Paris, 1925.

Hamilton, G.H., "The Origin of Barye's Tiger Hunt," *Art Bulletin,* 1936, XVIII, pp. 249–57.

"Baltimore: Animal Bronzes by Barye," *Art News,* August 1937, XXXIV, p. 21.

Hubert, G., "Barye et la critique de son temps," *Revue des Arts,* 1956, VI, pp. 223–30.

Zieseniss, C.O., *Les Aquarelles de Barye, Etude critique et catalogue raisonné,* Paris, 1956.

Lengyel, A., *Life and Work of Antoine-Louis Barye,* Dubuque, Iowa, 1963.

Raynor, V., "Barye Exhibition at Alan Gallery," *Arts,* December 1963, XXXVIII, p. 64.

Johnson, L., "Delacroix, Barye and the Tower Menagerie, an English Influence on French Romantic Animal Pictures," *Burlington Magazine,* September 1964, CVI, pp. 416–17.

Benge, G.F., "Barye's Uses of Some Géricault Drawings," *Walters Art Gallery Journal,* 1971, XXXI–XXXII, pp. 13–27.

————, "The Sculptures of Antoine-Louis Barye in the American Collections, with a Catalogue Raisonné," 2 vols., Ph.D. diss., University of Iowa, Iowa City, 1969.

New York, Parke-Bernet Galleries, Inc., *Nineteenth Century Works of Art...,* March 5, 1970.

Horswell, J., "Antoine-Louis Barye," *Bronze Sculpture of "Les Animaliers" Reference and Price Guide,* Woodbridge, Suffolk, 1971, pp. 1–80.

New York, Parke-Bernet Galleries, Inc., *Bronzes by Antoine-Louis Barye. The Bernard Black-Hughes Nadeau Collection,* December 3, 1971.

Benge, G.F., "Lion Crushing a Serpent," *Sculpture of a City: Philadelphia's Treasures in Bronze and Stone,* ed. N.B. Wainwright, New York, 1974.

Pivar, S. *The Barye Bronzes,* Woodbridge, Suffolk, 1974.

Cambridge, 1975, pp. 89–107.

Lewis, C.D., Jr., "The St. Petersburg Bronzes of Barye's 'War' and 'Peace,'" *Pharos,* May 1977, XIV, pp. 3–11.

Benge, G.F., "A Barye Bronze and Three Related Terra Cottas," *Bulletin of the Detroit Institute of Arts,* 1978, LVI, pp. 231–42.

Pingeot, A., "Jaguar Devouring a Hare," and "War," 1978, pp. 209–11.

Benge, G.F., "'Napoleon I Crowned by History and the Fine Arts': The Drawings for Barye's Apotheosis Pediment for the New Louvre," *Art Journal,* Spring 1979, XXXVIII, no. 3, pp. 164–70.

————, "Barye's Apotheosis Pediment for the New Louvre: 'Napoleon I Crowned by History and the Fine Arts,'" *Essays in Honor of H.W. Janson,* New York, in press.

Born Rosine Bernard, Sarah Bernhardt was the daughter of Judith Van Hard, a Dutchwoman, and Edouard Bernard, a law student from Le Havre. Her early years were largely lonely and unhappy, as she was left in the care of a Breton peasant woman while her mother and sister pursued the lucrative profession of courtesans. Sarah stayed with her mother only briefly about the time of the Revolution of 1848 and was eventually sent off to a boarding school for young ladies in Auteuil. Later, thanks to one of her mother's well-placed admirers, she was admitted to the convent of Grandchamps at Versailles. Her mother, a Jew, realized that Sarah needed a grounding in the doctrines of the church in order to have a chance for a successful marriage. Grandchamps was not only a select Catholic school, but also proudly Royalist. During her stay in the convent, Sarah apparently became a fervent Catholic. She contracted pneumonia when she spent a night in the school chapel clad only in a nightgown, offering flowers to the Blessed Mother and having "a talk with the archangel Raphael."[1] Her penchant for the dramatic had already begun.

At the age of fifteen she was taken out of Grandchamps, and thus her formal education ended. One of her mother's admirers, the Duke of Morny, suggested that Sarah be sent to the Conservatoire to learn acting; after violently refusing, she studied there for two years and then was accepted as a *pensionnaire,* or beginner, at the Comédie Française. In 1862 she made her debut in Racine's *Iphigenia,* playing the title role. The temperamental Bernhardt was dismissed from the Comédie after a backstage incident in which she slapped an older, established actress. Bernhardt did not appear there again for ten years. She found work at the *Gymnase,* a popular boulevard theater, but was forced to leave there, too, after a recital given for the Bonapartist Court at which she unwittingly read selections from the anti-imperial Victor Hugo. In despair she left Paris and traveled to Brussels, where her liaison with Henri Prince of Ligne resulted in the birth of a son, Maurice, in 1864. In 1866 she was hired by the Théâtre de l'Odéon. After two bad performances she found her style as Cordelia in *King Lear* and Zacharie in Racine's *Athalie.* In 1868 her role of Anna Damby in Dumas' *Kean* launched her now-

legendary career. She stayed at the Odéon for six years, and her fame increased rapidly from this time.

In about 1869, to remedy boredom, Sarah turned to several of her friends for instruction in painting and sculpture. She devoted great effort to her artistic pursuits and proved herself quite apt at both drawing and modeling. The artists Alfred Stevens, Georges Clairin, and Gustave Doré found her both charming and talented. Her sculpture instructor Roland Mathieu-Meusnier, a successful academic artist, probably urged Bernhardt to produce lofty allegorical sculpture such as the *Figure of Music* (installed in the Monte Carlo Casino) and *After the Storm,* a bronze depicting a Breton woman holding the body of her drowned son. This last work received an honorable mention at the Salon of 1876. Three years later she had her first exhibition of painting and sculpture in London, under the patronage of the Prince of Wales. The President of the Royal Acad-

emy, Sir Frederick Leighton, praised her work, and in all, ten pictures and six sculptures were sold. Later she modeled portraits of Clairin, Louise Abbema (see cat. no. 1), the journalist Emile de Girardon, Victorien Sardou, and her recently deceased sister Regina.

Bernhardt continued to sculpt all of her life and exhibited in the Salon until 1886. In 1880–81 she had an exhibition of paintings and sculptures at the Union League Club of New York, followed by a second in the Union League of Philadelphia. Later, despite a demanding career, she sculpted small floral and animal ornaments which were cast in bronze and exhibited in 1900 at the Exposition Universelle in Paris. It is even said that René Lalique's jewelry was inspired by certain of these works. In 1914 Bernhardt was made a *chevalier* of the Legion of Honor. After World War I, failing health greatly diminished her activities, and her final American tour was given in 1916. J.A.

28.
Inkwell, Self-Portrait as a Sphinx (Encrier Fantastique)
Bronze with new ostrich feather plume
h: 12½ in. (31.8 cm.); w. at base: 7½ in. (19 cm.); d: 9 in. (22.9 cm.)
Dated: 1880 (on right side of base)
Foundry mark: THIEBAUT FRERES/ FONDEURS/ PARIS (on back of base)
Provenance: Shepherd Gallery, Associates, New York
Lender: Museum of Fine Arts, Boston, Helen and Alice Colburn Fund

The *Encrier Fantastique* departs drastically from Sarah Bernhardt's more conventional academic or Romantic genre subjects. If there was outside inspiration for this work, one must turn to the Symbolist painters of the day, with whom she had close connections: "Sarah Bernhardt can be included in the choir of Symbolism's muses; whether in

28.

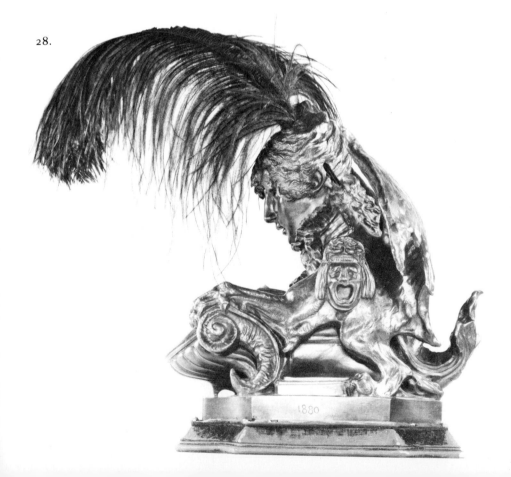

the role of the 'Princess Lointaine' (the Distant Princess) or of 'Gismonda,' she popularized the Symbolist aesthetic in much the same way as Clairin, her favorite painter, popularized her image in his academic renderings of high-flown subjects."[2] Gustave Doré and Alfred Stevens both encouraged and helped Sarah.[3] Through them and others she must have known the Symbolist painters of the time and seen the fantastic motifs such as chimeras, sphinxes, bats, and other animals often combined with human form in the works of Moreau, Redon, and others.

Her own career probably provided additional inspiration for this departure from her usual subjects: in 1879 she must already have been rehearsing for the role of Blanche de Chelles in Octave Feuillet's play, *Le Sphinx.* Perhaps at that time she decided to portray herself in that role, for the heroine of the play always wore a poison ring in the form of a sphinx. The diabolical, mysterious connotations of Blanche's character must have struck Sarah as being integral to her own. As far as contemporary photographs indicate,[4] the resemblance of the inkwell to the actress is remarkably faithful and exhibits an amazing facility for modeling in the round as well as a sensitivity to the juxtaposition of smooth and rough surfaces. This unsettling amalgam of the human and nonhuman, the real and the surreal—especially when seen in profile—brings to mind the wonderful bronze grotesques of the Renaissance sculptor Riccio.

The inkwell was not commissioned, but seems to have been conceived as a small symbolic celebration of the artist's role in Feuillet's play as well as an evocation of what she perceived herself to be.[5] Henry James wrote that "her greatest idea must always be to show herself...her finest production is her own person." Her view seems to have coincided with that of critic Jules Lemaître, who described her as "a distant and chimerical creature, both hieratic and serpentine, with a lure both mystic and sensual."[6]

The public did not receive Bernhardt's work enthusiastically. Her exhibition in London was written up only in the society pages, not in the art section,[7] and Rodin "railed against its banality;"[8] Zola, however, defended her against the critics' sharp

and personally derogatory remarks.[9] The inkwell, despite contemporary comments to the contrary, is a fascinating and important stylistic document for the last decades of the nineteenth century. Darkness, foreboding, and exotic myth are suggested by the traditional symbols of bat, skull, and sphinx. Woman, as in other *fin-de-siècle* art, is depicted as diabolical, mercurial, dangerous. Bernhardt characterized herself as part woman, part bat, part griffon, part sphinx in a metamorphosis that recalls jewelry done by René Lalique (Bernhardt was a client of his), as well as works done by many artists in the broadly termed Art Nouveau movement both in France and in England. In more conventional terms, she has also evoked her profession as an actress by including the masks of comedy and tragedy as epaulettes; the pseudo-Oriental characters engraved on the left side of the base probably allude to her interest in Eastern art, or merely to a fascination with the arcane.

From the incomplete records at hand, it would seem that Bernhardt sculpted the model for the inkwell in 1879, for a cast (possibly this Boston example) was shown in London at 33 Piccadilly that year. The following year, that cast or another was shown in New York at the Union League Club.[10] One cast of the inkwell is in the collection of Queen Mary of England. In 1973 another cast was shown at the Ferrers Gallery, London, and the Boston version was exhibited in New York.[11] Of an estimated forty pieces of sculpture by Bernhardt, only seven, including the Boston bronze, can be located today. J.A.

Notes

1.
Skinner, 1967, p. 15. Skinner is the primary source of biographical information for the present biography and entry.
2.
P. Julian, *The Symbolists,* London, 1973, p. 21.
3.
Skinner, 1967, p. 95.
4.
Illus. in London, 1973, pp. 12–13.
5.
Ibid., p. 10.
6.
Skinner, p. 232.
7.
Ibid., p. 133.
8.
Ibid., p. 97.
9.
Ibid., p. 98.
10.
Union League Club of New York, *Sarah Bernhardt Souvenir,* no. 18.
11.
New York, 1973, cat. no. 68.

Selected Bibliography

Union League Club of New York, *Sarah Bernhardt Souvenir, Including the Authorized Catalogue of Her Paintings and Sculptures,* New York, 1880.

Skinner, C.O., *Madame Sarah,* Boston, 1967.

London, *Sarah Bernhardt 1844–1923,* Ferrers Gallery, London, 1973.

Applegate, J., "A Sarah Bernhardt Inkwell and a Louis-Ernest Barrias Bronze," *Boston Museum Bulletin,* 1975, LXXIII, no. 369, pp. 36–39.

JEAN-BAPTISTE CARPEAUX
1827 Valenciennes—Courbevoie 1875

Jean-Baptiste Carpeaux was the son of Joseph, a mason, and Adèle, née Wargny, a lacemaker. The eldest of five children, he received rudimentary instruction at the Ecole des Frères in his northern birthplace and at the local Académie de Peinture et Sculpture. In the late 1830s the family left Valenciennes for Paris. By 1842 Carpeaux was enrolled at the Ecole Gratuite de Dessin, the school maintained by the French government to offer workers free instruction in basic skills like drawing, mathematics, and modeling. He stayed there only two years; his talent made him a likely candidate for study at the Ecole des Beaux-Arts, where he enrolled in the fall of 1844, presenting himself as a student of the sculptor François Rude, whose studio he had only recently entered.

Two friends from Valenciennes, J.-B. Foucart and Victor Liet, both slightly older than Carpeaux, had introduced their young countryman to Rude; they were motivated as much by agreement with his republican sentiments as by their interest in his sculpture. Carpeaux shared their admiration for Rude, which he would feel throughout his lifetime; however, his determination to succeed as a sculptor eventually demanded that he leave Rude's tutelage. The latter's students were almost systematically denied the official prizes and commissions that nourished sculptors' careers, since the academicians found his teaching methods and politics too controversial. In 1850 Carpeaux left Rude for Francisque Duret, a talented but uncontroversial sculptor.

Duret promised Carpeaux the Prix de Rome within two years. In fact, it took the young artist until 1854 to win that prize, for which he had competed annually since 1845. Winners were expected to enroll at the French Academy in Rome in January of the following year, but Carpeaux's departure for Rome was delayed while he struggled with illness (an eye infection) and his own erratic temperament in order to complete the bas-relief, *Napoleon III Receiving Abd-el-Kader at Saint Cloud* (fig. 69), an official commission won after it was shown at the Salon of 1853. Besides this relief, his other major early works include a small group—*Empress Eugénie Protecting Orphans and the Arts*—a decorative sculpture commissioned for the Louvre, several busts, and his Ecole competition sculpture.

Finally, by January 31, 1856, the director of the Villa Medici, the painter Victor Schnetz, could report Carpeaux's arrival in Rome with the annual crop of new *pensionnaires*.[1] Carpeaux was thus a year behind in the required studies for his five-year fellowship. Letters from Schnetz to François Halevy, permanent secretary of the Academy, indicate that the young sculptor began the copy required for first-year students.[2] Although Schnetz does not specify the antique statue Carpeaux had chosen to copy, he does say that an Italian *practicien* had begun to rough out the marble while Carpeaux was on a trip to Naples in August 1856. Carpeaux's poor health prevented him from completing the marble; instead he was forced to return to Paris, and it was not until January 1857 that he was back at the Academy. The rules required that second-year *pensionnaires* submit "a figure in the round of his own composition" and a "bas-relief of an important composition, comprising less than eight figures." Carpeaux never executed the relief (see cat. nos. 30–32).

His stay in Rome was to be chaotic, frequently interrupted by ill health, by two return trips to France in 1857 and 1861, and by conflicts with Schnetz. Their disputes arose over the manner in which Carpeaux would fulfill the requirements imposed on all students at the Academy. He fought continually to escape from the yearly tribute the Academy demanded; he preferred immersing himself in the life and art of Rome. He drew ceaselessly, filling notebooks with quick pencil sketches of any aspect of the Roman scene that caught his eye. With these rapid sketches, continuing a habit begun years earlier, he attained new fluency as a draftsman. He discovered Michelangelo, whose art he studied with both fellow *pensionnaires* and other artists. These studies are clearly reflected in the two *envois* he executed in Rome, the naturalistic *Neapolitan Fisherboy* (cat. no. 29) and the grandiose *Ugolino and His Sons* (cat. nos. 30–32). The former was received in Paris in 1858 and a bronze version exhibited at the Salon of 1859. The latter, conceived in 1857 but not completed until 1861, arrived in Paris behind schedule and was shown at a special exhibition held in the chapel of the Ecole des Beaux-Arts.

The *Ugolino* aroused controversy, and Carpeaux's resulting notoriety helped launch him on the official career he had so eagerly sought. The year 1863 brought major commissions including the sculpted decor of the Pavillon de Flore at the Louvre; a group, *Temperance,* on the facade of the Paris church La Trinité; and a bust of Princess Mathilde. Aristocrats and government officials such as the Marquis de Piennes and the Marquis de la Valette, whom he had met in Rome, provided introductions that resulted in numerous portrait commissions in the 1860s and early 1870s. In 1864 he won the chance to execute a portrait of the young Prince Imperial (cat. no. 39). This work, which introduced a new element of informality in nineteenth-century portraiture, was shown in plaster at the Salon of 1866. By that time his reputation was fully established, although the controversy surrounding him had not yet quieted, and he continued to receive important architectural commissions. As early as 1860 he had been at work on a monument to the painter Watteau for his native city of Valenciennes; this was not inaugurated until after Carpeaux's death. Another monumental group, *The Four Parts of the World,* was commissioned in 1867 as the crowning element of the Fontaine de l'Observatoire, designed by the architect Gabriel. In 1863 the architect Charles Garnier, an old friend and fellow *pensionnaire* at the Villa Medici, offered Carpeaux the chance to sculpt one of the monumental groups for the facade of the new Opéra. The official commission came in 1865, and four years later *The Dance* was unveiled. Its a-rhythmic, unbalanced composition and sensuous rendering of the female figure in "stone made flesh" shocked public morals and expectations. It was vandalized and threatened with removal. It provoked outrage not only because it violated contemporary standards of decency but also because it redefined the possibilities for sculptural expression.

In 1866, Carpeaux established an atelier to reproduce his works for sale, an enterprise meant to cope with the financial difficulties which hounded him. He undertook the venture with his younger brother Emile, who as sales manager made the rounds of Parisian specialty shops and arranged auctions in foreign cities including London, Amsterdam, and Brussels. In 1868, the year before his marriage to Amélie de Montfort, Carpeaux purchased a lot in

Auteuil, then a not-so-suburban region of Paris open to middle-class residential development, where he built a house and studio. Many of his works of the late 1860s and early 1870s—e.g., *Suzanne surprise,* the *Rieur,* and the *Rieuse* — were conceived primarily for sale and calculated to appeal to the taste of a bourgeois market. Carpeaux increased the output of the studio by reworking individual sculptures with variations in decorative details, such as roses or laurel leaves, and by mining his public monuments for single figures or busts that could be extracted from their original context and issued as separate, self-sufficient works. Carpeaux was extremely interested in the technical processes used in the atelier and, with Meynier, a technical overseer hired in the early 1870s, developed a technique of casting terracotta that allowed the reproduction of large-scale groups such as the *Ugolino* and *The Dance,* as well as their individual elements.

Carpeaux's last years were unhappy. His marriage was not a success, and he was frequently estranged from his wife. The events of the Commune and the Franco-Prussian war, many of which he recorded in his notebooks as well as in painting and sculpture, forced him to leave Auteuil and, eventually, France. He lived for a time in London, where he met fellow exiles Gérôme and Gounod and modeled their busts. London offered him British as well as French patronage, and he found there a market for both portrait busts and purely decorative pieces. It was his first trip to England, and he spent time sketching sculpture in the South Kensington Museum and drawing horsewomen in Hyde Park. He made a second visit in 1873, at the behest of the Empress Eugénie, to make a portrait of the dying Napoleon III.

Carpeaux began to lose his health and his ability to manage his life, which was complicated by difficulties with his family. His childhood friend, the painter Bruno Chérier, and a new patron, Prince Georges Stirbey, aided him in the final torturous stages of a cancer which killed him on October 12, 1875. Stirbey retained the large mass of drawings Carpeaux left, and in 1883 divided them among the Musée de Beaux Arts in Valenciennes, the Ecole des Beaux-Arts, and the Louvre. Carpeaux was buried first in Paris, where the artistic

world turned out in throngs at his funeral. Several months later, as a result of a dispute between his parents and his wife, his body was removed to Valenciennes and re-interred there with the highest civic honors. After bitter struggles, Carpeaux's widow won control of the Auteuil atelier, which she supervised until her death in 1906. A.W.

29.
Neapolitan Fisherboy
Bronze
h: 35½ in. (90.1 cm.); w: 18 in. (45.7 cm.); d: 19 in. (48.3 cm.)
First version cast in bronze, 1859; this variant c. 1873
Signed: Carpeaux (on left front of base)
Foundry mark: PROPRIETE CARPEAUX, and small eagle cachet
Provenance: Heim Gallery, London
Lender: The Minneapolis Institute of Arts, The John R. Van Derlip Fund

In January 1857 Carpeaux began work on the *Neapolitan Fisherboy,* the work that was to be his second-year project at the Academy in Rome. This figure of an adolescent boy holding a shell to his ear was cast in plaster by April 3, 1858, too late to be sent to Paris with the other *pensionnaires'* works.[3] The plaster followed in a second shipment, and arrived in time to be put on view in June at the Ecole des Beaux-Arts with the other students' projects. This was the first of many occasions when the model was exhibited. A bronze cast by the founder Victor Thiébaut was shown at the Salon of 1859 and purchased by the Baron James de Rothschild for 4,000 francs; a second bronze, shown in Metz, was sold in 1861 to the manufacturer A. Patoux of Aniche, one of Carpeaux's early patrons, for 1,500 francs. A marble begun in Rome was shown partially finished at the Ecole des Beaux Arts, with the exhibition of student works for 1861, and again, completed, at the Salon of 1863, when it was purchased by the Emperor. The same marble was again on view at the Exposition Universelle of 1867.[4]

In 1861, when he had seen the *Fisherboy* for the fourth time in an exhibition, Paul Mantz expressed the hope that he had seen the last of it. "M. Carpeaux," he protested, "cannot decently spend his life constantly

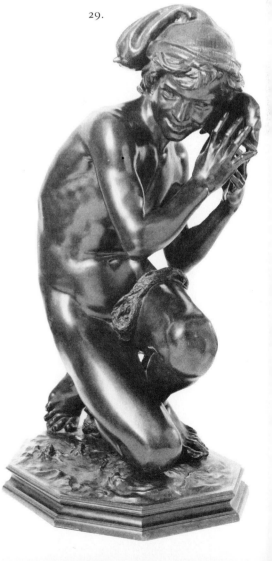

29.

redoing the same statue."[5] Although he readily confessed his dislike for its "grimace," Mantz was also willing to grant the artist "success in a loyal search for truth."[6] Most critical praise was equally mixed: Maxime Du Camp wrote disparagingly that the figure would make a nice clock.[7] In its official comment on the work, the Academy qualified its recognition of Carpeaux's talent for the precise study of nature with the desire that he would apply his gift to more noble subjects.[8] The import of the Academy's message, however, is exactly the opposite of Du Camp's. The critic took aim at the trite subject Carpeaux presented to a Salon besieged annually by a crop of fisherboys wearing cap and scapula and playing some seaside game. For Carpeaux, the use of the familiar subject was a joint tribute to his teachers Rude and Duret, as the critic Louis Auvray recognized.[9] While he was sculpting the model, Carpeaux sent to Paris for a cast of the head of Rude's *Neapolitan Fisherboy* (cat. no. 210), and later directed that his bronze be patinated to the color of Duret's *Dancer* (cat no. 122).[10] Carpeaux's figure looks back to works first shown in Paris some three decades before, works whose evocation of a free, natural, Romantic idyll both nurtured and fed on Romantic myth. It combines Rude's mastery of a naturalist anatomy with the active imbalance that gave life to Duret's bronze. Critics called Carpeaux's figure easy and graceful. Their reading is the product of his control of the multiple angular oppositions within the figure, of bent leg and bent arm, of its counterpoint of weight and thrust, which would be even further extended in the *Ugolino and His Sons* (cat. nos. 30–32). It was undoubtedly because of the figure's vitality that the Academy praised its truth and condemned its lack of nobility.

Once Carpeaux had completed the model of his figure, he gave considerable thought to the management of his artistic property. The tactic of displaying the work in several media that struck Paul Mantz as so indecent was one commonly used by sculptors to keep their works in the public eye. Carpeaux refused an early offer of 2,000 francs for the marble of the work since the conditions of the sale would have prohibited him from reproducing it.[11] Instead he made preparations for an edition of the

piece and, in July 1863, was billed 240 francs for the necessary reduction made by the firm of F. Barbedienne.[12] By late 1863 he was paying the *practicien* B. Bernaerts to execute a marble bust of the *Fisherboy,* and by 1866 he had designed a variation on the bust, the *Rieur aux Pampres.* In 1864 Carpeaux exhibited a figure meant to be the pendant of his work, the *Young Girl with a Shell,* which also led to variant and bust-length versions. These figures, and their variations, were the mainstay of Carpeaux's atelier operation, as the catalogs of sales in London, Brussels, Paris, and Amsterdam indicate. In 1873 he made yet another variation on the original models of both figures, this time issuing them with a fishnet draped artlessly across their laps. This more modest version was produced both in marble (Paris, Fabius Collection) and in bronze, as in the present example.

A.W.

30.

Sketches after Michelangelo and for Ugolino
Brown ink on light blue laid writing paper
h: 10⅝ in. (27 cm.); w: 8⅛ in. (20.6 cm.)
Dated, inscribed, and signed: Florence ce 25 Aout 1858/Monsieur le Directeur/Me trouvant ici dans une (on top half of sheet), Moise/I^{RE} 7^{bre} 1858–Jean Baptiste/HEUREUX (on bottom half of sheet)
Lender: The Art Institute of Chicago

31.

Ugolino and His Sons
Bronze (sketch)
h: 20 in. (50.8 cm.); d: 12½ in. (31.7 cm.); w: 9 in. (22.9 cm.)
After 1860
No marks
Lender: Chrysler Museum at Norfolk, Virginia

32.

Ugolino and His Sons
Bronze (finished model)
h: 19 in. (48.3 cm.); d: 14 in. (35.6 cm.); w: 9 in. (22.7 cm.)
Signed and dated: JB^{te} Carpeaux Roma, 1860 (on lower left of base)
Foundry mark: Proprietaire/Carpeaux [illegible mark] (on base on lower left)
Lender: Chrysler Museum at Norfolk, Virginia

30.

Carpeaux first considered appropriating the story of Count Ugolino from Canto XXXIII of Dante's *Inferno* as he searched for a theme for the bas-relief "consisting in less than seven figures" required of second-year students at the Villa Medici. Several drawings of that first scheme present the imprisoned tyrant Ugolino brooding above his sons like some consuming vulture, a conception that if executed would have overturned rules of balance and legibility governing academic relief.[13] On a visit to Florence in August 1858, however, Carpeaux rethought his approach to the theme, transforming it into a plan for a multi-figure group which he intended to submit as his fifth-year project. His experience of Michelangelo's art during his stay in Florence inspired that change; it released a kind of creative explosion whose intensity is demonstrated by the drawings he executed there.

One sketch in particular (cat. no. 30) reveals this process. Executed on a piece of writing paper dated August 25, 1858, its active, curving pen lines convey the speed with which he resolved his new composition, grouping the curving figures of the dying youths around the central rigid figure of Ugolino. Carpeaux seems to have experienced a great sensation of calm when he reached this solution, as an inscription at one corner of the sheet indicates. He wrote the date September 1, 1858, with the word *HEUREUX*—happy. He added the name *Moïse*—a reference to Michelangelo's Moses in San Pietro Laterano, Rome, which he also reproduced in a free sketch. Both sketch and inscription suggest that the creative energy that produced the *Ugolino and His Sons* was sparked by contact with Michelangelo in Florence and fed by the sum of his understanding of the Italian master's art.

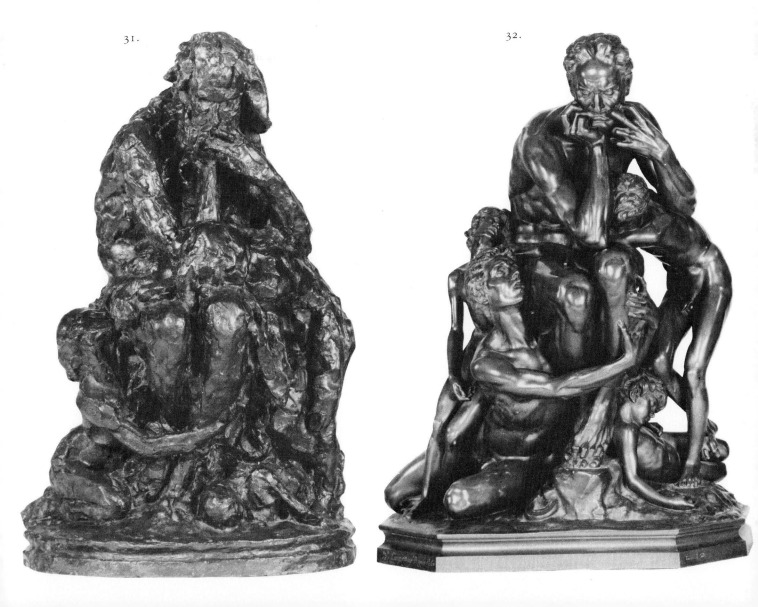

31.

32.

Soon after his return to Rome, Carpeaux began to turn his drawn idea into a clay sketch. It must have been realized by late December 1858, when the Italian *practicien* Malpieri cast a *bozzetto* for him.[14] It seems safe to conclude that a version of this plaster maquette, which records an early stage of the piece in which only three sons are represented, was the one which remained at the Villa Medici after Carpeaux's departure and also furnished the model for the many casts subsequently taken from it by succeeding generations of students there. Several later bronze casts (see cat. no. 31) document this stage of Carpeaux's composition and further suggest his method of building up a figure from pellets of clay pressed roughly together.[15]

From this point, the artist's progress slowed considerably. He was hindered by Schnetz, who opposed the choice of subject as both inappropriate to sculpture and outside the conditions of the assignment.[16] The director urged Carpeaux to consider a *St. Jerome* instead, a subject that would make use of the seated male figure Carpeaux had already begun. But on December 31, 1859, Carpeaux's fellowship expired while his project was still incomplete. Out of funds, he returned to France to petition the Minister of Fine Arts, Achille Fould, to subsidize the continuation of his work. The indemnity was granted, and Carpeaux returned to Rome by April 1860, still faced with Schnetz's opposition, but now beginning to collect the approbation of visitors to his studio. The physical labor involved in the life-size realization of his ideas was enormous. Because Carpeaux was no longer a *pensionnaire,* he dealt directly with whatever workmen helped him; no records of these transactions exist. He canvassed his friends for money as the 3,000 francs awarded him by Fould ran out, and he periodically bailed out of jail the model who posed for Ugolino. With such difficulties plaguing him, it was only in November 1861 that he could write to Paris that the plaster cast of the group was complete. With Schnetz's support (since the reluctant director had by then been completely convinced by the group), he won permission to have it transported to France at government expense. By early 1862, Carpeaux and his statue were both in Paris.

The approval won in Rome forced the Ecole des Beaux-Arts to exhibit the plaster and to comment on the work. *Ugolino and His Sons* was put on view in the school's chapel, and the Academy heard a report which the sculptor Petitot and his colleagues in the Sculpture Section had drawn up. The report is a catalog of faults: it attacks the work for having an inappropriate subject, an unclear composition, nudity that is improper for a historical figure, and too great an emphasis on anatomical form.[17] It praises only the "great energy" of Carpeaux's representation of Ugolino and the "heartfelt, truly touching expression" of the two youngest boys. In conclusion, however, the academicians admitted the undeniable strength of the work: "Despite these critical observations, we are pleased to recognize, in sum, that M. Carpeaux's group is a remarkable work on more than one level, but most of all in execution."

The ambiguity of this report—the imbalance between the detailed, specific objections and the general approval which the artist's technical mastery demanded—demonstrates the Academy's difficulty in coming to terms with the sculpture. It was not alone. Government reaction was equally equivocal, and its hesitancy affected the conditions under which it was willing to acquire the sculpture. An official commission named by the Ministry of Fine Arts recommended that Carpeaux modify the group before it was executed in a more permanent material; only after the artist's supporters came to his defense was this demand annulled. Even so, bronze rather than marble was the chosen medium; its selection carried with it implications of the hierarchical opposition between *sculpteur* and *statuaire,* with marble the nobler material and *statuaire* the more elevated profession. The cast was made by the foundry of Victor Thiébaut and shown in the Salon of 1863; a marble, executed under the terms of a contract between Carpeaux and the firm of Mm. Dervillé et Cie, controllers of the marble quarries at Saint-Béat, was shown in 1867 at the Exposition Universelle. By July 11, 1863, the firm of F. Barbedienne had executed a model for a reduction of the group, for which Carpeaux paid 110 francs. The sculpture had won a first-class medal at the

Salon, and the artist clearly was planning an edition that would capitalize on the notoriety of his work.

The various editions of the *Ugolino* have been described elsewhere.[18] What must be emphasized here, however, is the critical role the work played in launching the sculptor's career. Its ambition and expressiveness forced critics to come to terms with it, just as the Academy had. The *Ugolino* is Carpeaux's statement of intention, mapping out a territory of sculptural expression that he was to dominate until his death. A.W.

33.
Portrait of Alphonse Roussel
(1829–1869)
Electrotype with bronze-colored patination
h: 7¼ in. (18.4 cm.); w: 5⅞ in. (14.9 cm.)
Original model c. 1859; this cast c. 1869
Signed and inscribed: a l'ami Roussel JB^te Carpeaux (at lower right)
Provenance: Bruno de Beyser, Paris
Lender: Private Collection, Los Angeles

Unlike his early portrait medallions of patrons in Valenciennes or later ones of members of the imperial court, Carpeaux's medallions of friends executed during his stay in Rome are among his most original works. His likenesses of fellow students at the Villa Medici, such as the painter Elie Delaunay or the architect Emile Vaudremer, combine direct references to earlier art—in these instances, a medallion by David d'Angers and Greek coins—with a new assertion of a Romantic portrait image. This is equally true of his medallion of his friend, the painter Alphonse Roussel (1829–1869). The oval plaque is a quick, slightly nervous portrait whose energy comes from its broken, almost busy surface. While it conveys the features of an individual (the description of Roussel on his passport tallies well with the features we see),[19] it simultaneously evokes the memory of Michelangelo's *Head of a Faun,* a drawing at the Louvre that Carpeaux copied at about this time.[20] The reference fits this portrait well, since Roussel was one source of the young sculptor's own knowledge of Michelangelo; they were in Rome together and seem to have discussed their idol frequently. In October 1859 the painter even supplied his friend with a series of notes on the life, art, and temper-

ament of "Michelange le Puissant," high-
lighting among other things the grandeur
and energy for which they both admired
him.[21]

Carpeaux maintained contact with Roussel,
sometimes through their mutual friend
Dr. Batailhe, after both men returned from
Rome.[22] When the painter died in 1869,
Carpeaux was responsible for having his
canvases framed and draped in black and
exhibited posthumously at the Salon. It
seems possible that this electrotype cast as
well as another in a New York private col-
lection might have been produced at this
time, as mementos for the dead man's
family. A.W.

34.
Bust of Pierre-François Eugène Giraud (1806–1881)
Bronze
h: 21¾ in. (55.2 cm.); w: 11¾ in. (29.8
cm.); d: 10 in. (25.4 cm.)
c. 1862
Signed: Carpeaux (on left shoulder)
No foundry mark
Lender: Los Angeles County Museum of
Art, Museum Purchase

A member of Princess Mathilde's circle,
the painter Eugène Giraud is today best
known for his watercolor caricatures of that
fashionable literary and artistic set, al-
though he also painted orientalist subjects
and designed most of the costumes for
Alexandre Dumas' dramas.[23] Carpeaux
modeled Giraud's bust in 1862 during a
visit to Princess Mathilde's estate, St.
Gratien. (In return, it is said, Carpeaux
received a portrait of his mother painted
by Giraud.)[24] The likeness was not publicly
displayed until 1857, when a bronze
was one of the three male busts Carpeaux
showed in the Exposition Universelle
(Groupe 1, Classe 3, No. 650). It was none-
theless a fixture in Giraud's atelier on the
Avenue des Terne and can be seen in
drawings and descriptions of that exotic
interior, amid Turkish carpets, Oriental
bronzes, and armor, souvenirs Giraud
collected during his eastern travels in
the 1840s.[25]

Giraud's widow gave a bronze cast of her
husband's bust to the Louvre in 1893. The
painter himself donated a plaster to the
Musée des Beaux-Arts, Valenciennes;
another plaster, possibly the example in

unspecified material shown at the Ecole des
Beaux-Arts in 1894, no. 419, was sold at
the Galerie Manzi on May 30, 1913 (no.
49). The history of the present bronze is
unknown. It differs from the Louvre bronze
in its darker patination, its inscription, and
its base. Both bases have the same curved
contour, but the Louvre base is bronze, cast
in one piece with the head, and not red
marble. While this difference suggests that
the Los Angeles bronze may slightly pre-
cede the Louvre piece, a hypothesis sup-
ported by the fine quality of the cast, no
documentation exists to confirm it. The
listing in the Exposition Universelle
catalog gives no owner's name, further
suggesting the existence of at least two
bronze casts by that date.

33.

Carpeaux's decision to exhibit three male portraits in 1867 is interesting, and his choice of subjects — Giraud, Beauvois, and Vaudremer — was deliberate. Though begun in Rome, the likeness of his fellow *pensionnaire* Vaudremer was completed only in 1862, the date of the two other portraits. All three works present their sitters' features by means of a broad, firm, and direct modeling conscious of facial planes and the massing of hair. Their direct, simple handling provides the first inkling of the refinements of realism pursued in Carpeaux's later male busts. A.W.

35.
Allegory of France (La France sous les traits d'une nymphe)

Black chalk heightened with white on grayish-beige paper
h: 10⅝ in. (27 cm.); w: 8 in. (20.3 cm.)
1863
Signed: Bte Carpeaux (at lower right)
Provenance: Marcel Guerin sale, Paris, Hôtel Drouot, October 29, 1975, no. 38, Huguette Bères, Paris
Lender: Yale University Art Gallery, Everett V. Meeks, B.A. 1901, Fund

36.–38.
Allegory of France Lighting the World
Allegory of Science
Allegory of Agriculture

Plaster
h: 14½ in. (36.1 cm.); w: 12 in. (30.4 cm.); d: 9⅞ in. (25 cm.)
h: 9½ in. (24.1 cm.); w: 14⅝ in. (37.1. cm.);
d: 8 in. (20.3 cm.)
h: 10⅜ in. (26.4 cm.); w: 15¼ in. (38.7 cm.); d: 8 in. (20.3 cm.)
Models for all three works c. 1863
All three works signed: Bte Carpeaux
Lender: The Art Institute of Chicago, Ada Turnbull Hertle Fund

The commission Carpeaux received in 1863 to execute the sculpted decoration on the south facade of the Pavillon de Flore was part of a program to renovate the wing of the huge palace that stretches from the Pavillon Lesdiguières east and terminates in the Pavillon de Flore.[26] Directed by the architect H. Lefuel, the renovation also employed Barye, Bosio, Dumont, Duret, Cavelier, and Guillaume. It was the second time Lefuel had asked Carpeaux to contribute to the enormous decorative program that was integral to his vast enterprise.

But that earlier commission, the *Genius of the Navy,* a trophy completed on the Pavillon de Rohan in August 1854, was one of some fifty similar figures (see cat. no. 215) representing aspects of French commerce. The Pavillon de Flore, by contrast, was a major decorative ensemble made up of three separate motifs: the crowning element, *France Enlightening the World and Protecting Agriculture and Science;* the relief the *Triumph of Flora;* and a frieze of putti and vegetation surrounding a string of three *oeil-de-boeuf* windows.

Carpeaux wrote to a friend that the nature of the commission allowed him to make use of studies done at the French Academy in Rome. Despite his avowal, the many preparatory drawings in which he elaborated his ideas for the pediment figures are extraordinarily diverse in inspiration.[27] They range from sketches of the three figures drawn from memory of Michelangelo's Medici tomb, to studies of eagles drawn from nature.[28] The Yale sheet, an early drawing for the central figure of *La France,* offers valuable information on how these various sources came into play as his ideas developed. In it, repeated strokes of a black crayon and white heightening help establish a sense of three-dimensional form, and Carpeaux's emphasis on shadows and attention to the foreshortened posture of the figure further indicate his interest in understanding plastic volume. The nymph's limbs are widespread, yet linked by the suggestion of a drapery. Dark hair floats out behind her and conveys a sense of movement. Carpeaux's final solution for her pose was to place the figure on the back of an imperial eagle, her right arm raised, as in this drawing. Here the few curving lines near her left knee indicate the beak of her winged mount. As was often the case, other works of art studied earlier in his career must have come to mind as he later worked through his own compositions. His attempt to solve the positioning of *France's* limbs brought to mind a somewhat analogous figure, Michelangelo's Giuliano de Medici, which he quickly sketched from memory in one corner of his sheet.

Sometime in late summer 1863, probably after his return from a voyage to Belgium in July, the ideas Carpeaux had been considering in drawings took sculpted shape. By August 19, 1863, he showed Lefuel a first maquette, now preserved in plaster casts such as those at the Art Institute of

34.

Chicago. Despite the sketchiness of these small-scale figures, the major elements of the group are clearly indicated, and few changes were made in the design as Carpeaux went ahead to produce the half-scale model from which the monumental version would be produced. By May 1865 he was directing his *practiciens'* work as they carved the group in situ. The arduous process of execution was completed only in August 1866. Carpeaux anticipated the unveiling of the decor by exhibiting the half-size plasters of the entire scheme at the Salon of 1866. His tactic was meant to bring his work directly before the public eye, as some critics recognized and censured. Reactions varied widely, from attacks against the broad treatment of forms, evident in these sketches as well, to recognition of the source of Carpeaux's inspiration in Michelangelo's Medici tombs, to condemnation of the composition's active flouting of the laws of subdued symmetry governing architectural sculpture.[29] Lefuel, too, was opposed to the light-capturing

work, which broke up the building's stony surface. As Clément-Carpeaux reports, it was only through the protection of Napoleon III that Carpeaux was able to unveil the work unchanged.[30]

Carpeaux's atelier retained the molds to reproduce the first maquette model. An undated prospectus drawn up in the studio soon after Carpeaux's death indicates that the sketches of the three pediment elements were available in terracotta, although there is no information about the size of the editions.[31] Even before Carpeaux's death, however, examples of the sketch casts were available at auctions of his work in answer to a growing taste for such spontaneous pieces and the evidence of artistic creativity they documented. When the two smaller figures were offered at auction in Amsterdam in 1874, they were called simply *Work* and *Study,*

as if to divorce them from their official source and to aid their more general appeal.[32] A.W.

39.
The Prince Imperial and His Dog
Silvered bronze on red marble base
h: 26 in. (66 cm.)
Model executed 1865; this cast, 1874
Signed: JB CARPEAUX/AUX TUILERIES
(on right side of base)
Dedication: L'IMPERATRICE EUGENIE/AMN. STRODE/DECEMBRE 1874 (on foot of marble base)
Inscribed after casting: SA. LE PRINCE IMPERIAL (on front of self base)
No foundry mark
Provenance: Nathaniel Strode, Chislehurst
Lender: Christopher Forbes, Far Hills, New Jersey

This statuette is a reduction of the full-length portrait of the Prince Imperial (1856–1879) commissioned from Carpeaux in late 1864 and first shown publicly at the

35.

36.

37.

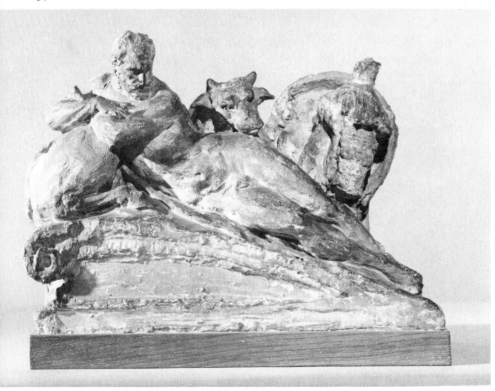

38.

Salon of 1866.[33] Using the Collas process, the firm of F. Barbedienne produced four different-sized small-scale versions of the work in November and December 1866.[34] The Forbes example corresponds to reduction no. 4 and, at one-fifth life-size, was the smallest of the four. All of the reductions, as well as those of Carpeaux's busts of the young prince which Barbedienne also made, were meant to serve as models for editions of the portrait Carpeaux intended to market commercially. Despite his efforts and those of Emile, his brother and collaborator, the venture was not a success; in April 1869 Carpeaux sold the government his right to edit the works.[35]

During their short initial run, the many variations of the portrait were produced in an equally varied selection of materials: marble, plaster, bronze, terracotta, aluminum. Molds for a porcelain edition were made first by the firm of Michel Aaron and, later, after the state had acquired rights to the edition, at the National Manufactory in Sèvres. The foundry of Victor Thiébaut cast a life-size, silver-patinated bronze of the statue, whose existence was noted on an inventory drawn up by the Ministry of Fine Arts when it acquired rights to the works; that cast is now at the Ny Carlsberg Glyptotek, Copenhagen. Another silvered version, probably modified in details of costume, was shown at the Salon of 1868.

The use of silver patination refers directly to two nineteenth-century prototypes, Bosio's *Young Henri IV* and Rude's adolescent *Louis XIII*. Carpeaux was well aware of these precedents. In a letter describing his commission to a friend, he stated that it was "to be cast in silver like the little *Henri IV* at the Louvre."[36] The use of the precious metal came in fact only after the statue had been finished in marble; it transformed the naturalistic portrait into a luxury object.

Although documents do not exist to establish which founder produced this cast, it is clear that it was fashioned between December 1866 and April 1869. The most likely founders are Thiébaut or Barbedienne, although it may have been cast in Carpeaux's own atelier. The piece bears

two cachets of the Carpeaux *propriété,* in a combination and format used before the establishment of the Auteuil atelier. In any event it seems possible that it was made on order for Empress Eugénie. The imperial family used small-scale versions of the portraits, both busts and statuettes, as gifts to friends and political associates. As the inscription indicates, the empress gave this cast to Nathaniel Strode, the proprietor of Camden House at Chislehurst, the estate where the royal family took up residence after its exile from France. Strode's own family seems to have kept the statuette after his death, since it was not included in any of the three sales held in 1889 to dispose of his estate. A.W.

40.
The Genius of the Dance
Bronze
h: 40⅛ in. (1.02 m.); w: 17 in. (43.1 cm.); d: 21½ in. (54.6 cm.)
Model c. 1869
Signed: J B CARPEAUX (on the base)
Foundry mark: PROPRIETE CARPEAUX, and small eagle cachet on figure's supporting element
Provenance: H. Peter Finlay, Inc., New York
Lender: Dr. and Mrs. Coleman Mopper

"Génie" (literally "genius") in French is the equivalent of the English "spirit" or "motivating force." In sculpture, the representation of a *génie* allows an artist to give form to an abstract idea. Thus Carpeaux's *Genius of the Navy (Génie de la Marine)* was a stocky putto, with attributes like the prow of a ship to suggest a nautical identity in a straightforward language of association. A more sophisticated characterization of a *génie,* Bartholdi's *Genius in the Clutches of Misery (Génie dans les griffes de la misère,* fig. 64) communicates in a more complicated way, representing an emotional state seemingly enacted by a naked male figure struggling to rise above the wretched human who restrains him.

Carpeaux's *Genius of the Dance* owes a debt to Bartholdi's example, although Duret's *St. Michael Overcoming the Demon,* part of the Fontaine Saint Michel, was equally present in his mind. Duret's sculpture is in turn indebted to Raphael's *St. Michael* (Louvre), and Carpeaux's drawings show that he studied both precedents directly. He also turned to Michelangelo's *Risen Christ,* which he drew several times during his career, to understand the upward movement needed in his own figure. In addi-

tion, studies of male and female models— the princess Hélène de Racowitza and the workman Sebastian Visat—also weighed in his final resolution of the central figure of *The Dance,* executed at the behest of the architect Charles Garnier for the facade of the Opéra.

The story of the commission, from Carpeaux's first news of it in 1863 until its unveiling to a shocked Parisian public in 1869, need not be repeated here.[37] The scandal Carpeaux's group provoked was enormous, and the work was threatened with removal. In the avalanche of protest dislodged by *The Dance,* the accompanying female dancers were more attacked than the male *génie,* satirized as "un Apollon sans pantalon."[38] The anatomy of his slim body is no less realistically rendered than the naked women who dance to the beat he strikes on his upraised tambourine, but it is less threatening.

Public attention was soon distracted by political events, although the outcry was remembered at Carpeaux's death. One obituary notice called *The Dance* "the most impure work by which modern sculpture has been desecrated."[39] Carpeaux soon began to mine the group for busts, individual figures, and groups of figures to be issued for sale. By the end of 1871 a head of a dancer "from the group at the New Opera House, Paris," was offered at auction in London.[40] Terracottas of the *Genius of the Dance* were not sold until 1873; three sizes (c. 210, 105 and 58 cm. high) were produced in the atelier during Carpeaux's life. Plasters in the first two of these dimensions were inventoried in the Carpeaux studio at his death. Later, Carpeaux's studio edited bronzes such as the work in this exhibition. In addition, unauthorized versions were also produced.[41] Both the Maison Collin and Susse Frères marketed editions of *The Dance* years after Carpeaux's death. In the first case, the edition was unauthorized by his heirs, while the Susse edition was produced under the terms of a 1909 contract between the foundry and the heirs. A.W.

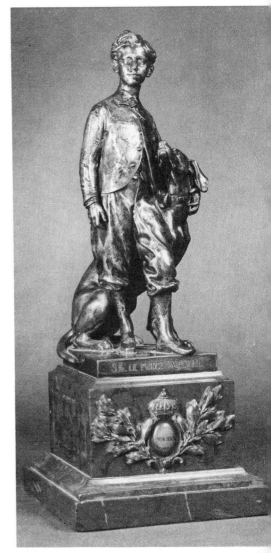

39.

40.

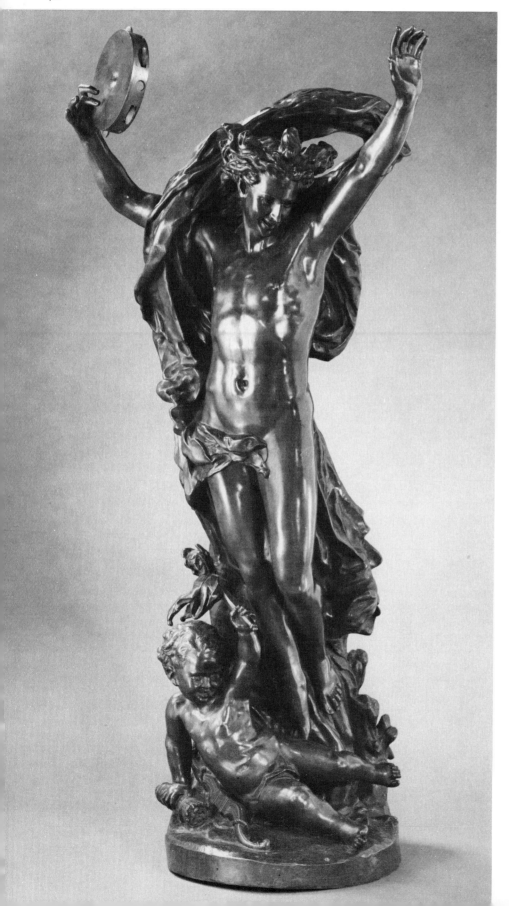

41.

Bust of a Chinese Man (Le Chinois)
Bronze
h. including black marble base: 27½ in.
(69.9 cm.); w: 20⅛ in. (51.1 cm.); d: 13⅝
in. (34.6 cm.)
c. 1872
Signed: Carpeaux (on right shoulder)
No foundry mark
Lender: The Fine Arts Museums of San
Francisco, Collis P. Huntington Memorial
Fund and the Walter Buck Fund

In 1872 Carpeaux reworked the first ver-
sion of the bust *Le Chinois* executed in
1868. The purpose of this revision is clear
from the nature of the changes he made.[42]
In place of the broad treatment of the chest
in the first bust, where costume was merely
suggested by bold, roughly applied strokes
of clay, Carpeaux substituted a finely de-
tailed rendering of a side-closing tunic and
carried the long braid of hair down around
the back to the side of the bust. Sketchi-
ness thus gave way to finish, encouraging a
fuller reading of the subject in the round.
As a result, the second bust is both more
conservative and more independent of its
source. It has lost its character as a study
first conceived as Carpeaux developed ideas
for his monumental group the *Quatre Par-
ties du Monde,* commissioned in 1867 by the
city of Paris as the crowning element of
architect Davioud's Fontaine de l'Obser-
vatoire.[43] Rather, the most striking aspect
of the later bust is the close observation
of racial type. The work approaches the
meticulous scientific mastery of Charles
Cordier's male and female ethnic busts
(see cat. no. 63), without Cordier's use of
luxurious materials which inflect his
realism with an exotic orientalism.

Carpeaux evidently believed it necessary to
make *Le Chinois'* separate existence clear,
a belief perhaps best explained by the hos-
tility expressed by some critics toward the
full-scale model of the group when it was
shown at the Salon of 1872. Paul Mantz,
always ready to oppose Carpeaux, was dis-
mayed by the wild, ill-nourished women
who made up "this gawky shindig."[44] His
opposition was typical: it was no wonder
that Carpeaux reworked the bust to a
quieter, less movemented form. An exam-
ple of this new bust was probably shown
in Brussels on January 19, 1874, as a "new
work;" when another *Chinois* was sold at auc-
tion in Amsterdam on October 19, 1874, it
was distinguished as the "sketch."[45] The fin-

ished version was the model for a reduction
to approximately half-size, i.e., 31 cm.; it
forms a pair with the similar reduction of
The Negress. The original plasters of these
two small-scale versions were sold in the
second atelier sale.[46] Terracotta examples
have recently appeared on the New York
art market; however, they are not men-
tioned in the listing of terracottas offered
for sale by the Carpeaux atelier in 1878.

<div align="right">A.W.</div>

42.
The Artist's Studio
Oil on canvas
h: 19½ in. (49.5 cm.); w: 13¾ in. (34.9
cm.)
1870–73
Signed and inscribed: A Mme Reny 186(?)/
J.B. CARPEAUX
Provenance: Julius Weitzner, London
Lender: Dr. and Mrs. A.K. Solomon,
Cambridge, Massachusetts

This small canvas presents a view of a
sculptor's studio furnished in classic atelier
fashion. A pot-bellied stove heats a room
cluttered by busts and sketches on shelves
that reach into a corner filled by a stack of
wooden chairs. A thin-legged modeling
stand supports a figurine, and the whole
scene is bathed in the light from a bank of
windows. Seated in a chair, informally
reading a newspaper, is the sculptor him-
self. While none of the works in the room
can be identified with his known sculp-
tures, Carpeaux probably has meant to
suggest his own atelier. Although the in-
scription is not fully legible, it indicates
that the canvas was a gift to a friend,
which helps to support the suggestion of
its autobiographical content.[47] Moreover,
both the man's posture and his summarily
indicated features are reminiscent of pho-
tographs of the artist taken in the latter
years of his career.

Carpeaux made careful and uncharacteristic
use of three-point perspective to order his
composition. He applied paint in deft
touches, with colors ranging from the
warm red of the ground through pale
pinks and grays, enlivened by strokes of
light greens and blues that build up indi-
vidual objects. This technique contrasts
with the bolder palette of primary colors
and looser handling of other Carpeaux can-
vases of the mid-1860s. It suggests the
influence of the detailed investigation of
pigment and paint-handling he undertook

42.

41.

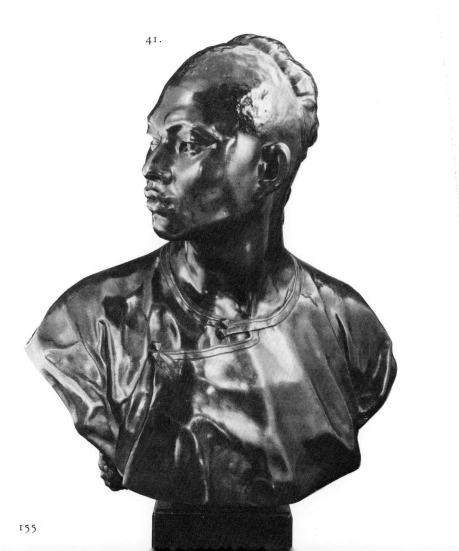

in those years, including studies of Couture's treatise on painting[48] (if we can believe the notes he made in a pocket memoranda book), as well as the preparation of elaborate tables outlining color mixtures and tonal relationships.[49] A.W.

43.
Daphnis and Chloe
Painted plaster
h: 26½ in. (67.3 cm.)
Signed and dated: JBte Carpeaux 1873 (on top of base)
Provenance: Wildenstein and Company, New York
Lender: The Dixon Gallery and Gardens, Memphis

In 1873 Carpeaux returned to England at the bidding of the Empress Eugénie to model a deathbed portrait of Napoleon III. During his visit he received a commission from Alexander Hugh Baring (1835–1889), the fourth Lord Ashburton and scion of a family of connoisseurs, to execute a pendant to the peer's statue *Cupid and Psyche,* then considered an original by Canova.[50] Carpeaux had been familiar with his subject, *Daphnis and Chloe,* at least since 1859, when he borrowed a copy of the Greek romance by Longus, doubtless in Amyot's French translation, from the library of the Villa Medici.[51] The novel, the most famous of ancient Greek pastoral romances, recounts an exciting tale of budding love between two beautiful adolescents, the goatkeeper Daphnis and the shepherdess Chloe. Although Carpeaux's statue does not interpret any one moment in the story's four books, it does respond to Longus' description of their innocent—and titillating—love play, as did Dalou's depiction of the same theme, shown at the Salon four years earlier.[52]

Carpeaux's composition has its formal roots in drawings and clay sketches of the early 1860s for a *Paul and Virginia,* a literary theme that offers similar, if less light-hearted, possibilities for the depiction of two linked youthful bodies. Later, while working on the *Daphnis and Chloe,* Carpeaux roughed out the model for another

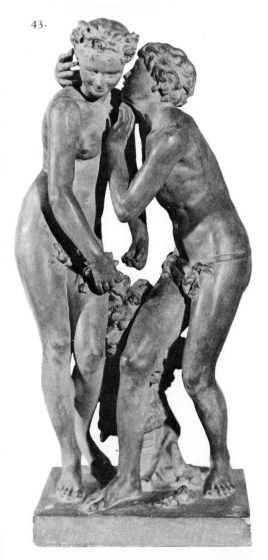

43.

full-scale group, *The Confidence,* a parallel motif without a literary source. The compositions for both sculptures were resolved in painted grisaille studies, executed in London at a moment when Carpeaux was especially prolific as a painter. He copied in the city's galleries, and his 1873 painted study after Correggio's *Mercury, Venus, and Cupid* (London, National Gallery) was the direct source of the pose he used for Chloe.[53]

Although the group was conceived in London, its production in various sizes and media was carried out in Paris. By July 1873 the firm of Cajani had made a mold of the group and poured three full-size plaster proofs.[54] In August they cast the accessories for the figures—that is, the garlands—again in an edition of three, with a fourth set made up "pour Londres," a reference whose meaning is now obscure. The same month another full-scale plaster was cast to be used as a model for the reduction necessary to edit the work. Shortly thereafter Carpeaux must have begun producing plaster reductions of the group, since the example in this exhibition bears the date 1873. The marble (Fabius Frères, Paris) was not begun until July 1874, as Carpeaux's contract with the *practicien* N. Jacques indicates. By the terms of this contract, Jacques was bound to complete the group within five months, to employ a second *practicien* if necessary to meet this deadline, and to forfeit ten francs for each day's delay.[55] In turn he was to be paid three thousand francs in two installments. The contract further stipulated that the recognition of his "perfect" execution of the work and its acceptance rested with Carpeaux and Meynier, who was then supervising the Auteuil atelier; this provision indicates Carpeaux's close control of the quality of his workers' handling of marble and the strength of his affiliation with Meynier. Jacques delivered the completed marble to Ashburton's London residence on January 8, 1875.[56] The production of reduced terracotta versions of the work seems to have been delayed somewhat, since, as Chesneau indicates, they were still not ready in March 1875.[57] In the second 1913 sale of Carpeaux's works, there appeared two plaster reductions, one with and one without accessories.[58] A.W.

44.
The Winkle Gatherer (La Pêcheuse des Vignots)

Bronze
h: 29 in. (73.7 cm.)
Signed and dated: JBte Carpeaux Dieppe
1874 (on side of self base)
Stamped: PROPRIETE CARPEAUX
Inscribed: PUYS (on front of base)
No foundry mark
Provenance: Black-Nadeau Gallery,
Monte Carlo
Lender: Mr. and Mrs. F. Daniel Frost

Carpeaux spent several weeks in July and
August 1874 at the village of Puys, near
Dieppe, where the hospitality of Alexandre
Dumas *fils* and his wife offered the sculptor
some relief from the physical and familial
troubles then plaguing him. It was while
traveling between Dieppe and Puys that he
saw the young woman who posed for *The
Winkle Gatherer*. In a frequently cited let-
ter, he describes how he caught sight of her
fine legs as she strode along, and that he
sent his traveling companion Osbach to
engage her to come to model for him in
the studio he had set up in Puys.[59] Car-
peaux later wrote that he had trouble keep-
ing her services; she preferred a few sous'
wage and her freedom to posing, even for
several francs.[60] Nonetheless, he did
manage to model a statuette whose striding
pose and knee-length skirt recall his
description of his first sight of the girl.
Despite its source in a real event, the figure
is neither informal nor particularly realistic.
The sculptor suppressed the tatters in her
clothes and her downtrodden sabots, and
his depiction of her tightly controlled
posture and almost severe features gives
the work a grave classicism, the result of
his sympathetic ennobling of a less-than-
noble subject.

That statuette was probably finished by
late July. Carpeaux seems to have trans-
ported it to Paris when he returned there
briefly for the baptism of his son Charles
on July 29. This is suggested by a bill
dated July 1874 which set the price of one
hundred francs for a mold made by the
firm of casters he employed for a *"Pêcheuse
debout."*[62] Plasters, bronzes, and terracottas
were soon cast from the model; Chesneau
noted that seven terracottas existed at Car-
peaux's death in 1875.[62] At least one mar-
ble was carved from the model by the
practicien Jacques. The widow Carpeaux
paid him the balance due for the job in

October 1876.[63] Both marble and plaster
versions were included in the May 30,
1913 sale.[64] A.W.

Notes
1.
Varenne, 1908, p. 579.
2.
Archives, Institut de France, Académie des
Beaux-Arts, 5E40, 1856: Schnetz to
Halevy, August 23, 1856. Clément-
Carpeaux 1934–35, I, p. 73, states that his
copy was of the *Thorn Puller*.
3.
Archives, Académie de France à Rome,
Carton 73, Accounts 1858: bill submitted
by Leopoldo Malpieri, for 18 *scudi* for
executing cast of "statua" by Carpeaux.
4.
See Paris, 1975, unpagin., nos. 31, 37–46,
for catalog information and related works.
5.
Mantz, 1861, XI, p. 465.
6.
Mantz, 1859, pp. 364–66; P. Mantz,
"Exposition de Lyon," *Gazette des beaux-arts,*
1861, IX, p 332.
7.
Du Camp, 1859, p. 184.
8.
Institut de France, Académie des Beaux-
Arts, *Rapport sur les travaux des pensionnaires
de l'Académie de France à Rome pendant
l'année 1857,* Paris, 1857, pp. 33–34.
9.
L. Auvray, "Ecole Imperiale des Beaux-
Arts: Concours des Grands Prix et envois
de Rome en 1858," *L'Europe Artiste,*
October 31, 1858, p. 18.
10.
"Lettres inédites de J.-B. Carpeaux," *Le
Figaro, Supplément littéraire,* June 16, 1906,
letters of March 27, 29, 1858, February 29,
1859.
11.
Varenne, 1908, pp. 580–81: Schnetz to de
Mercey, October 30, 1858.
12.
This and following information about ver-
sions of the statue from Dossiers Carpeaux,
Bibliothèque Municipale, Valenciennes.
13.
See, for example, Paris, 1975, cat. nos. 58,
62, 63.

44.

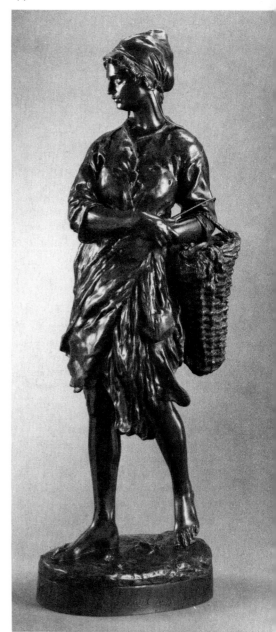

14.
Archives of the Académie de France à Rome, Villa Medici, Rome, Carton 73, Accounts 1858: bill dated December 29, 1858.

15.
See Cambridge, 1975, pp. 113–17 for an account of the various Villa Medici reproductions.

16.
Varenne, 1908, pp. 579–93.

17.
For the text of the report, see Clément-Carpeaux, 1934–35, I, p. 130.

18.
Cambridge, 1975, pp. 119–23, 139–40.

19.
Ambassade de France au près de Sainte Siège, Rome, Registre des Passeports, 1860–63, no. 66, April 7, 1860. Roussel had traveled from France on a passport issued there on April 12, 1858.

20.
Musée des Beaux-Arts, Valenciennes, CD 112. See Hardy and Braunwald, 1975, p. 13, cat. no. 1.

21.
Bibliothèque Municipale, Valenciennes, Dossier Michel Ange.

22.
See Pailhas, 1909, pp. 187–88. Bills sent to Carpeaux for the framing and transport of Roussel's paintings are among the Carpeaux papers, Bibliothèque Municipale, Valenciennes.

23.
For a biography of Giraud, see La Chronique des Arts, 1882, no. 1, pp. 5–6.

24.
Fromentin, undated manuscript, appendix. The Louvre bust is dated 1862 and inscribed St. Gratien, although some authorities give 1864 as its date (Valenciennes, 1927, p. 18; Clément-Carpeaux 1934–35. I, p. 164).

25.
For a description of Giraud's atelier see P. Eudel, L'Hôtel Drouot et la curiosité en 1885–86, Paris, 1887, p. 109. A painting of it with the bust in its place on one wall, by Giraud's brother Charles, is at the Musée National de Compiègne.

26.
For the general history of the commissions see Clément-Carpeaux, 1934–35, I, pp. 193–98, and Paris, 1975, cat. nos. 245–83.

27.
Many of these have been cataloged by Duclaux, (1962), pp. 72–110.

28.
See Paris, 1975, nos. 248–50, 255, 258 for examples.

29.
For the first group, see for example the review by G. Maire, La Foule, June 30, 1866, cited and rebutted in Auvray, 1866, pp. 99–100, and About, 1867, pp. 294–95. For the second, see P. de Saint Victor, La Presse, June 24, 1866, and A. Hemmel, "Salon de 1866," Revue nationale et étrangère, 1866, XXIV, p. 483. For the last, see Blanc, 1866, p. 59.

30.
Clément-Carpeaux, 1934–35, I, pp. 193–98.

31.
Dossiers Carpeaux, Bibliothèque Municipale, Valenciennes.

32.
Notices d'une collection de groupes, statuettes, bustes, etc., en bronze et en terrecuite de M. J. B. Carpeaux, sculpteur a Paris, Amsterdam, October 19, 1874, no. 21.

33.
The history of the work has been most thoroughly discussed by A. Pingeot in Philadelphia, 1978, cat. no. V-7.

34.
Dossiers Carpeaux, Bibliothèque Municipale, Valenciennes. See Cambridge, 1975, pp. 15–16 for a partial transcription of Carpeaux's account with Barbedienne for Prince Imperial edition.

35.
Paris, Archives Nationales, F²¹124.

36.
Clément-Carpeaux, 1934–35, I, p. 172.

37.
For a summary of the commission, see Cambridge, 1975, pp. 125–27; Paris, 1975, cat. nos. 289–329.

38.
L'Eclipse, September 11, 1869.

39.
The Art Journal, 1876, XXXVIII, p. 5.

40.
London, Christie, Manson and Woods, December 1, 1871, no. 77, sold to H. Emanuel.

41.
Cambridge, 1975, pp. 132–33.

42.
Paris, 1913, cat. no. 21; Paris, 1975, cat. no. 335.

43.
Ibid., for a description of the commission. For the iconography of the Fontaine, see Kocks, 1976, pp. 131–44.

44.
"Salon de 1872," Gazette des Beaux-Arts, 1872, VI, p. 63.

45.
Vente Carpeaux, marbres, bronzes, terrecuites, Brussels, January 19, 1874, no. 43; Notice d'une collection de groupes, statuettes, bustes, etc., en bronze et en terrecuite de M. J. B. Carpeaux, Sculpteur à Paris, Amsterdam, October 19, 1874, no. 21.

46.
Paris, 1913, cat. nos. 31, 32.

47.
I am grateful to Margery Cohn for her help in reading the inscription.

48.
T. Couture, Méthodes et entretiens de l'atelier, Paris, 1867.

49.
Musée des Beaux-Arts, Valenciennes, CD 64, endpaper; Bibliothèque Municipale, Valenciennes, Dossier Peintures.

50.
Clément-Carpeaux, 1934–35, I, pp. 369, 371; II, p. 95; Paris, 1955–56, cat. no. 222.

51.
Archives of the Library, Académie de France à Rome, Villa Medici.

52.
J. M. Hunisak, The Sculptor Jules Dalou, New York, 1977, pp. 51–53.

53.
Paris, 1955–56, cat. nos. 238, 239.
54.
This and following information on casting from records of Carpeaux's atelier, Dossiers Carpeaux, Bibliothèque Municipale, Valenciennes.
55.
Contract dated July 10, 1874. Dossier Daphnis et Chloe, Bibliothèque Municipale, Valenciennes.
56.
Jacques to Carpeaux, January 8, 1875, on file in ibid.
57.
Chesneau, 1880, pp. 277–78.
58.
Paris, Galérie Manzi, December 8–9, 1913, nos. 8–9.
59.
Chesneau, 1880, pp. 160–61; Clément-Carpeaux, 1934–35, II, p. 55. Chesneau dates the letter July 2, 1874, but Clément-Carpeaux corrects that date to July 24, 1874, which is the date Chesneau gives to the second letter about his model's unwillingness to pose.
60.
Chesneau, 1880, p. 162.
61.
These and the following dates from Dossiers Carpeaux, Bibliothèque Municipale, Valenciennes.
62.
Chesneau, 1880, p. 277.
63.
Dossiers Carpeaux, Bibliothèque Municipale, Valenciennes.
64.
Paris, 1913, cat. nos. 8–9.

Selected Bibliography

Mantz, P., "Carpeaux," *Gazette des Beaux-Arts,* 1875, I, pp. 593–631.

Clarétie, J., *J.-B. Carpeaux 1827–1875,* Paris, 1875.

Chesneau, E., *Le Statuaire J.-B. Carpeaux, sa vie et son oeuvre,* Paris, 1880.

Paris, Ecole National des Beaux-Arts, *Exposition des oeuvres originales et inédites de J.-B. Carpeaux,* exh. cat., preface by M. Guillermot, May 20–28, 1894.

"Lettres Inédites de J.-B. Carpeaux," *Le Figaro, Supplément littéraire,* June 16, 1906.

Varenne, G., "Carpeaux à l'Ecole de Rome et la genèse d'*Ugolin,*" *Mercure de France,* 1908, pp. 579–93.

Jamot, P., "Carpeaux peintre et graveur," *Gazette des Beaux-Arts,* 1908, XXXX, pp. 177–97.

Pailhas, Dr. "Le Docteur J.-F. Batailhé et le statuaire Carpeaux," *Revue du Tarn,* 2ème ser., July–August, 1909, XXVI, pp. 187 ff.

Fromentin, E., "La vie de J.-B. Carpeaux, statuaire valenciennois," undated manuscript, Département des Manuscrits, Bibliothèque Nationale, Paris.

Bouyer, R., "L'atelier de J.B. Carpeaux avant sa dispersion," *Revue de l'art ancien et moderne,* May, 1913.

Paris, Galérie Manzi-Joyant. *Atelier J. B. Carpeaux. Catalogue des sculptures originales, terres cuites, plâtres, bronzes, par Jean-Baptiste Carpeaux,* May 30 (first sale); December 8, 9 (second sale), 1913.

Mabille de Poncheville, A., *Carpeaux inconnu ou la tradition recueillée,* Paris and Brussels, 1921.

Clément-Carpeaux, L., "La genèse du groupe de *la Danse,*" *Revue de l'Art,* 1927, I, pp. 285–300.

Valenciennes, Musée des Beaux-Arts, *Catalogue de l'Exposition du Centenaire de Carpeaux,* exh. cat., 1927.

Mabille de Poncheville, A., "Les Carnets de Carpeaux," *Revue des Deux Mondes,* 1927, III, pp. 794–818.

Clément-Carpeaux, L. *La Verité sur l'oeuvre et la vie de J.-B. Carpeaux, 1827–1875,* 2 vols., Paris, 1934–35.

Paris, Petit Palais, *Catalogue Exposition J. B. Carpeaux, 1827–1875,* exh. cat., 1955.

Terrier, M., "Carpeaux à Compiègne," *Bulletin de la Société historique de Compiègne,* 1960, XXV, pp. 199–208.

Duclaux, L., "La Sculpture monumentale dans l'oeuvre dessinée de Carpeaux," unpublished thesis, Ecole du Louvre, 1962.

Caso, J. de, "Jean-Baptiste Carpeaux," *Médecine de France,* April 1965, no. 161, pp. 17–32.

Paris, Galeries Nationales, Grand Palais, *Sur les Traces de Jean-Baptiste Carpeaux,* exh. cat., 1975.

Hardy, A., and A. Braunwald, *Dessins de Jean-Baptiste Carpeaux à Valenciennes,* Valenciennes, 1975.

Cambridge, 1975, pp. 108–43.

Courbevoie, Musée Roybet-Fould, *Jean-Baptiste Carpeaux, sa famille et ses amis,* exh. cat., 1975.

Kocks, D., "La Fontaine de l'Observatoire von Jean-Baptiste Carpeaux. Zur Ikonographie des Cosmos Vorstellung in 19. Jahrhundert," *Wallraf Richartz Jahrbuch,* 1976, XXXVIII, pp. 131–44.

_____, "Jean-Baptiste Carpeaux: 'Der Triumph der Flora,'" *Jahrbuch der Staatlichen Kunstsammlunger in Baden–Württemberg,* 1977, XIV, pp. 93–113.

Hardy, A., and A. Braunwald, *Catalogue des Peintures et Sculptures de Jean-Baptiste Carpeaux à Valenciennes,* exh. cat., Valenciennes, 1978.

Wagner, A. M., "An Unknown Funerary Relief by Jean-Baptiste Carpeaux," *Burlington Magazine,* November 1979, CXXI, no. 920, pp. 725–27.

_____, "Learning to Sculpt: Jean-Baptiste Carpeaux, 1840–1863," Ph.D. diss., Harvard University, [1980].

ALBERT-ERNEST CARRIER-BELLEUSE
1824 Anizy-le-Chateau–Sèvres 1887

When his father disappeared, leaving the family in financial straits, thirteen-year-old Carrier-Belleuse sought to earn a living as an apprentice to Bauchery, a little-known chiseler, and then to Fauconnier and the Fannière brothers. With the assistance of David d'Angers, the sixteen-year-old boy enrolled briefly at the Ecole des Beaux-Arts, but he preferred to study decorative arts at the Petite Ecole. While still a student there, he produced statuettes for the commercial manufacturers beginning to flourish in the 1840s. He had developed sufficient renown by 1850 to be called to the Minton China Works in England; after his return to Paris in 1855, he continued for three decades to supply English companies with models.

He made his debut as a serious sculptor at the Salon of 1857, but his first critical triumph was the beguiling nude *Bacchante*, bought by the Emperor for the Tuileries from the 1863 Salon. In 1867 the *Messiah* earned him the Medal of Honor and, in turn, admittance to the Legion of Honor. He participated regularly in the Salons, astutely selecting an array of works to maintain his status, such as *Angelica* (cat. no. 49), *Sleeping Hebe*, as well as maquettes for monuments and vivacious portraits. *Massena* (1867) and *Dumas père* (1884) are his principal public monuments in France, but his most ambitious ones are spread across two continents, from *Michael the Brave* (1873) in Romania to *General St. Martin* (1879) in Buenos Aires.

During the 1860s his animated compositions, accentuated with realistic detail, were at odds with the academic tradition of the official school; however, he and Carpeaux were among the forces of change that brought about a decline of classical in favor of more Baroque and Rococo tendencies. His sources ranged from the antique to the contemporary, but he demonstrated a remarkable talent for transforming them into his own style. The frivolous themes and the precious handling in many of his large-scale works reflected his decorative tendencies.

Carrier-Belleuse excelled in fresh, crisply defined likenesses that broke with the smooth, idealized busts prevalent at midcentury. Strongly influenced by the terracotta tradition of eighteenth-century masters such as Houdon, the sculptor helped to revolutionize the portraiture of his era through images of contemporaries, including *Daumier, Duret, Gautier, Nieuwerkerke*, and twice the *Emperor* himself. His male sitters were drawn from the world of politics, literature, and the arts—the cafe society that he frequented—all in a more straightforward style than his often flamboyant renderings of feminine ones. More than two hundred Parisians sat for him, and he imagined as many more fantastic and historical busts.

Sculptural ornament on architecture assumed an importance after 1850 that it had not held since the seventeenth century; and, with Haussmann's rebuilding of Paris, sculptors benefited enormously. Carrier-Belleuse contributed to a dozen major edifices: the Louvre, the Tribune of Commerce, St. Augustins, the Théâtre-français, the Bank of France, and of course the new Opéra.

Despite his busy career in monumental sculpture, his early commitment to the decorative arts never slackened, and no aspect of the decorative arts was untouched by his craft. He collaborated with goldsmiths such as Froment-Meurice for unique creations in precious materials; at the same time he sent models to Boy to be cast in zinc. He executed commemorative trophies, statuettes, furniture, clocks, vases, dolls, jewelry, swords—anything that the human figure could conceivably ornament. The notorious la Païva was but one of the generous patrons whose mansions he embellished.

Two hundred of his drawings were published by Goupil in 1884 in *L'Application de la figure humaine à la décoration et à l'ornementation industrielles,* to promote quality designs for the decorative arts. His generation sincerely believed that the advances of the Industrial Revolution would make high-quality art objects available to every household. His substantial endeavors to this end were acknowledged with the Diploma of Honor from the Union Centrale in 1884 and promotion to *officier* in the Legion of Honor for "services rendered to the Decorative Arts by his fabrications." From 1876 until his death, he directed works of art for the of Sèvres porcelain manufacture, which he guided into a new era of productivity.

His artistic fecundity was matched only by his prodigious energy, making him the most prolific artist of his day (see cat. no. 91). He had the rare acumen of a born entrepreneur: instead of depending on more passive forms of patronage, he determined to sell works directly to the public at auction. In 1868 his first sale at the Hôtel Drouot proved so lucrative that he offered sixteen more over the next two decades. They sold groups, statuettes, and busts of historical and fictitious persons in terracotta and marble, all executed under his supervision. His exact process for terracotta repetitions is unclear, but it differed from the truly commercial means in quality as well as quantity. Even the "cast" terracottas were reworked while the clay was wet to have a fresh look. Among his list of apprentices were Rodin, Dalou, Joseph Chéret, and Falguière. He changed his signature from "A. Carrier" to "A. Carrier-Belleuse" about 1868.

He had eight children, who adoringly called him "Papa-Bon." Schoenewerk, alluding to his friend's numerous offspring and artistic fecundity, said, "God gave him ten children and put a chisel in every finger."[1] Carrier-Belleuse died in 1887 of albuminuria, which had gradually blinded him. The sale that year of the studio contents and collections lasted five days, beginning on December 19. The sculptor Allouard, who had known him well, remembered him "as a true Romantic, as much in appearance as in spirit."[2] J.E.H.

45.
The Young Raphael
Bronze
h: 23½ in. (59.7 cm.); w: 8½ in. (21.6 cm.)
Signed and dated: A. Carrier/1855 (on top of second step)
Foundry mark: Deniere F.[T] (on top of second step)
Inscribed: RAPHAEL (on front of base)
Lender: Ackland Art Museum, University of North Carolina, Chapel Hill

During the Romantic era, statuettes of historical personalities came into a vogue that lasted until the end of the century. Carrier-Belleuse began to provide models for such statuettes, similar to those by Feuchère and his friend Salmson,[3] quite early in the 1840s for commercial foundries such as Denière and Charpentier. The young artist's training as a goldsmith prepared him well for the task of defining the minute details of these small figures, often dressed in elaborate period attire. *Raphael*

pauses on a flight of stairs, lost in thought. He rests his hands, with a drawing tool, on his sketchpad, propped against his thigh; the composition complements that of a *Michelangelo,* also dated 1855, which shows the sculptor pensively coming down the steps carrying a small *écorché.*[4] The two were probably designed as a pair. They emulated Vela's famous *Spartacus* of 1847, shown in Paris, who likewise descends steps, but their style demonstrates the pronounced influence of Feuchère's statuettes (cat. no. 138). The *Raphael* has a generalized, more academic flavor than the artist's statuettes from the 1860s, which included a *Cellini,* a *Veronese,* and a *Murillo.* The Denière sale of March 10–12, 1903, paired statuettes of *Michelangelo* and *Raphael,* in two sizes, 54 cm. and 68 cm., nos. 551–554. He executed a different design of the pair to be cast in zinc by the firm of Boy before 1863.[5] Similar but not duplicate portraits of both were also done in bust form in the 1860s. J.E.H.

46–47.
Pair of Torchères
Silvered and gilded bronze on black onyx bases with red marble plaques
h: 109½ in. (2.78 m.); w: 27 in. (68.6 cm.)
c. 1862
Signed: CARRIER (on socle of left figure), A CARRIER (on socle of right figure)
Inscribed: Charpentier / Bronzier / Paris (at rear of both figures)
Lender: The Minneapolis Institute of Arts, Gift of Mrs. Maude H. Schroll

Although anthropomorphic torchères served the palaces of the seventeenth and eighteenth centuries, the Second Empire revived them with zest for every decor, on every scale. Carrier-Belleuse had supplied designs for torchères that ranged from his early garniture of soldiers in the 1840s to the stunning groups that flank the Grand Staircase of the Paris Opéra.

In the present works, two slim "Greek" maidens steady the tall torchères from which blossom ornate branches for the lights.[6] Freed from the task of caryatids, these figures delicately counterbalance the vertical thrust of the poles through their graceful contrapposto. The two figures have been carefully varied, but their regularized features and "antique" accessories give them a pseudo-classical aura that enchants rather than instructs. The light drapery coils in loops and elegant swirls

around their nude bodies. The silvered bronze figures, highlighted with gilding, sparkle in the light, enhancing the static poses with the impression of life.

Each torchère stands on a black onyx base that rests on bronze feet. Red marble plaques applied to the pedestal bear bronze cameos, and bronze lion masks adorn the two sides. The exceptional quality of the workmanship is a tribute to Charpentier. The crisp casting, the exquisitely chased detail, and the orchestrated contrast between the luxurious materials match the splendid conception of the "neo-Greek" torchères. Their magnificence reserved them for only the wealthiest of clients, like the King of Belgium who bought another pair of Carrier-Belleuse torchères cast by Barbedienne.

The torchères were exhibited at the 1862 Universal Exposition in London, where Brockhaus wrote: "This candelabrum is meant for an entry hall, a vestibule or a large salon and as such it is naturally as important in regard to its execution as a highly remarkable work of art. The modeling seems especially successful on the female figure on the pedestal, which carries the shaft of the light-fixture with twelve sockets for gas-jets."[7]

The height of elegance, these torchères were the latest in convenience. A second version, substituting white fluted socles for the neo-antique bases, appeared at the 1867 Exposition Universelle. Darcel commented, "It is also M. Carrier-Belleuse who has modeled two charming figures of young women, French by their features and easy grace, Greek by their borrowed garb and the quasi-symmetry of their robes and poses—Parisians trying their hand at Greek dignity."[8] Possibly no two sets were mounted alike and the treatment of the surfaces may have also varied. J.E.H.

48.
Orpheus
Gilded bronze
h: 19 in. (48.3 cm.); w: 24 in. (61 cm.)
c. 1863
Signed: A. CARRIER (on the chair front)
No foundry mark
Provenance: Sold Christies, New York, Dec. 1, 1978, no. 121
Lender: A. Velis–F. Donoughe, New York

The exact subject of this seated youth holding a lyre is somewhat controversial.

45.

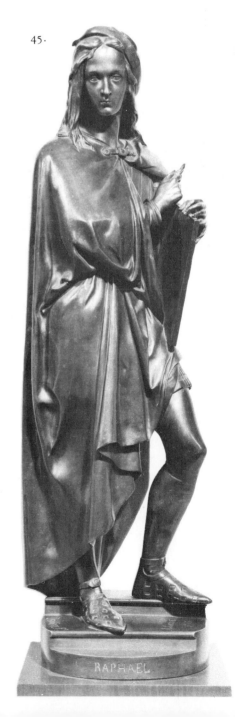

46. 47.

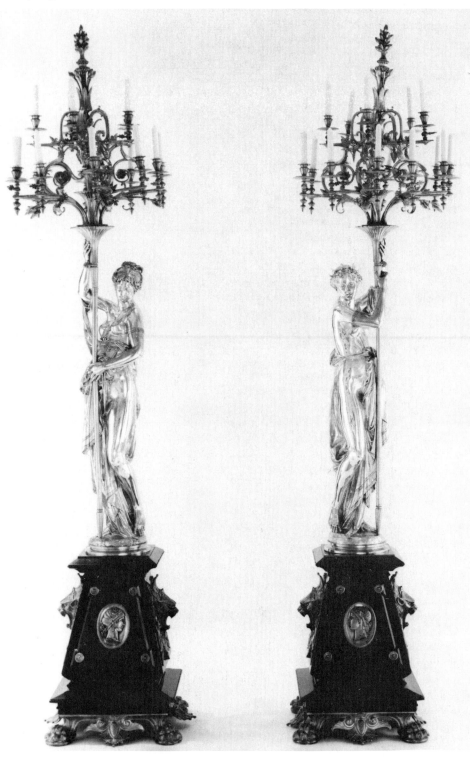

The Boyer foundry exhibited an *Orpheus* by Carrier-Belleuse in the 1867 Exposition Universelle,[9] and a bronze of this figure, now in the Cleveland Museum of Art, was cast with the Boyer signature. A photograph of the maquette, among a series of illustrations that seems to have been taken for the 1863 exhibition of the Union Centrale des Arts Décoratifs, was described as *Orpheus*.[10]

Orpheus is historically "poetry thinking about itself,"[11] and the contemplative air of the bronze suits this definition. Offenbach's lyric opera *Orphée aux Enfers* had been the rage of Paris since its 1858 debut and was still topical in the 1860s when this piece was modeled.

The animal skin on which the youth sits, however, raises some question as to how positively the figure can be identified as Orpheus. The horned animal resembles a cow or an ox. Orpheus received the lyre from his father Apollo. Although his ability to calm wild beasts with the sweetness of his music was famous, his closest association with a horned domestic animal is at best remote and anything but gentle. According to Ovid, in Book II of the *Metamorphoses*, the Thracian women slaughtered oxen before they dismembered Orpheus. In contrast, Apollo has many affiliations with cattle. In the *Hymn to Hermes*, Homer describes how Hermes gave Apollo the lyre in retribution for having stolen his herd and skinned two of the sacred cattle. While this would more convincingly explain the skin's presence in the bronze, as there is no known reference to an Apollo by Carrier-Belleuse, the more plausible identification seems to be Orpheus.

Seated figures, especially on classical themes, abounded after Pradier's sensational *Sappho* of 1848; the work inspired Carrier-Belleuse's seated *Virgil,* also cast by Boyer, which is very similar to *Orpheus* in handling. A chalk drawing of a woman (1860, French private collection) is closer to *Orpheus* in pose but may have served as a study toward both bronzes. Carrier-Belleuse tended to create a series of loosely related compositions during the same period, which partly accounts for his enormous productivity.

The style of both bronzes conforms to works of the 1860s. The modeling of the

face and hair, the intricate folds of the drapery with its ornamental border, the proportions, and the musculature parallel other works of that date.

This gilded bronze is larger than the Cleveland version. Although both may have been cast by Boyer, the July 24–August 29, 1879, sale of Romain, the successor to Paillard, cites an *Orpheus*, no. 158, and Paillard excelled in gilt bronze. J.E.H.

49.
Angelica
Terracotta
h: 32 in. (81.3 cm.), including base; w: 11 in. (27.9 cm.); d: 11 in. (27.9 cm.)
After 1866
Signed: A Carrier-Belleuse (on ground below left foot)
Lender: Dr. and Mrs. H.W. Janson, New York

The themes of Angelica, drawn from Ariosto's *Orlando Furioso*, enjoyed continuing favor among the artists of the nineteenth century. Ingres himself had twice painted her rescue by Roger, à la Perseus and Andromeda, before Carrier-Belleuse sent his marble statue, enriched with gilt bronze chains, to the 1866 Salon and the Exposition Universelle of 1867. In comparison to Franceschi's tamer *Angelica* of 1859, Carrier-Belleuse's writhing figure broke radically with the canons of the classical school and became an overt pretext to display a sensuous nude. He went further in provocative movement than his often mentioned nude *Bacchante* of 1863.

The critical storm heightened with the *Angelica*'s arrival. Jahyer harangued that the artist "can't be accused of copying given traditions; he abandons himself, on the contrary, a bit much to his temperament. If there is a merit that dominates all the other qualities, it is to never be insignificant. Don't ask him for correctness, or even grace, he can't give them, but count on him for all that speaks of force: energy, breadth, or suppleness."[12] Beaurin countered, "Life blossoms in the surface modeling.... He touches by the affinities of race and of genius to his great predecessors of other times. The truth, of which he gives such an eloquent proclamation in marble, is the essential motive of his will and his inspiration."[13] Others compared

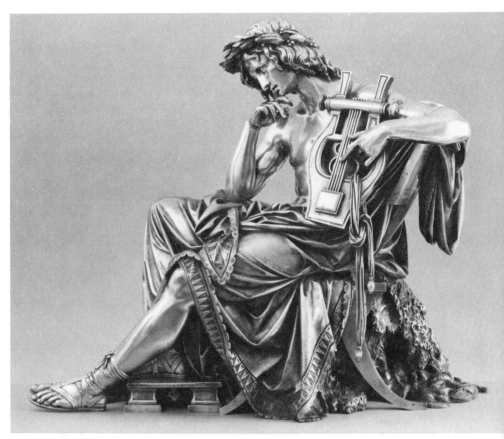

48.

the work to Rubens, Puget, and Bernini because the violence of gesture and animation was so neo-Baroque in spirit. Burger accurately observed that Clésinger, in works like the *Woman Bitten by a Serpent* (cat. no. 58), had influenced Carrier-Belleuse.[14] Charles Blanc, who vehemently disapproved of his friend's "colorism," commented, without elaboration, "think of the impression [it] would make in Germany!"[15] The addition of gilding resulted from the growing use of polychrome, led by Cordier.

From the descriptions, the terracotta *Angelica* is a reduction of the Salon piece. It was one of the items in the December 26, 1868, sale, no. 48, and models of the work in terracotta or marble were included in every subsequent sale. The sculptor was too astute not to capitalize on the public attention aroused by the official exhibitions to further his entrepreneurial ventures. His celebrated modeling ability is nowhere more evident than in the convulsive charms of the *Angelica*. J.E.H.

49.

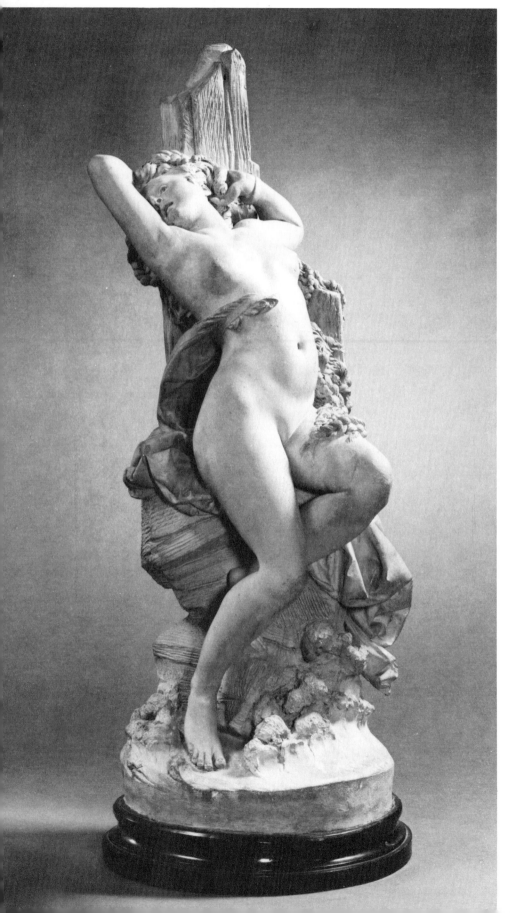

50.
Abduction of Hippodamie
(L'Enlèvement)
Bronze
h: 25½ in. (64.8 cm.); l: 21⅞ in. (55.6 cm.); w: 11½ in. (29.2 cm.)
c. 1871
Signed: CARRIER-BELLEUSE (on top of base)
Inscribed: L'ENLEVEMENT (on side of base)
No foundry mark
Provenance: Michael Hall Fine Arts, New York
Lender: National Gallery of Art, Washington, D.C., William Nelson Cromwell Fund 1977

Pirithous, King of the Lapiths, invited the centaurs to join the lavish celebration of his marriage to Hippodamie. As the revelry turned into a drunken orgy, the bride became the object of the guests' lust. Desire finally kindled action, and a battle broke out between the hosting Lapiths and their boisterous guests, during which a centaur absconded with the bride.

The massive centaur, every muscle swelling with tension, rears ferociously as he slings the frail nude over his back to take flight. His wreath of roses slips over his brow, the picture of debauchery, while the maleficent wine spills unheeded onto the ground. Hippodamie twists against his body, tearing her hair in terror. The irregular silhouettes and the strong diagonals give the ensemble a dynamic baroque force.

The theme of rape had been popular since the Renaissance, and Carrier-Belleuse had a long tradition to draw upon for the *Abduction.* The best-known precedent was Giovanni Bologna's *Nessus and Deianira,* though Clodion had more recently treated the *Centaur Abducting a Woman.* Carrier-Belleuse's composition, however, was more indebted to Bologna's *Rape of the Sabines* for the figure of Hippodamie, though here she is thrown at a more horizontal angle. Her proportions and smooth forms show Carrier-Belleuse's taste for French Mannerism. The body of the centaur is almost identical to the silhouette of the horse in Barye's *Lion Attacking a Horse,* with the same position of all four legs, the angle of the body, and the outstretched tail. The eclecticism of the sculptor's sources reflects his protean ability to assimilate ideas from across the history of art.

The *Abduction* in terracotta joined the models that Carrier-Belleuse marketed

himself at Brussels July 11, 1871, under reproductions "retouched by the author specially for the sale," no. 39. This phrase is crucial to understanding Carrier-Belleuse's terracotta reproductions. The commercial casts of his models are distinguished from his own editions by a brittle stiffness and more granular texture. His studio technique has not yet been explained fully, but the results, reworked while the clay is still pliable, have the freshness usually found only in hand-modeled pieces. A marble version and a patinated terracotta, as well as other terracottas, of the *Abduction* were offered in the sculptor's later sales.

In 1874 the artist was asked to design the winner's trophy for the prestigious Jockey Club race at Longchamp. He responded with an *Abduction of Hippodamie* in silver on a repoussé gilded base by Mallet, an *ornemaniste* at Christofle. An engraving in *Le Monde Illustré* reveals that this was a slightly modified version of the earlier *Abduction.* The individual components are the same, but the silver centaur clamps the despairing bride to his chest. A larger vase below and a fluttering cape for the centaur are the only other changes. "Very active, very spontaneous in its composition, very successful in every detail, this object of art has had great success in the enclosure with the public who hastened to admire it."[16] Falize informs us that the Jockey Club prizes were unique: "They are original works of which the plasters were broken after casting; to the artistic merit is added a value of curiosity that the bronze repetition of an edition does not have."[17] Carrier-Belleuse was not one to waste opportunity. If he could transform one group into another without reservations, he may have been no less hesitant to retain his model. Ten years later, in the sale of December 21, 1885, he offered terracottas of both the *Abduction,* no. 47, and the *Abduction of Hippodamie by the Centaur,* no. 50, which is probably the Jockey Club version.

Pinédo cast the *Abduction* in bronze, bearing a title plate.[18] The date of 1871 for the first *Abduction* invites speculation.[19] Rodin had worked in Carrier-Belleuse's atelier from 1864 until the spring of 1871, when a rift ended their arrangement.[20] Rodin had joined him in Brussels to assist with the frieze for the recent Exchange building, but the two fell out within weeks over a dispute about Rodin's "freelancing" with Belgian commercial foundries while he was

50.

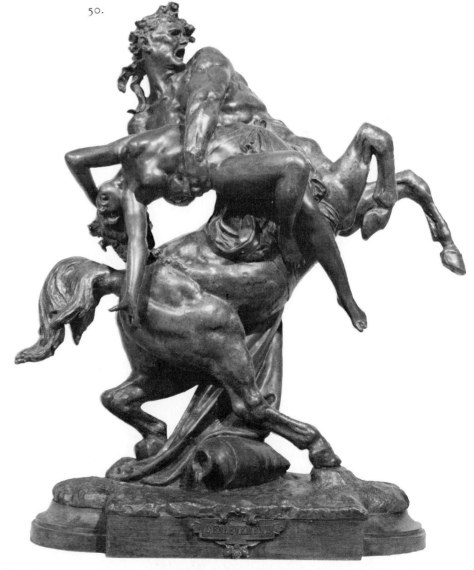

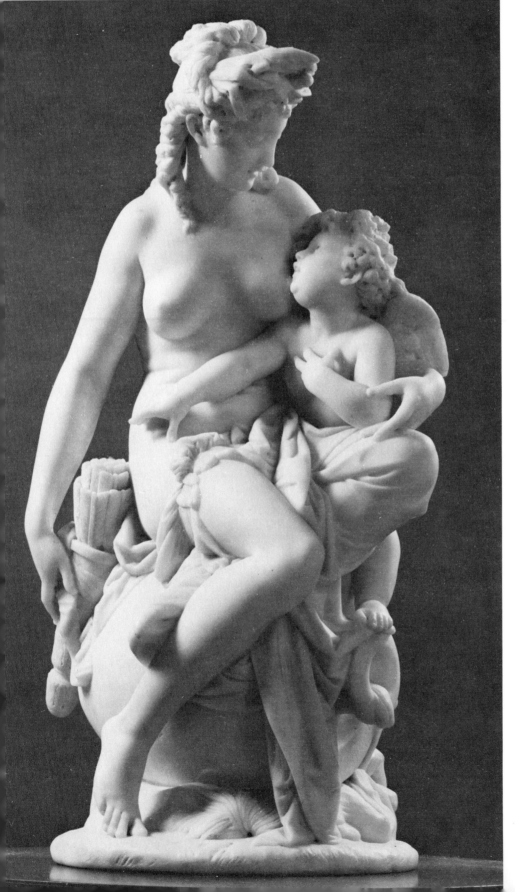

employed by Carrier-Belleuse. The dispute had calmed down enough by August 1871 for the latter to arrange a passport for the young sculptor to travel to Italy. Rodin did not resume contact with his former mentor until after his return from Italy.

Sometime later in the 1870s, he supplied the models for the four titans that support the *Vase of the Titans* (cat. no. 194), designed and signed by Carrier-Belleuse, but executed by Rodin. The powerfully articulated musculature of the titans, so characteristic of Rodin, bears a striking resemblance to the richly modeled body of the centaur, particularly evident in the powerful back. The gaping mouth howls with an explosive force that recalls Rodin's *Call to Arms* (cat. no. 192). There is a marked difference in style between the lithe Hippodamie and the rough centaur that may be explained either by the attempt to emphasize the masculine and feminine types or by the fact that more than one hand participated in the creation. The *Vase of the Titans* was done when Rodin was independent of Carrier-Belleuse's atelier, and the existence of his maquettes documents the figure's origins. Similar proofs for the *Abduction* are less likely since it was executed entirely under the roof of the older sculptor.

The exact nature of the participation of studio assistants in Carrier-Belleuse's production is not clearly understood. His works have a consistency of style that evidence one dominating artistic vision, whatever aid his apprentices supplied, but certain exceptions, like the *Abduction,* raise legitimate questions of connoisseurship that cannot be easily dismissed. J.E.H.

51.
Cupid Disarmed
Marble
h: 28 in. (71.1 cm.)
c. 1871
Signed: A. CARRIER-BELLEUSE (on the urn)
Lender: Pennington-Evans Antiques,
Los Angeles

If Carrier-Belleuse had had to confine his delight in the past to one era, he would unhesitatingly have chosen the eighteenth century. The playful eroticism, the delicacy of sentiment, the Clodionesque exuberance, and the decorative treatment of the figures were all important aspects of his style derived from the Rococo.[21] His own involvement with the manufacture of

Sèvres made him even more susceptible to the influence of the charming *biscuits* produced under Boucher's leadership, and he must have known Sèvres' eighteenth-century model, *Cupid Disarmed (l'Amour désarmé)*.

In his similar *Cupid Disarmed,* Venus holds her son's quiver of fatal arrows just beyond his exasperated grasp, as she tenderly restrains him in her embrace, the indulgent mother announcing that playtime is over. The sculptor had sent a pseudo-classical, deliciously ambiguous, large-scale group of this type entitled *Between Two Loves* to the Salon of 1867, though he rarely exhibited such purely decorative pieces there. The Medal of Honor from that Salon encouraged him to pursue such light-hearted confections for small-scale decorative groups, greatly in vogue during the second half of the nineteenth century. The spiral movement of the composition, which Carrier-Belleuse consistently used to instill dynamic action, suits the demands of a table group meant to be seen from all sides.

The theme and the handling are typical of the groups designed for his own limited editions sold at auction. *Cupid Disarmed* appeared in the London sale of December 1, 1871, no. 19, described as a reproduction in terracotta. By the December 21, 1872, sale, *Cupid Disarmed* could be had in marble, no. 3, or terracotta, no. 65. Henceforth, it was one of his auction staples, an example included in almost every sale through 1887 in both materials, and in at least one, December 22, 1884, no. 15, in patinated terracotta.

Both the marble and terracotta versions demonstrate a high quality of handling that did not diminish with repetition. This disappointed critics like Lagrange, who hoped that "the day that he attacks marble, he will perhaps be surprised to see his happiest temerities compromised by an execution neighboring on softness."[22] A comparison between the marble and terracotta versions would reveal the degree to which he was able to switch from one to the other while retaining the crispness of detail usually associated with clay.

Marble versions are in the Ponce Art Museum and a private collection; the Musée Comptois in Besançon possesses a terracotta. J.E.H.

52.

Portrait of Bartolome-Esteban Murillo (1618–1682)
Terracotta
h: 16 in. (40.6 cm.); w: 13¼ in. (33.7 cm.); d: 8¾ in. (22.2 cm.)
c. 1872
Signed: A. CARRIER (on back)
Lender: The Art Institute of Chicago, Gift of Mr. and Mrs. Gardner Stern

Portraits of historical personalities—artists, writers, composers—proved to be highly marketable in Carrier-Belleuse's sales. He had done some for commercial editions in the 1860s both as busts and statuettes (cat. no. 45). The earliest record of the terracotta model of *Murillo,* paired with *Velásquez,* is in the December 21, 1872, sales, no. 80, and the two were included in subsequent ones.

Carrier-Belleuse gave his sitters, even those known to him only through engravings, a vivid presence through the modeling techniques that he derived from eighteenth-century masters like Houdon. He began to enliven his subjects by a strong turn of the head, deeply cut eyes, and informal touches in the costume, when most sculptors were still laboring under the idealized constraints of the Neoclassical tradition. Despite the sharp criticism which befell these realistic images, they were extremely popular. Even an artist as devoutly academic as Duret admired Carrier-Belleuse's "busts so adroitly touched, so happily colored by light and shadow, because he [Duret] saw in them an abundance of two qualities with which he believed himself feebly endowed: the precious gift of life and the sentiment, incidentally dangerous, of color."[23] The sharp detail and distinctive features of Murillo demonstrate Carrier-Belleuse's finished portrait style at its best. The finely cut locks of hair frame the face with a vigorous flourish. The unbuttoned jacket adds to the aura of spontaneity. George Bedford wrote of Carrier-Belleuse's terracottas in general:

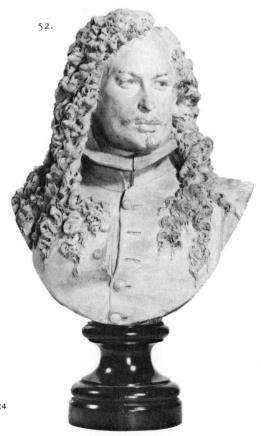

52.

Madame Carpeaux has a very fine collection of the works of her deceased husband. For crispness of finish and 'colour' in modeling, I prefer those of M. Carrier, but this slight superiority is doubtless due to the fact that he is happily still able to superintend their reproduction. But the terracottas of all the Paris firms are beautifully made and with the modeling tool, not the sponge.[24]

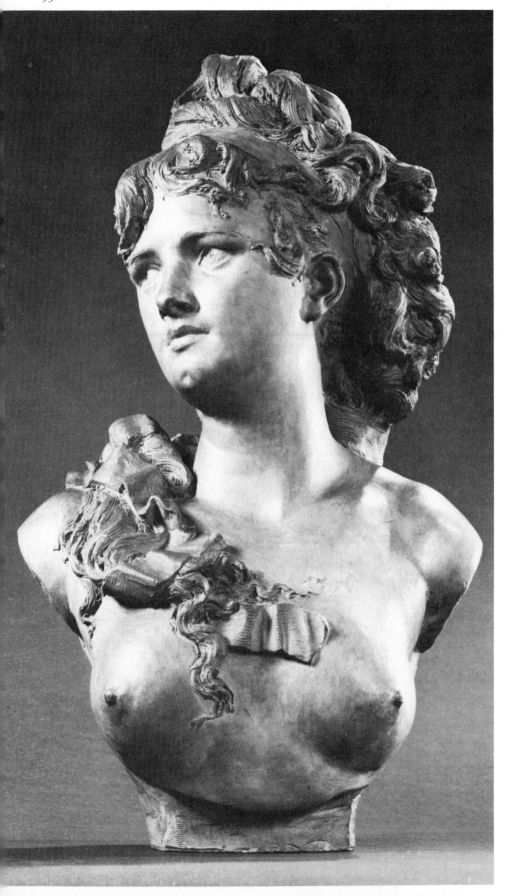

Pinédo issued a bronze version, possibly arranged posthumously by the artist's widow, along with nine other of his historical busts.[25] The sculptor modeled a statuette of *Murillo* before 1863 for casting in zinc by the firm of Boy. The bust differs considerably though the two works are recognizably the same individual.[26] J.E.H.

53.
Fantasy Bust after Mlle. Sophie Croizette (1847–1910)
Terracotta
h: 25 in. (63.5 cm.); w: 14½ in. (36.8 cm.); d: 12 in. (30.5 cm.)
c. 1874
Signed: A Carrier Belleuse (on the back)
Lender: Los Angeles County Museum of Art, purchased with funds donated by Chandis Securities Co.

Carrier-Belleuse sent a plaster bust of the actress Sophie Croizette to the Salon of 1874; it epitomized his vivid portrait likenesses in combination with his more extravagant use of theatrical costumes. With her hair piled loosely on the head, her gown slipping off her shoulder, the bust could only depict a woman from the nether world of the theater, frequented but not received by high society. She was on the threshold of her decade of triumph at the Comédie Française, whose eminent director Arsene Houssaye may have arranged for his close friend Carrier-Belleuse to sculpt her portrait. Her brother-in-law, Carolus-Duran, painted her around the same date. "Lips too thin, hair frizzy... her features made an ensemble that was... bizarre...but full of seductive power."[27]

The "colorism" of Carrier-Belleuse's handling—that is, the deep modeling which creates strong shadows, seeming to "paint" the features—gave his portraits a lively, vital realism that offended many of the conservative critics but made him the darling of the demimonde, and even some bourgeois matrons. Among his thespian sitters were Théo, Céline Chaumont, and Marguérite Bellanger, the circus performer who became Napoleon III's beloved. In addition to the Salon plaster of 1874, Carrier-Belleuse did at least one other portrait of Mlle. Croizette, which is now lost.[28]

The Los Angeles terracotta is a fantasy bust inspired by the features of Mlle. Croizette. A portrait with bare breasts—no matter how notorious the reputation, and Mlle. Croizette does not seem to have acquired a

particularly scandalous one—seems unimaginable. The small round chin, the ears, high forehead, pointed nose, and straight brows resemble hers; however, the sculptor deliberately generalized the features. As with Marguérite Bellanger, of whom there are several "fantasies," the sculptor would become enamoured of a sitter's aura and would create ornamental busts for his limited editions under her inspiration.

Carrier-Belleuse did several dozen decorative busts in an array of expressions and costumes that are each of great allure and as a series are astonishing in their inventiveness. Never stale, rarely tiresome, they testify to his celebrated fecundity. The basic form of a given model seems to have been cast from molds and then meticulously reworked with tools to insure a fresh, crisp appearance, an art in itself that Carrier-Belleuse had perfected. The accessories could vary so radically as to be virtually another composition. His working methods had as much impact on the next generation as his style.

The sale of April 25, 1876, lists under "Original busts and studies after the portraits of artists," no. 92 as *"Poetry (Mlle. Croizette),"* and no. 107 offers a portrait of the actress herself. The Los Angeles terracotta may be another version of the terracotta in the Museum of Fine Arts in Douai, registered as *La Russie*.[29] The sale of December 22, 1884, offered a *Russe*, no. 95, terracotta, which appeared in subsequent sales, that could plausibly be the same piece. The iconography in any case is too vague to insist on either title. J.E.H.

54.
Portrait of John Milton (1608–1674)
Bronze
h: 22⅞ in. (58 cm.) including bronze socle and marble base
1880s
Signed: Carrier-Belleuse (on back)
Inscribed: EXPon de Chicago (on left shoulder)
Foundry mark: Pinedo Bronzier Paris (on back)
Lender: Fine Arts Museums of San Francisco, Mrs. Prentiss Cobb Hale Memorial Fund

The portrait of *Milton* in his later years, when he had gone blind, seems the more poignant for the sculptor's own tragic loss of sight at the end of his life. The artist had been progressively unable to work for two years before his death. A terracotta bust of *Milton* was sold in the 1887 auction of the studio, no. 177, with a pendant *Shakespeare;* however, the model cannot be precisely dated. Although in this sale the *Milton* was grouped with the other historical portraits, such as the *Murillo* (cat. no. 52), it had not appeared in earlier ones, which implies that it was executed in the 1880s.

While this may be the case, the *Milton* is unlike Carrier-Belleuse's other late portraits, contemporary or historical, with their sophisticated, intricate detail. The powerfully sculpted face, with its finely modeled brow and sunken cheeks, is characteristic of his masculine portraits, but the abbreviated handling of the hair and the sketchiness of the drapery should be noted as unusual for him. They recall early works like the 1859 *Desaix,* which the *Milton* resembles in composition, and the more freely defined *Daumier* of 1862. Carrier-Belleuse may have intended the suggestive surfaces to evoke the poet's blindness.

The *Shakespeare,* an example of which is in the Folger Shakespeare Library in Washington, D.C., shares something of the looser handling, but it also includes an abundance of detail more distinctly related to the other historical portraits. The two busts answer each other by the pronounced turn of the heads in opposite directions. Both wear contemporary costumes that are masked by the deep folds of the toga-like drapery that unifies them. They are among the series cast by Pinédo in two sizes, 35 cm. and 58 cm.[30] Statuettes of *Milton* and *Shakespeare,* which may be related, were auctioned in the July 24–31, 1879, sale of the Romain foundry, nos. 560–63.
 J.E.H

55.
Diana Victorious
Marble with bronze bow
h: 82 in. (208.3 cm.), including base
Model 1885; probably carved shortly thereafter
Signed: A. Carrier-Belleuse (on base)
Provenance: Loie Fuller
Lender: Maryhill Museum of Art, Goldendale, Washington

54.

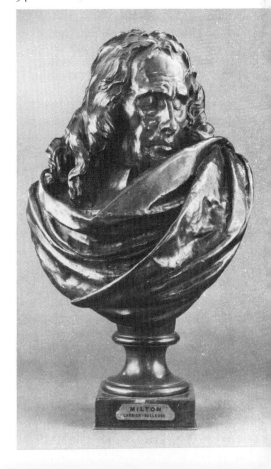

56.

Diana Victorious
Terracotta
h: 26¾ in. (67.9 cm.); w: 10 in. (25.4 cm.); d: 11¼ in. (28.6 cm.)
Model 1885
Signed: A. Carrier Belleuse (on top of base)
Lender: Private Collection

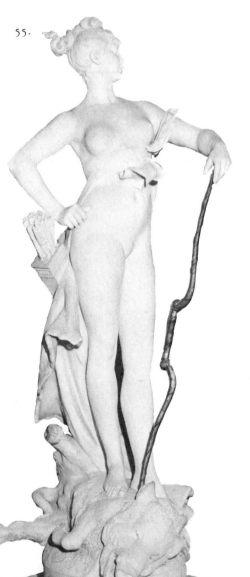

55.

The last work Carrier-Belleuse modeled was exhibited in plaster as *Diana Triumphant* at the Salon of 1885, the year his health began to decline. A marble statuette of the same composition, entitled *Diana Victorious,* appeared in the Salon of 1887, the year he died, and a bronze was shown in 1888. Carrier-Belleuse requested that the *Diana* be displayed after his death with the model for the voluptuous *Bacchante* of 1863. He understood how well these two works bracketed his career. The *Diana* is the ultimate refinement of a style that had begun to mature with the earlier marble. The figure's jaunty elegance and graceful contrapposto infuse the purely decorative figure with a vigorous appeal. The fluttering drapery and many accessories are meant to emphasize her bare flesh. The subtle surface distinctions, such as the boar's furry coat, continue to display the goldsmith's craftsmanship he had acquired in his youth, in marked contrast to contemporary works like Falguière's idealized nude goddesses—not that other sculptors were wanting in love of detail during the Third Republic.

Carrier-Belleuse had peopled Parisian salons with countless mythological delights, and Diana had been a favorite theme: in addition to several statues of her, he made a torchère and a chimney crowning. Recently, he had also completed for Sèvres a *surtout* of hunting nymphs that are similar in spirit to the *Diana.* The artist's well-known sense of humor spilled into his work. He must have chuckled as he stood his self-satisfied huntress, her hair still spinning, on his stiff-legged prey.

Gustave Deloye, once a student of Carrier-Belleuse, wrote an appeal to Castagnary, then Director of Fine Arts, that the state should buy the "ravishing statuette in marble, *Diana,* his last work, that is one of his most successful works." The State would have complied, but the marble had already been sold.[31]

An engraving of the *Diana Victorious* statuette from the Salon of 1887 confirms that it was identical in composition to the Maryhill marble (cat. no. 55).[32] This later work was probably executed posthumously under the supervision of Joseph Chéret, Carrier-Belleuse's assistant for two decades and his son-in-law. It ornamented a garden in France—which explains its rough surface—until the dancer-turned-connoisseur Loie Fuller arranged for its transport to the Maryhill Museum in the 1920s.[33] The bronze bow was probably accompanied by a picturesque hunting horn, now lost, like the one in the terracotta (cat. no. 56).

Carrier-Belleuse may have reversed the earlier process of reducing a successful Salon sculpture to sell in an edition, by sending the statuette to the Salon to promote later sales. As his blindness worsened, he must have worried increasingly for his family's future. He knew that a successful debut at the Salon would enhance the sales of an edition after his death. A terracotta of *Diana Triumphant* appeared in the December 20, 1886, sale, no. 76, and again in 1887 as no. 109, though no. 105 was *Diana Victorious.* What, if any, distinctions account for the two titles is unknown. The terracotta, identical to the marble, shows how easily the sculptor moved from one medium to another, up and down the possible range of scales. He succeeded only because he understood the limitations of the materials and the designs. Pinédo produced a bronze.[34] It was not unusual for Carrier-Belleuse to produce a large marble, several small ones, a limited edition of terracottas, and commercial bronzes. Many others, notably Carpeaux, followed his lead. J.E.H.

Notes

1.
Salmson, 1892, p. 75.
2.
Allouard's speech was included with a manuscript of the 1924 inauguration of a commemorative plaque on Carrier-Belleuse's house on the Rue de la Tour d'Auvergne in Paris.
3.
Hargrove, 1977, pp. 9, 184.
4.
The *Michelangelo,* now in the Berlin Dahlem, is discussed in Hargrove, pp. 200—201.

5.
The archives of the museum at Calais include photographs of the models executed by Boy.
6.
Hargrove, 1974, pp. 34–39; Philadelphia, 1978, cat. no. V-10.
7.
Brockhaus, ed., *Illustrirter Katalog der Londoner Industrie — Ausstellung von 1862,* 2 vols., 1863–64, II, p. 122.
8.
Darcel, 1867, p. 425.
9.
Exposition Universelle, 1867, Paris, 1869, p. 54.
10.
This collection has remained in the family.
11.
E. Sewell, *The Orphic Voice,* New Haven, 1960, p. 47.
12.
Jahyer, 1866, p. 252.
13.
C. Beaurin, "Le Salon de 1866," *Revue du XIX Siècle,* June 1, 1866, p. 481.
14.
Thoré-Burger, 1870, II, p. 332.
15.
Blanc, 1876, p. 512.
16.
"Enlèvement d'Hippodamie," *Le Monde Illustré,* 1874, XXXIV, p. 264.
17.
L. Falize, *Rapport du Jury International, Paris, Exposition Universelle Internationale, 1889,* Paris, 1891, p. 76.
18.
Pinédo, n.d. [before 1896], no. 98. In addition to the work in the present exhibition, there are several known bronze versions including those in the Chrysler Museum at Norfolk and the Longstreet Collection in Beverly Hills. A terracotta variant is in the Michael Hall Collection, New York.
19.
In a verbal discussion in 1975 Michael Hall first raised the question of Rodin's possible participation in the 1874 *Abduction.* This now seems more probable since one knows of the 1871 terracotta *Abduction* which seems to have been virtually identical to the Pinédo bronze.

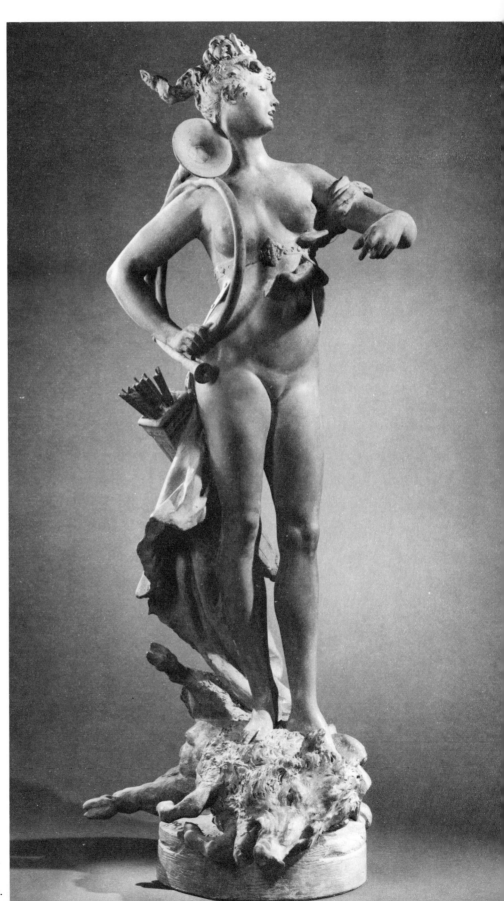

20.
On Rodin's involvement with Carrier-Belleuse, see Hargrove, 1977, pp. 160–64, 239–47.

21.
Millard, 1975, pp. 15–20, gives the theoretical background for the Rococo revival.

22.
Legrange, 1861, p. 170.

23.
C. Blanc, "Francisque Duret," *Gazette des beaux-arts*, 1866, XX, p. 113.

24.
G. Bedford, "Terra Cotta," *Society of Arts: Artisan Reports on the Paris Universal Exhibition of 1878*, London, 1879, p. 93.

25.
Pinédo, n.d. [before 1896], no. 158.

26.
The archives of the museum at Calais contain photographs of some of the figures designed for Boy with the notation "before 1863." The museum at Douai owns one of the *Murillo* busts.

27.
P. Mahalin, *Les Jolies Actrices de Paris*, Paris, 1878, p. 199.

28.
The Salon Portrait is known through a photograph in the museum at Calais; the other is illustrated in Ségard, 1928, p. 13.

29.
Lami, 1914–21, I, p. 281, mentions *La Russie* in Douai. The March 23, 1896, sale of works by Albert and Louis Carrier-Belleuse included *La Moscovite*, no. 75, which may be related. A third example of the Los Angeles bust is in the Comédie Française, where it is called *Sophie Croizette*.

30.
Pinédo, n.d. [before 1896], no. 144.

31.
Archives Nationales, F²¹ 311. See also Hargrove, 1977, pp. 29, 61.

32.
The engraving from the 1887 Salon may be seen in the Carrier-Belleuse folder of the New York Public Library. A drawing of the *Diana* is illustrated in the 1887 sale catalog, after Paul Mantz's biography of the artist.

33.
Letter from Loie Fuller probably to Sam Hill, the museum's founder, c. 1920. She mentions the location of the statue, a gift to the museum, as "the park of the Chebian."

34.
Pinédo, n.d. [before 1896], no. 58.

Selected Bibliography

Carrier-Belleuse, A.-E., *Etudes de figures appliquées à la decoration,* Paris, 1866.

————, *Application de la figure humaine à la décoration et à l'ornamentation industrielles,* Paris, 1884.

St. Juirs [René Delorme], "Carrier-Belleuse," *Galerie Contemporaine,* ed. P. Lacroix, Paris, [1876], II, n.p.

Paris, *Catalogue des oeuvres originales... de Carrier-Belleuse...,* sale cat., Dec. 19–23, 1887, preface by P. Mantz, 1887.

Lami, 1914–21, I, pp. 276–85.

Ségard, A., *Albert Carrier-Belleuse 1824–1887,* Paris, 1928.

Hargrove, J.E., "Sculpture et dessins d'Albert Carrier-Belleuse au Musée des Beaux-Arts de Calais," *La revue du Louvre et des musées de France,* 1976, XXVI, nos. 5–6, pp. 411–24.

————, *The Life and Work of Albert Carrier-Belleuse,* New York and London, 1977.

Henri Chapu's origins did little to indicate the direction of his future. Born to the family of a modest coachman, Chapu's formal education was limited. The primary legacy of his youth was an abiding love of nature that remained a constant source of revitalization for his spirit as well as his art. What culture he later acquired was largely through exposure to the larger world. When his father accepted work as a caretaker, the family moved to Paris. There his parents apprenticed him to a *tapissier,* the nineteenth-century version of an interior designer, on the understanding that he study drawing. To this end he enrolled in 1847 in the school of decorative arts, the Petite Ecole, where his aptitude for art emerged. He entered the Ecole des Beaux-Arts two years later.

By 1850 Chapu was working in the studio of the renowned Pradier, where his provincial manner and naive diligence made him the butt of endless pranks. The flippant Pradier once left the boy to move an enormous block of marble and on his return found that Chapu had succeeded through sheer will. After this, the master revised his opinion of the youth and devoted considerable attention to him. With Pradier's unfortunate death in 1852, Chapu sought instruction from Duret; thus Chapu had two academic masters under the auspices of the Ecole, and his work was imbued from the start with the prevailing classical style. After a series of predictable subjects drawn from antiquity, a *Cleobis and Biton* brought him the coveted Prix de Rome in 1855. At the French Academy in Rome he was distinguished by his seriousness of purpose. An early relief, *Christ with the Angels* of 1857, was poorly received by the Institut in Paris, although it in fact anticipated the elegant, flowing lines of his later work. His next endeavors vindicated him: the academic *Triptolème,* the model for his later bronze, the *Sower,* and *Mercury Inventing the Caduceus.*

Upon his return to Paris in 1861, the State bought the *Triptolème* for 8,000 francs, enabling him to establish a career. He supplemented his income with architectural ornament and industrial commissions, as he was to continue to do. The *Joan of Arc,* seated with folded hands, earned wide acclaim at the Salon of 1870 for its simple purity.

His most famous work, the marble figure of *Youth* for the *Monument to Regnault* (fig. 22), was awarded the Medal of Honor at the 1875 Salon. This triumph was followed by his *Monument to Berryer* of 1877. *Reconnaissance,* the group for the base of his 1878 *Monument to Schneider,* was an early instance of the owner-worker theme that he developed in the latter decades of the century. Chapu executed other straightforward, realistic portrait monuments, such as the *Galignani Brothers,* 1880, at Corbeil, and *Le Verrier,* 1880, in Paris, but his preference, on the whole, was decidedly allegorical.

His first great funerary commission was finished in 1877 for the Countess d'Agoult, better known under her pen name Daniel Stern. In a marble relief reminiscent of Greek stele, the Countess is represented as *Thought* unveiling herself with an expansive gesture of inspiration. Chapu's use of allegory is traditional, but he distinguished his compositions through a personal adaptation to his subjects and a refined handling. The graceful pose echoed by sinuous drapery, almost Art Nouveau in feeling, is characteristic of his mature style. After the tomb of the philosopher Jean Reynaud representing *Immortality,* begun in 1877, the admiration elicited by these monuments made Chapu sought for memorial statuary. One critic commented, "The author of *Youth* makes himself a specialist of funerary sculpture. The ideal, when one wishes to leave an immortal trace, consists in being entombed by M. Chapu."[1] Mercié did high reliefs in a similar style.

Although Chapu frequently employed allegorical reliefs for tombs, he also created exceptional variations of the subject's effigy on the death bed. His most elaborate was the *Monument of Msgr. Dupanloup,* Bishop of Orléans, for the cathedral in 1877. Peculiar circumstances challenged the artist when he was commissioned in 1885 for the *Tomb of the Duchess of Orléans* (fig. 105), who died young in 1858, exiled to London. Her will expressed her wish to be interred in the family mausoleum at Dreux, but as a Protestant she could not lie in the Catholic chapel proper. Chapu placed her reclining marble effigy in an annex, opening directly onto her husband's tomb, toward which she gently extends an arm. At the 1889 Sa-

lon, the eloquent figure unjustly provoked a discussion more dogmatic than aesthetic.

Among his ornamental commissions in the 1870s was the work for the architect Paul Sédille's own sumptuous mansion, and in the early 1880s the Vienna Rothschilds requested pieces to embellish their garden. His plaster of *Steam* was placed opposite Barrias' *Electricity* (fig. 63) in the Gallery of Machines at the 1889 Exposition Universelle.

With so many major commissions, in addition to portrait busts and medallions, three studios barely sufficed. Yet Chapu was a man of reflection, never totally at ease in society, though he was welcome everywhere. He preferred the quiet comfort of his apartment and the companionship of his wife and adopted daughter. His work consumed his energy. An apprentice would read out loud on art while the other worked, "to occupy the spirit and maintain it in the higher realms, without distracting the hand from working on the marble."[2] In addition to his active career, teaching at the Académie Julien and working on countless committees sapped his time. He was elected to the Legion of Honor in 1867, was received into the Institut in 1880, and assumed the presidency of the Académie des Beaux-Arts in 1889. He was too good-hearted and too conscientious to refuse public service, even when, at forty-eight, he began to sense his strength fading. Perhaps because of that, he began to give plasters of his works to the town of Le Mée where they remain today.

Chapu fell seriously ill in late 1889, but improved enough by the spring of 1890 to travel to Italy to finish his *Monument to Flaubert.* He died, prematurely worn by hard work, in 1891. The important pieces in progress were parceled out to colleagues and students to complete. All the pomp befitting a famous artist accompanied his burial, but the most touching eulogy was a simple one by the painter Elie Delaunay, his lifelong friend, himself on his deathbed. Tears streaming down his cheeks, he sighed, "Chapu, Chapu, angelic soul!"[3]

J.E.H.

57.

Truth (Reduction of a Monument to Flaubert)

Bronze relief with red marble frame and brass plate at base
h: 24 in. (61 cm.); w: 15¼ in. (38.7 cm.); d: 3⅝ in. (9.2 cm.), without marble frame
h: 29⅛ in. (74 cm.); w: 19¼ in. (48.9 cm.); d: 6½ in. (16.5 cm.), with marble frame
Model c. 1890
Signed: h. Chapu (at lower right)
Foundry mark: THIEBAUT FRERES/FONDEURS/PARIS (at lower left)
Lender: Private Collection

When Chapu arrived in Servezza, Italy, in April 1890, workers had roughed out the *Monument to Flaubert* in marble for him to finish. He had been involved with the commission for ten years, since the author's death in 1880, when the Friends of Flaubert, headed by Edmond de Goncourt and de Maupassant, first organized a subscription for a monument in his honor. The sculptor explored dozens of ideas for the monument; over a hundred related drawings exist at the Louvre. A terracotta model in the Louvre shows the figure in a similar pose, set against an architectural framework.[4]

Given Chapu's proclivity for the allegorical relief, already pronounced in his tombs of *Thought* and *Immortality,* his fundamental approach would seem preordained. A nude female sits on a well, the symbol of creative resources, presumably about to inscribe Flaubert's name for posterity, in the manner of Fames and Histories borrowed from antiquity. Although the motif of Truth was popular at the end of the century, Chapu's inspiration for the pose came from Bernini's famous example.[5] The mirror, signifying the truth that the author of *Madame Bovary* reflected in his work, lies on the ground. The sculptor used the suggestion of nature, the immortal laurel tree and rocky background, to refer further to Flaubert's realistic style. In the completed monument, the writer's medallion portrait appears in the upper left corner, above the leaves, and major publications are listed below.

The monument, on the external wall of the museum in Rouen, was dedicated on November 23, 1890. Edmond de Goncourt praised the sculpture effusively at the ceremonies but privately depreciated it.

The partisans of realism found the use of a conventional allegory inexcusable to commemorate a man whose work was diametrically opposed to the classical tradition. This elegant figure had "the pretension of being true while remaining beautiful."[6] Still, the marble attracted its share of admiration at the Salon of 1890. Regardless of its incongruity for Flaubert, the composition summarizes all those qualities that made the sculptor famous, "noble plastic imagination, surety of execution, and above all the mysterious and soft charm of his women, this penetrating and chaste grace that was his distinctive mark."[7]

The marble was subsequently moved to the interior of the museum in Rouen. The Thiébaut Frères foundry eliminated the portrait medallion and inscriptions when they issued bronze reductions—an example of which is exhibited here—in four formats entitled *Truth (La Vérité).* J.E.H.

Notes

1.
Fidière, 1894, p. 131, quoting an unnamed critic.
2.
Jouin, 1900, p. 347.
3.
Fidière, 1894, p. 160.
4.
Pingeot, 1979, p. 35.
5.
Ibid., p. 37.
6.
Fidière, 1894, p. 154.
7.
Ibid., p. 155.

Selected Bibliography

Albert, M., "Le Salon des Champs-Elysées. II," *Gazette des beaux-arts,* 1890, IV, pp. 59–68.

Fidière, O., *Chapu, sa vie et son oeuvre,* Paris, 1894.

Lami, 1914–21, I, pp. 328–42.

Dauvergne, M., et al., *Le Mée à la recherche de son passé,* Le Mée-sur-Seine, 1976.

———, *Henri Chapu au Mée-sur-Seine,* Le Mée-sur-Seine, 1977.

Pingeot, A., "Le *Flaubert* et le *Balzac* de Chapu," *La Revue du Louvre et des musées de France,* 1979, no. 1, pp. 35–43.

Jean-Baptiste Clésinger first studied with his sculptor father. In 1832 he was taken to Rome where he worked in the studios of the sculptor Thorwaldsen and the architect Salvi. He then spent a few years wandering between his hometown and Switzerland and in 1838 went to Paris. The following year he studied briefly under David d'Angers. The young Clésinger seems to have been undisciplined, impatient for immediate success, and unwilling to apply himself under the direction of a teacher. In 1840 he again went to Switzerland and then to Florence from where, in 1843, he sent his first work for exhibition at the Paris Salon. In 1844 he returned to Besançon and in 1845 he was back in Paris. Ferociously ambitious, he set out to win the friendship of leading art journalists and to prepare a favorable critical reception for his Salon works. His tactics succeeded in 1847: at the Salon of that year he caused a sensation with his *Woman Bitten by a Snake* (cat. no. 58). In 1847 he also made an advantageous marriage with Solange-Gabrielle Dudevant, the daughter of George Sand (the marriage dissolved in 1852). Clésinger followed his *Woman Bitten by a Snake* with *Reclining Bacchante,* which won a first-class medal at the Salon of 1848. In the same year, with the establishment of a new government, the sculptor suddenly became an ardent republican: he executed a monumental bust of *Liberty,* offered to the provisional government, and a statue of *Fraternity* which was erected on the Champ de Mars. In 1849 he was awarded membership in the Legion of Honor.

From 1854 to 1856 he worked on a State commission for an equestrian statue of François I. As a result of criticism and ridicule of the work—by, among others, Clésinger's *bête noir,* Préault—the proud sculptor left Paris and settled in Rome. There he was enormously productive and lived in high style. After a number of years' absence from the Paris Salon exhibitions, Clésinger sent eight marbles to the Salon of 1859 and six more sculptures to the Salon of 1861. In 1864, apparently in need of money, he returned to Paris; in the same year he was promoted to the rank of *officier* in the Legion of Honor. By this time, ever searching for the means to recognition, some of his works were executed in a more conventional, academically ac-

57.
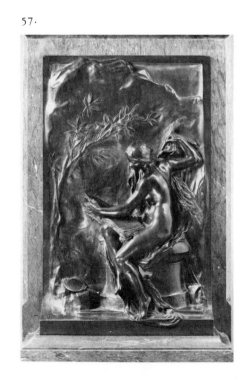

ceptable style. In reviewing the Salon of 1863, the critic for *L'Artiste* remarked: "Clésinger . . . will become a member of the Institut if there is a forty-first chair available in the Académie des Beaux-Arts. Is it not to obtain this more promptly that Clésinger has finally thrown himself into the arms of Greek revivalism (*néotism grec*)?"[1]

In 1867, disdaining the Salon, Clésinger held his own exhibition on the Rue Royale, thus inviting one critic to group him with Courbet and Manet (who also held their own exhibitions): "Ce sont trois tempéraments originaux."[2] In 1868 and 1870, with the help of Théophile Gautier who wrote catalog introductions for him, Clésinger organized public auction sales of his work. He continued exhibiting at the Salons until 1880; however, after 1870 his works were, for the most part, ignored by critics. His last major project was a commission from the Beaux-Arts administration for four equestrian portrait statues—representing Marceau, Kléber, Hoche, and Garnet—to decorate the facade of the Ecole Militaire. Only the first three were completed.

In many respects Clésinger's work seems tied to his personality. His nearly lifelong correspondence with a hometown friend and protector, Charles Weiss, provides the image of an artist who was proud, arrogant, brash, full of energy, conniving but naive in his ambition, and most concerned with immediate impressions and needs. His sculpture, whether through naturalistic or decorative devices, tends to provoke the senses, most frequently by being blatantly erotic. Like many artists of the period, his conscious models were the antique and Michelangelo; at the same time, in his choice of subjects, he must be credited as one of the initiators of the Rococo revival in mid-nineteenth-century sculpture. Along with the more or less persistent element of eroticism in his works, his oeuvre reveals a degree of experimentation with subjects, poses, and materials. Unlike most sculptors of the period, he took pride in carving his own marbles, inviting comparison to illustrious predecessors like Puget and Michelangelo. His greatest

flaw was a lack of taste, but as Baudelaire said, "As vices go, I agree with him [Clésinger] that excess is worth more than meanness."[3] P.F.

58.
Woman Bitten by a Snake
Bronze
h: 7 in. (17.8 cm.); l: 23 in. (58.4 cm.); w: 6⅞ in. (17.5 cm.)
After 1847
Signed: A.J. CLESINGER (near feet)
Foundry mark: F. BARBEDIENNE FONDEUR (on top of base near back of figure)
Stamped: REDUCTION MECHANIQUE A. COLLAS BREVETE (on back of base)
Numbered: 4 (incised underneath)
Lender: Private Collection

Clésinger obtained his first and greatest success with a life-size marble statue, *Woman Bitten by a Snake,* exhibited at the Salon of 1847. Representing a voluptuous reclining nude, realistically rendered in an erotic pose of abandonment, the work caused an enormous stir among critics. Thoré hailed Clésinger as a new talent and described the sculpture in lyric terms: "What serpent has bitten her? How she

58.

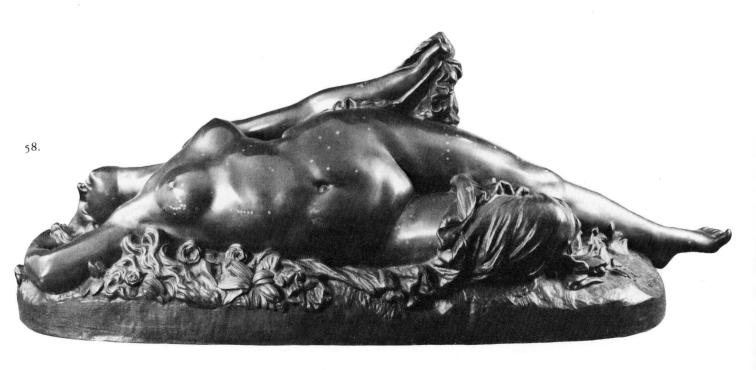

writhes! How her beautiful thighs move and swell in superb relief! How her thrown-back head bathes in the flow of her hair!"[4] Théophile Gautier was equally ecstatic, noting that Clésinger "had the daring, unheard of in our time, to exhibit without a mythological title a masterpiece which is neither a goddess, nor a nymph . . . but simply a woman."[5] Gautier also informs us that the artist was advised by friends to add a snake wrapped around one leg of the figure in order to give it the appearance of an historical or mythological subject; in this way it could be interpreted as Cleopatra or Eurydice and would not be rejected by the Salon jury. Gautier especially praised the figure for its realism and its originality. Another critic, Pierre Malitourne, devoted half of his 1847 Salon review to discussing the *Woman Bitten by a Snake*.[6]

Not everyone, however, looked upon the work favorably. Gustave Planche protested that it was in bad taste and accused the artist of casting his figure from life.[7] In fact, there is some truth to this accusation. The model for the work was Apollonie Sabatier, the beautiful and extraordinary courtesan who inspired much of Baudelaire's best poetry. From about 1844 to 1846 Mme. Sabatier was Clésinger's model and mistress.[8] In 1846 she became the lover of the financier and newspaper owner Alfred Mosselman, who then commissioned Clésinger to sculpt his former mistress in the nude. Mosselman desired a faithful reproduction of her body, which he considered a specimen of rare perfection. From an assemblage of various partial molds, Clésinger seems to have produced an entire plaster cast of Mme. Sabatier; in the marble, the artist evidently altered slightly the model's pose and features.[9] This story—several aspects of which are still unclear—was apparently fairly common knowledge, and it undoubtedly added to the stir caused when Clésinger's work was exhibited publicly. This is clear from the letter written by a scandalized Chopin on June 8, 1847: "The statue that Clésinger recently exhibited represents a nude woman in an attitude which is more than indecent—so much so that to justify the pose, he had to wrap a serpent around one of the legs of the statue. It is fearful how she writhes. She was simply commissioned by Mosselman . . . and represents his mistress. . . . She is a very well known kept

woman in Paris."[10] The following year, at the Salon of 1848, Clésinger exhibited a similar figure—without a snake and slightly altered in pose—titled *Bacchante*. Also utilizing Mme. Sabatier as a model, it too was a great success. From this time on statues of reclining female nudes, twisting in agony or ecstasy, became one of the staples of Clésinger's production. His other works in this vein include *Magdalen Dying* (1856) and *Cleopatra Dying* (Salon of 1861).

Considerable confusion exists in the identification and dating of several works related to the *Woman Bitten by a Snake*. A life-size plaster figure, on deposit from the Louvre at the Musée Calvet in Avignon, was recently published with the title *Woman Bitten by a Snake* and dated 1847.[11] The plaster in Avignon, however, depicts a woman holding a large snake running the entire length of her body and held in her left hand; thus, it cannot be the model for 1847 Salon marble. It would seem to correspond to the description of a later modified version which Estignard dates c. 1873–75,[12] but the Avignon plaster bears the date 1846. The Louvre possesses a life-size marble figure, signed and dated 1847 (Rheims dates it c. 1864),[13] which one tends to assume was the work exhibited in the Salon of that year; but the Louvre marble has a small snake around one wrist while the Salon marble was said by contemporary reviewers to have the snake around a leg. The Louvre also possesses a small variant plaster, from which the bronze exhibited here was cast, with no snake, bearing no date, but traditionally titled *Woman Bitten by a Snake*. Is it possible that the Louvre plaster, and our bronze, should be identified with the work called *Dream of Love (Rêve d'Amour)*, apparently begun by Clésinger about 1844?[14] Like the *Woman Bitten By a Snake* of 1847 and the *Bacchante* of 1848, it was supposedly inspired by Mme. Sabatier.[15] A further complicating element is Estignard's discussion of a second marble *Reclining Bacchante* of 1870.[16]

Clésinger's various reclining female statues combine a Romantic interest in themes of total physical abandonment with, for that time, a shocking realism in execution. In the case of the *Woman with a Snake,* he

even went so far as to tint the marble flowers upon which the figure rests. While many mid-nineteenth-century sculptors— in search of new, unconventional poses— were to experiment with horizontal figures, few were to exploit as blatantly as did Clésinger the erotic potential of the female nude offered up, as it were, on a platter.

P.F.

59.
Portrait of Thomas Couture (1815–1879)
Bronze
h: 31 in. (78.7 cm.), including self bronze socle
Signed and dated: A. CLESINGER 48 (on back)
Foundry mark: F. BARBEDIENNE Fondeur Paris (on right shoulder)
Marked: HIC6 H.C6 (on right side)
Lender: Los Angeles County Museum of Art, Gift of Michael Hall in honor of Kenneth Donahue

At the Salon of 1847 two works received the greatest public acclaim: Clésinger's sculpture, *Woman Bitten by a Snake* (see preceding entry), and Thomas Couture's painting, *The Decadence of the Romans*. It was probably as a result of their new, jointly shared renown that the two young artists became acquainted. Clésinger's *Bust of Thomas Couture*, executed in 1848, was undoubtedly an expression of friendship rather than a formal commission. The painter is depicted in an apparently unguarded moment—head turned brusquely to one side, hair flowing in the wind, and shirt casually opened at the throat. The *en négligé*, unbuttoned shirt is a hallmark of portraits of artists (see discussion, cat. no. 3), while the inclusion of a scarf, loosely knotted on the sitter's chest, is a motif that Clésinger may have adopted from earlier, republican busts of Philippe-Laurent Roland (1746–1816). It is probably more than coincidence that Clésinger employed the scarf motif in a work executed just as a new Republic was being proclaimed; it is also worth noting that Clésinger's teacher, David d'Angers, had recently published a two-part study on Roland.[17] In any case, the nonchalantly draped scarf contributes —along with the work's size (over-life) and its broad, sketchy handling of surface—to a Romantic image of dramatic immediacy and bold abandon.

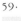

The work was cast by Clésinger's close friend, the founder Barbedienne, but does not appear to have been edited commercially. One other version, in the museum of the Château de Compiègne, is known.

P.F.

60.
Roman Bull (Taureau Romain)
Bronze
h: 8⅛ in. (20.6 cm.); base: h: 9½ in. (24.1 cm.); w: 3½ in. (8.9 cm.)
Signed and dated: A. CLESINGER, Rome, 1858 (on right rear of base)
Foundry mark: Barbedienne (on base)
Inscribed: TAUREAU-ROMAIN (on side of base)
Lender: Private Collection

Clésinger executed the marble of his *Roman Bull* in Rome in 1858. Along with several of his other works—*Sappho Victorious, Sappho Singing, Zingara,* two busts, and three paintings—it was sent to Paris for exhibition at the Salon of 1859. This barrage of works at one Salon, after five years of not exhibiting, was undoubtedly calculated to make an enormous impact and recapture for the artist the renown that had continued to dwindle since his first success at the Salon of 1847. To coincide with Clésinger's reappearance on the Paris art scene, his childhood friend, the poet Armand Barthet, published a monographic article on the artist's recent works. As one would expect, Barthet was full of praise. Of the *Roman Bull* he wrote:

It is impossible to describe, one must see it. I swear I was dazzled; I have never seen or dreamt of anything like it, and I know of only one thing in this genre which one can compare to it—Barye's Seated Lion which guards the gardens of the Tuileries. . . . This bull is a miracle. If Clésinger had never done another thing, on the basis of this bull alone, he would be in the first ranks of modern sculptors.[18]

If Barthet's flattering comparison to Barye's *Seated Lion* was intended to catch the attention of the earlier work's owner, it may have borne fruit since Napoleon III eventually also acquired a version of the *Roman Bull* for the Tuileries Palace. Along with

Barthet, other critics were impressed by the work. Baudelaire, in his review of the 1859 Salon, wrote that Clésinger's *"Roman Bull* has received well-deserved praise from everybody; it is really a very fine work,"[19] and then proceeded to denigrate the genre of animal sculpture in general. In fact, aside from Barye's works, few nineteenth-century sculptures representing a single animal ever received the amount of critical attention given to the *Roman Bull*. Its popularity is attested to by the replicas and variants of it—*Combat of Roman Bulls* (1864 Salon), *Victorious Bull* (1868 Salon), and a second *Roman Bull* (1878 Salon)—which Clésinger continued to produce. The work was also edited commercially by Barbedienne in six different sizes; our example is next to the smallest. The work is distinguished by its ample, majestic proportions and by an anthropomorphic quality which, as some contemporaries remarked, imbued it with the sense of a mythological incarnation.[20] The subject of the work, as well as its hyper-realism, was probably inspired by the sculptures in the Sala degli Animali at the Vatican.

P.F.

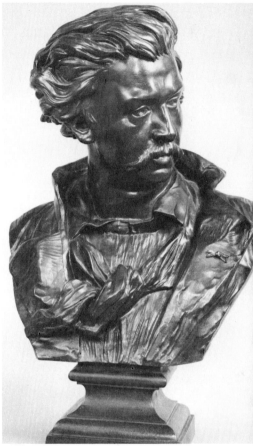

61.
Bacchante and Faun
Marble
h: 34½ in. (87.6 cm.); w: 26½ in. (67.3 cm.); d: 13½ in. (34.3 cm.)
Signed and dated: J. CLESINGER 1869 (on base at right)
Lender: The Minneapolis Institute of Arts, The John R. Van Derlip Fund

This work is, as it were, a fused variant of two earlier pendant works, *Seated Faun* and *Seated Bacchante,* which Clésinger had executed in Rome and sent back to Paris for exhibition at the Salon of 1863. It is probably to be identified with the marble group entitled *Faun and Fauness* in the 1870 sale of Clésinger's works (although the male figure with pipes might better be called Pan).[21] Clésinger produced several marble sculptures dealing with bacchic themes during the late 1860s and early 1870s. In these he attempted to monumentalize a tradition of classicizing erotic subjects which one most immediately associates with small statuettes: the Renaissance bronzes of Riccio and the Rococo terracottas of Clodion. By focusing upon the world of fauns and bacchantes, he may

60.

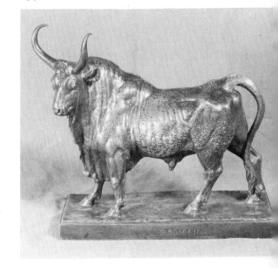

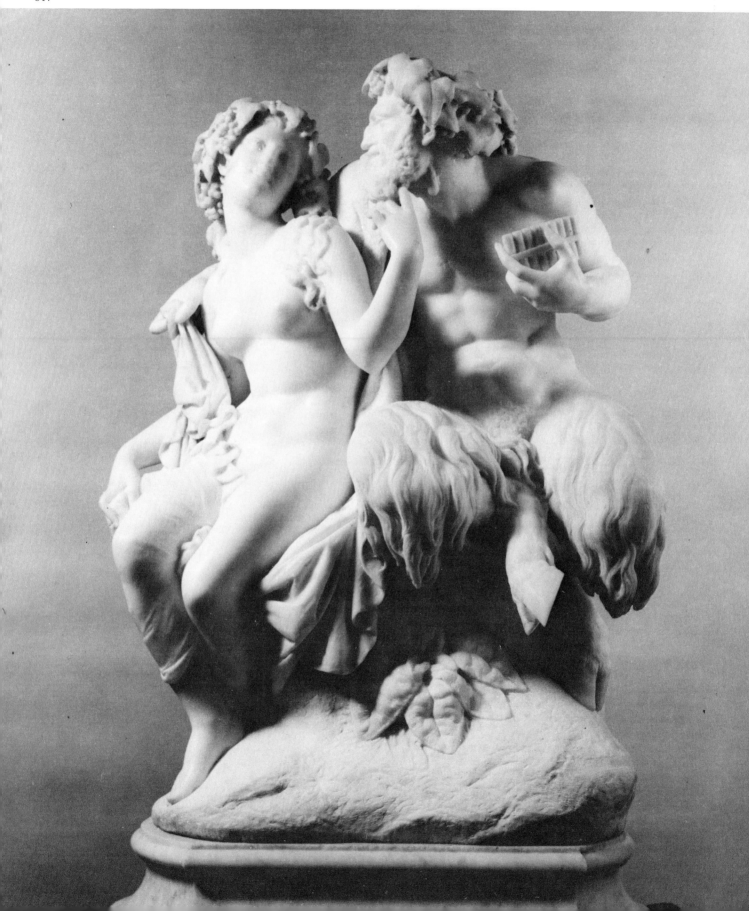

have been seeking to find a mythological justification for the overt eroticism that pervades most of his works. It is difficult for the modern viewer to empathize with the sensuality of the *Bacchante and Faun;* the faun's leering glance, and the bacchante's lolling head and chin-chucking gesture bespeak lascivity but lack the powerful eroticism that the artist had captured in his earlier *Woman Bitten by a Snake* (cat. no. 58). The *Bacchante and Faun* is typical of the widespread outbreak of the bacchanalian sculpture that, as an aspect of the Rococo revival, occurred in the 1860s in the works of many sculptors including Carpeaux, Carrier-Belleuse, and Rodin.[22] Symbolic of this interest, Perraud's *Infancy of Bacchus* won a grand prize for sculpture at the Exposition Universelle of 1867. P.F.

62.
Owl and Skull

Cast terracotta
h: 11½ in. (29.2 cm.); w: 10½ in. (26.7 cm.); d: 11¾ in. (29.8 cm.)
c. 1871
Signed: J. CLESINGER (on self base)
Lender: Los Angeles County Museum of Art, Gift of J.B. Koepfli by exchange

A terracotta version of the *Owl and Skull* appeared in the 1870 sale of Clésinger's works.[23] In the preface to the sale catalog Clésinger's friend and supporter, Théophile Gautier, wrote of the work:

Let us stop for a moment and look at this owl who with the philosophical interrogation of a feathered Hamlet, turns over the skull.... What a serious mingling of irony in the expression of this bird, the traditional companion of Minerva, ringing this empty skull like a small bell and declaring with dramatic stress, "Alas, poor King!" Full of humor, this fantasy is a marvel of execution.[24]

As Gautier suggests, this curious work would seem to be a *memento mori,* a reminder of the inevitability of death and the vanity of earthly concerns. Is it, perhaps, the autobiographical musing of an artist who had devoted so much of his life, without success, to obtaining wealth and glory?

All of the elements in the sculpture are part of the standard repertory of *vanitas* symbols. The skull represents death. The owl, in addition to being the traditional companion of Minerva and a symbol of wisdom, was also, because of its nocturnal nature, associated with darkness and death.

The broken crown, worn by the skull, undoubtedly represents the transience of earthly glory and worldly possessions. These elements appear together frequently in *vanitas* paintings—a genre that had its greatest currency during the seventeenth century—but unlike most of these works, Clésinger's sculpture contains an interesting interaction between the assembled symbols. The owl not only probes the skull with one claw, but with his bulging eyes —stressed by the strong contrast with the hollow eye sockets of the skull—he also appears to scrutinize the meaning of the symbol of death. Perhaps influenced by Auguste-Nicolas Cain's *Vulture and Sphinx* (1864), Clésinger's *Owl and Skull* is an unusual work, verging on being a still-life in sculpture. It may have been intended as a pendant to Clésinger's one other similar work, *Owl Standing on the Back of a Tortoise,* executed by at least 1868.[25] Bronze versions of both works, in more than one size, have appeared on the art market in recent years. P.F.

Notes

1.
Cantrel, 1863, p. 192.
2.
Montifaud, 1867, p. 278.
3.
Baudelaire, 1962, p. 376, "Vice pour vice, je pense comme lui que l'excès en tout vaut mieux que la mesquinerie."
4.
Cited by Estignard, 1900, pp. 50–51.
5.
Gautier, 1847, p. 122. Gautier also wrote a poem inspired by the work; see M. Cottin, "Théophile Gautier, 'Le poème de la femme,'" *Gazette des beaux-arts,* 1967, LXX, pp. 303–7.
6.
Malitourne, 1847, pp. 170–71.
7.
Estignard, 1900, p. 52.
8.
On the relationship of Clésinger, Madame Sabatier, and Alfred Mosselman, see J. Ziegler, "Madame Sabatier (1822–1890): Quelques notes biographiques," *Bulletin du Bibliophile,* 1977, pp. 365–82.

62.

9.
Ibid., p. 373.
10.
Ibid., p. 371.
11.
Licht, 1967, fig. 77.
12.
Estignard, 1900, p. 92.
13.
Rheims, 1972, p. 46.
14.
Estignard, 1900, p. 46. Benoist, 1928, p. 296, and 1931, p. 95, states without documentation that the Louvre plaster was executed in 1874.
15.
Ziegler, 1977, p. 374.
16.
Estignard, 1900, p. 92.
17.
D. d'Angers, "Roland," *L'Artiste,* 1846, VIII, pp. 17–21, 30–37; reprinted separately as *Roland et ses ouvrages,* Paris, 1847.
18.
Barthet, 1859, p. 25.
19.
Baudelaire, 1962, p. 386.
20.
Barthet, 1859, p. 25, refers to it as a "quasi-minotaur"; see also Gautier in the preface to Paris, 1870, p. 15.
21.
The work has been studied recently by Hargrove, 1974, pp. 29–34 and in Philadelphia, 1978, cat. no. v-15.
22.
For the beginning of this phenomenon in the early 1860s, see Chesneau, 1864, pp. 297–98.
23.
Paris, 1870, p. 38.
24.
Ibid., p. 20.
25.
Paris, 1868, p. 27, cat. no. 20.

Selected Bibliography

Gautier, T., "La Femme piquée par un serpent de M. Clésinger," *L'Artiste,* 1847, X, pp. 122–23.

Barthet, A., "Poésie A. Clésinger," *L'Artiste,* 1854, XIII, p. 142.

Dumas fils, A., "De la sculpture et des sculpteurs, L'Andromède de Clésinger," *L'Artiste,* 1855, XIV, pp. 74–76.

Barthet, A., "Le Sculpteur Clésinger," *L'Artiste,* 1859, VI, pp. 24–26.

Houssaye, A., "Galerie du XIXᵉ Siecle, Clésinger," *L'Artiste,* 1862, I, pp. 54–58.

Paris, *Catalogue des marbles, bronzes et terre-cuites de Clésinger*, pref. by T. Gautier, 1868.

Paris, *Catalogue des marbres, bronzes et terre-cuites de Clésinger,* pref. by T. Gautier, 1870. Gautier's preface also published as "La question du marbre & des statues dans le luxe parisien," *L'Artiste,* 1870, XXIV, pp. 96–104.

Houssaye, A., "Clésinger," *L'Artiste,* 1883, I, pp. 79–90.

Fournel, 1884, pp. 301–9.

Gigoux, 1885, pp. 253–57.

Estignard, A., *Clésinger, sa vie, ses oeuvres,* Paris, 1900.

Gourmont, R. de, *Clésinger, notice biographique, catalogue des oeuvres,* Paris, 1903 (not available to the present author).

Lami, 1914–21, I, pp. 393–405.

Benoist, L., "Le sculpteur Clésinger (1814–1883)," *Gazette des beaux-arts,* 1928, II, pp. 283–96.

————, "La Femme piquée par un Serpent d'Auguste Clésinger," *Bulletin des Musées,* 1931, pp. 95–97.

Hargrove, 1974, pp. 28–43.

Cordier began his career in art school in Cambrai and then went to Paris where he was admitted to the Ecole des Beaux-Arts in April 1846. In the fall of the following year he was awarded 500 francs from the Northern Council to continue studies in Paris. He joined the atelier of François Rude and exhibited for the first time in the Salon of 1848. Subsequently Cordier was awarded several medals in various Salons: a third-class medal in 1851, a second-class in 1853, and a *rappel* in 1857. In 1860, he was made a *chevalier* in the Legion of Honor. He exhibited for the last time in the Salon of 1904, a year before his death.

In 1854 Cordier requested that he be sent on a governmental mission to Africa for six months "in order to reproduce there the various types that are at the point of merging into one and the same people."[1] Two years later he was awarded a sum for travel to Algeria to pursue his ethnological studies; he produced twelve busts of different racial types from that part of the world and exhibited them in the Salon of 1857. His *Negro of the Sudan* served as a prototype for many subsequent models in bronze and onyx, or in colored marble, often referred to collectively by the same original title. In addition to sculpting these different types, Cordier also photographed many North Africans, carefully noting their national or racial heritage. These and the many variations on this theme constitute his best known sculptures, but he also worked on some conventional projects for the *Tour St. Jacques* and the churches of St. Clotilde (1851) and St. Augustin (1862) in Paris, the Château of Ferrières (four polychrome caryatids, 1864) and the cathedral of Monaco (1887–89). Abroad he is represented by a monument to Christopher Columbus in Mexico City (1872–74). In addition, he executed many portrait busts and several commemorative monuments. J.A.

63.
Negro in Algerian Costume
Silvered bronze and Algerian jasper on porphyry
h: 38¼ in. (97.2 cm.), without base; w: 25 in. (63.5 cm.); d: 11½ in. (29.2 cm.)
c. 1856–57
No marks
Lender: The Minneapolis Institute of Arts, The William Hood Dunwoody Fund

This handsome bust is a version of Cordier's *Negro of the Sudan,* the sculptor's most famous work inspired by his journey to Algeria in 1856–57. The sculpture is not a pure fantasy of a far-off land, such as Frémiet's *Snake Charmer* (cat. no. 144), nor is it simply a dry transcription of physiognomic features. Like Delacroix and De camp, the sculptor was attracted to North Africa and undoutedly hoped to convey some of the picturesque, exotic charms of the region to the French public. Fascinated by the rich, colorful dress of the Algerian people, Cordier clad several of his subjects in sumptuous native costumes made from precious materials.[2] The bust exhibited here is identical to one in the Louvre, except that this turban and robe are carved from heavily striated jasper rather than onyx. The predominantly light-colored garments complement the dark, sensitively modeled portrait bust.

Although Cordier is credited with initiating a revival of polychrome statuary in the nineteenth century, he was not the first sculptor of the period to work in the mode —Simart and Clésinger attracted attention for their mixed media sculptures in the early 1850s.[3] It was Cordier, however, who gained fame specifically for his polychromed works, though they were often criticized for being too decorative or commercial.[4] Polychromy grew in popularity during the closing years of the nineteenth century, as demonstrated in the sculptures of Barrias and Gérôme (see cat. nos. 10, 153, 156). M.B.

Notes

1.
Philadelphia, 1978, p. 225.
2.
See Rheims, 1972, no. 7, following p. 408.
3.
Philadelphia, 1978, p. 225.
4.
Ibid., p. 225.

Selected Bibliography

Andrei, A., "Galerie anthropologique et ethnographique de M. Cordier," *L'Art au dix-neuvième siècle,* 1860, v, pp. 188–89.

Lami, 1914–21, I, pp. 417–23.

63.

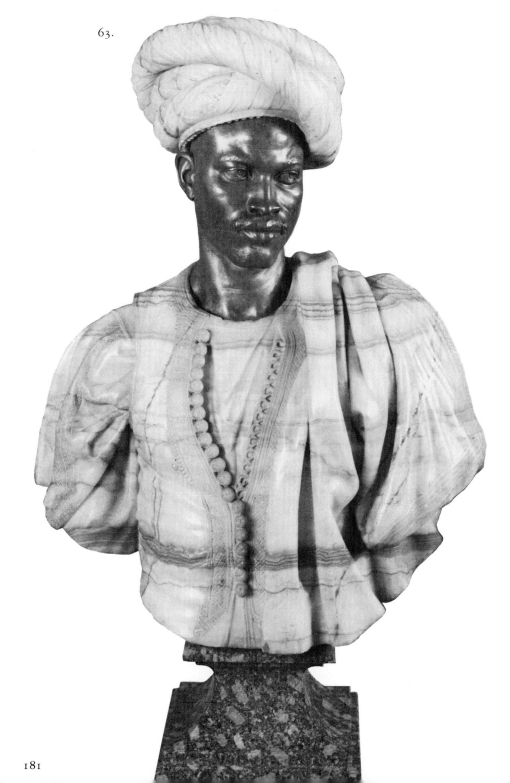

JEAN-PIERRE CORTOT
1787 Paris 1843

Cortot's father, a grocer, permitted his son to study sculpture with Charles-Antoine and Pierre-Charles Bridan from the time he was thirteen. The aspiring artist won a second prize at the Ecole des Beaux-Arts in 1806 with a figure of *Philoctetes Wounded while Leaving Lemnos.* In order to support himself, Cortot subsequently worked in the studios of Boizot, Lemot, Moitte, and Roland and made reductions of antique statues. In 1809 he was awarded the Prix de Rome for a statue of *Marius on the Ruins of Carthage.* While in Rome, he executed a colossal statue of Louis XVII (1816–17) for the Villa Medici. After he returned to Paris, Cortot made his debut at the Salon of 1819, submitting two marble statues: a *Narcissus* and a *Pandora,* for which he received a prize shared with his master, Pierre-Charles Bridan. In 1825 he was elected a member of the Institut as the successor of Dupaty and became a professor at the Ecole des Beaux-Arts. He completed several works left unfinished at Dupaty's death, notably the equestrian statue of Louis XIII for the Place des Vosges (1829) and the *Monument to the Duc de Berry* (abandoned at the time of the Revolution of 1830).

Throughout his career, Cortot produced a wide variety of works—portrait busts and allegorical, mythological, and religious figures—in addition to numerous public monuments and memorials. He is known best for his high relief, the *Triumph of Napoleon I* on the Arc de Triomphe (1833–36). Lacking the dynamism of Rude's adjacent relief, the *Departure of the Volunteers* (fig. 71), Cortot's piece was criticized as possessing an "empty perfection and cool expression"[1] inappropriate to its prominent public location. Cortot is also remembered for his *Monument to Louis XVI,* which depicts the executed monarch as a Christian martyr surrounded by allegorical figures of Justice, Piety, Charity, and Moderation (Paris, Place de la Concorde, 1842). Other important commissions include a statue of *Marie Antoinette Supported by Religion* (fig. 80) for the expiatory chapel of Louis XVI; *The Soldier of Marathon Announcing the Victory* (1834, Louvre); the *Monument to Casimier Périer* (1837, Paris, Père-Lachaise cemetery); and an allegorical relief, *France, between Liberty and Public Order, Calling the Genii of Commerce, Agriculture, Peace, War, and Eloquence,* to decorate the pediment of the Chamber of Deputies (1841). Cortot exhibited at the Salon for the last time in 1840. In 1841, two years before his death, he was appointed an *officier* in the Legion of Honor.

M.B. & G.S.

64.
Immortality

Bronze
h: 17¼ in. (43.8 cm.); w: 9¼ in. (23.5 cm.); d: 5¼ in. (13.3 cm.)
Dated: 1835 (on side of self base at back)
Signed: P.J. CORTOT (on top of self base)
No foundry mark
Lender: Private Collection

Draped female allegorical figures, carrying symbolic instruments, were standard characters in the iconographic repertoire of academic artists throughout the nineteenth century. Cortot, who executed several allegorical sculptures, must have been well versed in the representation of such figures. Nevertheless, the identity of this signed bronze is not clear from its attributes, a crown and a palm branch. Although the figure could personify Victory or Liberty, neither subject is recorded in Lami's catalog of Cortot's works. Instead, the sculpture appears to have been cast after a model for Cortot's colossal statue of *Immortality,* commissioned in 1835 by the Minister of the Interior to replace the cross on the dome of the Panthéon, which had been secularized in 1830. The sculptor completed a plaster model in 1836, but the projected work was never cast in bronze. In 1840 the model was placed in the apse of the Panthéon, only to be destroyed during the uprising of June 1848.

In 1859 the government ordered Jacques-Edouard Gatteaux to cast a bronze from a small model of the sculpture in the collection of Cortot's niece, the Countess de Comps.[2] This work, larger than the statue exhibited here, is now in the Louvre. In 1881 Gatteaux bequeathed to the Louvre a smaller bronze of the same design, which is identical to our sculpture.[3] M.B. & P.F.

Notes

1.
Gustave Planche, cited in Lami, p. 425.
2.
Lami, p. 430.
3.
Information provided by Jean-René Gaborit, Chief Curator, Department of Sculpture, the Louvre.

Selected Bibliography

Rochette, R., "Sculpteurs modernes: Cortot," *L'Artiste,* 1845, V, pp. 271–75.

Lami, 1914–21, I, pp. 424–32.

Granet, S., "Le monument à Louis XVI de la place de la Concorde," *La revue des arts,* 1956, IV, pp. 238–40.

64.

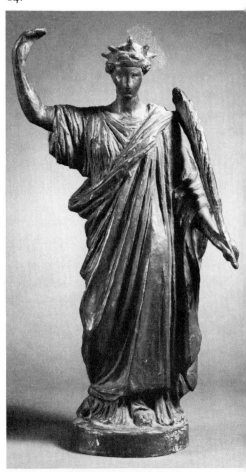

CHARLES CUMBERWORTH
1811 United States—Paris 1852

Little is known of Cumberworth's family background except that he was the son of an English officer and a Frenchwoman.[1] Brought to Paris as an infant, he later studied sculpture under Pradier. Four years after entering the Ecole des Beaux-Arts in 1829, he began exhibiting at the Salon and continued to do so until 1848. He won the Prix de Rome in 1842 but was disqualified when it was discovered that he was not a Frenchman. Only three of his works are known to have been acquired by the state: a statue of Marie-Amélie, Queen of the French (1842); a statuette of Marie, one of the characters in *Paul and Virginia* (1846); and a bust of Chateaubriand (1848). He is said to have produced a number of small-scale models for the Susse foundry. His most interesting subjects are those that reflect the taste of the July Monarchy such as a *Neapolitan Fisherman Playing the Mandolin* (1838),[2] *The Indian Huntress* (1841),[3] and characters from *Paul and Virginia*. Baudelaire had a few friendly words for Cumberworth's *Lesbia Mourning Her Sparrow* (after a poem by Catullus) in his review of the Salon of 1845.[4] H.W.J.

65.
Paul and Virginia
Bronze
h: 13⅜ in. (34 cm.); w: 13½ in. (34.3 cm.); d: 8 in. (20.3 cm.)
After 1844
No marks
Lender: Private Collection

The identification of this group as *Paul and Virginia* and its attribution to Cumberworth are conjectural. Cumberworth is known to have exhibited a compositionally similar, but fully clothed plaster group, *Paul and Virginia*, at the Salon of 1844.[5] Few other sculptors portrayed the subject. Bernardin de Saint-Pierre's romance *Paul and Virginia*, published in 1787, illustrated Jean-Jacques Rousseau's belief in man's natural goodness and the evils of civilization by describing the life of the hero and heroine on a South Sea island. The book enjoyed enormous success during the First Republic.[6] It was temporarily eclipsed in public favor by Chateaubriand's *Atala*, but seems to have had a revival between 1830 and 1848. Our group does not represent a specific event in the story. It might be described, rather, as a love idyll in the tradition of Daphnis and Chloe with an exotic setting. The nude Paul holds a primitive bow in his right hand; a quiver filled with

arrows hangs from the tree stump on which he leans with his left arm. He sits on the skin of an animal he has slain and is thus characterized as the prototypical male: hunter, provider, and protector. Virginia has found a bird's nest with eggs and is showing it to Paul, hinting at the primitive woman's role of food gatherer. As Paul has a couple of feathers stuck in his hair and Virginia wears a small cross on a ribbon around her neck, the pair might instead represent Chactas and Atala.
 H.W.J.

Notes
1.
R. Gunnis, *Dictionary of British Sculptors,* p. 118. See also *The Art Union,* 1846, VII, p. 299.
2.
Scenes of Italian folklife, introduced by the Swiss painter Léopold Robert in the 1820s, became an established subject of

65.

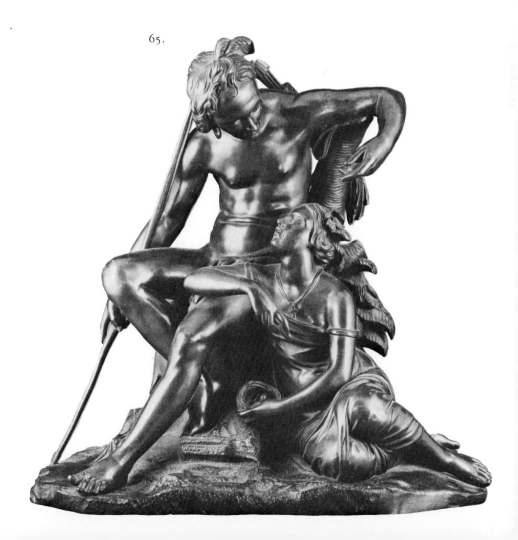

CHARLES COURTNEY CURRAN

1861 Hartford, Kentucky–? 1942

sculpture in the wake of Rude's *Neapolitan Fisherboy* (cat. no. 210) and retained their popularity for the next forty years (see cat. nos. 117, 122).

3.
Presumably an American Indian, perhaps suggested by the success of Duret's *Chactas* (1836); for bronze reductions of that statue, see the Cleveland Museum of Art, *The European Vision of America*, exh. cat. by Hugh Honour, 1975, no. 275.

4.
Baudelaire, 1965, p. 76. For illustrations of a few of his works, see Berman, 1974, I, p. 100, and II, 1976, p. 247.

5.
The group was later reproduced in china by Copeland; illustrated in *Art Union*, 1846, VIII, p. 299.

6.
The Salon of 1795 included two pieces of sculpture, by Dumont and Chaudet, respectively, showing episodes from *Paul and Virginia*.

Selected Bibliography

Lami, 1914–21, I, pp. 469–70.

Gunnis, R., *Dictionary of British Sculptors*, London, 1953, p. 118.

66.

Charles Courtney Curran was a painter of landscapes and genre scenes as well as a prolific portraitist. He first exhibited at the National Academy of Design in New York in 1883. During the 1880s he attended classes at the Art Students League in New York, and from 1889 to 1891 he studied at the Académie Julien in Paris. In 1893 he won a medal at the Columbian Exposition in Chicago, and in 1900 he received an honorable mention at the Exposition Universelle in Paris. Successful on a minor scale during his lifetime, Curran died in relative obscurity. His works have received little scholarly attention. P.F.

66.
At the Sculpture Exhibition
Oil on board
h: 18 in. (45.7 cm.); w: 22 in. (55.9 cm.)
1895
Signed and dated: Chas. C. Curran/1893 [*sic*]
Provenance: W.T. Evans; National Sculpture Society
Lender: Yale University Art Gallery, Stephen Carlton Clark, B.A. 1903, Fund

Despite the date on this picture, it has been convincingly demonstrated that it was painted in 1895 and not in 1893 as signed by the artist when he later retouched the work.[1] The scene represented is the second annual exhibition of the National Sculpture Society held at the American Fine Arts Society Building in New York. This type of genre painting—depicting people looking at art—was particularly popular during the second half of the nineteenth century. It first became current in France, in part as a reflection of the flourishing interest in art exhibitions such as the annual Salons. Such subjects were sympathetic to artists of the period since they permitted the representation of a natural slice-of-life simultaneously with a statement about the current art scene. In the context of the present exhibition, Curran's painting is an interesting document on the importance and influence of French sculpture in America at the end of the nineteenth century. Rodin's *Bust of Saint John the Baptist* occupies the place of honor in the painting. The other works represented besides the *Saint John* have been identified,[2] and it is noteworthy that they are all by American sculptors who studied in Paris. The man seated on the pouf at the left of the painting is apparently the artist and critic Kenyon Cox;[3] in his book *Painters and Sculptors* (New York, 1907), Cox devoted an entire chapter to Rodin whom he considered a "modern Greek" and the most important sculptor of the nineteenth century. P.F.

Notes
1.
K. Silver, "'At the Sculpture Exhibition' by Charles Curran," *Yale University Art Gallery Bulletin,* summer 1974, p. 21.
2.
Ibid., pp. 22–23.
3.
Ibid., p. 23.

66.

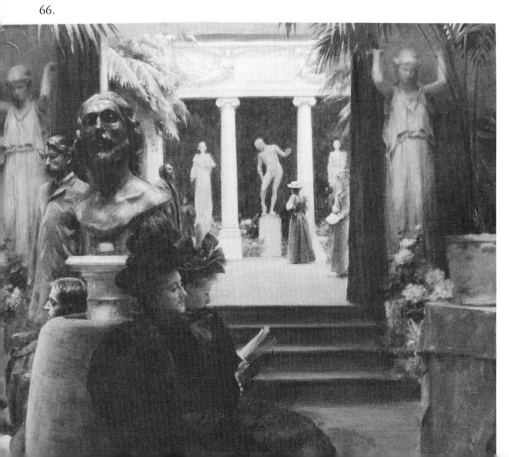

JULES DALOU
1838 Paris 1902

Jules Dalou was surely one of the most prolific, and arguably the most successful, monument makers in France for the last two decades of the nineteenth century. His sculptural achievements encompassed an enormous range, from the intimate poetry of nursing mothers to the colossal rhetoric of *The Triumph of the Republic*. Although he was a humble man who remained passionately attached to his working-class origins, Dalou could also assume the role of a proud and manipulative artist, so much so that Rodin accused him of wanting to become a Lebrun to the Third Republic.[1]

The son of a Parisian glovemaker and an instinctive modeler of clay as a youth, Dalou was discovered by Carpeaux, who persuaded the youngster's family to let him enter the Petite Ecole. For the rest of his life Dalou remained grateful to Carpeaux and regarded the older sculptor as his real master. At the Petite Ecole, in the company of Legros, Fantin-Latour, and Aubé, Dalou learned the rudiments of the artistic profession in the context of a curriculum that stressed drawing and study of eighteenth-century French masters. In 1854 Dalou was accepted at the Ecole des Beaux-Arts in the atelier of Francisque Duret, but this three-year association was not a happy one. Dalou always resented academic instruction and later declined an invitation to become a professor at the Ecole at the time of his great success in the Salon of 1883.

After four unsuccessful attempts to win the Prix de Rome (1861, 1862, 1864, and 1865), Dalou abandoned hope for establishing his career according to the normal academic procedure. His marriage in 1866 necessitated regular employment, and he turned to decorative sculpture in order to support his family. Dalou's most notable works as a decorator were done at the Hôtel Païva on the Champs-Elysées and at the Hôtel Menier on Avenue Van Dyck, just off the Parc Monceau.

During the 1860s Dalou exhibited four times at the Salon without achieving significant critical or popular recognition, although he did have a moderate success at the Salon 1869 with his *Daphnis and Chloe*. This Clodion-like pair of lovers was praised by Gautier in *La République Française* and purchased by the State. At the Salon of 1870, however, Dalou's success was undeniable. His *Embroiderer,* the life-size plaster figure of a woman seated in a chair and embroidering, won a third-class medal, was purchased by the State, and received considerable praise. With this work, Dalou achieved a personal idiom based upon modern life and established a stylistic and thematic direction that would dominate his work for the next decade.

The development of his art was destined not to take place in Paris, however. Dalou was a staunch republican, and his political sympathies were decidedly left-wing. When the Commune was established in the spring of 1871 after the French surrender to the Prussians, Dalou became a founding member of the Fédération des Artistes. During those anxious days of May, he acted as an adjunct curator of the Louvre. When Paris was recaptured by the Versailles troops, Dalou and his family fled the Louvre and went into hiding. Although he escaped the firing squads during the savage reprisals of late May, he was forced into exile and went to London.

The English public warmly received Dalou, and his works elicited enthusiastic praise and eager buyers at the annual Royal Academy Exhibition. The sculptures primarily responsible for establishing him as a unique artist in the English mind were his maternal subjects: modern women, either urban or provincial, responding with rapturous wonder to infants who nurse or slumber in their arms (see cat. no. 67).

Among Dalou's many English patrons were the Duke of Westminster, Lord Carlisle, and Constantine Ionides. Through the assistance of Legros, his old friend from the Petite Ecole, Dalou obtained a teaching position at the South Kensington School of Art. Since he never learned English, his classes were in fact practical demonstrations in modeling clay. One of his pupils was the Princess Louise; through her, Queen Victoria commissioned Dalou to create a memorial to her dead grandchildren for the private Royal Chapel at Windsor (see cat. no. 69).

A turning point for Dalou came in 1877 when he received his first commission for a public monument: a life-size figure of *Charity* to surmount a drinking fountain behind the Royal Exchange in London. Never again would he be content to create the intimate and maternal themes that had established his reputation. When he was finally to return to Paris after the amnesty of 1879–80, his ambitions would be very different from those he had when he fled his native city. Only monuments celebrating the greatest men and ideals of his era could ever again completely satisfy him.

During the spring of 1879, while still in London, Dalou learned of a competition sponsored by the city of Paris for a monument to the Republic: here he found an opportunity to test his ambition while expressing his most fundamental political beliefs. Although the sketch that Dalou entered did not win the competition, the jury nevertheless recommended that his monument be erected in addition to the winning entry. Thus Paris has two colossal monuments to the Republic resulting from one competition: Morice's work located on the Place de la République and Dalou's *Triumph of the Republic* (fig. 18) on the Place de la Nation. More than forty tons of bronze were necessary to cast that triumphant, Rubensian ensemble: a sumptuously decorated chariot surmounted by the Republic; harnessed lions, one of which bears the Genius of Liberty; and Labor and Justice, who assist in propelling the chariot forward while Peace-Abundance scatters her bounty to all peoples. This monument was twice inaugurated, and each inauguration was the occasion for a massive political manifestation organized by the city of Paris. On September 21, 1889, the work was unveiled as a plaster patinated to look like bronze, and on November 19, 1899, the definitive bronze ensemble was officially installed.

Although Dalou returned to Paris in 1880, he avoided exhibiting at the Salon until 1883. He was, of course, busy working on the *Triumph of the Republic,* but that massive undertaking does not seem to be the sole reason for his abstention. He no longer cared to exhibit any of his English works based on intimate or maternal themes, nor did he choose to send any of his portrait busts. Instead he waited until he had completed two enormous, multi-figure reliefs that would be overwhelming in effect. These were the *Estates General, Meeting of June 23, 1789 (Mirabeau Responding to Dreux-Brézé)* and *The Republic* (also known as *Fraternity*). For these, he received a Medal of Honor at the Salon of 1883 and was subsequently named to the Legion of Honor. Philippe Burty wrote that "the triumph of M. Dalou is complete and

legitimate"[2] and christened that year's exhibition "the Salon of Dalou."[3]

The 1880s remained a time of extraordinary creative activity for Dalou. At the Salon of 1885 he again exhibited two major works: the joyous, even ribald *Triumph of Silenus* as a life-size plaster group and the bronze *gisant* for Blanqui's tomb monument at Père-Lachaise. The *Blanqui*, done without recompense as an act of homage to that indomitable socialist and radical, is a worthy successor to Rude's *Cavaignac* (fig. 111). Blanqui's emaciated body is wrapped in a magnificently executed shroud, and at his feet lies a crown of thorns, an unmistakable Christological reference which aggrandizes the sacrifice of this secular and socialist martyr.

The works that Dalou sent to the Exposition Universelle of 1889 amounted to a recapitulation of his triumphs during the preceding years. In addition to two portrait busts, he sent his two reliefs from the Salon of 1883 and the plaster model for the *Blanqui*. For these he received a *grand prix*. At the inauguration of his *Triumph of the Republic* later in the year, he was also promoted to *officier* in the Legion of Honor. The final inauguration of that monument in 1899 was probably the greatest moment of his life. As Dalou had hoped, the celebration was dedicated to peace and labor. On that day, he was also decorated with the *grand cordon* of the Legion of Honor. Surrounded by an estimated crowd of 250,000—including tens of thousands of workers, many of whom were dressed in work clothes and carried the tools of their trade—Dalou's monument became not only the tangible embodiment of his beliefs as a man and artist, but a great popular symbol as well.

During the 1890s a number of Dalou's monuments erected to commemorate distinguished individuals were inaugurated in Paris. Each of these individuals was someone with whom Dalou felt a particular artistic, social, or political affinity, as had been the case with his *Blanqui* effigy. Rarely did he consent to do a monument or execute a commission simply because it was offered to him. He firmly believed in the didactic purpose and moral force of public monuments and did not accept commissions without a concomitant sense of personal urgency. Among these monuments are those to the great chemist and

agronomist Boussingault (inaugurated at the Conservatoire des Arts et Métiers on July 7, 1895), to the entrepreneur Jean Leclaire, who shared profits with his workers (inaugurated on the Place des Epinettes on November 1, 1896), and to the influential left-wing politician Floquet (inaugurated at Père-Lachaise on May 14, 1899). When Dalou died he was working on a monument to Senator Scheurer-Kestner, the courageous defender of Dreyfus (completed after Dalou's death by assistants and inaugurated in front of the palace in the Luxembourg Gardens on February 11, 1908).

Following the inaugurations of his *Triumph of the Republic* in 1889, Dalou nurtured a secret plan for another grand monument: a *Monument to Workers* (fig. 54). As Zola and other naturalists had done earlier, Dalou traveled to observe his subjects directly in order to gather sources for his eventual images. During the summers of 1891–94, he went to the seashore, countryside, and factories to watch manual workers at their toil. He also observed workers in the gardens, streets, and ateliers of Paris. At first he drew to record his observations,[4] and later he created small, clay sketches which number among the most brilliant sculptures produced during the nineteenth century. Many dozens of these sketches were discovered in his studio after his death and have subsequently become part of the holdings of the Musée du Petit Palais in Paris.

Dalou believed that such a monument was an inevitable necessity of modern times, a thing that was "in the air."[5] When he read the front page of *Le Journal* on March 21, 1898, he discovered just how accurate his assessment had been. There in print, Armand Dayot had proposed precisely such a monument to be constructed in time for the Exposition Universelle of 1900. Shortly thereafter it became clear that Dayot intended that the monument would be designed by Rodin and worked upon by a team of other sculptors, including Dalou.[6] Although Dalou categorically refused any notion of collaboration and insisted that his own monument was "at the threshold of execution,"[7] the sad truth is that he never found a satisfactory solution for its

format. At the time of his death on April 15, 1902, he left behind not only his magnificent sketches of workers, but also three different maquettes for the entire monument which must be regarded as failures, unworthy of the creator of so many superb monuments.

Dalou not only labored in secret on his proposed *Monument to Workers,* but he was reluctant to reveal the preliminary stages of any of his works. He believed that the finished sculpture was what counted and anything leading up to it was the artist's province, not that of the public. This aura of privacy is mirrored by the way in which Dalou's biographer Dreyfous consciously altered the facts concerning the artist's funeral. A first-hand witness, Dreyfous correctly reported that the occasion was one of absolute simplicity, that there were no military honors (to which Dalou was entitled because of his Legion of Honor membership), and that there was no discourse delivered at graveside. But he also claimed that relatively few people were in attendance, that the cortege included no delegation or society, that passersby had no indication they were witnessing the funeral of a great man.[8] These latter reports are simply untrue.

Although many important newspapers in Europe and America noted Dalou's death, almost none reported on the funeral ceremonies. *La Petite République Socialiste,* however, carried a lengthy account which completely discredited the latter aspects of Dreyfous' report. In fact, a great number of people were in attendance, including the artists Carolus-Duran, Carrière, Barrias, Bartholdi, Bartholomé, and Rodin.[9]

Also, Dreyfous' insistence that Dalou was an exceedingly private and nonsocial being and was above art-world intrigues cannot stand uncorrected after scrutiny of existing evidence, especially Dalou's own letters and the first-hand accounts of others. It seems that the memory of Dalou that Dreyfous wanted preserved for posterity was that of a much simpler and more straightforward person: his friend may have regarded this as the artist's more authentic or more essential side. This view, however, is belied by the number of people with such a variety of sympathies who showed their respect by attending his funeral. These ambiguities show the complexity of understanding Dalou in the context of his

times. His art, like his life, deserves more
probing analysis than Dreyfous led us to
believe was possible. J.M.H.

67.
Maternal Joy
Bronze
h: 23 in. (58.4 cm.)
Model 1871–72
No marks
Lender: Baltimore Museum of Art, Gift of
Lawrason Riggs

Maternal Joy was one of three works that
Dalou sent to the Royal Academy in 1872,
making his official debut as an artist in
London. The work appeared there as a life-
size terracotta statue and was an immediate
success with the public and with critics.
One found in the pose "great beauty,
naturalness and simplicity,"[10] while
another noted that "the mother and child
are modeled with a simple directness of in-
tention, guided by so fine a perception of
beauty in life and just the right mode of
rendering it in art that they attain a quite
classic charm."[11] The following year Dalou
sent a variation on this same theme to the
Royal Academy, a life-size French peasant
woman nursing her child.

As with the *Seated Woman Reading* (cat. no.
68), Dalou brought a reduced version of
Maternal Joy back to Paris in 1880. It was
edited in porcelain by Sèvres during his
lifetime, and one of these was in Dalou's
collection at the time of his death.[12]
 J.M.H.

68.
Seated Woman Reading
Bronze
h: 21¾ in. (55.2 cm.); w: 13¼ in. (33.7
cm.); d: 15⅛ in. (38.4 cm.)
Model c. 1872–77
Signed: DALOU (on top of base)
Foundry mark: SUSSE FRERES (on top of
base)
Lender: Mead Art Museum, Amherst
College, Massachusetts

This work is very close in spirit to the
Embroiderer which Dalou exhibited at the
Salon of 1870 and even closer in disposi-
tion of forms to the *Maternal Joy* (cat. no.
67) which he sent to the Royal Academy in
1872. A date in the early 1870s is therefore
probable, although he could have reworked

67.

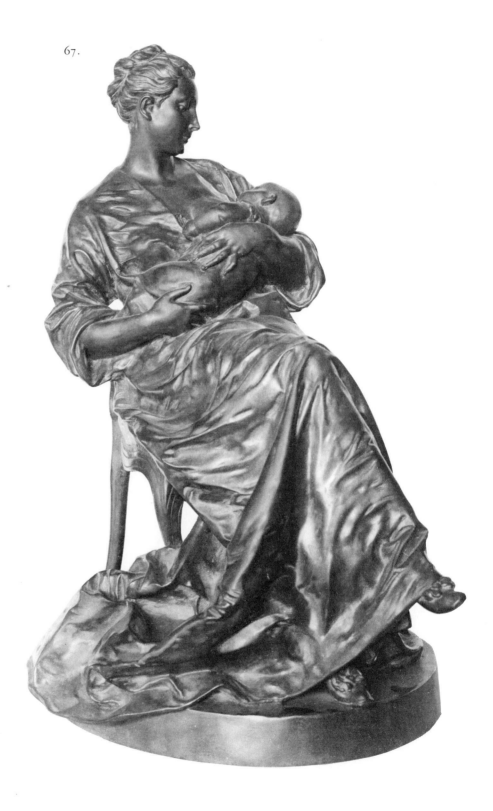

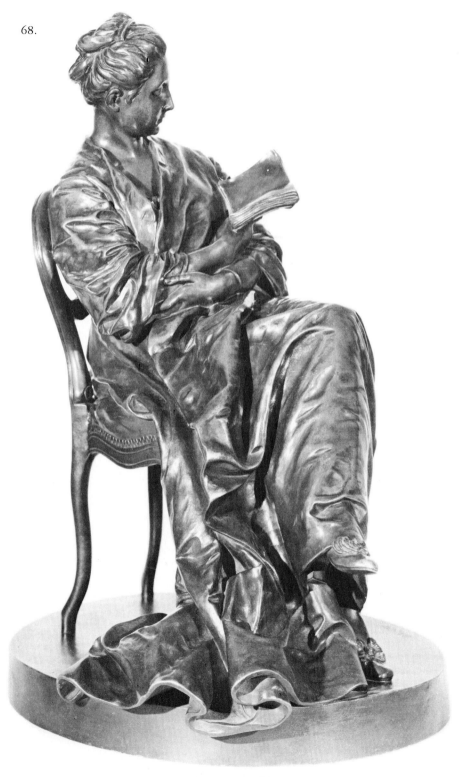

68.

the composition almost any time before the late 1870s, when intimate subjects no longer challenged his ambition sufficiently. The theme of a woman reading was used by Dalou on more than one occasion, and this particular *liseuse* was edited by Sèvres during the artist's lifetime. One of these porcelain figures was in Dalou's collection at the time of his death.[13]

Dalou used the motif of crossed legs and abundant, carefully disposed drapery to create considerable formal interest, this time in the context of a mundane subject drawn from contemporary life. Madame Dalou almost certainly was the sitter who became so deeply lost in her thoughts. This notion of a contemporary theme — handled with absolute artistic seriousness, but without any external reference, high-mindedness, or cloying sentiment — is Dalou's contribution to the history of nineteenth-century French sculpture.

J.M.H.

69.
Final Sketch for the Monument to the Grandchildren of Queen Victoria
Bronze
h: 18 in. (45.7 cm.); w: 10 in. (25.4 cm.); d: 10 in. (25.4 cm.)
Model c. 1878; cast by 1905
Signed: DALOU (on base by angel's left foot)
Foundry mark: CIRE PERDUE/A A HEBRARD (on base by angel's left foot)
Lender: Dr. and Mrs. H. W. Janson, New York

Victoria's daughter, the Princess Louise, arranged the commission for this monument. The finished work in terracotta is 31½ inches high and rests in a niche at the Royal Chapel at Windsor Castle. This bronze was cast after a maquette which is considerably freer in handling than the final work.

There also exists a first version of this monument which is quite different in conception. Clearly based on a Bernini terracotta sketch in the Louvre for the *Angel with the Crown of Thorns,* Dalou's work consists of a winged, standing angel holding one infant in its arms. Ciechanowiecki has suggested that the transformation to a seated angel with five infants refers to the deaths of more royal grandchildren.[14]

Dalou did not exhibit this work at the Royal Academy, nor apparently did he show the finished group at a private gallery

before delivering it to the queen, although he considered doing so.[15] At the time of the Royal Academy Exhibition of 1879, *L'Artiste* reported that Dalou had withheld the group in his studio.[16] It seems, therefore, that the English public never saw the work before its installation at Windsor. J.M.H

70.
Head of Sleeping Infant
Bronze
h: 7¾ in. (19.7 cm.); w: 6⅞ in. (17.5 cm.); d: 5⅝ in. (14.3 cm.)
Model c. 1878
Signed: DALOU (on right shoulder)
Foundry mark: A A HEBRARD
Numbered: 16
Lender: Museum of Art, Carnegie Institute, Pittsburgh, Gift in Memory of Mr. and Mrs. George Magee Wyckoff from Mr. and Mrs. Frederic L. Cook, Mr. and Mrs. Barry Durfee, Jr., Mr. and Mrs. George M. Wyckoff, Jr.

This is one of the most engaging images ever produced by Dalou. Surely not meant as a finished work of art in its own right, this fragment was a detailed study for the head of one of the three infants in the arms of an angel from the *Monument to the Grandchildren of Queen Victoria* (cat. no. 69). It is also closely related to another image of a sleeping infant dating from Dalou's English period: the one who appears in the arms of his mother in *Hush-a-Bye,* exhibited as a life-size terracotta at the Royal Academy in 1874, and again as a marble in 1876.

In addition to this work's intrinsic interest, it also inspired an important later work of art. Undoubtedly, Brancusi saw this *Head of a Sleeping Infant* at the Salle Dalou, which opened at the Petit Palais in July 1905, and used it as the basis for his *Torment* (1905–6). If the similarities between these two works are undeniable, their differences indicate a noticeable change in content, a change that marks a transformation from nineteenth-century realist concerns to those of the early twentieth century. The placid, undisturbed sleep of Dalou's child gives way to some unmotivated psychic discomfort. Dalou has created art by finding sculptural equivalents for the flesh, skin, and gesture of a sleeping child, nothing more. Brancusi has taken Dalou's declarative statement and imbued it with the poetry of contemporary disquiet. J.M.H

69.

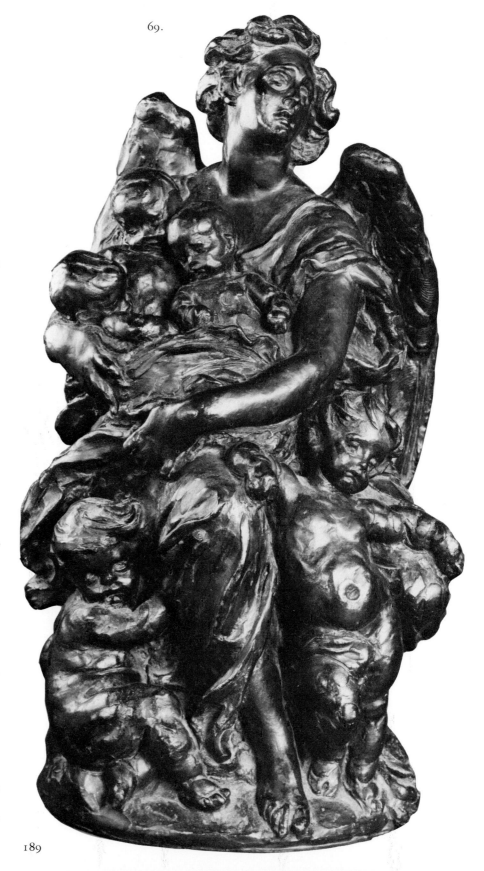

70.

71.

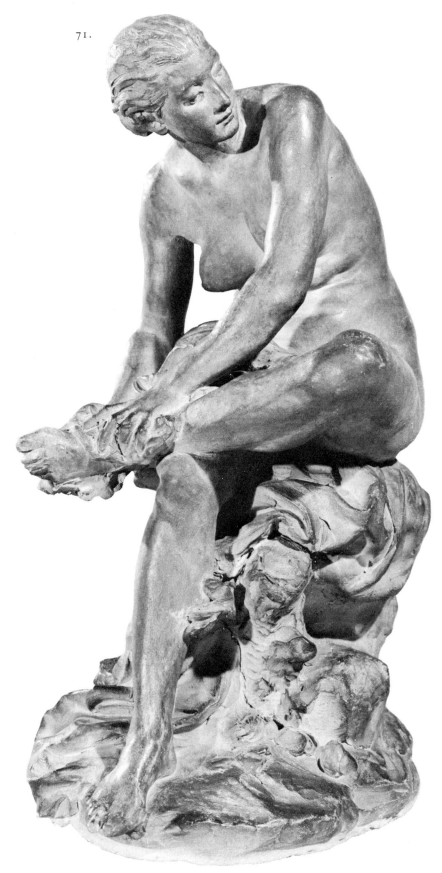

71.

Seated Bather

Terracotta

h: 16¼ in. (41.3 cm.); w: 8⅛ in. (20.6 cm.)

Signed: J. DALOU (inside)

No foundry mark

Lender: The Detroit Institute of Arts, Founders Society Purchase, Robert H. Tannahill Foundation Fund

Dalou's figures of female bathers form a notable subgroup in his oeuvre. Often made of terracotta, they display a vibrancy and sense of immediacy that can be lacking in his finished marbles or bronzes. They are part of a tradition that dates back to the eighteenth century and had been revived with great distinction by Carrier-Belleuse prior to Dalou's work in the medium.

The particular pose of this Detroit *Bather,* with a tapering focus of sculptural energies at the point where ankle, knee, and hands intersect, was often reworked by Dalou. It was a source of considerable formal interest to him because of the complex anatomical interactions which naturally result from this gesture.

Although the female bathers number among Dalou's finest works, he never sent them to the Royal Academy or the Salon for exhibition. Nevertheless, such works were known and collected during his lifetime. They could be seen in his studio or on exhibition in private galleries such as Grosvenor in London or Durand-Ruel in Paris. A few were edited in porcelain by Sèvres. Dalou worked and reworked single figures of the female nude in terracotta throughout his entire career, making it very difficult to date an individual piece with any precision. J.M.H.

72.

Standing Bather

Marble

h: 32½ in. (82.6 cm.); d: 12 in. (30.5 cm.); w: 10 in. (25.4 cm.)

Signed: DALOU (on back of base)

Lender: Nelson Gallery-Atkins Museum, Kansas City, Nelson Fund

Since Dalou's bathers are apt to be smaller in terracotta (see cat. no. 71), an enlarged figure in marble such as this one was probably created according to the specifications of a particular patron. Caillaux mentioned two such commissions: one for Colonel Heseltine and the other for the Countess of Rouvres.[17] The fact that Dalou almost

never carved marble places him among the majority of nineteenth-century sculptors who preferred to leave the working of marble to skilled craftsmen called *practiciens.*

The use of a rocky base and ample, volumetric drapery is typical of Dalou's handling of the female bather motif. Her glance which establishes an external dramatic focus makes it seem as if she had been startled while lost in contemplation. In this respect, too, the Kansas City *Bather* is closely related to her terracotta counterparts in Detroit and at the Petit Palais in Paris. J.M.H.

73.

Portrait of a Man, possibly Jean-Paul Laurens (1838–1921)

Bronze

h: 20 in. (50.8 cm.); w: 10 in. (25.4 cm.); d: 10 in. (25.4 cm.)

Late 1870s

Signed: J. Dalou (lower left)

Foundry mark: Lehmann Freres Fondeurs Paris (lower right side)

Lender: Private Collection

Dalou kept plasters of most of his portrait busts done after he returned to Paris in 1880. These, along with all his plasters, bronzes, and terracottas in his studio at the time of his death, were sold to the city of Paris by his executors in 1905. All are preserved at the Petit Palais, but a plaster of this particular bust is not among them. This suggests that the work dates from his English period, from which very few plasters survive.

Dalou did a great number of portraits and regularly exhibited them at the Royal Academy and the Salons. In general, his portraits of men are inferior to those of women and children, but there are notable exceptions such as the Delacroix bust for the painter's monument in the Luxembourg Gardens, and the present work.

The identification of the sitter as the painter Jean-Paul Laurens is made on the basis of the physical similarity between this head and a self-portrait by Laurens dating from 1876.[18] The physiognomies seem identical in the bone structure of the face, the curve of the nose, the set of the eyes in the skull, the shape of the ear, and the style of the hair and beard. This is a much more youthful man than Rodin represented in his portrait of Laurens exhibited at the Salon of 1883.

72.

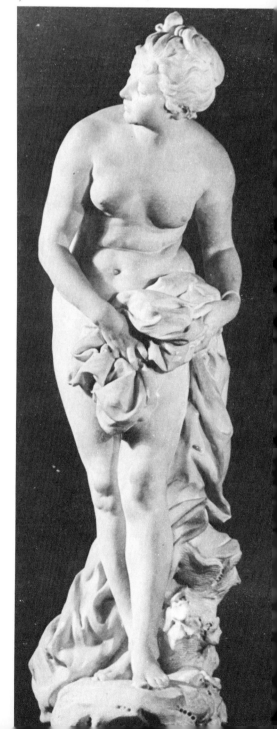

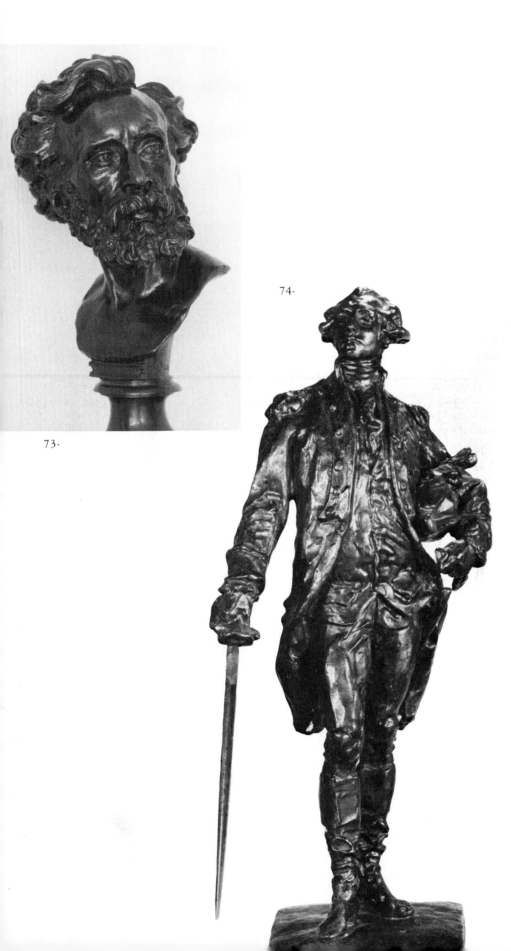

74.

73.

Dalou and Laurens had much in common: they were exact contemporaries; both came from comparably modest backgrounds; neither won the Prix de Rome, but both became major artists and received many official commissions. They often served on various committees together, and both were founding members of the Société des Artistes Français in 1881.

This bust has the extroverted force of a Baroque portrait. The gaze is intense, and the turn of the head is dramatically convincing. The only known portrait by Dalou that shares these traits is the terracotta bust of George Howard (Lord Carlisle), which was exhibited at the Royal Academy in 1877. J.M.H.

74.
Marquis de Lafayette (1757–1834)
Bronze
h: 13¾ in. (34.9 cm.); w: 7 in. (17.8 cm.);
d: 6 in. (15.2 cm.)
Model 1880–81
Signed: DALOU (on right side of base)
Foundry mark: Susse Frs Edtr (on left side of base); Paris/[illegible stamp]/Cire Perdue (on back of base)
Lender: Herbert F. Johnson Museum of Art, Cornell University, Gift of Arthur H. and Mary Martin Dean

This statuette of Lafayette relates to part of a vast project that was never realized. Early in 1880, while Dalou was still in London, the competition was announced for an enormous monument to be built at Versailles commemorating the Constituent Assembly of 1789. The format was described in the following manner: "a granite pedestal, supporting a bronze or stone column, surmounted by a statue of the Republic. . . . At the base of the monument will be placed four statues, representing in historical costume, Bailly, Mirabeau, Sièyes, and Lafayette." Furthermore, on the pedestal would be monumental bas-reliefs representing two sessions of the assembly: those of June 23, 1789, and August 4, 1789.[19]

During April 1881 there was an exhibition of the competition entries even though it was apparent that the monument would never be built. Gambetta, the president of the Chamber of Deputies, interceded on behalf of Dalou's colossal plaster relief, *Estates General, Meeting of June 23, 1789 (Mirabeau Responding to Dreux-Brézé),* urging that it be acquired, translated into durable material, and placed in the Salle

Casimir-Perier at the Palais Bourbon. As a result, the State purchased Dalou's relief on October 15, 1881.[20] After it had been cast in the *cire-perdue* method by Gonon, it was installed as planned in the entrance hall of the Palais Bourbon. The plaster relief was a grand success at the Salon of 1883, winning the Medal of Honor for Dalou that year.

Presumably Dalou's figures of Mirabeau and Lafayette were included in that April exhibition. Although the Mirabeau was also purchased by the State (and eventually consigned to the Musée de Chambéry, Savoie), there is no record of what happened to the Lafayette. As an independent statue, however, it gained enough popularity during Dalou's lifetime to be edited in porcelain by Sèvres. Two of these porcelain Lafayette figures were in Dalou's collection at the time of his death and became part of his estate.[21]

Editions of Dalou's work in bronze were almost unknown during his lifetime. Only on three occasions (see cat. no. 77) did he publish a limited edition after a certain work, and these he supervised closely to insure the highest quality of the final casts. All other works cast in multiples and even some which exist as *pièces uniques* are posthumous. Between 1902 and 1905, the executors of his estate authorized limited editions cast in the *cire-perdue* method by Hébrard. Of other known casts, the most frequently encountered are those by Susse.

J.M.H.

75.
Bust of Madame Paul-Michel Lévy
Bronze
h: 29⅞ in. (75.9 cm.)
Signed and dated: DALOU 1885 (on truncation of right shoulder)
Foundry mark: Bingen Fondeur (on socle)
Lender: Portland Art Museum (lent for Los Angeles exhibition only)

Dreyfous claimed, erroneously, that Dalou accepted no commissions for portraits in France before 1893.[22] This bust is a striking exception to his normal policy during the 1880s, as well as an anomaly among his portraits. No plaster of this bust was found in Dalou's studio at the time of his death, and its existence remained unknown until it came to Henry Lapauze's attention in 1922. The sitter, Mme. Paul Michel-Lévy, spoke with Lapauze and explained the unusual circumstances that surrounded the

creation of her portrait. Two versions of the work were made: one a bronze, cast by the *cire-perdue* method, and the other a marble, which Lapauze photographed and illustrated in a brief article.[23]

The format of this bust, with a great swath of neo-Baroque drapery, a tiara, and an aura of aristocratic aloofness, has no known parallel among Dalou's portraits. Although it bears an unmistakable affinity with one aspect of eighteenth-century French portraiture, the type dates back to Bernini's absolutist portraits. Carpeaux's bust of Princess Mathilde (1862, Salon of 1863) served as an intermediary between tradition and Dalou's unique essay in this mode.

Madame Michel-Lévy related how, during five or six sessions together, Dalou personally reworked the surfaces of the marble version of her portrait. Lapauze speculated that some *practicien* had left it in an unsatisfactory state, but even if that were the case, this would be unprecedented practice for Dalou, who normally did not carve marble.[24] In all probability, this was an instance of Dalou's making a gesture that might aggrandize his art historical stature. Between 1883 and 1885, the *Gazette des beaux-arts* had published serially the recently discovered *Journal du voyage du Bernin* by Chantelou, and one detail must have particularly impressed Dalou. While doing this bust in a mode that can be traced back to Bernini, Dalou chose to emulate the bravado of the seventeenth-century master who had worked on details of Louis XIV's marble bust in the king's presence.

J.M.H.

76.
Seated Female Nude with Legs Crossed
Red crayon on paper
h: 8½ in. (21.6 cm.); w: 5⅜ in. (13.7 cm.)
c. 1886
Mark of Auguste Becker Collection: A.B. (at lower right)
Lender: Private Collection

Until recently, it was impossible to know anything about the role that preliminary drawings played in Dalou's creative process. The two drawings preserved at the Louvre were isolated instances without a context. Although many of Dalou's drawings were published in art periodicals during the 1870s, these were finished drawings

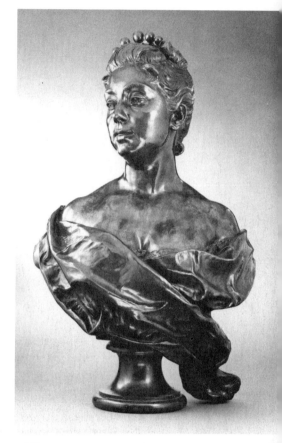

75.

after his own works. Dalou's secrecy about the evolution of a final image led him to destroy drawings, as well as clay sketches,[25] and Dreyfous admitted to destroying others after Dalou's death, in keeping with his friend's wishes.[26]

Then it was discovered that Dalou's *practicien* and assistant, Auguste Becker, had preserved a considerable number of these drawings, still extant and in the possession of his heirs. This is one of those drawings. During the fall of 1978, these were shown at the Galerie Delestre in Paris in an exhibition entitled *Dalou inédit.* That exhibition made it apparent that Dalou relied heavily on drawings during the creative process, using them to establish and refine poses that he would later crystallize in three dimensions.

It seems that the present drawing is an early stage in the evolution of the pose of the *Lavoisier* (cat. no. 77) for the New Sorbonne. Since there exists a terracotta sketch of a female nude (Petit Palais) that is clearly a study for the *Lavoisier,* it appears that Dalou used a female model in arriving at the disposition of forms which would ultimately serve for a male figure. Thus, there is no contradiction in associating this drawing with the *Lavoisier* commission of 1886. François Delestre also related this drawing to Dalou's small bas-relief entitled *Let Us Love One Another (Aimons-nous les uns les autres).*[27]

J.M.H.

77.
Reduction of the Monument to Antoine-Laurent Lavoisier (1743–1794)
Bronze
h: 20 in. (50.8 cm.); w: 13⅞ in. (35.2 cm.); d: 13⅞ in. (35.2 cm.)
Original model 1886–88
Signed: DALOU (on left side of base)
Foundry mark: Susse Frs. Edts. (left side of base); Susse Freres Editions Paris (on back)
Numbered: 2 (on back)
Lender: The Wellesley College Museum, Massachusetts

On August 26, 1886, Dalou received the commission from the city of Paris for a stone statue of Lavoisier, 2.29 meters high, for the Grand Amphitheater of the New Sorbonne.[28] Statues of other notables from the history of French intellectual accomplishment were also commissioned for the same amphitheater, and all are seated

in niches. The format for these works, which might be called the seated, contemplative-philosopher type in contemporary historical dress, dates back to the eighteenth century. A series of these figures, which were displayed in the Grand Vestibule of the Institut de France, had been commissioned by Louis XVI, and others were made after the Revolution.

The motif of the crossed legs sets up the kind of anatomical dynamics that Dalou often included in his figures of single bathers; it also calls to mind the pose that Julien had used for his over-life-size, seated *Lafontaine,* now in the Louvre.

Dalou's *Lavoisier* was exhibited as a plaster model at the Salon of 1890 and again, as a bronze statuette, at the Salon of 1901. This latter example was part of a small edition that Dalou had cast under his close supervision. (The only two other works done in a bronze edition during Dalou's lifetime were the bust of Rochefort and a reduction of his bacchic relief for the Fontaine Fleuriste at Auteuil.) Permission to produce this edition was granted by the city of Paris on January 25, 1892.[29] The extraordinarily high quality of surfaces and patination of the Wellesley bronze suggest that it is one of the original edition, produced under Dalou's watchful and critical eye.

J.M.H.

78.
Monument to Delacroix
Bronze
h: 34¾ in. (88.3 cm.)
Model completed by January 1887
Signed: DALOU (on base)
Foundry mark: CIRE PERDUE/A A HEBRARD (on plinth)
Inscribed: pièce unique (on plinth); EUGENE DELACROIX
Lender: The Toledo Museum of Art, Gift of Edward Drummond Libbey

In 1884, at the instigation of Auguste Vacquerie, a committee was formed with the intention of erecting a monument to Delacroix. Its members were among the most prestigious personalities of the French and British artistic communities: Bonnat, Bouguereau, Breton, Cabanel, Chesneau, Dalou, Dubois, Durand-Ruel, Falguière,

76.

Fantin-Latour, Garnier, Gérôme, Gonse, Leighton, Meissonier, Antonin Proust, Puvis de Chavannes, Ribot, Rochefort, Alfred Stevens, Richard Wallace, and Albert Wolff.[30]

The exact time and circumstances under which the committee entrusted one of its members, Dalou, with the commission are not clear. But by early January 1887, Dalou wrote to a friend and asked him to stop by the studio at 84 Boulevard Garibaldi to see, among other things, the sketch for the *Monument to Delacroix* which presumably had been completed recently.[31] During the spring of 1888, construction of the base of the monument was underway in the Luxembourg Gardens on the tree-lined alleyway between the Palace and the Orangerie.[32]

When the inauguration of the monument took place on October 5, 1890, Dalou's pleasure must have been severely compromised. While Bourgeois, the Minister of Public Instruction and Fine Arts who presided at the ceremony, declared the work a masterpiece,[33] only Dalou knew that for the first time in his life he was deeply in debt. The founder Bingen, who was in charge of casting the monument by the *cire-perdue* method, had provided too small an estimate (40,000 francs) for the entire enterprise. When an additional 10,000 francs were needed, Dalou signed a note, taking full financial responsibility in order to assure the completion of his monument. Eventually his friends Auzoux and Liouville learned of his plight and secretly paid off the debt. At first Dalou was furious, but later he did a portrait bust of each friend out of gratitude for their financial rescue.[34]

This monument is one of Dalou's most inspired compositions. Certain changes in detail were made between the maquette now in Toledo and the definitive work, but both convey the extraordinary energy and excitement of Dalou's sculptural inventiveness. A female figure reaching upward to place a wreath or bouquet before the bust of a person commemorated frequently occurred on temporary tomb monuments. One notable precedent was Chapu's figure called *Youth (Jeunesse)* for the *Monument to Regnault* at the Ecole des Beaux-Arts (inaugurated in 1876). Dalou has integrated this reaching female figure (her attributes are

77.

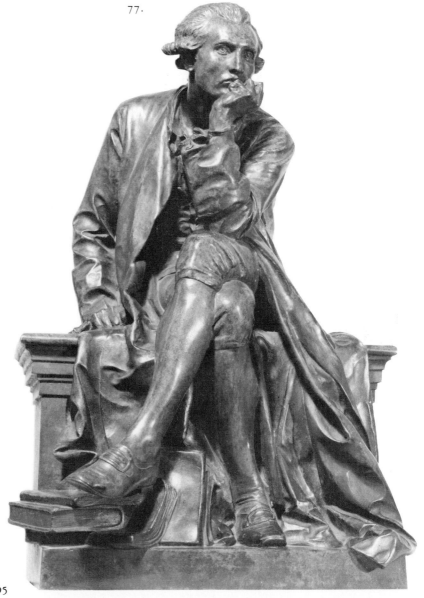

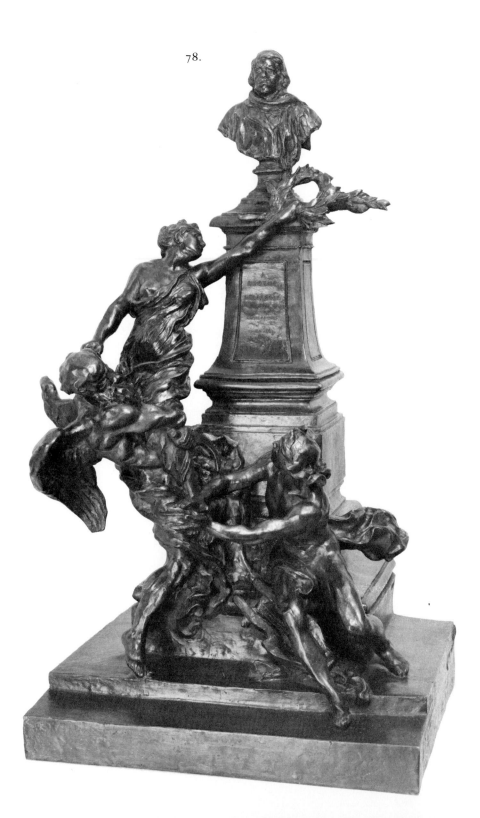

78.

not clearly designated: she is probably a composite of Truth and Glory) into a graceful and asymmetrical upward sweep with the figures of Time and Apollo (or the Genius of Art as it was called at the time of the monument's unveiling). The joyous movement and extroversion of these three figures are in marked contrast to the solemnity and intense inner energy of Delacroix's portrait. J.M.H.

79.
Punishment of the Damned (Les Châtiments)
Bronze
h: 9⅝ in. (24.4 cm.); w: 7¼ in. (18.4 cm.), without frame
Model mid-1880s
Signed: DALOU (lower left)
Foundry mark: SUSSE Frs Edes Paris
Lender: Mead Art Museum, Amherst College, Massachusetts

This relief was made so that an etching after it might be included as a frontispiece to *Les Châtiments* in a national edition of the works of Victor Hugo. Dalou's contribution was to be one among many. He later exhibited a bronze cast of this relief at the Salon of 1890. The work was edited by Sèvres during Dalou's lifetime, and one of the porcelain reliefs was in his collection at the time of his death.[35]

Dalou admired Hugo as both artist and political man, and this relief is one of several works by Dalou associated with the great Romantic writer. Surely that admiration had grown during the 1870s while Dalou was in exile and Hugo demanded again and again that amnesty be declared for the Communards.

During the last year of Hugo's life, Dalou became friendly with the family, so much so that Hugo's daughter, Mme. Ménard-Dorian, called Dalou to make the death mask after her father died.[36] At the Salon of 1886, Dalou exhibited two works with the hope of obtaining the commission for Hugo's tomb in the Panthéon, a project that did not materialize until 1889 but was widely discussed immediately after Hugo's death. One work exhibited was the sketch for a grandiose monument with Hugo's body lying beneath a triumphal arch; the other appears to have been the death mask reworked and entitled *Souvenir of May 22, 1885: Victor Hugo on His Deathbed.* With

this title, Dalou made explicit his intimate association with Hugo's death and probably hoped to create a climate in which this prestigious commission might become his. His ploy was not successful, however. These actions infuriated Rodin, and although reconciliations took place in 1889 and again in 1899, the friendship between the two was basically severed at this time.

J.M.H.

80.
Study for (or after) the Tomb of Victor Noir (1848–1870)
Chalk drawing
h: 11 in. (27.9 cm.); w: 14 in. (35.6 cm.)
c. 1890
Mark of Auguste Becker Collection: A.B. stamped at lower right corner
Lender: Private Collection

This drawing is an exact depiction of one of the most extraordinary tombs of the nineteenth century: Dalou's *Tomb of Victor Noir* (fig. 116) in Père-Lachaise. It may be either an advanced working sketch or a drawing of the monument after it was installed in the cemetery. The presence of bouquets on the ground alongside the tomb slab suggests the latter possibility. Even today, when hardly any visitor to Père-Lachaise has any idea who Victor Noir was, this startling tomb attracts not only a great deal of curiosity, but small bouquets of flowers as well.

Victor Noir was the pseudonym for Yvan Salmon, a young journalist who, at the time of his death, worked for Rochefort's paper *La Marseillaise*. He had been sent as a witness, along with Ulric de Fonvielle, to set the conditions for a duel between his editor, Grousset, and Napoleon III's cousin, Prince Pierre Bonaparte. The prince received them at his apartment in Auteuil, insulted the two, and then drew a revolver, fired, and killed Noir. This event took place on January 10, 1870, and the political repercussions were potentially disastrous for a much-discredited regime. Even

more damaging was the Prince's acquittal on the following March 21. The twenty-two-year-old reporter was raised to the status of a martyr, and Noir's death sent shock waves through the Empire.

The funds for erecting this monument were raised by a national subscription, and Dalou contributed his services without payment, as he had earlier done for Blanqui's tomb. At the Salon of 1890 Dalou exhibited the plaster model, and on July 15, 1891, the tomb effigy was inaugurated.

Although he had the precedent of Aimé-Millet's *Baudin Tomb* in Montmartre cemetery (1872) for showing a dead man in contemporary clothing after he had been shot, Dalou was far more radical in his treatment of this grisly motif. There is no shroud; the figure of Noir lies at knee level and not high on a sarcophagus. There is no reference to the law or any higher moral force.

Dalou's representation conflates two moments in contemporary accounts of Noir's death. After having been shot, he struggled to the street where he fell to the pavement and died. His fatal wound was only discovered after his top coat and jacket had been undone. Later, Noir was laid out on a bed at his home, and he was described as having something of a smile on his face, while his gloves remained on his hands; to onlookers, he gave the appearance of a large doll asleep.[37]

Dalou created a stunning, realistic depiction of this senseless murder, presenting the facts as recorded and nothing more. Indeed, one reviewer of the Salon of 1890 called this work, unflatteringly, "a kind of photography in sculpture."[38] But therein, too, lies its power. Without reference to conventional symbolism or martyrology, Dalou created a new kind of symbol, appropriate for the modern era. This accomplishment was aptly summarized by Auguste Vacquerie in his discourse when the monument was inaugurated: "One feels this before the statue as one felt it before the corpse. One feels in this recumbent figure the fall of the Empire. One feels that the Empire will never revive itself, any more than this bronze cadaver might do so."[39]

J.M.H.

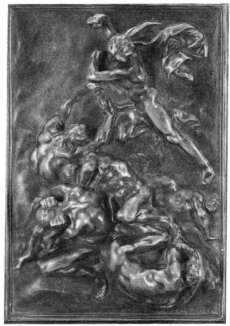

79.

80.

81.

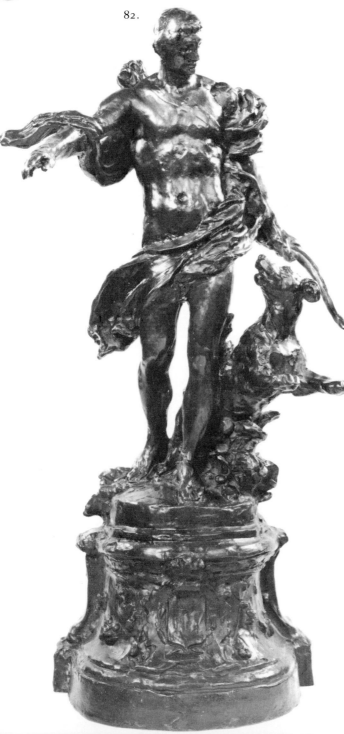

82.

81.
Man Killing a Bull
Bronze
h: 3 in. (7.6 cm.); l: 7½ in. (19 cm.)
Model 1890s
Signed: DALOU (on base)
Foundry mark: CIRE/PERDUE/A A HEBRARD
(on base)
Lender: Sterling and Francine Clark Art
Institute, Williamstown, Massachusetts

This is a bronze cast after one of the
sketches of workers found in Dalou's atelier
following his death. While accumulating
evidence for his projected *Monument to
Workers,* Dalou observed the entire spectrum
of contemporary labor: factory workers,
workers in the streets and gardens of Paris,
fishermen, peasants in the fields. His in-
spiration for this sketch was obviously
either a visit to an urban slaughterhouse
or an event witnessed in the countryside.
One doubts that Dalou imagined he could
ever include this particular narrative scene
in the context of his finished monument.
This sketch indicates, rather, the scope
of Dalou's fascination with contemporary
workers and the dignity he perceived in
all aspects of manual labor. J.M.H.

82.
Hunter with His Dog
Bronze
h: 25 in. (63.5 cm.); d: 12½ in. (31.8
cm.); w: 10 in. (25.4 cm.)
Model c. 1898
Signed: DALOU (on top of base)
Foundry mark: CIRE PERDUE/A A HEBRARD
Numbered: 7 (edition of 10)
Lender: The Detroit Institute of Arts,
Founders Society Purchase, Robert H.
Tannahill Fund

This is a bronze cast after the sketch for a
statue which was never completed. One of
the rare private commissions in Dalou's
oeuvre, *The Hunter with His Dog*—often,
for unknown reasons, entitled *Meleager*—
was intended for the Duke of Gramont's
Château de Vallière where it would have
been the focal point for a grand staircase.
Had this work ever reached completion, it
would have been the second major sculp-
ture that Dalou made for the Gramont
family. During 1890–92, he executed
a figure group known as *Les Epousailles,*
exhibited at the Salon of 1892 and in-
tended for the Gramont mansion in Paris.
That work was later moved to the grounds
of the same Château de Vallière.

The pose of the *Hunter* clearly refers to two well-known figures from Versailles: a seventeenth-century bronze copy of the *Apollo Belvedere* and a marble *Diana* after the antique by Desjardins, also done during the seventeenth century. According to Dalou's own admission, he preferred the style of Louis XIV's era above all others.[40] On another occasion he told a reporter that "the task of the future will be to put at the service of democracy all the glittering pomp of the century of Louis XIV."[41] It was while wandering about the gardens of Versailles as a student that Dalou developed this attachment to the sculpture of the *grand siècle.* J.M.H.

Notes

1.
A. Rodin, *Art,* ed. P. Gsell, trans. R. Fedden, London, 1912, p. 149.
2.
Burty, 1883, p. 177.
3.
Ibid., p. 190.
4.
Until recently it was believed that all of these drawings had been lost or destroyed. François Delestre discovered a considerable number of them in the possession of the heirs of Dalou's assistant, Auguste Becker. See Paris, Galerie Delestre, 1978.
5.
Journal entry dated April 28, 1897; reproduced in Dreyfous, 1903, pp. 248–49.
6.
Le Journal, April 2, 1898.
7.
Journal entry dated April 9, 1898; reproduced in Dreyfous, 1903, p. 257.
8.
Ibid., 1903, pp. 277–78.
9.
C.V., "Les obsèques de Dalou," *La Petite République Socialiste,* April 19, 1902.
10.
"Royal Academy Exhibition, Sculpture," *The Athenaeum,* May 25, 1872.
11.
"Royal Academy Exhibition," *The Academy,* May 15, 1872.
12.
Paris, Hôtel Drouot, 1906, cat. no. 107.

13.
Ibid., cat. no. 108.
14.
London, 1964, p. 15.
15.
Letter of April 6, 1878, cited in Dreyfous, 1903, p. 83.
16.
"L'Exposition de l'Académie royale des Beaux-Arts, Londres 1879," *L'Artiste,* Sept. 1879, p. 166.
17.
Caillaux, 1935, pp. 104, 127.
18.
Illustrated in Hunisak, 1977, fig. 87.
19.
"Chronique," *L'Art,* 1880, I, p. 52.
20.
Archives Nationales, F21 2070.
21.
Paris, Hôtel Drouot, 1906, cat. nos. 112, 113.
22.
Dreyfous, 1903, p. 202.
23.
H. Lapauze, "Sur un buste inédit de Dalou," *La Renaissance de l'art français et des industries de luxe,* 1922, p. 134.
24.
Dalou's first employment in London was as a *practicien.* His facility was not great, and he was fired for ruining the bust he had been given to carve (Dreyfous, 1903, pp. 48–49).
25.
Ibid., 1903, pp. 36, 56, 211.
26.
Ibid., p. 36.
27.
Paris, Galerie Delestre, 1978, cat. no. 35.
28.
Archives de la Seine, 10624/72/1.
29.
Ibid.
30.
"Chronique de l'art," *L'Artiste,* 1884, I, p. 381.
31.
Letter to M. Magnier, dated January 4, 1887, preserved at the Bibliothèque d'Art et d'Archéologie, Paris.
32.
"Chronique," *L'Artiste,* 1888, II, p. 142.
33.
"Monument à Delacroix," *L'Artiste,* 1890, II, p. 304.
34.
Dreyfous, 1903, pp. 189–90.

35.
Paris, Hôtel Drouot, 1906, cat. no. 110.
36.
Her letter to Dalou on the day of Hugo's death is reproduced in Dreyfous, 1903, p. 213.
37.
A. Zévaès, *L'Affaire Pierre Bonaparte (Le Meurtre de Victor Noir),* Paris, 1929, p. 31.
38.
C. Phillips, "Salon of 1890," *The Portfolio,* 1890, p. 17.
39.
E. Grimbert, *Assassin et victime ou l'affaire Victor Noir,* Nîmes, 1894, p. 55.
40.
Letter of July 28, 1879, cited in Dreyfous, 1903, p. 103.
41.
Fourcaud, "Jules Dalou," *Le Gaulois,* April 16, 1902.

Selected Bibliography

Brownell, W. C., "Two French Sculptors: Rodin, Dalou," *The Century,* November 1890. (This essay was reprinted in the various editions of Brownell's *French Art,* from 1892 onward).

Brisson, A., "L'Oeuvre de Dalou," *Revue illustrée,* November 15, 1899.

Geoffroy, G., "Dalou," *Gazette des beaux-arts,* 1900, XXXIII, pp. 217–28 (reprinted in *La vie artistique,* VIII, 1903).

Dreyfous, M., *Dalou: Sa vie et son oeuvre,* Paris, 1903.

————, "Dalou inconnu," *L'Art et les artistes,* II, 1905–6, pp. 71–83.

Paris, Hôtel Drouot, *Succession de feu M. Jules Dalou,* December 23, 1906.

Cornu, P., *Jules Dalou,* Portraits d'hier, no. 8, Paris, July 1, 1909.

Lami, 1914–21, II, pp. 2–14.

JEAN-PIERRE DANTAN
1800 Paris—Baden-Baden 1869

Caillaux, H., *Dalou: l'homme, l'oeuvre,* Paris, 1935.

London, Mallett at Bourdon House, *Sculptures by Jules Dalou,* exh. cat. by A. Ciechanowiecki, 1964.

Paskus, B. G., *Jules Dalou in England,* unpublished master's thesis, University of California at Berkeley, 1965.

Galerie Delestre, *Jules Dalou, 1838–1902,* exh. cat., Paris, 1976.

Hunisak, J. M., *The Sculptor Jules Dalou: Studies in His Style and Imagery,* New York, 1977.

————, Jules Dalou: the Private Side," *Bulletin of The Detroit Institute of Arts,* 1978, LVI, no. 2, pp. 33–40.

Paris, Galerie Delestre, *Dalou inédit,* exh. cat., 1978.

At the age of nine, Jean-Pierre Dantan was an apprentice to his father, a sculptor of ornaments; at age thirteen he worked in an arms factory carving designs on gun stocks. By 1819, four years later, he was employed as an ornamental sculptor on the restoration of Saint-Denis Cathedral. Dantan then spent some time at Salins, in the Jura mountains, and in Switzerland. He returned to Paris in 1820 and worked on the decor of the Palais de la Bourse and on the Expiatory Chapel of Louis XVI; he also did work for the provinces. In 1823 he entered the Ecole des Beaux-Arts, where alongside his elder brother Antoine-Laurent Dantan (1798–1878) he attended the classes of Flatters and Bosio. In 1827 he made his Salon debut with eight portrait busts (he continued to exhibit regularly and prolifically until his death). In 1828 he went to Italy with his brother, who had won the Prix de Rome. After returning to Paris in 1831, Dantan received a number of State portrait commissions for Versailles. From 1833 to 1834 he lived in London, returning there for a trip in 1842. He visited Algeria in 1844 and Egypt in 1848.

Although Dantan executed statues for the new wing of the Louvre and the churches of the Madeleine, Sainte-Clotilde, and the Trinité, his primary activity was as a portraitist. He made more than four hundred portraits—statues, statuettes, medallions, and busts—and more than five hundred caricatures in sculpture. Praised by Baudelaire in 1846,[1] his serious portraits are eclectic in style, combining aspects of both Bosio's classicism and David d'Angers' Romantic realism; although academically correct, and at times decoratively charming —especially with female sitters—they are generally uninspired and somewhat dull.

It was for his caricatures, called *portraits chargés* (literally, loaded portraits) that Dantan became famous.[2] He began making them in 1826, reproducing them in 1831, and marketing them commercially in 1832 (see cat. no. 85). The *charges* were much copied and incorporated by others in works of various media. In 1834 they inspired the costumes for a ball. Eventually they became so famous that the artist was solicited by people who wished to be caricatured in order to obtain notoriety. Although Dantan's *charges* probably reached their height of popularity in the late 1830s, the artist

continued making them until the end of his career, earning for himself the nicknames *Le Praxitèle de la foule* (The Poor Man's Praxiteles) and *Le Michel-Ange des bossus* (The Michelangelo of Hunchbacks). Théophile Gautier said of Dantan that he, better than anyone, had succeeded in making plaster grimace and in bringing a smile to sculpture, that most serious of the arts.

By the end of the 1830s Dantan had collected enough of his own work—the serious portraits in one space, the *charges* in another—that his residence became known as the Musée Dantan; in addition he formed a *Musée Secret,* devoted to erotic art. As a result of these collections and the popularity of his *charges,* Dantan became a celebrity in his own right, and his studio became a tourist attraction and a salon meeting place, as well as the headquarters of a club for playing dominoes.

The largest extant collection of Dantan's works is in the Musée Carnavalet, Paris.

P.F.

83.
Caricature of Honoré de Balzac (1799–1850)
Plaster
h: 12¾ in. (32.4 cm.); w: 6 in. (15.2 cm.); d: 5½ in. (14 cm.)
Signed and dated: DANTAN f. 1835 (on the back)
Lender: Private Collection

84.
Caricature of Balzac's Cane
Wood engraving by Théodore Maurisset (active 1834–1859) after Dantan
h: 8¾ in. (22.2 cm.); w: 6¾ in. (17.1 cm.)
Sculptural model of the caricature, 1835; wood engraving exhibited here, published in *Musée Dantan, galerie des charges et croquis des célébrités . . . ,* Paris, 1839
Lender: Los Angeles County Museum of Art, Mrs. Caryll Mudd Sprague Fund

Since antiquity, amusing, distorted, or grotesque portraits were produced in various forms and media, but Dantan was apparently the first academically trained, or "serious," artist to specialize in sculpted caricatures. His devotion to this art form and its popularity in the early nineteenth

83.

84.

century should be viewed within the context of certain interests that were central to the Romantic movement: the cult of the individual and the consequent flourishing of portraiture in general, the fascination with the grotesque, and the mania for statuettes of all kinds (see cat. no. 4).

The humor of Dantan's *charges* results primarily from the selected exaggeration of the sitter's physical traits, his clothing, or the objects associated with him. In contrast to Daumier, whose psychologically penetrating vision caricatured human types in order to criticize society through ridicule, Dantan's *charges* focus upon individual personalities and aim only to amuse. Dantan avoided political subjects and only once, at the insistence of the sitter, did he caricature a woman.[3]

Dantan executed more than one caricature of a few particularly engaging personalities, and this was the case with Balzac. This plaster depicts the famous writer and notorious gourmand as a swollen, bloated figure with long stringy hair, wearing a grotesque smile and holding an enormous bejeweled cane (one of Balzac's well known, and often mocked, vanities).

In discussing the *charge* of Balzac, journalist Louis Huart wrote that Balzac's admiring female readers must have been disappointed to see "this fat man with fat cheeks, a fat stomach, fat legs, and a fat cane.... M. de Balzac guessed the effect that his physique... would produce upon his charming female readers; thus, he never permitted his portrait to be published and we are indeed astonished that he has not sued Dantan."[4] Although Balzac is known to have been vain about his appearance, Huart's assertion is playful fantasy, for on March 11, 1835, Balzac wrote with delight to his friend Madame Hansak, "They are taking me seriously; and so much so that Dantan has done my *charge*."[5]

Dantan's other caricature of Balzac is represented in the exhibition by a contemporary woodcut illustration. In this *charge,* Balzac has become his cane. The woodcut was executed by Théodore Maurisset as part of a series of a hundred illustrations—published in twenty installments during 1838, and as a book in 1839—of Dantan's *charges.* Each of the woodcuts was accompanied

by Huart's semidescriptive, semibiographical, satirical text.

About the *Cane of M. de Balzac* Huart wrote:

Here is a celebrity with whom one was much concerned three or four years ago and, indeed, one whose glory shined upon M. de Balzac and served in part to draw him from obscurity. Alas, vanity of vanities.... Who thinks today of this famous cane of M. de Balzac? A few more years and this cane will be a hieroglyph like the ibis *which one finds on Egyptian monuments. ... Then the future Champollion [an archeologist] will explain to the Academy... how in the year of Our Lord 1835 a novelist, named Honoré de Balzac, could find no better way to attract attention than to appear in public with a cane in comparison with which drum majors appear to wield mere wands. ... Today, as one is no longer concerned either with the cane of M. de Balzac or with M. de Balzac himself, public attention is focused upon... M. Théophile Gautier's hairdo."[6]* P.F.

85.

Muséum Dantanorama (frontispiece)
Lithograph by J.J. Grandville (1803–1847)
h: 9⅛ in. (23.1 cm.); w: 12½ in.
(31.8 cm.)
1834, here exhibited as published in *Le Charivari,* 1836
Signed: J.L./G./INVENIT (left)
Inscribed: Muséum Dantanorama (top); Salon/DE SUSSE (center)
Lender: Armand Hammer Foundation, Los Angeles

It was both a reflection of and a contributing factor to the popularity of Dantan's caricatures that they were reproduced in inexpensive media and marketed commercially at modest prices by several firms including Aubert, Jeanne, and, most notably, Susse Frères. This last company had its showrooms in the *Passage des Panoramas,* one of the flourishing shopping arcades near the Boulevard Montmartre.[7] Still in existence today, Susse Frères is now thought of primarily as a bronze foundry, but during the reign of Louis-Philippe its interests were more diverse. The firm had a specialty gift shop, with stationery, curiosities, and souvenirs of Paris; it was also a dealer in prints and drawings, a restorer of paintings, and a manufacturer of statuettes in bronze, plaster, and pasteboard.

By 1832, Susse was handling and publicly displaying Dantan's *charges*.[8] Along with its other activities, Susse published lithographs and naturally employed this new medium to advertise its wares. On February 7, 1834, the journal *Vert-Vert* announced that Monsieur Susse had issued the first number of his *Muséum Dantanorama;*[9] this was perhaps the earliest of the several lithographic collections of Dantan's *charges* which were to be published in England and France. Susse employed Grandville, a superb caricaturist in his own right, to make the lithographs after Dantan's *charges*. They first appeared as a separate album and then in the journal *Le Charivari*. The February 28, 1836, issue of *Charivari* (exhibited here) published the frontispiece of the *Muséum Dantanorama* along with a brief notice by the journal's editor Charles Philipon:

Everyone in Paris knows the charges of Dantan; everyone in France knows how true, comic, and resembling they are. But only a small number of friends, artists, and illustrés *are familiar with the secret of the names because few are conversant with the punning and hieroglyphic language in which these names are written on the socle of each* illustré. *Thus we hope to please the frequenters of Susse's beautiful stores ... and our subscribers by helping ... them to appreciate the talent of Dantan ... and to know the name of each celebrated grotesque. ... The complete gallery will pass before the eyes of our readers. ... Le Charivari will be in a position to offer both the* Metamorphoses du Jour *by Grandville and the charges of Dantan, that is to say, the most biting caricatures which have been done today outside of political circles.*[10]

Philipon goes on to identify several figures in the frontispiece. In the center, amid the public gazing at Dantan's works, is Monsieur Susse guiding a rich amateur of "colossal reputations." At the left, the foremost *charge* represents Grandville, while on the right, wearing a crown of grotesque busts, is the king of caricature, Dantan. Grandville parodies the viewing public by distorting their features as much as those of the *charges*, whose overinflated importance he mocks by blowing them up into colossal sculptures. P.F.

Lithographié par GRANDVILLE,

RAMELET ET LEPRUDRY.

Chez Aubert, galerie Véro Dodau et galerie Colbert

85.

Notes

1.
Baudelaire, 1962, p. 191.
2.
The information in this paragraph is drawn from Seligman, 1957, pp. 27–37 and 48–54 passim.
3.
Ibid., pp. 64, 97–98.
4.
Ibid., p. 8.
5.
Cited in ibid., p. 54.
6.
Delloye, 1839, p. 10.
7.
Seligman, 1957, pp. 50–51.
8.
L'Artiste, 1831, II, p. 4.
9.
Cited in Seligman, 1957, p. 86.
10.
Le Charivari, February 28, 1836, col. 4.

Selected Bibliography

Delloye, H., ed., *Musée Dantan ... Galerie des charges et croquis des célébrités de l'époque, avec texte explicatif et biographique,* Paris, 1839. Contains one hundred wood engravings by Théodore Maurisset and accompanying texts by L. Houart.

Dantan, J.P., *Les dominotiers de Dantan jeune,* Paris, 1848.

Dantan, J.P., *Catalogue des bustes, statuettes, charges et caricatures de Dantan jeune, à Paris,* Lille, 1862.

[Andry, F.], *Charges et bustes de Dantan jeune ..., Esquisse biographique, dedíée à Méry, par le Docteur Prosper Viro ...,* Paris, 1863.

Lami, 1914–21, II, pp. 24–46.

Vienna, Kunsthistorisches Museum, *Die Karikaturen des Dantan, Paris-London, 1831–39,* Vienna, 1933.

Hale, R.W., *Dantan jeune, 1800–1869, and his satirical and other sculpture, especially his "portraits chargés,"* Meridan, Conn., 1940.

Seligman, J., *Figures of Fun: the caricature statuettes of Jean-Pierre Dantan,* London and New York, 1957.

HONORÉ DAUMIER
1808 Marseilles–Valmondois 1879

Daumier's father, Jean-Baptiste, was a glazier who aspired to be a classical poet; his mother was a strong, practical woman from the Basses-Alpes. In 1814 Jean-Baptiste moved from Marseille to Paris in search of literary recognition he would never achieve. His wife and children joined him a year later. Young Honoré's childhood was far from idyllic—between 1815 and 1832 the family moved at least ten times from one poor Parisian quarter to another. Although he apprenticed to a bailiff and later worked as a clerk in a bookshop, Daumier was interested in art even at an early age. Alexandre Lenoir, founder of the Musée des Monuments Français and a family friend, encouraged him to pursue an artistic career. Under his instruction, Honoré learned to draw from casts of ancient sculpture. During his teens he frequented the studios of several Parisian artists, notably Boudin's atelier, where he was able to make life drawings and mingle with other painters including Diaz, Huet, and Jeanron. These young men, along with the talented Romantic sculptor Préault, shared similar democratic sentiments wholeheartedly espoused by Daumier. Another friend, Ramelet, taught him to prepare and print from lithographic stones—a technique he quickly mastered.[1]

Beginning with the Revolution of 1830 and throughout the subsequent political upheavals in France, Daumier employed his talents to support his political beliefs. His professional career was launched in 1830 when Charles Philipon, editor and founder of the satiric newspapers *La Caricature* and *Le Charivari,* hired him as an illustrator-journalist. Although Philipon himself wrote most of the text of these two papers, artists such as Grandville, Monnier, Devéria, and Charlet provided illustrations, recently made feasible through the inexpensive process of lithography. In the course of his lifetime, Daumier would execute more than 4,000 lithographs, primarily for *Le Charivari,* commenting on both social and political topics. His satires against Louis-Philippe were so caustic that the quiet, reserved rebel was imprisoned for a few months in 1832. He wrote humorously of this experience to his friend Jeanron from jail: "Prison won't leave any painful memories for me. I'm getting four times as much work done in my new boarding house as I did at papa's. I'm mobbed by citizens who want their portraits drawn."[2]

Daumier's earliest sculptures date from 1832 when, possibly at Philipon's suggestion, he produced a series of clay *bustes chargés* (loaded busts), in which he caricatured the deputies in Louis-Philippe's Parliament. He may have modeled, then painted, as many as forty-five of these small clay busts; thirty-four survive today. These busts were not cast in bronze until after his death. All political lampoons, including *La Caricature,* were suspended under Louis-Philippe's censorship laws against the press in 1835. Until the fall of the July Monarchy in 1848, Daumier was forced to turn his attention to illustrating the mores of society, particularly its materialistic bourgeois values.

As a young artist in the 1830s, he was well regarded by the critics. By the time Daumier was thirty-seven, Charles Baudelaire placed him on a par with two of the most famous contemporary painters, Delacroix and Ingres, in his review of the Salon of 1845. After the Revolution of 1848, Daumier's works, like those of other republican artists, were deemed politically acceptable—the government even encouraged him to enter paintings in the Salons. *Le Charivari* was revived and once again Daumier's barbed caricatures entertained the French public. Yet this tolerant climate soon shifted under the regime of Napoleon III. Beginning in late 1848 Prince Louis-Napoleon, recently elected President of the Republic, initiated a widespread propaganda campaign in hopes of securing absolute authority. Enraged by the Prince's underhanded tactics, Daumier created *Ratapoil* (cat. no. 89), symbol of the sinister agents hired by Bonaparte to pave the way for the coup d'état that made him emperor. Because of the repressive measures instituted during the Second Republic, his lithographs dealt more with social issues and the theater than with political controversies. During this period he also executed many paintings. Daumier's sight began to fail in the 1860s and by 1873 he rarely drew. In 1878 he enjoyed a retrospective exhibition of his works at Durand-Ruel Gallery, prepared by his friends in his honor. He died the following year at his country home in Valmondois.

Although his art was restricted by official censorship for nearly forty years, Daumier produced a remarkably extensive and varied oeuvre. In addition to his 4,000 lithographs, he made more than 1,000 wood engravings, 300 paintings, 1,000 drawings, and nearly 50 clay sculptures. Since his death, bronze replicas of his clay models number into the thousands. Reproductive techniques have led to inevitable variations upon the artist's original conceptions. Thus the quality of a Daumier bronze cannot be established without determining its relationship to his original clay model or its plaster cast. A.D.

86.
Bust of Pataille
Bronze
h: 6⅝ in. (16.8 cm.); w: 5¼ in. (13.3 cm.); d: 4¼ in. (10.8 cm.)
Model c. 1832–35; this cast c. 1934
Foundry marks: MLG BRONZE (on lower right rear) and 23/30 (inside)
Provenance: Maurice Le Garrec, Paris; Sessler Gallery, Philadelphia
Lender: National Gallery of Art, Washington, D.C., Rosenwald Collection

87.
Bust of Prunelle
Bronze
h: 5⅛ in. (13 cm.); w: 4⅛ in. (10.5 cm.); d: 5⅞ in. (14.9 cm.)
Model c. 1832–35; cast c. 1929–30
Foundry marks: MLG (on lower left side); 3/30D2 (on bottom rim); 3/30 (inside)
Provenance: Maurice Le Garrec, Paris; Sessler Gallery, Philadelphia
Lender: National Gallery of Art, Washington, D.C., Rosenwald Collection

Although many unauthorized Daumier bronze caricature busts exist, the two in the current exhibition were cast by the Barbedienne foundry from the artist's original polychromed unbaked clay sculptures in the collection of Maurice Le Garrec. These small busts, which satirize the members of Louis-Philippe's Chamber of Deputies, are thought to have served as models for two series of lithographs, *Chambre non prostitué* and *Celebrités de la caricature,* both published in *La Caricature.* Charles Philipon announced the *Celebrity* series in *La Caricature* on April 26, 1832, with Daumier's portrait of Lambeth.[3] The approximate date of these busts is confirmed by the artist's friend Champfleury, who mentioned that "from 1832 to 1835 Daumier unceasingly redid the same political personalities [both in clay and in lithographs]."[4]

The clay busts belonged to Philipon's family from the 1830s until 1927, when they were purchased by Maurice Le Garrec. They are currently owned by his widow. In 1929, Le Garrec asked Fix-Masseau, a sculptor, to repair each of them and to make plaster molds, which were then sent to Barbedienne for casting in bronze. According to Mme. Le Garrec, thirty numbered bronzes were made of d'Argout, Fulchiron, Guizot, Harle, Lameth, Odier, Pataille, Prunelle, Viennet, and "Girod," and a total of twenty-five was made from the rest. After Barbedienne went out of business in 1953, she had the Valsuani foundry make three more casts of each and in 1965 ordered the plaster molds destroyed. Casts of the entire set of heads are located in the National Gallery of Art, Washington; the Musée des Beaux-Arts, Marseille; the Musée des Beaux-Arts, Lyons; the Akademie der Künste, Berlin; and in the collections of the late Count Aldo Borletti di Arosio and Mme. Le Garrec.

86.

87.

88.

The satiric busts in this series are Daumier's first recorded sculptures. In conceiving these caricatures, Daumier disregarded the traditional canons of anatomical proportions and purposely exaggerated the most dominating features of his subjects' physiognomy for comic effect. Since antiquity, artists had produced distorted, satirical portraits of well-known personalities, but primarily in painting, drawings, and prints. Caricatures in sculpture only became common in the early nineteenth century, due in large part to Daumier's contemporary, Jean-Pierre Dantan, whose numerous and mass produced *charges,* or loaded portrait-caricature sculptures, were sold commercially (cat. nos. 83–85).

In his bust of Alexandre-Simon Pataille[5] Daumier exploited the magistrate's pointed chin, sharp nose, squinty eyes, and large bump protruding from his forehead. The artist also depicted his lively character in two lithographs: a bust portrait (1833) and the famous *Ventre législatif* (1836). The subject of the other bust displayed here, Dr. Clément-François-Vincent-Gabriel Prunelle, was known in his day as "The Bison," due to his homely, shaggy physiognomic characteristics.[6] *Prunelle* is one of Daumier's most memorable caricatures. His beady eyes and beaked nose are frankly birdlike. His scowling expression recalls the artist's other grimacing portrait busts of *Soult* and *Girod de l'Ain.*[7] Because of its small size and the fact that *Prunelle* is mentioned frequently in the press in 1831, Dubré believed the original clay bust was executed early—in 1832.[8] In addition to the sculpture, Prunelle appears in a full-length lithograph by Daumier (1833) and in the *Ventre législatif.* A.D.

88.
The Emigrants
Bronze
h: 14½ in. (36.8 cm.); w: 30 in. (76.2 cm.); d: 2¾ in. (7 cm.)
Model c. 1848–1850
Signed: H. Daumier (lower right)
Numbered: 4
Provenance: Armand Dayot, Paris; M. Knoedler and Company, Inc., New York
Lender: The Minneapolis Institute of Arts, The John Van Derlip Fund

The Emigrants represents a marked departure from the satirical side of Daumier's sculptural oeuvre. In this work, his only bas-relief, the artist aspired to make a serious sculpture with social meaning. Also known as *The Refugees,* the relief represents a solemn procession of nude men, women, and children marching into exile. By eschewing all drapery, landscape, and other pictorial embellishments, and concentrating upon muscular human forms, Daumier created a sculpture of extraordinary monumentality and power. The figures, stripped of nearly all their belongings, are crowded together, united in their tragic dilemma by the nakedness they share in common and the movement of their forms. To suggest recession into depth, the figures at the extreme ends are modeled in shallower relief and in less detail than those in the center. The central female figure, carrying one child and holding another by the hand, links the two dense groups to her left and right. The right hand figures, their shoulders sagging and heads bent low, appear more destitute than the others. The figure at the far left leans back, thus resolving the general movement from left to right and closing off the composition.[9]

According to Gobin, Daumier originally created two clay reliefs, since disappeared, of *The Emigrants:* these were cast in plaster and tinted by the artist's friend Victor Geoffroy-Dechaune before 1862. The two plasters are nearly identical except for minor differences in overall size, modeling, and proportion. Both remained with the Geoffroy-Dechaune family until 1960, when the version designated by Gobin as "first" was acquired by the Louvre. For years Daumier specialists have debated the exact date of the reliefs. The subject without doubt refers to a contemporary event but scholars disagree as to which one. Some scholars date the work as early as the 1830s — when the Polish revolution drove many people from Poland to France — or as late as 1870–71, while many specialists believe that it was produced about 1848–50, in memory of the supporters of the May and June insurrection who were deported to the French colonies in Africa.[10] After a technical analysis of the plaster casts, Arthur Beale of the Fogg Museum's Conservation Department proposed that the Geoffroy-Dechaune version may have been executed in the 1850s and that the Louvre version may date from the 1830s.[11] In any case, the theme of mass exodus would haunt Daumier for many years. In addition to the two clay reliefs, he portrayed the subject in several drawings and at least four paintings. A drawing in the Roger-Marx collection, Paris, is closest to the relief compositions.[12]

Shortly before 1960, George Rudier made an edition of ten numbered casts from the version now in the Louvre. These are apparently the only bronze sculptures cast from the piece. Around 1890, one of Victor Geoffroy-Dechaune's sons, Adolphe, used his plaster relief to make four additional plaster casts. He retained one of these for himself;[13] the others were sold to Roger-Marx, Armand Dayot, and the sculptor Desbois. The Minneapolis bronze relief was cast from the Dayot plaster by the Siot-Decauville foundry about 1893. It is numbered "four" in an edition of five bronze casts. A.D.

89.

89.
Ratapoil
Bronze
h: 17¼ in. (43.8 cm.); w: 6¾ in. (17.1
cm.); d: 7⅝ in. (19.4 cm.)
Model c. 1850–51; this cast c. 1890
Signed and numbered: DAUMIER 17 (top of
base left corner and left rear)
Foundry mark: SIOT-DECAUVILLE**
FONDEUR/PARIS (side of base near left)
Provenance: Maurice Le Garrec, Paris;
Sessler Gallery, Philadelphia
Lender: National Gallery of Art,
Washington, D.C., Rosenwald Collection

During a visit to Daumier's studio in 1850 or 1851, the eminent historian Jules Michelet discovered the artist "modeling in clay a statuette, the idea of which haunted him."[14] The sculpture which so intrigued Michelet was *Ratapoil.* Unlike Daumier's *bustes chargés,* this figure did not satirize a particular individual, but rather served as a symbol for all of Louis-Napoleon's unscrupulous agents who spread pro-Bonapartist propaganda among the public. These scoundrels played vital roles in the future Emperor's political tactics prior to the coup that placed him in power in 1851. As Oliver Larkin observed, *Ratapoil* epitomized "the storm trooper, the vigilante, the bribed thug, the stool pigeon of all time . . . the creature sent ahead when Louis-Napoleon traveled, to cheer him at railroad stations, dispatched to the farms where peasants needed to be convinced, and sent into alleys to club unlucky republicans."[15] The name of this figure, coined by the artist himself, appears to mean "Ratskin."[16] His beaked profile, handlebar moustache, and goatee were clearly intended to resemble Napoleon III's own features. *Ratapoil*'s insolent, deceptively debonair attitude, aggressive swagger, and menacing club are telling indictments of Bonapartist chicanery and corruption. Noting the figure's sinister character, Michelet exclaimed that Daumier had "struck the enemy full force."[17]

Although Daumier evidently first modeled the statuette in clay, the fragile object was soon cast in plaster. The clay model was probably destroyed during this process.[18] Fearing the destruction of *Ratapoil* by Napoleon III's police, the artist kept the figure hidden throughout the Second Empire. It is not known if the statuette preceded the forty-odd lithographs of the same subject Daumier executed beginning in 1850. Even though he never copied the pose exactly, the statuette could have served as a kind of model or point of departure for the figure in his prints. In addition to its timely political significance, the sculpture is one of Daumier's most inventive works from an artistic standpoint. Thin and wiry, this almost skeletal, linear figure reminds us of the artist's incisive draftmanship. The axial twists and angularity of his pose, along with Daumier's rough, agitated modeling, lend energy to the sculpture. In accordance with Realist aesthetics, he dressed *Ratapoil* in contemporary, albeit battered, clothing that accentuates the figure's roguish nature.

In the early Daumier literature only one plaster *Ratapoil* is documented;[19] today there are three plaster versions: in the Albright-Knox Gallery, Buffalo, New York; in the Musée des Beaux-Arts, Marseille; and in a private collection in Milan. Recently Joan M. Lukach proposed that the Buffalo statuette is the only one cast from Daumier's original clay model.[20] Two bronze editions were produced posthumously from this plaster by the Siot-Decauville foundry about 1890 and by Alexis Rudier in 1925.[21] The sculpture exhibited here is numbered "17" in the Siot-Decauville series. In 1959–60, a third edition of thirteen bronzes was cast by the Valusani foundry from the plaster figure in the Milanese collection. In addition to the fifty-five known bronze *Ratapoil*s, an unlimited number of reproductions cast from the Rosenwald bronze is currently produced in a synthetic material by Alva Museum Reproductions. A.D.

90.
Sad Appearance of Sculpture Placed in the Midst of Painting
Lithograph
h: 9¾ in. (24.8 cm.); w: 8¼ in. (21 cm.)
1857
Signed: h.D. (at lower left)
Caption: Triste contenance de la Sculpture placée au milieu de la Peinture (below)
Lender: The Art Institute of Chicago

Since the beginning of the nineteenth century, one of the most frequently repeated complaints of Salon reviewers was the relatively shabby treatment of sculpture, as compared with painting, at the annual exhibitions. The Salon sculpture reviews from the 1830s through the 1850s, in periodicals such as *L'Artiste,* almost invariably began with general remarks on the current state of sculpture relative to that of painting. Although critics differed in their opinions on this matter, they generally agreed that the sculptor's profession, if not necessarily his art, was more difficult. This was attributed to various factors including the greater expense of the sculptor's materials, the greater dependence of sculptors upon commissions, the indifference of the general public toward sculpture, and the inadequacy of the space provided for display of sculpture at the annual Salons. As Théophile Gautier summarized in his review of the 1857 Salon, "La situation des sculpteurs est donc des plus difficiles."[22]

Daumier was sensitive to the sculptor's problems—undoubtedly through his friends Préault, Feuchère, Michel-Pascal, and Carrier-Belleuse—and he touched upon them in many of his caricatures. Of his seven prints in the series *Le Salon du 1857,* published in *Le Charivari* from June through August 1857, three deal with the exhibition of sculpture: *Sad Appearance of Sculpture in the Midst of Painting* (exhibited here); *What, the sculptures are in this cellar? . . . Never mind seeing them, I'm afraid of rats!* (Delteil no. 2960); and *Decidedly, that which obtained the greatest success at the sculpture exhibition this year . . . are the ducks!* (Delteil no. 2962). The latter two works deride the dark, dank rooms, provided for sculpture at the exhibition while *Sad Appearance of Sculpture . . .* is probably Daumier's most telling jibe at the public indifference. Heads raised, gazing at paintings, the seated spectators all turn their backs to the work in their midst. The sculpture which Daumier invented to be ignored—a screaming female figure with fists clenched in rage—is a sort of allegory of frustration. Possibly it was inspired by the plight of Aimé Millet's *Ariadne Abandoned* which, at the Salon of 1857, was first exhibited in the center of one of the painting rooms but then removed to a garden outside.[23] P.F.

91.

**Caricature of Albert-Ernest
Carrier-Belleuse (1824–1887)**

Lithograph
h: 14½ in. (36.8 cm.); w: 11¼ in. (28.6 cm.)
1863
Signed: (on lower right) H. Daumier
(printed in reverse)
Inscribed: A. CARRIER-BELLEUSE (lower
center); Lith. Destouches Paris (lower left)
Lender: Private Collection

One of twelve lithographs Daumier executed for the journal *Le Boulevard,* this portrait of Carrier-Belleuse was published May 24, 1863. Within Daumier's vast graphic oeuvre it is one of the rare caricatures of a personal friend. Preliminary drawings—at least four survive[24]—may have been made in 1862, the year Carrier-Belleuse executed a terracotta bust of Daumier (Musée de Versailles). Carrier-Belleuse was affectionately nicknamed "grosse-tête" (big head),[25] and Daumier capitalized on this trait.

The portrait not only exaggerates the large head of Carrier-Belleuse but also spoofs his enormous productivity and the facility of modeling for which he was well known and, at times, criticized.[26] Carrier-Belleuse made portraits of more than two hundred different sitters and created again as many historical and fantasy busts; many of these works were produced in numerous versions. He perfected the art of mass producing "hand modeled" terracottas (see cat. no. 52). Daumier portrayed Carrier-Belleuse as a maestro, standing on a podium and orchestrating, as it were, two works at the same time, pulling the mouth of one bust while he pokes the eye of another. The audience for this comic virtuoso performance is composed of rows of already completed portraits. Interestingly, these portraits resemble not so much the work of Carrier-Belleuse, but rather the sculpture of Daumier. P.F.

90.

91.

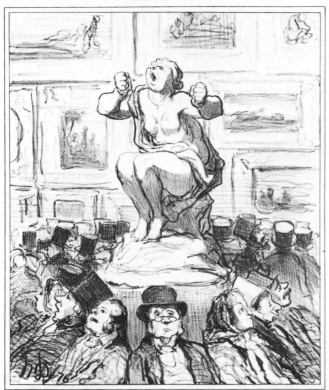

Triste contenance de la Sculpture placée au milieu de la Peinture.

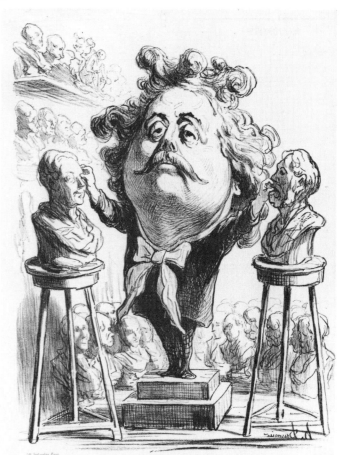

A. CARRIER-BELLEUSE

Notes

1.
Larkin, 1966, pp. 5–6, describes the controversy over whether his first lithographs date from 1822–1824 or 1830.

2.
Ibid., p. 7.

3.
The accompanying text reads: *"La Caricature . . .* promised a gallery of portraits of the celebrities of the Juste-Milieu, whose likenesses, conscientiously studied would possess that energetic character, that burlesque trait, known as a *charge.* Accustomed to finding all possible means of success for its publications, *La Caricature* deferred the realization of this project for some time so that it could have each personage modeled en maquette. These drawings were executed after these modelings of clay." Cited in Cambridge, 1969, pp. 29–30. For the hypothesis that Daumier modeled these busts on two occasions, between January and April 1832, and between 1830 and 1835, see Milan, 1961, pp. xv-xx, and Cambridge, 1969, p. 30.

4.
Ibid., p. 30.

5.
During his lifetime, Pataille (1781–1857), President of Aix and deputy from Bouches-du-Rhône, was noted for his "vigorous eloquence, his tight dialectic, his irresistible argument;" ibid., p. 122.

6.
Prunelle (1774–1853) was a doctor, Mayor of Lyon, and a deputy blessed with excellent administrative abilities; ibid., p. 133.

7.
Ibid., p. 133.

8.
Milan, 1961, pp. 12–13.

9.
For more on the composition of the work, see M. Rueppel, "Bas-Relief by Daumier," *Minneapolis Institute of Arts Bulletin,* Spring 1957, XLVI, no. 1, part 2, p. 9.

10.
For a brief discussion of the dating of the sculpture, see Cambridge, 1969, p. 174.

11.
Ibid., p. 178.

12.
Illustrated in ibid., p. 180.

13.
It was acquired by the Ny Carlsberg Glyptotek in Copenhagen in 1947.

14.
Alexandre, 1888, pp. 295–96.

15.
Larkin, 1966, p. 103.

16.
H. Vincent, *Daumier and His World,* Evanston, 1968, p. 143.

17.
Alexandre, 1888, pp. 295–96.

18.
Gobin, 1952, p. 294.

19.
Ibid., p. 294, asserted without documentation that two plasters were originally cast.

20.
Cambridge, 1969, p. 169. Lukach believes that the Marseille plaster, marked with a Siot-Decauville stamp, was made from a bronze cast by that foundry. The Milan plaster figure was probably produced from the Buffalo version; see ibid., pp. 17–21, 169.

21.
Twenty bronzes were cast in the Siot-Decauville edition at the French government's expense. Another twenty were produced by Rudier for Henry Bing. For a detailed discussion of the casting of *Ratapoil,* see ibid., pp. 161–69.

22.
Gautier, 1857, p. 161.

23.
Ibid., p. 162.

24.
Maison, 1968, II, cat. nos. 47–50.

25.
Salmson, 1892, p. 70.

26.
For example, Champfleury, 1865, pp. 60–66, says that Daumier's bust of Carrier-Belleuse bears "faults of . . . 'fato presto.'"

Selected Bibliography

Alexandre, A., *Honoré Daumier, l'homme et l'oeuvre,* Paris, 1888.

Geffroy, G., "Daumier sculpteur," *L'Art et les Artistes,* April–September 1905, pp. 100–108.

Delteil, L., *La Peintre-Graveur illustré Honoré Daumier,* 11 vols., Paris, 1925–30.

Gobin, M., *Daumier Sculpteur, 1808–1879,* Geneva, 1952.

Milan, Museo Poldi Pezzoli, *Daumier Scultore,* exh. cat. by D. Dubré, 1961.

Dubré, D., *Daumier,* I maestri della scultura, fasc. 52, Milan, 1966.

Larkin, O., *Daumier, Man of his Times,* New York, 1966.

Wasserman, J., "Les Emigrants, a Bronze Relief by Honoré Daumier," *Fogg Art Museum Newsletter,* October 1966, IV, pp. 3–4.

Maison, K.E., *Honoré Daumier, Catalogue Raisonné of the Paintings, Watercolors and Drawings,* 2 vols., London, 1968.

Cambridge, Mass., Fogg Art Museum, *Daumier Sculpture: A Critical and Comparative Study,* exh. cat. by J.L. Wasserman, J.M. Lukach, and A. Beale, 1969.

Roger-Marx, C., *Daumier,* Chefs-d'oeuvre de l'art, grands sculpteurs, fasc. 135, Paris, 1969.

Louisville, 1971, pp. 125–33.

PIERRE-JEAN DAVID D'ANGERS
1788 Angers–Paris 1856

Pierre-Jean David was born in modest circumstances, the son of a woodcarver of Angers who specialized in ornamental work. During the Revolution his father took along the little boy when he fought in the republican army, and David remained a staunch and openly declared republican throughout his life in opposition to the succession of monarchies that accounted for few of his major commissions. The Angevin painter Delusse, an early teacher, sent him to Paris in 1808, where David worked with Philippe-Laurent Roland (1746–1816). In Napoleonic Paris the name "David" meant the greatest painter of the time, Jacques-Louis David; Pierre-Jean therefore added the name of his native town to his own and has ever since been known as David d'Angers. On recommendations of the aged sculptor Pajou and of J.-L. David, he received a generous fellowship from his native town and during its long extension received the Prix de Rome, spending 1812 through 1815 in the papal capital. There, in 1814, he began his forty-year career as the most indefatigable of great portraitists with a medallion of the composer Herold. Soon after his return from a brief and frustrating trip to London in 1816, he received his first major commission. Roland had died while he was working on the sketch-models for a colossal marble statue of the Grand Condé for the Pont de la Concorde, and it was decided that his promising young student should inherit the project (see cat. no. 92 and the essay on "Portrait Sculpture"). David produced a colossal marble cavalier which became a clarion call of future French Romanticism in sculpture. Its execution stretched over nearly a dozen years, during which he received numerous major and minor commissions that allowed him to explore alternatives to the bold new proposition of the *Condé*. Most important were a group of Christ, the Virgin, and St. John *(Calvary)* of 1821, for the cathedral of Angers, exceptional for this agnostic; a monumental marble pedestrian René d'Anjou in Aix-en-Provence (1818–22); memorials to General Bonchamps in Saint-Florent-le-Vieil (1819–24) and the famous author Fénelon, Bishop of Cambrai in that city (1821–26); several tombs, the most important that of General Foy in Père-Lachaise cemetery (1827), its monumental standing marble figure complemented with a cycle of bio-graphical reliefs; and the memorial to Marco Botzaris, with its lovely figure of a Greek girl mourning the hero (the model is in Angers; the damaged Athenian monument was posthumously restored in Paris). Of these, the *Bonchamps* and the *Greek Girl* are both beautiful and eloquent—and not susceptible of ready-made art historical categorization. In any event, David seems to have found that the explorations undertaken in arriving at the destinations represented by these and other early works—including a host of busts and medallions from what might well be called the "Condé phase"—had led into byways. A member of the Institut from 1825 and a professor at the Ecole des Beaux-Arts, he seems nevertheless to have taken stock of his career and his life at forty (c. 1828) and decided on new directions for the future.

For the matured David, art was a subsumption of moral philosophy: both the special faculty and the obligation of sculpture are to glorify great men, noble causes, and inspiring accomplishment in thought, politics, the sciences, and the arts. Yet even though ethics must rule aesthetics, clearly only excellent, vital art could preach David's philosophy with persuasive conviction. In these very years David became the friend of all the major Romantic writers, not only those already established, such as the precursory Chateaubriand and the precocious Lamartine, but especially the more radical extreme that emerged in the late 1820s and above all Victor Hugo and his circle (Nodier, Gautier, Merimée, et al.). In 1828 he made a manifesto of his admiration for the art of Delacroix in the form of a portrait medallion of the painter. Obviously the man who soon afterward was judged by Lenormant in 1831 as the one who "has undertaken the revolution of sculpture," and by Thoré in 1844 as responsible for the regeneration of our school," had to devise forms and techniques that would provide new aesthetic means for his new ethical ends. From about 1828, his portrait busts increasingly demonstrate a new, modern imagery of exploratory morphology, capable of both conveying and eliciting higher intensities of emotional and spiritual communication. The physiognomy of Lavater and the phrenology of Gall and others were David's points of departure, but the expressive forms are his own: a systematic hyperbole of towering foreheads often arbitrarily furrowed or frowning, vastly domed craniums, lengthened and ennobled noses and necks, visionary eyes (their blankness in Neoclassical sculpture yielding to the subtlest soft-focus approximation of iris and pupil), splendid Romantic coiffures often endowed with gesticulatory eloquence, and upward- or downward-tilted heads with a variety of unfamiliar results. The *Lamartine* of 1828, the *Chateaubriand* and *Goethe* of 1829, and the *Paganini* (fig. 25) of 1830–33 illustrate the rapid emancipation of the style and form of David's imagery. This demands, and in the *Paganini* receives, equivalent innovations of technique that amount to a revolution in modeled (as opposed to carved or hewn) sculpture. The soft clay, yielding to the impetuous pressures of powerful fingers and to the subjective interpretations dashed off by the modeling tools, assumes a configuration that seems hardly compatible with carved stone; neither do the rough and varied textures and sketchy surfaces, every fresh touch of which is graphologically idiosyncratic. The *Paganini* needed and got Gonon's superbly sensitive casting in bronze by the lost-wax process. Together with Barye's great bronzes of the same years, it made a definitive demonstration of the potentialities of modeled sculpture in bronze—fully rehabilitating this major but long-slighted sculptural means and elevating it at least to equality with marble —and is the basis for what later became an essential dogma of modern sculptural aesthetics.

The bronze statue of *Jefferson* in Washington (1832–3, fig. 26a, b and cat. no. 99) expanded this art—somewhat moderated for public decorum—to monumental scale. It is the first in a long series of bronze memorial sculptures that established worldwide norms for nearly a century. A few of David's most outstanding examples are the *Riquet* of 1838 in Béziers, the *Paré* in Laval and the *Carrel* in Saint-Mandé of 1839, the *Gutenberg* of 1840 in Strasbourg (cat. no. 102), the immense *Jean Bart* in Dunkerque of 1845, the *René d'Anjou* in Angers of 1846, and the *Bichat* in the Parisian Ecole de Médecine of 1855.

Even the few works by David that might be thought of as "art sculpture," such as the *Philopoemen* (1837, cat. no. 101), are actually didactic, never art for art's sake, as are the famous nudes of his great rival Pradier (cat. no. 179).

The most neglected of all of David's neglected accomplishments are his history reliefs, another genre in which his prolificacy was unequalled. His two most ambitious relief projects were the Triumphal Arch (Porte d'Aix) of Marseille (1828–35) and the pediment of the Panthéon (1830–37). His veneration of both Phidias and Jean Goujon obviated imitation but impelled him to extract from them and from more recent Neoclassical relief styles basic principles of architectural relief and frieze form. These teeming compositions of very low-relief figures, often stylized into patterns like imbrication, intimate a private archaism without immediate aftermath. At the same time they are an early prophecy of the importance of the primitive and the archaic for future innovations in modern sculpture. David's was the only bas-relief art of recent times to be singled out for enthusiastic praise by Rodin.

After the Revolution of 1848 this lifelong republican and sympathizer with early socialism briefly but vigorously entered political life. He was a departmental deputy, as well as mayor of his Parisian arrondissement. Immediately after the 1851 coup d'état that made Napoleon III emperor, he went into exile for a year (to England, Greece, and Belgium). Another important aspect of David's accomplishment was his three-decade tenure as professor of sculpture at the Ecole des Beaux-Arts. Among his many dozens of students were the two most interesting sculptors among the younger arch-Romantics, Auguste Préault and Hippolyte Maindron. Later, J.-B. Clésinger, whose sculpture represents the transition to the Second Empire, and Carrier-Belleuse, whose early work embodies that next phase of French civilization, both studied for a while with David, as did many others whose names are soon likely to become more familiar (J.-L Brian, Cavelier, Franceschi, the painter Hébert, Princess Marie of Orléans, Aimé Millet, Perrault, and Schoenewerk, to name a few).

During the second quarter of the nineteenth century, David was considered by a majority of French critics and intellectuals to be the great representative sculptor of his time. Although they were increasingly admired, Barye and Rude seemed somehow special and apart, rather than norms. The whole generation had been able to see David's immense production one work at a time, before each was dispatched to the provinces or to private retreats. But for Rodin's generation and those to follow, except for the ubiquitous medallions, only the *Philopoemen,* in the Louvre, was readily accessible among the master's major works. Uncountable thousands of later derivations from his monuments not only obscured the force and originality of David's prototypes, but eventually even made the whole tradition of public memorial sculpture irrelevant to the makers and the audience of modern art. In Angers the vast accumulations of mainly plaster models were crammed into inadequate spaces that looked like storerooms. Those who ventured there were suddenly confronted with an indigestible surfeit, as large collections of dusty plaster casts suddenly seemed to be chambers of horror and began to be recklessly destroyed everywhere. David's best works were not so much disdained as almost unknown. Still, even though Rodin was also probably not familiar with most of them, there is a kernel of truth in his deliberately over-simplified judgment of David: in comparison with Rude, Barye, Carpeaux—and Rodin himself—David is a great sculptor who did not produce a great masterpiece on a level with theirs.[1] But David had other goals and convictions. J.H.

92.
The Grand Condé
Bronze
h: 14 in. (35.6 cm.); w: 6⅞ in. (17.5 cm.); d: 5½ in. (14 cm.)
Model c. 1817
No marks
Lender: Private Collection

Everywhere in the Occidental world of 1816, the paragon not just of sculpture but of art itself had been for three decades the Neoclassical marbles of the Romanized Venetian Antonio Canova. David d'Angers' model for his rousing statue of *The Grand Condé* was the critical milestone that indicated the turn toward Romanticism in sculpture, much as Géricault's even more uninhibited pictures of spirited or pathetic military figures, painted during these same years, marked the beginning of French Romantic painting (see the essay on "Portrait Sculpture"). For decades, statues and groups had been antiquarian in imagery and becalmed in theme and composition; even the very rare examples of violent physical action, such as Canova's *Hercules and Lichas* of 1795–1815, are not real exceptions, since formal priorities of compositional equilibration and of the closures of contours and of relieflike planarity contrive to cast an aesthetic spell on action, immobilizing it as a beautiful tableau. The Restoration government of the Bourbon Louis XVIII had chosen to displace the Napoleonic associations of Neoclassicism and its Greek and Roman heroes by reviving the *ancien régime*'s exploitation of the much less hackneyed and more immediately patriotism-inspiring heroes of the glorious Bourbon past, especially those of the seventeenth century who had helped to establish France as the most prestigious country in the world. On the other hand, the equally patriotic but firmly republican David could recall Condé's occasions of opposition to the crown; and, more important for the coming art of Romanticism, he could also galvanize the old eighteenth-century traditions of *style trouvère* into much more excitatory and thus more Romantic evocations of the glorious deeds of dashing cavaliers. Later, David's young friend, the critic Charles Blanc, described the "arrant boldness of its movement, as agitated as marble can permit, vibrant in its stability."[2] The old David himself liked to explain his intentions with a metaphorical story of a simple woman of the masses who looked at the model in 1817 and exclaimed, "A hurricane!"[3] No one had ever reacted to a Neoclassical statue in that way.

One of the first decisions of the government of the restored Louis XVIII in 1815 was to reactivate the patriotic propaganda of his brother, Louis XVI, by commissioning a dozen colossal marble statues of great Frenchmen to stand on the Pont Louis XVI (now Pont de la Concorde), which extends

the north-south axis of the imposing urban complex of the Place de la Concorde from the Madeleine to Poyet's new façade for the Palais Bourbon (Chambre des Députés).[4] The statue of the Grand Condé was allotted to David d'Angers' master, Phillipe-Laurent Roland, who had distinguished himself in 1787 in his smaller but still monumental marble statue of the same subject in the d'Angiviller cycle of great men,[5] a work admirably analyzed by David himself in an extensive study of his master, published in 1846.[6] Roland died in July 1816, leaving only a sketch-model for a quite different interpretation of the Grand Condé, precisely described by David in his essay.[7] David had made a brief trip to London, returning only a week after Roland's death; the Minister of the Interior François Grille made the courageous decision — which surely he would not have dared without the persuasive insistence of the dying Roland — to transfer the commission to Roland's most promising student. In spite of grave afflictions — among them, the death of his beloved sister Louise, who was sharing David's straitened circumstances in Paris — David completed the huge, half-sized plaster model (2.11 m., Musée des Beaux-Arts, Angers) in time for the opening of the Salon of 1817.[8] A full decade passed before the immense marble was ready for exhibition. Because of its size it could not be shown in the Louvre, but the *Livret du Salon de 1827* announced that it could be seen in the government ateliers in the esplanade of the Invalides. The decision to install the statue instead in the forward Cour d'Honneur at Versailles seems to have been part of Louis-Philippe's program to make the great château into a museum of national history. Between the First and Second World Wars, it was decided to move the military subjects to the Academy of Saint-Cyr, where they were demolished during the bombardments of the Second War.[9]

David decided not to continue Roland's recent iconography but rather to return to that of his master's earlier statue in the d'Angiviller series, undoubtedly inspired by the text of Turpin's *La France illustrée ou le Plutarque français* (1775—80). The

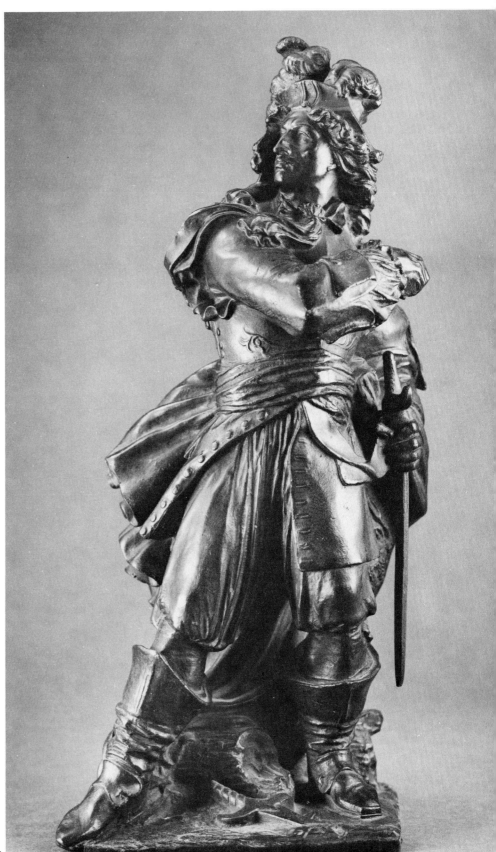

92.

twenty-three-old officer has dismounted from his horse to lead on foot his volunteers in the charge against the Bavarian troops at Freiburg, in 1644. Leaning forward beyond the point of balance in a vigorous stride that sends his cloak streaming behind him, his head turns back to exhort his courageous, outnumbered soldiers. His right hand grasps the baton that in a moment he will hurl defiantly at the enemy.

The plaster sketch-model, 36 cm. high, belonged to the sculptor Crauk, who left it to the Musée des Beaux-Arts in Angers. The 1934 catalog of the museum describes it as "retouched by David,"[10] which seems to confirm what Madame David wrote Jouin in 1867, namely that the more "finished" model ("esquisse soignée") had been retouched by David himself in preparation for the edition as a bronze figurine.[11] A small bronze of the composition in the Louvre (no. 1011), which Lami records as given by David's daughter Madame Hélène Leferme,[12] measures three cm. higher than this Crauk-Angers model; the example in our exhibition, at 14 inches only slightly smaller than that model, is perhaps more immediately derived from it. A crayon drawing of the Condé is listed in the 1934 Angers catalog (no. 918, 30 cm. high, c. 11⅞ in.).

Certain small bronze reductions of David's monumental statues, such as the *Philopoemen* (cat. no. 101) and the Barbedienne edition of the Ambroise Paré monument in Laval, appear occasionally on the Parisian art market. The edition of the *Condé,* prepared with David's own retouching of the model, must have been smaller, since it is seen much more infrequently.

J.H.

93.
Théodore Géricault (1791–1824)
Bronze
diam: 5⅞ in. (14.9 cm.)
Signed and dated: DAVID/1830
Inscribed: GERICAULT PICTOR
No foundry mark
Lender: Los Angeles County Museum of Art, purchased with funds donated by Camilla Chandler Frost

94.
Pierre-Paul Prud'hon (1758–1823)
Bronze
diam: 6¾ in. (17.1 cm.)
c. 1830
Signed: P.J. DAVID
Inscribed: Prud'hon
Foundry mark: Eck et Durand (on back)
Numbered: 389 (on back)
Lender: Private Collection

95.
Seventeen Bronze Portrait Medallions Mounted on Wood Panel
h: 28⅜ in. (72.1 cm.); w: 51 in. (1.3 m.); d: 2 in. (5.1 cm.)
Lender: Hirshhorn Museum and Sculpture Garden, Smithsonian Institution, Washington, D.C.

a. François René de Chateaubriand (1769–1848)
h: 5¼ in. (13.3 cm.); w: 5⅛ in. (13 cm.)
Signed and dated: DAVID/1830
Inscribed: CHATEAUBRIAND
b. Gasparo Spontini (1774–1851)
h: 5½ in. (14 cm.); w: 5⅞ in. (14.9 cm.)
Signed and dated: DAVID/1830
Inscribed: SPONTINI

94.

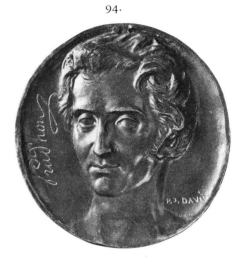

c. Antoine-Jean, Baron Gros (1771–1835)
diam: 6⅝ in. (16.8 cm.)
Signed and dated: P.J. DAVID/1832
Inscribed: A.J. Gros
d. Auguste-Marseille Barthélemy (1796–1867)
h: 6⅜ in. (16.2 cm.); w: 6⅝ in. (16.8 cm.)
Signed and dated: P.J. DAVID/1832
Inscribed: MARSEILLE-AUGUSTE/BARTHELEMY
e. Charles Lenormant (1802–1859)
diam: 5⅝ in. (14.3 cm.)
Signed and dated: DAVID/1830
Inscribed: CHARLES/LENORMANT
f. Jean-Pierre de Béranger (1780–1857)
diam: 5⅝ in. (14.3 cm.)
Signed and dated: DAVID/1830
Inscribed: J.P. DE BERANGER
g. Alphonse-Marie-Louis Prat de Lamartine (1792–1869)
diam: 5⅝ in. (14.3 cm.)
Signed and dated: DAVID/1830
Inscribed: ALPHONSE/DE LAMARTINE
h. Charles Nodier (1780–1844)
diam: 6 in. (15.2 cm.)
Signed and dated: DAVID/1831
Inscribed: CHARLES NODIER
i. Frédéric-Louis Zacharie Werner (1768–1823)
diam: 6½ in. (16.5 cm.)
Not dated (c. 1830)
Signed: P.J. DAVID
Inscribed: FREDERIC LOUIS ZACHARIE WERNER DE KOENISBERG [*sic*]/LES FILS DE LA VALLEE/LA CROIX A LA MER BALTIQUE/MARTIN LUTHER 1806/ATTILA/WANDA/24 FEVRIER/CUNEGONDE/LA MERE DES MACHABEES/P.J. DAVID

93.

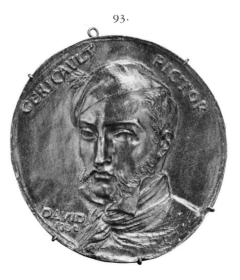

j. Pierre-Simon Ballanche (1776–1847)
diam: 5⅝ in. (14.3 cm.)
Signed and dated: DAVID/1830
Inscribed: P.S. BALLANCHE
k. George Gordon, Lord Byron
(1788–1824)
diam: 5¾ in. (14.6 cm.)
1830–32
Signed: DAVID
Inscribed: LORD BYRON
l. l'Abbé Hugues-Félicité-Robert de
Lamennais (1782–1854)
h: 6¼ in. (15.9 cm.); w: 6⅜ in. (16.2 cm.)
Signed and dated: DAVID/1831
Inscribed: LABBE/DE LA MENNAIS
m. Alfred Johannot (1800–1837)
h: 6⅛ in. (15.6 cm.); w: 6¼ in. (15.9 cm.)
Signed and dated: DAVID/1831
Inscribed: ALFRED JOHANNOT
n. Léon Cogniet (1794–1880)
h: 5⅝ in. (14.3 cm.); w: 5¾ in. (14.6 cm.)
Signed and dated: DAVID/1831
Inscribed: LEON COGNIET/PICTOR

o. Guillaume-Charles Pigault-Lebrun
(1753–1835)
diam: 5½ in. (14 cm.)
Signed and dated: DAVID/1831
Inscribed: PIGAULT LEBRUN
p. Louis-Jean-Népomucène Lemercier
(1771–1840)
h: 6½ in. (16.5 cm.); w: 6⅝ in. (16.8 cm.)
Signed, dated, and inscribed: P. J. DAVID 1832/
AGAMEMNON/OPHIS/CLOVIS/FREDEGONDE/
CHARLEMAGNE/LOUIS IX/CHARLES VI/
PINTO/PLAUTE/CHRISTOPHE COLOMB/
RICHELIEU OU LA JOURNEE DES DUPES/
MOYSE [sic] HOMERE ET ALEXANDRE/
L'ATLANTIADE/LA PANHYPOCRISIADE/
NEPOMUCENE L. LEMERCIER
q. Benjamin Constant (1767–1830)
diam: 5⅞ in. (14.9 cm.)
Signed and dated: DAVID/1832
Inscribed: BENJAMIN/CONSTANT

95.

97.

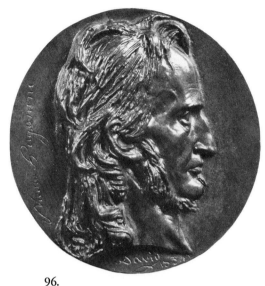

96.
George Sand (1804–1876)
Bronze in gilt bronze frame
diam: 7¼ in. (18.4 cm.) without frame;
8¼ in. (21 cm.) with frame
Signed and dated: David 1833
Inscribed: George Sand
No foundry mark
Lender: Michael Hall, Esq., Connecticut

97.
Nicolo Paganini (1784–1840)
Bronze
diam: 6⅝ in. (16.8 cm.) (top to bottom);
5⅞ in. (14.9 cm.) (left to right)
Signed and dated: David 1834
Inscribed: Nicolo Paganini
Foundry mark: Eck et Durand (on back)
Numbered: 358 (on back)
Lender: Los Angeles County Museum of
Art, purchased with funds donated by Elsa
Lanchester

98.
Architecture
Plaster
diam: 11½ in. (29.2 cm.)
Signed and dated: DAVID/1839 (lower
right)
Inscribed: A LA MEMOIRE/DE CHARLES
PERCIER/ARCHITECTE/MEMBRE DE
L'INSTITUT/SES ELEVES/SES AMIS ET LES
ADMIRATEURS/DE SON GRAND TALENT/ET
DE SON NOBLE/CARACTERE (on left); NE
A PARIS/LE 22 AOUT 1764/MORT LE
5/7ᴮᴿᴱ1838 (on right) ARCHITECTURE
(at bottom center)
Lender: Private Collection, New York

96.

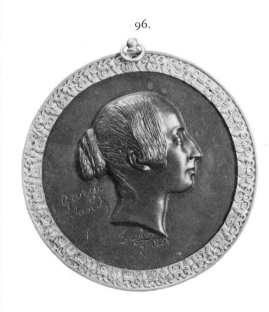

Over a period of just forty years David produced more than 500 medallions. The first was a portrait medallion of Ferdinand Hérold (1791–1833), the future composer of *Zampa* and *La Fille Mal Gardée,* made in 1815 when both men were fellows of the French Academy in Rome, and the last was of the painter Rosa Bonheur, made in 1854, the year following the enormous Salon success of her huge *Horse Fair* (New York, Metropolitan Museum). Most often the portraits are in true profile, although many are in variations of a three-quarter angle. A rule-proving exception is the distinguished Byronic image of Uriah Phillips Levy, an American navy lieutenant and the donor of David's bronze *Jefferson* in the Washington Capitol (1833), in exactly frontal, full-face view, and set in an exceptional but by no means unique concavity that attains the depth of a centimeter. All but a few medallions are one-sided, usually modeled for sand casting in bronze rather than to be minted, although a few were later adapted by others and struck as medals. Cheap plaster casts were made widely available; indeed, the generous sculptor sometimes presented his sitters with molds for producing their own copies in plaster. Most of them are thirteen to eighteen cm. in diameter, but there are exceptions, such as the large *Architecture* in memory of Percier (cat. no. 98). Some were modeled in wax, others in clay.

The earlier medallions do not seem to constitute a definable moral program, but from about his fortieth year David consciously planned what he called his "Gallery of Great Men" as an enduring didactic encyclopedia. Predictably and happily, the Gallery is full of surprising inconsistencies, but the socially and artistically progressive criteria that prevail are generally exemplified by men and women whose works were consonant with the values of the rather severe and straight-laced David. The exclusions are telling. In music, for example, certain composers demanded recognition: the austere art of Cherubini (medallion, 1840) or Spontini (cat. no. 95b, 1830, soon after the premier of his experimental opera *Agnese di Hohenstaufen),* or the grandeur and stirring popular heroism of the first grand opera of High Romanticism, *William Tell* (1829) by Rossini (medallion, 1829); however, David presumably was deafened to the genius of Chopin and Berlioz by what seemed to him

98.

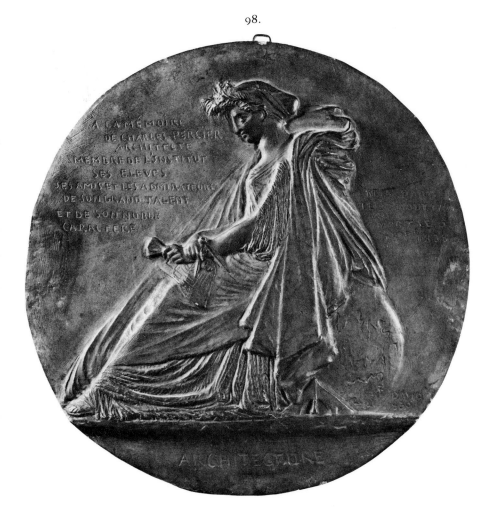

the time of her first successes, *Indiana* and *Lélia*. Many less familiar writers are honored for their social and philosophical views, such as Ballanche (cat. no. 95j), idealist and prophet of social renovation, or Barthélemy (cat. no. 95d), a dissident satirical poet persecuted by government reactionaries. David also honors certain writers like the German dramatic poet Zacharie Werner (cat. no. 95i). The American authors in this pantheon are, predictably, James Fenimore Cooper (1833) and Harriet Beecher Stowe (1853). In painting, David pays homage to all the greatest masters of the older generation, such as J.-L. David, Prud'hon (cat. no. 94), Baron Gros (cat. no. 95c), Ingres, and especially the late forerunner of Romantic painting, Géricault (cat. no. 93), but also to many of the contemporary Romantics, beginning with Delacroix (1828) and including such representatives of the less extreme middle way as Cogniet (cat. no. 95h) and the charming illustrator and history painter Alfred Johannot (cat. no. 95m). In landscape painting, David remained for generations one of the few Frenchmen to know and understand the genius of Caspar David Friedrich, whose profound mysticism demanded recognition in the Gallery (medallion, 1834); but the aesthetic landscape of Corot and the naturalistic landscape of Rousseau apparently did not satisfy David's ethical demands. American collectors (and hence this exhibition) have rather slighted a distinctive yet representative aspect of the Gallery: its glorification of every stripe of political liberalism. The medallion of the extraordinary theologian Lamennais (cat. no. 95l) was taken at the time of his transformation from a favorite of the establishment who could have been a cardinal into a radical populist who believed that the revitalization of the Church could come only from the people, and whose inevitable rupture with Rome followed a few years later. Benjamin Constant (cat. no. 95q) is included not as the attractive *petit maître* of Romantic letters known today but as the exemplar of the moderate liberalism of the not always quite loyal opposition during the Restoration. The Gallery provides a remarkable anthology of political radicals, beginning with the numerous medallions of the old *conventionnels* of the Revolution whom David ferreted out from sometimes obscure retirement and whose wonderful ancient faces occasioned some of his most moving portraits. There are several generations and many varieties of socialists—

egocentricity without a loftier moral purpose. One can only guess why the sculptor was so moved by the virtuosity of the violinist Paganini (cat. no. 97) but not by that of Franz Liszt. David was a close friend of nearly every important writer of that golden age of French literature —poetry in praise of his sculpture was published by Victor Hugo, Nodier, Sainte-Beuve, and numerous others—and the medallions in this exhibition provide a characteristic sampling of his literary preferences. There are the expected heroes who were recognized as the prophets of 1830 Parisian Romanticism, such as Chateaubriand (cat. no. 95a), Byron (cat. no. 95k), and the poet Lamartine (cat. no. 95g, 1830; in the same year Lamartine was the first Romantic accepted into the French Academy). In addition there are extraordinary profiles of Charles Nodier (cat. no. 95h), host to the inner circle of the radicals of Romantic literature, and of the young novelist George Sand (cat. no. 96) at

ranging from the more familiar *mon-tagnards* to the agrarian communism of Babeuf, whose follower Filippo Buonarroti (also a *conventionnel* and remotely related to Michelangelo's family) passed on the Babouviste principles to Blanqui (whom David hid in his house in 1840 and portrayed in a preparatory drawing for a medallion unfortunately never realized). There are portraits of Raspail, Louis Blanc, Barbes, and many others; but not of the young P.-J. Proudhon.

The belated maturity of David's philosophy (as we have seen, from about his fortieth year) coincided with his stylistic and technical maturity (see the essay on "Portrait Sculpture"), seen at its height in the greatest busts and medallions of the half-dozen years after 1828. The early medallions are attractive but scarcely distinguishable from the best works of numerous younger contemporaries who imitated them. But David's new powers of bold and expressive modeling now coordinate with a deeper understanding of the implications of physiognomy and phrenology, sciences to which David was passionately devoted, and with a more voraciously searching vision. The results are masterpieces like the bust of Paganini (fig. 25) or the more modest medallion of Lamennais (cat. no. 95l), tragically resigned to his destiny. Not a few of the best medallions are deeply affecting. As early as 1876, the critic Charles Blanc excerpted from David's private notes a passage that has since become famous as David's most quoted words: "I have always been profoundly stirred by a profile. The [full] face looks at us; the profile is in relation with other beings. It is going to shun you; it doesn't even see you. The [full] face shows you several characteristics, and it is more difficult to analyze. The profile is unity." Or, "the profile of the visage gives the reality of life, whereas the [full] face gives only the fiction."[13] These arresting passages have too often been presented as the abiding principles of David's art, but they actually represent only the notions of the moment, often contradicted by the much more deeply pondered sculptures themselves. Fine as it is, the medallion of Lamennais can hardly overwhelm the viewer with the heart-straining intensity radiated from the great marble bust of the theologian in Rennes, which David carved eight years later, in 1839.[14]

The problems of connoisseurship in David's medals cannot now be more than sketchily presented. Many fine and demonstrably early casts have no founders' marks. Numbers of those in David's Gallery at Angers were cast by Louis Richard (1791–1879) in association with his brother Jean-Jacques, and have the (sometimes rather illegible) mark "Richard Frères" on the reverse. By 1840, Richard joined Eck et Durand for at least a few years; but by the later 1840s and early 1850s the latter firm seems to have been preferred, not only by David but by many other leading sculptors, and the mark of Eck et Durand is found on some of the best as well as on other more ordinary casts. Recently a very large (and once perhaps more nearly complete) collection of the medallions has come to light, consecutively numbered and bearing such traces of founder's work as masses of wax; it seems quite certain they were foundry models from which further casts could be produced. Some have no founder's marks, others have "Richard Frères," and more read, "Eck et Durand." One has the otherwise unknown mark of "Thiebaut et fils" (with no accent) and is possibly the mark of the father of Victor Thiébaut (spelled both with and without acute accent), an important independent founder by 1860. Nos. 94 and 97 in the present exhibition come from this series of founder's models, which range in quality from ordinary respectability to exceptional excellence. Very satisfactory posthumous casts were produced by the Fumière foundry[15] (the possibility that the large founder's collection just referred to was once theirs may be hypothesized). Pirated castings (*surmoulages,* or casts of casts) of them existed from an early date: Etex reports in 1859 on the activities of bronze pirates who had long plagued David,[16] and M. Pastoureau of the medal cabinet in the Bibliothèque Nationale believes that at least some unauthorized copies were made about 1880 by one Liard.[17] Production of the medallions has continued for a century and a half. Samuel P. Avery of New York, who had a substantial collection, wrote in 1902, "Some [of the medallion portraits] are now supplied by the heirs of David at very low prices."[18] The 1934 catalog of the Angers museum offers plaster casts of the medal-

lions,[19] and for decades the salesroom of the Paris Mint (La Monnaie) has sold bronze casts of them: in 1979, several of David's most famous subjects were available. J.H.

99.
Thomas Jefferson (1743–1826)
Bronze
h: 15⅜ in. (39.1 cm.); w: 6⅝ in. (16.8 cm.); d: 4⅞ in. (12.4 cm.)
c. 1834
Signed: DAVID (on right edge of base)
Inscribed: JEFFERSON (on front) and Tout homme/a deux Patries/la Sienne/et/la France (on scroll)
Foundry mark: CIRE PERDUE/LE BLANC BARBEDIENNE/A PARIS (on back of base)
Lender: National Gallery of Art, Washington, D.C., Ferdinand Lammot Belin Fund 1975

Probably because it was commissioned by a foreigner in 1832 and shipped to America in 1833 without public exhibition in Paris, virtually everything that has ever been printed in France about David's bronze *Jefferson*—in over two dozen publications—is incorrect; one reads, for example, that it was financed by public subscription; it is invariably (and as recently as 1975) located in Philadelphia, and it is usually given the date 1834. The work was in fact privately commissioned by Lieutenant Uriah Phillips Levy (1792–1862), one of the first Jewish officers of the United States Navy, who had brilliantly speculated in Manhattan real estate and decided to devote a substantial part of his fortune to the memorialization of Jefferson: his hero had abolished religious discrimination in the armed forces. (In 1836 Levy bought Monticello, where the family lived well into the twentieth century.) Granted leave to visit Paris in 1832, Levy called on and charmed Lafayette with his altruisitc proposal. He was advised to go to Versailles to examine the colossal marble *Condé* of 1816–27 (cat. no. 92) by Lafayette's friend, David d'Angers. Levy pronounced it "magnificent." Lafayette then presented Levy to David and lent sculptor and patron his version of Sully's portrait of Jefferson. Work on the statue progressed steadily until January, 1833, when an otherwise unrecorded (and possibly fictional) indisposition of David's occasioned Levy's request for an extension

of leave.[20] By autumn, the bronze must have been en route, for Gustave Planche could announce in *L'Artiste* that "In some weeks, Philadelphia will own a statue of Jefferson,"[21] information that must have come from David himself, who would have known where the shipment was going. Since Jefferson is shown holding the Declaration of Independence, the possibility that Levy at some time intended his statue for Philadelphia cannot be excluded. In any case, on March 23, 1834, Levy was in Washington and wrote a letter to the House of Representatives officially offering it to the American people.[22] The bronze had certainly arrived in Washington before June 27, 1834,[23] and was set up temporarily in the Rotunda of the Capitol, whence, on February 16, 1835, the Senate resolved to have it put into storage pending a final disposition.[24] Soon after his inauguration in 1845, President Polk had it placed directly in front of the White House,[25] where it was photographed by Matthew Brady and remained until 1874, when it was installed in the Capitol's Hall of Statues.[26] In 1900 it was moved back to the Rotunda and remains there.[27]

It is understandable that French writers took no notice of Jefferson's absence from the company of large models given by David to his native town, since Planche has been as enthusiastic about Honoré Gonon's *cire-perdue* cast as he has been about David's sculpture, and it was well known that models had been sacrificed to produce Gonon's superlative bronze castings (e.g., Barye's famous *Tiger and Gavial*, of which the plaster, a sensation of the Salon of 1831, must have been destroyed in producing the brilliant cast of 1832 in the Louvre); the natural assumption was that David's model had met the same fate. The big plaster does survive, however, in a place as accessible as the Council Chamber in the City Hall of New York, and has even been amply published, admittedly in places no sane art historian would venture. Levy presented the handsomely patinated plaster to the city where his fortune had been made, and the Board of Aldermen gratefully accepted the offer on January 27, 1834, later proffering the document of acceptance to Levy in a gold box that cost $247.[28]

The exile of the bronze to remote Washington, however, removed an essential milestone from the ken of later plotters of

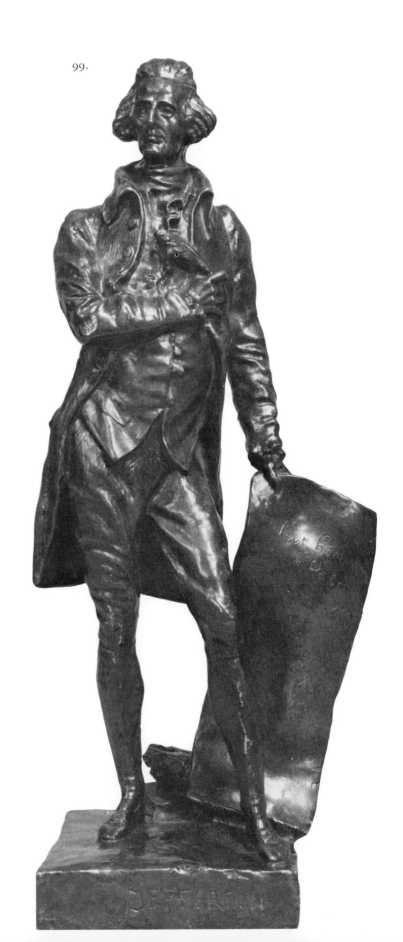

99.

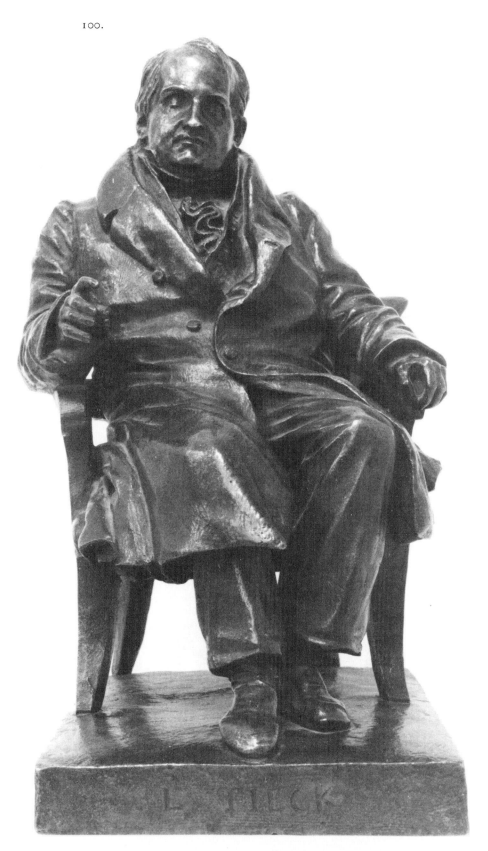

100.

the course of nineteenth-century sculpture. For decades, the choice of material of virtually every monumental bronze —nearly all of them equestrian monuments—has been determined by the incontrovertible decorum of tradition (Marcus Aurelius) and practical considerations of conservation; a rare pedestrian bronze here or there does not make even the exception that proves the rule.[29] Hitherto all of David's monuments and grander sculptures, as indeed every other major non-equestrian statue for decades, had been in marble. But the bold new extremes of expressive modeling explored by David around 1830 (see the essay on "Portrait Sculpture") demanded the precise record of his fingers, touches possible only in *cire-perdue*-cast bronze; in this very year of 1832, Honoré Gonon had demonstrated (with Barye's *Tiger and Gavial*) his mastery of the technique. Furthermore, Donatello and many other masters of the past had proved the aptitude of bronze for this intensity of realism and also for this kind of paintinglike differentiation of textures: Planche marvels at the way David has "been able to vary the cloth of every passage of clothing."[30] In sum, the *Jefferson* is the first modern public portrait-monument in bronze taking full aesthetic advantage of that medium, and the prototype of untold tens of thousands of derivations over the next hundred years.

Our reproductions (figs. 26 a–c) reveal striking differences between the extraordinary realism of the atrophied old man in the New York model and the somewhat more ennobled image in bronze, a revision probably wrought partly in the wax epidermis covering a lost working cast in plaster of the New York model and partly in the chasing of the bronze itself. Progressive critics in Paris offered the warmest praise: "one of his best and most solid works," cast "with religious fidelity" (Planche)[31] and "striking in its sentiment and its lifelikeness" (Thoré).[32] Nevertheless, it was too much to expect bumpkins in Washington to understand a statue so unlike the sleek marble of George Washington as an ancient Roman that Canova had sent years earlier to North Carolina. Senator Archer complained that "it was not of that finished order which...it ought to be."[33] Senator Mercer, unable to cope with the expressive distortions of David's High Romantic style, agreed "that it

was not a good likeness," [34] and a Southern senator, shocked at the unmarmoreal color of Gonon's sable bronze, swore, "By God, it makes old Tom a negro!" [35]

In addition to the full-size patinated plaster model in New York and the bronze in Washington, which Levy always called a "colossus" (at six feet seven inches, it is only slightly taller than one of the tallest men of his time), there must have been a sketch-model (now lost) for the composition, of which the Musée des Beaux-Arts in Angers has a beautifully retouched cast in bronze 39 cm. high, given by David's son Robert, and the Louvre a slightly larger one 40 cm. high, also probably given by Robert David and the likeliest candidate as the source of other Jefferson statuettes. The quantities of detailed photographs recently made of the figure in our exhibition indicate that it is a later cast, and this is confirmed by the cachet of the founder. On the other hand, it is unfair that a recent trend of American scholarship has sought to discredit late proofs of bronzes like this beautiful statuette. We may be grateful that it is possible in America to compare this perky and rather neo-Rococo maquette in the National Gallery of Art in Washington with the harshly realistic full-scale model in the New York City Hall and then with the nobler vibrations of the great bronze in the Capitol. J.H.

100.
Ludwig Tieck (1773–1853)
Bronze
h: 12½ in. (31.8 cm.)
Signed and dated: P.J. DAVID/1836 (on right side of base)
Inscribed: L. TIECK (on front of base)
No foundry mark
Lender: Helen Foreman Spencer Museum of Art, University of Kansas, Lawrence

This amiable statuette represents considerably more than at first meets the eye. One learns with surprise that what seems a characteristic portrait-statue composition of the mid- to late-Victorian era was actually modeled as early as 1834 and that it has received the most complete exegesis ever accorded a work of Romantic sculpture. [36] It was executed during David's second German trip in the autumn of 1834, a trip made principally to augment his Gallery of Great Men. He added to the Gallery medallions of writers and philosophers like Schelling, Ludwig Tieck,

and Chamisso, the architects Schinkel and Klenze, the painter Caspar David Friedrich, the composer Hummel, the sculptors Dannecker and Rietschel, and the artistic physician-anatomist Carus. David soon afterward made a bust of Carus, as well as monumental busts, eventually realized in marble, of Tieck and of the sculptor Rauch.

Ludwig Tieck, who in his youth had been greeted as a successor to Goethe and whose poetry, fiction, and criticism were fundamental to German and indeed continental Romanticism, had by 1834 settled into a professorial existence in Dresden as a sexagenarian elder statesman of literature. A French translation of some of his Romantic tales had been published in Paris the previous year (1833) and must have warmed the enthusiasm of David and his circle of literary friends. On October 24, David was presented to Tieck by the painter Carl Vogel von Vogelstein, who later worked up a painting that shows David sculpting the colossal bust of Tieck while Vogel is engaged on a painted portrait, surrounded by representatives of the intellectual and artistic world of Dresden—an unusually evocative biographical document of international Romanticism. [37]

Although David attended and was much impressed by one of Tieck's famous readings (a translation of *The Merchant of Venice*), he was disappointed that German literature had declined from the glory of the previous generation. David kept extraordinary notes of the successive sittings, which totaled twenty-four hours and produced both the huge official bust and this statuette. [38] The two works represent the opposite poles of his portraiture.

The big marble bust now seems cool, remote, and somewhat awkward. The dimmed Romantic writer, now decorous and dignified and sometimes not very outgoing, was scarcely capable of eliciting from David a mythical masterpiece such as his fairly recent busts of Lamartine, Chateaubriand, and Paganini; and it seems that in the bust of Tieck, the honest David could not dissimulate his disappointment. The much more human and vital portrayal of

Tieck in our bronze is an important index of a trend in much of David's portraiture during the following two decades, and indeed in the work of many progressive sculptors of the time. As the fires of Romanticism are (intermittently) banked, a recognizably sincere and searching naturalism becomes more and more apparent, with objectivity quite outweighing subjectivity. Among David's later portraits, those most admired by recent critics, such as the marble bust of Lamennais in Rennes (1839)[39] and the terracotta of Boncenne in Angers (1840),[40] are those that pursue this enterprisingly naturalistic vein.

In our exhibition, the Tieck statuette usefully complements other representative portrait figurines so typical of the decade, such as the *Louis-Philippe* (cat. no. 176) and *Darcet* (cat. no. 178) by David's rival Pradier, and the *Fanny Elssler* (cat. no. 4) by Barre. In David's oeuvre, however, the little Tieck is unique as the only full-length portrait designed for a small scale and distributed in little bronze and plaster casts, the production of which the artist initiated (he also authorized some commercial editions of other bronzes based on his small sketch-models or reduced from large works by the Collas system). Equally remarkable is the fact that of David's thirty-odd full-length portrait figures, this is the only one actually taken from life, and its unexpected *Gemütlichkeit* is, as Jacques de Caso observed, a "thaw . . . from his lofty, inaccessible conception of a hero." [41] The *Jefferson* of about 1834 (cat. no. 99) and this statuette of 1834–35 are the first examples of David's later standing and seated full-length naturalistic portrait figures in bronze, which provided the formulas for later nineteenth-century public portrait monuments everywhere. Many American campuses and parks have memorialized professors and judges and other worthies in much the same manner as this Tieck, comfortably seated in study-chairs—but these unintentional homages to David date from half a century later.

What Jouin believed to be the plaster maquette for this work belonged then (1877) to Xavier Marnier in Paris[42] but is not now traceable. De Caso has shown that what Jouin also called a "model" in patinated plaster in the Angers museum is

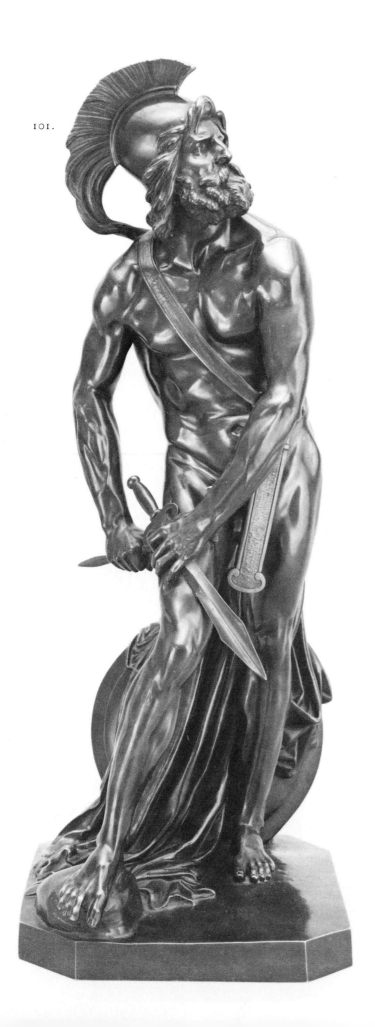

101.

actually just an example of an old plaster casting that seems to have enjoyed some currency in the nineteenth century (another is in Saumur). He also lists bronzes in Angers and Bayonne. Both Tieck himself and Carus, in Dresden, had copies. J.H.

101.
Philopoemen
Bronze
h: 25¾ in. (65.4 cm.); w: 10½ in. (26.7 cm.); d: 11½ in. (29.2 cm.)
Signed and dated: DAVID D'ANGERS 1837 (on back of tree stump)
No foundry mark
Lender: The David and Alfred Smart Gallery, The University of Chicago (Anonymous Loan)

The *Philopoemen* was commissioned in 1832 by the government of Louis-Philippe as part of a program of didactic marbles for the Tuileries Gardens, where some still stand. Charles Lenormant, one of David's most discriminating early admirers and perceptive critics, was then Director of Fine Arts. Knowing David's republican opposition to the new citizen-king, Lenormant used diplomatic skill in offering David government commissions the political and moral content of which the sculptor could not resist. Such was Philopoemen of Megalopolis (253–184 B.C.), "the last of the Greeks," patriotic general of the Achaeans, and victorious enemy of tyrants. The work must have presented the most arduous challenge of all the statue commissions of David's maturity (after 1830)—and remains today the most challenging of his masterpieces. The commission came at just the time (1832) when works like the busts of Chateaubriand and Goethe and the statue of Gouvion Saint-Cyr in Père-Lachaise had been completed in marble, and, more important, while others like the bust of Paganini (fig. 25) and the statue of Jefferson (cat. no. 99) were taking shape in more boldly modeled clay for casting in bronze—all explicitly modern works whose intense Romanticism had made David the recognized leader of the revolt against academic Neoclassicism in sculpture.[43] Now his art had to be stretched to configure in some new way the Neoclassical propositions of his conservative elder colleagues in the Institut and the Ecole: the nude standing figure of an ancient Greek hero, in marble, well over life-size (model in Angers, 2.78 m., a bit over nine feet). The reconciliation of

old and new was well characterized by Jouin: "antique in subject, modern in realization [execution]... there are audacities there"[44] and even better by David himself.[45] Plutarch's *Lives* provided the episode of the Battle of Sellasia (222 B.C.) in which the young hero yanked out a javelin that had pierced his leg and then proceeded to victory. David explained the characteristic Romantic license, criticized by pedants, that turned the hero into an aging man, more effectively embodying the "last of the Greeks" and implying the twilight of Hellenic civilization. He also persuasively justified the unorthodox statics of the posture (which a decade later he considered too rash) and the deliberate disjunction of the side views:

In bending it too much on [its] right side... I've removed the nobility of line viewed from that side... but I aimed to oppose, in a single figure, the moral being and physical nature. When one observes it from [its own] left side [as it was originally first seen, approached from the Rue de Rivoli], the hero is full of pride, his head held high, and seems to say the combat will be rejoined when the obstacle has disappeared. Seen from the opposite viewpoint, the work changes aspect. Nature has found again her rights, man pays his tribute to suffering. Yet I believe I have shown that the struggle between physical nature and the moral being will go to the latter. No doubt the Greeks would have sacrificed the expression of pain to the cadence of the lines, because they professed above all the religion of form.[46]

It is not impossible that David's articulation of his content owes something to an 1837 article on the *Philopoemen* published by Gustave Planche when the statue was unveiled.[47] In 1857, the year after David's death, his students petitioned Napoleon III to buy his cousin's marble *Bara* for the Louvre and thus fill a scandalous lacuna: there was no major David in the national museum. The Emperor, permanently resentful of David's republicanism and somewhat disenchanted with his old-fashioned art, took the cheap way out and had the *Philopoemen* moved into the Louvre in 1859, where it long remained his only major work (one other was privately donated in 1896).

Besides the Louvre marble and its full-sized plaster model in Angers, the latter museum has three variant models in plaster just under a foot high. The list made by Madame David in 1867 of fourteen works which she knew to have been edited as small bronzes does not include the *Philopoemen*,[48] but it also omits the only small bronze David himself edited, the "portable" *Tieck* (cat. no. 100), and it seems that many more were authorized.[49] The known reductions of the *Philopoemen* are of excellent quality and one wonders whether they were made by Collas himself rather well before his death in 1859, when for some time he had been protecting his editions by his stamp; in any case, the bronzes are unmarked except for the "signature." They exist in three sizes: that in our exhibition, 26¾ inches high; 14 inches, as is one in the David Daniels Collection, New York;[50] and a tiny bronze of exquisite precision, c. 8 inches high, of which there is an example in a private American collection. J.H.

102.
Johann Gensfleich Gutenberg (c. 1400–1468)
Bronze
h: 15¾ in. (40 cm.); w: 6½ in. (16.5 cm.); d: 6⅞ in. (17.5 cm.)
Signed and dated: P.J. DAVID / 1839 (on right side of base)
Inscribed: Gutenberg (on front); Et la lumiere fut (on scroll)
No foundry mark
Lender: B. G. Cantor Collections, New York and Beverly Hills

David's Gutenberg monument in Strasbourg is given the date 1840 in the literature, but, as it was dedicated in June of that year, this is obviously no more than a *terminus ante quem*. David reports, in a letter of September 8, 1837, that it (presumably the model) was then nearly completed,[51] and another letter, dated September 2, 1838, relates that it had just been finished and that he was about to go to Strasbourg to work on its emplacement.[52] Earlier that year an article in the *Magasin Pittoresque* had described the inauguration in 1837 of Thorvaldsen's Gutenberg monument in the printer's native city of Mainz, and the same article, at least a little mischievously, announced David's forthcoming monument for the French side of the border.[53] Johann Gensfleisch Gutenberg was claimed by Strasbourg as the long-term resident who in that city had invented printing with movable type about 1440, even if his first book was printed in Mainz a decade later. David shows him holding

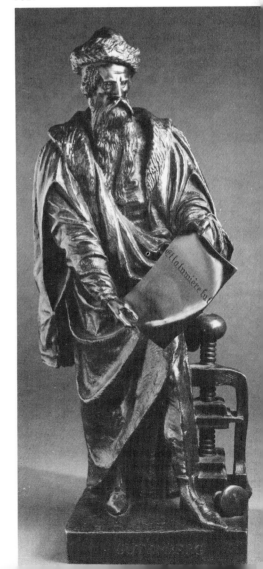

102.

the first page of that book, the Bible, to issue from the little press at his left and takes the liberty of quoting only one very legible verse from the opening of Genesis (1: 3), "And there was light." The effectiveness of this metaphor was repeatedly admired by nineteenth-century writers, who for once made no pedantic complaints about David's artistic license, here the choice of French rather then Gutenberg's Latin.

The *Gutenberg* is one of the most evocative in the long series of historical portraits David had begun in 1816 with the *Condé* (cat. no. 92). Discreet allusions in imagery, form, and composition are meant to evoke an aura of northern late Gothic sculpture. The great length of the flowing, pointed beard with its interminable moustaches adds a hint of the medieval Merlin-like sorcerer to an image rather like a *Meistersinger,* but of patrician rather than *bürgerlich* mien. From the advanced left foot in its pointed Gothic boot, the composition develops strong upward impulses accelerated by the towering proportions of the bony figure; this verticalization is given a heterodox tilt toward the figure's (own) right, which slightly but palpably compromises—"gothicizes"—academically correct statics. Even in the enormous plaster model (3.3 m., Angers), the tensility of the whole readily suggests metal rather than stone. By now David was a master in the full exploitation of bronze: the rich play of varied surface textures in the Strasbourg statue can be inferred even from the sketchier statuette in our exhibition, which hints at some of the contrasts of furs, varyingly coarse woolens, hair, skin, leather, vellum, wood, and metal. David's characterization of Gutenberg has been amply analyzed in Jouin's wonderful monograph of 1877–78: the perplexity daunting the noble severity of the head conveys Gutenberg's troubled awareness of the awesome potentialities and responsibilities of his invention.

Various states and versions of the *Gutenberg* composition are known, but their precise history can be proposed only hypothetically. An earlier and possibly first project, quite unlike the final result, is adduced from a drawing with an elaborate verbal explication apparently written by David himself; this was described and recorded by Jouin as belonging in 1877 to the sculptor's son Robert, most of whose col-

lection was left to the Musée des Beaux-Arts in Angers;[54] however, this drawing is not listed in the (admittedly very incomplete) drawing section of the Angers catalog of 1934.[55] Besides the huge plaster model in Angers and the bronze in Strasbourg, David gave an iron cast to the Royal Printing Press (now in the garden-court of the Imprimerie Nationale, Paris).[56] In 1867, Madame David wrote Jouin that a statuette of the *Gutenberg* had been produced by the Collas reduction technique without David's active participation (thereby implying that it was done during his lifetime;[57] but this scarcely excludes the possibility of his encouragement, since he not only specifically and enthusiastically praised Collas' reductions[58] but even made a portrait medallion of Collas in 1835 for his Gallery of Great Men. He also believed religiously in the widest democratic availability of his didactic art. A miniature figurine in green bronze, only 15 cm. high, was given to the museum in Angers by his daughter Hélène David,[59] and it is there presented as a Collas reduction. However, the little statue is far more Gothic than the decorous monument itself or the larger bronze statuette in our exhibition; all Collas reductions known to the writer remain much closer to the original model in Angers,[60] which can be postulated as its source. A similar bronze in the Louvre (no. 1014)[61] shows interesting minor discrepancies, such as additional apparatus behind the printing press and the name on the plinth spelled "Guttemberg" as it is on the Angers terracotta; it is also a centimeter larger than the bronze of the Cantor Collection, as is the terracotta. David himself expressed his admiration for the way little reductions can often effectively convey the essentials even of colossal sculpture, also citing ancient Greek statuettes to reinforce his argument,[62] and this handsome small bronze is a good case in point. J.H.

Notes

1.
Auguste Rodin: Readings on his Life and Work, ed. A. Elsen, Englewood Cliffs, New Jersey, 1965, p. 184.
2.
Blanc, 1876, p. 131.
3.
David d'Angers, 1910, p. 82.
4.
See Frémy, 1828. The publication turned out to be premature, since very soon afterward the statues were installed at Versailles, at least by 1832.
5.
Dowley, 1957, pp. 259–77.
6.
Mémoires de la Société royale des sciences, de l'agriculture et des arts de Lille, Lille, 1846; reprinted in Jouin, 1878, II, pp. 216–45, where the discussion of the d'Angiviller *Condé* is on pp. 228–29.
7.
Ibid., p. 240.
8.
Livret du Salon de 1817; Explication des ouvrages de peinture, sculpture... des artistes vivants au Musée royale des arts, Paris, 1817. no. 808.
9.
Monsieur Lemoyne of the Versailles museum has been kind enough to furnish much of this information.
10.
Chesneau and Metzger, 1934, p. 74, no. 56.
11.
Jouin, 1878, II, p. 512.
12.
Lami, 1914–21, II, p. 60.
13.
Blanc, 1876, p. 135.
14.
Illustrated in Paris, 1966, p. 66.
15.
Freeman, 1948; this modest and little-noticed exhibition checklist is one of the first publications to broach the problem of David's founders. The exhibition was made up of the holdings of three institutions in the Baltimore area: two "early collections," one of forty-two medallions, many marked "Eck et Durand," at Johns Hopkins University; the other, of twenty-eight medallions including marks by "Eck et Durand" and "Richard Frères," in the Maryland Institute; and a third, later, collection in the Walters Art Gallery, containing casts by Fumière.
16.
A. Etex, *Pradier: Etude sur sa vie et ses oeuvres,* Paris, 1859, p. 32.
17.
Personal communication, July, 1979.

18.
C.E. Fairman, *Art and Artists of the Capitol of the United States of America,* Washington, 1927.

19.
Chesneau and Metzger, 1934, p. 8.

20.
Information to this point derives mainly from D. Fitzpatrick and S. Saphire, *Navy Maverick: Uriah Phillips Levy,* Garden City, 1963, pp. 128–30.

21.
G. Planche, "La Statue de Jefferson," *L'Artiste,* 1833, VI, pp. 198–99.

22.
Journal of the Senate, 23rd Congress, 1st Session, February 16, 1835, p. 453: "I beg leave to present . . . a colossal bronze statue of Thomas Jefferson . . . executed under my eyes in Paris by the celebrated David and Honore [*sic*] Gonon, and much admired for the fidelity of its likeness to the great original, as well as the plain republican simplicity of the whole design."

23.
Gales and Seaton's Register, 23rd Congress, June 27, 1834, Col. 4787.

24.
Journal of the Senate, 23rd Congress, Resolution, February 16, 1835.

25.
Record of telephone conversation between Mrs. Pearce at the White House and Mr. Stewart at the Capitol, October 13, 1961, in which each discussed independent investigations. I am deeply grateful to the Architect of the Capitol for making this record available to me.

26.
Keim, *Illustrated Handbook of Washington and its Environs,* Washington, 1875, pp. 107–8.

27.
G. Brown, *History of the United States Capitol,* Washington, 1903, II, p. 179: "In 1900 it was moved [from the Hall of Sculpture] to the Rotunda."

28.
Brochure, *Art in City Hall,* New York [c. 1950], p. 4. *Proceedings of the Boards of Aldermen and Assistant Aldermen,* New York City, Municipal Building, 1833–35, II, p. 118; 1834, VIII, pp. 83–84.

29.
There are two quite remarkable bronzes. The first is Gois' *Joan of Arc* in Orléans, set up in 1804. The second is Raggi's more monumental bronze monument to Bayard in Grenoble, 1822. The effects of agitated draperies and minutely depicted plumes in both of these works could only have been possible in bronze, never in marble, but the images of both are still typically *style trouvère,* and their surfaces have been so elaborately chased that they seem more chiseled than modeled.

30.
G. Planche, "La Statue de Jefferson," *L'Artiste,* 1833, VI, pp. 198–99.

31.
Ibid., p. 199.

32.
T. Thoré, "L'Art sociale et progressif," *Le Moniteur,* 1834, VII, p. 40.

33.
Gales and Seaton's Register, 23rd Congress, June 27, 1834, Col. 4787.

34.
Ibid., Col. 4787.

35.
M. D. Peterson, *The Jefferson Image in the American Mind,* New York, 1960, p. 13.

36.
Caso, 1963, pp. 2–13.

37.
Illustrated in ibid., p. 9. Vogel sent David a large wash drawing of the composition now in the museum at Angers (illustrated in Paris, 1966, p. 14). Since the image of Tieck in Vogel's picture reproduces with great precision the very posture of our seated statuette, which is dated 1836 like the painting, we may wonder whether Vogel actually used the statuette as his model; there are early records of at least two casts of the piece in Dresden.

38.
Bruel, 1958, I, pp. 303–10.

39.
Illustrated in Paris, 1966, no. 77, pp. 66–69.

40.
Illustrated in Morant, 1956, fig. 10.

41.
Caso, 1963, p. 11.

42.
Jouin, 1878, II, p. 479.

43.
Lenormant, 1833, p. 34, had written in 1831, the year before he commissioned the *Philopoemen,* "M. David has undertaken the revolution of sculpture."

44.
Jouin, 1878, I, p. 317.

45.
Bruel, 1958, II, pp. 41, 177.

46.
Ibid., II, p. 269.

47.
Reprinted in Planche, 1853, pp. 99–110.

48.
Jouin, 1878, II, p. 512.

49.
Caso, 1963, pp. 10–11.

50.
Louisville, 1971, no. 52.

51.
Jouin, 1878, II, p. 381.

52.
Ibid., p. 388.

53.
Magasin pittoresque, 1838, VI, pp. 89–90.

54.
Jouin, 1878, II, p. 491.

55.
Chesneau and Metzger, 1934, pp. 289–309.

56.
Jouin, 1878, II, p. 491.

57.
Ibid., II, p. 512.

58.
Ibid., II, pp. 76–77.

59.
Chesneau and Metzger, 1934, p. 76, no. 67.

60.
Ibid., p. 76, no. 66; illustrated in Morant, 1956, fig. IV.

61.
Paris, 1966, p. 41, cat. no. 54.

62.
Jouin, 1878, II, pp. 76–77.

Selected Bibliography

Lenormant, C., *Les Artistes Contemporains, Les Salons de 1831 et 1833,* Paris, 1833.

Thoré, T., *Les Salons de T. Thoré, 1844, 1845, 1846, 1847,* Paris, 1870.

Planche, G., *Portraits d'artistes peintres et sculpteurs,* Paris, 1853, II (reprints essays on David from 1837–50).

_____, *Etudes sur l'école française,* Paris, 1855 (Salons de 1831–52).

Marc, E., *Oeuvres Complètes de P.-J. David d'Angers,* Paris, 1856.

AUGUSTE-HYACINTHE DE BAY
1804 Nantes—Paris 1865

David, R., and E. About, *Les Médaillions de David d'Angers, album photographique,* Paris, 1867.

Blanc, C., *Les Artistes de mon temps,* Paris, 1876.

Jouin, H., *David d'Angers,* Paris, 1878.

Delaborde, H., "David d'Angers, ses oeuvres et ses doctrines," *Revue des Deux Mondes,* May 15, 1878, pp. 423–45.

Jouin, H., ed., *David d'Angers et ses relations littéraires: Correspondance du maître,* Paris, 1890.

David d'Angers, R., *Un statuaire républicain, David d'Angers: sa vie, ses oeuvres par son fils,* Paris, 1910.

Lami, 1914–21, II, pp. 53–117.

Valotaire, M., *David d'Angers,* Paris, 1932.

Chesneau, G., and C. Metzger, *Ville d'Angers, Musée des Beaux-Arts, Les Oeuvres de David d'Angers,* Angers, 1934.

Freeman, S.E., *Medallions from the "Galerie des Contemporains" by Pierre-Jean David d'Angers,* Homewood, Maryland, 1948.

Morant, H. de, *David d'Angers et son temps,* Angers, 1956.

Bruel, A., ed., *Les Carnets de David d'Angers,* Paris, 1958.

Caso, J. de, "David d'Angers' 'Portable Tieck': an intimate aspect of Romantic Portraiture," *The Register of the Museum of Art, The University of Kansas* (now the Helen Foreman Spencer Museum of Art) Lawrence, 1963, III, no. 1., pp. 2–13.

Paris, Hôtel de la Monnaie, *David d'Angers,* exh. cat. by F. Bergot, 1966.

Louisville, 1971, pp. 135–53.

Before entering the Ecole des Beaux-Arts in 1817, Auguste-Hyacinthe De Bay studied sculpture with his father, Jean-Baptiste the elder (1779–1863), and painting under Baron Gros. A child prodigy, at age thirteen he created a colossal bust of Louis XVIII for his native city of Nantes; a year later he exhibited two plaster portrait busts at the Salon of 1817. Although both his father and his brother, Jean-Baptiste the younger (1802–1862), were distinguished sculptors, Auguste concentrated his energies on painting, a medium in which he received official recognition while still a youth: at the Salon of 1819 he won a medal for his portrait of Baron Geslin; in 1822 he was awarded second grand prize in the Prix de Rome competition; and in 1823 he received the coveted first prize. During the following years he exhibited primarily historical canvases, many of which were commissioned for the museum at Versailles.

Although he practiced sculpture infrequently—Lami records only about twenty pieces—De Bay was a gifted sculptor who worked in both marble and bronze. His most important sculptures are bronze allegories of the *Ocean* and the *Mediterranean* for the fountain in the Place de la Concorde (1838), *The First Cradle* (1845, cat. no. 103), the *Tomb of Msgr. Affre* (fig. 109) in the Chapel of St. Denis in Nôtre Dame (1849–60), colossal heads of *Painting, Architecture,* and *Sculpture* for the facade of the Ecole des Beaux-Arts, Paris (1860–61), and a relief of the *Resurrection* in the pediment of St. Etienne-du-Mont (1861). In 1855 he was awarded a first-class medal for sculpture at the Exposition Universelle and was decorated with the Legion of Honor in 1861. M.B. & P.F.

103.
The First Cradle (Le Berceau Primatif)
Patinated Plaster
h: 17¾ in. (45.1 cm.); w: 6 in. (15.2 cm.); d: 8⅝ in. (21.9 cm.)
Model c. 1845
Signed: A. De Bay (on right side) and monogramed AB in a seal at lower back
Lender: Dr. and Mrs. H.W. Janson, New York

The First Cradle was extremely popular in the nineteenth century and has remained De Bay's best-known work. It is the only

sculpture he exhibited publicly after 1817 until the time of his death. The original marble version, displayed at the Salon of 1845 and the Exposition Universelle of 1855, was purchased by Prince Demidoff,[1] who later sold it for 13,500 francs as part of the contents of his Villa Donato, Florence, in 1870. The marble has since disappeared. The work exhibited here is one of what appears to have been a fairly large edition of plasters.

A tender statement of motherhood, *The First Cradle* represents Eve seated with the infants Cain and Abel nestled asleep on her lap. Eve's arms encircle the children, holding them close to her in a gesture that is both protective and symbolic. The idyllic mood of the group is broken by the reliefs on the base that depict the future sacrifices of the two sons and the tragic fratricide. Perhaps due to the success of Etex's *Cain and his Race* (cat. no. 124) Adam, Eve, and their children became popular subjects for sculptors throughout the nineteenth century (see cat. no. 6). At the Salon of 1845, for example, Gabriel-Joseph Garraud exhibited a work of a similar theme entitled the *First Family.* In form, *The First Cradle* recalls traditional representations of Charity in which a woman is generally shown nursing one or both of the infants she holds upon her lap. The themes of motherhood and charity are in a sense secular counterparts to that of the Madonna and Child; and increasingly throughout the nineteenth century, the secular themes were to displace the religious ones in popularity. Cain's facial features and muscular build bear a striking resemblance to the figure of Christ in Michelangelo's *Bruges Madonna* —a work the artist might have known firsthand, or through his father, who was born and raised in Belgium.

The First Cradle was admired by both the public and the critics throughout the nineteenth century. Baudelaire praised the artist's original conception and charming composition in his review of the Salon of 1845.[2] Arsène Houssaye in *L'Artiste* hailed it as a masterpiece.[3] Later, when the work

appeared at the Exposition Universelle of 1855, Théophile Gautier called it an "ingenious idea" and likened the children to birds clustered in a nest.[4] An engraving of the sculpture appeared in *L'Illustration* (May 10, 1845, p. 172), and it was immortalized by having its own entry in the *Nouveau Larousse Illustré.*[5] M.B. & P.F.

Notes

1.
Apparently referring to the *Berceau Primatif,* David d'Angers mentioned in a note of November 28, 1844, that Balzac told him De Bay had just made a sculpture which he sold for an exorbitant price. See A. Bruel, ed., *Les Carnets de David d'Angers,* Paris, 1958, II, p. 218.

2.
Baudelaire, 1933, pp. 199–200.

3.
Houssaye, 1845, p. 4.

4.
Cited in London, 1978, cat. no. 34.

5.
Nouveau Larousse Illustré, Dictionnaire Universel Encyclopédique, Paris, 1898–1904, II, p. 22.

Selected Bibliography

Lami, 1914–21, II, pp. 132–34.

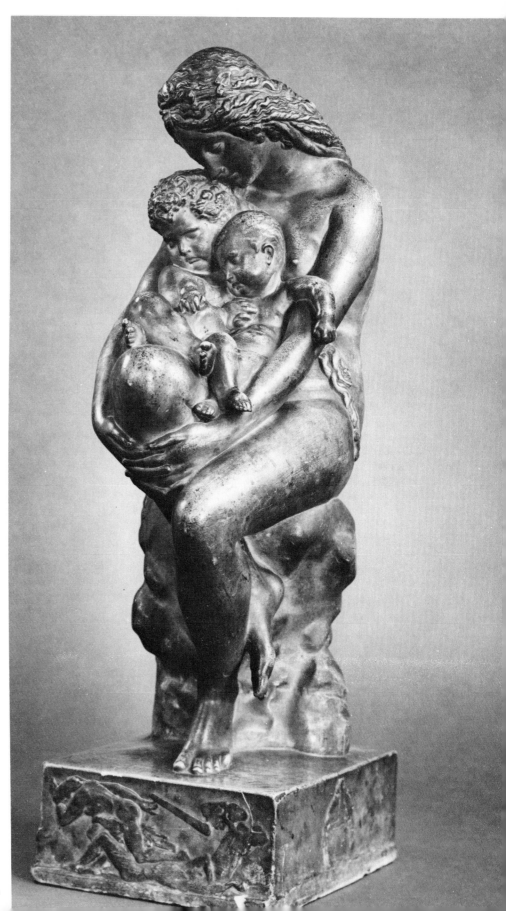

EDGAR HILAIRE GERMAIN DEGAS
1834 Paris 1917

Although Degas was and continues to be known principally as a painter, his artistic activity after the age of forty was increasingly that of a draftsman, particularly in pastel, and a sculptor. By the time he gave up working altogether, in 1912, sculpture had become his principal, if not his exclusive, medium.

Degas seems to have had a vocation for sculpture from the very beginning of his career, but to have pursued it only after the mid-1870s. The first documented example is dated 1878. Sculpture permitted him to realize completely his interest in three-dimensional form, as well as to explore highly abstract relationships between that form and real space. He used the same subjects in two and three dimensions—horses and dancers during his first decade as a sculptor, and bathers thereafter. His last sculpture subjects, all probably executed after the turn of the century, were seated bathers. Since in his lifetime he exhibited only one piece of sculpture, the *Little Dancer, Fourteen Years Old* (cat. no. 105), his three-dimensional work remained unknown except to the few who had access to his studio. Even those who knew it assumed it to be a hobby for him, or saw it as a way of studying figures for paintings or pastels. In fact, Degas probably seldom used his sculpture as maquettes for two-dimensional works, and in many instances drawn or painted poses that are identical to those in sculpture precede the latter. Sculpture was a wholly independent medium for him, and one that was the logical extension of his interest in three dimensions.

Some 150 pieces or fragments of sculpture were found by his dealer, Joseph Durand-Ruel, in Degas' studio after his death.[1] Since Degas was fond of destroying and remaking his waxes, this undoubtedly represents only a fraction of his total sculptural output. His interest in perfecting and restudying his figures also meant that he never cast his work in bronze, although three pieces were cast in plaster, apparently about 1900.[2] In addition to wax, his materials included plasticene and, for the portrait heads, plaster. Placed under the protection of Durand-Ruel, Degas' sculptor friend Paul-Albert Bartholomé, and Bartholomé's founder A.-A. Hébrard, the seventy-four salvageable pieces were cast by Hébrard in an edition of twenty-

two, plus one master set of bronzes, after the First World War. Hébrard's chief founder, Albino Palazzolo, was in charge of the work, which probably continued for at least a decade.

Despite the fact that Degas' sculpture was commercially available from about 1921, it only came to prominence after the Second World War, and then slowly. Its extraordinary quality, and the boldness with which it moves away from conventional sculptural ideas toward abstract contemporary conceptions, assure it a place of crucial importance in the development of modern art. C.W.M.

104.
The School Girl
Bronze
h: 10¾ in. (27.3 cm.); w: 4¾ in. (12.1 cm.); d: 6 in. (15.2 cm.)
c. 1880
Signed: Degas
Foundry mark: Cire perdue/AA HEBRARD
Provenance: Fine Arts Associates, New York, 1956
Lender: The Detroit Institute of Arts, Gift of Dr. and Mrs. George Kamperman

Pencil sketches for this figure appear in one of Degas' notebooks, dated 1880–84 by Reff,[3] and it is related to the right-hand figure in the drawing *Portraits in Frieze for Decoration of an Apartment,* dated 1879, said by Lemoisne to be a portrait of Ellen Andrée.[4] It is also closely related to the pastel *Woman in a Purple Dress.* The piece has had a shadowy history, apparently cast separately from the remainder of Degas' sculpture in only a few examples. The wax appeared on the market in the mid-1950s and was cast in an edition of twenty-two by M. Knoedler and Co. before joining the other waxes in the Mellon Collection. Its outspoken naturalism, while not unprecedented, is unusual, and the *School Girl* may be seen as a study for the *Little Dancer,* to which it is clearly related. Its pose may be ultimately derived from that of the Donatello *David,* which was sketched by Degas on one of his student trips to Italy.
 C.W.M.

104.

105.

Little Dancer, Fourteen Years Old
Polychromed bronze, gauze, and satin
h: 40 in. (1.02 m.) including 1½ in.
(3.8 cm.) base
Base: w: 20 in. (50.8 cm.); d: 20 in.
(50.8 cm.)
1878–81
Signed: Degas (on top of base)
Foundry mark: E. HERRARD (in medallion
behind left foot on top of base)
Lender: Mr. and Mrs. Nathan Smooke
(for Los Angeles showing only); The
Metropolitan Museum of Art (for
Indianapolis showing only)

The *Little Dancer* is Degas' largest surviv-
ing sculpture (although not the largest he
attempted), his best known, and the only
one he titled and exhibited. Shown at the
1881 Impressionist exhibition, the original
wax is dressed in pink slippers, a gauze
skirt, and a ribbed silk bodice and has real
hair tied with a greenish satin ribbon.
Degas began exploring this composition in
1878, but probably in the nude version,
and it may well have been that piece rather
than the present work that was listed in
the catalog of the 1880 Impressionist
exhibition, in which it never appeared.
The dressed figure was probably developed
during 1880 and 1881 for exhibition in
the latter year.

Although critical reaction to the *Little
Dancer* was mixed—the public seems to
have been outraged at its uncanonical
realism—Degas never again exhibited his
sculpture. Indeed, asking a public accus-
tomed to carefully finished marble statues
to accept a statuette dressed in colored and
textured materials was a radical demand,
although one with art historical precedent
in eighteenth-century Spain and Naples.
Degas occasionally dressed others of his
waxes, notably the jockey that rides one of
his horses, and more than once rendered
dress in the wax itself. The *Little Dancer* is,
however, his most aggressive essay of this
kind, as well as a spatial statement of great
sophistication. The opening and closing of
the spaces as one walks around the work
result from the opposite orientation of the
legs, the counter-thrusts of the body, and
the clasping of the hands behind the back.
Nina de Villars' characterization of the
Little Dancer as "the first formulation of a
new art"[5] was one of the few public recog-
nitions of Degas' sculptural achievement.

 C.W.M.

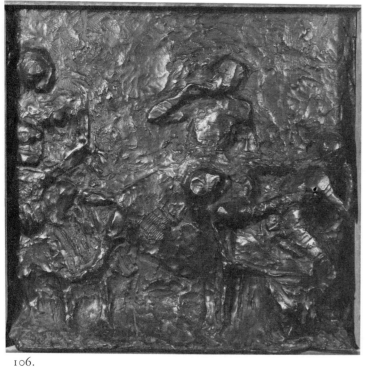

106.

106.
Picking Apples
Bronze
h: 17¾ in. (45.1 cm.); w: 18¾ in. (47.6
cm.); d: 2⅝ in. (6.7 cm.)
1881–83, probably reworked after 1890
Signed: Degas (front lower left)
Foundry mark: Cire/Perdue/A.A. Hebrard
Numbered: 37/D
Lender: The Minneapolis Institute of Arts,
Gift, 1954: Mr. and Mrs. Justin K.
Thannhauser, in memory of their son Heinz

The original version of Degas' only relief
seems to have been about three feet high,
to have been executed in clay, and to

107.

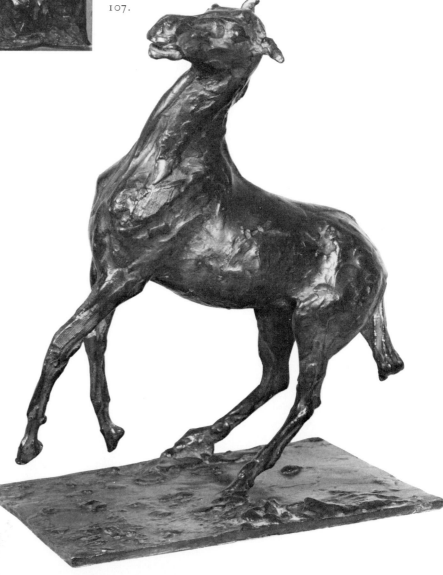

have represented "young girls gathering apples."[6] So described by Bartholomé (through Lemoisne), it was also seen by Renoir, who found it "as beautiful as the antique."[7] A letter of March 1882 to Degas' niece Lucie, who posed for at least one of the figures, establishes its date.[8] The wax original of the present composition is now in the Mellon Collection along with all but four of the other surviving Degas waxes. The relief was probably made in the early 1890s, perhaps at the moment the earlier work was disintegrating. Originally the left side of the relief seems to have represented boys climbing a tree, but this area has been reworked into two standing figures in the present version. The right-hand figures are probably substantially the same as in the original. The seated figures at the right may well be Degas' first sculptural attempt at the pose with which he was preoccupied during his last years. The breadth of the modeling and pattern of light and shadow in this work are particularly daring. C.W.M.

107.
Rearing Horse
Bronze
h: 12⅛ in. (30.8 cm.)
1880s
Signed: Degas (on top of base)
Foundry mark: CIRE PERDUE/A.A. HEBRARD (on top of base)
Numbered: 4/L (on top of base)
Lender: Private Collection

Among the most active of Degas' equine poses, *Rearing Horse* undoubtedly dates from well after he had become acquainted with the stop-motion photographs of Eadweard Muybridge about 1880. Degas seems to have been deeply interested in such photographs, and the analogy between their movement when reconstituted in a zootrope (the horses seeming to move without progressing) and sculptural movement (movement around a center) is not without interest for his work. In the case of *Rearing Horse,* Degas has taken advantage of simultaneous forward and backward movements —a sort of rocking motion—that draw the hind legs forward and the front legs back, permitting a sculptural configuration of some freedom and complexity. Adding to that complexity is the fact that the horse shies its head to the side and its two front legs are raised off the ground. The result-

ing abstract sculptural force is married to an intense observation of real equine forms in a combination typical of Degas. This work and a few others of its date are among the last horse sculptures executed by Degas, who no doubt found the bulk of the body capping the open configuration of the legs too constricting, whereas the forms of the human body could be more variously arranged and more intimately harmonized. C.W.M.

108.
Grande Arabesque
Bronze
h: 17¼ in. (43.8 cm.); fingertips to toes 25 in. (63.5 cm.)
1885–90
Signed: Degas (on top of base)
Foundry mark: Cire Perdue/A.A. Hebrard (on top of base)
Numbered: 60/D
Lender: Los Angeles County Museum of Art, Mr. and Mrs. George Gard de Sylva Collection

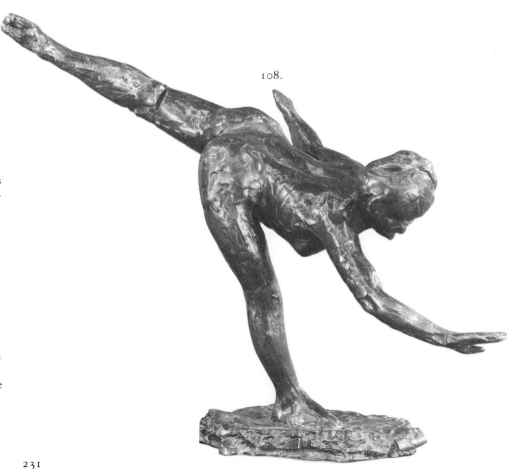

108.

231

The dating of this piece, as with almost all the Degas sculpture, is conjectural and based on the general development of Degas' sculptural style. The pose represents a fairly advanced development of the type in which a complex windmill-like configuration of the body and limbs is anchored to the ground by only one foot. There are two other versions of this piece (Rewald XXXIX, XLI), more broadly worked and almost certainly later in date. In both, Degas begins to return his sculptural motion to the ground by tipping the upper part of the body downward. The extraordinary synthesis of movement embodied in pieces such as these was demonstrated to Walter Sickert by Degas when he projected a similar wax (Rewald XXXVI) against a sheet, rotating it as he did so.[9] The resulting seamless motion, which can only be described as proto-cinematic, evidences how thoroughly and with what subtlety Degas had developed the interactions of his solids and his voids. C.W.M.

109.
The Tub
Bronze
h: 8½ in. (21.6 cm.); l: 18 in. (45.7 cm.);
w: 16¼ in. (41.3 cm.)
Model executed 1889
Signed: Degas (on top of base in corner near right side of figure's head)
Foundry mark: CIRE PERDUE A.A.
Hebrard (on base edge on figure, left side)
Numbered: 26/D
Lender: The Art Institute of Chicago, Wirt D. Walker Fund

The Tub is one of the few pieces of Degas' sculpture for which a definite date can be established. In a letter of June 13, 1889, to his friend Bartholomé, the artist mentions that he is working on it and has completed its socle of plaster-soaked rags.[10] The original consists of a wax figure reclining in a lead tub partially filled with plaster, the whole resting on the socle mentioned in Degas' letter. The resulting coloristic variation both articulates the composition and evidences Degas' continuing interest in introducing color into his three-dimensional work (see cat. no. 105). Spatially, it is among the most advanced of his works. The compression of the body by the circular tub forces the limbs to be thrown over one another, resulting in a complex play of solid and void. Even more remarkable is the fact that the piece is clearly meant to be seen from above, without a pedestal or accessory plinth. Both the intended viewpoint and the fact that *The Tub* is developed, as it were, along the floor make it almost unique in the nineteenth century. C.W.M.

Notes

1.
Letter from Joseph Durand-Ruel to Royal Cortissoz dated June 7, 1919, in Beinecke Library, Yale University. Reprinted in part in "Degas as He was Seen by His Model," *New York Tribune,* October 19, 1919, section IV, p. 9.
2.
Lemoisne, 1919, p. 115.

109.

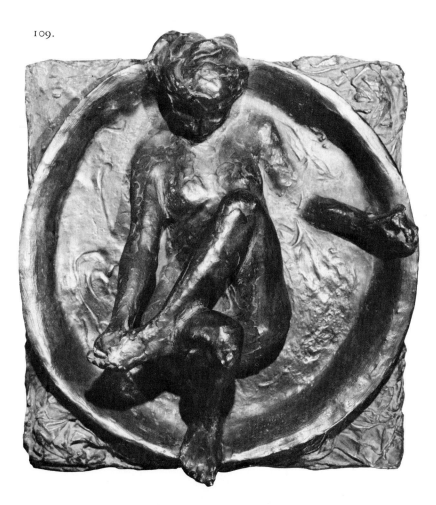

3.
Reff, 1976, I, p. 141.
4.
P.-A. Lemoisne, *Degas et son oeuvre,* Paris, 1946, II, p. 302. Reff, 1976, I, p. 141 points out the similarity between the sculpture and Degas' etching of Ellen Andrée.
5.
N. de Villars, "Exposition des artistes independants," *Le Courrier du Soir,* April 23, 1881, p. 2.
6.
Lemoisne, 1919, p. 110.
7.
Pierre Auguste Renoir quoted in A. Vollard, *La Vie et l'oeuvre de Pierre-Auguste Renoir,* Paris, 1919, p. 88.
8.
Reproduced in R. Raimondi, *Degas e la sua famiglia in Napoli, 1793–1917,* Naples, 1958, pp. 276–77.
9.
W. Sickert, "The Sculptor of Movement," *Works in Sculpture of Edgar Degas,* Leicester Galleries, London, 1923. Reprinted in O. Brown, *Exhibition,* London, 1968, pp. 179–81.
10.
M. Guérin, ed., *Lettres de Degas,* Paris, 1945, ltr. CVIII, p. 135.

Selected Bibliography

There have been two books devoted to the Degas sculpture, each of which contains an extensive bibliography. Such a listing is, therefore, omitted here except for the first important article on the subject and the book that first illustrated the waxes themselves *in extenso.*

Lemoisne, P.-A., "Les Statuettes de Degas," *Art et decoration,* September–October 1919, pp. 109–17.

Rewald, J., *Degas, Works in Sculpture: A Complete Catalogue,* rev. ed., New York, 1957.

Borel, P., *Les Sculptures inédites de Degas,* Geneva, 1949.

Millard, C.W., *The Sculpture of Edgar Degas,* Princeton, 1976.

Reff, T., ed., *The Notebooks of Edgar Degas,* 2 vols., Oxford, 1976.

Little is known about the life and works of this minor sculptor who was a student of François Rude and the painter Charles Bazin. His first recorded sculpture, a statuette of Leonardo da Vinci, was exhibited at the Salon of 1838. A review in *L'Artiste* described the piece as "A small figure ... with grace and allure. The arrangement of the costume is felicitous and in good taste."[1] In the following years Delarue exhibited about ten works, primarily portrait busts and religious statues. His last Salon appearance was in 1853, but he remained active as a sculptor until his death in 1868. His final sculpture was a bronze portrait medallion of Pierre Rode, later placed on the subject's tomb in Père-Lachaise cemetery. M.B.

110.
Portrait of Princess Marie d'Orléans, Duchess of Württemberg
Bronze
h: 20 in. (50.8 cm.); w: 10⅞ in. (27.6 cm.); d: 7 in. (17.8 cm.)
Signed and dated: Delarue 1839 (on right side of base)
Inscribed: S.A.R./LA/PRINCESSE/MARIE/DUCHESSE/DE/WURTEMBERG (on front)
Foundry mark: Noel Guillet Jⁿᵉ/Fondeur a Paris (inside)
Lender: Shepherd Gallery, Associates, New York

Delarue executed this sculpture of Marie d'Orléans in 1839, the year of her death. It cannot be determined if the work was commissioned or if the sculptor created it on his own initiative. He may have intended it as a personal tribute to a recently departed fellow artist, who was regarded by some as the most popular member of the royal family.[2] Contemporary accounts praise her intelligence, charm, modesty,

and artistic talent.[3] Her premature death at the age of twenty-five was mourned not only by her immediate family, but also by the entire nation.

As in Ary Scheffer's portrait of the Princess (cat. no. 174), Delarue commemorated her as a sculptor, standing next to her celebrated statue of Joan of Arc (cat. no. 173). Marie d'Orléans appears to pause from her work and gaze upward, absorbed in meditation. In her right hand she holds a punch, or point—a common sculptor's tool used with a mallet—such as the one depicted at the feet of *Joan of Arc.* Delarue accentuated the Princess's delicate features: her tiny waist, sloping shoulders, long, thin neck, and oval face. (On the popularity of portrait statuettes of this type, see cat. no. 4.) Antoine Moine also created a statuette of Marie d'Orléans (Musée de Châlons-sur-Marnes). M.B.

Notes
1.
"Salon de 1838," *L'Artiste,* 1838, p. 173.
2.
J. Janin, "La Princesse Marie de Wurtemberg," *L'Artiste,* II, no. 9, 1839, p. 117.
3.
J. Janin, *L'Artiste,* pp. 117–118. See also Ary Scheffer's memoir of Marie d'Orléans in Mrs. Grotte's *Memoir of the Life of Ary Scheffer,* London, 1860, pp. 37–48.

Selected Bibliography
Bellier et Auvray, I, 1882, p. 391.

Jouin, 1897, p. 136.

Thieme-Becker, 1913, VIII, p. 594.

Lami, 1914–21, II, p. 149.

Lami, 1916, II, p. 149.

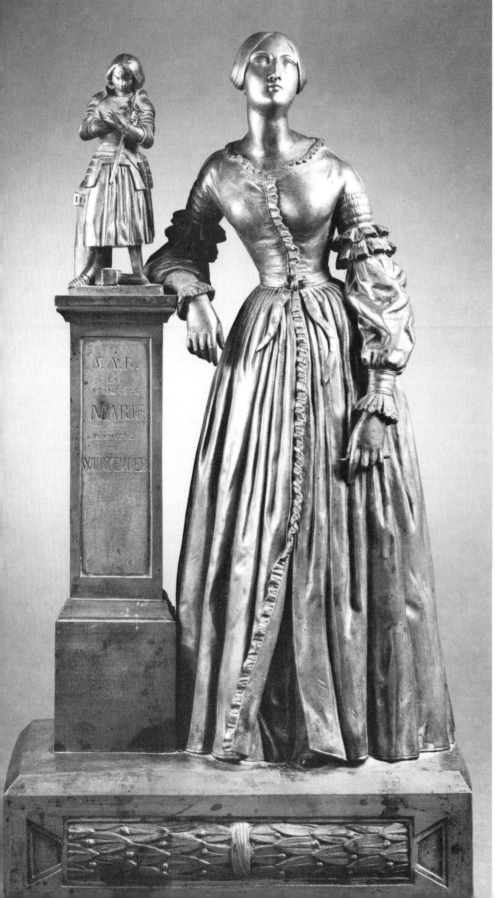

LOUIS DESPREZ
1799 Paris 1870

Louis Desprez entered the Ecole des Beaux-Arts in 1813 as a pupil of Bosio, the leading Neoclassical sculptor of the day. He made his debut at the Salon of 1824 with a *Portrait of a Man* and continued to exhibit throughout his life, the last time posthumously in 1872. In 1828 Desprez was awarded the Prix de Rome, his competition subject being *The Death of Orion.* While in Rome he was commissioned by Chateaubriand, then French ambassador at the Vatican, the execute a bas-relief after Poussin's *Et in Arcadia Ego* for the tomb of the painter in the church of San Lorenzo in Lucina. On his return to Paris, his marble *Innocence,* now in the Musée de Peinture et de Sculpture at Grenoble, was purchased from the Salon of 1831 by Louis-Philippe, winning him a second-class medal. In 1843 he obtained a first-class medal with his *Ingenuity,* now in a museum at Amiens, which also helped win him an honorable mention at the Exposition Universelle of 1855. Desprez, who was decorated with the Legion of Honor in 1851, passed most of his mature career creating religious statues and portrait busts; many of both types were commissioned by the State or the city of Paris. Among the former are a colossal *Saint Matthew* (1837–40) for the Madeleine, sixteen saints for the restoration of Saint Germain l'Auxerrois (1841), and figures for the churches of Saint Merri (1842), Saint Nicolas des Champs (1843), and Saint Augustin (1862). Portrait subjects include the painter Girodet (1826, for his tomb in Père-Lachaise cemetery), the sculptor Puget (Salon of 1835), the Duke of Talleyrand-Perigord (Salon of 1839, now at Versailles), the violinist Artot (Salon of 1865), and the painter Brascassat (Salons of 1869 and 1870, now in Bordeaux). In addition, Desprez executed various full-length portrait statues for the Louvre, the old City Hall of Paris, and other public buildings.

C.W.M.

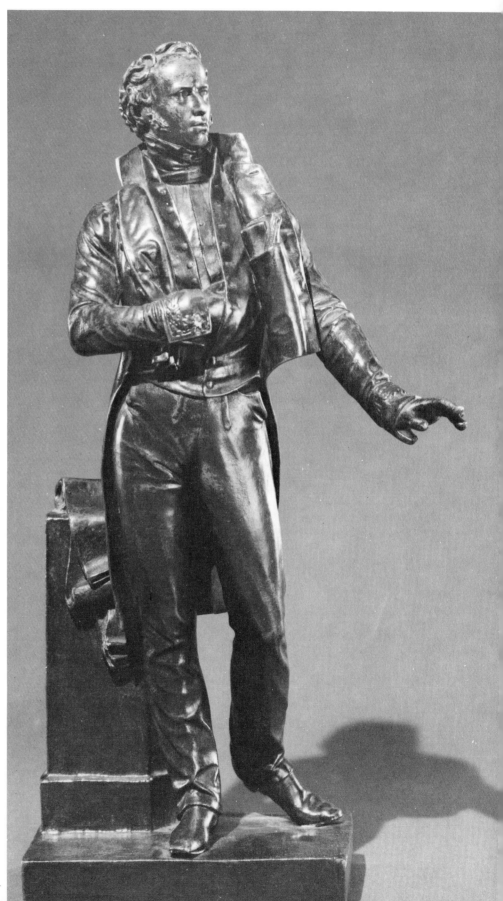

111.
General Foy
Bronze
h: 14½ in. (36.8 cm.); w: 7⅞ in. (20
cm.); d: 4⅞ in. (12.4 cm.)
1837
Signed: Desprez (on lectern at bottom right)
Provenance: Heim Gallery, London
Lender: Hirshhorn Museum and Sculpture
Garden, Smithsonian Institution,
Washington, D.C.

This statuette is a reduction of one of two
works commissioned by the government
for the Chamber of Deputies; the other was
Force, exhibited in plaster in the Salon
of 1833. The original marble of the *General
Foy,* destined for the Salle Casimir Perier,
was commissioned in August 1833.[1] A
model was ready by January 1836,[2] and the
finished work was exhibited in the Salon
of 1837 where Planche, noting that it was
in the "modern style," found it wanting in
execution.[3] Desprez' sculptural problem
was a particularly difficult one, since the
commission to him followed by only
twenty months David d'Angers' popular
statue of Foy in antique draperies, unveiled
on the General's tomb in Père-Lachaise
cemetery at the very end of 1831. Choosing
to represent his orator subject in contem-
porary costume, Desprez enlivened his
work by the momentary gesture of the left
hand, the movemented pose of the legs,
the rolled manuscript in the pocket of the
opened jacket, and the concentrated
expression of the individualized features.
Whatever dryness may characterize the
life-size marble is overcome in the bronze
reduction; the scale, color, and fine detail
enhance its overall vitality. Despite such
distortions as the elongated feet, this must
count among the liveliest of Romantic
statuettes, a type created to make popular
monuments more widely available, and it
is clearly one of the sculptural antecedents

of Daumier's *Ratapoil* (cat. no. 89). It is
probable that the *General Foy* was commis-
sioned in 1833, the moment before the
progressive hopes raised by Louis-Philippe's
accession turned sour in a repressive con-
servatism, not only because that year was
the heyday of sculptural Romanticism, but
because of the subject himself. Maximilien
Sebastien Foy, a veteran of Napoleon's
Spanish campaign, was wounded at Water-
loo and became a liberal member of the
Chamber of Deputies in 1819, gaining
fame as an orator. His funeral in December
1825 was the occasion for a massive popu-
lar demonstration, and a public subscrip-
tion raised for his widow and children
made them wealthy. Both in subject and
execution, Desprez' work is, thus, a memo-
rial to the invigorating political and artis-
tic ideals of the early 1830s. C.W.M.

Notes

1.
Lami, 1914–21, II, p. 184.
2.
"Nouvelles des Arts," *Journal des Artistes,*
January 24, 1836, p. 64.
3.
Planche, 1855, II, p. 102; see also *L'Artiste,*
XIII, 1837, p. 183.

Selected Bibliography

There is no article or book devoted exclu-
sively to Desprez. The most extensive
source is the entry in Lami, 1914–21, II,
pp. 182–87.

Jacques-Augustin Dieudonné entered the
Ecole des Beaux-Arts in 1816. He was a
pupil of the painter Baron Antoine-Jean
Gros (1771–1835), who followed the
austere Neoclassicism of David, and of
Francois-Joseph Bosio (1768–1845), a
sculptor born in Monaco who became close
to the imperial family and executed several
portraits of its members. Following the
tradition of most of the students at the
Ecole, Dieudonné competed in 1819 for
the Prix de Rome and won a second prize
for his entry of the competition's subject,
Milo of Crotona Attacked by a Lion.
Perhaps emulating Bosio's successful culti-
vation of the royal family, Dieudonné
showed a portrait medallion of the Duke of
Orléans in the 1819 Salon, followed in
1822 by more medallic portraits of various
sitters. His medal of the Duke of Orléans
may well have brought him royal favor, for
Louis-Philippe commissioned several works
from him that same year, many of which
are now in the museum at Versailles.

Dieudonné then turned from making med-
als to sculpture. By 1843 he had won a
third-class medal at the Salon; the follow-
ing year he was awarded a second-class
medal, and he showed a model for one of
his religious sculptures, *Christ in the Gar-
den,* reproduced in stone the same year by
ministerial decree. It was shown in a final
marble version in the Salon of 1848 and is
now in the museum at Nantes. In 1845
Dieudonné was given a first-class medal.

Although the majority of his works are
portraits, he did model several religious or
historical subjects: an *Adam and Eve* for
the 1853 Salon (now in Montpellier) and
an *Alexander the Great Overcoming a Lion*
(Tuileries Gardens, Paris). Although
Dieudonné had long since turned his atten-
tions to sculpture rather than to medals, he
submitted a model for the five-franc piece
in 1848 for the new currency in the Second
French Republic. He was also represented
in the Exposition Universelle of 1855 by
his *Christ in the Garden* of 1848, and in the
Exposition Universelle of 1867 by the final
version of *Alexander the Great.* That same
year he was made a *chevalier* of the Legion
of Honor. J.A.

112.
Louis-Philippe (1773–1850)
Bronze
h: 15 in. (38.1 cm.); w: 12 in. (30.5 cm.);
l: 7½ in. (19.1 cm.)
Signed and dated: Dieudonne 1829 (on back)
No foundry mark
Provenance: Michael Hall Fine Arts, Inc., New York
Lender: Museum of Fine Arts, Boston, William Nickerson Fund #2 and anonymous gift

Dieudonné's portrait medallion of the Duke of Orléans, exhibited at the Salon of 1819, may well have brought him the commission to sculpt a bust of Louis-Philippe. It follows almost identically the format chosen by his teacher Bosio in his bust of the Marquis de Lauriston, done in marble about 1820.[1] Dieudonné, like Bosio, represented Louis-Philippe in military attire, wearing the evening dress of a marshal, the Grand Cross of the Order of Saint-Louis and its *grand cordon,* along with special decorations.

Each texture on the Boston bust is rendered with startling fidelity: the watery patterns of the moiré *grand cordon* sweep in a smooth, shimmering stripe against the crisp, raised metallic thread of the oak-leaf embroidery on his jacket and the jagged outlines of the three medals pinned to his left breast. The epaulettes are chiseled in authoritative, resilient coils; these sharper materials contrast markedly with the softer modeling of the face itself. The highly abstract, stylized treatment of the hair echoes the similarly bold, decorative treatment used by Bosio in his Lauriston bust; both works share an almost surreal precision in the rendering of form and texture. Dieudonné also executed at least three marble portrait busts of Louis-Philippe (Salons of 1831, 1833, and 1838), and a plaster bas-relief of the marriage of Louis-Philippe at Palermo (Salon of 1833). J.A.

Notes
1.
C.W. Millard, "Bosio's Bust of the Marquis de Lauriston," *Los Angeles County Museum of Art Bulletin,* 1977, XXIII, p. 24.
2.
Bénézit, 1976, X, pp. 158–59.

Selected Bibliography

Lami, 1914–21, II, pp. 197–200.

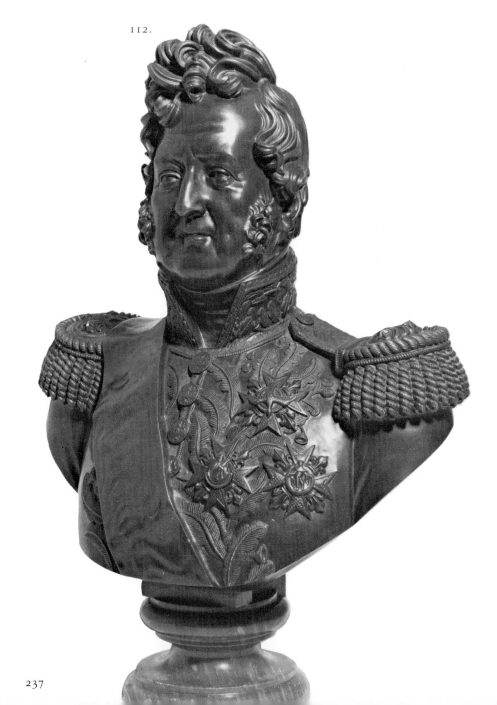

112.

GUSTAVE DORÉ
1832 Strasbourg–Paris 1883

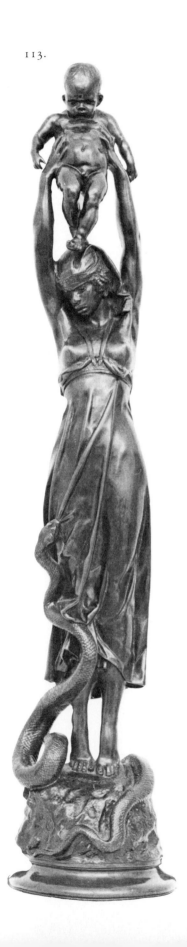

113.

Precociously talented, Gustave Doré was an accomplished self-taught draftsman by the age of ten. When his family moved to Paris in 1848, he became a contributor to Philippon's newly founded *Journal pour rire,* and he made his Salon debut with a pen and ink drawing. Throughout much of his career he continued to work for newspapers and journals; he was also one of the greatest and most prolific book illustrators of the century. Increasingly he grew to dislike being considered only as an illustrator and sought critical recognition, first as a painter and, toward the end of his life, as a sculptor. At the Salon of 1851 he first exhibited a painting, and in the late 1860s and 1870s he devoted more and more of his time to painting. His most extraordinary works in this medium include a series of huge and ambitious scenes from the New Testament. In 1868 he made the first of many trips to London; soon thereafter he established a Bond Street gallery where, for several years, the public could view his paintings for the price of one shilling. In England his paintings received the attention that the artist had sought in vain at home.

Evidently Doré first began to sculpt in 1871,[1] and his earliest sculpture was a clay bust of Christ modeled in England.[2] However, it was not until 1877 that he made his Salon debut as a sculptor, with a group entitled *Fate and Love (Le Parque et L'Amour).* The work was relatively well received by critics, but more than anything else they seemed surprised that the famous illustrator should take up another medium.[3]

In 1878 Doré entered three sculptures, each in a different exhibition. In fact, few full-time sculptors were to offer to the public an equally impressive group of works that year. At the annual Salon, Doré showed perhaps his most interesting sculpture, an allegorical group entitled *Glory* (fig. 65).[4] This work depicts a nude youth clasped in the arms of a winged female, Fame, who simultaneously drapes him with laurel and stabs him with a knife. Although some critics praised it highly,[5] others complained that its meaning was "difficult to decipher" and that "the role of sculpture is not to pose riddles."[6] In the same year, at an exhibition held by the Cercle de l'Union

Artistique, Doré exhibited an impressive allegory of Night, a sculptural project for a candelabrum. Contemporaneously, the Exposition Universelle of 1878 contained Doré's plaster model for an immense sculpted vase entitled *The Vine,* or *Poem of the Vine.* Over ten feet high, shaped like an Italian wine bottle, covered with vines and grapes, and teeming with winged cupids, fauns, and bacchantes, this extraordinary tour de force met with mixed critical reviews.[7] Doré was evidently disappointed that it elicited neither an award nor a commission to be cast in bronze. In the next few years, however, it was cast (perhaps on speculation or for advertising purposes) by the Thiébaut Frères foundry; the bronze was shown at the Salon of 1882, at the 1893 Columbian International Exposition in Chicago, and at the 1894 California Midwinter Exposition in San Francisco, where it was then purchased by the newly founded California Palace of the Legion of Honor.

At the Salon of 1880 Doré won a third-class medal for *The Madonna* (cat. no. 114), and for the remaining years of his life he continued to sculpt and to exhibit his works publicly. His last work is the charming but conventional *Monument to Alexandre Dumas Père* (Paris, Place Malesherbes). Begun in 1882, it was completed after Doré's death. The artist undertook to execute it without a fee, simply for the opportunity to leave behind a public work of sculpture. Doré's close friend and biographer Blanchard Jerrold wrote of the artist that "in his latter years sculpture was the delight of his life." Doré's various biographers and the catalog of the 1885 sale of his works mention approximately twenty sculptures in addition to the thirteen works included in Lami's oeuvre list for the artist.[8]

P.F.

113.
The Terror
Bronze
h: 22⅞ in. (58.1 cm.); w: 4¾ in. (12.1 cm.); d: 4¾ in. (12.1 cm.)
c. 1879
Signed: G. Dore (on left side of rock base)
No foundry mark
Lender: The David and Alfred Smart Gallery, The University of Chicago, Anonymous Loan

Doré exhibited a plaster version of this work at the Salon of 1879. The Salon reviewer for the journal *L'Illustration* typified the negative reaction to Doré's works that were not book illustrations: "Doré has two great enemies; first painting, then sculpture. *Terror,* an Indian mother who raises her infant above her head to save him from a serpent, is a sort of illustration in plaster."[9] Indeed, the work is a "sort of illustration" insofar as it possesses a narrative quality that was relatively rare in the sculpture of the period. The mother appears to be a Negro, not an Indian, and one assumes that she was intended to represent a literary, historical, or biblical figure such as the outcast Hagar with the infant Ishmael. The motif of the child above his mother's head was probably inspired by Carrier-Belleuse's famous statue of *The Messiah* (1867, St. Vincent de Paul, Paris), in which case Doré may have been suggesting a parallel between Hagar's son —according to certain traditions, the first black man—and Christ. Doré's work was forward-looking in style and provided a close formal precedent for Auguste Paris' allegorical group of *The French Republic Presenting the New Century to the World* (Salon of 1899). P.F.

114.
The Madonna
Bronze on marble base
h: 22 in. (55.7 cm.), including base of 2⅝ in. (6.7 cm.)
c. 1880
Signed: G. Dore (on top of self base)
Foundry mark: Thiebaut Freres / Paris (on top of base)
Lender: Art Museum, University of New Mexico, Albuquerque

Doré exhibited a large plaster version of the *Madonna* at the Salon of 1880, and it was awarded a third-class medal. The work fared much better at the hands of critics than had his earlier sculptures. It was illustrated in *Le Monde Illustré,*[10] and the critic for *L'Artiste* praised it,[11] as did the reviewer for *L'Art:*

A third-place medal—and that is really quite little—rewarded the effort of M. Gustave Doré. M. Doré modeled a life-size Madonna,

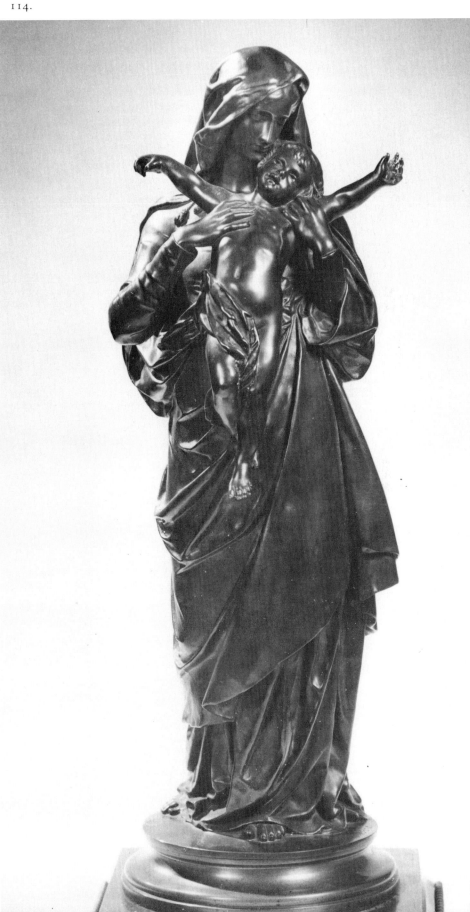

standing and holding the infant Jesus in her arms; the latter, in stretching out his little arms like an unruly child, evokes the spectacle of the last scene of the Passion drama. M. Doré had until now shown himself more intemperate than reasoned. This time he must be accepted in earnest as a creator of statues. What energy of will in this nature which nothing astonishes and nothing fatigues, in this imagination which conceives of the most diverse scenes and which moves with such abundant verve from the pencil to the modeling clay.[12]

The symbolic gesture of the infant holding out his arms like a cross was probably adopted from Carrier-Belleuse's 1867 group *The Messiah,* a work that apparently also influenced Doré's *The Terror* (cat. no. 113). In contrast to Doré's earlier sculptures,

such as *Fate and Love* (Salon of 1877) and *Glory* (Salon of 1878), with their flamboyant style and recherché allegorical character, the *Madonna* possesses a simple, clear symbolism which undoubtedly facilitated its reception by contemporary critics. P.F.

115.
Cupid and Skulls
Terracotta
h: 7¼ in. (18.4 cm.); l: 9⅝ in. (24.4 cm.); w: 5⅞ in. (14.9 cm.)
Signed: Gve. Dore (front right corner)
Lender: Museum of Art, Rhode Island School of Design, Providence, Gift of Uforia

Two variants of this work, one with fewer skulls than the other, are listed in the 1885 sale catalog of Doré's work where they are entitled simply *Cupid and Skulls (Amour et têtes de mort).*[13] The infant's position, on top of a pile of skulls, might suggest a "Triumph of Love over Death" — the cataloged title of the work at the Rhode Island School of Design. However, Cupid's worried face and precarious pose seem to indicate that he is about to take a tumble into the pile of skulls. Are we to conclude that all love is equally precarious and must end with death? The work must certainly have been intended as a *momento mori* of some kind. In general, the opaque symbolism of Doré's sculptures disturbed contemporary critics, but it seems unlikely that works such as this terracotta were ever intended to possess the clarity of meaning found in the more academic allegorical sculpture of the period. The juxtaposition of a naked infant and a pile of skulls has a hallucinatory, dreamlike quality which is evocative and rich in allusions and invites various interpretations. Doré's *Cupid and Skulls* may owe a debt to small Baroque sculptures, such as those by François Duquesnoy, of the infant Christ sleeping with a cross or a crown of thorns. P.F.

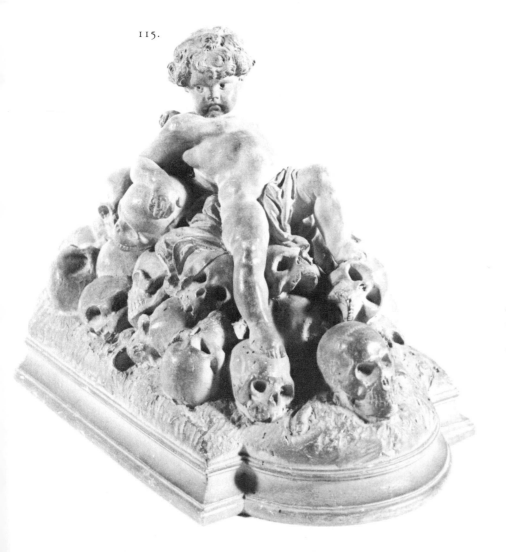

115.

116.

The Acrobats

Bronze

h: 50⅝ in. (1.29 m.); diam. of base: 10½ in. (26.7 cm.)

c. 1880–83(?)

Signed: Gve Dore (on top of base)

No foundry mark

Lender: The John and Mable Ringling Museum of Art, Sarasota, Florida

Throughout his life, one of Doré's passions was gymnastics. His studio on the Rue Bayard was a former gymnasium; there, for a time, the artist retained a trapeze hanging from the ceiling.[14] As an extension of this interest he created what is one of the more curious works in the history of sculpture. A gigantic, three-dimensional illustration, *The Acrobats* depicts a series of ten figures climbing on top of each other to form a human pyramid. Although individual forms are rendered in the traditional, academically realistic fashion, the composition of the work is totally unconventional and, in a sense, non-sculptural. It ignores the time-honored principles of contrapposto and compositional balance, since the subject dictates instead a precarious balance of figures disposed in an additive, vertical arrangement. The Sarasota bronze is presumably identical, at least in size, with the largest of three different-size bronze models for the *Acrobats* that appeared in the 1885 sale of Doré's studio;[15] small bronze versions, cast by Thiébaut Frères, have appeared on the art market in recent years. There is a more subdued gymnastic element in other sculptures by Doré (see cat. nos. 113 and 114). P.F.

Notes

1.
Leblanc, 1931, p. 10.
2.
Jerrold, 1891, p. 349.
3.
See J. Comte, "Le Salon," *L'Illustration,* June 16, 1877, no. 1790, p. 390; C. Timbal, "La Sculpture au Salon," *Gazette des beaux-arts,* 1877, XV, p. 544.
4.
Illustrated in Farner, n.d., II, pl. 303.
5.
Saint-Victor, 1878, pp. 224–25.
6.
Cited by Caso, 1973, p. 7.
7.
T. Chasrel, "Exposition Universelle de 1878: La Vigne de Gustave Doré," *L'Art,*

1878, XIV, pp. 296–97; Anon., "Le vase de M. Gustave Doré," *L'Illustration,* July 6, 1878, LXXII, no. 1845, pp. 3–6.
8.
Jerrold, 1891, pp. 355, 410; Leblanc, 1931, pp. 544–45.
9.
L. Pate, "Salon de 1879," *L'Illustration,* June 7, 1879, LXXIII, no. 1893, p. 367.
10.
Le Monde Illustré, 1880, XLVI, p. 285.
11.
J. Peladan, "L'Esthétique à l'Exposition Nationale des Beaux-Arts, *L'Artiste,* 1880, II, p. 442.
12.
Cited by Caso, 1973, p. 7.
13.
Leblanc, 1931, p. 544.
14.
Fournel, 1884, p. 427.
15.
Leblanc, 1931, p. 544.

Selected Bibliography

Paris, *Catalogue de la vente de l'atelier de Gustave Doré,* April 10–15, 1885.

Roosevelt, B., *Life and Reminiscences of Gustave Doré,* New York, 1885.

Jerrold, B., *Life of Gustave Doré,* London, 1891.

Geffroy, G., "Gustave Doré," *La Vie artistique,* Paris, 1893, II, pp. 116–26.

Lami, 1914–21, II, pp. 204–6.

Leblanc, H., *Catalogue de l'oeuvre complet de Gustave Doré,* Paris, 1931.

Farner, K., *Gustave Doré der industrialisierte Romantiker,* 2 vols., Dresden, n.d.

Caso, J. de, "A Little-Known Sculpture by Gustave Doré: The Madonna," *Bulletin, The University of New Mexico, University Art Museum,* 1973, no. 7, pp. 5–7.

116.

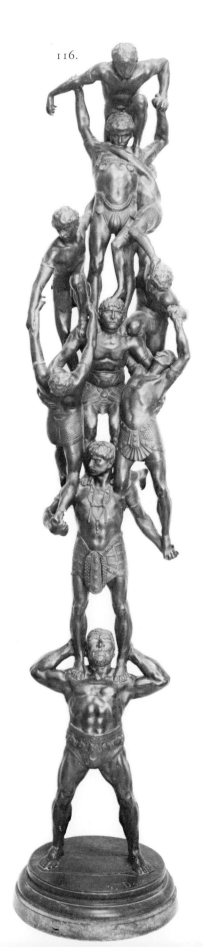

PAUL DUBOIS
1829 Nogent-sur-Seine–Paris 1905.

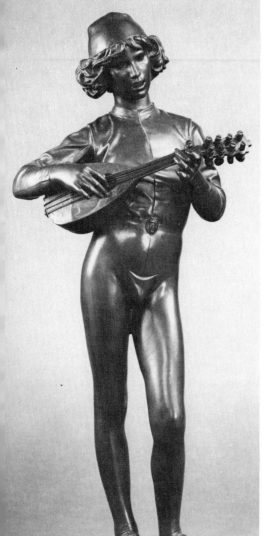

Unlike many other nineteenth-century French sculptors, Dubois did not have to struggle with financial problems or familial objections to his career as an artist. His father, a notary in Nogent-sur-Seine (Aube), supported his studies in Paris from the age of eight. After completing his course of instruction at the Lycée Louis-le-Grand, Dubois began the study of law, but his strong preference for music and art led to a change of career. He studied sculpture under Armand Toussaint and made his debut at the Salon of 1857 with two busts, one of a child and the other of *The Countess de B. . . .* The following year he was admitted to the Ecole des Beaux-Arts.

Although Dubois would later become director of the Ecole and hold that post from 1878 until his death in 1905, he did not long remain a student in that official training ground for artists. With his family's financial support, in 1859 he went to Rome where he remained for four years of independent study, keeping company with Chapu and Falguière, both of whom had followed the "normal" course of instruction at the Ecole and won the Prix de Rome. The beginning of Dubois' public acclaim occurred when he sent two plasters, both of them standing figures, to the Salon of 1863: the youthful *John The Baptist* and *Narcissus Bathing.* For these, he was awarded a second-class medal.

Many notable successes followed. At the Salon of 1865, the *Florentine Singer* (see cat. no. 117) was exhibited as a plaster and won him his first Medal of Honor. A statue of *The Virgin Holding the Infant Christ* was commissioned for the new church of the Trinity in 1864. With his *Monument to Général de Lamoricière* for Nantes Cathedral, Dubois achieved his greatest critical success and won a Medal of Honor for the third time when that monument was exhibited at the Exposition Universelle of 1878. An *Equestrian Joan of Arc* (cat. no. 121), first exhibited as a plaster at the Salon of 1889, was inaugurated in its definitive bronze format before Rheims Cathedral on July 15, 1896. On that occasion the president of the Republic conferred upon Dubois the *grand cordon* of the Legion of Honor.

The honors conferred and the responsibilities entrusted to Dubois were well-deserved recognition for his ability and accomplishment. As the American critic W. C. Brownell perceptively observed, "Dubois will never . . . give us a work that could be called insignificant. . . . [He is] probably the strongest of the Academic group of French sculptors of the day."[1] In spite of his admiration for Dubois as an artist representing a specific aesthetic stance, Brownell also detected "the defect of impeccability" in his works. Louis Vauxcelles echoed the same reservation when he noted in Dubois' style "a slight affectation of execution, goldsmith's work meticulously wrought."[2]

The style which Dubois introduced to French sculpture during the 1860s and practiced with distinction thereafter was labeled "néo-florentin" by his contemporaries. Renaissance sculpture, particularly that of Quattrocento Florence, had made a lasting impression on Dubois during his four years in Italy, and his revival of that style was subsequently adopted by a number of other sculptors. The first works that Dubois sent to the Salon upon his return from Italy announced this stylistic predilection. His young *John The Baptist* in particular recalled the same adolescent prophet, in a frenzy of divine inspiration, that Donatello had created four centuries earlier. The most famous of these "néo-florentin" works were Dubois' own *Florentine Singer* (Salon of 1865, cat. no. 117) and Mercié's *David,* (Salon of 1872, cat. no. 166). Rodin's *Age of Bronze* (Salon of 1877, fig. 66) and *St. John the Baptist Preaching* (Salon of 1880, cat. no. 191) can also be located within this stylistic tendency.

J.M.H.

117.
Florentine Singer
Bronze
h: 15⅛ in. (38.4 cm.); diam. of base: 5⅜ in. (13.7 cm.)
Signed and dated: P. DUBOIS 1865 (on top of base)
Foundry marks: F. BARBEDIENNE FONDEUR; REDUCTION MECANIQUE/A. COLLAS/BREVETE (on top of base)
Lender: Private Collection

Dubois' *Florentine Singer* (in plaster) was an immediate success at the Salon of 1865 and became one of the most popular sculptures of the nineteenth century. At the time

of its first exhibition it earned Dubois a Medal of Honor. It was subsequently exhibited at the Exposition Universelle of 1867, at Vienna in 1873, and again at the Exposition Universelle of 1889 in Paris. Various editions in bronze and porcelain made the *Florentine Singer* well known throughout the Western world. Not until 1953 did Barbedienne finally break the contract for editing the work in bronze.[3]

In his initial enthusiasm for the work, Paul Mantz claimed that "[Dubois'] statue is of a perfect unity; the head, a happy mingling of rusticity and finesse, is really that of a Florentine of the glorious times; the body, supple and nervous, is full of youth and elegance."[4] Although Mantz related the *Florentine Singer* to figures by Masaccio which appear in the Brancacci Chapel frescoes at the Carmine in Florence, sketches from Dubois' notebooks indicate that figures by Gozzoli, Pinturicchio, and Lorenzo da Viterbo are closer sources.[5]

Dubois managed to create an engaging synthesis of generalized forms and specific details in this figure. If this aspect of its character charmed vast numbers of viewers from the time of its appearance onward, critical acceptance was not unanimous. W. C. Brownell felt that "the moment M. Dubois gives us the *type* in a 'Florentine Minstrel,' to the exclusion of the personal and the particular, he fails in imaginativeness and falls back on the conventional."[6]
 J.M.H.

118.
Charity
Bronze
h: 24¼ in. (61.6 cm.); base: 8½ in. (21.6 cm.); d: 7¾ in. (19.7 cm.)
Model executed by 1876
Signed: P. DUBOIS (on back)
Foundry marks: F. BARBEDIENNE, fondeur (at left side of base); REDUCTION MECANIQUE/A. COLLAS/BREVETE (on lower back)
Lender: Manuel A. and June M. Greenbaum, Long Beach, California

This is a reduction after one of four allegorical works in bronze that adorn the corners of the *Monument to the Memory of General Juchault de Lamoricière* (1806–65) in the left transept of Nantes Cathedral. The other three are *Military Courage* (cat. no. 119), *Faith,* and *Meditation;* all four are seated figures. In addition to these allegories for

this monument, Dubois also created the recumbent effigy *(gisant)* of the General in marble and various reliefs and medallions (also in marble) that embellish the architectural superstructure designed by Louis Boitte (1830–1906). The entire ensemble recalls the most famous French monument of the sixteenth century, the *Tomb of Henry II* in Saint-Denis.

At the Salon of 1876, Dubois exhibited the *Charity* and *Military Courage* separately as plaster models. The entire monument, subsequently exhibited at the Exposition Universelle of 1878 and installed at Nantes the following year, was regarded as one of the aesthetic wonders of its age. In 1892, W. C. Brownell could survey the past decades and claim that the *Lamoricière Tomb* "has remained until recently one of the very finest achievements of sculpture in modern times."[7] This critic's appreciative assessment of Dubois' achievement remains unmatched:

The virtues of "Charity" and "Faith" and the ideas of "Military Courage" and "Meditation" could not be more adequately illustrated than by the figures which guard the solemn dignity of General Lamoricière's sleep. There is a certain force, a breadth of view in the general conception, something in the way in which the sculptor has taken his task, closely allied to real grandeur. The confident and even careless dependence upon the unaided value of its motive, making hardly any appeal to the fancy on one hand, and seeking no poignant effect on the other, imbues the work with the poise and purity of effortless strength. It conveys to the mind a clear impression of manliness, of qualities morally refreshing.[8]

Allegorical groups representing Charity, one of the three Cardinal Virtues according to Catholic teaching, have a long history in the Western tradition of sculpture and have often been included on tomb monuments. Roughly contemporary with Dubois' *Charity* are other Charity figures by Carpeaux (mid-1860s, sketches preserved at the Louvre), Duret (1864, in front of the church of the Trinity, Paris), and Dalou (1877, behind the Royal Exchange, London). During the latter half of the nineteenth century, the virtue of Christian Charity often came under attack from the secular left, which saw it as an excuse for

ignoring the inequities of society and avoiding reform. Its inclusion on this tomb monument can be seen as an affirmation of a traditionally Catholic point of view.

As a work of art, Dubois' *Charity* was often singled out for praise at the time of its appearance at the Salon of 1876 and Exposition Universelle in 1878. During the summer of 1876, engravings after it were reproduced in the *Gazette des beaux-arts, L'Art,* and *The Magazine of Art.* Charles Yriarte saw in the figure "a perfect simplicity" and declared it "a true source of joy for those who love art."[9] An English critic praised this *Charity* for being "no sentimental nymph. She is strong and brave and the mother of men; her broad breasts feed not only her own sturdy child, but also the poor puling waif which depends on her for food."[10] Charles Blanc noted the difficulty of representing theological virtues in modern times, when artists might have them "in their hearts and feelings, but not in their forms." He went on to locate this figure in the context of contemporary imagery: "a modern woman, whose rustic drapery in large pleats recalls the peasants of Jules Breton and François Millet."[11]
 J.M.H.

119.
Military Courage
Bronze
h: 20 in. (50.8 cm.)
Model executed 1876
Signed: P. DUBOIS (on back)
Foundry marks: F. BARBEDIENNE, Fondeur, Paris (on left side of base); REDUCTION MECANIQUE/A. COLLAS/BREVETE (at back)
Numbered: 42 (underneath)
Lender: Private Collection

This figure is a reduction after one of four allegorical works in bronze that adorn the corners of the *Monument to the Memory of General Juchault de Lamoricière* in the left transept of Nantes Cathedral (see cat. no. 118). If the other three allegories refer to the General's personal qualities, this one bears witness to his public and historical significance. After distinguishing himself in the Algerian campaigns during the 1840s, Lamoricière was instrumental in the capture of Abd el-Kader in 1847. Between 1848 and 1851 he was an active opponent of Louis Napoleon and, after the coup d'état, was arrested and exiled. During 1860 he was the commander of the papal army in Italy.

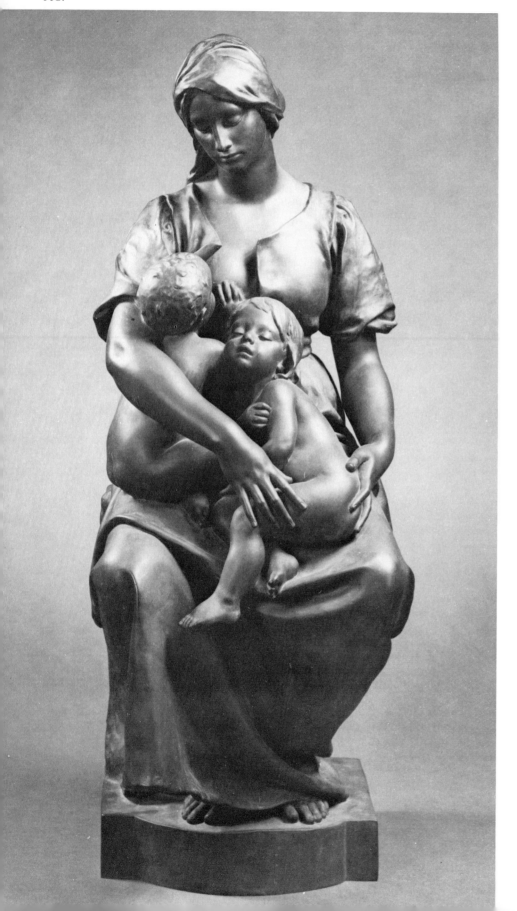

This figure contains unmistakable references to Michelangelo, a fact that was noted at the time of its appearance. If *Military Courage* seems most closely related to the Lorenzo de Medici effigy in San Lorenzo, Dubois has nonetheless incorporated aspects of other Michelangelesque poses. In its resolute character and extroversion, *Military Courage* evokes *Giuliano de Medici*'s more active pose, or even that of *Isaiah* from the Sistine ceiling.

When *Military Courage* and *Charity* were exhibited at the Salon of 1876, critical response often treated them as a pair. Henry James reported that they were "altogether the most eminent works in the Salon."[12] Eugène Véron singled out this work in the pages of *L'Art,* however, and praised Dubois' accomplishment: "It is no small thing to remake, without falling into pastiche, those moral allegories which abound and sometimes overabound in the sculpture of all ages."[13] Sir Coutts Lindsay was so impressed by the work that he ordered a plaster cast of it to be on permanent display in his Grosvenor Gallery in London, along with Delaplanche's *Maternal Education* and Chapu's *Joan of Arc,* as the preeminent examples of modern French sculpture.[14] J.M.H.

120.
Louis Pasteur (1822–1895)
Sèvres porcelain
h: 15½ in. (39.4 cm.); w: 11½ in. (29.2 cm.); d: 7 in. (17.8 cm.)
Original model completed by 1880
Inscribed: L. Pasteur (on front)
Lender: The Fine Arts Museums of San Francisco, Gift of the French Government

This is a reduction in porcelain of a bust which was first exhibited at the Salon of 1880 (as a plaster) and subsequently at the Salon of 1890 and Exposition Universelle of 1900 (as a bronze). The bronze was installed at the Institut de France in 1901. Dubois did the portraits of various contemporary luminaries from the world of arts and sciences, including the composers Bizet, Gounod, and Saint-Saëns; the painters Baudry, Bonnat, Cabanel, and Henner; and the doctors Parrot and Gavarret.

The seriousness and simplicity of this portrait seem particularly appropriate for the great chemist and humanitarian who is represented. He and Dubois first met in 1865. After Dubois' great success at that

year's Salon with *Florentine Singer* (cat. no. 117), he was invited to Compiègne for one of the famous series of receptions for notables organized by the Emperor. Viollet-le-Duc and Pasteur were also present, and Pasteur later referred to both Dubois and his famous *Singer* in a letter to Madame Pasteur.[15] J.M.H.

121.
Equestrian Joan of Arc
Bronze
h: 24½ in. (62.2 cm.); l: 21 in.
(53.3 cm.); w: 9⅞ in. (25.1 cm.)
Original model finished by 1889
Signed: P. Dubois (on top of base)
Foundry marks: F. BARBEDIENNE, Fondeur;
REDUCTION MECANIQUE/A. COLLAS/
BREVETE (at back)
Numbered: 42 (underneath)
Lender: Manuel A. and June M.
Greenbaum, Long Beach, California

At the Salon of 1889, two preeminent French sculptors, Dubois and Frémiet (see cat. no. 142), exhibited their respective versions of an equestrian Joan of Arc in what was called "a happy coincidence of patriotic inspiration . . . a spontaneous competition."[16] Frémiet's work was the revision of a monument completed in 1874; Dubois' statue was on public view for the first time. Such major efforts glorifying the fifteenth-century deliverer of France cannot be separated from the political and emotional situation of the country at that time.

Indeed, 1889 was the year in which the antagonism between right and left in France focused on the campaign of General Boulanger, who hoped to found a military dictatorship after winning that year's elections. His supporters were a broad coalition of the dissatisfied, including most enemies of the Republic as it then existed. For the left, this was the centenary of the Revolution, a celebration of secular republicanism, and Boulanger's threat had to be overcome at all costs.

Ever since the Franco-Prussian War, the Commune, and the founding of the Third Republic, the memory of Joan of Arc had served to console France's wounded pride, particularly as a rallying figure for Monarchists, Bonapartists, and the Catholic Right. The appearance of these two equestrian *Joan*s at the Salon called to mind not only a venerable artistic tradition dating back to the Renaissance, but also to

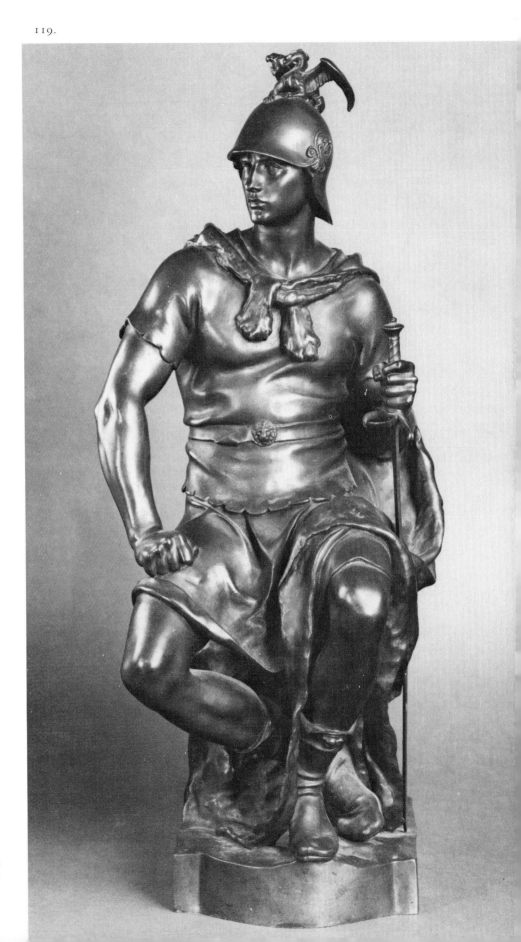

the meaning of the saint in present-day political terms. For those who believed in the glory of France's traditional values, this focus on Joan of Arc at the Salon of 1889 must have been as reassuring as the view of Sacré-Coeur under construction on the heights of Montmartre.

Dubois' *Joan of Arc* was quite different in conception from other images of the saint, including that of Frémiet. Georges Lafenestre interpreted her representation as that of a "missionary in action."[17] Her doll-like features recall the proportions of early Christian sculpture. It seems impossible that her enormous sword could be held aloft by such a frail arm so far extended from the body. She barely clasps the reins of her aggressive and determined mount; her feet seem almost spasmodic as they push the stirrups away from the horse's body. This Joan is truly a visionary, a saint who responds to her sacred calling and whose body obeys beyond its physical capabilities.

After Dubois' equestrian *Joan of Arc* was cast in bronze, it was exhibited once again, at the Salon of 1895. The following year, on the occasion of its inauguration at Rheims before the cathedral, Dubois was advanced one more degree in the Legion of Honor: President Faure awarded him the *grand cordon.* Four years later a full-size replica was installed in Paris in front of the church of Saint-Augustin. J.M.H.

120.

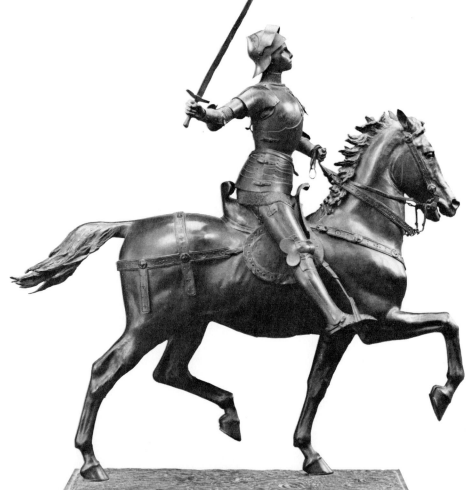

121.

FRANCISQUE-JOSEPH DURET
1804 Paris 1865

Notes

1.
Brownell, 1901, p. 147.

2.
Fontainas and Vauxcelles, 1922, II, p. 266.

3.
Archives Nationales 368 AP 3, cited by
A. Pingeot in her catalog entry on Dubois
in Philadelphia, 1978, p. 227.

4.
P. M[antz], "Salon de 1865," *Gazette des
Beaux-Arts*, 1865, XIX, pp. 35–36 (quoted
in Louisville, 1971, p. 163)

5.
A number of Dubois sketches after works
by these Italian Renaissance masters have
been published by Delahaye, 1975, pp.
340–41.

6.
Brownell, 1901, p. 148.

7.
Ibid., p. 147.

8.
Ibid., p. 149.

9.
Yriarte, 1876, p. 123.

10.
"Salon of 1876," *The Magazine of Art*,
1878, I, p. 55.

11.
C. Blanc, "Exposition Universelle:
Sculpture," *Le Temps*, July 21, 1878.

12.
H. James, *New York Daily Tribune*, June 5,
1876.

13.
E. Veron, "Le Courage militaire par
M. Dubois," *L'Art*, 1877, I, p. 273.

14.
Ibid, p. 275.

15.
Delahaye, 1975, p. 341.

16.
Lafenestre, 1889, p. 89.

17.
Ibid., p. 91.

Selected Bibliography

Claretie, 1882–84, II, pp. 321–44.

Brownell, 1901, chap. V.

Saint-Marceaux, R., de, *Notice sur la vie et
les travaux de M. Paul Dubois...*, Paris, 1906.

Lami, 1914–21, II, pp. 217–22.

Delahaye, J. M., *Paul Dubois Statuaire,
1829–1905*, thesis, Ecole du Louvre, 1973.

————, "Le 'Chanteur florentin' de Paul
Dubois," *Revue du Louvre et des Musées de
France*, 1975, nos. 5–6, pp. 338–43.

The son of a sculptor, Duret was only twelve years old when his father died. His first inclination was to the theater, and he studied briefly at the Conservatoire before he determined to follow the profession of his father. He applied to the studio of the renowned Bosio and entered the Ecole des Beaux-Arts at fourteen. Precocious, he obtained the Prix de Rome in 1823, though he had to share it with Dumont, for a bas-relief of *The Grief of Evander Confronting the Body of His Son Pallas*. He arrived in Italy in 1824, to stay six years.

His career flourished after his return to Paris. The two final works sent from Rome, *Mercury Inventing the Lyre* and a *tête d'expression* (the study of a specific emotion in bust form) of *Malice*, won a first-class medal at the Salon of 1831, and both were acquired by Louis-Philippe.

The *Neapolitan Fisherboy Dancing the Tarentella* attempted to "resolve the problem of bringing a modern sentiment to the choice of antique forms."[1] Charles Blanc suggested that the lithe physical types Duret often depicted may have reflected a mild narcissism. "Thin of form, agile and supple, given a constitution delicately solid, robust but small, Duret was, from the beginning, his own model."[2] The *Fisherboy* sealed Duret's official success with a Medal of Honor and membership in the Legion of Honor, and his career was secure. His major portrait statues include *Casimir Perier*, 1833, *Molière*, 1834, *Cardinal Richelieu*, 1836, *Philippe d'Orléans*, 1840, and *Chateaubriand*, 1855.

Duret's formal education stressed imitation of the antique, but the ambiguity of his personal taste is evident in his excursions into the Romantic—such as *Chactas Meditating on the Tomb of Atala*, (1836, fig. 76) drawn from Chateaubriand's novel of thwarted love among the American Indians—or into genre, such as the *Improvising Vintager* of 1840. In a letter to Ingres, who had evidently reproached the sculptor for his indiscretions in executing genre figures, Duret insisted that if he "took a subject of second order,... it was to study nature," and then to apply that to the "grand Greek style," with "nobility and truth," the catch-words of Ingres' philosophy.[3] But in reality, Duret's greatest talent lay in less formal, more delicate compositions. Gigoux regretted that the artist made comparatively few busts, as those he did were full of "charm and great style;" he had "missed his calling."[4]

The huge bronze caryatids, *Military Force* and *Civilian Force*, at the entrance to the crypt of Napoleon I under the Dome of the Invalides, after 1841, are typical of his impressive classical handling. Because his idealizing style was consonant with the subdued tone of contemporary religious art, he received a number of important church commissions, including works for Nôtre-Dame de Lorette, the Madeleine, St. Jean-St. Francois, Ste. Clotilde, St. Vincent de Paul, and Trinity. Duret also completed his share of ornamental sculptures, including several for the Louvre, the pediment for the Pavilion Richelieu, *France Protecting Her Children*, and the *Victories* decorating the Salle des Sept Cheminées. In 1857 his *Comedy* and *Tragedy* were installed in the vestibule of the Théâtre Français. The portrait of *Rachel*, the great tragedian in her most famous role as Phaedra, was done for the same institution in 1865. Of his two fountains, both from 1860, the *St. Michael Trampling the Dragon* has greater allure and presence than the *River* for the Medici Fountain in the Luxembourg Gardens.

Nervous and impatient, Duret preferred bronze to marble. He was a modeler, not a carver. "He entered his studio, played with a little clay, and then left again. And always the same thing, many times a day," but, "in spite of his habitual nonchalance, he could finish a large work very quickly when he wanted to."[5]

Duret was invited into the Institut in 1843, became a professor at the Ecole des Beaux-Arts in 1852, was made an *officier* of the Legion of Honor in 1853, and was awarded a Medal of Honor at the 1855 Exposition Universelle. He was exceptionally popular as an instructor because he had the rare ability to be impartial; he held his students to the fundamental rules of sculpture but allowed them to express their own personalities.

His private life was calm and happy, with a devoted wife. He was well liked even though he expressed his opinions quite

bluntly. He repeatedly insulted his friend and neighbor Pradier, who never took exception—perhaps because the two of them mutually disapproved so strongly of Rude. The irony of life saw work by the two of them later exhibited at the Louvre in the Salle Rude![6] Duret refused to admit the gravity of his heart condition and was planning a grand decorative project for the city of Marseille when he died suddenly at the Institut in 1865. J.E.H.

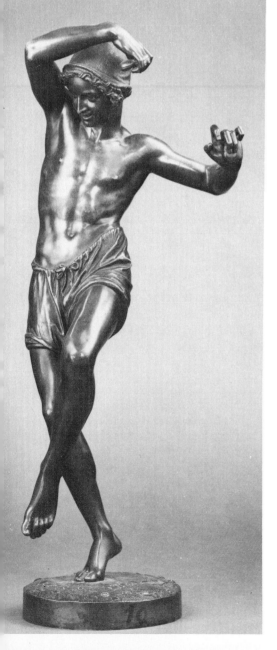

122.

122.
Dancing Neapolitan Boy
Bronze
h: 21 in. (53.3 cm.); w: 8⅝ in. (21.9 cm.); d: 6⅞ in. (17.5 cm.)
Model 1833
Signed: F. Duret (on top of base)
Foundry mark: Delafontaine (on top of base)
Lender: Private Collection

Duret was prompted by a visit to Naples to model his figure of a fisherboy dancing the tarentella. When its appearance coincided with Rude's marble *Neapolitan Fisherboy* (cat. no. 210) at the 1833 Salon,[7] the two were inevitably compared.

MM. Rude and Duret, without agreeing, and probably without knowing the other, have departed from the same point. . . . It is the protestation of two sensitive artists . . . against the glacial dreams of the ideal. In taking their models from the social class closest to nature, in imitating not what the kindled imagination conceives, but what one sees every day, they have proved that the real superiority of the ancients consists in living with nature.[8]

Rude's plaster, shown at the 1831 Salon, may have encouraged Duret's choice, but the theme of Neapolitan fishermen, the *lazzaroni,* appealed to the Romantic flirtation with poverty as a quaint, carefree escape from the bourgeois world. One of countless scenarios was printed in *L'Artiste* written by E. B. de Bourdonnel, the year before Duret's triumph:

On seeing a fisherman gazing lovingly at his family, the Frenchman's eyes filled with tears: Lucky Neapolitan, I envy your life. . . . If I ever find a heart that understands me, a pure and fresh young girl who wishes to share my fate . . . I will say to her . . . come, let us abandon this world we do not need, let us hide our life and our happiness in the wilds of Naples. There we will have a beautiful sky, an eternal spring, the sweet far niente, love. What more do we need?[9]

The picturesque charm of Naples appealed more to the budding Romantics than did the grandeur of Rome. The greater realism was a breath of fresh air, not always appreciated in the face of the "intransigence of the classical purity" dominating the Salon.[10] Still, Duret's aspirations were decidedly academic, and he was probably inspired by the famous *Dancing Faun* of antiquity in the Vatican collection. The slender youth, with his graceful movement, was the precedent for later dancing figures such as Clésinger's *Zingara* and Carrier-Belleuse's virtual replicas. The State bought the bronze, cast by Gonon, for the Musée du Luxembourg.

A pendant *Neapolitan Dancer,* with the pose reversed and a tambourine in place of the castanets, was exhibited by Duret at the Salon of 1838.[11] In the same year the Delafontaine foundry began to market bronze versions of both models. At the 1855 Exposition Universelle, Delafontaine won a first-class medal, because "its exhibit recommends itself for its good taste. The models, due to . . . M. Duret, are well rendered. . . . The chasing is generally careful and polished."[12] J.E.H.

JEAN-BERNARD
DUSEIGNEUR
1808 Paris 1866

Notes

1.
Blanc, 1866, p. 102.
2.
Ibid., p. 101.
3.
Ibid., p. 103.
4.
Gigoux, 1885, p. 163.
5.
Ibid., pp. 163, 170.
6.
Ibid., pp. 171, 166.
7.
See *L'Artiste,* 1833, V, p. 142, and C. P. Landon, *Salon de 1833: Annales du Musée,* Paris, 1833, pp. 106–17, pl. 58.
8.
L. de Fourcaud, *François Rude et son Temps,* Paris, 1904, p. 142, quoting C. Lenormant from *Le Temps,* March 21, 1833.
9.
E. B. de Bourdonnel, "Le Pêcheur Napolitain," *L'Artiste,* III, 1832, p. 172.
10.
J. Calmette, *Rude,* Paris, 1920, p. 72.
11.
See *L'Artiste,* 1838, XV, p. 173.
12.
Paris, Exposition Universelle de 1855, *Rapports du Jury Mixte International,* 2 vols., Paris, 1856, II, p. 257.

Selected Bibliography

Beule, C.E., *Notice sur la vie et les oeuvres de Francisque Duret,* Paris, 1866.

Blanc, C., "Francisque Duret," *Gazette des beaux-arts,* 1866, XX, pp. 97–118.

Gigoux, 1885, passim.

Lami, 1914–21, II, pp. 262–70.

Louisville, 1971, pp. 165–68.

The son of a bronze manufacturer, Jean-Bernard (known as Jehan) Duseigneur entered the Ecole des Beaux-Arts at age fourteen, to study under Bosio. He continued his education in the studios of Dupaty and Corot. In 1831 he made his Salon debut with a plaster model of *Roland furieux* (fig. 74), an emotionally charged, writhing nude figure that broke with the strict formalism of his academic training. This work won him immediate notoriety and allied him with the burgeoning Romantic school of sculpture headed by Rude, Préault, and Barye. In the same year Duseigneur's close friend Théophile Gautier celebrated the sculpture in a poem.[1] *Roland furieux* was also displayed at the Exposition Universelle of 1855. Despite its appeal to the prevailing Romantic sentiments of the period, the piece was not cast in bronze until 1867, after the artist's death. When it was exhibited at the Salon of that year, some critics considered it already outmoded.[2] As a landmark in the development of Romantic sculpture, *Roland furieux* eclipsed the popularity of Duseigneur's other works, including a plaster *St. Michael and the Dragon* for which he earned a second-class medal at the Salon of 1834.

Today Duseigneur is remembered—perhaps justly—only for the *Roland furieux;* but he produced numerous other works which have yet to be studied. In addition to more than eighty portrait medallions and several busts—including one of King Louis-Philippe (Saint-Omer)—he received many ecclesiastic commissions. In Paris alone, he worked for the churches of the Madeleine, Nôtre-Dame-des-Victoires, St. Vincent de Paul, Ste. Elisabeth, St. Roch, and St. Laurent.[3] He made decorative sculptures for the Palais du Louvre, the old Hôtel de Ville, and the tower of St. Jacques-la-Boucherie. An archaeologist and art historian, Duseigneur contributed to the *Revue universelle des arts.* He was preparing a history of sculpture from the fourth to the fifteenth centuries at the time of his death. M.B. & P.F.

123.

123.
Victor Hugo (1802–1885)
Bronze
h: 11 in. (27.9 cm.), including bronze self
base
Signed and dated: Jean Duseigneur 1841
(on back)
Foundry mark: Quesnel (on back)
Inscribed: V^tor Hugo (on front)
Lender: Private Collection

Victor Hugo—poet, novelist, dramatist—
is generally regarded as the guiding light
of the Romantic movement in France.
The author of many brilliant works,
notably *Hernani, Nôtre-Dame de Paris,*
the *Feuilles d'Automne, Ruy Blas,* and *Les
Misérables,* he exerted a widespread in-
fluence on his contemporaries. Indeed, as
early as 1833 a critic in *L'Artiste* claimed
that the so-called Romantic school of
sculpture drew its inspiration entirely from
his writing.[4] The impact of his works on
the visual arts has yet to be studied, but
according to one critic Duseigneur was the
first sculptor to "rally to the call of Her-
nani's horn."[5] In August 1831 the sculptor
began his plaster group of *Esmeralda and
Quasimodo*—only four months after Hugo
published his tragic medieval romance
*Nôtre-Dame de Paris (The Hunchback of
Nôtre-Dame).* Duseigneur's sculpture, now
lost, was exhibited at the Salon of 1833. A
review in *L'Artiste* described the figure of
Quasimodo as "repulsive," and Esmeralda
as "without life . . . grace . . . and . . . light-
ness." The reviewer warned against Hugo's
preoccupation with the bizarre and the
ugly as a dangerous influence which would
undermine the noble, didactic role tra-
ditionally assigned to sculpture.[6]

The work in the present exhibition may be
a reduced version of a bust of Victor Hugo
also displayed at the Salon of 1833 by
Duseigneur. His portrayal of the author as
a proper, bourgeois gentleman rather than
a passionate writer is surprising. The only
indication of his Romantic temperament is
the large forehead which contemporaries
understood as a sign of genius. The other-
wise bland, straightforward portrait is
similar to the numerous non-caricature
busts produced by Dantan and many other
sculptors during the first half of the
nineteenth century. The small bust ex-
hibited here was cast by Quesnel, one of
the most highly respected bronze founders
active in the 1840s. Along with the
Esmeralda and Quasimodo, it must have
been Duseigneur's tribute to the eminent
author. Despite the sculptor's close associa-
tion with several other Romantic writers
—including Nerval, Borel, O'Neddy,
and Gautier—he does not appear
to have executed subjects inspired by
their work. M.B. & P.F.

Notes
1.
T. Gautier, "Poésie. Ode à Jean Duseig-
neur," intro. by P.L. Jacob, *L'Artiste,* 1866,
I, pp. 186–87.
2.
Mantz, 1867, p. 546, believed the
sculpture to be representative of the
Romantic age, but noted that one had to
make a "retrospective effort" in order to
understand it.
3.
He also did work for provincial churches
including Nôtre-Dame-de-Bonsecours,
near Rouen, and the cathedrals of Bordeaux
and St. Quentin.
4.
"Salon de 1833 (VIIIᵉ article)—Sculpture,"
L'Artiste, 1833, V, p. 141.
5.
Michel, 1899, p. 298.
6.
"Salon de 1833 (IXᵉ article)—Sculpture,"
L'Artiste, 1833, V, p. 154.
7.
Ibid, p. 153.

Selected Bibliography

"Jean du Seigneur, statuaire, par les amis
de Jean du Seigneur. Catalogue par
Duseigneur," *Revue universelle des arts,* 1866,
XXIII, pp. 67–110.

Lami, 1914–21, II, pp. 271–79.

By the age of fourteen Antoine Etex was
assisting his father, an ornamental sculptor.
They worked together, under Romagnesi's
direction, carving capitals for the Expiatory
Chapel of Louis XVI. In 1823 Etex entered
the Ecole des Beaux-Arts to study under
Bosio, whom he quickly left for Dupaty.
After the latter died in 1825, Etex studied
with Pradier, whom he was to consider his
true master. Evidently Pradier first met the
young sculptor after having seen and ad-
mired his *Young Greek Expiring on the Ruins
of Ancient Greece,* the model for which had
been sold to a bronze manufacturer.[1] The
title of this lost work may be taken as a
harbinger of the Romantic attitude and the
admiration for classical Greece which ap-
pear in the artist's later works.

While in Pradier's studio, Etex made the
acquaintance of the painter Ingres, who
also became his instructor. In 1827 Etex
competed for the Prix de Rome but placed
last among the sixteen contestants. Accord-
ing to Etex, Ingres was outraged by this
injustice and offered to pay for the young
artist to cast his competition model.[2] In
1829 Etex won second prize in the Prix de
Rome competition, with a figure represent-
ing *The Death of Hyacinthe;* when in 1830
he failed again to place first in the compe-
tition, he left the Ecole. He took an active
part in the Revolution of 1830; as compen-
sation for being arrested, he received from
the new Ministry of the Interior a pension
permitting him to study in Rome. There
he modeled what was to be his greatest
work, *Cain and His Race Accursed of God*
(cat. no. 124). He traveled to Algeria and
Spain before returning to Paris in 1832.
The following year he made his Salon
debut with the *Cain.* Due to the success of
this work, and also his personal and politi-
cal contacts, he received the commission
for reliefs representing *The Resistance of
1814* and *The Peace of 1815* on the Arc de
Triomphe. It is still difficult to understand
how Adolphe Thiers could have been so un-
diplomatic, vis-à-vis the art establishment,
to assign two of the major reliefs on the
Arc to the twenty-five-year-old Etex, one
relief to Rude, and one to Cortot, rather
than divide such an important public
project equally among four sculptors. The
work brought Etex considerable renown,
but also the envy of his colleagues. It
was perhaps for this reason that his *Bust
of Thiers* was refused by the Salon jury
in 1837.

Etex received numerous State commissions and purchases—again, mostly through the agency of Thiers—throughout the 1830s, 1840s, and 1850s: *Sainte Geneviève* (Salon of 1836, church of Saint-Martin at Clamecy); *Blanche de Castille* (Salon of 1837, commissioned by the King, Musée de Versailles); *Saint Augustin* (Salon of 1838, church of the Madeleine); *Charlemagne* (1840–47, Palais du Luxembourg); *Olympia* (Salon of 1842, Versailles); *Saint Louis* (1843–44, Place de la Nation, Paris); *Nyssia* (Salon of 1850, Musée de Caen); *Paris Imploring God on Behalf of the Cholera Victims of 1832* (Salon of 1852, Lariboisière Hospital, Paris); *Monument to Vauban* (1842–c. 1852, Dome

Church of the Invalides); *General Lecourbe* (1852–57, Place de la Liberté, Lons-le-Saunier); *Maternal Grief* (Salon of 1859, Parc de Blossac, Poitiers); statues of *Paris* and *Helen* (1857–59, Louvre courtyard decoration); *Sainte Anne* (1860, Saint-Paul-Saint-Louis, Paris). Few other sculptors received such constant State patronage for relatively important works over such an equally long period. In the 1860s, 1870s, and 1880s, with Thiers no longer in power, State commissions dwindled, but Etex remained active and continued to produce numerous busts, tomb monuments, projects for commemorative monuments, and occasional Salon statues. He exhibited for the last time in 1885.

124.

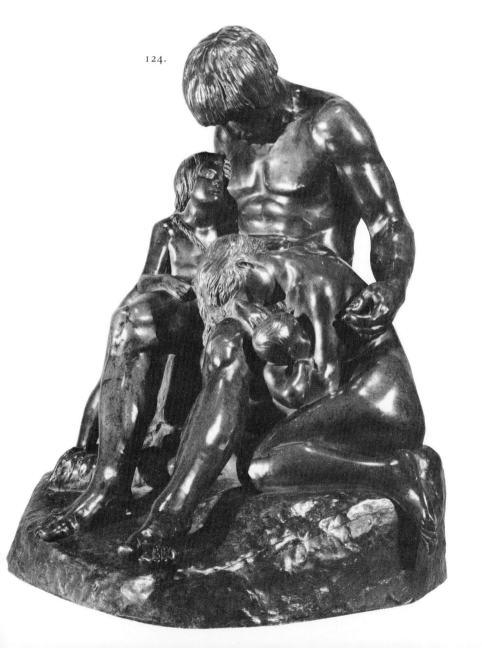

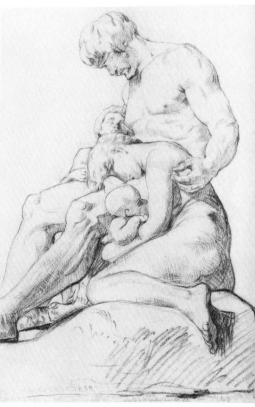

125.

A secondary but multifaceted talent, Etex preached and practiced the life of a Renaissance man. He was a painter, an architect, an engraver, a writer, and a would-be politician. He first exhibited as a painter at the Salon of 1844, although he had begun to paint as early as 1828. As an architect he designed projects for the reconstruction of the Opéra and for the embellishment of various quarters of Paris. He also designed several monuments, the most interesting of which are those to Géricault (Salon of 1841, fig. 112, for which Etex received the Cross of the Legion of Honor) and to Ingres (1869–71, fig. 20). As a writer, Etex contributed to *L'Artiste, La Presse,* and *Le Siècle.* Perhaps motivated as much by a desire to bathe in their glory as to pay them homage, he wrote about artists he knew and admired: David d'Angers, Pradier, Ary Scheffer, and Paul Delaroche. Etex's major publications include an elementary drawing course (first edition, 1851), a review of the 1855 Exposition Universelle (1856), and an autobiography (1878). The major recurrent theme of these works is the necessity for interrelating the arts of painting, sculpture, and architecture. He also delivered a series of lectures on this subject in Paris in 1860–61. His major work as an engraver was *La Grèce Tragique* (Paris, 1847), a volume of illustrations to several Greek tragedies.

Etex saw himself as a rebel, continually struggling against what he felt was an unjust failure to recognize his genius. Yet by most standards he was extremely successful. It is true that he never played an important role in the Ecole des Beaux-Arts (which he criticized in his writings), but this is probably so only because he left it while still an impatient youth. In a sense, his tremendous early successes in the 1830s may have spoiled him. Perhaps the constant need for recognition encouraged him to branch out into many activities for which he possessed only a mediocre talent. By the end of the 1860s this self-styled Renaissance man and rejuvenator of Greek art was, in many respects, out of touch with his times. Reviewing the Salon of 1869, one critic wrote, "You all know M. Etex. His battles and his triumphs go back to the era of Rude, David, and Pradier. He has remained standing and valiant, the only representative of a generation for which posterity has begun."[3] To what ex-

tent this assessment is true remains to be determined. Etex was to continue sculpting for another twenty years, but little of his work from that period has been studied. P.F.

124.
Cain and His Race Accursed of God
Bronze
h: 17½ in. (44.5 cm.)
Model c. 1832
Signed: ETEX
No foundry mark
Lender: The Arthur M. Sackler Collections, Washington, D.C.

125.
Cain and His Race Accursed of God
Black chalk and pencil on paper
h: 15¾ in. (40 cm.); w: 11¼ in. (28.6 cm.)
Signed and dated: ETEX/1832
Inscribed: (Salon de 1833 1ere Medaille) ce dessin a ete reproduit dans l'Artiste
Lender: The Arthur M. Sackler Collections, Washington, D.C.

In his autobiography Etex provides a considerable amount of detailed information concerning *Cain and His Race.* Most of what he recounts appears to have a factual basis, although it is tainted by the perspective of an aging, aggrieved author who felt he had been unfairly treated by the powers of the art world.

Etex began work on the *Cain* in 1831 while in Rome. He consciously set out to create a major sculpture that would bring him fame in Paris and compensate for his unsuccessful attempts to win the Prix de Rome.[4] Etex states that the sculptors Jean De Bay and Husson—the Prix de Rome winners of 1829 and 1830—had also been working in Rome on statues of Cain.[5] To thwart the potential success of Etex's group at the Paris Salon, the director of the French Academy in Rome, Horace Vernet, announced that the works of the Prix de Rome sculptors would be sent back to Paris earlier than normal. Thus, they would arrive before Etex's group and presumably undercut its impact. In fact, both De Bay and Husson did execute sculptures of Adam and Eve while in Rome[6] (it is un-

known whether either of these works also contained a figure of Cain), but they were not exhibited at the Paris Salons. Etex tells us that unintentionally his plaster group was shipped while it was still damp and, consequently, it absorbed some of the color of the sawdust in which it was packed, resulting in a harmonious tint "which made it resemble the marbles of the Parthenon."[7]

When the plaster model of the *Cain* was exhibited at the Salon, it was a great success, earning a first-class medal from the Salon jury and praise from the critics. The young sculptor achieved immediate renown and received invitations from a number of important people including Madame Récamier and Hippolyte Carnot.[8] To illustrate the sculpture in his newly founded journal, the *Magasin pittoresque,* the publisher Edouard Charton asked Etex for a drawing of the group; the drawing, included in the current exhibition, was indeed reproduced (1833, I, p. 117) along with a glowing description of the sculpture. Etex records that his teachers, Pradier and Ingres, praised the *Cain* highly, although Pradier became jealous when his figure of *Cyparisse* had to share the same room at the Salon, and Ingres recommended that once Etex had obtained a commission for a marble version of his work, he should take the money and execute his *Cain* in a different pose.

The critic for *L'Artiste* called *Cain* "one of the most remarkable productions exhibited in the last twenty years" and hoped that Etex would have the opportunity to execute it in marble.[9] A second article in *L'Artiste* addressed the following plea to the government "What! for a few thousand francs, will you leave this magnificent group of Cain incomplete, will you leave it lost and obscure in the atelier of the young man who dispensed for this work a part of his genius and his life, who waits, to make of it a complete chef d'oeuvre, that you would also give him a block of marble."[10] This was published a few days prior to the closing of the Salon. Etex tells us that, at the same moment, he received a visit from Alexandre Dumas who told him that the Minister of the Interior, Adolphe Thiers, had said Etex would receive the Cross of the Legion of Honor and a commission to execute *Cain* in marble for 35,000 francs.[11] Supposedly Louis-Philippe had promised all this to satisfy the request of his young son, the Prince of Joinville, who was dying; but after the Salon closed,

Etex first received only a commission for a portrait bust, and then the commission for two of the reliefs on the Arc de Triomphe. It was not until 1836 that Thiers, by then Minister of Foreign Affairs, and his successor as Minister of the Interior, Montolivet, commissioned the marble of *Cain*.[12] Completed in 1839, it was exhibited at the Salon and well received by critics.[13] The work was then given to the city of Lyon where today it is in the Musée des Beaux-Arts.

Etex exhibited his plaster of the group at the London Universal Exhibition of 1851 and at the Paris Exposition Universelle of 1855. On the latter occasion he was disappointed not to receive an award because, in his words, "the jury continued to show itself without pity for me."[14] Etex was also incensed when the organizing committee for the 1867 Exposition Universelle failed to request his *Cain* but included Carpeaux's *Ugolino* which he informs us, "would not have existed if I had not previously made my group of *Cain*."[15] Etex also complains in his autobiography that the *Cain* was criticized when first exhibited at the Salon of 1833, but that thereafter his other works were faulted for not living up to it.

To a great extent *Cain* embodies the aesthetic principles Etex was to profess—perhaps as an *a postieri* justification—in his writings. In his *Cours de Dessin*, citing Michelangelo as his authority, Etex says that "to be well composed a statue in marble should be able to roll from the top to the bottom of a mountain without being damaged, without breaking. That is to say that none of its parts should be detached from its mass, that everything should be linked to it; that in composing a statue it is necessary that it be of grand character, beautiful and severe, and of an imposing mass which inspires respect for its solidity."[16] Etex could well have been describing his *Cain*. Indeed, an important aspect of its impact is due to the fact that it is conceived in terms of an expressive mass as opposed to forms that create a series of silhouettes.

It seems probable that the form of the *Cain* owes a debt to Michelangelo, while its subject was likely to have been inspired by Byron's drama, *Cain*, of 1821.[17] The subject of Cain was particularly attractive to Romantic sculptors who saw in this biblical figure, as they did in Satan, a brooding, fallen rebel with whom they could identify (see cat. no. 137). As Etex was clear to point out in his autobiography, the *Cain* provided a formal prototype for Carpeaux's *Ugolino* (cat. no. 32) and for Gabriel Joseph Garraud's *First Family* (Salon of 1845).[18] Among other works influenced by it is Dieudonné's *Paradise Lost* (Salon of 1853, Musée Fabre, Montpellier). Etex himself also produced a variant of *Cain* in his *Paris Imploring God on Behalf of the Cholera Victims of 1832* (Salon of 1852); this latter work adopted the same composition but turned the heads of the three principal figures upward and outward, transforming the central figure of Cain into a female representing Paris.

It is unclear when Etex first produced bronze reductions of his *Cain*. It does not appear to have been cast in a large commercial edition. In addition to the example in this exhibition, another version in the Columbus Gallery of Fine Arts (Ohio) is inscribed on the front in English "CAIN AND HIS RACE," which suggests that it may have been executed in England, when the large plaster was exhibited at the Universal Exposition of 1851, or in the United States, where the artist visited in 1855. P.F.

126.
Doctor Jean-Louis Rostan (1791–1866)
Marble
h: 26½ in. (67.3 cm.)
Signed and dated: Etex 1835 (on left side)
Inscribed: Rostan (on front)
Lender: Hirshhorn Museum and Sculpture Garden, Smithsonian Institution, Washington, D.C.

This bust was exhibited at the Salon of 1835. Portraits were rarely singled out for comment by the Salon reviewers of the 1830s, and our work is no exception. However, it probably played a part in provoking the following tirade in a review of that year's Salon:

Permit us to not speak of the busts of bourgeois or of famous modern men which obstruct this year, like all the other years, the sculpture gallery. As much as we are indulgent toward the bourgeois who commissions his [painted] portrait, that of his wife and of his children, we are equally pitiless towards the bourgeois who consents to pose for his bust. How the devil can we abuse marble to the point of forcing it to reproduce traits without a name and without form! Respect to marble! Let us reserve it for great men! Let us reserve it for beautiful heads which are superior or thoughtful! Let us not compromise our nose and our mouth and our blank forehead by making them undergo this difficult experience. . . . To heal ourselves of this deplorable mania, it is sufficient to glance at the busts of this year; it is difficult to believe how everyone is ugly, old. . .and ridiculous. You ask why they are more ugly in plaster or marble than on canvas? For several reasons easy to understand: the painter is able at once to arrange, dispose, color a face; he has shadows and highlights at his service, and he can place his model in a certain light. The sculptor only has forms at his disposal; moreover, these bland physiognomies, reduced to their natural shape, present no resource to the sculptor; one represents them as they are in a bust; one arranges them in a [painted] portrait. Thus, let us leave marble to men who should interest the future.[19]

Few sculptors and sitters were to heed this injunction. Portrait busts continued to inundate the annual Salons and to provide a large percentage of nineteenth-century sculptors with the bread and butter of their lives. Even a sculptor such as Etex, who received numerous major commissions, was a fairly prolific portraitist, although few of his busts equal in quality the work in the present exhibition. The massive, blocklike, lower portion of the *Rostan* is an element that appears, along with a strictly frontal presentation of the sitter, in other busts by Etex such as that of F. Savart (1841, Académie des Sciences, Paris; not listed by Lami). In contrast to most of his other portraits, however, the bust of Rostan depicts the sitter with his head turned sharply to the left. Was Etex remembering the *Bust of Brutus* by his hero Michelangelo? The lively turn of Rostan's head, combined with the geometrically rigid block beneath the classicizing bared chest, imbues this work with a vibrant tension which is rare in portraits by Etex.

Rostan was one of the founding organizers of the system of French governmental health services; his principal writings include *Cours élémentaire d'hygiene* (Paris, 1822), *Traité élémentaire du diagnostic. . .* (Paris, 1826), and *Exposition des principes de l'organisme* (Paris, 1846). From 1817 he

126.

served as the doctor-in-charge at the Hospital of La Salpêtrière in Paris—an institution that was to house in its chapel the plaster model of Etex's *Cain and His Race Accursed of God*. It is probably as a result of this latter work that the artist and the subject of our portrait came to know each other. P.F.

Notes

1.
Etex, 1878, pp. 34–35.
2.
Ibid., p. 40.
3.
E. Roy, "Salon de 1869," *L'Artiste*, 1869, XIX, p. 106.
4.
Etex, 1878, pp. 120–24.
5.
Ibid., p. 125.
6.
Lami, 1914–21, II, p. 127, III, p. 172.
7.
Etex, 1878, pp. 183–84.
8.
This and the following details from ibid., pp. 182–88.
9.
"Salon de 1833," *L'Artiste*, 1833, V, p. 143.
10.
"Salon de 1833," *L'Artiste*, 1833, V, p. 155.
11.
Etex, 1878, p. 186.
12.
Ibid., p. 217.
13.
See Janin, 1839, p. 305.
14.
Etex, 1878, p. 272.
15.
Ibid., pp. 299–300.
16.
Etex, 1853, p. 48.
17.
Benoist, 1928, p. 44.
18.
Etex, 1878, p. 302.
19.
"Salon de 1835," *L'Artiste*, 1835, IX, p. 136.

Selected Bibliography

Etex, A., *La Grèce tragique...*, Paris, 1847.

———, *Cours élémentaire de dessin appliqué à l'architecture, à la sculpture, à la peinture ainsi qu'à tous les arts industriels*, 3rd ed., Paris, 1859.

———, *Essai d'une revue synthétique sur l'exposition universelle de 1855 suivi d'un coup d'oeil jeté sur l'état des beaux-arts aux Etats-Unis*, Paris, 1856.

———, *J. Pradier, sa vie et ses ouvrages, par le plus ancien de ses élèves, avec une eauforte*, Paris, 1859.

Forestie, E., *Notice sur le monument d'Ingres executé par Antoine Etex, érigé à Montauban...*, Montauban, 1871.

Etex, A., *Les Souvenirs d'un artiste*, Paris, 1878.

———, *Les Trois Tombeaux de Géricault 1837–1884*, Paris, 1885.

Paris, Hôtel Drouot, *Marbres, bronzes, terre cuites, plâtres, tableaux, aquarelles et dessins par A. Etex...*, February 25–26, 1889, preface by E. Chesneau.

Mangeant, P.E., *Antoine Etex, peintre, sculpteur et architecte 1808–1868*, Paris, 1894.

Brébion, E., "Antoine Etex, Le Monument de Brizeux," *Nouvelles archives de l'art français*, 1895, XI, pp. 366–68.

Lami, 1914–21, II, pp. 294–307.

Martin-Vicat, P., "La statue cognaçaise de François Iᵉʳ à cent ans," *Institute historique et archéologique, Cognac cognaçais*, 1964, II, pp. 47–54.

Viguie, P., "Le monument Ingres à Montauban," *Bulletin Musée Ingres*, 1967, no. 22, pp. 23–27.

JEAN-ALEXANDRE-JOSEPH FALGUIÈRE
1831 Toulouse–Paris 1900

Although relatively unknown today, Falguière was one of the most highly regarded sculptors in France during the latter half of the nineteenth century.[1] In fact, his career in many ways epitomized that of the successful academic artist, and there are few sculptors who garnered as many official honors. After studying in his hometown of Toulouse and then briefly working in Paris for the sculptors Carrier-Belleuse and Chenillon, Falguière was admitted in 1854 to study at the Ecole des Beaux-Arts under Professor François Jouffroy. In 1859 he won the coveted Prix de Rome and had the unusual good fortune to have his winning entry illustrated in two periodicals, *L'Illustration* and the newly founded *Gazette des beaux-arts* (fig. 5). At the Salon of 1864 he received a medal for his bronze *The Winner of the Cockfight,* and at the Salon of 1868 his marble statue *Tarcisius, Christian Martyr* (cat. no. 127) was awarded the Medal of Honor. Both of these sculptures, along with two of his works exhibited at the Salon of 1866 *(Omphale* and *Nuccia, the Trastevere Girl),* were acquired by branches of the French government. These early successes and the artist's quick rise in the art world were noted by contemporary critics,[2] and by the end of the 1870s he was considered one of the six or seven major French sculptors.[3]

In 1870 he was made *chevalier* in the Legion of Honor, where he eventually rose to the ranks of *officier* (1878) and *commandeur* (1889). In 1882 he became professor at the Ecole des Beaux-Arts and was elected to membership in the Académie des Beaux-Arts. Throughout much of his later career he operated a large and successful studio, attracting numerous students, especially those young artists who came to Paris from his native Toulouse.[4] In 1898 a special 104-page issue of the literary and art magazine *La plume* was devoted to the aging sculptor, and a large one-man retrospective of his work was held at the Nouveau-Cirque. After his death in 1900, in addition to the traditional eulogies read by his colleagues, another major exhibition of his work was held, this time at the Ecole Nationale des Beaux-Arts. Yet today, when he is remembered at all, it is usually as a talented but uninventive sculptor active while Rodin was changing the history of art.

Falguière's life was not only filled with honors but was also enormously productive. In retrospect it appears that he carefully orchestrated his career to keep himself constantly in the public eye. From 1863 to 1899 he exhibited at thirty-seven consecutive Paris Salons, frequently submitting several works in the same year. He also exhibited at the Expositions Universelles of 1867 and 1878 and at the Exposition Centennale of 1900. Along with a number of statues made for architectural decoration and several religious works, Falguière sculpted more than fifty portrait busts and executed, or at least provided models for, more than thirty commemorative monuments or statues in honor of famous men; most of these latter works were intended to populate the provincial city squares of France. In addition to these commissioned works, Falguière produced a series of statues of female nudes which seem to have been created for exhibition at the annual Salons to attract attention, potential buyers, and orders for marble or bronze reductions (see cat. nos. 130, 132).

P.F.

127.
Tarcisius, Christian Martyr
Bronze
h: 26 in. (66 cm.); l: 56⅝ in. (143.8 cm.); d: 25 in. (63.5 cm.)
Model executed 1867
Signed: A. FALGUIERE (on top of bronze base)
Inscribed: SANCTVS TARSICIVS (on front)
Foundry mark: Thiebaut Freres (at feet of figure)
Provenance: Michael Hall Fine Arts, Inc., New York
Lender: The Detroit Institute of Arts, Founders Society Purchase, Robert H. Tannahill Foundation Fund

Falguière spent the years 1859–64 in Rome, and his first major Paris Salon entries clearly revealed the influence of his Italian sojourn. *Winner of the Cockfight,* sent from Rome and exhibited in 1854, was a spirited study of a running figure posed on one foot *à la* Giambologna's *Mercury.* Two of Falguière's other Roman works, *Omphale* and *Nuccia, the Trastevere Girl,* were exhibited at the Salon of 1866. In contrast to these secular and mythological works, his Salon entry the following year was a major religious work, *Tarcisius, Christian Martyr.* Although it is undocumented whether this work was physically begun in Rome, Falguière was certainly indebted to his Roman experience for its subject and form. The subject is based on a story of a child martyr recounted in a popular novel—Cardinal Weisman's *Fabiola, or the Church of the Catacombs,* 1854—which Falguière read as a *pensionnaire* at the Villa Medici in Rome.[5] The general type of the *Tarcisius,* a recumbent martyr saint, is one that had its greatest and most extraordinary realizations in Roman Baroque sculpture such as Stefano Maderno's famous *St. Cecilia.*

The *Tarcisius* was a great critical success,[6] and the marble version exhibited at the Salon of 1868 was awarded the Medal of Honor. The work was one of the rare religious sculptures to receive this award. Its scrawny figure type—evidently inspired by the starving sons of Carpeaux's *Ugolino* (cat. no. 32)[7]—provides the first clear indication of the trenchant realism of form that Falguière was to pursue in his later works. However, the realism of the *Tarcisius* is combined with an essentially Romantic theme which has classical precedents: the tragedy of a youth dying. This theme and the depiction of recumbent youths had been dealt with earlier in the century, notably in Bosio's *Hyacinthe* (1817), David d'Angers' *Bara* (1839), and Giovanni Dupré's *Dying Abel* (1844), all of which recall the famous antique *Borghese Hermaphrodite.* While these earlier works represent idealized nude figures, Falguière's emaciated and robed *Tarcisius* possesses a very different, ascetic sensuality. The work is based on careful study of not only a live model but also photographs of the model.[8] This is a working procedure Falguière was to employ throughout his career and one which undoubtedly contributed to the *tableau vivant* quality that pervades the work.

P.F.

128.

Allegory of Resistance

Bronze

h: 23 in. (58.4 cm.); w: 15¾in. (40 cm.);
d: 11¾ in. (29.8 cm.)

Model executed 1870

Signed: A. Falguiere (on cannon)

Inscribed: LA RESISTANCE (on front)

Foundry mark: THIEBAUT
FRERES/FONDEURS/PARIS (in circular
cachet at lower back)

Provenance: Jacques Fischer, Paris

Lender: Los Angeles County Museum of
Art, Purchased with funds donated by the
Cantor Fitzgerald Art Foundation

La Résistance is a bronze version of what is
apparently Falguière's earliest known
rendering of the female nude. It is a reduc-
tion, not of one of his carefully planned
Salon statues, but of a spontaneously
modeled figure created under the most un-
usual circumstances.[9] When Paris was
being invaded by the Prussians in 1870,
Falguière was enrolled as a member of the
national guard. In December of that year,
during a snowball fight among some bored
volunteer soldiers, he modeled a colossal
figure of *La Résistance* in snow on the
ramparts where he was stationed. What
had begun as a playful interlude in the
siege ended with the building of two
patriotic snow sculptures: the statue by
Falguière and a bust of *La République* by
Hippolyte Moulin. These two works were
reproduced in etchings by Félix Bracque-
mond and published in a commemorative

pamphlet that heralded them as manifes-
tations of "the patriotic energy and artistic
genius of Paris."[10] The distinguished nine-
teenth-century poet and critic Théophile
Gautier, to whom we are indebted for a
contemporary account of *La Résistance*,[11]
records how a makeshift armature was
first constructed of boards and rubble,
and how the statue was then built up
around it. Masses of snow were relayed
to Falguière by his comrades, and he was
aided, in particular, by his fellow sculptor-
guardsman, Henri Chapu.

Executed at a moment when Paris had lit-
tle cause to rejoice, Falguière's patriotic
allegory was received by Gautier as a "chef
d'oeuvre" in a line of tradition with the
snow sculpture that, according to Vasari,
had been executed by Michelangelo.[12]
Gautier's pupil, the poet Théodore de Ban-
ville, was so moved by *La Résistance* that he
was "inspired" to write a poem about it.[13]
Both Gautier and de Banville extolled the
purity and ethereal quality of snow as a
medium, suggesting its appropriateness for
the elevated, noble subject of Falguière's
work. The bitter irony is that the medium
of snow was also an appropriate symbol of
the impermanence of the French resistance
to Prussian invaders.

127.

It is unclear exactly when Falguière first executed *La Résistance* in a more permanent medium. In his December 1870 account of the snow statue, Gautier remarked that Falguière "promised to make a terracotta or wax sketch to conserve its expression and movement."[14] However, in reviewing the first Salon after the siege, in 1872, Gautier expressed disappointment at not yet seeing the sculpture "solidified in plaster or marble,"[15] and he supposed that it would appear at a future Salon. It never did, and this is somewhat surprising, given the prolixity of Falguière's Salon entries and the likely approval *La Résistance* would have received. In any case, it appears that Falguière returned to the subject of *La Résistance* more than once over the course of several years and that, at some point prior to 1895, the artist finally realized what he felt to be a satisfactory remake of the snow statue.[16]

Interestingly, in the model for the Los Angeles bronze, Falguière maintained a sense of the original snow medium through the use of a rugged, patchy surface which is more modern in feeling than the smooth finish found in most of his other works.

The major attraction of *La Résistance* is in her outright brazenness. Although there were established traditions for representing French political allegories, such as "La Liberté" or "La République," as females of considerable physical consequence, they rarely appeared so scantily draped, their nudity so fully revealed.[17] The crossed arms of Falguière's figure not only fail to cover her breasts but actually encourage them to jut out. And the drapery, which leaves uncovered those portions of the female anatomy normally deemed in need of protection, only points up the figure's total lack of modesty. Her aggressive nudity is consistent with the figure's generally militant posture—chin up, chest out, shoulders back—and offers a challenge that is not without sexual overtones. In fact, the overall imagery of the work has a sexual element that cannot be ignored. The strong compositional opposition of the vertical figure with the horizontal cannon draws much of its impact from what is clearly the confrontation of the female

nude with a phallic symbol. Although the original snow sculpture of *La Résistance* was certainly not conceived merely as a colossal pin-up girl in front of a national guard post, it is likely that its sexual imagery owes something to the ambience in which it was created: the semiplayful, perhaps bawdy and irreverent atmosphere of a group of soldiers amusing themselves. In any case, regardless of the spirit that lay behind his work, Falguière created an effective visual double-entendre with the symbolic suggestion of a sexual encounter underlying and reinforcing the allegorical image of resistance to military attack. Proud and defiant, *La Résistance* dares us to try to conquer her and the country she represents. P.F.

129.
Allegory of Defense
Bronze
h: 15⅛ in. (38.4 cm.); w: 8 in. (20.3 cm.);
d: 10 in. (25.4 cm.)
Model c. 1879; cast 1906–18
Signed: A. Falguiere (on back)
Foundry mark: CIRE/PERDUE/A. HEBRARD
(on lower left front)
Lender: Fred and Meg Licht, Princeton,
New Jersey

The dating and original purpose of this work are, at present, conjectural. The female figure carrying a banner wears a Phrygian cap, the traditional symbol of the Republic. Although the work may relate to an 1879 Paris competition for a statue of the Republic,[18] for a number of reasons it seems more likely that it was cast from a model executed for another Paris competition of the same year. This second competition was for a monument to represent the Defense of Paris. According to Rodin,[19] who submitted his own entry (cat. no. 192), more than sixty sculptors produced projects for the Defense of Paris; one may assume that Falguière was among them.

128.

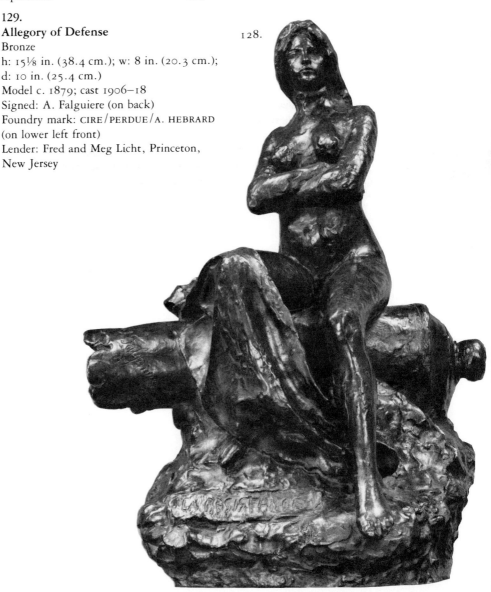

257

This seems especially likely since the 1902 exhibition of Falguière's works included a sketch of unspecified medium, *Monument to the Defense of Paris,* and a plaster, *The Defense of Paris,* listed in the exhibition catalog as a "project for a competition;"[20] it is possible that either or both of these works (present locations unknown) were made for the 1879 Defense competition. Also, Hébrard foundry records indicate that in 1904 four bronzes were cast from a Falguière model entitled *National Defense.*[21] The work in the present exhibition is presumably one of these four bronzes. Finally, the movemented composition of the present work seems more appropriate for a monument to the Defense of Paris than for a statue of the Republic. If, however, this hypothesis is correct, the present work can only be a study for a portion of Falguière's project, since the Defense of Paris competition required a two-figure group.

Whatever the genesis of the work, Falguière's small bronze sketch provides a glimpse of the vivacious, roughly modeled studies that lie behind many of his better-known, highly finished works. Compositionally it is organized in a spiraling movement of forms as the banner swirls around, behind, and in front of the figure. The figure leans slightly forward and pulls the banner back behind her head as if to protect it. Viewed from the left side (as illustrated here), the vertical banner pole, clutched with both hands by the figure, provides an element of stability—evoking a sense of firm resolution—in the midst of the embattled activity suggested by the broken, twisted forms of drapery. The figure is similar in character to Falguière's allegory of the Republic driving a quadriga which, in the form of a plaster and rags model, surmounted the Arc de Triomphe from 1882 to 1886.[22] P.F.

130.
Diana
Bronze
h: 18¾ in. (47.6 cm.); w: 7¾ in. (19.7 cm.); d: 7½ in. (19.1 cm.)
Model executed 1882
Signed: A. Falguiere (on top of base)
Foundry mark: THIEBAUT FRERES/FONDEURS/PARIS (in circular cachet on top of base)
Lender: Private Collection

It is probably for his statues of the female nude that Falguière is best known today. In addition to the *Diana,* he created a series of femmes fatales which includes *Eve, A Hunting Nymph* (cat no. 132), *Fighting Bacchantes, Woman with a Peacock (Juno), Diana-Callisto, Heroic Poetry,* and *A Dancer;* these were exhibited in various media throughout the 1880s and 1890s. Although often receiving mixed reviews, these statues, which verge on being pornographic, had considerable popular success and became an eagerly awaited and integral part of the annual Salons. Bénédite, writing in 1902, gives some idea of the stir aroused by these works, and he is typical in his suspicion that Falguière was consciously exploiting the public:

I would not decry all of these proud and provocative nude figures which one can recall having seen exhibited always in the same place, at the entrance to the former Palace of Industry. Each time it was for the general public an amiable little scandal, a counterpart or counterbalance to the less indulgently tolerated scandals of Rodin. Falguière was not indifferent to this. Like every good southerner, he was sensitive to glory and he did not disdain, occasionally, the accolades of a slightly unhealthy popularity.[23]

Whether their reactions were favorable or unfavorable, critics concurred in recognizing certain characteristics in these Salon nudes: the lack of idealization, or the realism, in proportions, anatomical forms, and facial features; the somewhat artificial liveliness and vitality of the poses, which have little iconographic significance (and today appear contrived simply to provide the greatest possible display of female charms); and the general irrelevance of the works' titles or purported subject matter.[24] Critics especially pounced on the question of subject matter. Falguière's figures were seen as remarkably accurate full-length nude portraits of recognizable studio models striking revelatory poses. As such,

129.

they could be appreciated as ravishing representations of the female nude, but certainly not as convincing images of the mythological and biblical creatures whose names and attributes they bear. The type of beauty they represent was simply too particular and too contemporary; as one critic remarked, these figures still seemed to show the traces of a recently removed corset.[25] Little wonder that they were found unconvincing as goddesses.

Perhaps intended to invite comparison with the famous eighteenth-century statues of *Diana*—such as those by Coysevox and Houdon—Falguière exhibited a life-size plaster version of his *Diana* at the Salon of 1882 and a large marble version (now in the Musée de Toulouse) in 1887. Evidently the work was enormously popular and the model was reproduced in numerous reduced versions in various media—such as the bronze in this exhibition—and in bust form (see cat. no. 131). P.F.

131.
Head of Diana
Bronze on marble base
h: 24⅛ in. (61.2 cm.) including 5 in. (12.7 cm.) base; w: 15¾ in. (40 cm.); d: 10¼ in. (26 cm.)
Model executed c. 1882
Signed: A. Falguiere (on left shoulder)
Foundry marks: Fumière et Gavignot S^ct (on right side) and 2831 (on inside of shoulder)
Lender: Smith College Museum of Art, Northampton, Massachusetts, in loving memory of Ruth W. Higgins (Class of 1913), given by her sister, Mrs. H. Ellis Straw, 1972

It is unclear whether the model for the *Head of Diana* was first conceived independently, as a study, while Falguière was working on his full-length *Diana* (cat. no. 130) or as a spin-off to capitalize on the popularity of the finished statue. In deciding to make both an independent bust and related full-length *Diana*, he may have been following the precedent set by the eighteenth-century sculptor Houdon. In any case, Falguière's *Bust of Diana* is one of the most successful ideal heads produced during the second half of the nineteenth century in France. Abstracted from the narrative context of the full figure—

preparing to shoot an arrow—the movement of the shoulders and turn of the head imbue the independent bust with an increased sense of disdain in keeping with the haughty, austere look of the face. The jagged, irregular truncation of the bust, perhaps influenced by Rodin's works, reinforces the sense of unapproachability in this work. The *Head of Diana* seems to have been extremely popular; it was cast commercially by Thiébaut Frères as well as by Fumière et Gavignot; a terracotta version of the bust is in the collection of the California Palace of the Legion of Honor, San Francisco. In at least one other case, *Woman with a Peacock*, Falguière also produced both a full-length statue and an independent bust.[26] P.F

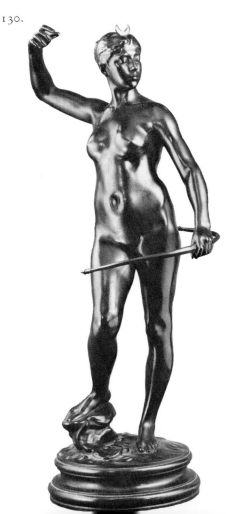

130.

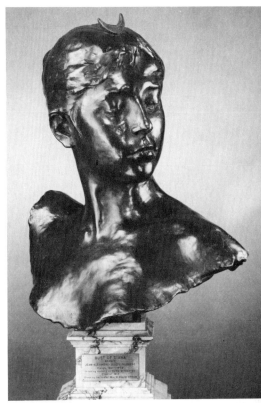

131.

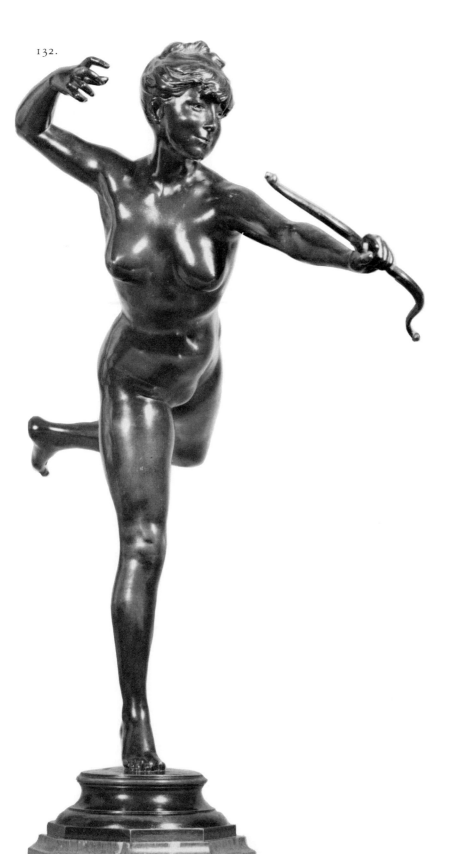

132.

132.
A Hunting Nymph
Bronze
h: 17⅜ in. (44.1 cm.); w: 16½ in. (41.9 cm.) from tip of toe to tip of bow
Model executed 1884
Signed: A. Falguiere (on top of base)
Foundry mark: THIEBAUT FRERES/ FONDEURS/PARIS (in circular cachet on top of base)
Provenance: Michael Hall Fine Arts, Inc., New York
Lender: Dr. and Mrs. H.W. Janson, New York

Evidently spurred on by the success of his bronze *Diana* of 1882 (cat. no. 130), two years later Falguière executed a companion figure which he entitled *Hunting Nymph.* This work was exhibited in plaster at the Salon of 1884, in bronze at the Salon of 1885, and in marble (now in the Musée de Toulouse) at the Salon of 1888.

Compositionally as well as chronologically, the *Hunting Nymph* is a kind of sequel to the *Diana.* While the *Diana* just begins to withdraw an imaginary arrow, the *Hunting Nymph* is in full pursuit of her prey and has just released her arrow. In contrast to the stationary *Diana,* the *Hunting Nymph* is running, poised on one foot in a pose that critics of the period noted finds its ultimate source in Giambologna's *Mercury.*[27] This famous sixteenth-century work had influenced Falguière earlier in his career, just after his return from Italy, in his *Winner of the Cockfight* shown at the Salon of 1864. The adaptation of a similar pose for the *Hunting Nymph* permitted the artist to exploit fully the curvaceous anatomy of his model and at the same time to sanction such exploitation in art historical terms. In contrast to the austere *Diana,* Falguière has depicted the *Hunting Nymph* as a figure of gleeful abandonment, and one suspects that with the life-size version of this work there was the implication that the nymph's prey may well have been the viewer. P.F.

133.
Offering to Diana
Oil on canvas
h: 39⅜ in.(100 cm.); w: 27⅝ in.(70.2 cm.)
1884
Signed: A. Falguiere (lower left)
Lender: Private Collection

In addition to his sculpture, from the early 1870s through the 1890s Falguière produced a number of paintings. Although this was clearly a secondary activity, he did exhibit some of these works, occasionally with considerable success, at the annual Salons. Certain paintings such as *Cain and Abel* (1876, museum at Carcassonne) relate closely to sculptural counterparts within the artist's oeuvre. Other paintings—for example, *The Begging Dwarfs: Souvenir of Grenada*, 1888, location unknown—appear to be completely independent creations. Falguière's painting style reveals the influence of early Spanish masters, particularly Velásquez, Murillo, and Goya. For the choice of some of his subjects—*The Bather* of 1879–80 and *The Slaughter of a Bull*—as well as his choice of palette, Falguière seems indebted not only to Spanish painting but also to the works of Courbet. Falguière received advice if not formal teaching from his friend, the painter Henner.

Offering to Diana was exhibited at the Salon of 1884 and was well received by at least one Salon reviewer.[28] The pose of the figure in this painting is extremely close to that of Falguière's sculpted *Diana* (cat. no. 130), suggesting that the painting was produced as a study while the artist was translating his 1882 plaster *Diana* into marble. As in the sculpture, Falguière's painted figure combines a sophisticated elegance of pose with extraordinary anatomical realism, and the mythological setting and title of the work may well have been afterthoughts. Somehow it seems appropriate that this artist, whose fame and fortune owed so much to his statues of the hunting goddess and her companions, should have produced at least one *Offering to Diana*. P.F.

134.
Revolution Holding the Head of Error and Striding over the Cadaver of Monarchy
Bronze
h: 37 in. (94 cm.); w: 24½ in. (62.2 cm.); d: 18½ in. (47 cm.)
Model c. 1893; cast c. 1900
Signed: A. Falguiere (on left front of base)
Foundry marks: GALERIA ARTISTICA/PERU; 134/S.C. REGUAN (on left front of base)
Provenance: Shepherd Gallery, Associates, New York
Lender: B.G. Cantor Collections, Beverly Hills and New York

During the 1880s and 1890s the French government commissioned more than a hundred works of art dealing with the theme of the Revolution. Until the legitimacy of the Third Republic was firmly established, it was evidently felt that constant reminders were needed to extol the glory of France's liberation from monarchic rule. In 1890 Falguière was asked to create a public monument to the Revolution in the form of an altar in the Panthéon. The full story of this monument remains to be studied in detail.[29] The artist worked for ten years on four successive projects, producing life-size models and innumerable drawings, sculptural sketches, and maquettes.[30]

The first project for the monument was composed of three central allegorical figures of *Liberty, Equality,* and *Fraternity* standing atop a pedestal surrounded by two allegorical groups representing *Moral Expansion of the Revolution* and *Devotion to Country.* Two sketches relating to this project are in the Louvre, and a third is in the Petit-Palais. In 1891 this project was unanimously approved by the governmental commission overseeing the monument; however, when members of the commission visited the Panthéon to view the life-size model in place, they found the figures too large for the space they were to occupy.

Whether or not it was Falguière's decision to change his project—rather than simply reduce the size of his figures—is unclear. In any case, from 1891 to 1894 Falguière produced two new projects, each with only one central figure and composed on one level. One of these new projects—presumably the earlier one—represented a nude female with a sword in her right hand, holding up a torch in her left, and standing with her right foot upon a figure symbolizing the dying past—an interesting fusion of traditional allegorical representations of Liberty, the Republic, and Virtue Overcoming Vice. The other project, exhibited here in a bronze cast, also depicted a single nude female, this time brandishing a long pike in her left hand and, in her right, holding up a blindfolded mask symbolizing Error; at her feet was the Cadaver of Monarchy. Both of these projects were rejected. By January 1895 Falguière had produced a fourth, final design which was much tamer in conception:

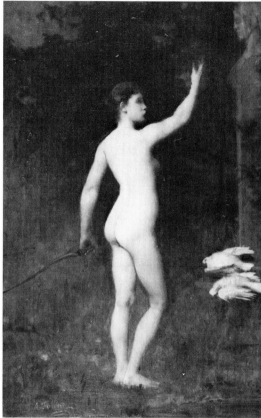

133.

it included a dressed figure of Liberty with head uplifted toward heaven—reminiscent of many representations of Joan of Arc—and a poplar branch in her right hand; at her feet was a toothless old woman symbolizing Ignorance. This model was evidently approved by the commission in charge of the monument, but when the full-scale model was placed on view in the Panthéon, it was badly received by the press; presumably because of the criticism and the then-reduced political need to extol the Revolution, this final project was never executed in a permanent medium.

In working on the altar to the Revolution for the Panthéon, Falguière was faced with a dilemma shared by many artists commissioned to produce public monuments during this period: the desire to create a work that was innovative and would be appreciated as such, and at the same time the need to convey a political message that would be readily understood by the general public. To please a committee or overseeing government commission was difficult, but to satisfy a large, extremely active, and politically diverse press was impossible. In contrast to Rodin, who eschewed traditional allegorical figures in his monuments—

such as the *Burghers of Calais* (cat. no. 201) and the *Balzac* (cat. no. 205)—and capitulated much less to public opinion, Falguière always relied on more or less traditional allegorical figures to convey meaning. In his final project he clearly compromised with an innocuous figure of *Liberty;* but even these efforts were to no avail.

By far the most daring of Falguière's four projects for the Panthéon was his *Revolution Holding the Head of Error and Striding over the Cadaver of Monarchy.* A drawing of this project (location unknown) was reproduced on the cover of the 1898 issue of the magazine *La plume*; a plaster model is preserved in the Musée des Beaux-Arts at Lille; and a bronze version, the work in this exhibition, is published here for the first time. In

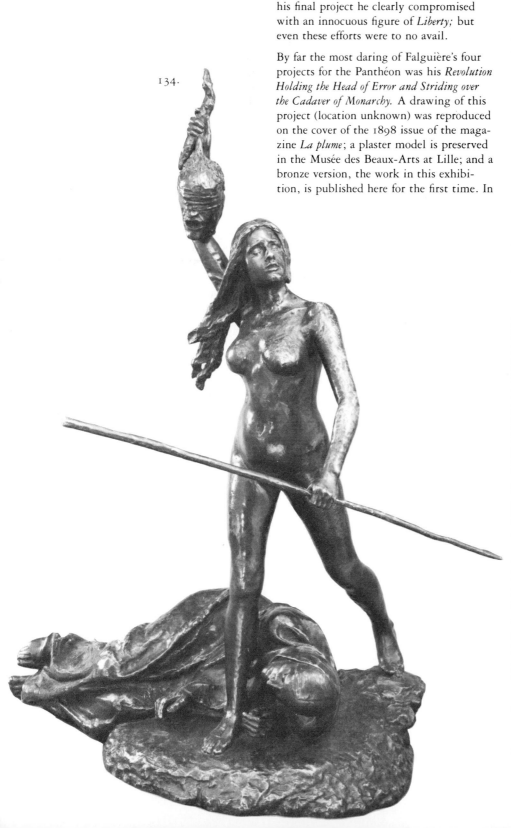

134.

certain respects this work is the logical extension of Falguière's earlier allegorical nudes. As in the *Diana* (cat. no. 130), the artist depicted a female figure in a "struck," rhetorical pose, but the slightly self-conscious, titillating quality of the earlier work is completely gone. The figure of *Revolution* is no longer posing for an audience; with eyes closed, completely involved in her own drama, *Revolution* is a figure of biblical seriousness, a modern Judith holding up the head of Holofernes. While Rodin's reaction to what had become an often sterile, academic tradition of rendering the human form was to break from this tradition and, ultimately, to destroy the human figure by fragmenting it and melding it with other forms, Falguière pushed the tradition of academic realism to a new extreme. Pot-bellied, with pendulous breasts and unkempt, matted hair, the figure of *Revolution* steps forward over a cadaver— thus recalling Delacroix's *Liberty Guiding the People*—with a somewhat hesistant, gauche movement creating an embarrassing, yet extraordinary, *tableau vivant.* P.F.

135.
Honoré de Balzac (1799–1850)
Marble
h: 19¾ in. (50.1 cm.)
Signed and dated: A. Falguiere/1899 (on left side)
Inscribed: BALZAC (on front)
Provenance: Michael Hall Fine Arts, Inc., New York
Lender: B. G. Cantor Collections, Beverly Hills and New York

Falguière's first known association with a portrait of Balzac occurred in 1891. When Henri Chapu died in April of that year, his *Monument to Balzac*—commissioned in 1888 by the Société des Gens de Lettres— was left unfinished. Falguière, along with Mercié and Dubois, was asked for advice; the three sculptors recommended that Chapu's maquette be enlarged and executed in marble by a *practicien.*[31] Ignoring this advice, the Société de Gens de Lettres, headed by its new president Emile Zola, proceeded to select another sculptor to begin the monument from scratch. By July 1891, Rodin was given the commission (see cat. no. 205).[32]

Rodin's final model for the Balzac monument was exhibited in 1898 and rejected by the Société. Amid enormous controversy, Rodin was dismissed and the commission

was given to Falguière, perhaps in the hope of settling the matter quickly, for at that moment Falguière was probably the best known and most widely respected sculptor in France. (The literary magazine *La plume* devoted a special, 104-page issue to Falguière in that year.) In the fall of 1898, a retrospective exhibition of Falguière's works was held at the Nouveau-Cirque, and included in the exhibition was his *Balzac*. Controversy over the monument continued, and Falguière's model was severely criticized. One writer noted that Falguière had copied elements—the powerful neck, broad shoulders, and the dress—from Rodin's *Balzac* and then simply seated the figure on a park bench.[33] In fact, the seated pose was a return to Chapu's conception of the monument. Despite the controversy, Falguière exhibited his *Balzac* at the Salon of 1899.[34] (To show that he bore his successor no ill feelings, Rodin exhibited a *Bust of Falguière* at the same Salon.) Falguière died in 1900, and his *Monument to Balzac* (Paris, Avenue de Friedland) was completed by Dubois in 1902.

The marble bust in the present exhibition was undoubtedly created as a result of Falguière's work on the Balzac monument, and it is, aside from minor variations in carving, identical with the head of the monument. The bust's thick neck and relatively abstract forms are, indeed, elements also to be found in Rodin's *Balzac*; but in contrast to the vividly expressive, impassioned, ugly physiognomy rendered by Rodin, Falguière depicted a calm Balzac with regular, almost handsome features. The *Bust of Balzac* differs from most of Falguière's portraits insofar as the sitter's chest is not placed above a distinct socle, but rather merges with or grows out of the supporting element—in this case, a solid, pyramidal block. This method of truncation is probably indebted to Rodin portraits such as the *Bust of Victor Hugo* of about 1883. P.F.

Notes

1.
The present biography is, with minor alterations, excerpted from Fusco, 1977, p. 37.
2.
P. Mantz, "Le Salon de 1869," *Gazette des beaux-arts,* II, 1869, p. 20.
3.
A. Baignères, "Le Salon de 1879," *Gazette*

des beaux-arts, XX, 1879, p. 146; Rayet, 1880, p. 536.
4.
Among Falguière's important pupils were Mercié, Marqueste, and Idrac. On other sculptors influenced by him, see T. Klingsor, "Falguière et les jeunes," *La plume,* 1898, pp. 82–85.
5.
A. Pingeot in Philadelphia, 1978, p. 228.
6.
Montifaud, 1686, pp. 57–58; Grangedor, 1868, pp. 29–30; T. Gautier, "Salon de 1868," *Le Moniteur,* July 19, 1868, p. 1075. Apparently the only negative reaction was Thoré-Burger, 1870, p. 540.
7.
A. Pingeot in Philadelphia, 1978, p. 228. A. Etex, *Souvenirs d'un artiste,* Paris, 1877, p. 303, informs us with typical modesty that Falguière's *Tarcisius* "was completely inspired by the *Saint Benoît* of Antoine Etex."
8.
Bénédite, 1902, p. 14.
9
For a full account of this work, see Fusco, 1977, pp. 36–50, from which the present entry is excerpted.
10.
Siège de Paris de 1870: Cinq eaux fortes par Bracquemond, Paris, 1874, p. 4.
11.
The circumstances surrounding the creation of the snow statue are given in T. Gautier, *Tableaux des sièges, Paris 1870–1871,* Paris, 1871, pp. 136–42.
12.
Ibid., pp. 139, 141.
13.
T. de Banville, "La Résistance, statue de Falguière," *Poésies de Théodore de Banville: Idylles prussiennes (1870–1871),* Paris, 1872, pp. 142–45.
14.
T. Gautier, *Tableaux des sièges, Paris 1870–1871,* Paris, 1871, p. 141.
15.
T. Gautier, "La Sculpture: M. Falguière," *L'Artiste,* June 1872, XXV, p. 267.
16.
H. Galli, "Statue de neige," *L'art français,* January 19, 1895, reprinted in *La plume,* 1898, pp. 93–94. On the presently known versions of this work, see Fusco, 1977, p. 43.

135.

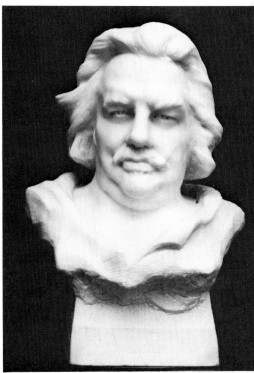

17.
On the representation of "La Liberté," see G. Hamilton, "The Iconographical Origins of Delacroix's 'Liberty Leading the People,'" *Studies in Art and Literature for Belle da Costa Greene,* Princeton, 1954, pp. 55–66. The image of a partially nude female seated on a cannon had been used by Couture to represent "La Liberté" in his 1848 sketch for the *Enrollment of the Volunteers;* see A. Boime, "Thomas Couture and the Evolution of Painting in Nineteenth-Century France," *Art Bulletin,* LI, 1969, pp. 48–56. On the representation of La République," see A. Boime, "The Second Republic's Contest for the Figure of the Republic," *Art Bulletin,* LIII, 1971, pp. 68–83, and T. J. Clark, *The Absolute Bourgeois,* Greenwich, Connecticut, 1973, chap. 2.
18.
See the discussion in J. Hunisak, *The Sculptor Jules Dalou,* New York and London, 1977, pp. 207 ff. for further bibliography.
19.
G. Coquiot, *Rodin à l'Hôtel de Biron et à Meudon,* Paris, 1917, p. 107.
20.
Bénédite, 1902, pp. 28–29, cat. nos. 63, 83.
21.
In 1918 two other casts were made by Valsuani, who worked for Hébrard during

World War I; Anne Pingeot kindly provided this information from the Hébrard foundry records.

22.
For illustrations of this work, see L. Riotor "Le Couronnement de l'Arc de Triomphe," *La plume,* 1898, pp. 91–92; Leroi, 1902, p. 195.

23.
Bénédite, 1902, p. 8. For other comments on the reaction to these female nudes and the regularity of their appearance at the Salons, see Jamot, 1897, p. 148; J. Clarétie, "Tribune Libre," *La plume,* 1898, p. 97; Geffroy, 1900, p. 402; Larroumet, 1904, p. 272.

24.
The generalizations presented here are based upon the following critiques of Falguière's nudes: Rayet, 1880, p. 539; Lostalot, 1882, p. 499; de Fourcaud, 1884, pp. 57–58; Lostalot, 1886, p. 23; Hamel, 1887, p. 38; Albert, 1890, p. 11; E. Bayard, "Les Dianes," *La plume,* 1898, p. 62; Bénédite, 1902, pp. 6–12; Larroumet, 1904, p. 274.

25.
Lostalot, 1882, p. 499.

26.
New York, 1973, cat. nos. 53, 54.

27.
Fourcaud, 1884, p. 58.

28.
J. Comte, "Le Salon de 1884: La Peinture," *L'Illustration,* May 3, 1884, p. 286.

29.
A full study of Falguière's monument to the Revolution is planned by Anne Pingeot, who supplied information for this entry, including the sequence for the four projects presented here.

30.
For illustrations of the various projects, see H. D. Davray, "Le Monument de la révolution au Panthéon," *La plume,* 1898, pp. 71–73; Rambosson, 1902, pp. 28–32.

31.
For Chapu's design, see A. Pingeot, "Le 'Flaubert' et le 'Balzac' de Chapu," *La revue du Louvre et des musées de France,* 1979, no. 1, pp. 35–43.

32.
On the Balzac monument, see J. de Caso, "Rodin and the Cult of Balzac," *Burlington Magazine,* 1964, CVI, no. 735, pp. 279–84; A. Elsen, "Rodin's 'Naked Balzac,'" *Burlington Magazine,* 1967, XIX, no. 776, pp. 606–17; Tancock, 1976, pp. 425–59.

33.
C. Chincholle, *La Petite République,* November 15, 1898, cited in Tancock, 1976, p. 452, note 71.

34.
Several of Falguière's studies for the Balzac monument were also exhibited shortly after his death; see Bénédite, 1902, pp. 29–30, cat. nos. 92–95, 141, 198.

Selected Bibliography

Clarétie, J., "Alexandre Falguière," *Peintres et sculpteurs contemporains,* Paris, 1884, pp. 369–88.

Bauzon, L., "Alexandre Falguière," *Artistes contemporains des pays de Guyenne, Bearn, Saintonge et Languedoc,* Bordeaux, 1889, pp. 43–52.

La plume (special edition devoted to Falguière), no. 219–23, 1898.

Geffroy, G., "Alexandre Falguière," *Gazette des beaux-arts,* 1900, XXIII, pp. 397–406.

Rambusson, Y., "Quelques oeuvres peu connues de Alexandre Falguière," *Les arts,* no. 2, March 1902, pp. 28–32.

Leroi, P., "Alexandre Falguière," *L'Art,* 1902, I, pp. 18–24, 124–28; II, pp. 192–200.

Bénédite, L., *Alexandre Falguière,* Les artistes de tous les temps, série C: Temps modernes, Paris, 1902.

Larroumet, G., *Derniers portraits,* Paris, 1904, pp. 257–81.

Lami, 1914–21, II, pp. 324–35.

Moreau-Vauthier, P., "Alexandre Falguière, sculpteur et peintre," *L'art et les artistes,* 1932, no. 24, pp. 288–92.

Fusco, P., "Falguière, the Female Nude, and 'La Résistance,'" *Los Angeles County Museum of Art Bulletin,* 1977, XXIII, pp. 36–50.

Pingeot, A., "Le fonds Falguière au Musée du Louvre," *Bulletin de la société de l'histoire de l'art français,* in press.

Ferrat was admitted to the Ecole des Beaux-Arts in Paris on April 8, 1841. He worked in the studio of Pradier, then at the height of his career, and remained associated with him for twelve years. In 1848 Ferrat received his first known independent commission, a *Bust of Tibulle,* for the Ministry of the Interior; and in 1850, still a student of Pradier, his rendering of *Achilles Dying* won the second grand prize for sculpture in the Prix de Rome competition. Ferrat made his Salon debut in 1849 (see cat. no. 136) and continued to exhibit until 1870.

Ferrat's career was divided between work for Paris and projects in the provinces, particularly his hometown of Aix. In the 1850s he executed a marble *Bust of Baron des Michels* for the museum at Versailles; a *Genius of Fishing* for the new wing of the Louvre; a statue of *Tronchet* for the palace of the Cour des Comptes; a copy after an antique statue; and a *Statue of Echo* for the interior courtyard of the Louvre. In 1865 he executed a pediment relief representing *Astronomy* for the Tuileries Palace. During the 1860s Ferrat seems to have worked primarily for Aix: a statue representing the fine arts for the fountain at the Place de la Rotonde; a pediment for the law faculty; a relief, *Condemnation,* for the Palace of Justice; three groups of infants—the *Genius of Puget,* the *Genius of Pradier,* and the *Genius of Painting*—for the facade of the Musée des Beaux-Arts; and a pediment, the *Genius of Science and the Arts,* for the Ecole des Beaux-Arts. Some of these latter works in Aix were executed in collaboration with his younger brother Charles (1830–1882). Ferrat's work remains to be studied. P.F.

136.
Fall of Icarus
Bronze
h: 19½ in. (49.5 cm.); w: 14¾ in. (37.5 cm.); d: 19½ in. (49.5 cm)
Signed and dated: H^{TE} FERRAT 1849
No foundry mark
Lender: Philadelphia Museum of Art: Given by Albert P. Brubaker

This work might well be an illustration for one of Baudelaire's nearly contemporary poems, *Les Plaintes d'Icare.* Ferrat has depicted the mythological Icarus in his last desperate moment, just as he is about to plunge into the sea where he will drown. (On the story of Icarus and its significance for the Romantics, see cat. no. 158). The

extraordinary upside-down pose of Ferrat's work recalls a number of early eighteenth-century French sculptures: François Dumont's *Titan Struck by Lightning* of 1712, Jean-Baptiste I Lemoyne's *Death of Hippolytus* of 1715, and Paul-Ambroise Slodtz's *Fall of Icarus* of 1743. All these works, now in the Louvre, were executed as *morceaux de réception* and may have been known to Ferrat. Typical of other early eighteenth-century *morceaux,* the three works cited deal with dying, falling figures that have lost control of their bodies. Such subjects provided especially challenging opportunities for sculptors to demonstrate their ability to deal with the human figure since, presumably, it was impossible for a studio model to sustain a falling pose; thus the artist was forced to rely on his understanding of the human anatomy. Much like the sculptors of the Academy *morceaux,* Ferrat may have chosen the subject of Icarus for his Salon debut—a plaster exhibited in 1849—precisely in order to show off his technical skills.

Ferrat carried the audacity of his work further than his predecessors; while they were required, for admission into the Royal Academy, to complete their works in marble—a medium that limited the extent to which the figure could project from its base—Ferrat was free to produce his work in other media with greater tensile strength: first in plaster (undoubtedly with a supporting metal armature) and then in bronze. He created a figure whose limbs are all in the air and who is linked minimally to the base. Ferrat cleverly avoided the sense of awkwardness we associate instinctively with any upside-down figure by giving his *Icarus* a graceful, if artificial, balletic pose which is most readily apparent when the work is viewed in a photograph which has been turned upside down. For the overall disposition of the figure, Ferrat turned on its head an often repeated traditional "dying warrior" pose which stems from antiquity.[1] Icarus' gesture of the left arm reaching behind the head recalls a dying figure by Ferrat's teacher: Pradier's *Son of Niobe.* Ferrat's *Icarus* was well received by mid-nineteenth century critics,[2] but apparently was never cast commercially. The Philadelphia bronze is the only version presently known. P.F.

Notes

1.
See O. Brendel, "A Kneeling Persian: Migrations of a Motif," *Essays in the History of Art Presented to Rudolph Wittkower,* London, 1967, pp. 67–70.
2.
L'Artiste, 1849, III, p. 211; 1852, VIII, p. 166.

Selected Bibliography

Bellier and Auvray, 1882–87, II, p. 546.

Lami, 1914–21, II, pp. 355–58.

Thieme-Becker, 1907–50, XI, p. 464.

136.

JEAN-JACQUES FEUCHÈRE
1807 Paris 1852

Although a sculptor of secondary rank, Feuchère was a Romantic personality *par excellence.* Son of the *ciseleur* Jacques-François Feuchère, Jean-Jacques was primarily self-trained although he studied with Cortot and Ramey.[1] In his youth Feuchère made a living by working for goldsmiths and chasing, or finishing, bronzes. He studied and became an amateur in the history of many earlier periods of art, and he tried his hand at a wide range of media: metalwork, enamelwork, painting, drawing, lithography, etching, engraving, and sculpture. He made designs for various objects including clocks, candelabra, lamps, ashtrays, and calling cards. His designs for decorative objects were inspired by the works of Renaissance artists, and some of his jewelry supposedly passed as Renaissance originals.[2]

Feuchère made his Salon debut in 1831 with five small works which were well received;[3] although he was associated in the minds of critics with Barye, Préault, and Moine,[4] unlike these artists he does not seem to have had works refused by the Salon juries. For the Arc de Triomphe he executed a relief, *Crossing of the Pont d'Arcole* (1833–34), which depicts a group of theatrically gesticulating figures in a picturesque, movemented style close to, but less grand and successful than, that of Rude's *Departure of the Volunteers* on the same monument. Feuchère's other public works, which now appear somewhat stiff and academic, include bronze statues of *Navigation, Agriculture,* and *Industry* (1838) for the fountain on the Place de la Concorde; a stone statue of *Saint Theresa* (1837–40) for the church of the Madeleine; and a statue of *Bossuet* (commissioned 1840) on the fountain at Place Saint-Sulpice, Paris. His *Joan of Arc* (1845), now in the Hôtel de Ville at Rouen, possesses a simplicity and Romantic lyricism that were appreciated by Baudelaire.[5] In the church of Saint-Paul he painted frescoes of Philippe-Auguste, Saint Louis, Charlemagne, and Louis XII. For the most part, however, Feuchère executed small reliefs, groups and statuettes, and portrait busts.

Feuchère was protected by the Duke of Orléans, and he worked for Prince Demidoff, the Duke of Luynes, and for the Sèvres porcelain works, whose director Meyer was a friend. In fact Feuchère seems to have had an unusually large circle of friends, including the artists Barye, Daumier (whom

Feuchère portrayed), Klagmann, and Soitoux, the latter two Feuchère's pupils.[6] Feuchère also knew Baudelaire, perhaps through the Club des Haschischins to which they both belonged. The poet wrote critically of Feuchère's "exasperating universality" and categorized him as one of those artists who would be happy to convert the Tombs of Saint-Denis into cigar boxes;"[7] nevertheless, Baudelaire seems to have been fascinated by Feuchère and considered using him as the model for a character in a short story or novel.[8] Feuchère possessed a *goût antiquaire* that manifested itself in the historicizing subjects of some of his works, and sometimes in their style, but primarily in his activity as a collector. Much like Balzac's Cousin Pons, Feuchère died poor while possessing an enormous (and enormously varied) art collection.[9] P.F.

137.
Satan
Bronze
h: 31 in. (78.7 cm.); w: 21 in. (53.3 cm.); d: 12½ in. (31.8 cm.)
First modeled c. 1833, cast 1850
Signed and dated: FEUCHERE 1850 (on right side of base)
Foundry mark: VITTOZ BRONZIER PARIS (on left side of base)
Provenance: Gallery 1020, New York,
Lender: Los Angeles County Museum of Art, purchased with funds donated by the Times Mirror Foundation

Feuchère exhibited a plaster model of *Satan* at the Salon of 1834 and a bronze version the following year; this latter work is presumably the small bronze example, now in the Musée de Douai, which was in the 1900 centennial exhibition of French art.[10] An illustration of *Satan,* after an etching by Feuchère, appeared along with Alexandre Decamps' review of the 1834 Salon in *Le Musée;*[11] in this review *Satan* was singled out for special praise among several sculptures representing winged creatures or demons.

Perhaps Feuchère's most interesting work, *Satan* in many ways epitomizes the interests of Romantic sculptors. Inspired by such literary works as Milton's *Paradise Lost* (translated by Chateaubriand), Goethe's *Faust,* and Dante's *Inferno,*

numerous artists of the period dealt with satanic themes. Perhaps the best-known image of this type is Delacroix's 1827 lithograph of *Mephistopheles in the Air,* executed as an illustration for Goethe's *Faust.* Among sculptors, Jean-Jacques Flatters exhibited a figure entitled *Milton's Rebellious Angel* at the Salon of 1827, Marochetti exhibited a *Rebellious Angel* at the Salon of 1831, and Duseigneur showed *Satan Overcome by the Archangel Michael* at the Salon of 1834. In a similar vein, Moine exhibited a *Sabbath Scene* in 1833 and an *Angel of the Last Judgment* in 1836. Bizarre, picturesque semihuman figures such as Satan, as well as the themes of melancholy and evil, were central to Romantic imagery both in literature and in art. Artists at this time often saw themselves, like Satan, as outcasts.[12] Along with Satan, the image of another figure with wings, Icarus, also recurs in Romantic art (see cat. nos. 136 and 158) and came to symbolize the artist's plight.

Feuchère's *Satan* was probably inspired by a number of sources. The general pose of the figure—seated and encircled by wings, with the chin resting upon the left hand, and the left elbow propped on a knee—is based upon Dürer's famous engraving of *Melancholy* of which Feuchère owned an example.[13] The physiognomy of *Satan*— with hooked nose, thick brows extending over the nose, and horns protruding from the forehead—may be influenced by medieval gargoyle figures such as the one on Nôtre-Dame that was later recorded by Charles Meryon in his famous etching *Le Stryge. Satan's* muscular body with taloned feet and large wings is similar to Delacroix's 1827 rendering of *Mephistopheles.*

Feuchère has depicted Satan after his fall, defeated and dejected, holding a broken sword in his right hand while he gnaws at the fingers of his left. The batlike, skeletal wings, with vestigial claws at the tips, add to the evil cast of this figure. Forming a scaly protective shell, the wings envelop the figure and emphasize its isolation. Feuchère's vivid depiction of melancholy evil is an important formal prototype for a number of later sculptures, most notably Duret's *Chactas Meditating on the Tomb of Atala* (1836), Carpeaux's *Ugolino* (cat. no. 32), Rodin's *Thinker* (cat. no. 195), and Joseph Geefs' *Angel of Evil.* At some point, Feuchère's *Satan* also apparently functioned as a symbol for the Freemason's Society in Paris.[14]

The Los Angeles version of *Satan,* dated 1850, was executed by the founder Vittoz, who had been casting for Feuchère since at least 1841.[15] Feuchère clearly changed the model for this later cast, which is not only larger but also more powerfully modeled and different in several details from the smaller bronze version of 1835 in Douai.[16] In recent years a number of other small— one is tempted to say paperweight size— versions of the *Satan* have appeared on the art market, and it is not unlikely that they were produced in large number. As Feuchère's principal biographer wrote of the sculptor in 1853, "He was not the artist of *cire-perdue* bronzes—this luxury of people who push taste to an extreme; to the contrary, he vulgarized his most charming models as much as he could."[17] The Los Angeles bronze is, however, the only known large cast of the *Satan*. P.F.

138.
Benvenuto Cellini (1500–1571)
Bronze with separately cast female figure at the base
h: 22½ in. (57.2 cm.)
Model executed 1835; bronze cast 1837 or later
No marks
Lender: A. Velis-F. Donoughe, New York

Although unsigned, this bronze can be identified as a work by Feuchère since it appears in one of the artist's etchings along with several other of his sculptures and is illustrated in a contemporary article on the work.[18] Having worked as a goldsmith and imitated Cellini's designs, evidently with great success,[19] Feuchère seems to have been particularly interested in his Renaissance predecessor.[20] He exhibited a plaster of his *Benvenuto Cellini* at the Salon of 1835 and a bronze version at the Salon of 1837, on both occasions eliciting favorable comments from reviewers.[21]

In its format—a statuette (on that genre see cat. no. 4)—and in its subject—a retrospective portrait of an artist—the *Cellini* satisfied both bourgeois patrons seeking small, affordable objects and those with a Romantic sensibility interested in art and artists of the past. Incorporating not only a portrait of Cellini but also what pretended to be examples of his decorative art and sculpture, this work apparently

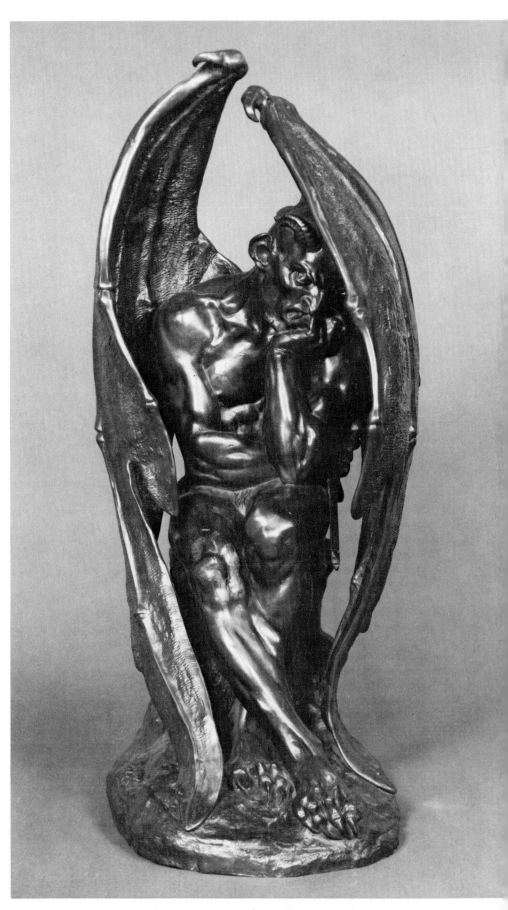

became very popular during the first half of the nineteenth century. In 1853 Janin wrote of it: "the adorable statuette of the Florentine Benvenuto Cellini, a work reproduced in plaster and in bronze...has become the obligatory ornament of the most beautiful Parisian drawing rooms."[22]

Feuchère made a speciality of famous artists' portraits. In addition to the *Cellini* he produced statuettes of Poussin and Leonardo (1843), a statue (1834) and a bust (1852) of Raphael, and a bust of Andrea del Sarto (c. 1852). Although unlisted in the biographical sources on the artist, Feuchère also made a statuette of Cellini's French counterpart, the French Renaissance ceramicist Bernard Palissy (1510–1590); Feuchère's *Palissy* (illustrated along with cat. no. 138, but not included in the exhibition) was evidently created as a pendant to the *Cellini*.[23] Feuchère's statuettes of artists influenced a number of French sculptors including Carrier-Belleuse (see cat. no. 45). P.F.

Notes
1.
Janin, 1853, p. 8.
2.
Ibid., pp. 8–9.
3.
L'Artiste, 1831, I, p. 314.
4.
L'Artiste, 1836, XI, p. 122.
5.
Baudelaire, 1962, p. 81.
6.
Janin, 1853, p. 14, lists several of Feuchère's friends.
7.
The present writer's translation from Baudelaire, 1962, pp. 189–90.
8.
Baudelaire, 1975, p. 242.
9.
Catalogue d'objets..., 1853.
10.
Catalogue officiel illustré de l'exposition centennale de l'art, Paris. 1900, p. 229, cat. no. 1647.
11.
Alexandre D[ecamps], "Revue du Salon de 1834," *Le Musée*, 1834, p. 74. Feuchère's etching of *Satan* is reproduced in Janin, 1853, unpaginated plate illustration. The *Satan* also appears along with several of Feuchère's sculptures in a second unpaginated illustration in the preceding work and in the frontispiece illustration to the

138.

journal *L'Art au dix-neuvieme siècle,* 1860, v.

12.
On the Romantic image of the artist, see R. Wittkower, *Born Under Saturn,* London, 1963, and G. Pelles, *Art, Artists, and Society,* Englewood Cliffs, New Jersey, 1963. Also see the following note.

13.
Catalogue d'objets..., 1853, p. 39, cat. no. 255: "Dürer, la Mélancolie, no. 47, ancienne et belle epreuve." For the association of the artist's image with melancholy, see R. Klibansky, E. Panofsky, and F. Saxl, *Saturn and Melancholy,* London, 1964; W. Hauptman, "Manet's Portrait of Baudelaire: An Emblem of Melancholy," *The Art Quarterly,* 1978, I, no. 3, pp. 214–43; W. Hauptman, "Couture's Damocles and the Subjective /Objective Icon," *The Art Quarterly,* 1978, I, no. 4, pp. 318–37. All of the preceding contain extensive further bibliography.

14.
See the extraordinary photograph, which includes a version of Feuchère's *Satan,* of Rosa Bonheur in Freemason's costume illustrated in A. Klumpke, *Rosa Bonheur: sa vie, son oeuvre,* Paris, 1908, p. 159.

15.
At the Salon of 1841 Feuchère exhibited a figure of *Poetry* and a group of *Infants* which were cast and chased by Vittoz; see *L'Artiste,* 1841, VII, p. 365.

16.
In addition to the Los Angeles and Douai examples, another bronze version "montée en pendule" was in the sale of Feuchère's collection, *Catalogue d'objets...,* 1853, p. 23, cat. no. 49. Also, a bronze version, signed and dated 1833, 35 cm. high, sold at auction, *Hôtel des Ventes Blandon,* Nancy,

April 24, 1977, lot 148.

17.
Janin, 1853, p. 10.

18.
Janin, 1853, unpaginated plate illustration; "Statue en plâtre par M. Feuchère," *Magasin pittoresque,* 1835, III, pp. 95–96.

19.
Janin, 1853, pp. 8–9.

20.
Feuchère owned a drawing and a cup by Cellini as well as a copy of his memoires; see *Catalogue d'objets...,* 1853, pp. 29, 53, 57, cat. nos. 114, 463, 538. The same catalog; p. 21, cat. no. 12, lists several drawings by Feuchère for his statuette of Cellini.

21.
L'Artiste, 1835, XI, p. 135; 1837, XIII, p. 184.

22.
Janin, 1853, p. 5.

23.
Paired examples of the *Cellini* and the *Palissy,* signed "E. Delabroue/Feuchere Scpt," are in the collection of the Buffalo and Erie County Historical Society, acc. nos. 62-1632 and 62-1633. Another bronze version of the *Cellini* sold at auction, Sotheby's Belgravia, London, March 28, 1979, lot 47.

Selected Bibliography

Janin, J., *Notice sur J. Feuchère,* Paris, 1853.

Paris, *Catalogue d'objets d'art et de curiosité... de M. Feuchère,* sale cat., March 8–10, 1853.

Labourieu, T., "A. Jean Feuchère, un Tombeau!" *L'Art au dix-neuvième siècle,* 1860, v, p. 292.

Brouilhet, 1910, II, pp. 186–281.

Lami, 1914–21, II, pp. 364–69.

Metman, 1944, pp. 197–200.

Beaulieu, M., "Deux bronzes romantiques d'inspiration classique," *La revue du Louvre et des musées de France,* 1975, XXV, no. 4, pp. 269–74.

LOUIS-JULIEN, called JULES, FRANCESCHI
1825 Bar-sur-Aube–Paris 1893

Son of an Italian ornamental sculptor, Jules Franceschi first studied at the Ecole de Dessin in Besançon. He then accompanied his sculptor brother Jean-Paul-Paschal (1826–1894) to Paris; in 1841, alongside Carpeaux, the two brothers became pupils of François Rude. In 1848, while Jean-Paul-Paschal returned to Besançon, Jules remained in Paris and made his Salon debut. He continued to exhibit regularly until the end of the 1880s, winning medals in 1861, 1864, and 1869. In 1874 he was made *chevalier* of the Legion of Honor.

Franceschi executed architectural sculpture for the Gare du Nord, the Louvre, the Tuileries, Palais-Royal, and the Hôtel de Ville in Paris. He also produced statues for the churches of Saint-Sulpice and Saint-François-Xavier. His most interesting works include a series of female mythological and allegorical figures that were exhibited at the Salons: *Young Huntress* (1857), *Andromeda* (1859), *Danaide* (1863), *Hebe* (1866, cat. no. 139), *Awakening* (1873), *Fortune* (1886), *Painting* (1888), and *Isis* (1894). Perhaps Franceschi's finest works are his portraits; they are similar in style to, and were almost as equally sought after as, the portraits of Carpeaux. Franceschi married Emma Fleury, an actress at the Comédie Française, and fathered two sculptor daughters. A serious study of Franceschi's works remains to be done. P. F.

139.
Hebe and the Eagle of Jupiter
Bronze
h: 23⅝ in. (60 cm.)
Model executed 1868
Signed: J. Franceschi, sc. (on front of base)
No foundry mark
Lender: Jacques de Caso, San Francisco

Hebe, the cupbearer of the gods and a symbol of youthful beauty and chastity, was a favored subject of nineteenth-century sculptors. She was sculpted by, among others, Nicolas-Victor Valadin (1844, Musée d'Orleans), François Rude (see cat. no. 213), Louis-Charles Buhot (Salon of 1865), Carrier-Belleuse (Salon of 1869), Etienne-François Captier (Salon of 1873), and Jean Coulon (1886). Most of these sculptors neglected Hebe's supposed chastity and depicted her as something of a temptress, tantalizing the Eagle of Jupiter with a cup of ambrosia and with her body.

In fact, a great deal of the subject's appeal seems to have been the opportunity it provided to focus upon the softness, curvaceousness, and vulnerability of a nude female—aspects highlighted by the textural (and mythologically required) contrast with the Eagle's feathers and his sharp, potentially dangerous beak. Under Napoleon III, the subject may also have been popular since it could be interpreted as an allegory of the powerful Empire guarding a trusting France.[1]

139.

Franceschi exhibited his *Hebe* in plaster at the Salon of 1866 and in bronze at the Salon of 1868; the plaster was also shown in Besançon in 1868. Ten years earlier Rude's *Hebe* had been an enormous success, and this may have inspired his pupil to take up the subject. Whereas Rude had depicted an adolescent figure standing next to the eagle, Franceschi sculpted a more mature and voluptuous female seated upon the bird. Most contemporary critics seem to have ignored the work, although H. Houssaye wrote that it "merits the greatest praises" and then went on to criticize it for not being chaste enough.[2] Houssaye also compared the figure's elongated proportions and svelte elegance to works of French sixteenth-century sculptors such as Goujon. When contemporary critics reviewed other works by Franceschi, they also noted the influence of Renaissance art (there was, indeed, a marked Michelangelesque influence in Franceschi's *Andromeda* of 1859).[3] Nevertheless, the closest sources for the *Hebe* would seem to be classicizing Rococo works such as Christophe Allegrain's *Venus at the Bath* (1756–57, Louvre)—the pose of which Franceschi's *Hebe* reproduced in reverse—and Pierre Julien's seated *Girl Tending a Goat* (1786–87, Louvre)—a work that also exploited textural contrasts for sensual effect by juxtaposing female flesh with a male beast.[4] At the end of his career Franceschi produced a variant of his *Hebe*'s pose in an allegory of *Fortune,* a female nude seated upon a winged wheel, which was exhibited at the Salon of 1886. P. F.

Notes

1.
This was the case with Carrier-Belleuse's rendering of the subject; see J. Hargrove, *The Life and Work of Albert Carrier-Belleuse,* New York and London, 1977, p. 56.
2.
Houssaye, 1868, pp. 318–19.
3.
See Baudelaire, 1962, p. 385; La Grange, 1864, p. 36; Mantz, 1869, p. 21.
4.
In the 1850s both Allegrain's *Venus* and Julien's *Girl Tending a Goat* were being edited commercially by Barbedienne.

Selected Bibliography

Lami, 1914–21, pp. 398–402.

CHRISTOPHE FRATIN

1800 Metz–Raincy (Seine-et-Oise)
1864

Christophe Fratin first studied under the artist Pioche in Metz. Later he traveled to Paris, where he worked in the atelier of the great Romantic painter Géricault. Fratin and Barye, the first *animaliers* of note, exhibited alongside each other at the Salon of 1831. Although Fratin would never rival the excellence of Barye, he nonetheless received many more State commissions. Some of Fratin's works are in Metz, while others are in museums at Compiègne, Tournus, and Châlons-sur-Marne. His monumental bronze group, *Horse Attacked by a Lion,* (design, Salon of 1853) is in the Square Montrouge in Paris.

Fratin's small bronze, *Lion Attacking an African Native* (Peabody Institute Collection on loan to the Baltimore Museum of Art) documents the admiring specificity of his quotations of Barye: the fallen African native is very like the fallen assassin of Barye's plaster group, *Charles II, Surprised in the Forest of Man* (Salon of 1833) now in the Louvre. Furthermore, a certain bulk

and a stylized quality of movement in the bronze clearly reflect eighteenth-century porcelain sculpture.

Fratin issued multiple castings of many of his designs, as did Barye, for the new middle-class art market of Paris. Fratin sold some seventy-eight of his terracottas, possibly including the relief in this exhibition, in a sale of March 17, 1857. He exhibited his works for the last time in 1863.

G. B.

140.
Lion Devouring African Deer

Terracotta in wood frame
h: 12 in. (30.5 cm.); w: 20¼ in. (51.4 cm.); h. of frame: 16½ in. (41.9 cm.) w: 24⅜ in. (61.9 cm.); d: 5¼ in. (14.6 cm.)
c. 1835–40
Signed: FRATIN (near the tail)
Lender: George and Betty Longstreet, Los Angeles

A restrained but threatening snarl crosses the lips of the *Lion Devouring an African Deer,* striking in its similarity to designs in-the-round by Barye (see cat. no. 17). Contrastingly passive is the head of the antelope, lying before the great paws of the lion, its tongue lolling in death. A painterly conception of relief sculpture is evident in Fratin's treatment of the background, a surface wiped smooth with a wet sponge so as to render it atmospheric, perhaps causing it to disappear altogether, in a manner reminiscent of certain of Caravaggio's paintings; like them, it implies a continuity of illusory space with the real ambience of the spectator. The rim of Fratin's relief suggests the raised, stacking rim of a coin. A similar coinlike rim and dished-out background were used in a work surely known to Fratin: in a monumental seventeenth-century relief, the lunette-shaped *Equestrian Louis XIV,* on the facade of the dormitory of the Invalides.

140.

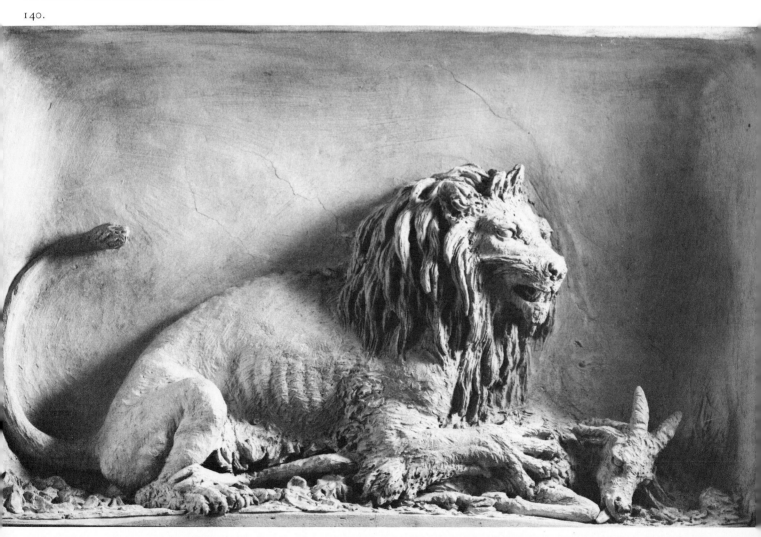

EMMANUEL FRÉMIET
1824 Paris 1910

An isolating tendency of design becomes apparent in Fratin's relief, the whole falling into fairly distinct passages, stressing an emphatic separateness rather than unity: for example, the deeply pocketed, wet-looking mane; the lion's forepaw, its digits widely separated as it pins the prey; the lion's hind paw, carefully placed so its extended claws project beyond the lower rim, with the antelope's cloven hoof resting upon it, dramatically exploiting the contrasting nature of the two creatures; the precise echo of the lion's arched back and tail; the protrusion of the lion's ribs; and finally, a decorative reworking of the wetted surface of the terracotta animals and the resultant uniform stickiness of appearance. Fratin apparently preferred this intricate, bronzelike surface to the simpler and bolder surfaces of, for example, the terracotta designs by Barye of the mid-1830s, such as *Stag Overthrown by a Bear* or the *Antelope Overthrown by a Jaguar* (both Detroit Institute of Arts).[1]

Anatomical accuracy, always of prime significance for a Romantic-realist, is questionable in the undersized haunch and lower jaw of Fratin's lion. The eyes of the lion, as well, seem more human than feline.

G.B.

Note
1.
See G.F. Benge, "A Barye Bronze and Three Related Terra Cottas," *Bulletin of the Detroit Institute of Arts,* 1978, LVI, no. 4, pp. 231–42.

Selected Bibliography

Lami, 1914–21, II, pp. 403–5.

Horswell, 1971, pp. 81–102.

Mackay, J., *The Animaliers: A Collector's Guide to the Animal Sculptors of the 19th & 20th Centuries,* New York, 1973, pp. 61–65.

Frémiet's aunt, who had married François Rude, awakened the boy's interest in art. He studied briefly with another relative, the natural history painter Jacques Christophe Werner (1798–1856), at the Petite Ecole and then at the museum of the Jardin des Plantes. He retained an interest in anatomy and animal sculpture when he became a pupil of Rude. In fact, he made his debut as an *animalier* at nineteen in the Salon of 1843; for the next decade almost all his Salon entries were animals. Public success, however, proved slow in coming; he won a third-class medal in 1849 and two second-class ones in 1851 and 1867. State commissions, too, were few and modest—a marble *Family of Cats* and a bronze *Wounded Dog* (1849–50)— and then, after much pleading by the artist, a life-size bronze of two basset hounds, *Ravageot and Ravageode* (1851–53, Compiègne). These attracted the attention of Napoleon III, who ordered a series of fifty-five realistically colored figurines of soldiers wearing the various uniforms of the French army. None of these survives, but reproductions of some of them exist at Compiègne.

Frémiet's most ambitious work of this period, the *Gorilla Carrying off a Woman* (see cat. no. 146), was rejected by the Salon jury of 1859. During the following decade, he produced two half-life-size equestrian bronzes, a *Gallic Horseman* and a *Roman Horseman* (1862–66), as well as two bronze equestrian monuments, *Napoleon I* (formerly in Grenoble, dismantled in 1870), and *Louis d'Orléans* (Pierrefonds). He had to depend for a living on commercial reproductions and reductions of his animal sculpture in bronze and plaster; a catalog of these from about 1860 lists sixty-four works. At the end of the Franco-Prussian War, Frémiet was so discouraged that he considered retiring from his "fruitless twenty-five-year struggle to make a living as a sculptor." He persevered nevertheless, and his career soon took a turn for the better. His equestrian *Joan of Arc* (1874) was a great success (see cat. nos. 141, 142), and in 1875 he took the place of Barye as professor of drawing at the museum of the Jardin des Plantes. Altogether, the latter half of his long life as a sculptor brought Frémiet all the honors and large-scale commissions he could wish for: advancement to *officier, commandeur,* and *grand officier* of the Legion of Honor (1878, 1896, 1900), membership

in the Ecole des Beaux-Arts (1892), a Medal of Honor at the Salon of 1877, and a grand prize at the Exposition Universelle of 1900. His last Salon entries date from 1908, sixty-five years after his first—probably an all-time record.

Frémiet was not only the most accomplished *animalier* after Barye—many of his small bronzes have both wit and charm—but also a pioneer in the field of life-size animal sculpture and, under the influence of Darwinism and anthropology, in exploring the relationship of the human race to the animal world, whether friendly or hostile. His most interesting large-scale works stem from the ill-fated *Gorilla* of 1859; a second version (1877) was eminently successful and must be seen in the context of related works, all at the Jardin des Plantes (*Man of the Stone Age,* the *Bear Cub Hunter, Orangutang Strangling a Native of Borneo;* see cat. nos. 145, 147).

H.W.J.

141.
Joan of Arc on Horseback
Bronze
h: 29 in. (73.7 cm.); l: 18½ in. (47 cm.); w: 7½ in. (19.1 cm.)
After 1874
Signed: FREMIET (on top of base)
No foundry mark
Lender: The Cleveland Museum of Art, Bequest of James Parmalee

142.
Joan of Arc on Horseback
Ink on paper with white highlights
h: 13⅞ in. (35.2 cm.); w: 8 in. (20.3 cm.)
c. 1889–99
Signed: E. Fremiet
Lender: Mrs. Noah L. Butkin, Cleveland

This bronze sculpture is a small version of Frémiet's equestrian statue of Joan of Arc, one of the most famous monuments raised to the heroine after the Franco-Prussian War (see cat. nos. 8, 9). Frémiet received the commission from the minister of Public Works in December 1872, largely through the influence of Charles Blanc, the Director of Fine Arts.[1] The projected location for the monument, the Place des Pyramides, was selected in April 1873. Four hundred years earlier Joan of Arc had been wounded close to this site, during a

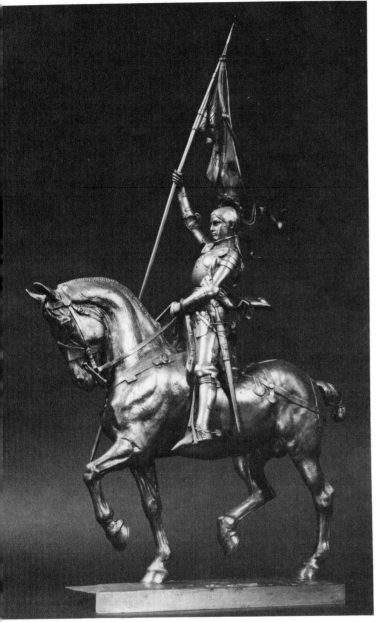

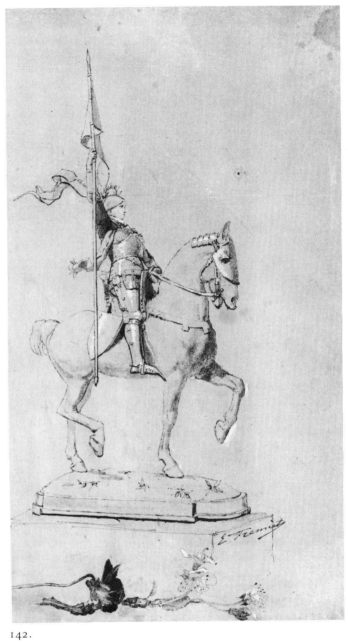

141.

142.

battle fought to liberate Paris from English invaders. The location was meaningful for contemporary politics as well, for nearby lay the ruins of the Tuileries Palace, burned by Communards in 1871.

By July 1873, Frémiet had executed the model of the sculpture and begun to design the pedestal.[2] The completed monument was inaugurated on February 20, 1874, in the presence of the artist, the bronze founder M. Thiébaut *fils,* and about fifty spectators.[3]

Frémiet's triumphant figure of Joan could well have served as an inspiration for the vanquished nation. Stern, authoritarian, and upright in pose and demeanor, she conveys a sense of steadfast determination and purpose. The rigid verticality of her form is accented slightly by the diagonal tilt of her scabbard, the angle of her left arm, and the staff of her banner. The fluttering oriflamme, echoed by the motion of the drapery on her waist, are the only indications of movement Frémiet introduced into her figure. The sculpture may have been directly inspired by fifteenth-century equestrian statues such as the *Gattemelata* by Donatello or the *Colleoni* by Verrocchio.[4] Like these works, Frémiet's sculpture is masculine and commanding, even on the small scale of the statuette.

After the unveiling of the monument, the figure of Joan was criticized for being too small in relation to the massive size of the horse. Frémiet realized the truth of this observation and admitted, "J'étais desolé, vraiment, d'avoir eu l'honneur d'un emplacement si beau et de m'être trompé de proportions."[5] He took the criticism so seriously that he could not even bear to look at it when he passed the Place des Pyramides. Despite his dissatisfaction with the equestrian statue, the work won him considerable popular acclaim. In the late 1880s, he received a commission for a replica of the sculpture from the city of Nancy. Because of the criticism directed at the first sculpture, Frémiet created a slightly revised version. A plaster model of the new statue, with the figure heightened five inches, was exhibited at the Salon of 1889. The bronze equestrian monument was dedicated in Nancy a year later with great ceremony and celebration. Frémiet probably made the highly finished drawing in the exhibition after the model, or the completed work, rather than as a preparatory study.

Unknown to all but his most intimate associates, Frémiet intended to replace the sculpture on the Place des Pyramides with a replica of the new version at his own expense. Funds for the casting of the sculpture were obtained through money left over from a commission for two statues from a wealthy American tourist.[6] The sculptor had the opportunity to replace the earlier monument with the modified version in 1899, when the Prefect of Police informed him that its base was sinking due to recent construction of the Paris Métro on the street below.[7] Frémiet received permission to move the statue to safety in order to decrease its weight. The sculpture was sent to the Barbedienne foundry so that the changes could be made. It is possible that Frémiet exaggerated the danger of the situation as an excuse to remove the statue because, upon investigation, the Prefect of the Seine found the problem was not serious enough to warrant the action.[8] Unknown to most city officials, the first sculpture was melted down at Barbedienne with two hundred foundry workers as witnesses. All that remained of the work was Joan's laurel crown, which the artist retained as a keepsake. On May 16, at six in the morning, the second version, brilliantly gilt, was substituted in its place. In spite of the visual differences between the first and second work, the secret replacement passed unnoticed by the majority of the population for over four years.

On December 17, 1903, the periodical *L'Eclair* published an article in which Roger-Ballu, recently dismissed from his position as Inspector of Fine Arts, accused Frémiet of substituting the new version for the earlier work in 1899.[9] He contended that several officers of the Fine Arts Administration were aware of the exchange and claimed, without much evidence, that the first sculpture had been sold with their consent. In protest, Henri Roujon, formerly the Director of Fine Arts, argued that Frémiet had only modified the original statue rather than substituted it with a completely new work. In *Le Matin,* December 19, however, Frémiet confirmed that the original sculpture had been replaced but maintained that it was destroyed at Barbedienne. The admission sparked debate in the press regarding artists' rights to modify or replace a work after it has become public property.

In addition to the two equestrian figures, Frémiet produced at least three other sculptures of Joan of Arc. One, exhibited at the Salon of 1875, represented the Maid in armor, kneeling in prayer.[10] Like Chapu and innumerable other sculptors, Frémiet also portrayed her as a barefoot peasant in a statuette, entitled *A Domrémy* (1893).[11] Another of his statuettes commemorates Joan as the Liberator of Orléans.[12] M.B.

143.
The Muse Crowning Pierre Corneille (1606–1684)
Silvered bronze
h: 24 in. (60.1 cm.)
Signed: E. Frémiet (on right side of base)
Dated: 1879 (on back of base)
Inscribed: CORNELIO MAGNO (on front of herm)
No foundry mark
Lender: David Daniels, New York

A silvered bronze group corresponding to ours was shown at the Salon of 1880 and is now in Corneille's house at Petit-Couronne. Evidently, however, Frémiet finished the group and had it cast in an edition of several copies the previous year. We may assume that he planned it as a "mini-monument" from the start; the flying Muse, precariously attached to the back of the herm, would present insurmountable technical problems if executed on a scale commensurate with a public monument. The piece maintains its balance only because of the altar, with its still life of fasces, sword, scroll, and other "classical" objects, that rises behind the herm. The choice of this specifically Greek type of portrait bust, traditional since the late eighteenth century for commemorative images of cultural heroes, serves to characterize Corneille as timeless. The Muse, in contrast, is daringly neo-Baroque in her spiraling movement and seemingly weightless flight. Unusual for Frémiet, who had made his reputation as a realist, she reflects a stylistic trend initiated by Carpeaux (compare cat. no. 40). Its next stage was to be Dalou's *Monument to Delacroix* (cat. no. 78), which clearly reflects the influence of Frémiet's *Corneille.*[13] Somewhat paradoxically, the immediate antecedents of our flying Muse are in marble rather than bronze: Loison's upward-floating *Soul,* one of the sensations of the Salon of 1872, was surely known to Frémiet;[14] it, in turn, brought to France a tradition of "antigravitational" figures such as Raffaello Monti's *Allegory of the Risorgimento* (much

admired at the South Kensington International Exposition in 1862) whose ancestors, if we were to trace them, would ultimately lead us to Bernini. Frémiet never did another flying figure in the round, but the neo-Baroque remained an option for him whenever the subject and purpose of a commission demanded it, as in the two huge—and splendid—groups in gilt bronze crowning the north pylons of the Pont Alexandre III (1900).[15] The *Corneille,* then, despite its modest scale, can claim considerable art historical significance.

H.W.J.

144.
Snake Charmer
Bronze
h: 17 in. (43.1 cm.); diam. of base: 4⅜ in. (11.1 cm.)
c. 1883
Signed: FREMIET (on top of base)
No foundry mark
Lender: Private Collection

A bronze statuette, *Snake Charmer,* was shown by Frémiet in the Salon of 1883, the only time he treated the subject. We assume that he had the figure cast in bronze in an edition of several copies, as he did in the case of *The Muse Crowning Corneille,* and that our cast is one of these. The title leads us to expect an Indian, in turban and loincloth, seated on the ground and playing a flute in front of a cobra. Nineteenth-century viewers were familiar with such scenes from paintings, descriptions, and perhaps from actual Indian snake charmers on occasion.

Frémiet's reptile, however, is not a poisonous snake but a boa constricter, and the native carrying it is not an Indian. He is naked except for a G-string, a neck band, and what at first glance looks like a turban but is actually a headgear made of ostrich plumes. His features suggest either an African or a New Guinean; only an anthropologist could determine which, and whether he corresponds to a specific ethnic group or is a compound "tropical native" invented by the artist. The native's feat, of course, consists of being on amicable terms with his burden—more questions for the specialist: can it be done, and, if so, where? Without this information, we cannot judge how realistic the statuette is. Visually, it carries a great deal of conviction. The model for the G-string could probably be

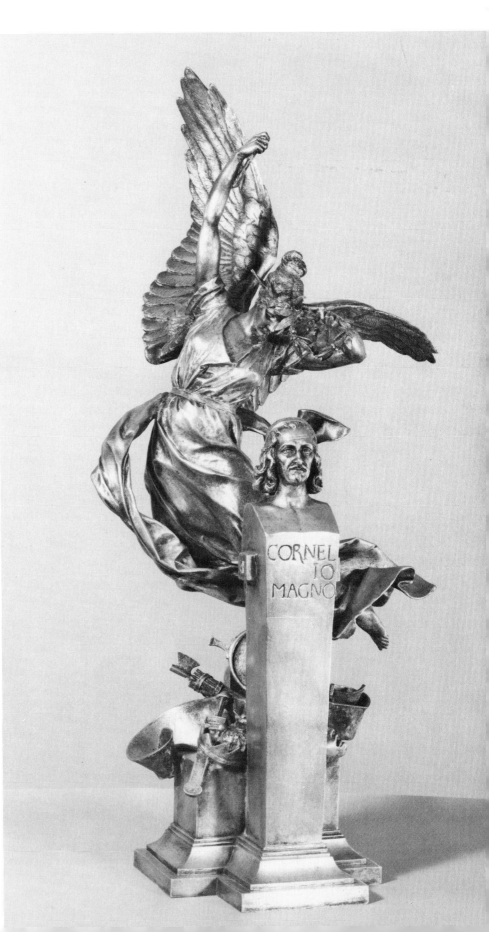

located among the collections of the museum of the Jardin des Plantes, and the powerful body of the native, with its long torso and short, muscular legs look equally authentic. He and the snake stare fixedly at each other, suggesting that the boa is mesmerized by his gaze. What might have been Frémiet's motivation in choosing this subject, one wonders: surely he meant to convey more than an anthropological curiosity? Perhaps he wanted to challenge the traditional relationship of man and snake as exemplified by a group he must have seen countless times: Bosio's *Herakles Fighting Acheloüs in the Shape of a Serpent* (1824) in the Tuileries Gardens. H.W.J.

145.
Bear and Man of Stone Age (Bear Cub Hunter)
Bronze
h: 90 in. (2.29 m.); w: 61 in. (1.55 m.); d: 52 in. (1.32 m.)
After 1885
Signed: E. FREMIET (on front of the base)
Inscribed: DENICHEUR/D'OURSONS (below man's right foot)
Lender: Krannert Art Museum, University of Illinois, Urbana-Champaign, Gift of Mrs. Stacy B. Rankin

This cast was bought by a Chicago collector who permitted the American sculptor Loredo Taft to keep it in his studio, together with another monumental Frémiet bronze, the *Gorilla Carrying off a Woman* (see cat. no. 146). Taft willed the contents of his studio to the University of Illinois; upon his death in 1936, the two Frémiet works came to the Urbana campus along with Taft's own sculpture. The heirs of the owner donated them to the University, which placed them in the park surrounding Allerton House at Monticello, also owned by the University.

The original plaster for our group was shown at the Salon of 1885, under the title *Ours et homme de l'âge de pierre (Bear and Man of the Stone Age)*. Frémiet seems to have chosen the shorter and more explanatory title *Dénicheur d'oursons (Bear Cub Hunter)* when the State ordered a bronze cast for the Jardin des Plantes. Ours is the only other bronze cast known of the group in its original size. The primitive hunter has caught and strangled the cub in a noose; it hangs lifeless from his belt. Surprised by the cub's mother, he has plunged his knife into her chest, but the thrust does not

prevent her from grasping him in a deadly embrace. The group represents the counterpart of an earlier bronze statue showing a man of the Stone Age as the triumphant hunter doing a kind of victory dance (original plaster shown in the Salon of 1872; the bronze, 1875, in the Jardin des Plantes).

The pathetic helplessness of the hunter in the grip of the grimly majestic beast had so strong an appeal for the public of the time that Frémiet produced a small-scale variant in bronze and terracotta for the private collector (cat. no. 147). He also treated the bear cub hunt as a bronze relief for the exterior of the museum at the Jardin des Plantes (1897). A *Wounded Bear* by him had been shown in the Salon of 1850; since the piece is described in the catalog as a "plaster group," it may have involved a hunter as well and thus could have been a predecessor of our group. The drama of the hunt, a subject as old as ancient Egypt and vastly popular in Greek and Roman art, had fascinated Romantic painters and sculptors; in the 1830s, Barye had made a series of splendid hunting groups as a *surtout de table* for the Duke of Orléans. In all of these, however, the prey, huge and powerful as it might be, succumbs to the hunters' onslaught: the hunt is an exhilarating if strenuous experience. The only precedents for Frémiet's life-and-death struggle of man and bear were the gladiatorial *venationes* of the Roman circus, a fact he was well aware of, since he turned the Stone Age hunter into a gladiator in the small-scale variant of our group.

H.W.J.

146.
Gorilla Carrying Off a Woman
Bronze
h: 17½ in. (44.5 cm.); w: c. 12 in. (30.5 cm.); d: c. 15½ in. (39.4 cm.)
Reduction of a group first exhibited in 1887
Signed: FREMIET (on the rock)
No foundry mark
Lender: Mr. and Mrs. Morris Rosenberg, Memphis

As noted before, Frémiet submitted a plaster group of this subject to the Salon of 1859, but it was rejected. That first version, known today only from photographs, showed the ape running, while that of 1887 shows him in a defensive posture, apparently surrounded by members of the tribe to which the woman belongs. He is also wounded by a spear thrust in his back, an important fact not evident in the stan-

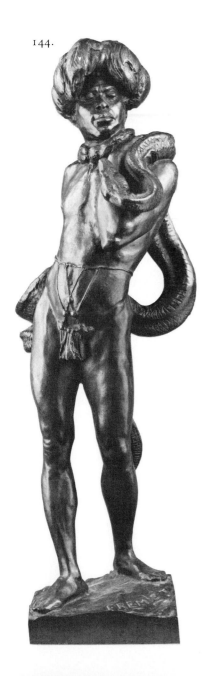

144.

dard frontal view of the group. The 1859 version apparently lacked this feature, as does an amusing small maquette in the Petit Palais, Paris, which corresponds to neither of the two large versions (it shows the woman limp as a rag doll, and the ape scratching his head with his free arm, as if he were at a loss what to do with his burden).

A discussion of the subject matter of our group might well begin with a review of Baudelaire's arguments against the 1859 version (which he mistakenly calls an orangutang and admits never having seen), since they apply equally to our piece. He accuses Frémiet of sensationalism, of seeking dramatic effects in ways that are incompatible with the idea of pure art:

Why not a crocodile, a tiger, or any other beast likely to eat a woman? Oh no, since here it is not a matter of eating but of rape. Only the ape, the giant ape who is both more or less than a man, sometimes shows a human craving for women.... He is dragging her off; will she know how to resist? Every woman is bound to wonder about this, with mixed feelings of terror and prurience.

Baudelaire concludes that such subjects are unworthy of a mature talent such as Frémiet's, and he lauds the jury for rejecting this vulgar drama. Aside from the unanswerable question of what he means by "pure art," Baudelaire here expresses a view of the sexual appetite of anthropoid apes that was surely shared by Frémiet and the public at large and continues to be part of present-day folklore, even though it has no basis in fact. Its origins are to be found in man's prescientific response to simians of any kind: since they are so obviously similar to us, they must be our "poor relations," i.e., a caricature of man, human beings transformed into humanoid animals in punishment of some sin even graver than that of Adam and Eve. The Middle Ages could term them *imago diaboli,* the devil's likeness, perhaps the offspring of those illicit unions of fallen angels and women briefly referred to in the Old Testament. Thus apes (actually tailless monkeys known as "Barbary apes," once common in southern Spain but now confined to the Rock of Gibraltar) were believed to have all human vices without any of our virtues: the female loved its young so possessively that it often killed them in the process; the male, inevitably, was "oversexed," with a special craving for the human female. The latter notion gained added credence when the

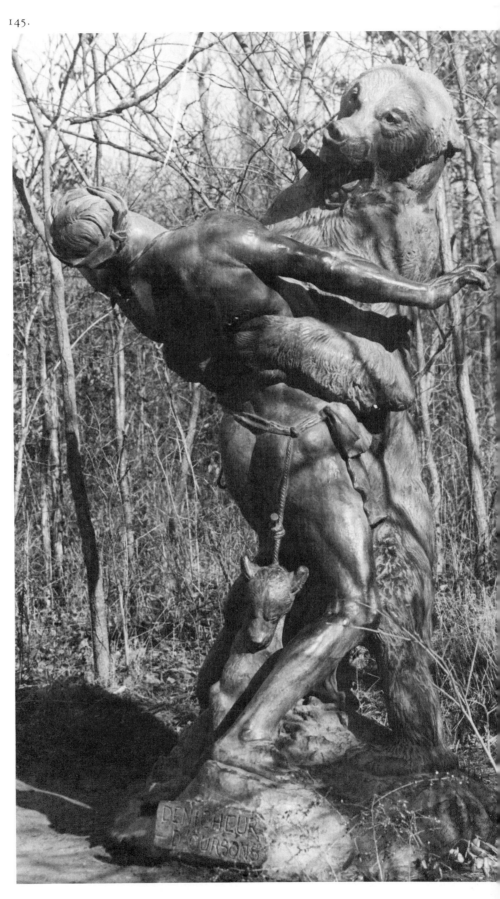

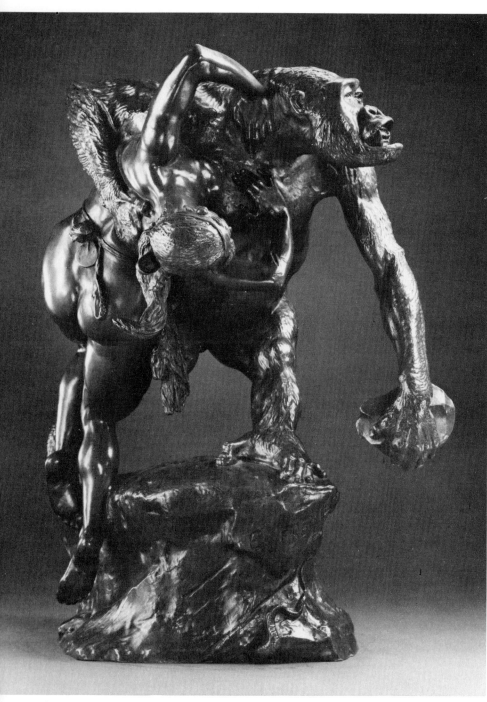

146.

first anthropoid apes (probably chimpanzees) were brought to Europe in the seventeenth century, inasmuch as these were even more embarrassingly like people. Thus Darwin, in asserting man's descent from apelike ancestors, contravened not only the biblical account of Creation but also a set of ideas about the nature of apes so deeply ingrained that he offended both religious and secular opinion.[16] It can hardly be coincidence that 1859, the year of Frémiet's first *Gorilla,* was also the year of *The Origin of Species.* Needless to say, Darwin did not accept the common view of the sexual rapacity of apes, but his theories lent new weight to the age-old canard. That Frémiet was familiar with Darwin's theories as early as 1859 seems extremely likely if not certain; first adumbrated in 1842 and elaborated two years later, they must have been fairly common knowledge among specialists long before the publication of *The Origin of Species* set off a public debate that was to last for decades. Since Frémiet had been closely linked with the Jardin des Plantes and its natural history museum even before he became Barye's successor there, he probably had heard of Darwin long before the general public did. As for the great apes' supposed appetite for women, it could have been an argument in Darwin's favor if it had been interpreted as a consequence of our common ancestry. In any event, the success of the 1887 *Gorilla,* in contrast to the failure of its predecessor of 1859, was due at least in part to the impact of Darwinism during the intervening years. The enthusiastic reception of the later group led Frémiet to compose a variant on the same theme in 1895, an *Orangutang Strangling a Native of Borneo,* for the museum at the Jardin des Plantes. Here the ape is female, a mother protecting her young whom the (male) native has been trying to seize: a situation analogous to the *Bear Cub Hunter.* For Frémiet, bear and ape were interchangeable as adversaries of primitive man, both being "man-like" because they could walk on their hind legs.[17] The *Bear Cub Hunter* and the 1877 *Gorilla* were counterparts, each showing a human being as the victim of an animal of the opposite sex. In 1876, halfway in time between the two gorilla groups, he had done a *Gladiator Fighting a Gorilla,* and soon after 1885 he substituted a gladiator for the hunter (see cat. no. 147).

H.W.J.

147.

Bear and Gladiator
Cast terracotta
h: 11 in. (27.9 cm.)
c. 1885–90
Signed: E. FREMIET (on top of base)
Lender: Mr. and Mrs. Joseph M.
Tanenbaum, Toronto

The same model, a small-scale variant of
cat. no. 145, also exists in bronze (David
Daniels Collection, New York; exhibited
at Shepherd Gallery, New York, 1973, no.
35a). The Stone Age hunter has here been
turned into a retiarius, a Roman gladiator
who fought almost naked, equipped only
with a net and a trident. The net is clearly
visible, but Frémiet has omitted the tri-
dent; the gladiator's knife, corresponding
to that of his Stone Age predecessor, is
plunged into the bear's left shoulder. The
cub, not snared, clings to its mother's left
leg. Frémiet had modeled a retiarius group
in 1876 (*Rétiaire et Gorille,* terracotta), un-
known today even in photographs, so that
its possible relation to our group and its
monumental model cannot be determined.
The change of scene from the Stone Age to
the Roman arena entails a new emphasis on
the animal; unlike the hunter, who is still
struggling against the bear's embrace, the

147.

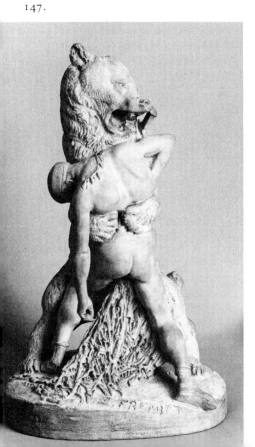

148.

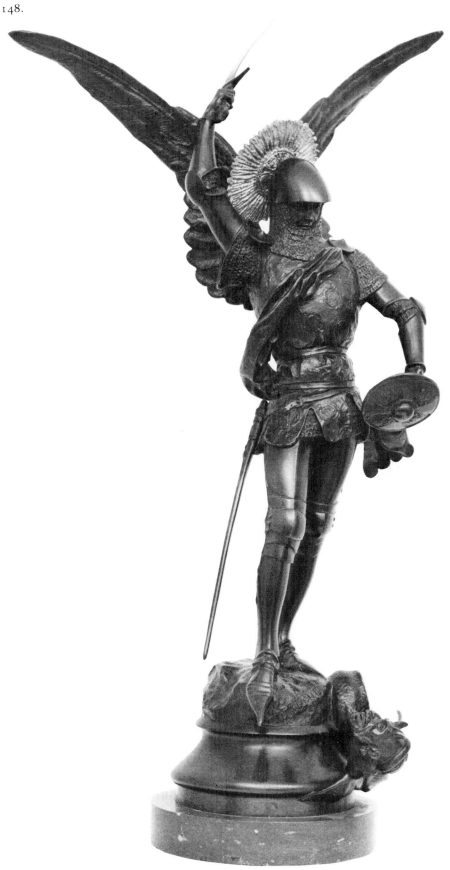

retiarius has lost consciousness so that the animal is both crushing and supporting him with its paws. To the private collector, for whom our group was intended, gladiatorial combats (often depicted by painters such as Gérôme), were a more familiar sight than Stone Age hunters, suited to the special environment of the Jardin des Plantes. H.W.J.

148.
St. Michael
Bronze on marble base
h: 22½ in. (57.2 cm.) including 1 in. (2.5 cm.) base; w: 13⅛ in. (33.4 cm.); d: 8¼ in. (21 cm.)
After 1879
Signed: FREMIET (on front of base)
No foundry mark
Lender: The David and Alfred Smart Gallery, The University of Chicago, Anonymous Loan

Frémiet produced two *St. Michaels*, a gilded bronze statuette exhibited in the Salon of 1879 and a bronze statue crowning the *flèche* of the church of Mont-Saint-Michel; he showed the plaster model of the latter in the Salon of 1896. The Salon catalogs describe the former as *St. Michael*, the latter as *St. Michael Vanquishing the Dragon*, which does not necessarily indicate the absence of the dragon in the statuette of 1879. Our statuette, in which only the saint's halo is gilt, may be either a cast of the 1879 *St. Michael* or a reduction of the large work of 1896. What the latter looks like is difficult to determine: the bronze at Mont-Saint-Michel can be seen only at a great distance, and the plaster model for it, donated to the Dijon Museum by Frémiet's widow, is unavailable for inspection. There are several observations, however, that argue in favor of identifying our piece with the statuette of 1879: the precise detail and fine finish suggest a "mini-monument" designed for viewing at close range, like Frémiet's *Corneille* (cat. no. 143), and the dragon is inconspicuous enough to be overlooked. Moreover, the piece of drapery descending in a curve from St. Michael's left shoulder has a close counterpart in the drapery of the figure of Fame in *The Muse Crowning Pierre Corneille*, also done in 1879. The wings of the two figures, too, are similar, even though St. Michael is not using his. There are, finally, the S-curves of the dragon's body and of the saint's two arms. One might well say, then, that our *St. Michael* is as neo-Baroque as a figure encased in fifteenth-century armor can possi-

bly be. The narrow circular base and the agitated silhouette of our piece make it suitable for crowning a Gothic pinnacle; the commission of 1896 for Mont-Saint-Michel must have been suggested by these qualities.[18] H.W.J.

Notes
1.
Angrand, 1971, p. 341.
2.
Ibid., p. 342.
3.
Biez, 1910, p. 142.
4.
D. Sellin, "Joan of Arc," in *Sculpture of a City: Philadelphia's Treasures in Bronze and Stone*, ed. N.B. Wainwright, New York, 1974, p. 126.
5.
Biez, 1910, p. 153.
6.
Ibid., pp. 152–53.
7.
Angrand, 1971, p. 346.
8.
Ibid., p. 346.
9.
Ibid., p. 347.
10.
Plaster, described as a tomb sculpture by Lami, 1914–21, II, p. 412. For an illustration see Biez, 1910, plate facing p. 260.
11.
Lami, 1914–21 II, p. 414; illustrated in Biez, 1910, p. 164.
12.
Illustrated in Paris, 1979, p. 229, no. 166.
13.
Dalou, self-exiled in London after the fall of the Paris Commune, returned to France in response to the general amnesty in 1879. Frémiet's *Corneille* must have been among his earliest impressions of what had happened in French sculpture during his eight-year absence.
14.
It was praised and given a full-page reproduction in Paul Mantz's review of that Salon (*Gazette des beaux-arts*, 1872, XVI, pp. 61–62).
15.
Each shows a Pegasus guided by a figure of Fame, the subjects being, respectively, *La Renommée des arts* and *La Renommée des sciences*.

16.
See H. W. Janson, *Apes and Ape Lore in the Middle Ages and the Renaissance* (Studies of the Warburg Library), London, 1952, pp. 261–86, 327–54.
17.
The persistent fascination with the ape as male sexuality incarnate is illustrated in the twentieth century not only by the success of the movie *King Kong* but still more recently by Ian McEwan's *In Between the Sheets And Other Stories,* New York, 1979, which includes the tale of a woman writer who has sexual relations with her pet ape. In the novel, *Bear,* by Marian Engel, New York, 1976, the ape's role is played by a bear. While it is true that the animals in both cases have symbolic overtones—the ape reads the *Times Literary Supplement,* and the bear stands for the untamed Canadian wilderness—they are no less real than Frémiet's gorilla and bear, and these too have symbolic overtones, although of a different sort. For reasons I do not dare to suggest, no author—ancient or modern, male or female—seems to have explored the opposite situation: a human male engaging in sexual relations with a female ape or bear.
18.
The plaster model, poorly reproduced in the *Gazette des beaux-arts* (1896, XV, p. 449), is a simplified and less graceful version of our statuette, the one significant difference being that the demon is no longer a human-headed snake but a conventional dragon.

Selected Bibliography

Biez, J. de, *Un Maître imagier: E. Frémiet,* Paris, 1896.

Bricon, E., "Frémiet," *Gazette des beaux-arts,* 1898, XIX, pp. 494–507; XX, pp. 17–31.

Biez, J. de, *E. Frémiet,* Paris, 1910.

Lami, 1914–21, II, pp. 405–19.

Faure-Frémiet, P., *Frémiet,* Paris, 1934.

Horswell, 1971, pp. 181–200.

Angrand, P., "Une—ou—deux Jeanne d'Arc sur la Place des Pyramides?" *Gazette des beaux-arts,* LXXVII, May–June 1971, pp. 341–52.

Louisville, 1971, pp. 175–83.

Cooper, 1975, pp. 149–52.

JACQUES-LOUIS GAUTIER
1831 Paris — ?

A student of Rude, Gautier made his Salon debut in 1850 with a bronze sketch bearing the Romantic-sounding title *Misery*. He continued exhibiting—mostly busts and decorative objects—until 1868. Much of his career was devoted to producing models for bronze decorations in various revival styles. In particular, he seems to have specialized in Renaissance designs. In 1865 he was chosen as the official sculptor for the bronze manufacturer Van Mons.[1] Participating in the Exposition Universelle of 1867, he was praised for a *Crowned Minerva*—a work not listed in Lami—by the critic Marc de Montifaud, who wrote of Gautier that "from him Barbedienne had gathered all his inspiration."[2] Apparently, Gautier's last recorded work is the *Bust of Hector de Callias*, exhibited at the 1868 Salon. Although Lami, following Bellier and Auvray,[3] distinguishes Jacques-Louis Gautier from a Jacques Gautier—whose only recorded works are portrait busts listed in the 1870–74 Salon *livrets*—it is unclear whether or not they really were two different artists. P.F.

149.
Mephistopheles
Bronze
h: 26½ in. (67.3 cm.); w: 5⅝ in. (14.3 cm.); d: 4¾ in. (12.1 cm.)
Model c. 1853, cast c. 1855
Signed: Les Gauthier/Bronze d'art (on left of base)
Lender: Private Collection

Gautier exhibited a bronze of the *Mephistopheles* in the section devoted to industrial arts at the Exposition Universelle of 1855. According to Lami, the work was first modeled in 1853, and versions of it were acquired by the Duchess of Alba and for the cabinet of Napoleon III.[4] The model seems to have enjoyed a certain popularity and, in addition to our example which bears only the artist's name, it was edited commercially by the firm of Duplan and Salles. In 1856 a critic reviewing contemporary bronzes and bronze manufacturers wrote: "Monsieurs Duplan and Salles are very active and intelligent young editors [of bronzes]. They have edited this strange *Mephistopheles* with a long and grimacing profile which one can see, not without some surprise, in the showrooms of the principal stores of Paris. A *Lucifer* [also by Gautier?] in the same mounted-asparagus taste, is even more baroque."[5] As a pendant to the *Mephistopheles*, Gautier produced an equally bizarre and elongated witch entitled *Macbeth*.[6] Lacking any real sculptural quality, these decorative curiosities nevertheless satisfied a certain taste for the macabre which was in vogue in mid-nineteenth-century Paris (see cat. no. 159). P.F.

Notes
1.
Villarceaux, 1865, II, p. 230.
2.
Montifaud, 1867, p. 353.
3.
Lami, 1914–21, III, pp. 25–27; Bellier and Auvray, 1882–87, II, p. 625.
4.
Lami, 1914–21, III, p. 26.
5.
Busquet, 1856, p. 275.
6.
Paired examples of *Mephistopheles* and *Macbeth*, signed "Duplan et Salles F. de Bronzes L. J. Gautier" were sold at Sotheby's Belgravia, July 26, 1978, lot 304.

Selected Bibliography

Villarceaux, N. de, "Les sculpteurs et le bronze: Jacques Gautier et Van Mons," *L'Artiste*, 1865, II, p. 230.

Lami, 1914–21, III, pp. 25–27.

149.

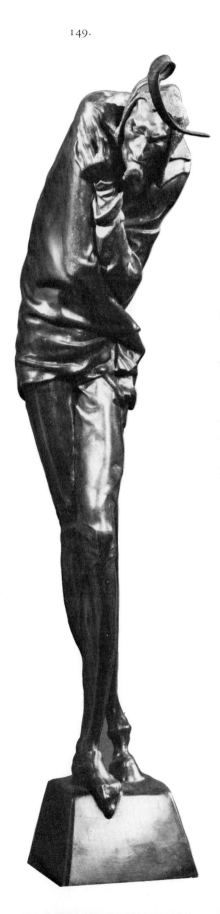

JEAN-FRANÇOIS-THÉODORE GECHTER

1796 Paris 1844

Born in the same year as Barye, Gechter shared the same masters, Bosio and Gros. He made his Salon debut in 1824 with three works: *Pirithous Overwhelming a Centaur, A Vanquished Gladiator,* and *A Warrior Removing an Arrow from His Heel.* At the Salon of 1833 he exhibited an equestrian battle group, *Charles Martel Combating Abderame, King of the Saracens,* commissioned in bronze that year by the Ministry of Commerce and Industry and later reproduced in commercial bronze editions. At the Salon of 1834 Gechter won a second-class medal for a plaster group entitled *Combat during the Egyptian Campaign of 1798.* In 1837 he was awarded the medal of the Legion of Honor after completing a large relief—*The Battle of Austerlitz,* commissioned 1833—for the Arc de Triomphe. His other major commissions included two bronze figures of *The Rhône* and *The Rhine* (1839) for the fountain on the Place de la Concorde, a stone *St. John Chrysostom* (1840) for the church of the Madeleine, and a marble statue of *Louis-Philippe* (1839–42). For the most part Gechter seems to have preferred bronze as a medium and to have been attracted to subjects that involved struggling groups and animals. Toward the end of his life he apparently began to specialize in animal bronzes. Gechter was presumably influenced by Barye; the relationship of these two artists warrants further study. P.F.

150.
Louis-Philippe (1773–1850)

Bronze
h: 15¾ in. (40 cm.)
c. 1839
Signed: T. Gechter
No foundry mark
Lender: The Minneapolis Institute of Arts, the Ethel Morrison Van Derlip Funds

This bronze is a reduction of Gechter's marble statue of Louis-Philippe (Versailles Museum), commissioned in 1839. Gechter's work records the moment of Louis-Philippe's accession to power in 1830; it depicts the *Roi des Français* (as opposed to past *Rois de France*) in elaborate coronation robes and crowned with laurel. Into his work Gechter incorporated a crown and a book, presumably the Bible on which the king swore to uphold the charter of the new constitutional monarchy. Despite the fact that the work is a retrospective portrait, it represents Louis-Philippe as

older and stouter than he appeared in portraits done at the time of his coronation (see cat. no. 176). P.F.

Note

1.
Some of Gechter's animal bronzes are illustrated in Cooper, 1975, p. 136, and Berman, 1977, III, pp. 701, 702.

Selected Bibliography

Lami, 1914–21, III, pp. 42–44.

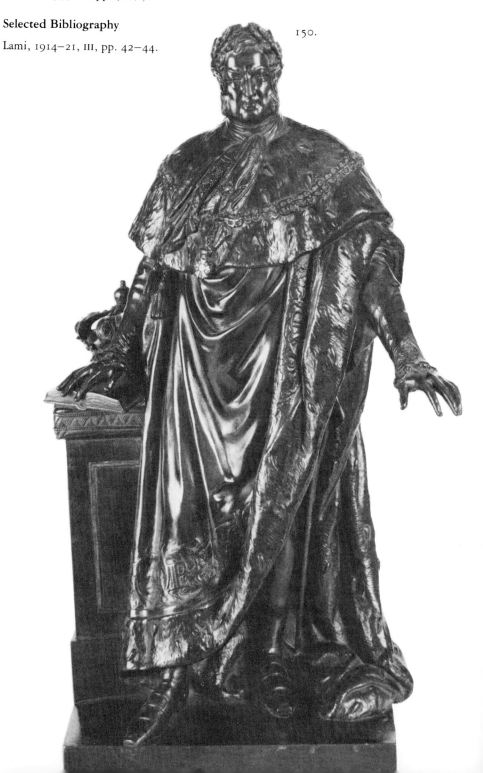

150.

THÉODORE GÉRICAULT
1791 Rouen–Paris 1824

The fame of Jean-Louis-André-Théodore Géricault resides in his brilliant and enigmatic career as a painter, but the seven small sculptures by his hand are ample evidence that, had he lived longer, he might have been the most significant painter-sculptor since the Renaissance.

In 1796 his well-to-do family moved to Paris. Defying his father in 1808, Théodore undertook the study of painting in the fashionable studio of Carle Vernet. The master allowed the boy to paint those themes that pleased him, and Géricault quickly fused the two great passions of his life, art and horses. His independent income freed him to pursue his art on his own terms, and he might best be considered self-taught.

To obtain a more structured knowledge of art, Géricault moved in 1810 to the studio of Pierre Guérin, a close follower of the Neoclassical school of David. His brief stay, less than a year, was punctuated by temperamental outbursts by the young artist against Guérin's rigorous formalism. Nonetheless, Guérin was able to recognize his student's prodigious gifts: "he has the stuff of three or four painters."[1]

Géricault spent his time increasingly in the Louvre, where he copied the masterpieces of the past. His early, small paintings of military and equine themes are realistic but freely handled. He made his Salon debut in 1812 with the *Charging Chasseur,* a baroque composition of great verve depicting an officer on a rearing horse. Two years later he exhibited a pendant *Wounded Cuirassier Leaving the Battlefield* that illustrates a stylistic shift toward more monumental, classically defined images of sculptural forms in more subdued colors. His affair with the youthful wife of his uncle, to end in calamity, began about this time.

When his bid for the Prix de Rome failed, Géricault departed for Italy in 1816 at his own expense, partly to escape his emotional entanglements, partly to study the antique and Michelangelo. Though he was only to stay a year, the experience intensified the two tendencies of his art — a realistic depiction of modern themes and a classical rendering of more antique ones. The *Race of the Barberi Horses,* his most important Italian endeavor, combined his love of horses with a theme that allowed him to explore his classicizing style on an epic scale. While it remained unfinished, the *Race* marks the maturity of his expressive genius and his gift for synthesizing radically different sources.

He cut short his stay for personal reasons to return to Paris in the fall of 1817. His aunt conceived a child by him in November, making the discovery of their illicit relationship unavoidable. Despite the extreme stress of his situation, Géricault channeled his energies into a search for a theme for the 1819 Salon. The subsequent *Raft of the Medusa* proved to be his masterpiece. The abandonment of crew members on a raft by the aristocratic captain of the foundered frigate *Medusa* scandalized the French and made Géricault's painting the focus of as much political as aesthetic controversy. The infusion of realism into a complex, stylized depiction of a contemporary theme on the level of history painting culminated the dual directions the artist had begun to master in Rome. Eighteen months of extensive artistic concentration, coupled with the emotional family rupture that occurred with the birth of his son in August, four days before the Salon opened, left the artist exhausted. He was never to regain sufficient strength to implement any of his plans for complicated projects of the intensity and scope of the *Raft.*

To relieve his burdens, he fled to England when the opportunity to exhibit the *Raft* arose. The favorable reception of his work, earning him a large sum, and his friendly contact with English painters encouraged him to prolong his visit almost two years. Paintings like the *Epsom Downs Race* demonstrate his sympathy with the British sporting-genre tradition. He had taken up lithography, perhaps because the ease of execution was less taxing to his health.

Only seven sculptures are known by the artist, and, according to Schmoll, he only attempted sculpture in the last four years of his life.[2] They are all small, roughly finished compositions that were motivated by the artist's intensive search to understand and render three-dimensional forms. Clément wrote that they are "masterpieces as much by the choice of forms as by anatomical science, and perfection of rendering."[3] All examine themes that he was exploring in painting and drawing, and some are related to specific works. They are characterized by richly modeled forms which grasp the essence of action with a potent disregard for superficial finesse. Clément observed that "like the majority of Renaissance painters Géricault made sculpture," and the artist's propensity for expressing form, regardless of the medium, through powerful masses belies a sculptural vision that may be likened to that of Michelangelo.[4] One biographer described him as a "repressed sculptor," but the promise of his few sculptural explorations indicates that, had he lived beyond thirty-three years, he would have devoted substantial energies in this direction.

Upon his return to Paris in 1882, Géricault's declining health was aggravated by several riding accidents and disastrous financial speculations. He continued to work on small paintings and lithographs that reflect his concern with the immediate. The series of ten *Portraits of the Insane,* undertaken for his friend Dr. Georget, a pioneer in the psychology of obsessive behavior, were probably done in 1822–23. His suffering grew worse, and he was bedridden after operations on his spine, decaying from a tubercular infection. Leaving his estate to his natural son, the painter died early in 1824. His studio was sold at auction on November 2–3 of that year.

Géricault was known to the public only by the three works exhibited at the Salon. Later generations have embraced him for diverse aspects of his life and style to justify their own ends. He epitomized the "Romantic" concept of an artist by his erratic, melancholy temperament, his rejection of traditional or facile solutions to art, and his tragic life cut off by an early death. His style could be described alternately as realist, Romantic, and classicist. Lorenz Eitner summarized: "The landscape of his art consists of rivers rather than peaks. . . . Like certain artists of the twentieth century, he seems on occasion to have been interested in the process rather than the product of composition." Eitner stresses the artist's unmitigated concern with what was tangible: "His fantasy, in its freest, most unfettered moments, gave birth to sculptural forms rather than ethereal visions."[5] Géricault's greatest contribution lies in his insistence on the present, his uncompromising modernity. J.E.H.

151.

Flayed Horse

Bronze
h: 9½ in. (24.1 cm.); w: 4½ in. (11.4 cm.); l: 9 in. (22.9 cm.)
Model c. 1820–24, cast 1959
No signature
Foundry marks: CIRE/VALSUANI/PERDUE (on top of base in left rear corner) and H.C. 4/5 (on top of base in right rear corner)
Lender: Saul Brandman, Beverly Hills

The *Flayed Horse* is a natural extension of the artist's equine obsession. His primary theme, horses are depicted through his paintings, drawings, and lithographs in infinite variety, from repose to gallop. The freestanding *écorché*, which is in fact only partially flayed to expose the play of muscles and tendons, seizes the animal with the left foreleg poised mid-step. Géricault modeled the horse in wax, a material eminently suited to his nervous, impatient nature by its easy pliability. Clément was uncertain of the date, only stating that Géricault "modeled this admirable work in

his youth." He considered it the most beautiful horse in existence.[6] Paul Mantz wrote of the *Flayed Horse*:

The interest presented by this precious morsel had frequently been cited. It demonstrates, as if that were necessary, with what sincere passion, with what ardent affection, Géricault studied the noble animal that played such an important role in his paintings and lithographs. When he modeled this wax, truly worthy of a museum, he not only showed an exact anatomy that put every muscle in its normal place, he above all made an artistic masterpiece in seeking the exact movement and the vital allure.

Mantz astutely characterized Géricault's compelling urge "to know the secret of forms and to put his finger on the heart of things."[7]

Clément states that the wax was bought from the 1824 sale of M. Susse, who sold it to Maurice Cottier, in whose family it remained until 1958, when the Reid and Lefevre Gallery, London, purchased it. It is presently in the collection of Mr. and Mrs. Paul Mellon. Two bronze versions are known. The first, marked "Fondu par H. Gonnon et ses deux fils/1832," cast before the wax was restored, is probably unique. The second cast, commissioned by the Lefevre Gallery in 1959, is after the present condition of the wax in which the tail and raised hind hoof have been slightly modified, and the ears are missing. Valsuani cast fifteen numbered bronzes, in addition to five marked "H.C." and numbered 1–5 for the Cottier heirs.

A pencil sketch for the anatomy of the horse's body is at the Musée Bonnat, Bayonne. Géricault's lithograph *Trotting Horse* (Clément no. 70) illustrates a remarkably similar horse of 1823, with the raised leg reversed, an indication that the artist may have drawn from his sculpture.[8] Plaster casts, found "in every studio" according to Clément, testify to the figure's widespread popularity.[9] J.E.H.

Notes

1.
Los Angeles, 1971, p. 12.
2.
Schmoll, 1973, brings the number of accepted sculptures to seven. He does not elaborate on his claim, p. 320, that Géricault only sculpted during the last four years of his life.
3.
Clément, 1867, p. 222.

151.

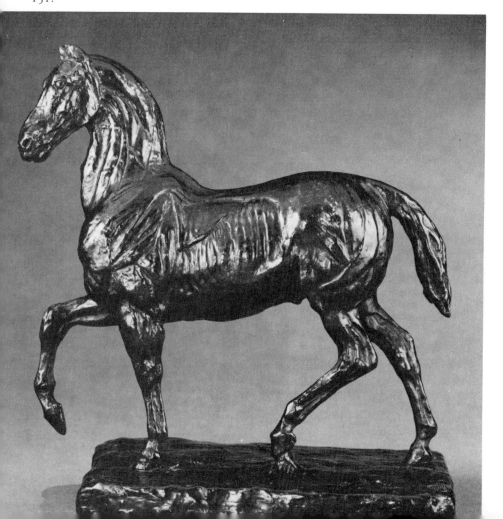

JEAN-LÉON GÉRÔME
1824 Vesoul–Paris 1904

4.
Ibid.
5.
Los Angeles, 1971, p. 14.
6.
Clément, 1867, pp. 325 and 222. The date remains problematic. Schmoll, 1973, p. 320, claims that Géricault only began to sculpt in the last four years of his life, but Clément's statement would imply an earlier date for the wax. The National Gallery dated the composition between 1817 and 1824. Mr. Peter Findlay and Mr. and Mrs. Paul Mellon kindly supplied information on the *Flayed Horse.*

7.
Mantz, 1872, pp. 382 and 384.
8.
The *Trotting Horse* is illustrated in L. Delteil, *Théodore Géricault,* Paris, 1924, no. 68.
9.
Clément, 1867, p. 325. The Louvre owns a plaster of the *Trotting Horse.* It is depicted in Sebastian Dulac's painting *The Model Cooking* (1832), illustrated in *Ingres & Delacroix through Degas & Puvis de Chavannes: The Figure in French Art 1800–1870*, New York, Shepherd Gallery, Associates, May–June 1975, p. 106. Van Gogh painted a study after the plaster horse (Amsterdam, Stedelijk Museum), and Redon made a drawing after it (exhibited at the Bernheim-Jeune Gallery, in the early 1960s).

Selected Bibliography

Clément, C., *Géricault, étude biographique et critique,* 1st ed., Paris, 1867; 2nd. ed., Paris 1868; 3rd. ed., Paris, 1973.

Mantz, P., "Galerie de M. Maurice Cottier," *Gazette des beaux-arts,* 1872, V, pp. 373–97.

Berger, K. *Géricault und sein Werk,* Vienna, 1852.

Rouen, Musée des Beaux-Arts, *Géricault, un réaliste romantique,* 1963.

Peignot, J., "Géricault Sculpteur," *Connaissance des Arts,* January 1965, CLV, pp. 46–51.

Los Angeles County Museum of Art, *Géricault,* exh. cat. by L. Eitner, 1971.

Schmoll, J. A., "Géricault sculpteur, à propos de la découverte d'une statuette en plâtre d'un moribond," *Bulletin de la société de l'histoire de l'art français,* 1973, pp. 319–33.

Gérôme was twenty-three when he had his first great success as a painter, at the Salon of 1847. He had sent only one painting, *The Cockfight* (Louvre), which depicted a young Greek boy and girl watching two gaming cocks battling in midair. Six years earlier Gérôme had left his native city of Vesoul in the Franche-Comté to study in Paris with Paul Delaroche. He spent three years in Delaroche's atelier and another with him in Rome. Returning to Paris in 1846, he studied for a few more months in the atelier of Charles Gleyre so that he could qualify as a contestant for the Prix de Rome. He was disqualified from the contest after the second problem; his compositional drawing for *Jacob Blessing the Children of Joseph* was criticized as having weak figures. To correct this weakness he started an intense study of the nude, and went daily with a friend, the young sculptor Emmanuel Frémiet, to the zoo in the Jardin des Plantes to study animal anatomy. The result was the great figure of the boy and the fine fighting cocks in *The Cockfight.* In the Salon of 1847 the work was noticed by the famous poet and critic Théophile Gautier; he gave it an enthusiastic review, and Gérôme's name was made.

From then on he had one success after another. He received a varied series of official commissions from succeeding governments, including two from the revolutionary Commune of 1848. Such commissions were exacting, poorly paid, but nonetheless honorific, and they put the artist's work on display in important public places. Each succeeding Salon included several pictures by him, usually quite different in subject matter, and always witty and skillfully painted; his entries always caused comment in the press and in the salons. By the early 1860s he was a *chevalier* of the Legion of Honor, a member of the Institut de France, a professor at the Ecole des Beaux-Arts, a visitor at the court of the Empress, a frequenter of the salon of Princess Mathilde, the husband of a very rich woman, the owner of a large house on the Boulevard de Clichy, a popular teacher, and a very famous painter. Whatever he chose to paint he sold, often before it was dry on the easel, and very often to rich American collectors.

With the success of *The Cockfight* in 1847, Gérôme had launched a new school or style, that of the Néo-grecs, a small group of painters who were mainly companions from the atelier of Gleyre: Hamon, Picou, Toulemouche, and Gustave Boulanger. They painted genre scenes set in antiquity. Their subject matter was usually witty and often erotic. Technically their work was precious: refined in detail and delicate in coloring. The result was obviously a compromise between the coming fashion of realism and the austere classicism of Gleyre. Gérôme was clearly the best of the lot: his technique, wit, and invention surpassed the others. Boulanger and Picou continued to paint Néo-grec scenes all their lives, but not Gérôme. Astonishingly enough, at the height of the style's popularity, he gave it up for a strict realism, not the optical realism of Courbet or Manet, but a realism based on scientific objectivity and the techniques of the Academy. In changing styles he showed great independence and courage, traits that would later help him switch from painting to sculpture. As an academic realist he painted nonheroic history pictures, such as the *Death of Caesar* (1867, Walters Art Gallery, Baltimore) and the *Death of Marshal Ney* (1859, Sheffield Municipal Gallery).

His career continued without a hitch—his wealth and his fame increasing—until the fall of the Second Empire. He spent the Siege of 1870 in London with his family and returned to Paris in 1871 to help get the Ecole des Beaux-Arts running again, and to reconstruct his family fortune and his own career. He put off exhibiting at the Salon again until 1874, when he made a great comeback with the still famous *Eminence grise* (Boston, Museum of Fine Arts).

In 1878 at the age of fifty-four he made another professional change, as great as that of dropping his Néo-grec manner for realism: he sent a sculpture to the Exposition Universelle, and it won him a Medal of Honor. It was a large bronze group, *The Gladiators* (Fort du Mont Valérien). A triumphant mirmillon, his sword down and his foot upon a conquered retiarius, looks up through his helmet for the instructions of the mob: "Thumbs up!" or "Thumbs down!" The group is almost the same as the central figures in his famous oil *Pollice Verso* (Phoenix Art Museum), painted at the same time, from the same models in the same costumes.

After this success as a sculptor, Gérôme continued to paint, but his compositions and themes were increasingly modest, and assistants finished many parts of his backgrounds, and even, sometimes, the main figures. His passion and his time were spent on sculpture; he took advice, even lessons from his old friend Frémiet. In fact, as late as 1901, he listed himself in the sculpture section of the Salon catalogue as "student of M. Frémiet."

Gérôme did his modeling in plaster. He gave the plaster "master" to professional marble carvers to be copied, under his supervision, or to professional foundries when he wanted a bronze made. He usually made his plasters life-size, working close to the model so that he could easily compare and measure both the model and the plaster. Degas repeated laughingly his remark that sculpture was easy with calipers.[1] If the work were for issuance as a small bronze, he nonetheless worked it in a plaster several times larger than the bronze was intended to be, trusting to the method of François Barbedienne for an exact reduction. Gérôme was so proud of his accuracy that he often had the plaster and the model photographed together so that their similarity could be enjoyed. He was exact in his costumes too, spending both time and money to insure their correctness. For *The Gladiators*, his models wore casts he had made after genuine gladiatorial armor from Pompeii.

Although he was no longer a young man, he had many new ideas about his sculpture. He experimented in many ways: tinting his marbles to make them lifelike, mixing materials such as bronze, marble, ivory, perhaps attaining more sumptuous effects than those of the ancient chryselephantine technique he emulated. Since the small bronzes are so numerous, they are the best known of his sculptured works. Their fine detail contrasts with his larger works where the emphasis is properly on the larger masses. The monumental works are, sadly, widely scattered, and it takes some effort to know even a few of them. The *Omphale* of the Salon of 1887 is in the city hall of Vesoul. The government had wanted to buy it, but Gérôme had refused to sell. "I am not permitted—a painter who earns a handsome living with my brush—to appropri-

ate for my benefit one penny from the yearly fund for sculptors," he wrote to the Minister of Fine Arts.[2] The statue was later given to the city of Vesoul. The *Tanagra,* Salon of 1890, now displayed in the Louvre after half a century in the basement, was bought by the government, but expressly from a separate fund. The Salons of 1890 and 1892 saw his two first elaborate chryselephantine works: *The Ancient Dancer* (private collection, Geneva) and the *Bellona* (Inn in the Park, Toronto). The latter is rather horrendous, what Waugh would call an "objet d'arts and crafts," and Gérôme would concur with the description; he thought of the work as an experiment employing new techniques to weld disparate materials.[3] The amusing and subtle *Pygmalion and Galatea,* Salon of 1892, is in the Hearst Castle in San Simeon, California. It was once lightly tinted but is now bleached white. Probably his most important and imposing piece is the huge equestrian monument to the Duke of Aumale in the stable courtyard of the Hippodrome at Chantilly, a large bronze of magnificent proportions. In an excellent compromise, broad clear masses support fine naturalistic details.

Gérôme died while sleeping in his sculpture studio in 1904. G.A.

152.
Anacreon with Bacchus and Cupid
Bronze
h: 28½ in. (72.4 cm.); w: 11¼ in.
(28.6 cm.); d: 12¾ in. (32.4 cm.)
1893
Signed: J. L. Gerome (on left side of base)
Foundry mark: F. BARBEDIENNE, FONDEUR, PARIS (on right side of base)
REDUCTION MECHANIQUE, A. COLLAS BREVETE (on back of base)
Lender: The Art Institute of Chicago, Gift of F. Le B. Barbedienne

The plaster of *Anacreon* (now at Vesoul) was modeled in 1878; it is 44 inches (1.1 m.) high. In 1881 it was exhibited at both the Paris Salon and the London Royal Academy Exhibition where it won Gérôme a first-class medal. A larger marble version, 85 inches (1.89 m.) high is in the Ny Carlsberg Glyptotek in Copenhagen. Smaller bronze castings were issued in four sizes, 55 cm., 76 cm., 90 cm., and 1.12 m. high. For this work, the larger the casting, the better the detail. Some of the casts are marked "Siot-Décauville," after the foundry, others "Barbedienne," after the in-

152.

ventor of the reductive process. Some twenty copies must have been produced over a long time.

Anacreon, the fifth-century Greek poet, sang of the glories of love and wine. His name is usually associated with revelry and frivolity. Gérôme presents him slightly drunk, carrying the infants Bacchus and Cupid in his arms, the living symbols of his interests. The poet had been a favorite of the Néo-grecs, and Gérôme painted him in 1848, playing his lyre for a bacchic revelry —a commission, oddly enough, of the revolutionary government. This painting, *Anacreon,* now hangs in the Hôtel d'Assezat in Toulouse. For it Gérôme had used the iconography of the poet as developed from antique sources by Girodet for his illustrations to his translation of the poet, the edition that certainly was the favorite of the Néo-grecs.[4]

Gérôme kept his copy of Girodet's *Anacreon,* and used it again for this statue and for a series of paintings he worked on in the early 1880s. They were based on the four engravings by Girodet for the Second Ode.

Anacreon's Second Ode tells of a rainy night on which the poet let a soaked Cupid take shelter in his house. Drying him by the fire, the poet fell in love with him, but Cupid flew away at dawn. The ode can be interpreted either as a metaphor for a heterosexual affair, or as the story of a homosexual one. Painters and sculptors have delighted in depicting both constructions.[5]

Elegantly dressed, Gérôme's Anacreon waddles drunkenly forward. He beams reverently and affectionately at the two infants in his arm, Bacchus and Cupid. Although the group might have been inspired by the frivolous story of an old man falling in love with a young boy, the mood of the statue is serious and noble. Gérôme has paid great attention to detail: the different cloths and furs of Anacreon's costume, the crisp folds of his pleated skirt in particular, and the contrast of the old man's muscular and veined arms against the plump flesh of the babies. The attention to detail almost outweighs sculptural qualities. Any hint of homosexuality has been toned down to one of grandfatherly affection. Gérôme's invention may have been aided by the Praxitilean *Hermes and*

the Infant Dionysus, discovered at Olympia in 1877 and immediately made world-famous through photographs, and helped as well by the Lysippian *Satyr with the Infant Dionysius* in the Louvre. Or again, he may have been moved by the happy presence of the first grandchildren in his family. We do know that he honored Phidias above all other artists and accepted him— piously, as everyone in the century did—as the author of the Parthenon sculptures, known in casts to every art student. Pausanius reports seeing a statue by Phidias on the Acropolis in Athens depicting Anacreon drunkenly singing in a state of divine ecstasy. Some have refused to believe that the subject could ever be depicted, even by Phidias, with enough taste to fit the sacred precinct; so there is a greater ambition behind this statue than a simple homage to Anacreon. Gérôme has come to the rescue of both his heroes' reputations by showing the two scandals of Anacreon's life—his drunkness and his homosexuality—as practically religious and familial states, thus producing a statue correct in both iconography and decorum.

It is fitting, and perhaps no accident, that the marble of Gérôme's *Anacreon* would end up in the Glyptotek in Copenhagen where the only candidate for a Roman copy of Phidias' *Anacreon* is housed. G.A.

153.
The Hoop Dancer (La Joueuse de Cerceau)
Tinted plaster
h: 9⅛ in. (23.2 cm.)
1891
Signed and inscribed: J. L. Gerome/a mon ami Dawant (on top of base)
Provenance: Albert-Pierre Dawant; Dawant's heirs; Tanagra Gallery, Paris
Lenders: Gerald M. Ackerman and Leonard R. Simon, Claremont, California

In the Salon of 1890 Gérôme exhibited a most original work, *Tanagra,* a tinted marble nude of magnificent proportions meant to be the *Tyche,* or Fortune, of the ancient Greek city. Tanagra is seated upright on an excavation mound; at her feet

is a pick axe, and sticking out of the soil of the mound are the heads and feet of statuettes. On the palm of her extended left hand she holds a small imitation Tanagran figurine, a hoop dancer. In 1874 the French excavators at Tanagra uncovered the grand cache of terracotta figurines that fill so many cases in the Louvre. Some of the figurines were of religious subjects, but most of them were genre subjects, brightly painted, that gave a new view of ancient Greek life much as Pompeii had given of Roman life. For Gérôme this discovery must have been both a revelation and a vindication, for it gave a justification and an ancient precedent to his own mixture of classicism and genre in his youthful Néo-grec paintings. Inspired by the polychromy of the statuettes to further experiments in realism, he tinted the nude: red hair, lips, nipples, and a light roseate tint to her skin which has now unfortunately faded away.

In 1891, the next year, Gérôme issued a small bronze based on the hoop dancer in Tanagra's hand. The figure was redone completely. One sees the plaster of the new version on a stand in depictions of Gérôme's studio; it was about 30 inches (76 cm.) high. More than a hundred casts of the bronze in a smaller size were sold, mostly gilt.

Our work is a small plaster, the same size as the bronzes; the bronze versions have a bit more detail in the drapery. Even so, it must have come from the same mold. Ours is painted by Gérôme in the tradition of the Tanagran statuettes. Gérôme evidently delighted in coloring plaster figurines of his sculptures for his friends, and a running joke was elaborated on the practice. (This figurine is inscribed to A. P. Dawant, a painter and a fellow member of the Legion of Honor.) Gérôme's friend the Danish sculptor L. B. Bernstamm did a life-size half-figure bust of Gérôme showing him painting the *Hoop Dancer.* Fernand Corman, another friend, painted Gérôme in his studio painting a different statuette. These paintings are both in the museum in Vesoul. Gérôme himself painted two scenes set in a Tanagran pottery shop which featured his *Hoop Dancer* (see cat. no. 154). In 1907, after Gérôme's death, Alma-Tadema painted a Roman matron reverently admiring a gilt *Hoop Dancer.* Alma-Tadema was paying his respect to his friend's memory and to his ambitions by using his work as a genuine antiquity. G.A.

153.

154.
Painting Breathes Life into Sculpture (Sculpturae Vitam insufflat Pittura)

Oil on canvas
h: 19¾ in. (50.2 cm.); w: 27⅛ in.
(68.9 cm.)
1893
Signed: J. L. Gerome (left center on box)
Provenance: John McVay: sold Parke-Bernet, 1969, Sale 2819; Ira Spanierman, New York
Lender: Art Gallery of Ontario, Gift from the Woman's Committee Fund, 1969

In this painting Gérôme has revived his earlier Néo-grec manner to publicize the antiquity of the traditions in which he worked. He does this with very good humor, but still with seriousness. He has also revised the subtle coloring of the Néo-grec manner to make his painting match the simpler and brighter colors of the Tanagran figurines. This is the better of two similar canvases of Tanagran pottery painters at work in their shops which he painted in the 1890s. The title clearly links the ancient practice of polychromy with his own realism: *Painting Breathes Life into Sculpture.* Furthering his point, Gérôme has the pottery painter coloring a series of his own *Hoop Dancer.* Each one is painted in different, bright colors. By the shop window, customers—one wearing the typical Tanagran hat known from the figurines—are talking with a shop girl, and on the shelf is a reduced version of *Tanagra* herself, seen from the side but clearly holding the *Hoop Dancer* in her hand. On the shelves behind the painter, mixed in with real and invented Tanagran figurines, are at least two other figures by Gérôme: the undressing Queen Rodophe from his painting of *King Candaules* (1861) and on the upper shelf *Bellona* (1890), her arms raised as she gives the call to battle.

The Latin of the title was invented by Gérôme; it is not an ancient motto. *Ars fingendi* is the ancient Roman word for sculpture; *sculptura* is medieval Latin. G.A.

155.
Bust of Sarah Bernhardt (1844–1923)

Patinated plaster
h: 27 in. (68.6 cm.)
1895
Signed and inscribed: A Sarah Bernhardt/ J. L. Gerome (on base left of center)
Provenance: Sarah Bernhardt; Le Pavillon des Arts, Paris, 1970; H. Schickman Gallery, New York, 1972
Lender: Mr. and Mrs. Joseph M. Tanenbaum, Toronto

The bust of the actress is surrounded by small playing putti and a diminutive masked Greek actor, references to comedies of love and tragedies. This is the original plaster for the polychromed marble version now in the Musée de Lunéville. After the marble version was carved, Gérôme painted the plaster, inscribed it, and gave it to the actress. In 1897, while haranguing the press about the dangers of the State accepting the Caillebotte bequest, Gérôme mentioned that the marble was under way, and that he intended it to be a gift to the State for the Musée du Luxembourg. However, the museum did not receive the bust until after his death, left to it in his will.

Despite the fantasy in the allegorical figures around the base, the modeling of the portrait itself is based on a careful and accurate observation of Sarah Bernhardt. The realism is even more startling in the polychromed version. Looking at the marble we see that Bernhardt's flesh is aging and losing its elasticity; it is sagging here, flabby there. One would say at once that she was in her early fifties. Perhaps the unflattering realism of the bust was the reason that Gérôme did not give it to the Luxembourg at once or exhibit the work except to visitors to his studio; maybe even at Miss Bernhardt's own request. She could more readily accept the painted plaster: the patination flattens the shadows and obscures the wrinkles; one has to look closely to see the signs of age so evident in the marble. If Miss Bernhardt did in fact ask Gérôme to delay the exhibition of the bust, she was too discreet to mention it (or him) in her memoirs, nor did she display the bust in her salon, well known from the many photographs that caught her lounging on its couches. They should have been good friends; they were both fellow sculptors and fellow Dreyfussards. Later on she did own, and display among the decor of her salon, a reduced bronze version of Gérôme's *Dying Eagle of Waterloo* (1902).

Gérôme did nine portrait busts in the 1890s. Only one other, a bust of his daughter Madeleine (Salon of 1894) was not a commission. The busts form a small but complete series within his oeuvre. In each the modeling is anatomically learned and firm. The *Général Cambriels* (plaster in the Musée de l'Armée, Paris) is bald and his cranium is marvelously studied, even to a head wound. The extent of realism is at times incredible: the bust of *Dieterle* (1892) in the Paris Opéra has a fine pore system developed on his nose and across his cheeks. One cannot help but compare the bust of Dieterle with the Carpeaux bust of Garnier on the same floor, for the turn of the head is the same. One sees, by the comparison, how much drama and excitement Gérôme had rejected for the objective reporting of appearance. It is this subservience to facts that makes most of Gérôme's portrait busts seem passive and bland, less marvelous than they are. Over the years, their modesty has let them become forgotten. In the *Bust of Sarah Bernhardt* it is the indomitable character of the actress that comes through, conquering Gérôme's objectivity and demanding our attention.

G.A.

156.
The Ball Player (La Joueuse de Boules)
Marble, covered with wax, tinted
h: 65 in. (1.65 m.); w: 25½ in.
(64.8 cm.); d: 21½ in. (54.6 cm.)
1902
Signed: J.L. GEROME (on top of base)
Provenance: Princess de Talleyrand, née Anne Gould, Paris; Shepherd Gallery, Associates, New York; Gemma Lee of Korea and New York; Shepherd Gallery, Associates, New York; Hans Neuffer, Vienna; Shepherd Gallery, Associates, New York
Lender: Stuart Pivar, New York

The plaster, the same size as our marble, is in the Musée Baron Martin at Gray (Haute-Saône). Another marble, half-life-size, was on the market in San Juan, Puerto Rico. *The Ball Player* was also cast in bronze in three different sizes, of which this writer has seen two (one 27 cm., the other 70 cm. high). Sometimes the copies are gilded, sometimes silvered, and some are patinated. The edition of the small version was rather large; it was a popular piece.

The game, evidently of dropping balls into the mouths of masks placed around one without moving the feet, seems to be an invention of Gérôme's. It is in the spirit of the Néo-grecs, who often painted ancient children at play. Needless to say, Gérôme's own *Cockfight* and *Hoop Dancer* fit in the same category.

The complicated pose is based on an ancient work that survives in several copies in Rome, a small statuette restored in the Museo delle Terme as a *Satyr Looking at His Own Tail,* and in the Vatican as a *Cymbal Dancer.*

The early publication of the piece in *Jugend,* the Munich magazine which gave its name to Art Nouveau in Germany (*Jugendstil),* helps us to understand its popularity. The combination of realistic proportions with the curving, sinuous outline and the rhythmic crossing of limbs would be appreciated by any admirer of the nudes of Ferdinand Hodler, Otto von Grenier, or Franz von Stück. Their nudes are admittedly more emotional than Gérôme's, but this fact makes clear Gérôme's allegiance to the aesthetic rather than to the expressive interests of the Symbolist movement. When the work was shown at

154.

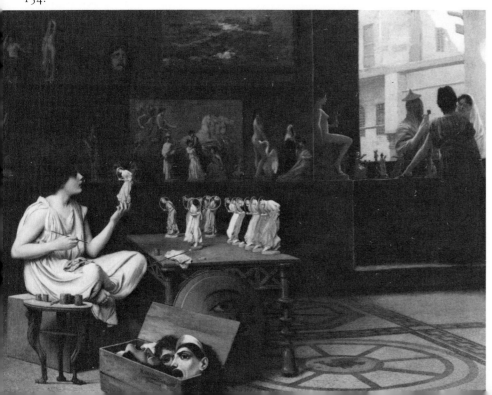

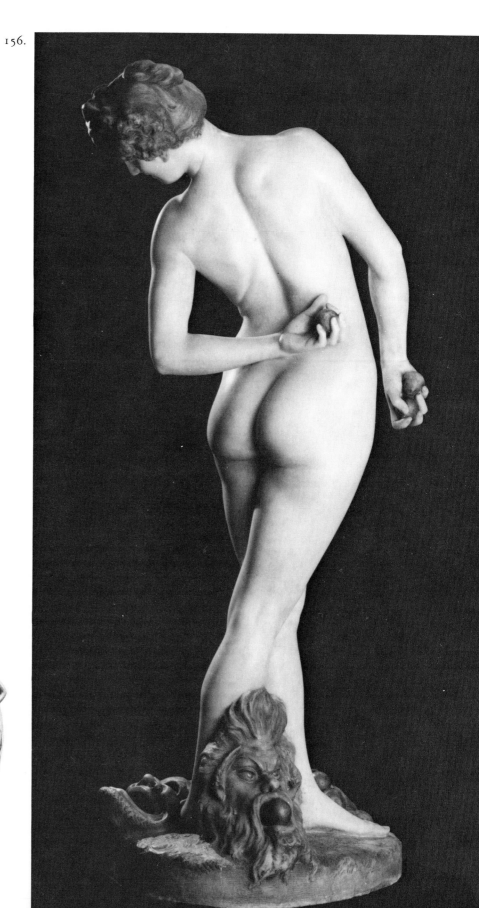

156.

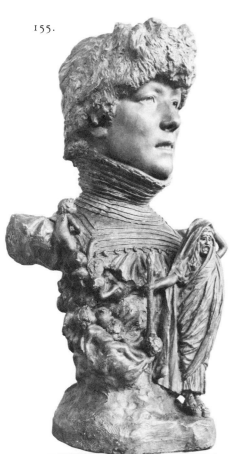

155.

the Salon of 1902, M. H. Spielman found it to be "elevated in style, nevertheless, as near the border line of realism as permitted in art."[36] The realism of the work, heightened by the waxing and tinting of the surface, which made the work odious to some critics as late as 1970,[7] nonetheless has produced wonder, amusement, and some admiration since the advent of neo-Realism, and the work has been exhibited along with sculptures by Duane Hansen and Frank Gallo.

This realism makes the work seem naked, not simply nude; it is probably the "borderline" between these two concepts that Spielman finds this work approaching. Consequently we must overcome some embarrassment to see how sensitive and full of observation Gérôme's realism is, particularly in the marvelous back of the figure, or in the handsome legs. The awkward position, as in many of the nudes of Degas, may be inelegant, but it brings out the peculiar beauty of a functioning body, a beauty observed, not invented or superimposed upon nature by an idealist. We have been taught to admire such learned anatomical observation in the statuary of antiquity, but curiously enough, we have also been encouraged to deride it in the sculpture of the nineteenth century.

G.A.

157.
Corinth
Gilt bronze
h: 29⅜ in. (74.6 cm.)
1904
Signed: J. L. Gerome (on lower right front)
Inscribed: NON LICET OMNIBUS ADIRE CORINTHUM (on front)
Foundry mark: SIOT FONDEUR PARIS (on lower back)
Provenance: Geraldine Rockefeller Dodge, sold by Sotheby Parke Bernet, New York, February 20, 1976, lot 46
Lender: Stuart Pivar, New York

Corinth is a *Tyche,* or Fortune, like the marble *Tanagra* which Gérôme had exhibited in the Salon of 1890. She represents the ancient Greek city, noted in Hellenistic times for its commercialized pleasures. A beautiful, bejewelled nude, seated on the capital form named after her town, she is both the *grande cocotte* of realist writers and painters and the *femme fatale* of the Symbolists. At the base of the capital is a motto, *Non licet omnibus adire Corinthum,* an old proverb in both Greek and Latin which

translates "Not everyone can go to Corinth," meaning that not everyone can afford its pleasures. Aulus Gellius proposes that the maxim was coined in reaction to Lais, a famous Corinthian courtesan of the fourth century B.C., and he recounts several tales of her charms and prices;[8] yet the proverb seems to be older than that. Gérôme certainly knew the passage in Gellius, but he called the piece *Corinth,* probably thinking that the reputation of the city would easily assume that of Lais. Corinth sits, seductive through her nakedness, alluring in her metallic finery, and forbidding with her calculating eyes.

The inventory of Gérôme's studio after his death lists a "*Corinth,* polychromed plaster on a column," and "*Corinth,* in white marble, in course of execution, bronze socle." Gérôme's able assistant Decorchement, whom Gérôme even referred to as "my collaborator,"[9] was able to finish the marble and to supervise an edition in bronze guided by the plaster and what he knew of Gérôme's practice from ten years of working with him. Photos of the plaster are so lifelike as to be confusing.

The marble version, on the Paris market in 1974,[10] is Gérôme's most beautiful chryselephantine work. Against the delicate, naturalistically tinted marble lies the dull gleam of gilded jewelry, set with large pieces of turquoise and smaller glitters of paste. She sits upon a gilded bronze capital that surmounts a short green marble column. The marble *Corinth* is the summary of Gérôme's almost thirty years of activity as a sculptor, a period in which he produced some thirty pieces (along with more than 220 oil paintings). His realism is apparent in the extreme accuracy and learning with which he presents the body. This accuracy can be checked against photos of the model posing for *Corinth.* At first one thinks that the model is another marble version. *Corinth* is also the climax of his polychromy, and of his mixing of materials. The sumptuousness of the ensemble joins his realism with the decorative richness of Art Nouveau.

Several bronze versions are known, all the same size as the marble. Most are seated merely on a capital. Each casting is a little different. Some have turquoise and paste insets in the jewelry; some are gilded,

157.

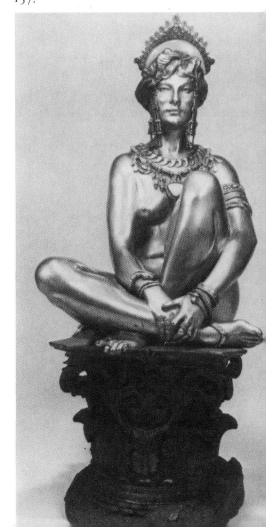

291

some are silver. The relative austerity of the present version allows us to see what a handsome work it basically is. G.A.

Notes

1.
G. Jeanniot, "Souvenirs sur Degas," *La Revue Universelle*, pp. 171–72. Gérôme probably learned the practice of continually using calipers from Frémiet, for it was a practice of Frémiet's master, Rude.

2.
The letter is in the Archives Nationales in Paris, F^{24}-4311.

3.
Gérôme described the technical innovations of *Bellona* with great pride but characterized the statue as "interesting from the decorative point of view" in a letter to Germaine Bapst who was writing an article "La sculpture chryséléphantine," for *La Revue de Famille* in 1892. The letter is bound in with an offprint of Bapst's article in the Bibliothèque Nationale in Paris.

4.
Girodet, *Anacreon, Recueil de compositions dessinées par Girodet et gravées par M. Chatillon*, Paris, 1825.

5.
For a short list of artists (which omits both Raphael and Thorwaldsen) see A. Pilger, *Barock Themen*, Budapest, 1974, II, p. 14. Perhaps more pertinent to Gérôme's work was Pradier's *Anacreon and Cupid* in the Salon of 1843 or J. B. Guillaume's seated *Anacreon, crowned with Roses*, exhibited in both the Salon of 1852 and the Exposition Universelle of 1855, formerly in the Musée du Luxembourg.

6.
Spielman, 1904, p. 204.

7.
Alfred Neumeyer found it "downright ridiculous...because the awkward crossing of the legs lacks solidity of stance and balance of pose," in "Art history without value judgements," *Art Journal*, 1970, XXIX, p. 419.

8.
Aulus Gellius, *Attic Nights*, book I, part 8. See also Horace, *Epistles*, 1.17.36.

9.
A photograph on the New York market in 1978 was inscribed by Gérôme, "to my collaborator, Decorchement."

10.
Tanagra Gallery, Paris. It is illustrated in color in *J. L. Gérôme sculpteur et peintre de "l'art officiel,"* exh. cat., Paris, 1974, no. 19.

Selected Bibliography

Galichon, E., "M. Gérôme, peintre ethnographe," *Gazette des beaux-arts*, 1868, I, pp. 147–51.

Timbal, C., "Gérôme: Etude biographique," *Gazette des beaux-arts*, 1876, XIV, pp. 218 ff. and 334 ff.

Shinn, E. [Strahan, E.], *Gérôme, a collection of the works of J. L. Gérôme in one hundred photogravures*, New York, 1881–83.

Bapst, G., "La Sculpture Chryséléphantine," *La Revue de famille*, 1892, II, pp. 334–43.

Hering, F., *Gérôme, his life and works*, New York, 1892.

Van Dycke, J., *Modern French Masters*, New York, 1896.

Spielman, M. H., "Jean Leon Gérôme, 1824–1904. Recollections," *Magazine of Art*, 1904, II, pp. 200–208.

Moreau-Vauthier, C., *Gérôme, peintre et sculpteur*, Paris, 1906.

Keim, A., *Gérôme*, New York, 1912.

Dayton Art Institute, *Gérôme*, exh. cat. by G. Ackerman and R. Ettinghausen, 1972.

Paris, Tanagra Art Gallery, *J. L. Gérôme, sculpteur et peintre de l'art officiel*, exh. cat., 1974.

New York, Sotheby Parke Bernet, *Animalier, and other 19th century bronzes from the collection of the late Geraldine Rockefeller Dodge*, February 14 and 19, 1976, nos. 45–55.

Of German birth, Grass spent most of his career working in Paris and eastern France. At sixteen he was sent to Strasbourg where he worked for four years in the studio of the sculptor Landolin Ohmacht (1760–1834). Grass then went to Paris where he entered the Ecole des Beaux-Arts on October 4, 1822. He was a student of Bosio and made his Salon debut in 1831, continuing to exhibit more or less regularly until 1873.

In 1842, for the southern portal of Strasbourg Cathedral, Grass executed a statue of *Sabina, Daughter of Erwin of Steinbach,* and in 1851 he became titular sculptor of the cathedral. For its main portal he sculpted a relief, *The Last Judgment,* and to fill several niches he executed a number of equestrian statues; these latter works were destroyed during the Prussian invasion of 1870. As a result of work for the cathedral, Grass seems to have become established as one of the major sculptors of Strasbourg. Most of his Paris Salon entries were made for clients of the eastern French city.

For the most part Grass was active as a portraitist, although during the 1830s and 1840s he executed several works dealing with Romantic themes. In addition to the *Icarus* of 1831 (cat. no. 158), he exhibited a plaster of *The Centaur Nessus Dying* (location unknown) at the Salon of 1833, and one of *The Prisoner of Chillon* (location unknown) at the Salon of 1835; the latter work was rejected by the Salon jury, apparently because Grass had incurred the enmity of a jury member whom he defeated in a competition for a monument to Kléber.[1] This statue of Kléber was erected on a public square in Strasbourg during the years 1835 to 1838.[2] Further Romantic-sounding Salon entries (all lost or location unknown) include his *Supplicating Slave* of 1846, a group of *The Sons of Niobe* in 1846, and a statue of a young girl playing with human bones, *Little Peasant Girl* of 1844.[3] In 1848 Grass exhibited a plaster entitled *The Thinker.* Because so many of his figurative works are apparently lost or have remained unrecognized, it is difficult to assess his style. P.F.

158.

Icarus Trying His Wings
Bronze
h: 21⅛ in. (53.7 cm.)
Model 1831; this cast c. 1841
Signed: P. Grass (on right side of base)
Inscribed: ICARE; D'apres la statue en
bronze detruite en 1870 a Strasbourg (on
front edge of base)
Foundry mark: Eck et Durand (on back of
base)
Lender: The Minneapolis Institute of Arts,
Gift of the Collectors' Club

According to myth, Icarus, carried away
by the excitement of flight, disregarded his
father's warning and flew too high. As
Icarus approached the sun, its heat melted
the wax of his wings and he fell into
the sea. Grass' choice of this subject for his
Salon debut—a plaster version exhibited
in 1831—was an ambitious one, perhaps
intended to suggest the young artist's
goals.[4] Icarus was seen by the Romantics as
an archetype of the artist who sought to
rise above the norm, disregarding danger,
in a quest for what was divine or immor-
tal.[5] As the nineteenth-century poet and
historian of Romanticism Théophile Gau-
tier wrote of the 1830s: "The fate of Icarus
frightened no one. 'Wings! wings! wings!'
they cried from all sides, even if we fall
into the sea. To fall from the sky, one must
climb there, if only for a moment, and
that is more beautiful than to spend one's
whole life crawling the earth."[6]

In certain respects the composition of
Grass' work is as daring and, ultimately,
as unsuccessful as was the mythological
character it depicts. Particularly audacious
is the idea of rendering a totally extended
figure, with the arms stretched forward,
the wings and left leg reaching back,
resulting in a work that juts out almost
equally in several different directions and is
penetrated throughout by space. Clearly
emulating Hellenistic sculpture (the flow-
ing hair and emotion-charged features
owe a debt to the *Laocoön,* while the
stretched-out pose recalls such works as the
Borghese Warrior and the *Bound Marsyas* in
the Louvre), the *Icarus* was probably in-
tended as a conscious break from the Neo-
classical compositional canons which had
predominated during the first two decades
of the nineteenth century. Ultimately,
however, Grass' figure appears stiff and
static. The modeling of the figure's anat-
omy is schematic[7] and its implied forward
and upward movement is vitiated by
a pose which—with the right knee raised
so high—in reality could provide little
leverage for rising off the ground. The
awkwardness of the pose also required the
inclusion of a self-conscious detail that is
normally an afterthought to classical
statues: the fig leaf.

In addition to the plaster of 1831, Grass
exhibited a bronze version of his *Icarus* at
the Salon of 1844 and, again, at the Expo-
sition Universelle of 1855. From the latter
exhibition the large bronze was acquired
by the Musée des Beaux-Arts at Stras-
bourg; it was destroyed when the museum
was bombarded during the Prussian inva-
sion of 1870. The *Icarus* does not appear to
have been cast in a large commercial edi-
tion.[8] The work provides an interesting
formal prototype, if not necessarily a direct
source, for two works with related themes
by Rodin: *Despairing Adolescent* (c. 1882)
and *The Prodigal Son* (c. 1888). P.F.

Notes

1.
On the rejection of Grass' *Prisoner of Chil-
lon,* see "Salon de 1835: Le Jury d'admission
et les ouvrages refusés," *L'Artiste,* 1835, IX,
p. 174.
2.
For a contemporary reaction to Grass'
Kléber, see A. Guillot, "Sculpture,"
L'Artiste, 1838, I, pp. 68–71.
3.
This statue was described as, and criticized
for, being too bizarre by J. Janin, "Salon de
1839," *L'Artiste,* 1839, II, p. 307.

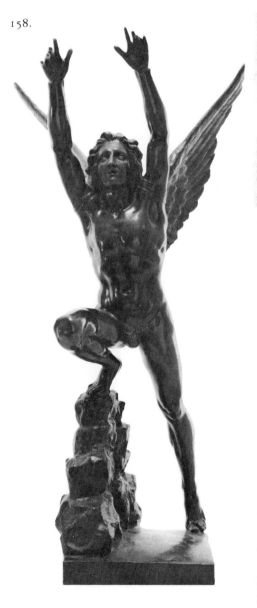

158.

PIERRE-EUGÈNE-ÉMILE HÉBERT
1828 Paris–Paris (?) 1893

4.
The work was well received by contemporary critics; see "Salon de 1831. Sculpture," *L'Artiste,* 1831, I, p. 245, and V. Schoelcher, "Sculpture," *L'Artiste,* 1831, II, p. 4.
5.
See M. Z. Shroder, *Icarus: The Image of the Artist in French Romanticism,* Cambridge, Massachusetts, 1961.
6.
T. Gautier, *Histoire du romantisme,* Paris, 1874, p. 153.
7.
Another of Grass' works, *Susanne au bain,* was criticized on similar grounds when it appeared at the Salon of 1834; see "Sculpture," *L'Artiste,* 1834, VIII, p. 149.
8.
Another bronze version, cast by Eck et Durand in approximately the same size as the one in this exhibition, is at the Bethnal Green Museum, London. According to Avery, 1972, p. 232, the London example is said to have been purchased from the "Paris exhibition of 1844" [*sic*].

Selected Bibliography

Fischback, G., *Philippe Grass, sa vie et ses oeuvres,* Strasbourg, 1876 (not available to present author).

Bellier and Auvray, 1882–87, II, p. 690.

Lami, 1914–21, III, pp. 91–93.

Thieme-Becker, 1907–50, XIV, p. 529.

The son of a sculptor and the cousin of another, Hébert studied with his father and Jean-Jacques Feuchère. He made his debut in the Salon of 1846, at the surprisingly early age of eighteen, and contributed to almost every Salon until the year of his death, although the only prize he ever won was a second-class medal, in 1872, for a marble relief, *The Oracle* (now in the museum at Vienne). The great majority of his works were portrait busts, mostly of contemporary sitters but including some historic figures and even Semiramis. Hébert also received a few commissions for architectural sculpture and public monuments of minor significance. Apart from two early pieces (a statuette of Mephistopheles of 1853 and the one discussed below) his independent work consists of conventional classical subjects (Bacchus, Oedipus, Bellerophon) or allegories. Hébert appears to have been a precocious youth who, after an early Romantic phase that failed to bring him public acclaim, settled down to an unremarkable career for the rest of his life. H.W.J.

159.
And Always! And Never!
Bronze
h: 59 in. (1.5 m.); w: 27 in. (68.6 cm.); d: 25 in. (63.5 cm.)
1863 (or soon after); from a plaster model of 1859
Signed: EMILE HEBERT (on base, behind the figures)
Inscribed: *Et Toujours! Et Jamais!* (on the tombstone)
Foundry mark: J. Fel Fondeur à Paris (on side of base)
Provenance: Shepherd Gallery, Associates, New York
Lender: Spencer Museum of Art, University of Kansas, Lawrence

A bronze cast of this work, possibly the one here exhibited since no others are known, was shown in the Salon of 1863; the original plaster was exhibited there four years earlier. The *livrets* of both Salons list the title as "Toujours et jamais" and state the material, but provide no further information, even though the relation of the title to the unusual and daring subject is far from self-evident. The form in which the title appears on the work itself was presumably the one Hébert submitted; it seems likely that the Salon jury, or the editor of the *livret,* abbreviated it and eliminated the two exclamation marks so as to make it look more like the other titles, which are descriptive rather than poetically allusive. *Et Toujours! Et Jamais!* has the ring of a line from a poem, probably one of recent date. The existence of such a source remains to be determined. If Hébert had been an artist of established importance in 1859 and 1863, the *livret* entries might well have been less laconic.

Before we give further thought to the meaning of the title, we must consider the visual evidence. A shrouded corpse, decayed almost to the condition of a skeleton, has risen from its tomb and is carrying (and embracing) a nude young woman who offers no resistance; her eyes are closed, and her head is turned toward that of the corpse as if the two were about to kiss. The subject derives from an iconographic model that can be traced back to the later Middle Ages and reached its greatest popularity in German sixteenth-century art (the best-known examples occur in the work of Hans Baldung Grien). The nudity of the woman signaled her devotion to the pleasures of the flesh, and she fought in vain against the amorous advances of the living corpse representing Death. The tradition was revived, but with its original meaning inverted, by Romantic writers and painters who shared an interest in the Dance of Death and similar late medieval *vanitas* themes. It now came to be known as "Death and the Maiden," with the nude woman appealing to our sympathy as one whose life is suddenly ended before it has been fully experienced; we are expected to take her side while she pleads or struggles with the Grim Reaper. In neither version, however, does Death rise from a tomb, nor does the victim yield willingly.

Hébert's group, then, offers a singular variant of a well-known prototype: the corpse here, we conclude, is not Death but the woman's dead lover who rises to claim her at the moment of her own death. A more intelligible version of the enigmatic "Always and Never" might be "Love Beyond the Grave" or "Lovers Reunited in Death." It is surely the artist's most original work and ought to have elicited a response from the critics on the two occasions when it was on public view. There is, unfortunately, no easy way to survey the Paris press of the time for such responses. The three most important—and most easily accessible

—critics, Baudelaire, Paul Mantz, and Thoré-Burger, may be representative of the rest: Thoré-Burger and Mantz take no notice of the group in either 1859 or 1863, but the latter notes that Hébert's *Spirit of Eternal Silence (Génie du silence éternel)* appeared in the Salon des Refusés, thus bringing to our attention a work overlooked by Lami.[1] He speaks of it as "a sombre figure modeled with great feeling that would do very well at the entrance to a cemetery," without describing it more precisely. Aside from *And Always! And Never!* it is the only other figure in Hébert's oeuvre dealing with the theme of death.

Baudelaire, in contrast, devotes a good deal of attention to this group in the sculpture section of his *Salon de 1859*.[2] He begins by confessing that he has not yet found an explanation for the puzzling title and suggests that its choice may have been an act of desperation or a caprice like the title of *Le Rouge et le Noir,* Stendhal's famous novel. His first sentence, however, states, "You will remember that we have already spoken of *Jamais et toujours"* (the whole Salon review is in the form of a letter); and so he has. In the poetic introduction to his chapter on sculpture, he imagines a prostrate figure of Grief on a tomb, teaching us that wealth, fame, and even the fatherland are sheer frivolities in the face of that undefinable *je ne sais quoi* which can only be hinted at by mysterious adverbs such as "Maybe, Never, Always."[3] Apparently, Baudelaire has simply appropriated Hébert's title and built it (without credit) into his melancholy meditation! "Whatever the motivation of the title," he continues, "he [Hébert] has made a charming sculpture, *sculpture de chambre,* one might say (although one doubts that the bourgeois would want it for their boudoir), a sculptural vignette which nevertheless, if it were enlarged to monumental scale, could perhaps yield an excellent funerary decoration for a cemetery or a chapel."

Obviously, these remarks do not fit our bronze, which is nearly five feet tall; the plaster model listed in the Salon catalog of 1859 (without any indication of the size) must have been less than half the size of the bronze. Perhaps Hébert was encouraged by Baudelaire's praise to produce the more ambitious version of 1863. The rest of what Baudelaire has to say adds little to our understanding of the group, and his description never comes to grips with the subject. Instead, he defends the use of the skeleton in sculpture and extols its "mysterious and abstract beauty," but points out that Hébert's is not a "skeleton, properly speaking." It evokes rather, "des fantômes, des larves et des lamies," which leads Baudelaire to conclude that Hébert wanted to convey "l'idée vaste et flottante du néant." He then veers off to discuss at considerable length two works by Ernest Christophe which, to his regret, were not in the exhibition; one of them, a female skeleton in festive dress, excites his imagination to the point of explaining the "subtle pleasure" the figure gives him in a poem of twenty-two lines.[4] This work (if indeed it ever existed) apparently never grew beyond the stage of a maquette. Be that as it may, Baudelaire's enthusiastic response to it as well as to Hébert's group demonstrates that *And Always! And Never!* was not an isolated phenomenon. Hébert was not the only one at that time with a taste for the macabre. H.W.J.

Notes

1.
Mantz, 1863, XV, p. 62.
2.
Baudelaire 1965, pp. 364, 373–76.
3.
In view of Baudelaire's admiration for Ernest Christophe (see note 4), the prostrate figure of grief may well reflect the latter's *La Douleur,* a project for a tomb exhibited at the Salon of 1855. The figure now decorates the sculptor's own tomb in the cemetery of Batignolles. There is a brief reference to *Et Toujours! Et Jamais!* in an earlier section of the *Salon de 1859*, "Le Public moderne et la photographie," where the author complains about the prevalence of unsuitable titles of works of art: "I was truly sorry to see a man of real talent indulging in a rebus."
4.
A somewhat longer version is included in *Les Fleurs du Mal* under the title, "Dance Macabre." The other work by Christophe described by Baudelaire was a maquette for *La Comédie Humaine;* it too inspired a poem in *Les Fleurs du Mal*, "La Masque." When Christophe showed the large-scale marble version in the Salon of 1876, he adopted Baudelaire's title. The statue was bought by the State and is in the Tuileries Gardens.

Selected Bibliography

Lami, 1914–21, III, pp. 142–44.

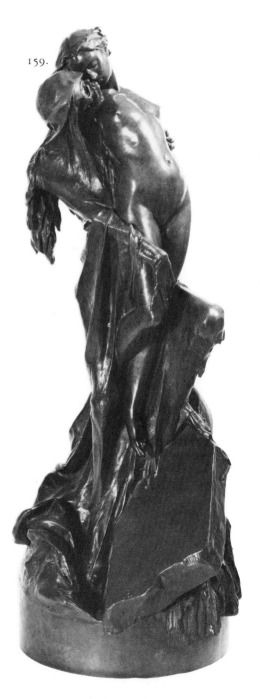

159.

FRÉDÉRIC-ÉTIENNE LEROUX
1836 Ecouché (Orne)–Paris 1900

Leroux entered the atelier of François Jouffroy (1806–1882) at the Ecole des Beaux-Arts in 1859. He began to exhibit at the Salon in 1863 and was first recognized in 1866 for his bronze, *The Violet Seller,* acquired by the Musée du Luxembourg. He showed regularly at the Salon, winning medals in 1867, 1869, and 1870; several of his works were bought by the State. At the Exposition Universelle of 1878 he was awarded a second-class medal; that same year he was made a *chevalier* in the Legion of Honor. He won silver medals at the Expositions Universelles of 1889 and 1900.

In Paris, Leroux worked on the church of St. Sulpice as well as on the town hall, and for the provinces he executed many busts, statues, and monuments. His most important works include *Young Mother Playing with her Child* (plaster, Salon of 1872); *Joan of Arc* (bronze, Compiègne, 1880); *Demosthenes* (marble, Salon of 1878, Caen); *Rachel* (marble, Salon of 1882, Rouen); the *Tomb of Msgr. Rousselot* (Sées); monuments to the poet Théodore Aubanel in Avignon (bronze; Salon of 1894) and to the painter Chappelin at Andelys (bronze, Salon of 1894); the *Spirit of Peace* (bronze, Salon of 1898); and a monument for President Carnot (bronze, 1897, Chabanais).

Leroux was a committee member of the Society of French Artists and for many years served on the jury of the Salon. He often took an interest in the careers of younger artists as well as in the general welfare of fellow painters and the state of the arts in France. J.A.

160.
Ariadne Abandoned
Terracotta
h: 10¾ in. (27.3 cm.); w: 7⅛ in. (18.1 cm.); d: 3¾ in. (9.5 cm.)
1865
Signed: Etienne Leroux 1865 (on side of base)
Provenance: M. Bela Hein, Paris
Lender: Museum of Fine Arts, Boston, Edwin E. Jack Fund

Greek legend recounts how Ariadne, daughter of King Minos of Crete, fell in love with Theseus, who was sent from mainland Greece as part of the annual sacrifice to the Minotaur. Knowing that Theseus would die once imprisoned in the labyrinth, Ariadne secretly gave him a ball of magic thread to facilitate his escape from the maze. After Theseus killed the Minotaur, he and Ariadne eloped to the island of Naxos where he abandoned her. Later, Dionysus discovered the spurned lover alone on the island and took her for his wife.

The pathetic tale of Ariadne, deserted and desolate, has inspired artists since antiquity and held particular appeal for the Romantics. The terracotta exhibited here is probably a preliminary sketch for a plaster *Ariadne* that Leroux exhibited at the Salon of 1865. Even with the lack of finish and detail in the *bozzetto,* one can observe how the choice of seating Ariadne on a Greek chair, known as a *klismos,* accentuates her nudity. The sophisticated, elegant lines of the chair repeat and counter the curves of her body and drapery. The inclusion of the *klismos* creates a mood far different from traditional representations of Ariadne abandoned on a rocky cliff, as Aimé Millet portrayed her in his critically acclaimed sculpture (Salon of 1857). Leroux's terracotta is closer in spirit to decorative statuettes, popular at mid-century, which depicted meditative figures in antique costume seated on Greco-Roman styled chairs. Popularized by sculptors such as Carrier-Belleuse (see cat. no. 48), Mathurin Moreau, and Jean-Jules Salmson, these statuettes undoubtedly served to ornament interiors decorated in the Néo-grec or Pompeian style fashionable during the Second Empire. The languorous, sensual pose of Leroux's figure bears a striking resemblance to antique sculptures of Ariadne which portray her reclining with an arm bent over her head. J.A.

Selected Bibliography

Lami, 1914–21, III, pp. 332–36.

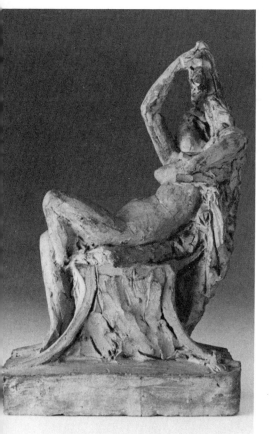

160.

ÉTIENNE-HYPPOLYTE MAINDRON

1801 Champtoceaux–Paris 1884

Maindron began his artistic training as a fellowship student at the Ecole des Arts et Métiers in Angers (1818–23). In 1827, supported by annual grants from his native province, the Département de Maine-et-Loire, he entered the Ecole des Beaux-Arts in Paris and studied with David d'Angers. Seven years later he submitted his first Salon exhibit, the statue of a *Young Shepherd Bitten by a Snake,* and continued to show at subsequent Salons until near the end of his life without, however, achieving any official distinction higher than a third-class medal (1838) and three second-class medals (1843, 1848, 1859). These modest rewards are, in Maindron's case, a fair measure of his rank among the sculptors of his time. His one great success, the statue of *Velléda* (fig. 77), came early in a career delayed for a decade by economic difficulties; the original plaster appeared in the Salon of 1839. Four years later, the State commissioned a marble version, still in its original place in the Luxembourg Gardens. A second marble, ordered in 1869 because of the poor condition of the first, is now in the Louvre.

Maindron's subsequent official commissions are either without distinction or verge on the comic (e.g., the two colossal groups, *Attila and Saint Geneviève* and *Clovis Baptized by Saint Remi* for the Panthéon). He obviously never mastered sculpture on a monumental scale. His best works are lyrical in sentiment, like *Velléda,* or intimate portraits in the tradition of his master, David d'Angers. Like the latter, Maindron retained a lifelong loyalty toward the city of Angers and donated many of his original plasters to the museum there. H.W.J.

161.
Monument to Beethoven
(1770–1827)

Bronze h: 19¾ in. (50.2 cm.); w: 7 in. (17.8 cm.); d: 6¼ in. (15.9 cm.)
c. 1850
Signed: PAR/MAINDRON/SCULPT (on lower right side)
Inscribed: Beethoven (below truncation of bust); Symphonies/Messes/Fidelio/Trios/Quatuors/Septior/etc. (on scroll)
Lender: Peabody Institute of Johns Hopkins University, Baltimore

This delightful little "monument" appears to have escaped the attention of scholars and critics; no reference to it has yet appeared in the literature on Maindron. Contrary to one's first impression, it is neither a maquette for a larger monument nor a reduction but a finished work intended for this size from the start. The patron, as is evident by the inscription on the base, was the Société des Concerts, for which the artist is known to have made a marble relief, *Reception of François Habeneck at the Champs-Elysées* (Salon of 1852).[1] Twenty years later, Maindron showed another musical subject, *Musical Inspiration;* the plaster model of this statue, in the Salon of 1872, is in the museum at Angers. What purpose our piece may have been intended for — perhaps as a prize in a musical competition — remains to be determined by an expert on the history of the sponsoring society. It seems likely that something of the sort was its purpose because of the still life of musical instruments behind the figure with the scroll, who must be a personification of musical fame rather than of the Société des Concerts. A fairly early date in Maindron's career is suggested not only by the fact that soon after 1850 he filled another commission from the same society, but also by the style of the monument, which still recalls that of his teacher in several respects. The bust, presumably derived from prints showing the composer's likeness without repeating any specific model, displays a fluid, spontaneous modeling in the hair and the kerchief reminiscent of many of David d'Angers' medallions. Beethoven looks austere but less bellicose than he does in many German portraits. Even more specifically related to David is the peculiarly shallow, or at any rate anti-illusionistic, handling of the relief on the base with its parallels in David's sketches for the reliefs on the Triumphal Arch of

161.

Marseille and for the pediment of the Panthéon.[2] David explained that "reliefs attached to wall surfaces are like a kind of writing or historical inscriptions. They cannot, and must not, have the qualities of *trompe-l'oeil.*" H.W.J.

162.
Jean-Georges Eck (?–1863)
Bronze
diam: 8¼ in. (21 cm.)
Signed, dated, and inscribed: H. MAINDRON 1840/Eck ainé (on front)
Foundry mark: ECK & DURAND/FONDEURS DE BARYE (on back)
Lender: The Walters Art Gallery, Baltimore

Jean-Georges Eck, the senior partner of the bronze foundry Eck et Durand, was portrayed twice by Maindron in medallions. Ours is the earlier and smaller; the second, 17 inches in diameter and signed and dated 1843, was later attached to the sitter's grave in the cemetery of Père-Lachaise, Paris. The type and scale of our medallion clearly follow the precedent of David d'Angers' medallion portraits (compare cat. nos. 93–97), except for the positioning of the artist's signature on the truncation of the bust rather than on the background. The sitter's name evidently imitates his own handwriting, as do those of many of David's portrait medallions (see cat no. 94), perhaps as a means of indicating that the sitter was done "from life" and to convey another aspect of his personality (there was considerable general interest in the pseudo-sciences of physiognomy, phrenology, and graphology during the Romantic era). For posthumous portraits, David preferred the sitter's name in Roman capitals and in Latin (see cat. no. 93, GERICAULT PICTOR). H.W.J.

Notes
1.
François Habeneck (1781–1849) was a French violinist and conductor famous for his outstanding performances of Beethoven's orchestral works. Since he died shortly before the Société des Concerts commissioned Maindron's relief, the Champs-Elysées of the title must be the Elysian Fields rather than the homonymous avenue in Paris.
2.
For illustrations of the former, see the catalog of the exhibition, *David d'Angers,* Paris, Hôtel de la Monnaie, 1966, pp. 38, 39. The original text of David's theory of architectural relief is to be found on p. 40.

Selected Bibliography

Rouyères, A. de, *M. Maindron, statuaire,* Paris, 1843.

Lami, 1914–21, III, pp. 376–81.

162.

MARCELLO, pseudonym of ADÈLE D'AFFRY, DUCHESS CASTIGLIONE-COLONNA
1836 Givisiez 1879

Adèle d'Affry was born on her family's estate near Fribourg, Switzerland, and was raised by her mother; her father, Count Louis d'Affry, died when she was only five. After early drawing lessons in Fribourg and Nice, she studied sculpture in Rome in 1854–55 with the Swiss sculptor Heinrich Maximilian Imhof, a disciple of Thorvaldsen. In the spring of 1856 she married Carlo Colonna, Duke of Castiglione, who died eight months later.

The young widow then resumed her sculptural career in earnest, working in Rome, Paris, and Givisiez, where she installed a studio. In 1861 in Rome she established close artistic and personal relations with Carpeaux, whose enthusiasm for Michelangelo she shared. In Paris, she even studied anatomy, by special permission, at the Ecole Pratique de Médecine. From 1863 until 1876, she showed her work at several Salon exhibitions and earned considerable critical success. This, together with her title, gained her entry to the Imperial Court. The identity of her pseudonym, Marcello, which she had picked as a precaution against the male chauvinism of the Salon jury, was no secret. Aside from the over-life-size marble bust of Bianca Capello, which established her reputation in 1863, Marcello's most ambitious work, and her best-known, is the *Pythia* (see cat. no. 163). She also did a number of fine portraits, most of aristocratic sitters, but including a head of Carpeaux and an Abyssinian chief. She left an important group of her own works, as well as her small but distinguished private collection, to the Canton of Fribourg. These now form part of the Musée d'Art et d'Histoire.

Marcello was clearly among the most gifted sculptors of any sex during the 1860s and, occasionally, like Carpeaux, a more than competent painter as well. That she was known, until very recently, only to specialists may in large part be due to her three names and her three nationalities: Swiss by birth and ancestry, Italian by marriage, French by aesthetic choice, she could not be fully claimed by any of these countries. Two of her works, bought for the Musée du Luxembourg, were later removed as those of a foreigner; her painted self-portrait hangs in the Uffizi, more because of her high aristocratic rank, one suspects,

163.

than for any other reason; yet her name does not occur in the standard four-volume history of Swiss art by Ganter and Reinle. The exhibition at the Musée d'Art et d'Histoire honoring the centenary of her death should help to redress the balance.

H.W.J.

163.
Pythia
Bronze
h: 31½ in. (80 cm.); w: 12 in. (30.5 cm.) from corner to corner of base
Model c. 1870
Signed: Marcello (on right side of base)
Foundry mark: FUMIERE ET/THIEBAUT FRES/GAVIGNOT SCT (on right side of base)
Provenance: Shepherd Gallery, Associates, New York
Lender: The Philadelphia Museum of Art, Purchase, Fiske and Marie Kimball Fund

The work is also known by the titles of *Gorgon* and *The Pythian Sibyl. Pythia* comes closest to the artist's own title, *La Pythie,* in the Salon catalog of 1870. The cast exhibited there is presumably the one in the Musée d'Art et d'Histoire in Fribourg, which corresponds to ours in size but has a dark green patination. Pythia, or the Pythian Sibyl, was the oracle at the Sanctuary of Apollo in Delphi who, perched on a tripod, transmitted the god's messages. The monsters attached to the legs of Marcello's tripod must refer to the python that Apollo had to slay in order to establish himself at Delphi, and the woman's gestures and facial expression are clearly meant to convey an exalted, visionary state. Only the snakes in her hair fit the interpretation of the figure as a gorgon. They are, as it were, a residue of the marble bust entitled *La Gorgone,* now in Fontainebleau, exhibited by Marcello in the Salon of 1866 and a direct ancestor of *Pythia.*

When Marcello, soon after 1866, decided to add a body to *La Gorgone,* she must have realized that she had to change the identity of the figure, since gorgons were not known to have done anything except to turn the beholder to stone by their frightful appearance. How she happened to choose Pythia, a subject never treated in sculpture before (so far as we know), remains to be determined. Such a shift of intention also occurred in Marcello's *Bianca Capello,* which started out as the portrait from memory of a woman the artist had

observed at a wedding and received her present title only after "I had already done a great deal of work on the bust."[1]

Femmes fatales of myth or history had a powerful attraction for Marcello: Bianca Capello (who became Grand Duchess of Tuscany but fell victim to her own intrigues when she poisoned her husband and herself), the Gorgon, and Pythia have their kin among her works in *Ananké ou la Fatalité* (a personification of Fate), *Hecate and Cerberus,* and *Helen of Troy.* Of all these, *Pythia* is the most original as well as the best known (in 1872, Charles Garnier ordered an enlarged version for the vestibule of the Paris Opéra). The wild-eyed prophetess, violently twisting on her stool, recalls the expressive power of Carpeaux's *Ugolino* (see cat. no. 32). She and the tripod — which serves both as a base and as an essential accessory — form a splendid compositional whole. The dragons supporting the base recall the intertwined monsters supporting Romanesque candlesticks.

H.W.J.

Note
1.
Philadelphia, 1978, pp. 232–34.

Selected Bibliography

Schweizerisches Künstler-Lexikon, ed. C. Brun, Frauenfeld, 1905, I, pp. 13–15 (s.v. "Affry," by Max de Diesbach).

Alcantara, O.d', *Marcello: Adèle d'Affry, duchesse Castiglione Colonna 1836–1879,* Geneva, 1961.

Bessis, H., "Marcello ou la Duchesse Colonna," *Bulletin de la société de l'histoire de l'art français,* 1967, pp. 153–59.

_____, *Adolphe Thiers et la Duchesse Colonna,* [1972], unpublished thesis.

New York, 1973, cat. no. 61.

Bessis, H., "Duo avec Carpeaux," *Connaissance des arts,* March 1975, no. 277, pp. 84–91.

A celebrated and successful painter during his lifetime, Meissonier studied in Paris under Jules Potier and Léon Cogniet. At the age of nineteen, Meissonier made his Salon debut with the painting *A Visit to the Burgomaster.* In a style influenced by Paul-Marc-Joseph Chenavard and seventeenth-century Dutch artists, Meissonier executed numerous paintings of smokers, readers, and other figures from daily life. Most of these works are small and are characterized by a meticulously detailed realism. A turning point in the artist's career occurred in 1859 when he was assigned to the staff of Napoleon III to record the events of the Italian campaign. During this mission, he not only became involved in painting battle scenes but also developed an interest in the history of Napoleon I, whom he decided to commemorate in a series of paintings. Although he devoted considerable time and energy to this project and became identified with it, Meissonier's career continued to flourish under the Third Republic. At the time of his death he had garnered practically every possible official honor.[1]

It is unclear when Meissonier first began to sculpt. The subjects of most of his recorded sculptures are related to those of his painted battle scenes; thus one may assume that little, if any, of his sculpture was created before the 1860s. His maquette for a *Fallen, Wounded Horse* (Grenoble) is dated 1884,[2] but it clearly relates to the horse in the foreground of the artist's painting *The Siege of Paris* (Louvre), dated 1870;[3] thus it seems that his sculptures may have been spin-offs from, as well as studies for, the paintings. His only other clearly dated sculpture is the wax *Equestrian Portrait of General Duroc;* this was the artist's last maquette, executed in December 1890.[4] If the two datable works are any indication, Meissonier may have taken up sculpture only at the end of his life. A total of nineteen sculptures by him are recorded: all of these are sketches of maquettes in wax or "pâte plastique grise."[5] If, like Degas, Meissonier employed these works in composing his paintings, he also seems to have valued them as ends in themselves. According to Lami, eight of Meissonier's maquettes were edited in bronze editions by the Siot-Decauville foundry.[6] It has been suggested that this occurred during the artist's lifetime and under his supervision;[7]

however, at least two of the bronzes were edited posthumously in 1893.[8] Meissonier's sculpture remains to be properly studied.

P.F.

164.
Retreat of Marshal Ney (Horseman in Storm)
Bronze
c. 1880–85(?)
h: 18¾ in. (47.6 cm.); w: 23 in. (58.4 cm.); d: 8⅝ in. (21.9 cm.)
Signed: Meissonier (on back of base)
Foundry mark: SIOT DECAUVILLE/FONDEUR/ PARIS (in circular cachet behind rear hoof)
Numbered: 15 (rear right side of base)
Lender: The Hirshhorn Museum and Sculpture Garden, Smithsonian Institution, Washington, D.C.

The specific subject of this work is unclear. It probably corresponds to the model, described as a windblown figure on horseback, entitled *The Traveler (Le Voyageur)* in the 1893 exhibition catalog of Meissonier's works.[9] Apparently the same model was cataloged in 1897 as *Horseman in the Wind, (Un Chevalier dans le Vent)*[10] while Lami, in 1919, listed a bronze of the work and called it *Voyageur*.[11] In 1966 the Schweitzer Gallery advertised a bronze version as *Napoleon in Russia*,[12] and more recently it has been identified as *Marshal Ney* or *The Retreat from Moscow*.[13] Whether or not is was intended as a portrait of Napoleon or Ney, the figure's hat and cloak clearly indicate a Napoleonic officer, and the work undoubtedly relates to Meissonier's series of paintings celebrating important events in the life of Napoleon. It should be noted, however, that for this series Meissonier planned to represent events from the years 1796, 1807, 1810, 1814, and 1815,[14] but not the retreat from Russia of 1812.

Regardless of the work's subject, it is one of Meissonier's most interesting sculptures. A balance between impressionistic modeling and detailed, realistic rendering of forms and textures supports the general windblown and rain-battered effect of the work. A genre painter at heart, Meissonier has infused a historicizing equestrian statuette with an aspect of narrative — a struggle against the elements — which has Romantic overtones.

P.F.

Notes
1.
For a succinct list of these honors, see New York, 1973, cat. no. 28.

2.
Rheims, 1972, p. 296, no. 11.
3.
Philadelphia, 1978, cat. no. VI–85.
4.
Gréard, 1897, p. 451.
5.
Ibid., pp. 451–52.
6.
Lami, 1914–21, III, p. 423; Lami refers to a *Catalogue des bronzes et objets d'art édités par Siot-Decauville* (no place or date of publication given) which I have been unable to locate.
7.
New York, 1973, cat. no. 28.
8.
Casts of an *Equestrian Group of General Duroc* and an *Equestrian Group of a Trumpeter,* both dated 1893, were sold at Sotheby Parke Bernet, New York, February 19, 1976, lot nos. 59–60.

9.
Paris, 1893, cat. no. 837.
10.
Gréard, 1897, p. 452.
11.
Lami, 1914–21, III, p. 423.
12.
Apollo, April 1966, LXXXIII, no. 50, p. xliv.
13.
New York, 1973, cat. no. 28.
14.
Philadelphia, 1978, p. 332.

Selected Bibliography
Paris, Gallery Georges Petit, *Exposition Meissonier,* 1893.

Gréard, M. O., *Jean-Louis-Ernest Meissonier, ses souvenirs, ses entretiens,* Paris, 1897.

Roujon, H., *Meissonier,* Paris, n. d.

Bénédite, L., *Meissonier,* Paris, 1910.

Lami, 1914–21, III, pp. 422–23.

164.

PIERRE-JULES MÈNE
1810 Paris 1879

Mène first worked with his father, a metal turner, who probably taught him the craft of bronze casting and finishing. He married at age twenty-two, earning his living at the time by making models for porcelain manufacturers and by producing small bronzes for the commercial market. Under the guidance of René Compaire, he developed his gift for the sculpture of animal forms. He also began studying serious literature on the science of animal anatomy and spent entire days in the menagerie of the Jardin des Plantes, where he made models and sketches from life. His progress was rapid, and he was soon a success.

He first exhibited in the Salon of 1838 with a bronze of a *Dog Seizing a Fox.* In subsequent Salons he was awarded various prizes: a second-class medal in the Exposition Universelle of 1855, and a first-class medal, in 1861, the same year he was given the Cross of the Legion of Honor.

Mène never attained the reputation of Barye, but he was nonetheless an enormously popular artist in his time. Both collectors and the general public avidly sought his works. He edited his own bronzes, producing numerous casts in his studio, of horses, stags, panthers, dogs, bulls, rams, hunting subjects—all small bronzes of an elegant refinement. Conscious of his talent, but disinterested in seeking patronage, he never obtained official commissions. Only one of his groups, *The Hound-Master on Horseback, Leading His Pack,* in the Musée du Luxembourg, was acquired by the State.

Having lived for many years in the Rue du Faubourg-du-Temple, he relocated about 1857 to a hotel in the Rue de l'Entrepôt, where he often met with his friends—artists, painters, sculptors, musicians—whom he attracted by his affability and his artistic taste. He was the teacher and father-in-law of a fellow *animalier,* Auguste-Nicholas Cain (1822–1894). G.B.

165.
Two Whippets Playing with a Ball
Bronze
h: 6¼ in. (15.9 cm.); w: 8⅜ in. (21.3 cm.); d: 4⅝ in. (11.7 cm.)
c. 1848
Signed: P. J. Mene (on top of base)
No foundry mark
Lender: Museum of Fine Arts, Springfield, Massachusetts, Gift of Miss Susan Dwight Bliss

Two Whippets Playing with a Ball nicely captures the springy quickness of the dogs whose anatomy is rendered with superb accuracy, as are their typical stances. A vivid sense of the dramatic instant marks this work in a way that suggests the artist's awareness of the fledgling art of photography. The style manifests a crisp, tactile quality of surface and line; an extreme of classical lucidity quite opposed to the more pictorial and more elaborately textural trends in *animalier* sculpture. Mène's style here has an economy of means that recalls the sparseness of certain ancient Greek coins. Within his own oeuvre, the alternative extreme of pictorialism is represented in the elaborate *After the Foxhunt in Scotland* (Salon of 1861).[1] A highly photo-

165.

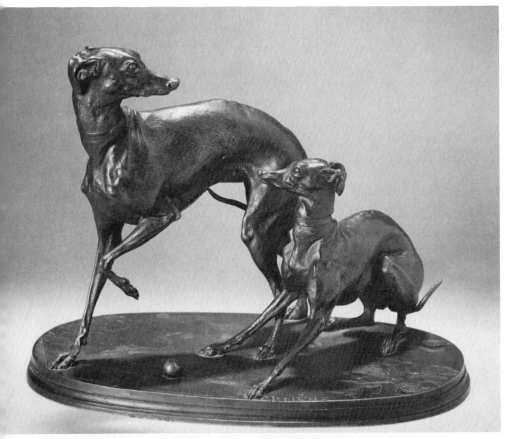

MARIUS-JEAN-ANTONIN MERCIÉ
1845 Toulouse–Paris 1916

graphic, instantaneous quality of action and mood is especially evident in Mène's pairs of hunting dogs pointing or flushing their quarry — *Pointer and Setter with a Partridge* (Salon of 1848), *Pointer and Setter Working in the Brush,* and *Two Setters with a Mallard* — as it is in other dog compositions: *Bloodhound Straining at its Leash, Retriever, Pointer,* and *Two Pointers Resting.*

Compositions by Barye were surely the inspiration for several of Mène's designs at various stages in his career, such as the *Stag Brought Down by Three Hounds* (Salon of 1844), the *Bull of Normandy* (Salon of 1845) — typical of the conceptions of Barye during the 1830s. Mène's *Moroccan Horseman* (Salon of 1878) has its prototype in the *Caucasian Warrior,*[2] offered in the 1865 catalog of Barye's bronzes. Nonetheless, several of Mène's principal groups have no direct counterparts in the oeuvre of Barye and reach beyond those limits, such as his Romantic *Battling Stags* (Salon of 1833) and *Boar Attacked by Hounds* (1846), and the later horse-racing designs: *Derby Winner,* or *Dismounted Jockey with his Racehorse* (1863), and *Horse and Jockey,* c. 1863.

G.B.

Notes
1.
The following compositions by Mène are illustrated in Horswell, 1971, pp. 103–73.
2.
Illustrated in S. Pivar, *The Barye Bronzes,* Woodbridge, Suffolk, 1974, p. 71.

Selected Bibliography

Lami, 1914–21, III, pp. 427–30.

Horswell, 1971, pp. 103–73.

Mackay, 1973, pp. 73–78.

Mercié's long career was a paradigm of academic success. At the Ecole des Beaux-Arts he studied under Jouffroy and Falguière. In 1868 he won the Ecole's grand prize for sculpture with the competition subject of Theseus vanquishing the Minotaur. In the same year he made his Salon debut with a portrait medallion of a young girl. He would continue to exhibit publicly for the next forty-six years. While in Rome from 1869 to 1873, he executed the models for two works, *David* (cat. no. 166) and *Gloria Victis!* (cat. no. 167), which were critically acclaimed at the Salons of 1872 and 1874. In 1873 he was given the Cross of the Legion of Honor — an unprecedented award for a sculptor who was still a student at the French Academy in Rome. Mercié's next great critical success was a work entitled *Quand Même!* (Salon of 1882), an allegorical group representing the defense of Belfort.

Famous by the age of thirty, Mercié was an incessant worker who, throughout the last quarter of the century, was generally considered one of the leading lights of French sculpture. In 1880 he took up painting, winning medals at the Salons of 1883 and 1889. As a sculptor he received the highest awards at the Expositions Universelles of 1878 and 1889. In 1889 he was elected to the Institut de France, and in 1900 he was named to replace Chapu as professor at the Ecole des Beaux-Arts; in the same year he was promoted to the rank of *grand officier* in the Legion of Honor. In 1913 he was elected president of the Société des Artistes Français.

Following the fame he won at the Salons of the 1870s, Mercié soon received several commissions for tombs, commemorative monuments, and portrait busts. He executed these works in an academic style and conventional manner, and they evidently met with success, for he continued to receive similar commissions throughout the rest of his life. To the long list of his works given by Lami should be added a *Monument to Byron* in the Zappeion Gardens, Athens.[1] Mercié's works have received remarkably little study.

P.F.

166.
David with the Head of Goliath
Bronze
h: 35¼ in. (89.6 cm.); w: 15¾ in. (40 cm.); d: 15⅞ in. (40.3 cm.)
After 1872
Signed: A. Mercie (on top of self base)
Foundry mark: F. BARBEDIENNE FONDEUR (on top of self base)
Lender: The David and Alfred Smart Gallery, The University of Chicago, Anonymous Loan

After Mercié completed the plaster model of his *David* in Rome, it was sent to Paris and exhibited at the Salon of 1872 where it was a great success. In reviewing that Salon, Paul Mantz rightly noted that Mercié was indebted to Donatello's famous bronze of the same subject and that it was one of many recent examples of a renewed interest — heralded by Paul Dubois' *Florentine*

166.

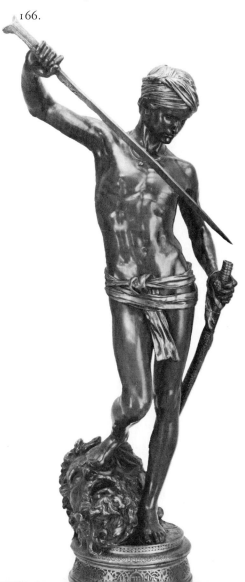

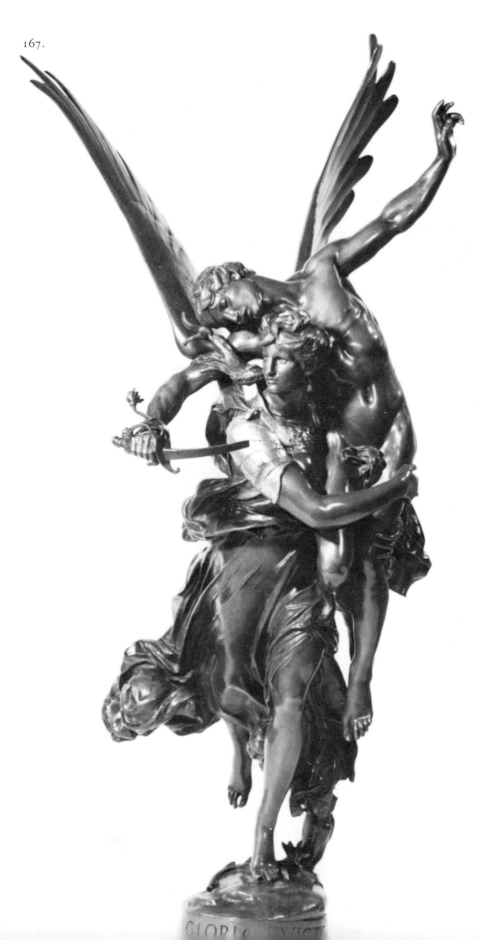

167.

Singer (see cat. no. 117) of 1865 — in Florentine Renaissance sculpture.[2] In its focus upon a youthful subject, Mercié's work is typical of many neo-Renaissance sculptures of the late 1860s and 1870s. It also seems likely that in deciding to sculpt a David, Mercié was consciously inviting comparison with the greatest sculptors of the Renaissance, for David had been the subject of famous works by Verrocchio and Michelangelo as well as by Donatello. These artists had all, in one way or another, suggested the miraculous aspect of the story of David, while Mercié's svelte youth appears to be concluding what is just another routine day's work as he nonchalantly steps on the face of Goliath and matter-of-factly returns his sword to its scabbard.

Mercié's contemporaries did not mind at all that his *David* was a slightly orientalized and decorative pastiche of its Renaissance predecessors. Not only did the work win a first-class medal at the Salon of 1872, but it also brought Mercié the distinction of being the only artist to receive the Cross of the Legion of Honor while still a student at the French Academy in Rome. A life-size bronze version of the work was exhibited at the Exposition Universelle of 1878 and acquired by the Musée du Luxembourg. By at least 1874, Barbedienne, who recognized a salable model when he saw one, was already producing bronze reductions such as the work in the present exhibition.[3] Mercié also executed a painted and gilded wax version of the work,[4] and at the Salon of 1876 he exhibited another *David,* a marble statuette depicting the youth before his combat.

P.F.

167.
Gloria Victis!
Bronze
h: 29 in. (73.6 cm.) including 1 in. (2.5 cm.) base
After 1874
Signed: A. MERCIE (near foot at right)
Inscribed: GLORIA VICTIS (on front of self base)
Foundry mark: F. BARBEDIENNE FONDEUR (on rear of self base)
Lender: The Cleveland Museum of Art, Gift of Robert Hayes Gries

During the Prussian invasion of France in 1870, Mercié was a student at the French Academy in Rome. At some point just after the war had begun, he executed a group with a figure of Fame supporting a

victorious soldier. When word arrived in Rome that the French had surrendered, Mercié changed his group, replacing the victorious soldier with a defeated one.[5] Thus, he transformed an allegory of "Glory to the Victors" into one of "Glory to the Vanquished;" and when the latter work was completed he coined the title *Gloria Victis!* as a proud rejoinder to the ancient motto "Vae victis!" ("Woe to the vanquished!").

The plaster model of *Gloria Victis!* was exhibited at the Salon of 1874. It won the Medal of Honor and was an enormous success with critics and public alike. The city of Paris purchased the plaster for 12,000 francs and had it cast in bronze by Victor Thiébaut for 8,500 francs.[6] The bronze was exhibited at the Salon of 1875, erected on the Place Montholon in Paris, and subsequently moved to a central courtyard at the Hôtel de Ville. The plaster was exhibited again at the 1878 Exposition Universelle and was awarded a grand prize; in the section devoted to industrial arts of the same exhibition, Barbedienne displayed a bronze reduction of the work;[7] presumably, this was similar to the example in the present exhibition.

At the Salon of 1875 the artist Jacquet exhibited two elaborate, highly finished engravings, one of Titian's *Sacred and Profane Love,* the other of Mercié's *Gloria Victis!;*[8] thus linked with one of the great works of the Renaissance, the modern sculpture had become an "instant classic." This was confirmed when it received its own entry in the *Nouveau Larousse Illustré.*[9] The response to *Gloria Victis!* was undoubtedly a patriotic one as much as it was aesthetic. With its beautiful young warrior, the stirring group was just what was needed to console a nation which had so recently suffered a bitter loss. In the years following 1870, if victory was no longer an appropriate theme for sculpture, it was still possible to salve national pride with works commemorating heroism in defeat (see essay on "The Public Monument").

To a certain extent, the popularity of *Gloria Victis!* must have been due to its compositional daring. In the early 1860s, influenced by the famous antique *Dancing Faun* and Giambologna's *Mercury,* a number of Salon sculptures such as Moulin's *A Lucky Find at Pompeii* (cat. no. 170) and Falguière's *A Hunting Nymph* (cat. no. 132) focused attention on the formal

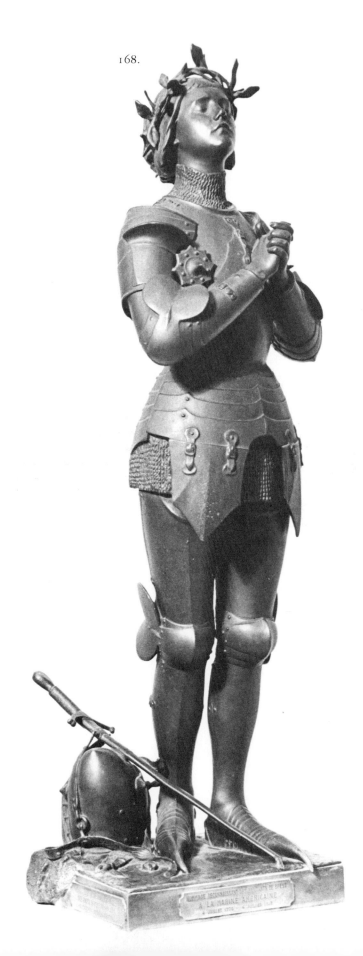

168.

problems of representing a figure balanced upon one foot. Mercié goes one step further and employs the same minimal support for a two-figure group; it, too, is based upon the antique and Giambologna, in this case the sources being the *Nike of Samothrace* and the *Rape of the Sabines*.[10] *Gloria Victis!* itself was, in turn, influential upon numerous later works, the most interesting of which are Doré's *Love and Fate* (1877) and Rodin's *Call to Arms* (cat. no. 192). P.F.

168.
Joan of Arc
Bronze
h: 28 in. (71.1 cm.); w: 10½ in. (26.7 cm.); d: 9½ in. (24.1 cm.)
1890s
Signed: MERCIE (on left side of base)
No foundry mark
Lender: U.S. Naval Academy Museum, Annapolis, Maryland

During the later years of his life Mercié created several sculptures of Joan of Arc, the medieval heroine of France (see cat. nos. 8 and 9).[11] Best known of these is a marble monument entitled *Joan of Arc Raising the Sword of France,* erected in front of her home in Domrémy in 1896.[12] The melodramatic group depicts Joan as a peasant, receiving her sword from an allegorical figure of France. Shortly before his death in 1916, Mercié completed a plaster model for a triumphal equestrian monument of Joan for the city of Toulouse. The bronze version was raised on the Place Matabeau soon after his death.[13] In addition, the sculptor executed at least two other statues of Joan. One work, shown at the Salon of 1914, represented the heroine listening to her heavenly messengers. Earlier, in 1906, Mercié exhibited a plaster statue entitled *Jehanne d'Arc,* which can be identified as the model for the sculpture in the current exhibition.[14] The artist depicted Joan in prayer, dressed in armor with a laurel crown of victory encircling her head. Her sword and helmet are placed at her feet. A gilt bronze, bust-length version of the work is in the collection of the George F. Harding Museum, Chicago.

This statuette was a gift to the American Navy from the citizens of Brest. A plaque on the base is inscribed, "HOMMAGE RECONNAISSANT DES HABITANTS DE BREST/A LA MARINE AMERICAINE/4 JUILLET 1776—4 JUILLET 1913." Joan of Arc's popularity reached its zenith in the years immediately preceding her canonization in 1920. During World War I, she became a potent symbol of resistance and fortitude against enemy forces. Her image appeared on posters and postcards to promote nationalism and patriotism. Several French and American soldiers even claimed to have had visions of her inspiring them to victory.
 M.B.

Notes
1.
H. E. Demetrius Caclamanos, "Some Plastic Figures of Byron," *Connoisseur,* 1932, XC, no. 376, p. 380.
2.
Mantz, 1872, p. 58.
3.
J. Lanove, "Exposition de l'Union Central," *Gazette des beaux-arts,* 1874, X, p. 519.
4.
E. Molinier, "La Collection Albert Goupil," *Gazette des beaux-arts,* 1885, XXXI, p. 387.
5.
M. Du Seigneur, "L'art et les artistes au Salon de 1882," *L'Artiste,* XLV, p. 44.
6.
Lami, 1914–21, III, p. 432.
7.
L. Falize, "Exposition Universelle, les industries d'art au Champ de Mars," *Gazette des beaux-arts,* 1878, XVIII, p. 616.
8.
L. Gonse, "Aquarelles, dessins et gravures au Salon de 1875," *Gazette des beaux-arts,* 1875, XII, pp. 172–73.
9.
Nouveau Larousse Illustré, 1898–1904, s.v. "Gloria Victis!"
10.
R. Butler Mirolli, *The Early Work of Rodin and Its Background,* Ph.D. diss., New York University, 1966, p. 196.
11.
For information on Mercié's sculptures of Joan of Arc, see Lami, III, pp. 431–36.
12.
The plaster model of the work (c. 1895) stands in a tower of Philippe-Auguste's palace in Rouen. See the photographs in Paris, 1979, pp. 206–7, nos. 53, 54.
13.
Illustrated in ibid., p. 244, cat. no. 253.
14.
The model is illustrated in ibid., p. 222, cat. no. 131.

Selected Bibliography
Lami, 1914–21, III, pp. 431–36.

A student of the *animalier* Paul Comoléra, Moignez first exhibited at the Exposition Universelle of 1855 with a hunting scene, *Pointer and Pheasant,* and a scene of predators fighting over prey, *Holly-Bird and a Weasel Struggling over a Woodlark.* In the Salon of 1859, he was awarded an honorable mention. Moignez took part in many Salons, exhibiting for the last time in 1892. His subjects embraced the broad spectrum typical of the *animaliers:* hunting scenes, both European and exotic, such as the *Boar Hunt* and the *Tiger Hunt* (Salon of 1880); racehorses, such as *Horse and Jockey* and *Thoroughbred Mare;* other horse subjects, including *Chief-Baron, Stallion* (1878) and *Bayard, Trotting-Horse* (1876); dog subjects like *King-Charles, Spaniel* (1861), *Pointer and Partridge,* and *Setter and Rabbit;* portrayals of goats and deer; and, occasionally, a splendid farm animal such as the *Merino Ram* (1861). After living in Paris for many years he retired about 1892 to Saint-Martin-du-Tertre (Seine-et-Oise). There, ill and suffering from intolerable headaches, he took his own life. The editing of his bronzes, begun by his father about 1855, was continued into the 1920s by Auguste Gouge. G.B.

169.
Wounded Heron
Bronze
h: 11 in. (28 cm.); w: 14⅝ in. (37.1 cm.); d: 7¼ in. (18.4 cm.)
Possibly Salon of 1859
No marks
Lender: Hudson Clauson, New York

Animals in the throes of agony—the wounded prey of a predator, the exhausted quarry of a hunter—were favorite subjects for the *animalier* followers of Barye. Romantic pathos of the sort they prized is well conveyed in the exquisite cast of a *Wounded Heron* by Jules Moignez, a design possibly shown in the Salon of 1859.

The small bronzes of Moignez are characterized by elaborately detailed surfaces, flashing with ever-changing reflections and shadows like the facets of some fabulous gemstone, as well as by the cultivation of an extreme fragility of form. These qualities are found particularly in his bird subjects,[1] such as *Sandpiper, Egret, Partridge, Cock Pheasant and Weasel,* and two other designs of the *Heron.* Their delicate bronze plumes and blades would doubtless have earned the scorn of Michelangelo, who advocated a highly compact treatment of

sculpture; the style of Moignez is closer in spirit to Ghiberti or Cellini, perhaps closer still to the late Rococo art of master goldsmiths. His bronzes also recall eighteenth-century paintings of the hunter's bag of game, like those of Oudry and Desportes. Even the porcelain forms of that age are reflected in the art of Moignez.

The pictorial silhouette of *Wounded Heron* is dominated by the bold shape of the heron's opened wing, rising vertically from the base. The planar wing contrasts with more linear passages such as the heron's curved neck, its opened beak, and its rigid leg. At the same time, the wing offers a large area for patterns of linear hachure in the tufts and striations of the feathers.

Classically lucid repetitions of motifs occur in *Wounded Heron:* the heron's closed and opened wings, echoed in the flexed and extended legs, or the heron's opened beak, repeated in the leafy blades of the plant at the foot of the design.

Elaborate negative forms are of great interest to Moignez—a remarkably forward-looking, abstract dimension of his art—but are kept simpler here than in his *Fighting Sparrows* (Salon of 1867) where the spaces among the undulating branches of a fallen tree attain a dazzling intricacy, their rhythms perhaps amplifying the idea of the frenzied beating of wings.

The action in *Wounded Heron* occurs at the water's edge, a setting symbolized in the abbreviated landscape of the base, where the lapping waves meet the pocketed, rocky bank. This sort of base is typical of several of the aquatic bird designs exhibited in Salons of the 1860s. G.B.

Note

1.
Illustrated in Horswell, 1971, pp. 217–48.

Selected Bibliography

Lami, 1914–21, III, pp. 459–61.

Horswell, 1971, pp. 214–48.

Mackay, 1973, p. 78.

The son of a poor shopkeeper, Moulin entered the Ecole des Beaux-Arts in 1855 but, for financial reasons, was soon forced to stop attending classes. To earn a living he gave language lessons at *pensions* in the Marais district of Paris. Although he studied with Auguste-Louis-Marie Ottin (1811–1890) and with Barye (see cat. no. 171), for the most part Moulin seems to have been self-taught. He made his Salon debut in 1857 and obtained his first success with a bronze, *A Lucky Find at Pompeii* (cat. no. 170), which won a medal at the Salon of 1864. Moulin continued exhibiting at the Salon until 1877, winning medals in 1867, 1869, and at the Exposition Universelle of 1878. He received a number of State commissions; the most important were a statue of *Victoria Mors* (plaster exhibited at the Salon of 1872) and *A Secret from on High* (plaster exhibited at the Salon of 1873; marble, now in the Louvre, exhibited at the Salon of 1875). This latter work, as well as *A Lucky Find at Pompeii,* is an inventive and amusing pastiche of antique statuary. Moulin spent the last years of his life in a rest home for the mentally ill. P.F.

170.

170.
A Lucky Find at Pompeii (Une Trouvaille à Pompeii)
Bronze on marble base
h: 35¾ in. (90.8 cm.) including 3 in.
(7.6 cm.) marble base
After 1863
Signed: Moulin s (on top of bronze base)
Foundry mark: Thiebaut Frères/Paris (on
top of bronze base)
Lender: David Daniels, New York

A Lucky Find at Pompeii is probably Moulin's best-known work. A life-size bronze version, signed and dated 1863, was exhibited and won a medal at the Salon of 1864; the same year it was purchased by the State for 7,000 francs; in 1867, it was included at the Exposition Universelle. Part of the Musée du Luxembourg collection during the nineteenth century, the life-size bronze is now in the Louvre.

Reviewing the Salon of 1864, the critic Léon Lagrange remarked that all the best statues of that year were balanced on one foot.[1] While certain of these works, such as Falguière's *Winner of the Cockfight,* adopted the pose of Giambologna's *Mercury,* Moulin's figure was inspired by the famous antique *Dancing Faun* from Pompeii (Museo Archeologico Nazionale, Naples).[2] Moulin's figure also grows out of nineteenth-century tradition which includes Duret's *Dancing Neapolitan Boy* (cat. no. 122). Somewhat contrived, both in pose and in subject, *A Lucky Find at Pompeii* combines several elements—an adolescent, a movemented unconventional pose, and an exotic genre subject—that recur continually in Salon sculpture of the period.

P.F.

171.
Antoine-Louis Barye (1796–1875)
Bronze
h: 24 in. (61 cm.) including 6 in.
(15.2 cm.) base
No signature
Foundry mark and date: F. BARBEDIENNE
Fondeur Paris 1875 (on left shoulder)
Lender: The Walters Art Gallery,
Baltimore

Moulin exhibited a bronze bust of Barye (along with a bust of Michelangelo) at the Salon of 1876, a year after Barye's death. The Salon version is presumably the same one that was placed on Barye's tomb in Père-Lachaise cemetery. Although Moulin does not seem to have spent a great deal of

time studying under Barye, he evidently considered the great sculptor his master. This is indicated by the inscription — lacking in the Walters version — on the Père-Lachaise bust: "A la mémoire de mon maître vénéré."[3] The somber, classicizing format of the portrait is unexciting but appropriate for a work that was intended as a memorial. Moulin had employed a nearly identical method of truncation, with bare chest, in a portrait of Henry Monnier (Salon of 1870).[4] P.F.

Notes

1.
Lagrange, 1864, p. 28.
2.
Ibid., p. 28, mentions the *Dancing Faun* but not specifically in connection with Moulin's work; the relationship between the two is pointed out by R. Butler in Louisville, 1971, p. 75.
3.
Jouin, 1897, p. 190.
4.
A reduction of the Monnier bust is illustrated in Berman, 1974–77, II, fig. 1273.

Selected Bibliography

Lami, 1914–21, IV, pp. 490–93.

Louisville, 1971, pp. 201–3.

171.

Nanteuil, a student of Cartellier, the principal teacher of sculpture at the Ecole des Beaux-Arts in Paris, won the Prix de Rome in 1817 and spent the customary five years at the Rome branch of the Academy. Toward the end of his stay, he modeled *Eurydice Dying.* The marble version, shown at the Salon of 1824, was bought by the State soon after and established the artist's reputation. Nanteuil's career brought him all the rewards French society had to offer; he won a first-class medal at the Salon of 1827 and four years later succeeded to the position of his teacher at the Academy. In 1837 he became a member of the Legion of Honor and an *officier* in 1865. Ambitious and lucrative public commissions were awarded to him during the Restoration, the July Monarchy, the First Republic, and the Second Empire, including a number of statues and busts at Versailles, the pediments of two Paris churches, Saint-Vincent de Paul and Nôtre-Dame-de-Lorette, and a pair of large reliefs for the entrance hall of the Panthéon. His most ambitious work in bronze is a colossal statue of General Desaix (1848) in Clermont-Ferrand. Among his portrait busts, that of Quatremère de Quincy (1850), the chief theoretician of Neoclassicism, deserves special note: he and Nanteuil were comrades-in-arms, immune to any shifts of the political climate, as defenders of "ideal beauty" and enemies of Romanticism. H.W.J.

172.
Eurydice Dying
Bronze
h: 13½ in. (34.3 cm.); w. of base: 5¼ in. (13.3 cm.); l: 7⅞ in. (20 cm.)
Reduction of a life-size statue modeled in 1822
No signature
Foundry mark: Susse Fres F (on side of base below tree)
Lender: Private Collection

The marble Eurydice acquired by the State in 1825 stood for many years in the garden of the Palais-Royal. In 1869 it was replaced by a bronze cast commissioned from the artist in 1862, and the marble entered the Louvre. Our bronze reduction may well date from those years, when the statue was honored once more, nearly half a century after its creation, as a "classic."

Eurydice is leaning against a tree trunk, too weak from the poisonous bite to grasp the snake coiled about her right foot, although her left hand reaches out for it. This initial event in the story of Orpheus and Eurydice, never represented in ancient art, became a favorite motif among Neoclassicists and their successors. Nanteuil, true to Canova's and Quatremère de Quincy's doctrine of emulating the Greek classics without copying them, has not borrowed any specific elements of the statue from the antique, yet Eurydice's bent head and facial expression recall the *Wounded Amazon*, the subject of a sculptural competition in the fifth century B.C. made famous by Pliny and known from Roman copies, while the position of the legs and the left arm recall Myron's *Discobolus.* *Eurydice Dying* may be said to have made the female nude-with-snake a respectable academic motif; it invited a number of later variants such as *Innocence Warming a Snake on Her Bosom, Eve before* [or *after*] *the Fall,* and the scandalous *Woman Bitten by a Snake* of 1847 by Clésinger (cat. no. 58). H.W.J.

Selected Bibliography

Lami, 1914–21, IV, pp. 1–5.

172.

Princess Marie d'Orléans was the youngest
daughter of Louis-Philippe and Queen
Marie-Amélie. At the age of twelve she
began to receive drawing lessons from Ary
Scheffer, one of the future king's favorite
artists, who continued to guide her artistic
career until the end of her life. Scheffer's
memoir of the princess, written shortly
after her death in 1839, contains invaluable
information regarding several of her
sculptures and provides insight into her
personality. According to the painter,
Marie was at first indifferent to her art in-
struction and was unable to make accurate
drawings from plaster casts. She preferred
instead to create historical compositions in
watercolor, which revealed genuine talent
and imagination. Like most women artists
of the period, the princess was restricted to
copying only abundantly draped live
models, so that she remained ignorant of
the structure of the human body. Scheffer
remarked: "I was somewhat tired of having
continually to correct her bad drawings of
legs and arms, often distorted and out of
shape. I suggested then to the princess the
idea of trying her hand at modeling and
sculpture; a walk of art in which I was
equally unpracticed . . . and which therefore
offered to both of us the attraction of
novelty."[1]

Her first efforts in sculpture were compe-
tent though undistinguished bas-reliefs
depicting a variety of Romantic literary
subjects. Scheffer related that one of these
early works, a group entitled *Ahasuerus Re-
fused Admittance within the Abode of the Angel
Gabriel* (an episode from Quinet's book
Ahasuerus), demonstrated considerable
ability in composition and expression. At
this time, Marie became impassioned with
the medium and desired to devote herself
to its practice. In the following years she
executed several works, both bas-reliefs and
sculptures in the round, the themes usually
inspired from history, literature, or the
Bible. The princess received a few com-
missions, notably the *Joan of Arc* for the
museum at Versailles and a marble group
of praying angels for the church of St.-Fer-
dinand-aux-Ternes. The majority of her
sculptures are now either lost or destroyed.
Models for a few of her works appear in a
portrait of the sculptor in her studio by
Scheffer (cat. no. 174), so that it is possible
to gain some idea of her oeuvre. Through-
out her life the princess suffered from poor
health; she died of pulmonary disease

at the age of twenty-five, two years after her marriage to Duke Alexander of Württemberg. M.B.

173.

Joan of Arc

Bronze

h: 20 in. (50.8 cm.); w: 8¼ in. (21 cm.); d: 7¾ in. (19.7 cm.)

Model c. 1835

Signed: MARIE D'ORLEANS (on top of base)

Foundry mark: Susse Fres Ed^ts Paris (on left side of base)

Label bearing inscription: A ME^LLE ALINE MONNOT/INSTITUTRICE A MOLINET/1885 a 1921/SES ELEVES/ET LA COMMUNE RECONNAISSANTES (on front of base)

Provenance: Shepherd Gallery, Associates, New York

Lender: Mr. and Mrs. Noah L. Butkin

Louis-Philippe awarded his daughter, Marie d'Orléans, the commission for a life-size marble statue of Joan of Arc about 1835, after Jean-Jacques Pradier failed to create a design that pleased the king.[2] A young but relatively experienced sculptor, Princess Marie undertook the project with enthusiasm and determination. She was aided by her teacher and intimate family friend, the painter Ary Scheffer, who in his memoir of the princess recorded the difficulties they encountered in producing a model for the now-famous work:

Instead of molding the form in clay, we took it in our heads to model it in wax. It fell to pieces more than once, then it bent down at a third attempt.... For all this, the statue finally came out the finest modern figure to be found at Versailles! Not only does its impressive attitude, its simplicity, and its distinctive feminine character contrast favorably with certain vulgar productions among which it stands, but it carries upon itself the stamp of the genius and the elevation of soul possessed by its author.[3]

A small model of the sculpture appears in Scheffer's portrait of the princess (cat. no. 174). The marble of the work was executed by Auguste Trouchaud, who served as the artist's *practicien* for several sculptures.[4]

In her sculpture of *Joan* at Versailles, Marie d'Orléans portrayed the medieval heroine in a private, introspective mood. With her head bowed, and her sword pressed close to her heart like a crucifix, Joan of Arc appears to pray for divine guidance. Ary Scheffer attributed the purity and dignity of the conception to the princess's own character. During her brief life, she was admired by the public for her piety and

173.

patriotism as well as for her talent.[5] Many recognized a spiritual kinship between Marie d'Orléans and the subject of her celebrated work.[6] The sculpture was an immediate success and has remained a sentimental favorite among the French public. After her death in 1839, the statue became a monument not only to Joan of Arc, but also to its creator. The sculptor Sébastien Delarue affirmed the association in his commemorative portrait of the princess standing next to her statue of Joan (cat. no. 110). Alfred du Musset expressed a similar sentiment in verse:

> *...Ce naif genié,*
> *Qui courait à sa mère au doux nom de Marie,*
> *Sur son oeuvre chéri, penchant son front rêveur,*
> *A la fille des champs qui sauva la patrie,*
> *Prête sa pitié, sa grace et sa pudeur.*[7]

Soon after her funeral procession passed through Orléans, the mayor requested a replica of the Versailles statue for the city.[8] The king, touched by his subjects' affection for his youngest and favorite daughter, granted his permission. A bronze version was erected in front of the Orléans city hall in 1851. In addition, Louis-Philippe authorized a bronze reduction of the work in 1843 for Joan of Arc's home in Domrémy.
M.B.

174.

Princess Marie d'Orléans (1813–1839)
Oil on canvas by Ary Scheffer (1795–1858)
h: 25 in. (63.5 cm.); w: 16⅛ in. (41 cm.)
c. 1833
Signed: Ary Scheffer (lower left)
Provenance: Shepherd Gallery, Associates, New York
Lender: The Cleveland Museum of Art, Gift of Mr. and Mrs. Noah L. Butkin

Although her career was brief, Princess Marie-Christine d'Orléans was one of a number of women in the nineteenth century to distinguish herself as a sculptor. Unlike many women artists of the period, the princess did not pursue sculpture merely as a pastime. According to her drawing instructor, Ary Scheffer, her dream was to "lead the life of an elevated, conscientious artist, and thus exercise a beneficial influence over high art in France."[9] Her early death at the age of twenty-five prevented her from realizing this noble goal. She is remembered best for her statue of Joan of Arc at Versailles (cat. no. 173).

Scheffer's portrait of Marie d'Orléans is a tribute to her as a dedicated artist. He portrayed the princess in her studio in the

Tuileries Palace, dressed in a smock and holding a chisel. Because she believed sculpture to be a virtuous if not a spiritual vocation, her studio served both as a workshop and as a chapel, where she could meditate in private.[10] Set on a table at her side are models of her works, including the Versailles *Joan of Arc* (lower left) and an equestrian statue of the same French heroine (upper left). The large sculpture of the angel on the right is entitled *Resignation* and would later serve as part of her tomb in the royal chapel at Dreux (fig. 106). The other statues in the painting cannot be identified with certainty, although they appear to correspond generally to the type of work she is known to have executed. Ary Scheffer mentioned the titles of a few of her sculptures in his memoirs: *The Peri Bearing the Tears of the Repentant Sinner to the Foot of the Throne of Grace, The Angel and the Gates of Heaven,* and *The Pilgrim* (from Schiller).[11] The recurrent religious and didactic themes that pervade her oeuvre reflect the princess's devout nature. In addition to Joan of Arc, Marie d'Orléans depicted other historical figures, notably Charlotte Corday.[12] Scheffer indicated that she also created several bas-reliefs inspired by the works of Goethe and Schiller. Her enthusiasm for German literature no doubt reveals the influence of her teacher, who frequently illustrated German drama and poetry. Her sculpture, like his paintings, is often marked by a Romantic sentimentalism characteristic of the period in general.

Scheffer was profoundly affected by his beloved student's death in 1839. He collected many of her drawings and sculptures and is reported to have preserved them as relics in a room of his apartment on the Rue Chaptal.[13] Studies for this portrait of Marie d'Orléans are conserved in the Ary Scheffer Museum in Dordrecht. Several versions of the painting were executed either by Scheffer or by his followers.[14]
M.B.

Notes

1.
Scheffer's memoir is reproduced in Grotte, 1860, pp. 37–48.
2.
Ibid., p. 43. See also J. Chaudes-Aigues, "La Jeanne d'Arc par la princesse Marie," *L'Artiste,* 1838, I, pp. 251–52.
3.
Grotte, 1860, pp. 45–46.
4.
Lami, 1914–21, IV, p. 324.

174.

JEAN-JACQUES, called JAMES, PRADIER

1790 Geneva–Bougival 1852

5.
L. Dupont, *Les Trois Statues de Jeanne d'Arc,* Orléans, 1861, p. 22; Kolb, 1937, p. 157.
6.
M. de la Bergerie, "Discours pour l'inauguration à Domrémy de la statue de Jeanne d'Arc," *Annuales de la société d'émulation du Département des Vosges,* 1843, V, pp. 175–76.
7.
Cited in V. Mourot, *Domrémy et le Monument National,* Nancy, 1897, p. 56.
8.
Dupont, 1861, p. 27.
9.
Grotte, 1860, p. 47.
10.
Kolb, 1937, p. 157.
11.
Grotte, 1860, pp. 46–47.
12.
"Nouvelle statue de la princess Marie," *L'Artiste,* 1838, I, p. 432.
13.
F. de Lasteyrie, "Ary Scheffer: Sa vie, son caractère, et ses oeuvres," *Le Siecle,* July 17–18, 1858, p. 178.
14.
Kolb, 1937, p. 491, lists three versions of the picture in the catalog at the end of her monograph. One is in the collection of the Duc d'Annale in the Musée Condé, Chantilly. Another, described as a replica, belonged to Jules de Lasteyrie. A third, in the collection of Mme. Noemi Renan, because of its size (61 x 39 cm.) is believed to be identical with the painting exhibited here. Yet another version, formerly in the collection of Georges Bernheim, is illustrated in Paris, Hôtel des Ventes, sale cat. by G. Loudmer and H. Poulain, April 25, 1979, cat. no. 9.

Selected Bibliography

Janin, J., "La princesse Marie de Wurtemberg," *L'Artiste,* 1839, I, pp. 117–21.

Trognon, *Notice sur la vie de Mme. la princesse de Wurtemberg,* Paris, 1840.

Ellet, E., *Women Artists in All Ages and Countries,* New York, 1859.

Grotte, *Memoir of the Life of Ary Scheffer,* London, 1860.

Lami, 1914–21, IV, pp. 24–25.

Kolb, M., *Ary Scheffer et son temps,* Paris, 1937.

A native of Geneva, Pradier was trained there as a medalist. At eighteen, he attracted the attention of Vivant Denon, Director General of French Museums under Napoleon and designer of medals for the Emperor, during a visit to Geneva while it was part of France. Denon brought him to Paris, where he studied at the Ecole des Beaux-Arts under the sculptor François Lemot. Having won the Prix de Rome, Pradier spent six years, 1813–19, at the French Academy in Rome, dutifully copying ancient sculpture while Napoleon went down to defeat and exile. Upon his return, he quickly established his reputation with two works in marble that gained him a first-class medal at the Salon of 1819, and he exploited this initial success with a series of orthodox Greek Revival statues during the 1820s (*A Son of Niobe,* 1822, and *Psyche,* 1824, both in the Louvre; *Prometheus,* 1827, Tuileries Gardens; *Venus,* 1827, Orléans). In 1827 he replaced his former teacher Lemot as a member of the Institut and professor at the Ecole des Beaux-Arts. The following year, he became a member of the Legion of Honor, and an *officier* in 1834.

Having flourished under the Restoration, Pradier did even better during the July Monarchy. He became, in fact, the favorite sculptor of Louis-Philippe, whom he portrayed repeatedly (see cat. nos. 176, 177) and who commissioned a number of works for Versailles and the Orléans Chapel at Dreux (see figs. 101, 102). Pradier also did several public monuments and a good deal of ambitious architectural sculpture during the 1830s, including four huge spandrel reliefs for the Arc de Triomphe, the frontispiece of the garden facade of the Luxembourg Palace, and a dozen colossal *Victories* for Napoleon's tomb in the crypt of the Dôme des Invalides. Yet he also maintained his links with Geneva; the bronze *Rousseau* (1835) is the city's finest public monument, and the Musée d'Art et d'Histoire contains more works by him than any other public collection.

Pradier's reputation, and his importance for the evolution of French sculpture during the second quarter of the nineteenth century, have been maligned by both conservative and progressive opinion. The former, as exemplified by Gustave Planche, accused him of too great dependence on the Greeks ("he never invented anything") coupled with an inability to understand the true nature of their art (his work lacks "chastity"). Préault and Baudelaire, at the other end of the spectrum, ridiculed him on the same grounds: "Every morning he sets out for Athens and arrives in the evening at the quartier Bréda [an ill-reputed part of Paris]," said Préault, and Baudelaire made Pradier the chief butt of his scorn in the notorious essay, "Why Sculpture is Boring," in his *Salon of 1846,* charging him with misuse of the "noble crutch" of Greek art. After Pradier's death, Etex, who called himself "the oldest of his pupils," came to his master's defense in an *Étude sur sa vie et ses ouvrages* that tried, among other things, to lay at rest the rumors about Pradier's loose morals.[1] Twentieth-century critics, on the evidence of his public commissions, have labeled—and libeled—Pradier as representing a hardened, dead-end phase of Neoclassicism.[2] Such an estimate holds true, however, only for the years before the July Revolution. From then on, Pradier was a straightforward Neoclassicist only on a few solemn occasions (such as the *Victories* for Napoleon's tomb); otherwise, in both his work and his friendships, he was part of the Romantic movement even when he dealt with classical subjects. The life-size marble group of *The Three Graces* (Salon of 1831) has a robust sensuousness that would have embarrassed Thorvaldsen and would have been unthinkable for Canova. Pradier's Geneva *Rousseau* in his open-necked shirt owes more to Houdon's *Voltaire* than to any classical statues of philosophers. A year later, in 1836, he modeled the tomb effigy of Louis-Philippe's brother, the Count of Beaujolais, who had died in Malta in 1808. The reclining figure of the youth, in the costume of his time, dreaming of his faraway homeland, is the very model of Romantic sentiment (see fig. 101). Pradier's most adventurous works, however, are his statuettes and small-scale groups. His satyrs and bacchantes (see cat. no. 183) led the way in the rediscovery of the Rococo; his intimate portraits (see cat. no. 177) rival those of David d'Angers; others are pioneer explorations of genre (*Woman Pulling on Her Stockings, Woman Taking off Her Shirt),* including women at work (see fig. 46.)

H.W.J.

175.

175.
Seven Studies for Personifications
of Fame
Pencil, black and white chalk on tracing
paper
Overall size including frame: h: 24½ in.
(62.2 cm.); w: 11½ in. (29.2 cm.)
Central drawing: h: 15¾ in. (40 cm.); w:
11½ in. (29.2 cm.)
c. 1832
Lender: Private Collection, Los Angeles

On June 15, 1833, the ministry for
sculptural decoration of the Arc de
Triomphe in Paris commissioned Pradier
to do four limestone *Renommées* (personifica-
tions of fame, with trumpet and laurel or

palm frond wreath) for the spandrels of the main arches. His fee, 25,000 francs, was paid the following February.[3] Presumably this was for the plaster models, two meters tall, now in the museum at Lisieux, rather than for the stone reliefs, which are six meters tall and could not possibly have been carried out in so short a time. Our set of drawings must be part of the preparatory studies for the final designs. It is no surprise, therefore, that they do not match the stone reliefs or their plaster models in detail, although they are clearly related to them. The scale of the large drawing, squared off in meter units we may assume, corresponds to the size of the spandrels on the arch: a fraction over six meters horizontally and vertically. On the back of the same sheet, faintly visible through the thin paper, there is another, sketchier drawing of a *Fame* and the word *Echelle* (scale) followed by illegible numerals. The six smaller drawings, interestingly enough, are all wider than they are tall—that is, designed to fill the spandrels of a segmental or flattened arch. Did Pradier here try to visualize the way his figures would look when viewed from street level? Be that as it may, this set of sketches enlarges what we know so far of Pradier as a draftsman, for the corpus of Pradier drawings in the Musée d'Art et d'Histoire in Geneva includes none for architectural sculpture or with the degree of polish of the large *Fame* in this group. H.W.J.

176.
Louis-Philippe (1773–1850) with Charter
Bronze
h: 9⅞ in. (25 cm.)
Signed and dated: J. PRADIER 1830 (on left side of base)
No foundry mark
Lender: The Forbes Magazine Collection, New York

177.
Studies for a Portrait of Louis-Philippe
Black chalk heightened with white on blue paper
h: 7½ in. (19.1 cm.); w: 4⅞ in. (12.4 cm.)
c. 1830
Signed: Pradier (at lower left)
Collector's mark on verso: Philippe de Chennevières (Lugt 2072B)
Lender: The Forbes Magazine Collection, New York

Pradier made two life-size portrait busts of the King of the French: one in 1834, known in several marble and plaster re-

plicas, and another in 1845, but no full-length statue. This statuette, which must have been done immediately after Louis-Philippe's accession to the throne, is not the reduction of a larger work, although it may be taken as evidence that Pradier modeled it in the hope of receiving such a commission. The King, in full uniform, leans with his left hand on a hexagonal pillar supporting a scroll (a reference to the charter defining the conditions of his office). One face of the pillar shows two symbols: a mirror for truth and a pair of clasped hands for fidelity. While Pradier may have made Louis-Phillippe somewhat less stout than he was at the start of his reign, he does not hide the sitter's baggy cheeks, which gave him a perpetually ill-humored expression, or the oddly pear-shaped facial contours that earned him the nickname *La Poire*.

In the exhibited drawing the small, quick sketches of the King's features are as unflattering as the head of the statuette, for

176.

177.

which they may well have served as a "data sheet." The costume, to the extent that it is included, seems the same, and the sitter is not visibly older. Since nothing suggests any specific relationship to the bust of 1834, a date of 1830 appears more plausible. H.W.J.

178.

Jean-Pierre-Joseph Darcet (1774–1844)
Bronze
h: 14½ in. (36.8 cm.); w: 6½ in.
(16.5 cm.); d: 5⅛ in. (13 cm.)
Signed and dated: J. PRADIER/1834 (on left side of column)
Foundry mark: Fonte sans ciselure/par honoré Gonon/et ses deux fils (on back of pillar)
Lender: Jacques de Caso, Berkeley

This work, apparently a unique specimen, is of great technical interest because of its inscription, which informs us that bronze casting without chasing was a novelty in the early 1830s. The model must be identical with *M.D...., membre de l'Institut*, a small statue in plaster shown in the Salon of 1835. Since our bronze dates from the previous year, the piece must have been modeled late in 1833 or early in 1834, a conclusion reinforced by the circumstances surrounding its creation. On August 27, 1833, Pradier had married Darcet's daughter Louise, who survived him by eight years. Darcet, a very distinguished member of the *haute bourgeoisie*—he was Inspector General of the Mint and a member of the Académie des Sciences, a division of the Institut—could hardly have looked with favor upon Louise's marriage to a sculptor from Geneva, even a very successful one, who had the reputation of being a *bohémien*. Our statuette, and especially the unique and novel bronze cast, which must have aroused Darcet's interest at least from a technical point of view, may well have been conceived as a domestic "peace offering." The elderly gentleman, despite his informal pose, certainly has an air of authority, reinforced by the pillar with scrolls (an adaptation of the pillar in cat. no. 176). It is a masterpiece of penetrating characterization in which the body speaks to us as eloquently as the face, very much in the same spirit as Ingres' unforgettable *Louis Bertin* of 1832.

A very similar plaster statuette by Pradier, representing Dr. Baron, a member of the Académie de Médecine, signed and dated

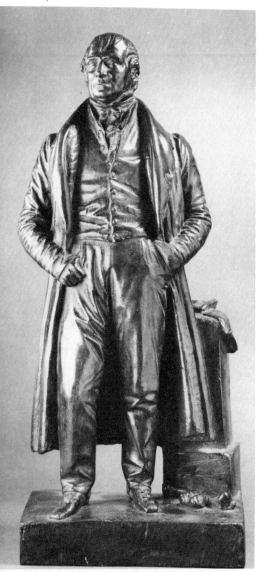

178.

1838, is in the Musée d'Art et d'Histoire, Geneva (inv. no. 1917–6).

How, one wonders, did Pradier meet Louise Darcet in the first place? The French Mint produced both coins and medals, and Pradier had been trained as a medalist; did he design any medals during the years of his maturity? Apparently he did, and he even taught medal-making at the Ecole des Beaux-arts, although the scanty references to these aspects of his work fail to cite specific examples.[4] His initial contacts with Darcet may thus have been purely professional. The collecting and the designing of medals—we are led to assume, remembering Vivant Denon—had been an activity accepted in the highest social circles, with its emphasis on their educational value and a tradition reaching back to the fifteenth century. Perhaps, in the eyes of Darcet, Pradier the medalist was a more acceptable son-in-law than Pradier the sculptor. Be that as it may, the sculptor's early training must have given him a special expertise in working on a small scale as evidenced by his statuettes. On occasion, he could also be a successful designer of jewelry.[5] H.W.J.

179.

Odalisque Seated
Bronze
h: 11½ in. (29.2 cm.); w: 11½ in.
(29.2 cm.); d: 10¼ in. (26 cm.)
c. 1841
No marks
Provenance: Michael Hall Fine Arts, Inc., New York
Lender: Fred and Meg Licht, Princeton

This figure is a reduction of the life-size marble in the Musée des Beaux-Arts, Lyon, signed and dated 1841. Other casts of the same size as ours are known, some of them carrying Pradier's signature. The reduction is very precise except for a few tiny simplifications in the drapery folds and the shape of the knob of the fan in the woman's left hand. It may well be that both the marble and the bronze reductions were made simultaneously from the original plaster, which has not survived. The Lyon marble and its bronze reduction have been completely disregarded in the literature on Pradier, perhaps because neither was exhibited in the Salon. The published

catalog of the artist's works in the Musée d'Art et d'Histoire in Geneva lists no less than four plaster statuettes of odalisques (sleeping, dancing, reclining, crouching), none of them dated, none known in other specimens, dimensions, or materials, yet there is no mention of the Lyon *Odalisque,* an hour's train ride from Geneva, the only dated, and clearly the most important, member of its class. Evidently the theme had occupied Pradier for some years— probably since the late 1830s—until the Lyon marble emerged as the most successful design. A drawing of a seated model in Geneva (no. 1852–52) shows a similar pose and may represent an early stage in the evolution of our figure. Odalisques— Turkish harem slave girls—had entered Western art a century before. It was Ingres, however, who created the type used by Pradier; the chief examples, all in the Louvre, are his *Grande Baigneuse* (1808), *Grande Odalisque* (1814), and *Bain Turc* (1852–63). Pradier surely knew the *Grande Odalisque,* nude like his and with a similar turban and peacock feather fan. The poses, on the other hand, are quite unrelated: the *Grande Baigneuse,* her back turned to the beholder, sits on the edge of a divan; the *Grande Odalisque* reclines on one, while Pradier's sits on a piece of cloth spread on the floor. In *Le Bain Turc,* we do find a similarly posed figure, the lute-playing odalisque (adapted from the *Grande Baigneuse*) who sits cross-legged on the floor; the resemblance is striking when Pradier's figure is viewed from the back. Yet the earliest sketches for *Le Bain Turc* cannot be traced back any farther than 1852, the year of Pradier's death and eleven years after the date of the Lyon statue. We are forced to conclude, therefore, that the lute player reflects the pose of Pradier's *Odalisque,* rather than the other way around. The two artists obviously knew each other at the Ecole de Beaux-Arts, perhaps even since Pradier's Roman years, and the younger man must have admired the Romantic aspects of the older one's work, although nothing is known about their personal relationship. Another link between them was the sculptor's older brother, Charles-Simon Pradier, who engraved several of Ingres' pictures. In any event, between 1841 and 1852 Ingres had ample time and opportunity, we may assume, to encouter Pradier's *Odalisque,* at least in its bronze reduction, which was probably issued in significant numbers.

Nevertheless, it is only fair to say that if Ingres was indebted to Pradier in this particular instance, Pradier's debt to Ingres was the greater of the two. Having acknowledged it, we must also point out Pradier's degree of independence: his *Odalisque* retains only a trace of Ingres' abstract sinuosity; she is far more natural, more casual, more tangible. Something has attracted her attention, and she turns her head with a coolly appraising glance rather than the wide-eyed stare of *La Grande Odalisque.* Moreover, it took considerable daring to translate Ingres into three dimensions. The Lyon marble remains the only life-size odalisque in the round that this writer has been able to find. What makes her still more extraordinary is that

179.

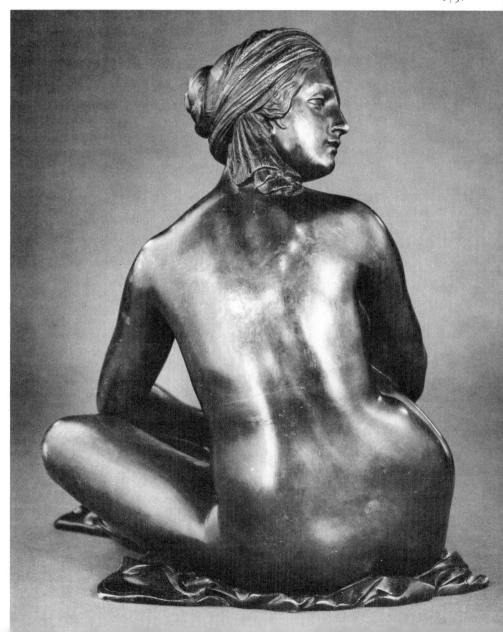

she has no principal view; her limbs are interlocked in such a way that one can read her pose only by looking at her from every possible angle. Finally, our figure has the distinction of being the first of several monumental women by Pradier sitting on the ground in similarly compact poses. She was to be followed by *Atalanta Fastening Her Sandal* (Salon of 1850) and *Sappho Seated* (Salon of 1852), both in the Louvre.

H.W.J.

180.

Sweet Leisure (Dolce Far Niente)
Bronze
h: 8 in. (20.3 cm.); l: 18¼ in. (46.4 cm.); w: 8¾ in. (22.2 cm.)
c. 1845–50
Inscribed and signed: DOLCE FAR NIENTE/ J. PRADIER (on side of base below the two infants at the woman's right thigh)
Foundry mark: DUPLAN E SALLES/Ed (on side of base beneath woman's head)
Lender: Fred and Meg Licht, Princeton

There is no record of any work by Pradier with this title, nor does it match any of the small-scale groups in bronze or plaster at the Musée d'Art et d'Histoire in Geneva. While the authorship of the main figure can be confirmed by comparisons with Pradier's other works, the title must have been posthumously conferred upon the bronze by the foundry. Not only does it lack parallels in the artist's oeuvre, but also it falsifies the subject, which clearly belongs in the realm of classical mythology rather than genre. The nude young woman, asleep on a panther's skin covering a rock by the water's edge, ought to be called a sleeping bacchante, for that is evidently what she is. The putti, too, are suspect as later additions to the model by a lesser hand, both on grounds of quality and because they are out of place iconographically. Far from sharing the bacchante's repose, they busy themselves in various ways: the one below the woman's head peers into the water, the next (going counterclockwise) is writing on a scroll—it must be poetry, to judge from his rapt expression— while he leans against his companion who wears a laurel wreath and plays the lyre; the fourth sits on the edge of the rock in a melancholy pose, a scroll in his

 180.

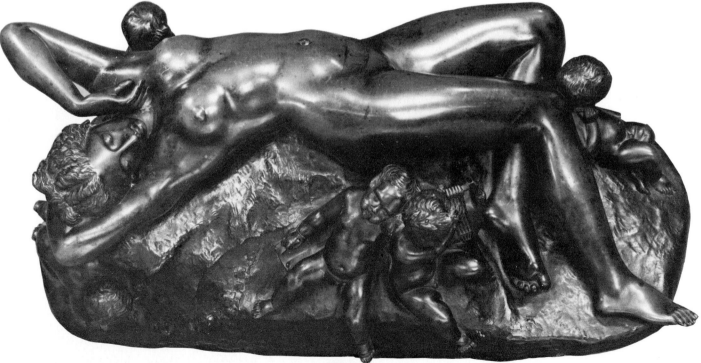

left hand; and the last two are engaged in amorous play. They seem to have been plucked from various allegorical contexts and planted around the bacchante, who remains blissfully unaware of them. Whoever had this implausible idea may have misinterpreted Pradier's *Bacchante with the Infant Bacchus*, a plaster group in Geneva (no. 1910–248), which shows a nude bacchante reclining on a rock covered by a panther's skin and supporting with her raised hands a male putto with a wreath of grapes and grape leaves. That *Bacchante* originally had another partner: her pose, half kneeling, half reclining, first appears in Pradier's *Satyr and Bacchante* (plaster, Geneva, no. 1910–224), where it is more logically motivated by the satyr's embrace. The rock covered with a panther's skin recurs in the *Drunken Bacchante* (plaster, Geneva, no. 1910–231) and in the bronze statuette of the same theme but different design (cat. no. 183). In comparing the sleeping figure in *Dolce Far Niente* with these other bacchantes, we become aware that the latter all have loose, streaming hair and are accompanied by a thyrsus, while ours lacks the thyrsus and has hair neatly coiffed in Hellenistic fashion. Her very identity, then, becomes questionable. Originally, it seems, she was simply a sleeping classical nude, converted into a bacchante *ex post facto* by the addition of the panther's skin and a bit of ivy. Pradier did use a very similar coiffure on at least one other occasion, in a variant (plaster, Geneva, no. 1910–212) of his *Phryne* (see cat. no. 181), which also shares the slenderness and the small head of this figure. A date of c. 1845–50 thus seems indicated for her (*Phryne* was shown in the Salon of 1845); the rest of the piece consists of "editorial additions" after the artist's death. The exact date of our nude would be a matter of considerable interest if we could ascertain it, for her sensuous pose bears an unmistakable relationship to that of Clésinger's *Woman Bitten by a Serpent* of 1847 (see cat. no. 58) of which it is, as it were, the relaxed counterpart. Did Pradier model his sleeper in response to the notoriety of Clésinger's figure? We probably shall never know for certain. On the other hand, there can be little doubt that Clésinger owed a debt to Pradier as a pioneer rediscoverer of the Rococo. As early as the Salon of 1834, the latter had shown a marble group, *Satyr and Bacchante*, lost sight of in

1870 with no surviving visual record. The Geneva plaster group of the same subject mentioned earlier may or may not be a reduction of the 1834 work, but it cannot be entirely unrelated even if it is regarded as a later variant. The Geneva group—which cannot be later than 1852—not only revives Clodion at his most sensuous but anticipates Carrier-Belleuse (see cat. no. 49).

H.W.J.

181.
Phryne
Partially gilt bronze on marble base
h: 28¾ in. (73.1 cm.); including 12¼ in. (31.1 cm.) base
After a marble of 1845
Signature, foundry mark, and inscription: J. PRADIER Susse F^res Ed^teurs Tirée du cabinet de M. Benjamin Delessert fils (running around side of bronze base)
Inscribed: OPYNH (on front of plinth)
Lender: Private Collection, New York

The reference in the inscription to the collection of Benjamin Delessert, Jr., assures us that the reduction of which our statuette is a specimen must have been made soon after the marble statue was shown in the Salon of 1845, for the marble sold to Delessert was broken a few years later. A letter by Pradier, unfortunately not dated,[6] complains that Delessert, who had shipped the statue overseas against the artist's advice, held him responsible for its breaking. Since it was the owner's obligation to treat the statue with care, to preserve it for future centuries, "he ought to pay me 100,000 francs for breaking it." The letter implies that at the time it was written Delessert's marble was the only one carved from the original plaster (apparently the plaster in the museum at Troyes). A second marble, produced soon after, is now in the museum in Grenoble. The first was distinguished by the addition of gold earrings and the pale blue coloring of the embroidery along the bottom edge of the garment, details objected to by purist critics. Even they, however, proclaimed the figure a masterpiece, and Pradier himself took special pride in it.

Phryne, an Athenean courtesan said to have been the mistress of Praxiteles, was accused of impiety. The judges, however, refused to condemn her when her counsel made her

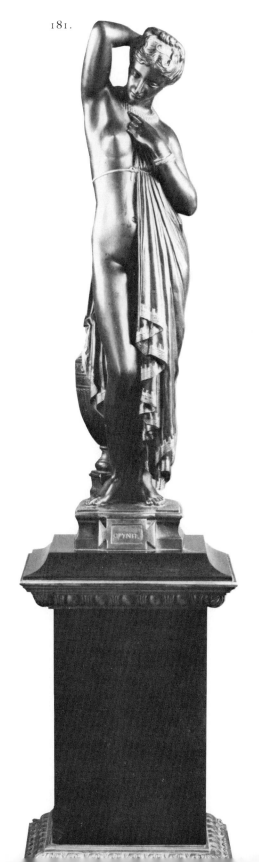

181.

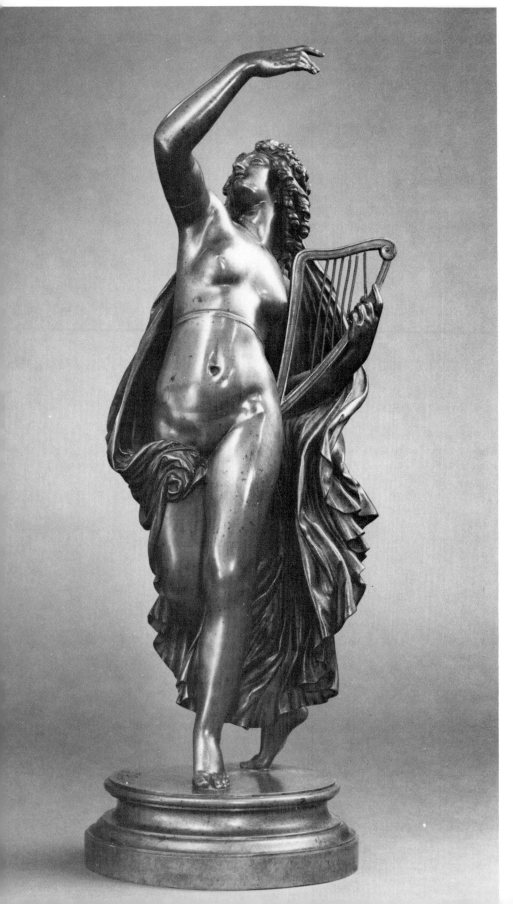

take off her clothes to reveal her perfect beauty. Although long familiar from a well-known Roman source,[7] the story did not enter the repertory of art until the late eighteenth century and remained rare even then.[8] Pradier's statue appears to be the first, and quite possibly the only, sculptural treatment of the subject on a monumental scale. What attracted him to the story, we may assume, was not the counsel's clever strategy (otherwise he would have shown him in the act of stripping Phryne's garments) but the Romantic idea that beauty is independent of —indeed, superior to—moral law. Thus Phryne, whose role was essentially a passive one, becomes his heroine. In a display of mock modesty, she reveals only half of herself; and since Pradier had to add a large vase (in lieu of the conventional tree trunk) for technical reasons, the statue might as well be called *After the Bath*. Only her name on the tablet enables us to identify the subject. A plaster statuette in Geneva (no. 1910–213) shows a franker alternative solution—Phryne completely nude except for her sandals, with both arms raised to hold up her cloak as a sort of backdrop—which the artist may have rejected as technically too risky for a life-size marble. The design he settled on emphasizes the elongation of the figure, as if she had to fit into a narrow rectangular frame, like Goujon's nymphs on the Fontaine des Innocents. One of these, the nymph carrying her water jar on the right shoulder, is a compositional mirror image of *Phryne*. But then there had been a "Fontainebleau revival" in French sculpture ever since the 1780s, when the Fontaine des Innocents was moved to its present position. Pradier, moreover, was very much aware of the great French sculptural tradition of the past; his last project, cut short by his sudden death, was a monument to Puget.

H.W.J.

182.
Light Verse (La Poésie Légère)
Bronze
h: 22½ in. (57.2 cm.)
After a marble of 1846
Signed: J. PRADIER (on top of bronze base)
No foundry mark
Lender: Private Collection, New York

The French title has no precise equivalent in English (present-day literary criticism seems to regard all poetry as serious, and all verse as light—and of a lesser breed); its companion piece would be *La Poésie*

Sérieuse, corresponding to the two marble statues, *La Comédie Légère* and *La Comédie Sérieuse,* which Pradier had contributed in 1842 to the Fontaine Molière in Paris. One suspects that he was not altogether satisfied with these heavily draped, scroll-laden figures, overpowered by their architectural setting. *La Poésie Légère,* exhibited as a life-size marble at the Salon four years later, is certainly a far cry from *La Comédie Légère.* She is equally far removed from the *Phryne* of the previous year (cat. no. 181), although the two have in common the enrichment of the marble with "alien" materials: *La Poésie Légère* has a bronze harp, bronze earrings, and a bronze bracelet on her right wrist. The marble statue, now at the Musée des Beaux-Arts in Nîmes, corresponds exactly to our bronze reduction except for the omission of the waistband, the somewhat faulty positioning of the harp (which probably could be adjusted), and the fact that, for technical reasons, the drapery between the legs reaches all the way down to the plinth. The bronze reduction lacks the bracelet and earrings, the harp is slightly simpler in shape and has fewer strings, and the hair is fuller and more loosely curled. The figure—perhaps we ought to call her "The Muse of Light Verse"—is simultaneously dancing, singing, and playing the harp. Her vigorous turning movement, emphasized by the rather fleshy thighs, is reflected—and exaggerated—in the curling rivulets of folds, which display an almost Baroque exuberance of their own. The small but not insignificant differences between the life-size marble and the bronze reduction suggest that the latter was carried out at the same time as the carving of the marble, under Pradier's careful supervision.

H.W.J.

183.
Bacchante
Bronze
h: 19⅝ in. (49.9 cm.); w: 10⅝ in. (26.9 cm.); d: 10½ in. (26.7 cm.)
Signed and dated: PRADIER/1852 (on the wine flask)
No foundry mark
Lender: Private Collection

The nearest relative of this bronze is a plaster statuette in the Musée d'Art et d'Histoire, Geneva (no. 1910–231), known as *The Drunken Bacchante (La Bacchante ivre).* Although not signed, the Geneva figure came to the museum in the early years of this century as part of a lot of thirty-five pieces,

many of them signed or otherwise known to be by Pradier, from the widow of Salvadore Marchi, who had worked for Pradier as an expert maker of plaster molds. Like ours, *La Bacchante ivre* sits on a rock or mound covered with a panther's skin, a wine flask of the same shape at her feet. She is, however, entirely nude; she leans back, her torso supported by her arms, and, looking upward, laughs uncontrollably. Our *Bacchante* has not yet reached the same degree of tipsiness. She looks up at the chalice in her raised left hand which she has just emptied, while her right hand, behind her head, plays with a string of beads attached to her hair. Her cloak covers only her right leg; soon it will have slipped to the ground, leaving her as nude as *La Bacchante ivre* except for the bracelet on her left upper arm. Since our *Bacchante* is both signed and dated, she helps to confirm the authenticity and the late date of the Geneva figure. Apparently during the last year of his life, in 1851–52, Pradier was captivated by the theme of the drunken bacchante for bronze statuettes. Bronzes of *La Bacchante ivre* may well exist, issued by Marchi, who presumably also had the plaster for our bronze. Of the two models, *La Bacchante ivre* clearly offers the happier alternative; in comparison, the pose of our figure looks strained and rhetorical, and her gaiety seems a bit synthetic. H.W.J.

184.
Leda and Swan
Bronze
h: 6¾ in. (17.1 cm.); l: 9 in. (22.9 cm.); w: 5 in. (12.7 cm.)
c. 1850
No marks
Lender: The Metropolitan Museum of Art, New York, Bequest of Walter M. Carlbach, 1969

The attribution of this striking small bronze to Pradier remains uncertain. There are two *Leda*s among the Pradier statuettes in the Musée d'Art et d'Histoire at Geneva: the *Léda des artistes* in bronze (no. 1910–212) with two preparatory drawings (nos. 1852–44, 1852–45) and *Léda attirant le cygne* (no. 1910–228) with one preparatory drawing (no. 1852–46). Neither of these, however, approaches the ecstatic sensuality of our group, which not only compresses the two participants into a single unit but lends physical and emotional

183.

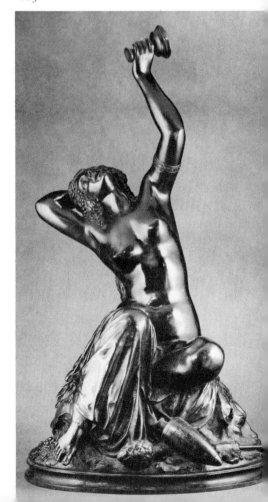

plausibility to an unlikely act. On the other hand, the sculptor who created *La Bacchante ivre* could also have invented our *Leda*. If it were not he, the group must be the work of a gifted younger artist under strong Pradier influence. Its anonymity is understandable enough: by mid-nineteenth century standards the group surely breaches the bounds of decency. Objects such as this were meant to be enjoyed by gentlemen in the smoking room, without the presence of ladies.　　　　H.W.J.

Notes

1.
A. Etex, *J. Pradier, étude sur sa vie et ses ouvrages*, Paris, 1859.
2.
A. Reinle, in *Kunstgeschichte der Schweiz*, Frauenfeld, 1962, IV, pp. 329 ff.: "Hauptvertreter des problemlos in sich gefestigten Klassizismus."
3.
Lami, 1914–21, IV, p. 104
4.
See L. Forrer, *Biographic Dictionary of Medalists*, London, 1909, IV, p. 682.
5.
H. Vever, *La Bijouterie française au XIXe siècle*, Paris, 1908, I, pp. 166, 174, 178 ff., records and illustrates a number of pieces, mainly bracelets, produced by F.-D. Froment-Meurice after designs by Pradier, several of them in a neo-Gothic style. The initiative apparently came from that enterprising jeweler, who also persuaded other sculptors of the mid-century to make designs for him (e.g., David d'Angers, Feuchère, Préault). I am indebted for this information to Mrs. Dora Jane Janson.
6.
Lami, 1914–21, IV, p. 107.
7.
Quintilian, *Institutio oratoria*, II, 15, 9, for whom it serves as a peculiar example of persuasion.
8.
A. Pigler, *Barockthemen*, 2nd ed., Budapest, 1974, p. 414, cites only two rather obscure examples of the 1760s (a miniature by Pierre-Antoine Baudouin and a drawing by J.-B.-Henri Deshayes), the Pradier statue, and the painting by Gérôme of 1861. In 1858–59, Charles Gleyre was at work on a picture of *Phryne devant l'Aréopage* but abandoned it when he learned that Gérôme was treating the subject. Gleyre's sketch, in the Musée Cantonal des Beaux-Arts, Lausanne, shows a seminude Phryne clearly influenced by Pradier's statue. See the catalog of the exhibition, *Charles Gleyre ou les illusions perdues*, Zurich, Schweizerisches Institut für Kunstwissenschaft, 1974–75, No. 55. I am indebted to Dr. Hans Lüthy, director of the Schweizerisches Institut für Kunstwissenschaft, Zurich, for bringing the Gleyre sketch to my attention.

184.

ANTOINE-AUGUSTIN PRÉAULT
1809 Paris 1879

Selected Bibliography

Etex, A., *J. Pradier, étude sur sa vie et ses ouvrages*, Paris, 1859.

Lami, 1914–21, IV, pp. 100–112.

Thieme-Becker, 1933, XXVII, p. 343.

Avenier, L., "J.-J. Pradier," *Pages d'art*, 1922, pp. 97–114, 125–40, 153–78.

Gielly, L., "Les Pradier du Musée de Genève," *Geneva*, 1925, III, pp. 347–57.

———, "Les dessins de James Pradier au Musée de Genève," *Geneva*, VII, 1929, pp. 242–50.

Lièvre, P., "Pradier," *Revue de Paris*, August 15, 1932, pp. 807–27; September 1, 1932, pp. 172–201.

Alaux, J.-P., *Académie de France à Rome, ses directeurs, ses pensionnaires,* Paris, 1933, pp. 64–67.

Gielly, L., "James Pradier," *Pro Arte,* December 1942, no. 8, p. 24.

von Waldegg, J. H., "Jean-Léon Gérôme's 'Phryne vor den Richtern,'" *Jahrbuch der Hamburger Kunstsammlungen*, 1972, XVII, pp. 134 ff.

Préault is said to have attended the College Charlemagne, where he would have encountered his future intimates Gautier, Delacroix, and Gérard de Nerval; he is also said to have been apprenticed to an ornamental sculptor.[1] The earliest documented reference to his training is the record of his enrollment in David d'Angers' studio at the Ecole des Beaux-Arts (although he seems never to have been formally a pupil at the Ecole) in November 1826.[2] Among his youthful friends were several minor Romantic painters[3] and perhaps Daumier, and by 1830 his literary and theatrical acquaintances included Balzac, Gautier, Nerval, and Petrus Borel, all of whom joined him in the famous claque at the premiere of *Hernani* by another of his acquaintances, Victor Hugo.[4]

Préault's Salon debut in 1833 included a group of *Two Poor Women* and a large bas-relief entitled *Beggary;* their socially conscious themes owe something both to the times in which he was living and to the socialism of some of his friends such as Théophile Thoré. His subjects of the 1830s also included such themes as *Slaughter* (fig. 58) and *Despair,* reflecting, like his broadly worked Michelangelesque style, his complete identification with Romanticism. Refused from all but three Salons during the reign of Louis-Philippe, Préault became widely known as one of the martyrs of the Salon juries. Surviving on the few public and private commissions that came his way during those years, he still managed to produce some of his best works, among them the *Silence* in Père-Lachaise cemetery (1842–43), the *Christ* in the church of St.-Gervais-St.-Protais (fig. 84), and the tomb of the Abbé Liautard (c. 1847). He also turned out a series of portrait medallions, a genre favored by David d'Angers to which Préault gave new stylistic life.

During the Second Empire, Préault received substantially more public commissions which, along with the *succès de scandale* produced by the reappearance of his earlier works and his acerbic comments on his contemporaries, made him something of a living legend. Among the most notable of his monuments are those to General Marceau (1845–51) and Jacques Coeur (1872–79). The styles of his earlier years, heroic in his freestanding groups and linear in his reliefs, were gradually modified, not

entirely to their benefit. In general, his clay sketches are preferable in their vigor to his finished stone monuments, and the latter frequently demonstrate Préault's inability to orchestrate complex compositions (see *War* and *Peace* on the Louvre, 1857). Bronze was thus an agreeable medium for him since it translated his models directly, although two of his best works—the St.-Gervais-St.-Protais *Christ* and the *Abbé Liautard Tomb*—were carved in wood.

Préault received the Legion of Honor in 1870, but in the years following the fall of Napoleon III he sank into the relative obscurity of a Romantic anachronism. He was quickly forgotten after his death in 1879, and despite an oeuvre that places him among the most interesting sculptors of his time, he has remained all but unknown ever since.　　　　C.W.M.

185.
Xavier Sigalon (1787–1837)
Bronze in wood frame
diam: 7⅜ in. (18.7 cm.); h. of frame: 11¼ in. (28.6 cm.); w. of frame: 10¾ in. (27.3 cm.)
Dated: 1830 (at bottom right)
Signed: Preault (under the neck); Preault Aug (in the exergue)
Inscribed: XAVIER SIGALON/PICTOR (around the perimeter)
No foundry mark
Provenance: Jacques Fischer, Paris
Lender: Private Collection

185.

Our example of this medallion is the larger of the two known, the increased size permitting room for the inscription but vitiating somewhat the effect of the head. The version in the Musée des Beaux-Arts at Lille measures 16.6 cm. (about 6½ inches) and is inscribed only with the words "Sigalon" at the left and "Pictor" at the right. It has faint traces of the signature under the neck. The detail of our example is somewhat sharper than that of the Lille version. Préault's treatment of the features in this work amounts almost to caricature, although the style is relatively restrained, perhaps reflecting its early date. The inclusion of the painter's skull cap may be an oblique reference to Sigalon's friend Géricault, tying the two together in Romanticism. Born in Uzès, Xavier Sigalon studied in Nîmes and then in Paris under Guérin. His principal *succès de scandale* was an *Athalia* exhibited at the Salon of 1827. He died of cholera in Rome, where he had been sent by the government in 1833 to copy Michelangelo's *Last Judgment*. C.W.M.

186.
Macquet
Bronze
diam: 6⅛ in. (15.6 cm.)
Signed and dated: PREAULT/1834
Inscribed: MACQUET
No foundry mark
Lender: Private Collection

Three examples of this medallion are known, the present version being the finest in detail and the only one to bear a full inscription. The Louvre version has the signature and date but no identification of the subject, while that in the Musée des Beaux-Arts at Lille has the identification but no signature or date. The latter cast is slightly larger than our example, measuring 16 cm. (about 6¼ inches). Clearly indebted to the medallions of David d'Angers in its composition, the *Macquet* is much freer in its workmanship than the portraits of the older master. Evidence of tool and finger is to be seen throughout the relief, typifying the breadth of facture for which the young Préault was widely criticized, despite the fact that it was precisely that breadth that conveyed the vitality of his works. Rather than recalling other sculpture, the *Macquet* brings to mind Daumier's lithographs such as the carica-

ture of Charles de Lameth, published in *Le Charivari* in 1832. The subject of the medallion is not Dumas' collaborator Auguste Macquet, although it could be a relation, perhaps his father. C.W.M.

187.
Félix Pyat (1810–1889)
Bronze
diam: 7⅜ in. (18.7 cm.)
Signed: PREAULT (on left shoulder)
Dated: 1835 (at right center)
Inscribed: Felix Pyat (at right center)
No foundry mark
Lender: Private Collection

A second example of this medallion in the Musée des Beaux-Arts at Lille is of approximately the same quality and dimensions (18.8 cm. wide and 19.1 cm. high) and bears the same inscriptions as our example. It was undoubtedly cast from the same model. Both examples, like all of Préault's medallions of this period, were almost certainly sand cast. The signature seems to have been inscribed in the model by Pyat himself. The roughened surface of the face and clothing, contrasted with the linear patterning of the hair, exemplifies the free and vigorous style Préault had developed by the mid-1830s.

186.

Félix Pyat—dramatic author, radical journalist, and politician—probably knew Préault almost from the moment he arrived in Paris in 1826. The character of Lysippe in his play *Diogène* (1846) was said by Théodore de Banville to have been based on Préault, although the part is such a minor one, exhibiting little more than a massive ego, that it is impossible to confirm this.[5] Banville also lists Préault as "Pyat's friend, who never ceased to be fond of him, even during the Commune."[7] Pyat's participation in the latter event, in part as a member of its Executive Committee, earned him his third exile from France, to which he returned only with the amnesty of 1880. In 1888, the year before his death, he was elected Socialist Revolutionary Deputy from Bouches-du-Rhône. There exists at least one other medallion portrait of him, dated 1888, by Auguste Verdier, which is unrelated to the Préault composition.[8] C.W.M.

188.
Rouvière in the Role of Hamlet Recoiling before the Ghost
Bronze
h: 20½ in. (52.1 cm.); w: 24½ in. (62.2 cm.)
Dated: 1866 (lower right corner)
Signed: DALOU (spurious; lower right corner)
Foundry mark: F. BARBEDIENNE. FONDEUR. (lower left)
Provenance: Shepherd Gallery, Associates, New York
Lender: The Metropolitan Museum of Art, New York, Rogers Fund, 1972

187.

The tragic actor Philibert Rouvière died in Paris on October 19, 1865, and was buried in Montmartre cemetery. Préault's two bronze reliefs for his tomb were finished by October of the following year, when Michelet saw them in his studio,[9] and both are dated 1866. They were set into a simple, upright round-headed stone, the upper composition being a head of Rouvière, probably modeled after a death mask, emerging from the bowl-shaped background favored by Préault for such works. It is ornamented with a tragic mask seen inverted beneath the proper left side of the actor's face. Below this medallion was set a shallow rectangular composition representing Hamlet encountering the ghost of his father (act I, scene iv). A drawing for the ensemble, its location now unknown, was reproduced in Eugène Montrosier's essay on the artist for the *Galerie contemporaine*.[10] Both reliefs were in place at least until 1920, when a photograph of the tomb was published by Jean Locquin.[11] According to Robert Kashey of the Shepherd Gallery in New York, the present relief, signed "Dalou" at the lower right, presumably in place of an effaced Préault signature, was acquired by him in the early 1960s at a minor auction in New York. At that time, his research established that the Montmartre cast had cracked and been removed from the tomb, and that half of it was in the possession of the cemetery authorities. That fact, combined with the fact that Henry Jouin, who was scrupulous in such matters, records only that the tomb relief was signed "A. Preault, 1866," making no mention of a founder's mark,[12] makes it almost certain that the present cast is not the one originally on the tomb.

In the relief, Préault indicates the location of the scene by a Romanesque column at the right and the time by a crescent moon at the upper left. He differentiates Hamlet and the ghost not only by enlarging the scale of the latter, but by playing off the broadly simplified forms of the ghost's drapery and profile — perhaps an effort to convey immateriality in bronze — against the relatively more active handling of Hamlet's clothing and his frenetic and dramatic gesture. A curious touch is the winged helmet worn by the ghost; whether it derived from the stage production or not is uncertain.

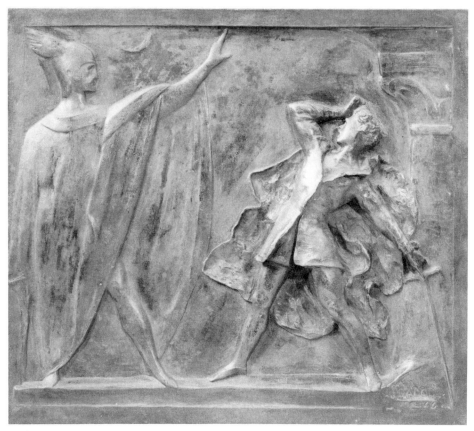

188.

Philibert Rouvière was born in the same year as Préault and certainly must have known the sculptor, since he was a Romantic figure and member of the generation of 1830 who was close to Delacroix and admired by Gautier.[13] Beginning as a painter, he studied with Gros and exhibited a revolutionary subject in the Salon of 1831. He made his acting debut in 1839 and eventually became best known for his Hamlet, a role he first performed in the production of Paul Meurice (whose tomb was also executed by Préault) and Alexandre Dumas at St. Germain in 1846. Although this production opened in Paris in 1847, it was not until its revival some years later that Rouvière's identity with the title role was firmly established. It was then that Baudelaire referred to his performance as "a tour de force that will make a mark in the history of the theater,"[14] although the poet seems generally to have preferred the actor in less introverted roles.

Rouvière portrayed himself several times in his paintings as Hamlet; he was so portrayed by Manet in *The Tragic Actor* now in the National Gallery, Washington. Rouvière was also portrayed as Hamlet in sculpture by Auguste Poitevin, whom one critic called "an imitator of Préault,"[15] in a large medallion exhibited at the Salon of 1866. C.W.M.

Notes

1.
Silvestre, 1856, p. 290.
2.
"Ecole spéciales de peinture et sculpture de Paris: Enrégistrement de MM. les élèves," Archives nationales, Paris, AJ52 234.
3.
P. Miquel, *Le Paysage français au XIXe siècle, 1824–74,* 3 vols., Maurs-le-Jolie, 1975, passim.
4.
A. Hugo, *Victor Hugo raconté par un témoin de sa vie,* Paris, 1885, I, p. 279.
5.
T. de Banville, *Mes Souvenirs,* Paris, 1882, pp. 267–68.
6.
Ibid., p. 261.
7.
J. Troubat, *Notes et Pensées,* Paris, 1888, p. 69.
8.
Illustrated in G. Bourgin, *La Guerre de 1870–1871 et La Commune,* Paris, 1938, p. 428.
9.
J. Michelet, *Journal,* ed. P. Viallaneix, Paris, 1959–76, III, p. 426, entry for October 18, 1866.
10.
Montrosier, n.d., p. 1 (unpaginated). The drawing is dated 1866.
11.
Locquin, 1920, p. 460.
12.
Jouin, 1897, p. 192. The *Inventaire des richesses d'art de la France. Paris, monuments civils,* III, Paris, [1902], p. 116, likewise fails to mention a founder's mark. The photograph in Locquin's article (see note 11) is not sufficiently clear to read whatever inscriptions may be on the bronzes.
13.
I have depended for these and the following facts on D. Solkin's extensive resume of Rouvière's life and career in "Philibert

Rouvière: Edouard Manet's 'L'Acteur Tragique,'" *Burlington Magazine,* November 1975, pp. 702–9.
14.
C. Baudelaire, "Rouvière," *L'Artiste,* December 1, 1859, p. 159 (reprinted with minor changes from "Philibert Rouvière," *Nouvelle galerie des artistes dramatiques vivants,* Paris, 1855).
15.
C. de Sault [Mme. Guy de Charnace], "Salon de 1866," *Le Temps,* July 4, 1866, p. 2.

Selected Bibliography

Silvestre, 1856, pp. 81–303 (reworked for "Préault" in Silvestre, n.d., pp. 154–72).

Bataille, C., "Auguste Préault," *Diogène,* January 25, 1857, pp. 1–4 (condensed and adapted for "Auguste Préault," *Le Boulevard,* July 15, 1862, p. 7).

Chesneau, E., "Auguste Préault," *L'Art,* 1879, II, pp. 3–15 (reprinted with additions and minor changes as "Auguste Préault" in Chesneau, 1880, pp. 119–54).

Montrosier, E., "Auguste Préault," *Galerie contemporaine,* Paris, n.d.

Clarétie, 1882–84, I, pp. 289–312.

Lami, 1914–21, IV, pp. 112–19.

Locquin, J., "Un grand Statuaire Romantique, Auguste Préault, 1809–1879," *La Renaissance de l'art français et des industries de luxe,* November 1920, pp. 454–63.

Barré, Y.-Em., "Le sculpteur A.-A. Préault, né rue Cambon," *La Cité,* January 1922, pp. 15–32.

Born in Paris of a Norman father and a mother from Lorraine, schooled in Rouen (1851–53), and formed as a professional sculptor in Brussels (1871–77), Rodin was nonetheless Parisian in the most essential sense. He tasted the broadest possible range of experiences offered by that richly endowed city in the late nineteenth century. He knew how to live simply, in the crowded part of the city on the Left Bank behind Ste. Geneviève, for that was how his family lived; he knew how to do mediocre work, for he was a poor student; he knew what it felt like to be the outsider, for he was never accepted at *la grande école*—the Ecole des Beaux-Arts —a truly amazing fact when we know what Rodin was to become. It was certainly part of the reason Rodin remained at a distance from most sculptors who were his contemporaries, men such as Chapu (b. 1833), Mercié (b. 1845), Barrias (b. 1841), and Saint-Marceaux (b. 1845). Only Dalou (b. 1838), whom he had met at the Petite École in the 1850s, became a real friend. All of these artists, even those younger than Rodin, showed their work in the imperial Salons. Rodin never did. He tried in 1864 with his *Man with the Broken Nose* (cat. no. 189), but he was turned away. Rodin also had a brief experience in the novitiate of the Society of the Blessed Sacrament, a religious order that combined attention to aesthetic matters with service to the growing number of workers in Paris. He also served as a soldier in the months that followed the collapse of the Empire. But these were the unusual things. What was normal for Rodin as a young man living in Paris during the Second Empire was learning to become an artist, trying to earn enough money to help his family, and, after 1864, supporting Rose Beuret and their son. He studied at the Petite Ecole, at the Louvre, and at the Bibliothèque Impériale, in Barye's anatomy course in the basement of the Musée d'Histoire Naturelle, and in the studio of Carrier-Belleuse (see cat. no. 198), one of the great decorative sculptors of the Second Empire.

In 1870, when the Second Empire collapsed, Rodin was thirty. For a man who was to become the world's most celebrated artist, his career and his life upon entering middle age were very tentative indeed. The confusion and the impossibility of making

a living once he was out of the National Guard drove him north to Brussels in 1871. There he became a regular sculptor, one who worked on big commissions such as the Bourse, the Palais des Académies, and the Conservatoire Royal de Musique. In addition he made decorative groups and busts (see cat. no. 190) that could be sold to the new bourgeois market, to people who were purchasing sculpture for the first time.

Brussels was also the city in which Rodin created his first masterpiece, in 1875. Thinking back to "the terrible year," to the agonies experienced by so many Frenchmen in 1871, he fashioned a warrior with a spear in his left hand and called his figure *Le Vaincu.* By the time Rodin sent his statue to Paris in the spring of 1877, he had removed the spear and changed the title to *The Age of Bronze* (fig. 66). It was a success, though controversial, for the naturalism of the figure was so superb that some accused him of having worked with the aid of a life-cast. Rodin fought against this slander. In the end controversy benefited him, for it brought him to the attention of Edmond Turquet, the Undersecretary of State for Fine Arts. Turquet gave Rodin the commission that would become the most extraordinary sculptural project of the century — *The Gates of Hell.* It was a commission for bronze doors to be installed in the newly planned Musée des Arts Decoratifs. Rodin conceived a scheme that would parallel the great medieval church portals with a central figure (*The Thinker,* cat. no. 195), bearing within it all the moral potency that Christ had once borne. Rodin's initial inspiration for the ensemble was Dante's *Inferno* — this, too, familiar and in a recognizable tradition, but Rodin managed to turn his doors into a personal vehicle for some of his most private conceptions in sculpture. When some of the individual figures began to appear in exhibitions in late 1882, both public and critics were shocked by their boldness.

The Third Republic established monuments in every corner of every city — "statuemania" it has been called. Like other sculptors, Rodin entered as many competitions as he could. His most successful monument was *The Burghers of Calais* (fig. 72). He began working on it in 1884, won the commission in January of 1885, and had the six figures in the final scale in plaster for the large exhibition that he held jointly with Monet at the Galerie Georges Petit in 1889.

The year 1889 was a watershed for Rodin. Throughout the 1880s his reputation grew steadily, primarily because of the spectacular portraits he showed in the Salons along with two great figures — *The Age of Bronze* and *St. John the Baptist Preaching* (cat. no. 191). He put them into the Salons of Paris, Ghent, Brussels, London, Munich, and Vienna, and he showed them again at the Exposition Universelle of 1889, which ran concurrently with the show at Georges Petit. There he installed a number of his more daring pieces from *The Gates of Hell,* as well as *The Burghers* in full scale and his model for a monument to Bastien-Lepage.

Within months of closing the two exhibitions, Rodin received a commission he desperately wanted: the commission for a monument to Victor Hugo. He chose to represent Hugo on the lonely rocks of Guernsey, evoking the memory of the poet's resolute resistance to the empire of Louis-Napoleon. Rodin thus entered the decade of the 1890s with many commissions in various states of completion, as well as a large body of completed works. By this time he had received the Cross of the Legion of Honor and counted famous politicians and writers among his close friends.

In response to his fame came one of the century's most talked-about commissions: the *Monument to Balzac.* Since Balzac's death in 1850, sculptors had been vying for this prize. In July 1891 the Société des Gens de Lettres voted to give the commission to Rodin. It became his most controversial work. Rodin went about his work carefully, reading Balzac's books, traveling to the Touraine to look at Balzac's people, and studying every representation of the great novelist that he could. The thinking

and the work resulted in numerous studies and variations (see cat. no. 205), and finally he decided upon a figure clothed in a long gown, the body tilted back, from which rises the great head with its deep-set eyes beneath the imposing forehead and shock of hair. Rodin presented the plaster at the Salon de la Société Nationale in 1898. It was more damned than praised by press and public alike. The Société des Gens de Lettres made a declaration eleven days after the opening of the Salon: the members refused "to recognize the statue of Balzac." The controversy that followed became the "Dreyfus Affair of the art world," and it made Rodin into a figure of world renown.

As the new century began, Rodin's profit from this *succès de scandale* was substantial. Paris had planned the biggest world's fair ever for the turn of the century, and Rodin established his own one-man show adjacent to the exhibition grounds in the tradition of Courbet and Manet. It was a huge success, both critically and financially. When it closed, it was safe to say that Rodin had achieved the position of "most celebrated artist" in Paris, the city where the clamor for fame exceeded most other human passions.

Rodin initiated no new work in the twentieth century that would compare to the grandeur of his accomplishment during the century just finished. He continued to work on *The Gates,* even after 1904 when the State withdrew the credit established in 1885 to cover the cost of casting; he enlarged some of his earlier sculptures, particularly *The Thinker* and *The Walking Man;* he executed many busts; he gave interviews so that books might be written about him; and he even wrote books himself, his most serious effort being *Les Cathédrales de France* (1914), written in collaboration with the Symbolist poet Charles Morice.

Rodin's last years were difficult. He lived them out during the First World War, and he was not in good health. The brightest spot was surely when his dream of creating a museum for his work became a reality. On December 15, 1916, the National Assembly voted to establish the Rodin

Museum in the Hôtel Biron, that beautiful eighteenth-century residence to which Rilke had taken him in 1908 and which Rodin gradually took as his own. The Hôtel Biron has been used to house Rodin's marbles, bronzes, paintings, drawings, his most important plasters, and his own art collection. The Villa des Brillants in Meudon, where Rodin died on November 17, 1917, became an annex to the museum. There we find the vast collection of plasters. Since Rodin's death, the Rodin Museum has not only been responsible for this unique collection, but it has also continued the productions of Rodin's sculpture in bronze which, according to a provision in his will, may be made in editions of twelve casts. R.B.

189.
Man with the Broken Nose
Bronze
h: 12½ in. (31.8 cm.)
1863
Signed: A. Rodin (on front lower left)
Foundry mark: ALEXIS RUDIER./
FONDEUR. PARIS. (on inside lower left)
Lender: The Fine Arts Museums of San Francisco, Gift of Mrs. Alma de Bretteville Spreckels

The imprint of Rodin's greatness as a sculptor—his ability to model richly and fluidly, his gift for creating expressive qualities through his modeling—is clear for the first time in the *Man with the Broken Nose.* We can recognize its superiority if we compare it to the bust of his father (1860), the bust of Father Eymard (1862), and the bust of the little Alsatian girl (1863). We would recognize the *Man with the Broken Nose* as special even if Rodin had not made such a point of it: "That mask determined all my future work...I have kept that mask before my mind in everything I have done." [1]

The circumstances in which Rodin created *Man with the Broken Nose* are important. He began it in 1863, the year in which he definitively decided to be a sculptor, having relinquished a brief vision of himself as a member of a religious order. When he left the Society of the Blessed Sacrament in May 1863, he rented his first studio, a stable near Gobelins in the Rue de la Reine Blanche. The only work we know for certain that Rodin produced in this studio is the *Man with the Broken Nose,* "made from a

poor old man who picked up a precarious living in the neighborhood by doing odd jobs for anyone who would employ him and who went by the name of 'Bibi.'" When asked why he had chosen this particular model, Rodin replied: "He had a fine head; belonged to a fine race—in form—no matter if he was brutalized. It was made as a piece of sculpture, solely, and without reference to the character of the model as such. I called it 'The Broken Nose,' because the nose of the model was broken." [2]

Rodin worked on his head for at least a year, through a winter of cold so extreme that the clay head froze and the back cracked and fell off. All the time he was working, he was trying to capture visual reality through the modeling. As Rodin himself emphasized, he was not interested in the personality of the sitter. This was probably one of the reasons he was unsuccessful when he presented the mask at the Salon of 1864. How well an artist captured the essence of his sitter's character was half the appeal for a typical nineteenth-century audience; a portrait of an unknown man by an unknown sculptor was not bound to gain automatic entrance at a Paris Salon. Rodin finally showed it successfully at the Brussels Salon of 1872, where it was greatly admired. Then in 1875 he hired a *practicien* to carve a marble version of it as a full-scale bust. This was accepted at the Paris Salon of 1875. Both the material and the completeness made it look quite classical, and the mask itself was finally accepted for the Salon of 1878, where it caught the eye of a critic who was reminded of the *Bust of Michelangelo* in the Louvre. [3] When an American correspondent saw it at the Grosvenor Gallery in London in 1882 he found it to be like "the best art of Greece." [4] Since it was not a proper bust, such comparisons made the *Man with the Broken Nose* more comprehensible and more acceptable to a Salon audience. From this time on, Rodin's male portraits were of identifiable people.

By 1882 the *Man with the Broken Nose* had appeared in Brussels, Paris, Nice, and London, and it began to be one of Rodin's most popular works, especially in England where ten casts were sold by 1889. [5] There

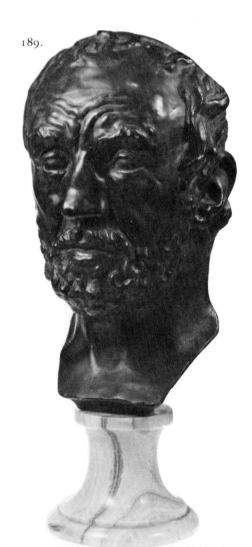

189.

are many variations in terms of size, material, format, and scale. In bronze, two versions are especially distinct: one that ends below the beard and one that continues to the sternum, as we see in the San Francisco version. The other most notable variation in the bronzes is the way the head is mounted. Most often it is at a tilt, though sometimes it is mounted upright, as in the San Francisco mask. R.B.

190.
Suzon
Bronze
h: 15¾ in. (40 cm.); w: 8 in. (20.3 cm.); d: 7 in. (17.8 cm.)
1872
Signed: A. Rodin (on lower back)
Foundry marks: C^ie des bronzes/Bruxelles (on left side)
Numbered: 7549 (on lower back)
Lender: Los Angeles County Museum of Art, Gift of Mrs. Leona Cantor

Suzon was one of the two terracotta heads that Rodin sold to the Compagnie des Bronzes in Brussels in 1872.[6] Lack of work had forced him to leave Paris in 1871 and go to Brussels. We can imagine that, whatever else he decided during that difficult period, he was determined to make some money. Rodin understood quite well what would sell in the mass market from a stylistic point of view. Unfortunately, he did not have an equivalent understanding of the business aspects of such work, and he sold his busts to the Compagnie des Bronzes for fifty francs each; they in turn had them cast in three sizes and sold them by the thousands. *Suzon* was in production at the Compagnie des Bronzes until 1939.[7]

For his popular money-making busts Rodin created a type of pretty young girl that had been popular during the Second Empire, especially in the studio of Carrier-Belleuse (see cat. no. 53). *Suzon* is an example of the type. With her head encircled by a ribbon, she turns, her eyes focus, her mouth opens, and she appears responsive and alive. A cameo hangs from a ribbon around her neck, and the bust ends in an easy curve with the gathered edge of her blouse extending over the right edge of the base. This contributes to the general feeling of intimacy, one that is familiar from eighteenth-century busts and which became prominent again in Second Empire portraits.

The patina chosen by the Compagnie des Bronzes for these works was, as we see it here, smooth and shiny, creating a very un-Rodin-like slickness. R.B.

191.
St. John the Baptist Preaching
Bronze
h: 31 in. (78.7 cm.); w: 19 in. (48.3 cm.); d: 9½ in. (24.1 cm.)
Model 1878; cast 1966
Signed: A. Rodin (on top of base)
Foundry mark: • Georges RUDIER •/ • Fondeur PARIS •(at back right side of base)
Lender: Los Angeles County Museum of Art, Gift of B. G. Cantor Art Foundation

Rodin created few works that we consider true Salon figures in the great tradition of statues taken from literature, mythology, the Bible, and from established decorative types in marble, bronze, and plaster. *St. John the Baptist Preaching,* along with *The Age of Bronze* (fig. 66), was the closest Rodin ever came to making a real Salon figure. Still, it was not a conventional *St. John.* The position, the movement, the overall feeling of aggressiveness betrayed an absence of academic decorum. Also it had no attribute, standard equipment for a Salon statue. Right up until the last moment, it appears that Rodin considered showing St. John with a cross in his left hand. In the end he removed it.[8] Even without the attribute, however, the subject was clear. In this hoary bearded head could be recognized the traditional religious portrayal. It was even clearer in Rodin's *Bust of St. John* which he prepared separately for the Salon of 1879 and for which he won his first Salon recognition—an honorable mention. The full figure, with its outstretched arm and pointed finger of the preacher, developed from images of St. John in the late Middle Ages and the Renaissance. The *St. John the Baptist* on the Baptistry in Florence by Rustici provides the closest comparison. It was surely a statue that Rodin noticed during his visit to Florence.[9]

190.

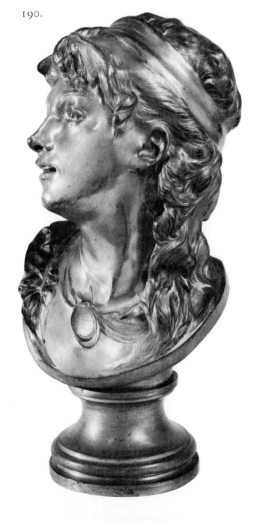

329

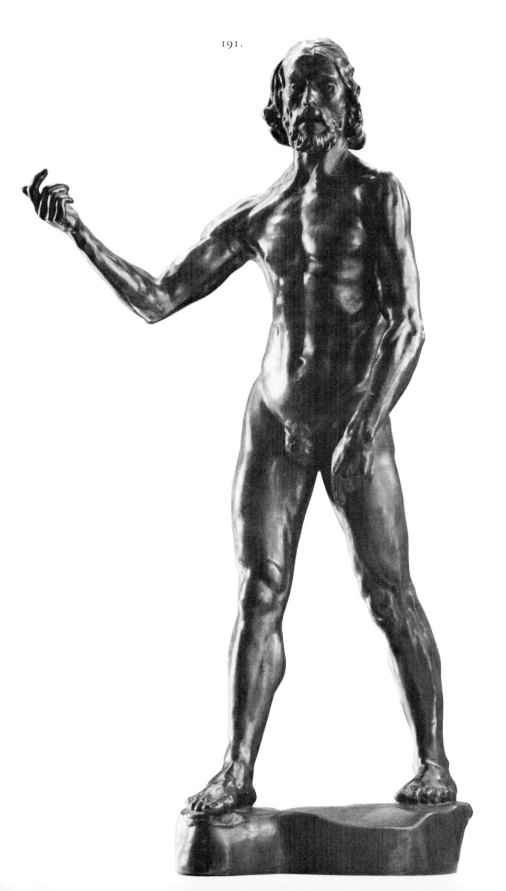

191.

Most probably Rodin began working on *St. John* in late 1877. Just as it had been with the *Man with the Broken Nose*, with the *St. John* Rodin was particularly open to the special traits of a model: "One morning, someone knocked at the studio door. In came an Italian, with one of his compatriots who had already posed for me. He was a peasant from Abruzzi, arrived the night before from his birthplace, and he had come to me to offer himself as a model. Seeing him, I was seized with admiration: that rough, hairy man, expressing in his bearing and physical strength all the violence, but also all the mystical character of his race. I thought immediately of a St. John the Baptist; that is, a man of nature, a visionary, a believer, a forerunner come to announce one greater than himself."[10] Rodin shared this recollection of the origin of *St. John* with Dujardin-Beaumetz about 1910. He probably simplified the story; Rodin was constantly in the process of fashioning the history of his own work during the last years of his life, but there is no doubt that the model, Pignatelli, had a body that provoked and aided Rodin as he formed his conception of St. John.

Rodin had his statue ready in plaster for the Salon of 1880. He presented it along with a bronze cast of *The Age of Bronze*. It was interesting to compare his two large statues and to discover that in his *St. John* Rodin had developed beyond the very beautiful and controlled *Age of Bronze*. He made *St. John* squarer, more angular and powerful, and he put great emphasis on the extremities. He fashioned hands and feet to be emphatic in order to give both meaning and visual punctuation to the work. But even more important was the movement, an element that was swiftly becoming the central issue in Rodin's work. Reaction to the statue was mixed: "powerful and healthy.... What fire in his look and on his lips. What authority in his gesture!...a marvel of reality...precise and significant execution." *St. John* was also seen as the "worst-built man in the world." It was said to give evidence that Rodin could approach the extremes of "ugliness and triviality... M. Rodin shows us in his 'St. John' that vice has its manner of expression and ugliness its degrees. It would be difficult to find anything more repulsive than this statue."[11]

The *St. John the Baptist Preaching* quickly came to be recognized as one of Rodin's great early successes. The State purchased the plaster out of the Salon in 1880, and it was often sent abroad as an example of modern French sculpture. How popular Rodin's *St. John* became is evident also from the number of casts that exist — about fifty in all. This became possible because of an agreement that Rodin made with Fumière et Cie in 1898 whereby his statue might be reproduced in three different sizes: 80 cm, 50 cm, and 20 cm.[12] There are fourteen full-size bronze casts of the *St. John* and five of them are in the United States.[13] R.B.

192.

The Call to Arms
Bronze
h: 44½ in. (1.13 m.); w: 22¾ in. (57.8 cm.); d: 16 in. (40.6 cm.)
1878
Signed: A. Rodin (on right side of base)
Foundry mark: ALEXIS RUDIER/FONDEUR, PARIS (at left rear of base)
Lender: Ackland Art Museum, University of North Carolina, Chapel Hill

The municipalities of the Third Republic generated numerous competitions to honor great men and past events relevant to the Republic and pride in national life. How strange it seems that the greatest sculptor of the Third Republic should have played so small a part in this process. Perhaps Rodin's experience in creating *The Call to Arms* and *Bellona* (cat. no. 193) contributed to steering him away from the big political competitions. He began both with high hopes of success, and, though they were noticed in the press, neither of these projects was considered by the judges as a serious candidate for the commissions.

The Prefecture de la Seine announced a competition in the spring of 1879 for an allegorical group of two figures that would commemorate the recent defense of Paris. The group would be placed at the *rond-point* of Courbevoie, to the west of the city, where a monument had been destroyed during the Franco-Prussian War. Sketches were to be submitted by November 5, so Rodin must have worked on his project through the summer and fall of 1879.[14]

192.

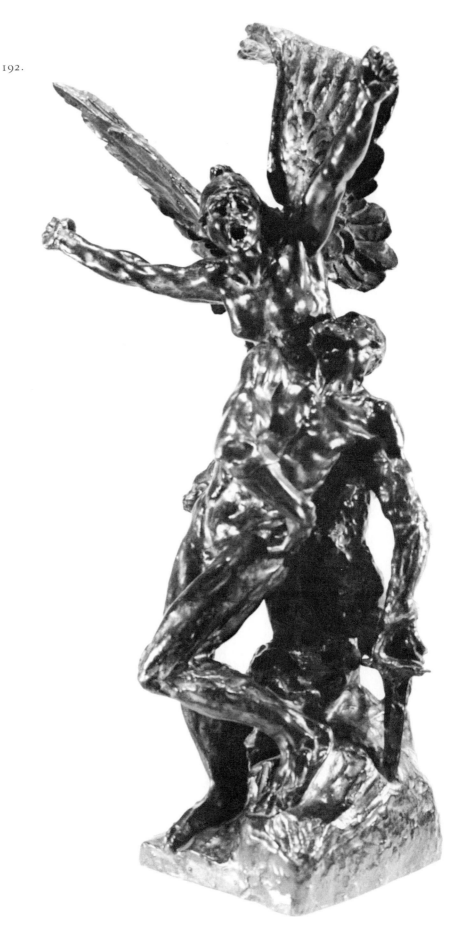

He chose to develop his group in terms of the powerful juxtaposition of a dying warrior and a fighting winged genius. Since the latter wears a Phrygian bonnet, we must recognize her as the Republic. Just as the young warrior slips from her bosom into death, she appears to rise up to begin the fight anew. The two works of sculpture that had the greatest influence on Rodin as he developed his group were the two most popular images in sculpture in France based on the theme of modern war: Rude's *Departure of the Volunteers of 1792,* or *La Marseillaise,* (fig. 71), and Mercié's *Gloria Victis!* (cat. no. 167). In Rude's relief, Rodin found inspiration for his winged genius. She, like Rude's *Genius of Liberty,* shouts, throws out her arms, and presses her body forward in urgent fury. Rodin even emulated Rude by using his mistress Rose Beuret as his model, for it was well known that Rude's wife Sophie had posed for *La Marseillaise.* Rodin's second source, Mercié's *Gloria Victis!* (cat. no. 167), was the most sympathetic response to the loss so many Frenchmen felt after the Franco-Prussian War, and it had become France's most loved modern monument. It provided Rodin with a model for a group that combined a winged female figure and a nude warrior holding a broken sword.

It seems strange that, in spite of Rodin's dependence on such solid and notable sources, his group was given no consideration among the finalists. The reasons should be understood in terms of both the way Rodin treated the subject and his stylistic approach. The finalists were more politically attuned to what the judges wanted. They all showed the city of Paris, not the Republic. After all, this was a group commemorating the Siege of Paris, so they fashioned their figures with the most realistic details of dress, setting, and arms. Another issue that must have counted against Rodin was the bellicose nature of his treatment. In 1879, when the Republic had finally solidified, after one of the most troubled decades in French history, people wanted to focus upon peace. To show a fighting Republic in 1879 was not in the national interest.

In terms of style Rodin's group must have appeared too ferocious and too full of movement. His figures express themselves broadly and their proportions and expres-

sions must have appeared jarring and wild when put beside the groups of Moreau, Lequien, and Barrias—the three finalists. In the twentieth century, Rodin reflected on the competition: "I still often ask myself why I ever entered. Indeed, I could not challenge Barrias and Mercié. My group must have appeared too violent, too intense. So little progress has been made since the *Marseillaise* by Rude, which also cries with all its strength."[15]

In the figure of the fallen warrior we see a recognizable shift in style from that of *St. John,* done only one year earlier. The proportions are broader and the body is anatomically ponderous. The figure is the first of Rodin's great Michelangelesque male nudes of the type we know best from *The Thinker* and *Adam,* both of 1880.

The size of the work in this exhibition is the same as the competition sketch. There are at least ten other casts in bronze in this dimension, five of which are in the United States, including the Ackland Art Museum version.

A concrete plan for using the group as a public monument was made possible by a group of Dutchmen who commissioned an enlargement in 1916 to be placed in front of the Porte St.-Paul in Verdun. In so doing they wanted to express their sympathy for the loss of the men of Verdun, of Lorraine, and of France during the World War. The monument was unveiled in 1920. R.B.

193.
Bellona
Bronze
h: 32 in. (81.2 cm.); w: 18½ in. (47 cm.);
d: 17¾ in. (45.1 cm.)
1879
Signed: A. Rodin (on lower right side)
Foundry mark: A. Gruet aine Fondeur/
PARIS (on lower back)
Provenance: Hugh V. Warreneler
Collection, Garrick Club Collection,
London
Lender: Stanford University Museum of
Art, Gift of B. G. Cantor Art
Foundation

One of the Parisian competitions of 1879 was for a bust of the Republic to be installed in the newly-built *mairie* of the 13ᵉ arrondissement. Fifty-four sculptors entered; their busts were put on exhibition at the Ecole des Beaux-Arts in December 1879. In the press, Rodin's entry was noticed as being among the most interesting; one journalist spoke of this "artist

193.

who has already attracted public attention with his work for the 'Defense of Paris,' M. Rodin has entered a work of outstanding originality, but one that will not be chosen by the jury. Instead of showing us 'The Republic' he has shown a fierce Bellona, one whose physiognomy is truly dramatic."[16] Another critic referred to the "tormented figure under the helmet" as being "one who brings to mind no traditional figure. No, it is certainly not here that we are able to see our amiable Republic."[17]

Just as in *The Call to Arms* (cat. no. 192), Rodin had created a work that was too powerful, too expressive, and too far outside the tradition for such a bureaucratic situation as a new *mairie*. Almost perversely it would seem, Rodin failed to include the Phrygian bonnet, thus not identifying the figure as the Republic, which was the essence of the competition. Instead, he placed a beautiful helmet on the thick rich hair that pushes up beneath the broad lion muzzle, curls back into volutes, and ends in a fan-shaped peak. The power of the headdress and the way it sits upon the head, casting a strong shadow across the eyes, appears to be a direct reference to Michelangelo's figure of Lorenzo in the Medici Tombs. But this did not help in making the bust into an image of the Republic as far as the judges were concerned.

With *Bellona (The Republic)* Rodin failed in the same way that he had with *The Call to Arms (The Defense of Paris)*. The subject did not match the goals of the competition, and from a stylistic point of view the work appeared too severe, too massive, and lacking decorum and grace. The work also succeeded in the same ways that *The Call to Arms* had, for it is powerful and expressive and it bears comparison with Michelangelo's works, both in specific details and in the general mood of seriousness.

Once again Rose was Rodin's model. If we compare the bust to the head of the *Genius of War,* or better still to a photograph taken of Rose in the early 1880s,[18] we can see the liberties that Rodin took with her face. Judith Cladel said that Rodin made a study of Rose's face after a domestic quarrel and that this expression became the basis for *Bellona*.[19] Rose was known for her temper and Rodin must have seen her angry moods quite often, but we cannot explain this face solely in terms of realism. All the features are exaggerated—the chin, nose, cheekbones, eye-

brows—as well as the powerful neck. Each part comes into strong relief, in a way that Rose's features did not.

The only other bronze cast of *Bellona* in the United States is in the Philadelphia Museum of Art. A unique marble version, shown in the 1889 Rodin/Monet exhibition at the Galerie Georges Petit, is in the collection of Dr. Jules Lane in Hicksville, New York. R.B.

194.
Vase of the Titans
Terracotta
h: 15 in. (38.1 cm.); d: 16½ in. (41.9 cm.)
c. 1879–80
Signed: A. Carrier-Belleuse
Provenance: Samuel Hill Collection (purchased between 1915 and 1923 from either Rodin or Loie Fuller)
Lender: Maryhill Museum of Fine Arts, Goldendale, Washington

The *Vase of the Titans* is a rare work by Rodin in that it has become known only in recent times. It was long hidden behind the Carrier-Belleuse signature. One of the two existing terracotta versions first appeared in an exhibition at the Musée Rodin in 1957. The show was "Rodin: His Collaborators and His Friends," and the vase was shown as a Carrier-Belleuse. The stylistic similarity to Rodin's work and the dissimilarity to that of Carrier-Belleuse drew attention to the work. Rodin connoisseurs did not have to wait long to have their suspicions confirmed. The following year two maquettes attributed to Rodin that were clearly the models for two of the four titan figures were sold at Parke-Bernet Galleries in New York.[20] The Maryhill terracotta is identical to the one that was shown at the Musée Rodin.[21]

In this work we see an intense concern with anatomical development, complicated contrapposto, and the creation of strong emotions through introverted gestures. These qualities date the work securely in the period following Rodin's trip to Italy during the winter of 1875–76 on which Rodin learned "a few of the secrets of the great magician," Michelangelo.[22] The things he learned on that trip were dominant factors in his style during the next five years. The question is: where to place the *Vase of the Titans* within this period? Most scholars have considered it a work that was done soon after Rodin's return

194.

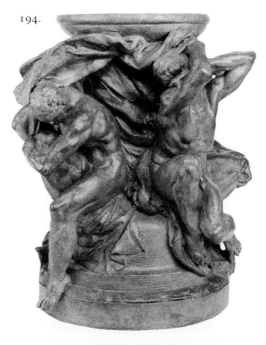

from Italy.[23] If that were true, the Carrier-Belleuse signature is mysterious, for Rodin did not rejoin his old master until 1879 when he accepted a position on the staff of the Manufacture de Sèvres, which Carrier-Belleuse had directed since 1876. It seems more likely that Rodin executed the *Vase of the Titans* while at Sèvres and working with Carrier-Belleuse. Although he primarily did low-relief compositions, Judith Cladel does mention that he modeled figures for a large *surtout de table;*[24] there also exists a porcelain example of the *Vase of the Titans* (Bethnal Green Museum, London), which would be the correct material for a work done at Sèvres. Stylistic evidence as well would argue for an 1879 or 1880 dating. The closest comparisons for the figures are to be found in the warrior of *The Call to Arms* and the male figures associated with Rodin's early work for the portal, figures such as *Adam, The Thinker,* and especially the *Despairing Man.*[25]

As we see the work in its present state it looks odd and unfunctional. It was intended to serve as a base for a large vase in another material such as faïence. We must look at works by Carrier-Belleuse in order to find examples that show us the intended assembly of base and vase.[26] R.B.

195.
The Thinker
Bronze
h: 28 in. (71.1 cm)
1880
Signed: A. Rodin (on the base)
Foundry mark: Alexis Rudier/Fondeur Paris
Lender: The Toledo Museum of Art, Gift of Edward Drummond Libbey in Memory of Dr. Frank W. Gunsaulus

The Thinker is Rodin's best-known work although it is not his best work. There are three major reasons for its fame: it is the focal point of Rodin's biggest and most important undertaking, *The Gates of Hell;* its lineage is particularly obvious; and, once enlarged, it could carry a wide variety of meanings for the general public.

Rodin received the commission for a set of portals for the new Musée des Arts Decoratifs in August 1880. He chose Dante's *Inferno* for his theme. Quickly he decided that there would be one figure high up and in the middle of the portals to serve as spe-

cial focus. Before the end of the year he had modeled an architectural sketch that included this figure: a seated naked man with one arm across his knee and the other raised to his lowered head. Even in this rough state, it was clearly inspired by Michelangelo's statue of Lorenzo de Medici —*Il Pensieroso*—which had also been on Rodin's mind the previous year when he had created *Bellona.* The nineteenth-century public was able to recognize another famous figure—Carpeaux's *Ugolino* of 1857–63 (cat. no. 32) also based upon subject matter taken from the *Inferno*—as an additional source for the seated figure.

Critics who visited Rodin's studio as early as 1882, in order to look at the figures he was making for the portal, spoke of the seated nude as the "superhuman Dante."[27] Most probably they would not have done so if Rodin had not also spoken of the figure with some kind of reference to the Florentine poet. In 1885 Octave Mirbeau saw the portal in an assembled state: "Below the capital, in a slightly vaulted, impressed panel, the figure of Dante detaches itself from the background in a pronounced, projecting position. Surrounded by bas-reliefs which represent his arrival in hell, Dante's pose recalls to a degree that of Michelangelo's *Thinker.* He is seated, his body leans forward, his right arm rests on his left leg, giving his body an inexpressibly tragic movement."[28] When the figure was shown separately in the Rodin/Monet exhibition of 1889 it was listed in the catalog as "Le penseur; Le poète; Fragment de la Porte." The association with Dante was not lost, but it was transformed into a more general idea of The Poet, poet in the sense of *poïetēs*—a maker, a creator. Albert Elsen has spoken of it as "a projection of Rodin the sculptor, and the artist in general, who confronts his own times and is judge of them."[29]

Throughout his career Rodin was concerned with scale and the effect that enlargement or reduction had upon individual sculptures. He found that he could work with scale changes in either direction, and each time he altered scale there was a remarkable effect both on the appearance and the content of a work. Particularly in the twentieth century he put much of his energy into his enlargements, and his greatest success was with *The Thinker.* Henri Lebossé began working on the enlargement in 1902. When the bronze cast was unveiled in front of the Panthéon

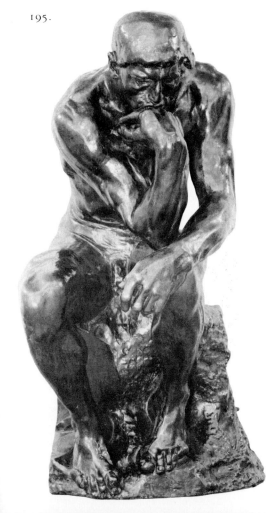

195.

in 1906, it became Rodin's first work to be placed in a prominent public setting in Paris. Secretary of Fine Arts Dujardin-Beaumetz spoke at the dedication, telling the people of Paris: "Before this great mute bronze, many generations will pass and succeed one another. His questioning gaze will ask them what they have done for the happiness of people. He will plumb the depths of their consciousness."[30] From that time on, *The Thinker* became one of the most monumental images ever made, one that could evoke a great variety of important human thoughts. In front of museums it has come to stand for man realizing his creative potential; on university campuses it is a symbol of deep intellectual search; and it takes on still other associations in front of a bank (Denver) or by a legislative building (Buenos Aires).[31] For Rodin himself, *The Thinker* became the one who ponders immortality in the most intimate way, for it was placed upon his grave in Meudon after his death in November 1917.

The 28-inch version from Toledo is the original size of the figure as it appears in *The Gates of Hell.* There are at least eleven other bronze casts in this size in the United States. R.B.

196.
Eve
Bronze
h: 68 in. (1.72 m.)
Begun 1880, finished in the 1890s, cast in 1913
Signed: A. Rodin (on top of base)
Foundry mark: Alexis Rudier, fondeur (at back of base)
Lender: Albright-Knox Gallery, Buffalo, New York, Gift of Colonel Charles Clifton

Every serious statement Rodin made in sculpture during his first nineteen years as a sculptor was based on the figure or the face of a man. He kept his representations of women light. That changed in 1879 when he entered two competitions, creating the Genius of War (see cat. no. 192) and the *Bellona* (cat. no. 193) with Rose serving as model for both. Soon after, he conceived of a truly great and serious woman—his *Eve.* We first learn of her existence in late 1880; Rodin wrote his friend Maurice Haquette, who was Secretary Turquet's brother-in-law, asking him as a favor to speak to his relative about "the two figures that are with my portal, but which have not been officially commissioned."[32] Rodin hoped to include in his

program for the doors a figure of Adam and one of Eve. Adam was an old concern for Rodin, dating back to 1876, long before he had the commission for the portal. But before 1880 he had never mentioned an Eve.

Clearly Rodin thought he would augment his vision for the portal by including *Adam,* the first human—his finger still quivering from the Creator's touch—and *Eve,* the first sinner—newly guilty and holding herself in remorse. The interpretation was easy, for everyone could recognize his references to Adam in *The Creation of Man* and Eve in *The Fall of Man* in Michelangelo's Sistine Ceiling. After having established the two basic events —creation and sin—the entire drama of hell was to follow.

There was a plaster *Adam,* over six feet tall, in the Salon of 1881. It was called *The Creation of Man,* and Rodin made it known that *Eve* would soon follow. After the Salon opened a critic wrote: "M. Rodin has put not a single note of elegance or of grace among the wedding presents of our first parents. *Eve,* which he has promised for next year, will be a worthy companion to this very unflattering figure of *Adam.*"[33] The reviewer spoke of *Eve* as if he knew what she looked like. Though expected in 1882, the large *Eve* did not appear until 1899. And strangely enough, none of the critics who were such frequent visitors to Rodin's studios during the 1880s mentioned a large *Eve.* The only person who claims to have seen her before 1899 (and we know this only second-hand) was Jules Desbois. He said that it was "turned toward the wall of a carriage-house in the Faubourg Saint-Jacques" during the period when Rodin was employed at Sèvres (1879–82).[34] There are three possibilities: that Rodin did not actually make his large *Eve* in 1880–81, and that which Desbois saw was, in fact, the 30-inch version;[35] or perhaps the large figure that Rodin made in the early 1880s was so tentative that he kept it out of sight; a further possibility is that he made it and then destroyed it. After *Eve* did appear in the Salon of 1899 she was mentioned regularly by biographers and critics, who always spoke of her as being an early work. When Lawton wrote about *Eve* he said: "Not taking into account the *Genius of War,* this

196.

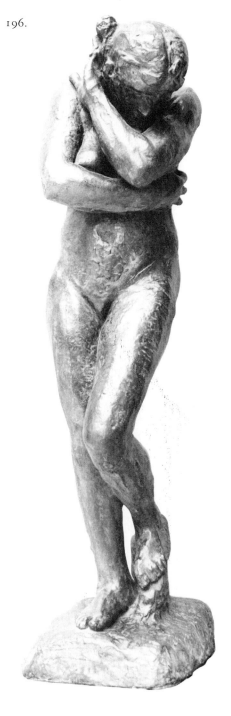

Eve was the first woman's life-size figure which the sculptor had placed before his countrymen."[36]

The history of the figure is not clear, but there is no doubt that Rodin began an *Eve* in 1880 to serve as pendant to *Adam*. We even know the model's name. She was Madame Albruzzezzi and Rodin loved to reminisce about her "sunburned skin, warm, with the bronze reflections of the women of sunny lands."

Without knowing why, I saw my model changing. I modified my contours, naively following the successive transformations of ever-amplifying forms. One day, I learned that she was pregnant; then I understood. . . . It certainly hadn't occurred to me to take a pregnant woman as my model for Eve; *an accident — happy for me — gave her to me, and it aided the character of the figure singularly. But soon, becoming more sensitive, my model found the studio too cold; she came less frequently, then not at all.*[37]

Perhaps Rodin did suspend work on his large *Eve* because he lost his model. We do not know how far he got in 1881, but the figure we see now, one of rough surface and lacking in finish, one that is so monumental in presence, is much more in the character of Rodin's work of the 1890s than of the 1880s. When the work was shown in the Salon of 1899 it caused a sensation, in part because Rodin chose to bury the base in sand rather than mount the statue on a pedestal; thus she appeared to be standing on the ground.

There are five life-size bronze casts of *Eve* in the United States. The casts owned by the Metropolitan Museum and the Toledo Museum were made slightly earlier than the Albright-Knox Gallery cast which was made in 1913. R.B.

197.
The Genius of the Sculptor
Brown ink and wash on brown transparent paper
h: 10⅜ in. (26.4 cm.); w: 7½ in. (19.1 cm.)
1880–82
Inscribed: la genie de la Sculpture/A. Rodin (in graphite on verso of old mount)
Provenance: Marcel L. Guerin (sold 1932); untraced period; Shepherd Gallery, Associates, New York
Lender: Mrs. Noah L. Butkin

The Genius of the Sculptor is a good example of Rodin's drawing style in the early 1880s. It depends on strong, swiftly drawn pen lines, shadows created through short rapid diagonal lines, and emphasis through the use of black blots. It shows Rodin's concern with creating compositions through the use of figures, and it is full of atmosphere, while lacking in descriptive detail. We can find good comparisons to this drawing from among the early *Gates of Hell* drawings,[38] as well as those related to Rodin's early drypoints, especially *Le Printemps*[39] and the drawings he did at Sèvres in the early 1880s.[40] The body position, the gesture of the sculptor, and the blackened faces create a certain feeling of anxiety and a general atmosphere that relates to Rodin's work during the formative stages of *The Gates of Hell*. The juxtaposition of a standing figure and a floating figure in different proportions was a challenge that excited Rodin all his life.

The most fascinating thing about *The Genius of the Sculptor* is its content. It is an early instance of Rodin's lifelong preoccupation with the nature of creativity and the sources of inspiration. Here is the sculptor in anguish before his work. Inspiration comes enigmatically from a small floating figure who holds him in an embrace. There are certain parallels with *The Thinker*, both stylistically and thematically, an idea that is perhaps confirmed by a group Rodin made in the 1890s, *The Sculptor and His Muse* (The Fine Arts Museums of San Francisco), in which we find a tormented *Thinker*-like figure with a face resembling that of the *Man with the Broken Nose* being inspired by a female figure pressing close to him and whispering mysteriously in his ear. In the sculptural group, Rodin made the sexual nature of inspiration very explicit, as he had not done in the drawing.

Another continuation of the theme that is introduced in *The Genius of the Sculptor* can be seen in some of the versions of the *Monument to Victor Hugo*, where the Muses breathe inspiration into the poet while he sits upon the rocks and raises his hand to his head in deep concentration. R.B.

198.
Albert-Ernest Carrier-Belleuse
(1824–1887)
Sèvres porcelain
h: 14½ in. (36.9 cm.); w: 9½ in. (24.1 cm.); d: 6 in. (15.2 cm.)
Model 1882, cast 1907
Signed: A. Rodin (on right side beneath shoulder)
Marked: Sèvres de/S/1907 (on back of socle) (on back of socle)
Inscribed: C B (on front of socle)
Lender: Indianapolis Museum of Art

Like many nineteenth-century sculptors, Rodin's first creations were busts. During his first twenty years of work he did more of them than anything else. The making of busts had become familiar and easy for Rodin, and many of his early ones are fine works; but suddenly in 1881, with his energies at a peak of intensity as he laid out his scheme for the great portal, he shifted to a new level of mastery in this area of sculpture. His male portraits of the early 1880s are extraordinary. Their value as portraits — likenesses that represent an individual — has seldom been surpassed.

One such bust was of Carrier-Belleuse (1824–1887), the most accomplished master of decorative sculpture in Paris. Rodin made his bust when Carrier-Belleuse was fifty-eight, had been showing and selling for over thirty years, and had settled down as the Director of Works of Art at the Manufacture de Sèvres, still maintaining a large studio in Paris. Rodin had known him for eighteen years; the older artist had employed him, taught him, used him, fired him, befriended him, and employed him again. When Rodin executed the bust he was still on the staff at Sèvres; so it seems highly appropriate that he should have conceived the bust that it might be reproduced in a *biscuit* edition. *Biscuit* had been one of Carrier-Belleuse's pet projects while director at Sèvres; he fostered a revival of this technique in porcelain that had been so popular during the eighteenth century. Rodin thus was paying homage to Carrier-Belleuse in more ways than one: not only fashioning his distinctive features, but doing it in such a manner that it could be reproduced in the technique revived by Carrier-Belleuse. This accounts for some of the differences between this bust and those of other artist friends in the early 1880s, especially Laurens and Dalou. In

his bust of Carrier-Belleuse, Rodin lavished attention on the clothes and the hair, creating a rich play of fluid movement and light and shadow.

Rodin showed his bust of Carrier-Belleuse in terracotta at the Salon of 1882, at the same time that he first exhibited his bust of Laurens. Critics preferred the latter. One critic, after having given high praise to the *Laurens,* indicated that he felt Rodin "loses a great deal of ground in a sketch like this Carrier-Belleuse in which he has simply massed the direction of the whole."[41] The immediate reception of the *Carrier-Belleuse* was reserved because it was considered in comparison to the *Laurens* which looked more daring, but the differences between the busts illustrate Rodin's ability to respond to his sitter and to adjust his approach according to the individual with whom he was working.

Twenty years after Carrier-Belleuse's death, Rodin thought back to his old friend and employer and his special nature as a nineteenth-century sculptor: "Artists always have a feminine side. Carrier-Belleuse had something of the beautiful blood of the eighteenth century in him; something of Clodion; his sketches were admirable."[42] By the 1880s when Rodin made the bust, his relationship with Carrier-Belleuse had become one of respect and warmth, and this shows in the portrait. The quality is seen even better in the unique bronze cast by Montagutelli in the Musée Rodin in Paris and in the terracotta in the Stanford University Art Gallery. The Rodin Museum in Philadelphia also had a *biscuit* from the 1907 edition. R.B.

199.
Jules Dalou (1838–1902)
Bronze
h: 18½ in. (47 cm.)
1883
Signed: A. Rodin (on back of left shoulder)
Foundry mark: P. Bingen fondeur (on back of left shoulder)
Provenance: Johanny Peytel Collection
Lender: The Detroit Institute of Arts, Gift of Mr. and Mrs. Walter B. Ford

Rodin was close to two sculptors during his lifetime: Carrier-Belleuse and Jules Dalou. He knew them intimately. Though they had been trained at the Ecole des Beaux-Arts, he knew that neither was truly an academic artist, and thus was able to identify with them. Once when musing about his own "prodigious quickness," he commented that "like Carrier-Belleuse and Dalou—I could work quickly."[43] These were the two sculptors who were his points of reference. But it was with Dalou—his own age and his companion from the Petit Ecole in the 1850s—that Rodin shared as real a friendship as he was able to have with another sculptor.

Rodin and Dalou also competed. They were the two best sculptors in France at the end of the nineteenth century. In the late 1880s an American author, W. C. Brownell, was writing a book about modern French art. His last chapter, "The New Movement in Sculpture," was devoted solely to Rodin and Dalou. Brownell pointed out that Dalou had been "recognized long before M. Rodin's work had risen out of the turmoil of critical contention to their present envied if not cordially approved eminence. But for being less energetic, less absorbed, less intense than M. Rodin's, M. Dalou's enthusiasm for nature involves scarcely less uncompromising dislike of convention."[44]

When Rodin executed his bust of Dalou in 1883, the two friends had been seeing each other regularly since Dalou's return from London in 1879 following the amnesty. Rodin recalled: "I saw Dalou after the amnesty; yes, he was carried away by Politics, but he did know how to profit from it, and he immediately got an important position at the Hôtel de Ville. Dalou was a fine speaker! Ah! on that score he was easily the winner."[45] Admiration from Rodin—and a note of envy. Soon after Rodin completed the bust, their competition was in full bloom; they both wanted the same prize— to create a monument to the most admired creator in modern France, Victor Hugo. Rodin won. It was his belief that Dalou never took the bust he had made of him because he was angry about Rodin's success in that competition. In spite of whatever unpleasantness that took place over the *Monument to Victor Hugo,* they were often in touch with each other until Dalou's death in 1902. In 1911 Rodin remembered Dalou as "a great artist who

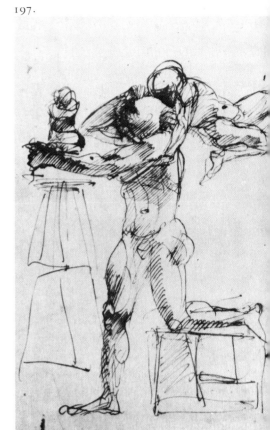

197.

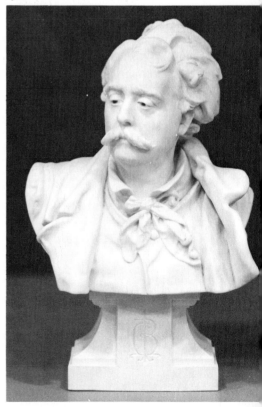

198.

created many sculptures of superb decorative quality which can be counted with the most beautiful work done in seventeenth-century French art."[46]

When Rodin's *Dalou* appeared in the Salon of 1884, the same year that he presented his bust of Victor Hugo, it was a sensation: "Next to the bust of the poet, we prefer the plaster that M. Rodin has made after M. Dalou showing the lean, nervous, energetic head standing straight up with an intensity of life that is more eloquent than life itself."[47] Another critic was of the same mind:

I prefer the bust of Dalou. Do you know this sculptor whom we see here as artist and as orator? This is how Rodin has made him appear, with his head straight, his eyes piercing, his short beard and irregular forehead. He does not speak, he challenges; he is anxious to impose his will rather than to share his convictions with you. Rodin has worked his surfaces forcefully in order to lay hold of life, and his execution is one that is full of authority.[48]

Gustave Geffroy also liked it best:

The bust of Dalou... is a consummate work. It is powerful, and yet refined and of an unforgettable expression. The separate parts do much more than simply acquaint us with the man; each feature is marked by the most incisive and precise detail, however, there is an astonishing degree of unity of expression in this face. What is true is that every line, every hollow, every rounded surface in relief contributes to portraying the character of the man.[49]

This bust has always been one of Rodin's most loved works and it has been often exhibited. There are five casts in bronze in the United States, including this example. R.B.

200.
The Helmet Maker's Wife
Bronze
h: 19½ in. (49.6 cm.); w: 9¼ in.
(23.5 cm.); d: 10½ in. (26.7 cm.)
Mid-1880s
Signed: A. Rodin (on top of base under figure's left hand)
Foundry mark: ALEXIS RUDIER/fondeur Paris (on center of base)
Lender: Philadelphia Museum of Art, Given by Jules Mastbaum

Rodin created *The Helmet Maker's Wife* during the mid-1880s as one of the numerous figures for *The Gates of Hell*.[50] As with

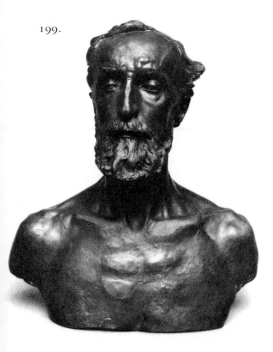

199.

so many of his works, a primary source of inspiration was the model who posed for the figure: "The original was a poor and aged Italian widow who came to Rodin's studio one day and was induced to pose."[51] Rodin was already known as a sculptor of bodies that were not beautiful; people found his *St. John* and his *Adam* at odds with the prevailing taste for pretty and graceful figures. But this old crone goes well beyond his earlier statues in the search for the innermost core of reality through an exploration of physical ugliness. What opened Rodin up to make such a search? Donatello's *Mary Magdalen* in the Baptistry in Florence, which Rodin must have seen in 1875–76, comes to mind. But even more important were certain images in *Les Fleurs du Mal*, Rodin had begun reading Baudelaire's poetry when he still lived in Brussels, and it exerted a great deal of influence over his aesthetic decisions of the 1880s while he was working on *The Gates of Hell*. In *Les Fleurs du Mal*, sins of the flesh and fear of physical decomposition were continually associated:

Et pourtant vous serez semblable à cette ordure,
 A cette horrible infection,
Etoile des mes yeux, Soleil de ma Nature,
 O mon âge et ma passion![52]

In quoting these particular lines from Baudelaire's "Une Charogne" ("The Carrion"), Rodin said, "Nothing can equal the splendor of this opposition between our desire for eternal beauty and the actual fact of atrocious disintegration."[53]

The title of the work, *Celle qui fut la belle heaulmière*, is taken from a line in a ballad by François Villon in which the helmet maker's wife mourns her lost beauty. It has long been clear that titles such as this were added to Rodin's sculptures once they were finished, rather than being subjects that were chosen and then executed in the manner of academic sculpture. This figure, however, was called *La Belle Heaulmière* very early and it appears to be one of the works for which Rodin chose the title with a real desire to evoke the famous text.

There are four bronze casts in the United States besides this Philadelphia example. The cast in the Metropolitan Museum is the earliest, having been purchased from Rodin in 1910. R.B.

201.
Burghers of Calais (The First Maquette)
Bronze
Group: h: 13⅜ in. (34 cm.); w: 13¾ in.
(35 cm.); d: 9½ in. (24.1 cm.)
Model 1884
Signed: A. Rodin Nº. 6 (on top of base
left front)
Foundry mark: © BY MUSEE RODIN (on
left rear side); GODARD Fondʳ (on right
rear of base)
Lender: Jay S. Cantor, Beverly Hills

*Since the honor of your visit, I have been think-
ing about the monument and was lucky to come
across a thought I liked, the execution of which
would be original. I have never seen an ar-
rangement suggested by the subject matter, nor a
more singular one; it would even be better since
all cities have ordinarily the same monument,
give or take a few details."*[54]

Written on November 3, 1884, these are
the first sentences that Rodin ever wrote to
Omer Dewavrin, the mayor of Calais.

Once Mayor Dewavrin had received ap-
proval from the Municipal Council of Calais
that he might proceed with his plans for
a monument to honor the great medieval
hero of Calais, Eustache de St. Pierre,
Dewavrin set about to find a sculptor.
Rodin wanted the commission very much.
Although he had his commission for the
portal and had made a figure of d'Alembert
for the new Hôtel de Ville in Paris, he
had never succeeded in obtaining a good,
serious public commission of the kind that
Dalou and most of his contemporaries
were working on during the 1880s. The
Burghers of Calais (fig. 72) became his
great public statement of an ideology
that is related to the Third Republic.
It functioned as such because he chose
to organize the monument around the
actions of a group rather than to single
out an individual to be praised above all
others. In that sense the *Burghers of Calais*
is most republican in its spirit. On Novem-
ber 20, Rodin wrote the mayor again:

*I have just made a sketch in clay and had it
cast. In that way, you will be able to make a
better judgment. If you would like to see it more
expressive, you could commission me to double
the size with a pedestal more articulated and
finished.*

*"The idea seems to me completely original, from
the point of view of architecture and sculpture.
Nevertheless, it is the subject itself that is impor-
tant and that imposes a heroic conception. The*

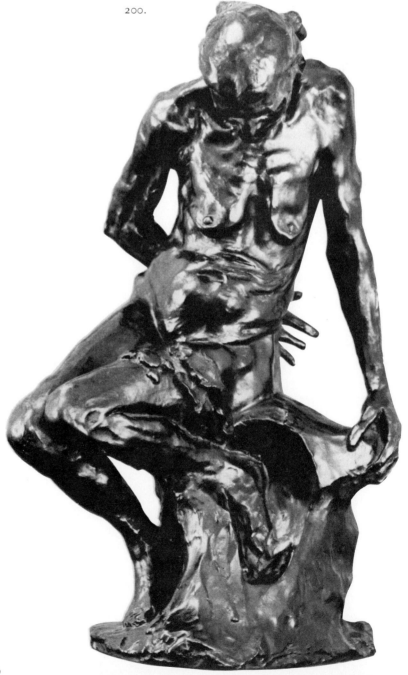

200.

general effect of six figures sacrificing themselves is expressive and moving. The pedestal is triumphal and the rudiments of a triumphal arch to carry, not a quadriga, but human patriotism, abnegation, and virtue.[55]

The nineteenth-century citizens of Calais had long been interested in raising a monument to Eustache de St. Pierre, the richest citizen of fourteenth-century Calais, the hero who had led five of his fellows to the camp of Edward III as hostages so that the siege of Calais by the English might be ended.[56] In the postwar period, such a monument seemed all the more urgent since Frenchman of all regions had suffered as they watched the cities of eastern France pass into the hands of another foreign power—Germany. Most previous conceptions of the monument were based on the solitary figure of Eustache de St. Pierre. As we see in this maquette, Rodin altered this approach by placing six figures on his high pedestal. This is the plan he presented to

the selection committee in January 1885, and they considered it along with studies by Emile Chatrousse and Laurent-Honoré Marqueste. Not surprisingly they were unsure about Rodin's most unusual group, so he came to Calais to speak to the members of the committee on January 10. He succeeded in convincing them that his was the right way to capture the true essence of the victory represented by the sacrifice of the early citizens of Calais.

There were important issues that Rodin was struggling to work out in his sketch. First, he wanted to form a group of several figures assembled according to a design that was totally different from conventional academic models based on symmetrical or geometrical groupings. Rodin also insisted on using expressive physical types. *The Burghers* continued his research into the function of special bodies such as he had done in his *St. John* (cat. no. 191) and *The Helmet Maker's Wife* (cat. no. 200). Finally, he had to learn to do something he had worked with in only a limited way until this time: to enhance the expressive quality of his figures through the use of drapery.

When he finished the maquette Rodin was delighted with himself: "Rarely have I succeeded in a study with so much eloquence and restraint."[57] The Municipal Council accepted his plan on January 23, 1885. Rodin moved ahead rapidly, making a full-scale model that was ready to be exhibited in plaster at the Rodin/Monet show in 1889. When Octave Mirbeau saw it at the Galerie Georges Petit he paid it a stunning compliment: "Perhaps only Michelet, the great resuscitator of the past, was to have had a similar vision that was able to lighten the darkness where dead centuries sleep."[58] Every nineteenth-century sculptor who had taken up large historical subjects would have dreamed of such praise. R.B.

201.

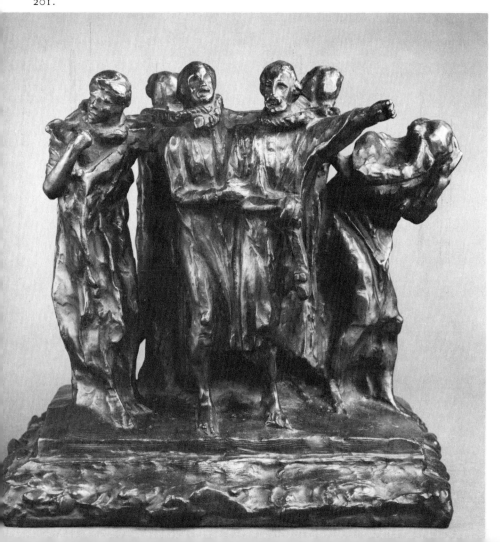

202.
Caryatid
Marble
h: 17¾ in. (45.1 cm.)
1886
No marks
Lender: Museum of Fine Arts, Boston, Gift of the Estate of Samuel Isham, 1917

Caryatids fascinated Rodin, and his conception of the type was unusual. Rodin's caryatids are squatting women that are compact enough to make beautiful marble

compositions. He made at least nine such marbles in the course of his career.[59]

Rodin shared with other nineteenth-century sculptors a very high regard for marble. It was the most noble material in which to finish a work that would be correct for formal presentation in a Salon. When a sculptor went to the expense of having a marble carved, he expected a certain kind of success. Thus, when Rodin entered his *Man with the Broken Nose* (cat. no. 189) at the Salon of 1875 in marble, it was accepted, whereas the same sculpture in plaster had been rejected eleven years earlier.

As a young sculptor Rodin had learned how to carve, exercising his skill in Paris and in Brussels as an employe of such masters as Carrier-Belleuse. When he wanted a marble, he hired a *practicien* to do it for him. He did this in the same way that he sent a work to the foundry when he wanted a bronze. In the twentieth century we accept the idea of casting as a specialized craft, but we expect sculptors to carve their own stone. This prejudice has greatly limited our ability to appreciate Rodin's marbles. They were, nevertheless, an extremely important part of his creative life. Throughout his career Rodin identified those figures and busts that he felt would be successful in marble and ordered his assistants to carve them. They were developed through the technique of pointing from plasters, often the same plasters that were used for bronzes. Usually, when they were fairly well along, Rodin himself would bring them to completion.

Rodin began to single out figures from among those he was creating for the portal to be executed in marble as early as 1882. He showed *The Fallen Caryatid Carrying Her Stone* in marble, along with another female figure in bronze, at the Exposition des Arts Libéraux in the Rue Vivienne during the winter of 1882–83. The journalist Charles Frémine reported that the figures were so shocking that they made him "fear for [Rodin's] talent.... Both are distorted, tormented pieces; both display violent and excessive energy, the first seemingly crushed beneath a rock it carries on its back, the second twisting, agonizing in some hideous nightmare."[60]

The Boston *Caryatid* is not exactly like the figure in the 1882 exhibition, but it is a close relative. It combines elements from two of Rodin's best female figures created during the first two years of work on *The Gates: The Fallen Caryatid Carrying Her Stone* and *The Crouching Woman*. The first is a figure with her arms wrapped around her right knee, her left leg curled in front of her, and a large stone sitting upon her shoulder and resting against the back of her head. *The Crouching Woman* is more radical and awkward; she squats, opening her legs wide, her right hand on her left ankle, and with her left hand she fingers her breast. Rodin took elements of both when he created the Boston *Caryatid.* It is basically in the pose of *The Crouching Woman,* although reversed—she leans to the left, not to the right—and the position of the right leg has been changed. The placement of the stone on her shoulder and against her head continues the idea developed in *The Fallen Caryatid Carrying Her Stone.* The Boston marble is a unique work and a wonderful example of Rodin's ability to work with figures compositionally, for he has treated the anatomical parts as ele-

202.

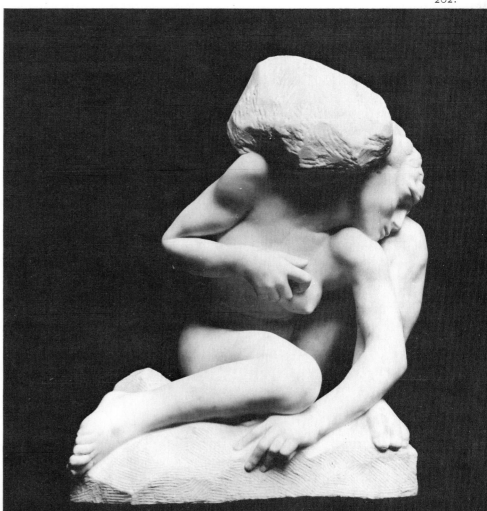

ments to be redistributed in unexpected visual clusters and sequences. We see this in the way the knee, head, shoulder, and rock meet in a knot far to the right of the center axis, and in the way the feet and left hand have been lined up and spaced across the base. Also in this marble we see typical Rodin dislocations and mistakes, such as the treatment of the left shoulder and the upper arm and the absence of a right breast.

Professor Rosenfeld has dated the *Caryatid* 1886. He bases this on the fineness of the carving, the high finish, the amount of detail, the regular treatment of the surface, and the way the figure clearly separates itself from the base, rather than melting into it, as so many of Rodin's later marbles do. He feels that it can be compared to some of the great marbles of the mid-1880s, such as the *Danaid* (1885) in Paris. R.B.

203.
Minotaur (Faun and Nymph)
Plaster
h: 13½ in. (34.3 cm.)
c. 1886
No marks
Lender: Los Angeles County Museum of Art, Gift of Mrs. Leona Cantor

"A woman defends herself against a satyr, her limbs still and tense with the struggle, her face convulsed with shame and horror at contact with the hairy, thick-lipped monster."[61] This is how Gustave Geffroy described this group after he saw it in the Rodin/Monet show of 1889.

Erotic couples were prominent in Rodin's work during the 1880s. He developed them in relief for *The Gates* and in three dimensions for shows and sales. Toward the end of the decade he became more and more fond of exotic mythological figures drawn from the works of Ovid. This old, horned, goat-footed faun is one of the first such figures to appear in Rodin's work.

There are several associations we can make as we look at the group. It reminds us of intimate, erotic couplings in the work of eighteenth-century sculptors. Rodin was very drawn to such groups; but in contrast to them, his groupings did not represent easy pleasure. Rodin's couples are often deeply ambivalent, particularly in the way the women withhold themselves. The *Minotaur* is much like *I Am Beautiful* (1883, originally called *The Rape*), a group in which there is a similar relationship between male and female. Part of the excitement of the sexuality is the woman's remoteness. This is also a major component of the imagery in *The Gates of Hell,* and it is one of the themes that Baudelaire so richly developed in *Les Fleurs du Mal:*

Et t'aime d'autant plus, belle, que tu me fuis,

. .

Et je chéris, ô bête implacable et cruelle,
Jusqu'à cette froideur par où tu m'es plus
* belle!*[62]

A further aspect of groups such as the *Minotaur* that should not be overlooked is the expression of personal feelings revealed in them. Rodin created many such groups during the period of his own most passionate involvement with Camille Claudel,

203.

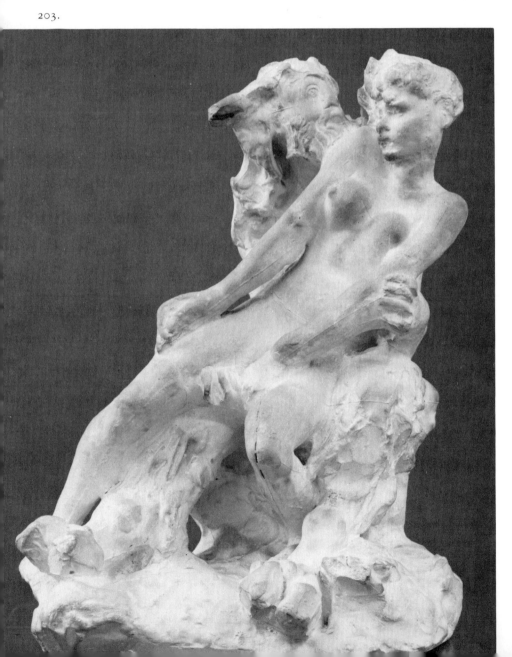

whom he met in 1883 and with whom he experienced the most intense feelings that he ever shared with a woman. The nineteenth-century public was fully aware of the personal factors evident in such works. They acknowledged the frankly lascivious side of Rodin's nature to the point of depicting him in caricatures in the form of a faun.[63]

Grappe stated that Rodin preferred *Minotaur* as the title for this group because it "looked like those rough, early civilizations that he enjoyed alluding to from time to time."[64] But in Rodin's interviews with Gsell he called the group *Faun and Nymph,* pointing out at the same time that "one shouldn't attribute much importance to the themes one interprets. Without doubt they have value in that they charm the public, but the real interest for the artist is to give life to the form of living muscle."[65]

This group was particularly popular among Rodin's writer friends: Edmond de Goncourt, Octave Mirbeau, Catulle Mendès, and probably Mallarmé all owned casts.[66] In the United States, in addition to this example, there is another plaster in the Maryhill Museum of Art, Goldendale, Washington, and bronzes in Maryhill, Philadelphia, and the Fine Arts Museums of San Francisco. R.B.

204.
Headless Female Torso Seated
Plaster
h: 5¼ in. (13.3 cm.); w: 4 in. (10.1 cm.); d: 4 in. (10.1 cm.)
c. 1890–1901
No marks
Lender: The Fine Arts Museums of San Francisco, Gift of Mrs. Alma de Bretteville Spreckels

Beginning in the early 1880s, one of the marvels of Rodin's sculpture was his ability to portray the female nude in every possible position and pose. It is well known that he asked his models to move and to rest freely in his studio so that he might watch their bodies take poses spontaneously and, by observing them, bring forth new works: "A model may suggest, or awaken and bring to a conclusion, by a movement or position, a composition that lies dormant in the mind of the artist. And such a composition may or may not represent a defined subject, yet be an agreeable and harmonious whole."[67] As he worked on *The Gates of Hell,* Rodin was creating in a small scale that allowed him to play end-

lessly with positions and with ways of fragmenting figures. The *Headless Female Torso Seated* is a work that comes out of this process.

He began exhibiting fragmented figures in 1889 in the Rodin/Monet show. Soon after, he created two fragmented female torsos that have come to be among his most admired works: *Iris, Messenger of the Gods*[68] and *Flying Figure* (both dated 1890–91). In particular, *Flying Figure,* which balances upon a stump that has been sliced off high up near the torso, is related to the *Headless*

Female Figure Seated. The model who posed for this figure had a full and fleshy body, a type that was particularly appreciated by Rodin in the early 1890s.[69]

There is a plaster cast of this torso in the Maryhill Museum of Art, Goldendale, Washington, that is about twice as large as the San Francisco cast. There is also a photograph of Rodin taken about 1900 in which we see the *Headless Female Torso Seated* on the floor in a dimension that is twice as large again.[70] To make a figure in three different sizes was characteristic for Rodin. R.B.

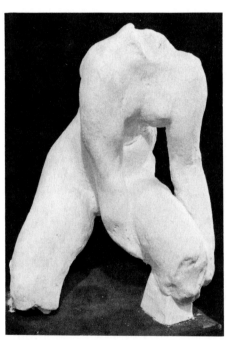

204.

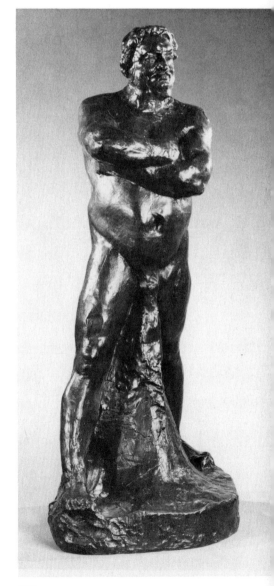

205.

205.

Nude Study for Balzac Monument

Bronze
h: 50¼ in. (1.28 m.)
Model 1892, cast 1967
Signed: A. Rodin (on left side of base)
Foundry marks: © by Musée Rodin 1967
(on rear left side of base); Georges
Rudier/Fondeur, Paris (at lower back of
work)
Lender: Los Angeles County Museum of
Art, Gift of B.G. Cantor Art
Foundation

When Emile Zola, president of the Société
des Gens de Lettres, maneuvered that group
of writers into giving the Balzac Monu-
ment commission to Rodin in July 1891, it
excited the sculptor so enormously that he
promised delivery in eighteen months. In
the words of Judith Cladel, "What im-
providence of imagination! What naïve
presumption!"[71] He made this extraordi-
nary promise even though he had not fin-
ished his *Monument to Claude Lorrain* and
had just begun a totally new composition
for his *Monument to Victor Hugo.* And surely
Rodin had no idea of how much research
would go into his *Balzac,* or how many
studies he would make for it — in the end,
more than fifty.

He proceeded in a manner that would have
been pleasing to Zola, for it was the ap-
proach of a good Naturalist. Rodin wanted
to know everything about his subject. He
read all of Balzac; he read what others had
written about Balzac;[72] he spent time in
Balzac country, Touraine; he worked from
models who looked like Balzac;[73] and he
studied every visual image that he could
find. He found many Balzacs — young, old;
with short hair, with long hair; smiling,
grimacing, speaking, absorbed in private
meditation. The problem was further com-
plicated by Balzac's physical appearance,
for at any age he was ugly, even outlandish-
ish. Rodin also contacted Balzac's tailor,
who was still alive, and ordered a suit of
clothes from the novelist's measurements.[74]
He tried Balzac in redingote, in the nude,
and in a monk's robe, as the great writer
was known to have dressed in such a gar-
ment when he worked. Rodin worked on
the nude and draped figures simulta-
neously, for they were different aspects of
the same problem.

The large *Nude Balzac* is one of the studies
that stands out as more than simply a step
on the path toward a final work. In 1894 a
journalist described it: "During the year
1892 . . . the artist . . . conceived of a strange
Balzac in the attitude of a wrestler, seem-
ing to defy the world. He had placed over
very widespread legs an enormous belly.
More concerned with a perfect resemblance
than with the usual conception of Balzac,
he made him shocking, deformed, his head
sunk into his shoulders."[75] Rodin has
showed Balzac in his maturity: he is fat
and his hair is short; his legs are parted to
frame and merge with a thick clod of ma-
terial. The position of the legs, developing
from those of *St. John* and *The Walking
Man,* is extremely forceful and gives the
image a firm and assertive presence. From
the journalist's comment quoted above we
can see one view of this figure — as an
intensely naturalistic interpretation of Bal-
zac. Albert Elsen has spoken of him in op-
posite terms — as a "metaphor of Balzac's
spirit as a creative artist," pointing to an
expression in Werdet's biography of Balzac
that spoke of him as the "courageous athe-
lete," a phrase Rodin had underlined in his
own copy.[76] The *Nude Balzac* can be seen
either as a work of naturalism or as a
visionary piece. Rodin's working method
involved the closest possible study of na-
ture and a wide range of information about
his subject; when he put his method into
a form, the form came to reveal more than
it depicted. In this study Rodin was con-
fronting the hardest thing about the com-
mission: that he was to fashion a man who
was physically unattractive. He focused on
it and made it into an element of character
and strength. In 1894 Rodin wrote to Jean
Aicard who had succeeded Zola as presi-
dent of the Société des Gens de Lettres: "I
think of [Balzac's] intense labor, of the dif-
ficulty of his life, of his incessant battles
and of his great courage. I would express
all that."[77] And Rodin did find a way to
make his studies in naturalism yield a
visionary image.

In a tentative form Rodin was already
engaged in a transforming process in *Nude
Study for Balzac Monument.* In its final
form the *Balzac Monument,* exhibited pub-
licly for the first time on May 1, 1898, is
so transcendent that, though it horrified a
large part of the public that first saw it, for
us in the late twentieth century it is the
best, the most complete, and the most revo-
lutionary work Rodin ever did. R.B.

206.

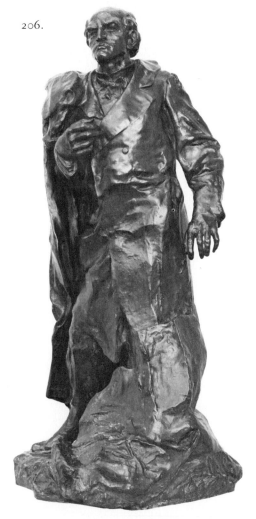

206.
President Sarmiento (1811–1888)
Bronze
h: 43 in. (1.09 m.); w: 23 in.
(58.4 cm.); d: 18 in. (45.7 cm.)
1894–96
Signed: A. Rodin (low on base to right)
Foundry mark: Alexis Rudier/Fondeur,
Paris (on back of base to left)
Lender: Philadelphia Museum of Art,
Given by Jules Mastbaum

Rodin signed an agreement with the government of Argentina on November 30, 1894, to make a monument in honor of Domingo Faustino Sarmiento, the former president of Argentina and the man most responsible for developing Argentina's educational system. That Rodin should have received such a commission is testimony to his fame. That he should have accepted in 1894, a year when he was in poor health, totally preoccupied with his two most important monuments — *Victor Hugo* and *Balzac* — both overdue (in 1894 the Société des Gens de Lettres threatened legal action if Rodin did not produce his *Balzac* immediately), is testimony to his ego. Probably he was also attracted by the amount of money the South American government was willing to pay — 75,000 francs. Only once before had anyone offered Rodin such a sum: the French government had agreed to pay the same amount for the *Monument to Victor Hugo*.[78]

The committee in Buenos Aires informed Rodin that they wished to have a figure on a pedestal bearing a bas-relief that would indicate something of the deeds and the character of Sarmiento. The figure should show an "expression of intelligent force . . . standing in an attitude that would convey the impression of strength in repose, the concentration of the intimate thought of a man of action who was also a thinker." For the relief they suggested: "Sarmiento as an educator with young children around him."[79]

Rodin acquired several photographs of Sarmiento from which to work: "For the likeness of the President the sculptor had to depend on the camera's fidelity and what he could gather from friends and written documents."[80] He developed his figure in contemporary dress. Though standing still, Sarmiento appears to move as he gesticulates and folds a sheet of paper in his left hand (not present in the Philadelphia study). His chin juts forward and the rhythms of the body are sharply set off by the long cape falling from his shoulders. It seems to respond well to the Argentinian group's desire for a figure showing both concentration and action, though clearly Rodin did not work in the same searching manner with which he had approached his monuments to Claude Lorrain, Victor Hugo, and Balzac. As far as we know, he did not even fashion the figure in the nude, which he had always done for his important monuments.

For the bas-relief Rodin departed completely from the committee's suggestions. He placed an over-life-size figure of Apollo sweeping out of the clouds with bow in hand and rushing toward the serpent Python, symbol of ignorance (borrowed from the Hercules myth), upon the base.[81] Here Rodin was continuing the ideas on which he had worked for the pedestal of the *Monument to Claude Lorrain*. He took the whole format of that monument as the basis for the Sarmiento monument. He did so in spite of the fact that the *Monument to Claude Lorrain* had been strongly criticized, especially the base, when it was unveiled in Nancy in 1892. But Rodin obviously liked the scheme, and it did not look like anyone else's monument, an important criterion for him.

When the Sarmiento monument was unveiled in Buenos Aires on May 25, 1900, the response was, in fact, quite critical. The nature of the criticism was exactly what was most often said against public monuments that did not win popular approval, whether in North or South America, or in Paris: "It does not look like him." R.B.

207.
Large Clenched Hand with Figure
Bronze
h: 18½ in. (47 cm.)
Model late 1890s, cast 1972
Signed: A. Rodin/No. 8 (on left side of base)
Foundry mark: © BY MUSEE RODIN 1972-E. GODARD/Fondʳ (on right side of base)
Lender: Los Angeles County Museum of Art, Gift of Mrs. Leona Cantor

In the course of the 1890s Rodin grew ever more adventurous in working with scale and in juxtaposing unlikely components. He produced extremely provocative assemblages in which form and content take the audience by surprise. Throughout this period, hands were a major element and theme in Rodin's work. They so attracted the Symbolist writer Gustave Kahn that he published a little article in 1900 on "Hands in Rodin's Work." He saw Rodin's hands as full of meaning; one, for instance, "seems at first twisted in a violent attempt to hold on to money, or a woman, or truth, and then, giving up and letting the iridescent bubble float away, suffering and trembling still from the effort contracting it."[82] Rodin fashioned extremely suggestive compositions through the use of fragments, and for this kind of creative thinking there was an eager audience around 1900.

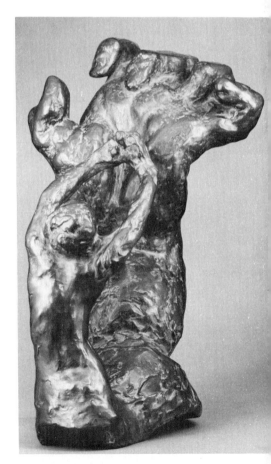

207.

The sources for the two parts of the *Large Clenched Hand with Figure* are to be found in Rodin's work of the 1880s. The female figure is one of Rodin's many transsexual rethinkings. She began in 1882 as one of Ugolino's sons for the portal. Alone he was called *The Despairing Adolescent.* The hand probably originated in Rodin's work on the *Burghers of Calais.* The group demanded that Rodin think very deeply about the expressive nature of hands, and in 1888, when he was enlarging the *Burghers,* he isolated and developed some of the hands separately. The *Large Clenched Left Hand* is very likely one of these hands.[83]

Here again, as in the *Minotaur,* we find partial interpretation in autobiographical terms—a big phallic hand of the sculptor before which a woman writhes, pleads, or worships, however we wish to see it. This interpretation of Rodin's hand compositions is reinforced by the fact that three weeks before his death one of Rodin's assistants, Paul Cruet, made a life-cast of Rodin's hand. Into it Rodin placed a tiny female torso.[84] R.B.

208.
Hand of God
Bronze
h: 26¾ in. (67.9 cm.); w: 17½ in. (44.5 cm.); d: 21½ in. (54.6 cm.)
Model 1890s (before 1898)
Signed: A. Rodin (on top of base to right)
Foundry mark: ALEXIS RUDIER/FONDEUR PARIS (on rear base at center)
Lender: Philadelphia Museum of Art, Given by Jules Mastbaum

The Hand of God emerges from the same circumstances responsible for the *Large Clenched Hand with Figure* (cat. no. 207), for Rodin assembled small figures and an enlarged hand fragment. Again, he chose a hand from his period of experimentation with expressive hands that he did for the *Burghers of Calais*[85] and the figures from *The Gates of Hell.*[86]

Again in this work we recognize the autobiographical content. This was borne out by Rilke on the first day he ever set foot in Rodin's studio. The young poet looked around and spied the hand holding the figures. Rodin watched him and then held up his hand saying: "It's a hand like this." Rilke said that with his own hand Rodin made "such a powerfully clinging and forming gesture that you fancied you could see things growing out of it." Rodin then pointed to "the two wonderfully deep and mysteriously united figures: 'C'est une création ça, une création.'"[87]

The Hand of God is more harmonious in form and comprehensible in content than the *Large Clenched Hand with Figure.* This surely accounts for its greater popularity. But there was an odd note struck by some of the early commentators when they first encountered the work. It is one that allows us to understand the powerful effect of a juxtaposition of an enlarged hand and small figures. Early in 1898 Edouard Rod visited Rodin's studio where he saw the group. Speaking of it as *The Creation,* he described the "two human beings emerging from a mound that supports the hand of God; they are two wretched beings, small, lean, and sad, carelessly thrown one

208.

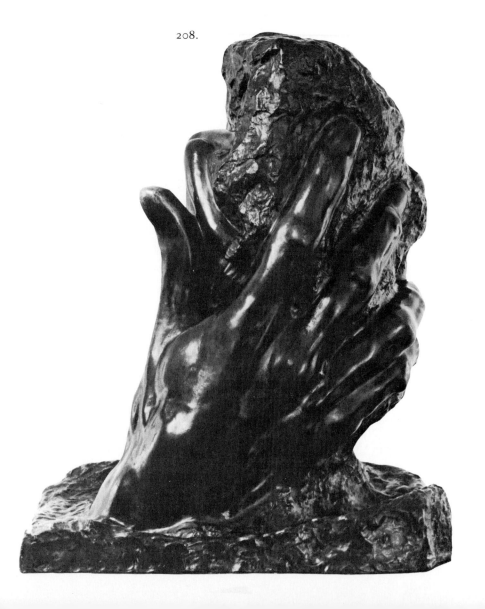

on top of the other."[88] A critic who saw the work in the Salon d'Automne in 1905 experienced the same feeling of smallness and vulnerability in the figures: *"The Hand of God* is one that clasps two fragile creatures. They are perfect in contour but so small in that powerful grasp which holds them. It is a hand that will never understand the human dimension as it faces this colossal mountain that will not feel the human trembling in the marble which exists here as the total immensity of pure, untamed nature before which we stand in our ephemeral destiny."[89]

The Hand of God exists in different dimensions, ranging from 6 to 39 inches. It has been most popular in the large marble versions, of which there exist at least three: in the Musée Rodin in Paris, in the Metropolitan Museum in New York (carved in 1907), and in the Museum of Art, Rhode Island School of Design, Providence.

R.B.

209.
The First Funeral

Bronze
h: 24 in. (61 cm.); w: 20 in. (50.8 cm.);
d: 15½ in. (39.8 cm.)
c. 1899–1900
Signed: A. Rodin (in the middle of the irregular mound supporting figures)
Foundry mark: Alexis Rudier/Fondeur, Paris (on bottom back edge of base)
Provenance: Baudouin Collection, Paris
Lender: Museum of Fine Arts, Boston, purchased in 1959, Helen and Alice Coburn Fund

Toward the end of the century, Rodin assembled preexisting figures to make highly provocative groups that were quite large and in three dimensions. *The First Funeral* is one of the best. Three figures are assembled so that we encounter a series of horizontals and a mesh of diagonals that make it impossible to understand from any one point of view. Pockets of space open and then close again, and limbs disappear to emerge again on the other side as we move around the group. It is a strong statement by Rodin in opposition to traditional methods of organizing a sculptural composition.

The individual figures are familiar from earlier works. The original body types for the two supporting figures can be found in *The Sirens* (c. 1888), and the body they hold has its origin in a type of female figure (here again Rodin altered the sex)

that he often used in *The Gates,* most notably in his *Paolo and Francesca* (1887). The figures have been altered, however, in the process of the breaking and reassembling of casts. The whole treatment is rougher and more summary than Rodin's figures of the 1880s. The group can be best compared to other groups that Rodin executed in 1899 and 1900, especially *Evil Spirits* and *The Good Spirit.*[90] In each of these groups there is a figure that is also seen in *The First Funeral.*

The subject matter evokes death, but it does so in the most general way. Rodin's approach to his subjects became ever more allied with a Symbolist point of view

around the turn of the century. One of the Symbolists, Arthur Symons, described Rodin's way of working:

Often a single figure takes form under his hands, and he cannot understand what the figure means: its lines seem to will something, and to ask for the completion of their purpose. He puts it aside, and one day, happening to see it as it lies among other formless suggestions of form, it groups itself with another fragment, itself hitherto unexplained; suddenly there is a composition, the idea has penetrated the clay, life has given birth to the soul. He endeavours to represent life in all its mystery, not to penetrate the mystery of life.[91]

The group was shown in plaster in Rodin's 1900 exhibition where it was called *Pur-*

209.

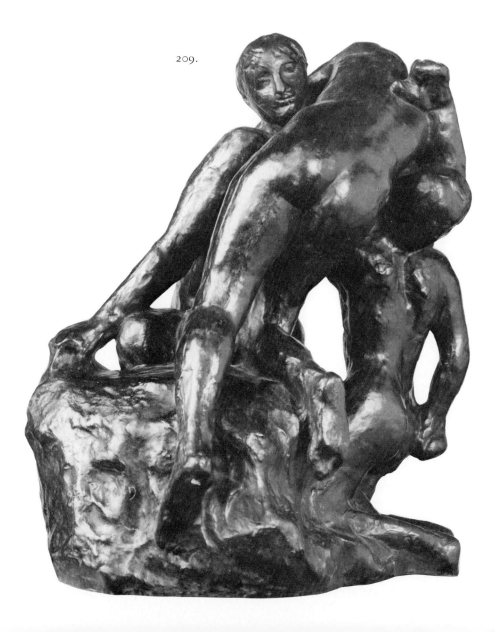

gatory. In a similar vein Roger-Marx spoke of it as *The Fall of the Soul into Limbo,*[92] but when the stone version entered the Musée Rodin in 1927, it was called *Les Premières Funérailles.* Most probably this title was taken from the famous group by Barrias (cat. no. 6) which certainly had an impact on Rodin. At the same time that he was working on *The First Funeral,* he was also creating *The Death of Alcestes,* which is very clearly under the influence of the Barrias group.[93]

The Boston Museum of Fine Arts group is an excellent cast in which to examine the seam marks remaining from the sand casting method, and to see how Rodin not only permitted those lines to remain in the finished work but also incorporated them and made them part of its expressive quality. This cast is one of an edition of three. There is another in the Maryhill Museum of Art, Goldendale, Washington. R.B.

Notes

1.
Bartlett, 1889, cited in Elsen, 1965, p. 21.
2.
Ibid., pp. 20–21.
3.
L. Ménard, "La Sculpture au Salon de 1879," *L'Art,* 1878, III, p. 277.
4.
A. Warren, "Our London Letter," *Boston Transcript,* May 20, 1882.
5.
Bartlett, 1889, cited in Elsen, 1965, pp. 87–88.
6.
C. de Boelpaepe, *Le Séjour de Rodin en Belgique,* unpublished thesis, Brussels, 1958. Previously *Suzon* and its companion piece *Dosia* were dated 1875 (Grappe, 1944, p. 13).
7.
Descharnes and Chabrun, 1967, p. 46.
8.
There is a drawing in the Fogg Art Museum in Cambridge, Massachusetts, which shows the cross. An engraving based upon the drawing was reproduced in *L'Art,* 1880, XXII, p. 24. Cladel stated quite clearly that Rodin had originally put a cross on *St. John's* shoulder (J. Cladel, *Rodin: The Man and His Art,* New York, 1917, p. 273); the same thing was stated by L. Bénédite, *Rodin,* Paris, 1926, p. 26.
9.
Rodin visited Florence during the winter of 1875–76. Elsen, 1963, p. 27, first

pointed out the relationship between Rodin's *St. John* and Rustici's figure.
10.
Dujardin-Beaumetz, 1913, cited in Elsen, 1965, p. 166.
11.
Rodin shared his early reviews with Truman H. Bartlett, an American sculptor who had been living in Paris and who met Rodin in 1887. Bartlett reported that he examined "twenty or more" reviews on *The Age of Bronze* and *St. John the Baptist* that followed the Salon of 1880. He summarized what he read and the above quotations are taken from his description of the reviews he read; see ibid., pp. 46–48.
12.
Caso and Sanders, 1977, p. 78.
13.
Tancock, 1976, p. 368. Tancock has assembled the most complete list of the locations of Rodin casts.
14.
Gazette des architects et des bâtiments of 1879 (ser. 2, a. 8), pp. 126–27, 220, 295. See Caso and Sanders, 1977, p. 202.
15.
Coquiot, 1917, p. 107.
16.
M.V., "Lettres, Science et Beaux-Arts," *La France,* December 18, 1879.
17.
Petit Moniteur universelle, December 17, 1879.
18.
Reproduced in Tancock, 1976, p. 485.
19.
Cladel, 1936, p. 237.
20.
Alhadeff, 1963, p. 366 and fig. 7.
21.
Janson, 1968, pp. 270–80. Janson presents a full discussion of the re-attribution and a photographic study of the Maryhill vase along with four terracotta maquettes for the individual figures that are also in the Maryhill Museum. He further shows photographs of two plaster casts of the *Vase of the Titans* that were sold to Mr. David Barclay of London as being works of Carrier-Belleuse although they bear no signature.
22.
Letter from Rodin to Rose Beuret cited in Cladel, 1936, p. 112.
23.
Alhadeff, 1963, p. 367; Janson, 1968, p.

279; Tancock, 1976, p. 240.
24.
Cladel, 1936, p. 238.
25.
Tancock, 1976, p. 238.
26.
Janson, 1968, figs. 22, 26, and 28, has illustrated two drawings by Carrier-Belleuse as well as a *jardinière* that show how the base and vase would have been assembled.
27.
"Current Art," *Magazine of Art,* 1883, IV, p. 176.
28.
O. Mirbeau, "Chroniques Parisiennes," *La France,* February 18, 1885.
29.
Elsen, 1960, p. 129.
30.
H. Dujardin-Beaumetz, "Speech for the Inauguration of Rodin's *Thinker* in front of the Panthéon," April 21, 1906. There is a printed copy of this speech in the archives of the Musée Rodin in Paris.
31.
For a list of the various casts and their locations see Tancock, 1976, pp. 120–21.
32.
Cladel, 1936, p. 140.
33.
H. Harvard, *Le Siècle,* June 18, 1881.
34.
Coquiot, 1917, p. 87.
35.
The 30-inch version, which differs somewhat from the life-size *Eve,* was extremely well known during the 1880s. It was shown in London and in Paris and it was particularly popular in marble.
36.
Lawton, 1908, p. 53.
37.
Dujardin-Beaumetz 1913, cited in Elsen, 1965, pp. 164–65. There is a similar account in A. M. Ludovici, *Personal Reminiscences of Auguste Rodin,* London, 1926, p. 123.
38.
See Elsen, 1960, plates 9–15.
39.
See San Francisco, 1975, figs. 15–17.
40.
See Marx, 1907, plates VI-VII. Plate VI, *Femme et Enfant,* is closer to *The Genius of the Sculptor* than any other drawing I have seen. It combines a standing figure raising one leg with a smaller figure and the composition is based upon strong verticals and horizontals.

41.
P. Burty, "La Sculpture," *L'Exposition des beaux-arts,* Paris, 1882, pp. 263–64.

42.
Dujardin-Beaumetz cited in Elsen, 1965, pp. 177–78.

43.
Ibid., p. 175.

44.
Brownell, 1892, p. 230.

45.
Coquiot, 1917, p. 110.

46.
Ibid., p. 109–110.

47.
A. Michel, "Le Salon de 1884, La Sculpture," *L'Art,* 1884, XXXVII, p. 39.

48.
Fourcaud, 1884, p. 63.

49.
G. Geffroy, "Le Salon de 1884," *La Justice,* June 20, 1884.

50.
A variation of the figure with arms raised and a young woman's head in its lap is seen in the lower half of the left pilaster of *The Gates of Hell.*

The dating is uncertain. Grappe, 1944, p. 46, placed it "before 1885." Elsen, 1963, p. 63, also considered it to be "about 1885." Tancock, 1976, p. 141, dated it between 1880 and 1883. He observed that the figure with the young woman in her lap as seen in *The Gates of Hell* duplicates a group found on one of the Sèvres vases (*Limbo and the Sirens*) that Rodin designed and that Jules Desbois executed. Tancock, therefore, puts the figure into Rodin's years at Sèvres (1879–82). But he overlooks the fact that Marx, who published the study of Rodin at Sèvres, said that this vase was not finished until 1887. See Marx, 1907, p. 28. Therefore Tancock's observation does not serve to establish an earlier date for *The Helmet Maker's Wife.*

There is another reference to the work that helps to keep it in the mid-1880s. Octave Mirbeau, who probably met Rodin in 1884, told Edmond de Goncourt that "one day he came upon Rodin modeling a marvelous work after a woman who was eighty-two years old, a work even superior to *Sources Taries* [*Dried-up Springs,* which consisted of two casts of *The Helmet Maker's Wife* facing each other and which was shown in the 1889 exhibition at Galerie Georges Petit]. A few days later when he asked Rodin where the clay model was, the sculptor told him that he had ruined it. Since Rodin felt very sad that he had ruined a work admired by Mirbeau, he then made the two old women that he put in the exhibition." *Journal des Goncourts,* July 3, 1889.

51.
Lawton, 1906, p. 128. A more detailed version of the old woman coming to Rodin's studio is given on p. 121. Jules Desbois told a contradictory story (see Tancock, 1976, p. 141). He said that Rodin got the name and address of the model from him after Rodin saw his statue of *Misery. Misery,* however, dates from the 1890s, so that cannot be.

52.
Baudelaire, *Les Fleurs du Mal,* XXIX.

53.
Rodin, 1911, p. 48.

54.
There have been two recent exhibitions devoted to the *Burghers of Calais,* and both catalogs contain the relevant documents about the commission: McNamara and Elsen, 1977, p. 66; Paris and Calais, 1977, p. 41.

55.
Ibid.

56.
McNamara and Elsen, 1977, p. 10; Paris and Calais, 1977, pp. 28–9.

57.
This sentence is part of Rodin's letter of November 20 quoted above.

58.
O. Mirbeau, "Auguste Rodin," *La Revue illustrée,* July 15, 1889, VIII, no. 87, pp. 75–80.

59.
Information provided by Professor Daniel Rosenfeld, Boston University, who is presently preparing a catalog of Rodin's marbles.

60.
C. Frémine, "Salon de 1883, *Le Rappel,* November 28, 1883.

61.
Paris, 1889, p. 66.

62.
Baudelaire, XXIV.

63.
See Caso and Sanders, 1977, pp. 107–8. For a reproduction of a cartoon showing Rodin as a faun, see Descharnes and Chabrun, 1967, p. 216.

64.
Grappe, 1944, p. 57.

65.
Rodin, 1911, p. 217.

66.
Caso and Sanders, 1977, pp. 107–8.

67.
Bartlett, 1889, cited in Elsen, 1965, p. 91.

68.
Iris was created for the *Victor Hugo Monument.* In 1908 *Headless Female Torso Seated* was published by O. Grautoff as a study for *Iris:* see Caso and Sanders, 1977, p. 321.

69.
Tancock, 1976, p. 288.

70.
For a reproduction of the photograph, see Descharnes and Chabrun, 1967, p. 229.

71.
Cladel, 1936, p. 185.

72.
"Rodin had read and reread not only all the works of Balzac, but also all that has been written about Balzac: Mme. Surville, Gozlan, Werdet, Gautier, Lamartine, d'Aurevilly, Bourget, Lovenjoul, Cerfberr, Christophe, Paul Flat, and many others." G. Geffroy, "L'Imaginaire," *Le Figaro,* Paris, August 29, 1893. Quoted in Tancock, 1976, p. 428.

73.
On September 6, 1891, Rodin wrote from Touraine: "I am making as many models as possible for the construction of the head, with trips in the country; and, with the abundant information I have secured, and am still procuring, I have good hope of the Balzac." Quoted in Lawton, 1906, p. 205.

74.
Le Petit Journal, May 9, 1899, Quoted in Tancock, 1976, p. 447.

75.
C. Chincholle, "Balzac et Rodin," *Le Figaro,* November 25, 1894. Quoted in Spear, 1967, p. 20.

76.
A. Elsen, "Rodin's Naked Balzac," *Burlington Magazine,* 1967, CIX, no. 776, p. 615.

77.
Cladel, 1936, p. 193.

78.
Tancock, 1976, pp. 460–62.

79.
Lawton, 1906, p. 210.

80.
Ibid., p. 135.

81.
Descharnes and Chabrun, 1967, pp. 154–55, have reproduced photographs of the studies and the base.

82.
G. Kahn, "Les Mains chez Rodin," *La Plume*, 1900, p. 316.
83.
Caso and Sanders, 1977, p. 323, have dated this and *The Mighty Hand* (right hand) in the early 1880s. They do so because "the exaggerated musculature and the strained posture of the hand are particularly close to works like *The Thinker* and *The Three Shades*."
84.
Illustrated in Tancock, 1976, p. 638, and in Descharnes and Chabrun, 1967, p. 271.
85.
It has been identified with the fragment known as *Right Hand of Pierre and Jacques de Wissant*. See Paris and Calais, 1977, figs. 42–48. The relationship was first recognized by Spear, 1967, p. 79.
86.
No absolute source has been recognized. Caso and Sanders, 1977, p. 71, have noted that the group is very close to *The Idyll of Anthony Roux*, which was exhibited in the 1889 Rodin/Monet show.
87.
Rilke's letter to Clara Rilke, September 2, 1902; *Selected Letters of Rainer Maria Rilke*, translated by R.F.C. Hull, London, 1946, pp. 3–4.
88.
This is the first time that *The Hand of God* is mentioned in a review. E. Rod, "L'Atelier de M. Rodin," *Gazette des beaux-arts*, 1898, XIX, p. 427.
89.
Valentine de Saint-Point, "La Double Personnalité d'Auguste Rodin," *La Nouvelle Revue*, 1906, XLIII, pp. 199–200.
90.
For illustrations, see Tancock, 1976, p. 313 and p. 317.
91.
A. Symons, "Rodin, *Fortnightly Review*, June 1902, p. 964.
92.
C. Roger-Marx, "Sur un group de Rodin," *Les Premières Funérailles*, no place, n. d.
93.
Grappe, 1944, no. 305. Illustrated in Tancock, 1976, p. 51.

Selected Bibliography

Bartlett, T.H., "Auguste Rodin, Sculptor," *American Architect and Building News*, January 19–June 15, 1889, XXV, pp. 682–703. Reprinted in Elsen, 1965 (see below).

Paris, Galerie Georges Petit, *Claude Monet, A. Rodin*, exh. cat. with intro. by G. Geffroy, 1889.

Maillard, L., *Auguste Rodin, statuaire: Etudes sur quelques artistes orginaux*, Paris, 1899.

Paris, Place de l'Alma, *Exposition de 1900: L'Oeuvre de Rodin*, exh. cat. by A. Alexandre, 1900.

Rilke, R.M., *Auguste Rodin* (Die Kunst, X) Berlin, 1903. English translation by G. Houston in *Rainer Maria Rilke, Selected Works*, New York, 1967.

Mauclair, C., *Auguste Rodin: The Man — His Ideas — His Works*, London, 1905.

Lawton, F., *The Life and Work of Auguste Rodin*, London, 1906.

Marx, R., *Auguste Rodin: Ceramiste*, Paris, 1907.

Cladel, J., *Auguste Rodin: l'oeuvre et l'homme*, Brussels, 1908.

Rodin, A., *L'Art: entretiens réunis par Paul Gsell*, Paris, 1911, English translation by R. Fedden, *Art*, Boston, 1912.

Coquiot, G., *Le vrai Rodin*, Paris, 1913.

Dujardin-Beaumetz, H., *Entretiens avec Rodin*, Paris, 1913.

Coquiot, G., *Rodin à l'hôtel de Biron et à Meudon*, Paris, 1917.

Grappe, G., *Catalogue du Musée Rodin, L'Hôtel Biron*, Paris, 5th ed., 1944.

Cladel, J., *Rodin: Sa vie glorieuse, sa vie inconnue*, Paris, 1936 (definitive ed., 1950).

Elsen, A.E., *Rodin's Gates of Hell*, Minneapolis, 1960.

Alhadeff, A., "Michelangelo and the Early Rodin," *Art Bulletin*, 1963, XXXXV, pp. 363–67.

Elsen, A.E., *Rodin*, New York, 1963.

New York, Charles E. Slatkin Galleries, *Auguste Rodin 1840–1917, An Exhibition of Sculptures/Drawings*, exh. cat. with intro. by L. Steinberg and catalog notes by C. Goldscheider, 1963.

Elsen, A. E., ed., *Auguste Rodin: Readings on His Life and Work*, Englewood Cliffs, N.J., 1965.

Spear, A.T., *Rodin Sculpture in the Cleveland Museum of Art*, Cleveland, 1967.

Descharnes, R. and Chabrun, J., *Auguste Rodin*, Lausanne and Paris, 1967.

Janson, H.W., "Rodin and Carrier-Belleuse: The *Vase des Titans*," *Art Bulletin*, 1968, L, pp. 270–80.

Elsen, A.E., and J. Varnedoe, *The Drawings of Rodin*, with contributions by V. Thorson and E. Chase Geissbuhler, New York, 1971.

Spear, A.T., *A Supplement to Rodin Sculpture in the Cleveland Museum of Art*, Cleveland, 1974.

San Francisco, The Fine Arts Museums of San Francisco, *Rodin Graphics: a Catalogue Raisonné of Drypoints and Book Illustrations*, exh. cat. by V. Thorson, 1975.

Paris, Musée Rodin, *Rodin et les écrivains de son temps; sculptures, dessins, lettres et livres du fonds Rodin*, exh. cat. by M. Laurent and C. Judrin, 1976.

Tancock, J., *The Sculpture of Auguste Rodin*, Philadelphia, 1976.

Caso, J. de, and P.B. Sanders, *Rodin's Sculpture*, San Francisco, 1977.

Calais and Paris, Musée des Beaux-Arts and Musée Rodin, *Auguste Rodin, Le Monument des Bourgeois de Calais*, exh. cat. by C. Judrin, M. Laurent, and D. Vieville, 1977.

McNamara, M.J., and A. Elsen, *Rodin's Burghers of Calais*, published by the Cantor, Fitzgerald group, no place, 1977.

Butler, R., *Rodin in Perspective*, Englewood Cliffs, New Jersey, 1980.

FRANÇOIS RUDE
1784 Dijon–Paris 1855

During his childhood, François Rude learned the craft of metal working from his father, a locksmith and stove maker. A staunch republican, Antoine Rude also imparted to his son a passionate commitment to the ideals of the Revolution. At eight, François was enrolled in the "Volunteers of Dijon," a children's group that espoused this political ideology. Although Antoine hoped his son would one day operate the stove-making shop he founded, young Rude was determined to study sculpture. Only reluctantly did his father permit him to attend art classes while the shop was closed in the late evening and early morning. François Devosge (1732–1811), the director of Dijon's art school, recognized and encouraged his talent. At sixteen, François enrolled in his school, where he learned the principles of Neoclassicism.

To gain greater artistic experience, Rude moved to Paris in 1807. A letter of recommendation from Devosge to Baron Vivant Denon, director of the Musée Napoléon, helped admit him to the workshop of Edmé Gaulle. There he modeled some of the reliefs for the Vendôme Column, a monument to the Emperor's victories. After admission to the Ecole des Beaux-Arts in 1809, he began to compete for the French Academy in Rome. He won the Prix de Rome in 1812 with a work entitled *Aristaeus Weeping Over the Loss of His Bees;*[1] however, due to the lack of public funds, the aspiring sculptor was not able to study in Italy.

Rude, a loyal Bonapartist, fled to Belgium in 1815 when the Bourbon dynasty returned to power. There he joined a colony of French exiles that included the painter Jacques-Louis David, who took a special interest in the sculptor. Rude resided in Brussels for twelve years; during that time he executed several portrait busts, including one of David, and architectural reliefs for the Théâtre Royale (1819), the Hôtel des Monnaies (1823), and the Château de Tervueren (1823). In Brussels, he married Sophie Frémiet, a student of David, and later opened a small atelier. His appointment as official sculptor to the court of the Netherlands increased his reputation in the northern countries.

Rude returned to Paris in March 1827. Though forty-three years old and an accomplished artist, he had yet to achieve fame in his homeland. Nevertheless, he received immediate critical acclaim at the Salon of 1828, where he exhibited two works, an *Immaculate Conception* and a *Mercury Attaching his Wings.* Charles Blanc praised the latter sculpture as "superior to Giambologna's *Mercury*" and as possessing "Olympian elegance."[2] His next work, the *Neapolitan Fisherboy* (1831, cat. no. 210), gained great popularity and earned him the Cross of the Legion of Honor. Thus, at the age of forty-seven, Rude was finally established as one of France's leading sculptors. His emphasis on elegant movement, naturalism, and sentimental genre subjects— all contained within a formally classicizing idiom—influenced the work of a number of other sculptors.

During the reign of Louis-Philippe, Rude was at last able to create sculpture that expressed his ardent republican beliefs. In 1833 the government awarded him the commission for two reliefs on the Arc de Triomphe. One was to depict the *Return of the Army from Egypt;* the other, the *Departure of the Volunteers of 1792* (fig. 71), would become his masterpiece. These reliefs were completed for the inauguration of the Arc on July 29, 1836. Despite his success, Rude received no further commission from the July Monarchy due to growing political tension between himself and the regime. He was forced to depend on private commissions, such as the *Louis XIII* for the Duke of Luyne's château at Dampierre, and some ecclesiastic commissions, notably a *Calvary* for the church of St. Vincent de Paul and a *Baptism of Christ* for the Madeleine. Between 1842 and 1848, Rude rarely exhibited at the Salons. His students, associated with the new Romantic school of sculpture, were denied official recognition; in 1846, they were all barred from the Salon. Rude himself was never elected to the Academy.

The sculptor's most important works from the 1840s were those that glorified Bonapartist and republican heroes. In 1840 Rude met Captain Claude Noisot, a supporter of Napoleon, who inspired the artist to create a monument to the Emperor. Seven years later, his bronze sculpture *Napoleon Awakening to Immortality* (fig. 12) was inaugurated on Noisot's property in Fixin, near Dijon. Rude described this work as "not a piece of historical sculpture; it is the echo of an emotion felt by us."[3] As two men's private monument it was, and remains, an extraordinary work—moving, monumental in scale, but totally isolated from public view. Concurrently the sculptor executed, also without fee, a bronze tomb for Godefroy Cavaignac, a republican leader of the opposition to the government, whom he represented as a powerful, *gisant* figure (fig. 111). After the Revolution of 1848, Rude again rose to prominence and received major public commissions. These included a giant plaster relief of the Republic for the Panthéon (destroyed in 1850 by a cannon shot) and the dramatic bronze statue of the Napoleonic hero Marshal Ney, calling his troops to battle (fig. 13). In its subject and emotional fervor, this monument recalls the *Departure of the Volunteers.*[4]

Rude's popularity waned with the advent of the Second Empire. In his final two large-scale marble sculptures, *Hebe and the Eagle of Jupiter* (see cat. no. 213) and *Love Ruling the World* (Musée des Beaux-Arts, Dijon), he returned to the calmer classicizing style of his earlier works. The sculptor considered these two statues to be his "artistic testament." Two years after his death they became triumphs for him at the Salon of 1857. Although a victim of academic and political ostracism, Rude was an eclectic genius whose passionate monumental sculptures made him one of France's most powerful and influential sculptors. A.D.

210.
Neapolitan Fisherboy
Bronze
h: 9½ in. (24.1 cm.); l: 10½ in. (26.7 cm.); w: 5½ in. (14 cm.)
Model 1831
Foundry mark: F. BARBEDIENNE FONDEUR/ 823 (on right rear edge of base)
Stamped: REDUCTION MECANIQUE/ A. COLLAS (on top of base)
Lender: Private Collection

The bronze exhibited here is a reduction of a life-size marble now in the Louvre. A small plaster model of the work was exhibited at the Salon of 1831. The sculpture portrays a young nude boy seated on a rock, playfully teasing a small tortoise. Although the work may not appear particularly innovative to our eyes, it created a sensation when it was exhibited at the Salon of 1833; as a result of its success, Rude was awarded the Cross of the Legion of Honor in the same year. The sculpture's historical significance was perhaps not too much inflated by the critic Edmund Gosse

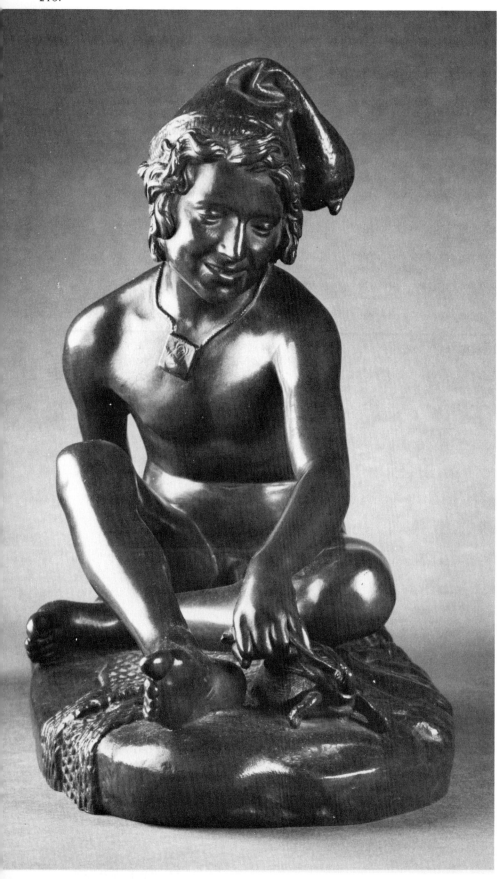

in 1894: "modern sculpture dates from 1833, when François Rude exhibited his *Young Neapolitan Fisherboy* in the Salon. This was the first attempt made anywhere to present the human body as it exists before our eyes."[5] Indeed, the nonheroic, sentimental subject, rendered naturalistically, marked a departure from the ideals of Neoclassical sculpture. In choosing to depict a youthful figure at play, the sculptor may have been aware of earlier Neoclassical works such as Chaudet's popular *Amour Playing with a Butterfly* (1802, Louvre); but Rude's work is without any apparent mythological framework to justify it as a "serious" sculpture.

Fanciful Italian genre subjects, similar to Rude's sculpture, were extremely popular among Romantic painters of the period. Francisque-Joseph Duret's *Dancing Neapolitan Boy* (cat. no. 122), also exhibited at the Salon of 1833, is another sculpture that reflects the same trend. The impact of Rude's statue, together with his rejection of formalism in the 1840s, can be traced in the works of other sculptors, including Barye and Frémiet. The *Fisherboy* exerted a direct influence on Rude's most talented student, Jean-Baptiste Carpeaux, whose work of a similar subject was clearly intended as an *hommage* to Rude (see cat. no. 29). Vincenzo Gemito's *Neapolitan Fisherboy*, exhibited at the Salon of 1876, is yet a later descendant of Rude's playful figure. Not only did it influence other sculptors, but Rude's *Neapolitan Fisherboy* was one of the most popular sculptures of the nineteenth century and was edited commercially in a variety of sizes and media. The dimensions of our bronze correspond to the second of three sizes of casts produced by the Barbedienne foundry.[6] A.D.

211.
**Head of the Genius of Liberty
(La Marseillaise)**
Bronze
h: 18½ in. (47 cm.)
Model c. 1833–35
Signed: F. Rude (on lower left side of neck)
Foundry mark: cire perdue/Le Blanc
Barbedienne/Paris (on lower back)
Provenance: Jean-Pierre Selz, New York
Lender: The Los Angeles County Museum
of Art, purchased with funds donated by
Camilla Chandler Frost

The *Head of the Genius of Liberty* is a bronze one-third the size of the original figure in Rude's monumental stone relief, the

Departure of the Volunteers (fig. 71), on the Arc de Triomphe. The relief depicts a group of six men of various ages rallying to the battle cry of Marianne, the French personification of Liberty, who appears above them. A stirring call to arms, the allegorical sculpture commemorates an event of 1792, when thousands of patriotic citizens from all over France banded together to form the first volunteer army in response to the threat of Prussian and Austrian invasion. Because the sculpture—in particular the figure of Liberty—so captivated the public's imagination, it was soon popularly dubbed *La Marseillaise* after the revolutionary marching song that later became the national anthem.

The Genius of Liberty clearly dominates the work. Adorned with large wings, armor, and billowing drapery, she recalls antique and Renaissance figures of Victory and Bellona. Her Phrygian cap is a familiar attribute of Liberty. She flies forward into battle, extending a sword to the left. Her commanding gesture, which summons the warriors to unite and follow, serves as the culminating point of the composition. Marianne's ferocious expression is equally compelling. According to tradition, Rude's wife Sophie modeled for the dynamic figure. When she grew tired and relaxed her pose the sculptor would shout "Cry louder!" in order to capture the desired expression.[7] Auguste Rodin, observing the power of her cry remarked, "It seems as though one must hear her—for her mouth of stone shrieks as if to burst your eardrum."[8] Inspired by this figure, Rodin adapted her pose and expression for his sculpture *The Call to Arms* (cat. no. 192). Many of Rude's contemporaries, however, were critical of the realistic rendering of the figure. As Gustave Planche noted: "If this is the Genius of War [sic], then the streets of Paris are populated with similar spirits."[9] David d'Angers characterized it as an "expression of false passion."[10] Nevertheless, Rude's relief was one of the few major Romantic sculptures to rival—in its successful merging of historical allegory and naturalism—Delacroix's *Liberty Leading the People* (Salon of 1830).

Rude became involved with the sculpture of the Arc de Triomphe in 1828, after the success of his *Mercury Attaching His Wings* at the Salon of that year. The state commissioned him, along with thirteen other sculptors, to complete the triumphal monument initiated by Napoleon in 1806. To demonstrate the political continuity of his regime with Bonaparte's, Louis-Philippe decided that the Arc would honor not only the Grande Armée, but all courageous Frenchmen who had fought since the Revolution to defend their country. The sculptural program underwent continual changes until 1833, when the Minister of the Interior, Adolphe Thiers, distributed the commissions for the four major reliefs. Rude received the *Departure of the Volunteers;* Jean-Pierre Cortot, The *Triumph of 1810;* and Antoine Etex was assigned the two friezes on the Neuilly side: the *Resistance of 1814* and the *Peace of 1815*. Clearly Thiers intended this scheme to express the logical progression of the 1792 Revolution toward the July Monarchy and his government's ability to preserve the peace. All four reliefs were completed for the inauguration of the Arc on July 29, 1836.

According to Rude's biographer, Louis de Fourcaud, the sculptor produced more than sixty maquettes for the *Departure*.[11] An original plaster model of the head is preserved in the Musée des Beaux-Arts, Dijon, while a terracotta-colored plaster is in the Louvre, and a third plaster, which once belonged to Rude's pupil, Paul Cabet, is in Nuit-Saint-Georges. The Los Angeles bronze is one of several known casts.[13] The fact that the head was reproduced several times throughout the nineteenth century attests to the patriotic appeal it held for the public. The figure's bellicose fervor demonstrates a marked counterpoint to Bartholdi's more benevolent *Liberty* created fifty years later (cat. no. 13). Although the sculptures represent radically different facets of Liberty, both have become national, if not popular, symbols of France and the United States. A.D.

212.
Head of the Old Warrior
Bronze
h: 24½ in. (62.2 cm.) including 4⅝ in. (11.7 cm.) socle; w: 13⅞ in. (35.2 cm.); d: 12⅞ in. (32.7 cm.)
Model c. 1833–35
Signed: F. RUDE (upper left shoulder)
No foundry mark
Provenance: Heim Gallery, London
Lender: The David and Alfred Smart Gallery, The University of Chicago, Anonymous Loan

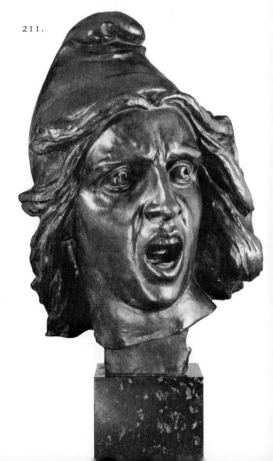

211.

The *Old Warrior,* sometimes called the *Old Gaul,* is the principal figure among the group of volunteer soldiers on Rude's heroic relief on the Arc de Triomphe. Like the *Head of the Genius of Liberty* (cat. no. 211), the *Head of the Old Warrior* was reproduced, independent of the entire figure, in various sizes and materials.[14] The bronze version exhibited here was probably cast in the late nineteenth century.

Rude was initially pleased with his design for the *Departure of the Volunteers* and expressed some of his enthusiasm in a letter to a friend: "I believe this time I have succeeded, because there is something there that makes my blood run hot and cold. My warriors hasten to defend their country and not in search of glory."[15] Rude's six warriors, dressed in Roman armor, are meant to symbolize an entire army. Representing several generations from youth to old age, each figure responds differently to the compelling call of war. Much of the emotional power of the relief is condensed in the figure of the *Old Warrior.* Placed under Marianne, he echoes her pose and communicates her message to the others. In Rude's preparatory drawings and in his maquettes for *La Marseillaise* (in the Louvre and Dijon), the sculptor originally depicted the central warrior as a helmeted nude youth. Only later, in his final project, did he transform him into a rugged, mature soldier in antique armor.[16] His furrowed brow, intense gaze, and long unruly mane —vaguely reminiscent of the Laocoön—convey the warrior's passionate dedication to the patriotic cause. In the bronze head in this exhibition one can observe a small portion of the lion's skin draped over the shoulders of the figure in the relief. The most poignant drama in the *Departure of the Volunteers* is the intimate interchange between this older, experienced warrior and the youth, possibly his son, placed at his side. With paternal affection, he embraces the boy, thus encouraging him to join the troops. This may reflect Rude's childhood memories of the Revolution and of his father.[17] A.D.

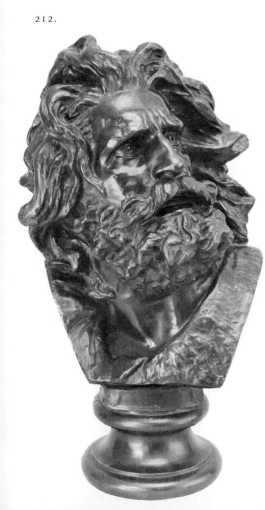

212.

213.

Hebe and the Eagle of Jupiter

Bronze
h: 30⅝ in. (77.8 cm.); w: 22 in. (55.8 cm.); d: 13¼ in. (33.7 cm.)
Model c. 1853–55
Signed: Rude Sculp[t] (on front of base)
Foundry mark: FUMIERE ET C[IE] SUC[RS]/ THIEBAUT[FRES]/PARIS (on base)
Provenance: Jacques Fisher, Paris
Lender: Los Angeles County Museum of Art, Gift of B. Gerald Cantor

Rude devoted most of his later life to two marble sculptures he considered his "artistic testament." One of these was *Love Dominating the World;* the other, represented here in bronze, was *Hebe and the Eagle of Jupiter.* Hebe, the Greek goddess of youth and cupbearer to the gods, is portrayed as a seductive nude who tantalizes Jupiter by holding a cup of ambrosia high above his head. The impetus to create the work began in 1846 when the mayor of Rude's native Dijon commissioned the distinguished artist to execute a sculpture for the Musée des Beaux-Arts. The city council, wishing to acknowledge Rude's importance, originally requested a replica of his *Neapolitan Fisherboy* (cat. no. 210). The sculptor refused this commission because he had hoped to design an original marble for his native town. Through the influence of Anatole Devosge, son of Rude's former instructor, the municipal council on November 11, 1846, granted the sculptor absolute freedom in his choice of subject and placed no restrictions on size, time, or cost.

A black lead drawing in Dijon of *Hebe Raising the Ambrosia* records the artist's early conception of the subject. Rude modeled *Hebe* first in terracotta. Because of other projects, nearly five years elapsed before he was able to devote more attention to the Dijon commission. After he resumed work on the sculpture about 1850–51, he executed several maquettes, including two wax models now in the Louvre and in Dijon.[19] The Dijon maquette demonstrates his initial plan for an antique-inspired pedestal ornamented with grotesques. The final work has a Neoclassical base inscribed with the names of Homer, Hesiod, Euripides, Ovid, Virgil, and Catullus. Both *Hebe* and *Love Dominating the World* (commissioned by Devosge in 1849) were nearly finished at the time of Rude's death in 1855. Paul Cabet, one of his students,

supervised their completion. Exhibited at
the Salon of 1857, these works were praised
by Théophile Gautier, who in his review
in *L'Artiste* hailed Rude as "le triomphateur
posthume de l'Exposition;" the critic con-
sidered *Hebe*'s grace and sleek elegance
particularly pleasing and comparable to
the greatest works of classical sculpture:
"Never has Plato's definition—beauty is
the splendor of truth—been better jus-
tified."[20] At the same time he noted that
the work possessed a "modern sentiment."
Rude strove to render antiquity in modern
terms throughout his career; yet, *Hebe* is
classical only in its subject and not in its
form.[21] The composition of the piece, with
its broken contour and diagonal move-
ment, relates more to Baroque sculpture.
Furthermore, the figure's sweet, prettified
face, coy expression, and slick finish are
contrary to classical principles. Instead,
Hebe embodies nineteenth-century ideals of
youth and beauty, and in this way, links
modern standards with those of antiquity.[22]

Bronze reductions of the sculpture appear
to have been cast in a fairly large edition
by Thiébaut Frères. In addition to the Los
Angeles *Hebe*, other casts of the same size
are located in The Minneapolis Institute of
Arts, The Art Institute of Chicago, The
David and Alfred Smart Gallery at the
University of Chicago, Princeton Univer-
sity, and the Louvre (casting model). Jules
Franceschi was no doubt inspired by
Rude's late masterpiece when he executed
his own *Hebe*, shown at the Salon of 1868
(cat. no. 139). A.D.

214.
Bust of the Genius of Liberty
Clay, fired at a low temperature, if at all
h: 12¾ in. (32.4 cm.); w: 8¾ in.
(22.2 cm.); d: 4¼ in. (10.8 cm.)
c. 1833
No foundry mark
Lender: Museum of Fine Arts, Boston, Gift
of Wildenstein and Company in memory
of George Swarzenski

This previously unpublished work im-
mediately calls to mind Rude's *Genius of
Liberty* (cat. no. 211) and poses a problem
of attribution that, at present, cannot be
fully resolved. In 1904 Louis de Fourcaud
wrote that, according to Rude's friend Dr.
Legrand, the sculptor produced more than
sixty maquettes for his *Departure of the Vol-
unteers* (fig. 71) on the Arc de Triomphe.[23] If

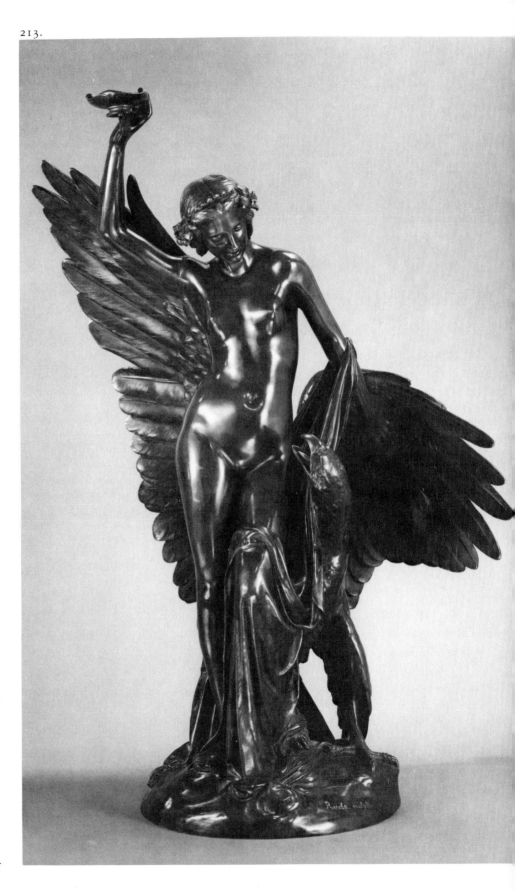

this is true, then it would be reasonable to assume that Rude's conception for the head of *The Genius of Liberty* may have changed more than once before he arrived at the final model for the monument; the small Boston clay differs considerably from the extant plaster models of the head of Rude's *Liberty* (see cat. no. 211). The plasters have larger, more widely opened eyes, more ferocious expressions, and more classically beautiful faces. The Boston clay is somewhat closer to the head in one of Rude's plaster sketches for the full figure of *Liberty* (Louvre),[24] but even here there are differences. All of Rude's previously recorded studies for the figure show her with wavy hair, while in the Boston bust the hair is rendered in a series of ringlets. Until further evidence is available, one cannot discount the possibility that the clay may have been executed by one of Rude's students or followers. It is known that Rude's *Genius of Liberty* had an enormous impact upon Rodin (see cat. no. 192); undoubtedly it also influenced some of the lesser sculptors involved with the myriad of commissions for busts and statues of the Republic as a female figure wearing a Phrygian cap. The attribution of the Boston clay is further complicated by the fact that it has been damaged and has undergone considerable repairs. A.D. & P.F.

Notes

1.
Although Rude destroyed his original plaster model, a bronze replica survives in the Musée des Beaux-Arts, Dijon.
2.
Quoted in Fourcaud, 1904, pp. 129–30.
3.
Cited in Drouot, 1958, p. 100.
4.
For a recent examination of the *Departure of the Volunteers,* the *Napoleon, Cavaignac,* and *Marshal Ney,* see Butler, 1978, pp. 92–107.
5.
Cited in Cooper, 1975, p. 14.
6.
Barbedienne, 1880, p. 35; 1884, p. 36.

7.
Bertrand, 1888, p. 66.
8.
Quoted from *On Art and Artists,* New York, 1957, pp. 98–100.
9.
Cited by Butler, 1978, p. 98.
10.
A. Bruel, ed., *Les Carnets de David d'Angers,* Paris, 1958, II, p. 89.
11.
Fourcaud, 1904, p. 471.
12.
The plaster model was found in Rude's atelier and belonged to Paul Vitry before it was acquired by the Musée des Beaux-Arts, Dijon.
13.
These include bronzes in the National Museum of Stockholm, the Musée d'Art Moderne, Geneva, and another exhibited at Bruton Gallery, England, in April–May 1977. A terracotta version was shown at Wildenstein, New York, in 1961, and a patinated plaster exhibited at the Heim Gallery, London, in 1977.
14.
The best documented of these is a bronze (Musée des Beaux-Arts, Dijon) cast from a maquette of the *Head* by Rude's student Paul Cabet. Bronze versions of the sculpture can be found in the Metropolitan Museum of Art, New York (25 inches high), the Philadelphia Museum of Art (28 inches high), the David Daniels Collection, New York (12 inches high), Glasgow Art Gallery and Museum (25¼ inches high), and the collection of Pierre Staudt, Epinay, France (11⅜ inches high). Terracotta casts are located in the Phoenix Art Museum (25¼ inches high) and in the Hirshhorn Museum and Sculpture Garden (25 inches high).
15.
Lami, 1914–21, IV, p. 204.

214.

16.
Louisville, 1971, p. 236, no. 87.
17.
Butler, 1978, p. 98.
18.
Dijon, 1955, p. 39, no. 68.
19.
Quarré, 1964, pp. 253–54. In addition, the museums in Dijon and Saumur each possess a plaster cast evidently taken from Rude's model for *Hebe;* see Lami, 1914–21, IV, p. 215; Fourcaud, 1904, p. 504.
20.
Gautier, 1857, pp. 161–62.
21.
M. Parsons, "Nineteenth Century French Sculpture: Jean Pierre Danton and François Rude," *The Minneapolis Institute of Arts Bulletin,* 1969, LVIII, p. 60.
22.
Ibid., p. 62.
23.
Fourcaud, 1904, p. 471.
24.
Illustrated by P. Vitry, "Les accroissements du département des sculptures au Musée du Louvre," *Gazette des beaux-arts,* 1922, I, p. 26.

Selected Bibliography

Legrand, M., *Rude, sa vie, ses oeuvres, son enseignement,* Paris, 1856.

Poisot, C., "Notice sur le sculpteur François Rude, lue le 26 novembre 1856," *Memoires de l'Académie des Sciences Arts et Belles-Lettres de Dijon,* Paris, 1857.

Betrand, A., *François Rude,* Les Artistes Célèbres, Paris, 1888.

Fourcaud, L. de, *François Rude, sculpteur; ses oeuvres et son temps (1784–1855),* Paris, 1904.

Calmette, J., *François Rude,* Paris, 1920.

Lami, 1914–21, IV, pp. 202–17.

DeVigne, "Sur deux oeuvres de Rude à Bruxelles," *Actes de Congrès d'Histoire de l'Art, 1921,* Paris, 1924, II, pp. 603–6.

Vitry, P., "Documents inédits sur Rude," *Bulletin de la société de l'histoire de l'art français,* 1929, pp. 30–42.

————, "Les dessins de Rude au musée de Dijon," *Gazette des beaux-arts,* 1930, IV, pp. 113–27.

Quarré, P., "Les Projects de Rude pour la décoration de l'Arc de Triomphe de l'Etoile," *Memoires de la commission des antiquaires de Côte d'Or,* 1938–39, XXI, pp. 359–61.

————, *François Rude, catalogue de ses oeuvres conservées à Dijon,* Dijon, 1947.

Pradel, P., "Musée du Louvre: deux oeuvres inédites de Pajou et de Rude," *Musées de France,* 1949, no. 2, pp. 34–36.

Hubert, G., "Nouvelles esquisses de Rude au Musée du Louvre," *Le revue des arts,* 1952, II, pp. 172–74.

Landowski, P., "Rude à Bruxelles—Ses méthodes et son enseignement considerés dans leur rapport avec théories esthétiques contemporaines," *Academie Royale de Belgique: Bulletin de la classe des beaux-arts,* 1955, XXXVII, pp. 126–41.

Quarré, P., "La Vierge deuillant de Rude," *La revue des arts,* 1955, no. 4, pp. 217–22.

Dijon, Musée des Beaux-Arts, *François Rude, 1784–1855: Commemoration du Centenaire,* ed. Pierre Quarré, 1955.

Drouot, H., *Un Carrière: François Rude,* Dijon, 1958.

Quarré, P., "Musée des Beaux-Arts de Dijon: Nouvelles Acquisitions," *La revue du Louvre,* 1964, XIV, no. 4–5, p. 253.

Louisville, 1971, pp. 233–39.

Butler, R., "Long Live the Revolution, the Republic, and Especially the Emperor! The Political Sculpture of Rude," *Art and Architecture in the Service of Politics,* ed. H. Millon and L. Nochlin, Cambridge, Massachusetts, and London, 1978, pp. 92–107.

Little is known of Soitoux. He came to Paris at an unknown date and was a pupil, presumably in the late 1830s and 1840s, of Jean-Jacques Feuchère and David d'Angers. Abbé Brune states that Soitoux collaborated with David on the bas-reliefs for the *Bonchamps Monument* at the church of Saint-Florent-le-Vieil (Maine-et-Loire),[1] but this is not possible since Soitoux was nine years old when the monument was completed in 1825. Confusion may have arisen from the fact that Soitoux owned one of David's models for a relief from the *Bonchamps Tomb.*[2] In any case, he seems to have revered David: in 1856 he initiated a subscription to place a bronze crown on his master's tomb; in 1857 he signed a petition for the admission of a work by David, *Young Barra Dying,* into the collections of the Louvre; and he was instrumental in drawing up the list of David's students published in Henry Jouin's 1879 monograph on the great sculptor.[3] Abbé Brune states that Soitoux was also a pupil of François Rude,[4] and although this is feasible on stylistic grounds (see cat. no. 215), Soitoux is listed in the Salon catalogs of 1857 and 1866 only as "élève de Feuchère et David d'Angers."

The major event in Soitoux's career came in 1848 when he won the competition organized by the provisional government of the Second Republic to create a symbolic figure of *The Republic.* The completed marble of this work was exhibited at the Salon of 1850, where it won a second-class medal. Despite this triumph as a republican artist, most of Soitoux's known activity was as a *sculpteur-statuaire,* providing decoration for two of Napoleon III's major building enterprises: the new wing of the Louvre and the Tuileries. After 1850, Soitoux exhibited at only two other Salons: in 1857 he showed stone figures designed for the exterior decoration of the Louvre (*The Genius of Combat, Montaigne,* and *Denis Papin*), and in 1866 he exhibited several works for the Tuileries (a pediment relief of *Generative Force,* bas-reliefs of *Material Force* and *Intellectual Force,* statues of *Erato* and *Clio*) and a plaster *Bust of Paul de Flotte.* Soitoux's other recorded works include his *Tomb of Jean-François Marcotte* (d. 1848) in Père-Lachaise; a stone group of *Astronomy* (1854) for the attic balustrade of the Louvre; a marble statue of *Archaeology*

215.

(commissioned 1859) for the courtyard of the Louvre; a statue of *Beauty* (1860s) for the Paris Opéra; a plaster statuette of *Democracy* in the Musée d'Art et d'Histoire, Geneva; and a *Silenus* and portraits of *Gambetta, Robert Houdin,* and *Affert* in the Musée de Blois.

Abbé Brune states that Soitoux was attacked by a nervous disease and forced to stop working at the age of forty-five, in 1861;[5] but this is contradicted by the artist's work for the Tuileries. Moreover, after the fall of Napoleon III, in response to another proposed but unrealized state competition, the artist produced a new project in 1879 for a statue of *The Republic* (illustrated in the journal *L'Illustration,* October 25, 1879). In 1880, Soitoux's 1848–50 marble statue of *The Republic,* which for political reasons had languished in storage, was resurrected and placed on public view in front of the Palais de l'Institut; at this time, the artist was awarded membership in the Legion of Honor.

Soitoux died in 1891 and his tomb, designed by his most famous pupil, Bartholdi, was inaugurated in Père-Lachaise in 1892. P.F.

215.
Genius of Combat (Putto with Instruments of War)
Plaster on marble base
h: 12¾ in. (32.4 cm.); w: 6¾ in. (17.1 cm.); d: 10 in. (25.4 cm.)
1855
No marks
Lender: Rhode Island School of Design, Providence, purchased with the help of an anonymous gift

Formerly attributed to François Rude, this work was identified by Jacques de Caso as a plaster cast of Soitoux's maquette for a monumental stone group, *The Genius of Combat,*[6] completed in 1855 as part of the decorative program on the new interior wing of the Palais du Louvre, a project begun under the direction of the architect Hector Lefuel in 1854. A year prior to *The Genius of Combat,* Soitoux had executed another group, *Astronomy,* as part of this decorative program which ultimately included nearly one hundred geniuses or putti with the instruments or symbols of various human endeavors. These groups were perched on the attic of the new Louvre wings framing the Place Napoleon and the Place du Carrousel. This program, harking back to a Baroque and Rococo predeliction for the emblematic use of putti or children, is typical of the stylistic revivalism which pervades much mid-nineteenth-century architecture and architectural sculpture. The composition of *The Genius of Combat,* with its series of strong but counterbalanced diagonals radiating out from the center, echoes on a minor scale the dynamic style of Rude's 1836 *Departure of the Volunteers* on the Arc de Triomphe. Soitoux's work also provides an interesting precedent, both stylistically and thematically, for Carpeaux's *Defense of Valenciennes* of 1870. The completed stone group of *The Genius of Combat* was listed in the 1857 Salon *livret* (p. 484) under the section devoted to public monuments.
 P.F. & G.S.

Notes
1.
Brune, 1912, p. 266.
2.
Jouin, 1878, II, p. 461.
3.
Ibid., I, pp. 582–84.
4.
Brune, 1912, p. 266.
5.
Ibid., p. 266.
6.
Caso, 1968, pp. 3–8.

Selected Bibliography
Brune, 1912, p. 266.

Lami, 1914–21, IV, pp. 265–66.

Thieme-Becker, 1907–50, XXXI, p. 219.

Lethève, J., "Une statue malchanceuse 'La République' de Jean-François Soitoux," *Gazette des beaux-arts,* 1963, LXII, pp. 229–40.

Caso, J. de, "Reexamination of a Putto with the Instruments of War Formerly Ascribed to François Rude," *Bulletin of the Rhode Island School of Design,* 1968, LIV, no. 3, pp. 3–8.

BARON HENRI DE TRIQUETI
1804 Conflans (Loiret)–Paris 1874

Born in the château of Perthuis, Triqueti inherited the title of baron from his father, Michel de Triqueti, a Piedmontese who served as ambassador of the King of Sardinia to the Russian court. As a youth he went to Paris to study painting with Louis Hersent (1777–1860). After having painted for a short time, Triqueti devoted all his efforts to sculpture. He made his Salon debut in 1831 with a bas-relief, *The Death of Charles the Bold,* for which he was awarded a second-class medal. This work was bought by the Duke of Istria. In 1833–34, Triqueti received two public commissions: the first, for the Chamber of Deputies in Paris, consisted of bas-reliefs representing *Avenging Law* and *Protecting Law;* the second, a scheme for the bronze doors on the church of the Madeleine, was completed in collaboration with Maindron. In addition, Triqueti worked on diverse projects for the church of St. Germain l'Auxerrois and for the Louvre, and he carved about half of the wood paneling in the meeting hall of the Luxembourg Palace. In the 1830s, he designed many objects—swords, daggers, cups, ewers, and vases—which were shown in the Salons or commissioned by private and royal patrons.

Although much of Triqueti's work leaned towards a Romanticism heavily tinged with the Gothic, his figure of Charity representing the city of Paris comforting cholera victims (Salon of 1833) is allegorical rather than historical.

At the Salon of 1838 Triqueti exhibited a bronze vase with bas-reliefs depicting Dante's divine and Petrarch's profane poetry on either side. Commissioned by the Duke of Orléans, the vase—including a marble pedestal with sculptures of Laura, Beatrice, and Eleanora d'Este—was left upon the Duke's death in 1842 to his nephew, King Leopold II of Belgium. Triqueti was asked to carve a memorial sculpture of the Duke as well as a *Descent from the Cross,* for the chapel of St. Ferdinand in Neuilly, where the Duke was fatally injured.

In 1839 Triqueti was awarded a first-class medal for his bronze bas-relief of Thomas More. In the following years he became involved with restoration projects for the Sainte Chapelle in Paris, and in 1846 he was commissioned to do a bronze Cruci-fixion for the altar in the church of the Invalides. In 1861 he became a member of the consulting commission for the royal museums. His relations with England began when he sold some ivory sculpture to Queen Victoria. In 1864 she summoned him to work on a memorial to Prince Albert: this included seventeen bas-reliefs in marble and thirteen statues for Wolsey Chapel at Windsor Castle. He also executed scenes from the *Iliad* and the *Odyssey* for University College, London.

Triqueti exhibited in the Salon for the last time in 1867, and he finished four figures in stone representing Asia, Europe, Africa, and America for the Ministry of Foreign Affairs in 1870. After his death many of the works and models remaining in his studio were given to the Musée Girodet in Montargis, near his birthplace of Conflans.

J.A.

216.

216.
Dante and Virgil
Bronze
h: 35½ in. (90.2 cm.); w: 33⅞ in.
(86.4 cm.); d: 25¼ in. (64.1 cm.)
Model 1861, cast 1862
Signed and dated: H. de Triqueti 1861 (on back right)
Foundry mark and date: F. BARBEDIENNE, fondeur Paris 1862 (on back left)
Inscribed: Liberate/va cercando/che/si cara (on scroll)
Lender: Museum of Fine Arts, Boston, Gift of Mrs. Edward Lee Childs

Dante (1265–1321) was greatly admired by Romantic writers—such as Balzac, Hugo, and Baudelaire—and artists, who commemorated the poet as well as episodes from the *Divine Comedy* in hundreds of paintings and sculptures.[1] Triqueti is only one of several artists who, like Delacroix in his famous painting *The Barque of Dante* (1822, Louvre), portrayed the medieval poet with Virgil, his guide during their journey through Heaven, Purgatory, and Hell. The sculpture—not listed in Lami—was apparently never exhibited at the Paris Salon; however, in 1862, the year it was completed, the work did appear at the London Royal Academy Exhibition where it was well received.[2] Several years earlier, Préault executed a bronze relief of *Dante and Virgil in Hell* (Musée des Beaux-Arts, Chartres), and between 1852 and 1853 he made individual bronze medallions of them both (Louvre). For his portrait of Dante, Triqueti may have relied, like Préault, on the well-known bust of the poet in the Museo Nazionale, Naples, thought to date from the fifteenth century. His bust of Virgil, traditionally represented as a bearded old man, may have been inspired by Préault's portrait medallion, which in turn could be based on Signorelli's youthful figure of the ancient poet in his frescoes in Orvieto Cathedral.[3] In Triqueti's sculpture, Dante holds a scroll inscribed: "Liberta va cercando che si cara." ("He who goes seeking freedom which is so dear," *Purgatory,* canto I.)

The form of this piece—a double half-length portrait—is unusual for nineteenth-century sculpture and ultimately refers to antique funerary portraiture. The broad, undetailed modeling of the busts is characteristic of Triqueti's facture in general. — J.A.

Notes

1.
Artists inspired by Dante include Carpeaux (cat. no. 32), Ary Scheffer, Ingres, Félicie de Fauveau (fig. 73), Géricault, Doré, Girodet, Blake, Rossetti, Jean-Paul Aubé, and Rodin.
2.
"The Royal Academy Exhibition, 1862," *The Art Journal,* 1862, XIV, p. 137.
3.
Phildelphia, 1978, p. 239.

Selected Bibliography

Les Tarsias de marbre du Baron Henri de Triqueti Decorateur de la Chapel Wolsey à Windsor, Nantes, 1869.

Girardot, Baron de, *Catalogue de l'oeuvre du baron Henri Triqueti,* 1874.

Huette, *Notice biographique sur M. le baron Henri de Triqueti,* Montargis, 1875.

The Tarsias Marbles in the Albert Memorial Chapel, photographed by Miss Davidson, London, 1876.

Leroy, A., *Henri de Triqueti, sculpteur et critique,* Orléans, 1894.

Lami, 1914–21, IV, pp. 318–24.

Beaulieu, M., "Un sculpteur français d'origine italienne, Henri de Triqueti, 1804–1874," *Publications de la société des études italiennes,* 1949, II, pp. 203–22.

Louisville, 1971, pp. 241–44.

After his family moved to Paris in the 1840s, Willème studied painting with Henri Philippoteaux; he also studied sculpture, but with whom is unknown.[1] He apparently earned a living by making models from bronze manufacturers, and in the 1850s he learned photography in order to document his sculptures.[2] In 1859 he conceived the idea of "mechanical sculptures" produced with minimal hand modeling from a series of profile photographs of a subject (see cat. no. 217). Within a year or two he developed a more elaborate process of "photo-sculpture" and took out patents on his inventions. In the early 1860s he also formed, with Charles de Marnyhac, a Société Générale du Photo-sculpture de France. About the same time he opened a large commercial studio; evidently a financial failure, it closed in 1867 or early 1868.

Willème then returned to Sedan where, in partnership with Charles Jacquard, he continued to make photo-sculptures. In addition to these works (portrait medallions, busts, and statuettes), at some point after 1870 he executed for the city of Sedan an allegorical group of *England Coming to the Aid of France.* Numerous documents concerning Willème's inventions and several of his photo-sculptures, including a self-portrait, are preserved in the International Museum of photography at George Eastman House, Rochester, New York — P.F.

217.
Bust of Woman
Unfinished wood photo-sculpture
h: 5½ in. (14 cm.); w: 3⅛ in. (7.9 cm.) including pedestal
c. 1859–61
No marks
Provenance: G. Cromer
Lender: International Museum of Photography at George Eastman House, Rochester, New York

This object appears to be a demonstration piece for one of the stages in the first process Willème developed for mechanically reproducing sculpture from photographs. The technique is based on the principle that a three-dimensional object is equal to the sum of its profile views. The subject, in this case a female head, would have been

photographed simultaneously from numerous, in this case fifty, different points of view by the same number of cameras, all equidistant from the subject. The fifty photographs were developed and printed. The profile outline on each photograph was then reproduced on a thin sheet of wood by the use of a pantograph, a mechanical copying device. The fifty sheets of wood, each with a slightly different profile of the same subject, were cut in half and the resulting one hundred wood sheets with half-profiles were then planed into wedge-shaped sections. Each of the hundred sections was cut, along the outlined half-profile it bore, into two pieces: a positive and a negative half-profile. The Eastman House bust is composed of one hundred positive half-profiles, reassembled like the wedges of a pie and tied together to form a solid object.

This object, however, was not the final aim of Willème's mechanical process. The finished product, or products, were casts in various media, which could be obtained by assembling the leftover one hundred negative half-profiles into a cylinder that would necessarily have at its center a void corresponding to the shape of the sitter's head. This process of "mechanical sculpture" evidently has not been employed commercially since. Willème quickly developed a slightly more elaborate and flexible process —"photo-sculpture"—to which he then devoted his attention. This later process enjoyed a certain vogue during the 1860s.

Within the context of the present exhibition, Willème's mechanically produced bust is simply intended to represent one of the numerous technological innovations that in various ways touched upon the history of sculpture. Other such devices included the physionotrace, developed by Gilles-Louis Chrétien in 1783; the physionotype, patented by Pierre-Louis-Frédéric Sauvage in 1836; the sculptural reducing and copying machine, invented by Achille Collas, also in 1836; and the plastimonographe, patented by Antoine-François-Jean Chaudet in 1865. Most of these devices focused upon portraiture and all of them sought economical means of

reproduction. The study of their impact upon sculpture—and that of photography and new casting techniques—is still in its infancy. P.F.

Notes

1.
For most of the material presented here I am indebted to Robert A. Sobieszek (see bibliography below).
2.
R. Lecuyer, *Histoire de la photographie*, Paris, 1945, p. 281.
3.
To date, the most important study of technological changes in relation to the production of sculpture is J. de Caso's "Serial Sculpture in Nineteenth-Century France," in Cambridge, 1975, pp. 1–27. See also Bogart, 1979, pp. 105–7, and the forthcoming study by Sobieszek listed below.

Selected Bibliography

F. Moigno, "Photo-sculpture: Art nouveau imaginé par M. François Willème,"*Cosmo*, 1861, XVIII, pp. 459–60.

T. Gautier, "Photo-sculpture," *Le monde illustré*, 1864, VII, pp. 396–98.

G. Cromer, "François Willème, inventeur de la photosculpture," *Bulletin de la société française de photographie*, 1924, XI, pp. 134–45.

B. Newhall, "Photo-sculpture," *Image*, May 1958, pp. 100–105.

R. A. Sobieszek, "Sculpture as the Sum of its Profiles: François Willème and Photo-sculpture in France, 1859–1868," forthcoming article.

217.

218.
St. Theresa
Bronze
h: 15 in. (38.1 cm.)
c. 1830–1840
No marks
Lender: J. Patrice Marandel, Houston

Religious sculpture is one of the least studied areas of Romantic art. To a certain extent this situation reflects what would seem to have been a relative lack of interest in religious subjects on the part of the better sculptors of the period (see essay on "Religious Sculpture in Post-Christian France"). Also, unlike secular sculpture and portraiture, few religious works—aside from crucifixes which functioned primarily as objects of devotion—were reproduced in reduced, portable versions for the private collector. In this respect, the exhibited bronze statuette of a female saint is something of a rarity. Stylistically, with its heavy drapery twisted gently into large simple folds, the bronze relates to works of the 1830s such as Marochetti's *Magdalen* (1834, church of the Madeleine, Paris). Its swooning gesture and ecstatic gaze, though inspired by Baroque sculpture, are relatively restrained. The backward tilt of the head is counterbalanced by the outstretched hands, and the overall effect is of a swaying figure caught in a moment of delicately poised balance. The sophistication of its design would seem to indicate the hand of a talented sculptor whom art historians should eventually be able to identify. P.F.

218.

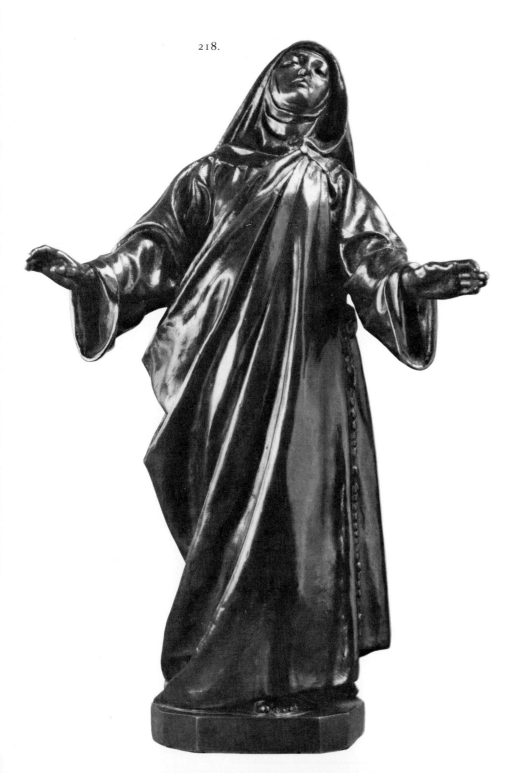

UNKNOWN ARTIST

219.
Bust of a Woman Wearing Pearls
Marble
h: 26 in. (66 cm.); w: 18 in. (45.7 cm.)
c. 1875
No marks
Lender: Michael Hall, Esq., Connecticut

This portrait of an unknown woman communicates an individual personality with a skilled, immediate rendering of her features. The lively movement implied both by the subtle modeling of temples, brow, mouth, and chin and by the complicated twist of the pose subordinates recognition of the sitter's social background to an understanding of her quick, sensitive intelligence. The dynamic pose, moreover, pushes at the static relationship customary between base and bust. Their normal alignment is replaced by an opposition of diagonals maintained by the set of the shoulders and tilt of the head and emphasized by the bow at one side. That small flourish of ribbon serves to close our progress through a composition conceived to be regarded sequentially and at length. Detailing and texture insure that attention. A lock of hair falls to touch beads meandering across the breast to a locket nestled in the eyelet-edged bodice—a seemingly artless, natural progress, yet won through artful devices like a few beads slipping to reveal the thread on which they are strung.

That the author of such an accomplished work is unknown reflects the rudimentary state of our knowledge of nineteenth-century French sculpture. The artist's understanding of Carpeaux's achievements in portraiture would seem to place it in the 1870s, and certainly works like Carpeaux's *Bust of a Lady (Fanny Coleman?)* of 1872 (Cleveland Museum of Art) provide close stylistic references.[1] The relationship is clearest in each artist's treatment of physiognomy; however, the naturalism of the present bust is not qualified by the full-blown manipulation of past sculptural styles which often marked Carpeaux's later portraits. A.W.

Note
1.
See H. Hawley, "Carpeaux's Mysterious Sculpture," *The Bulletin of the Cleveland Museum of Art,* 1976, LXIII, no. 4, figs. 1, 4, pp. 99–107.

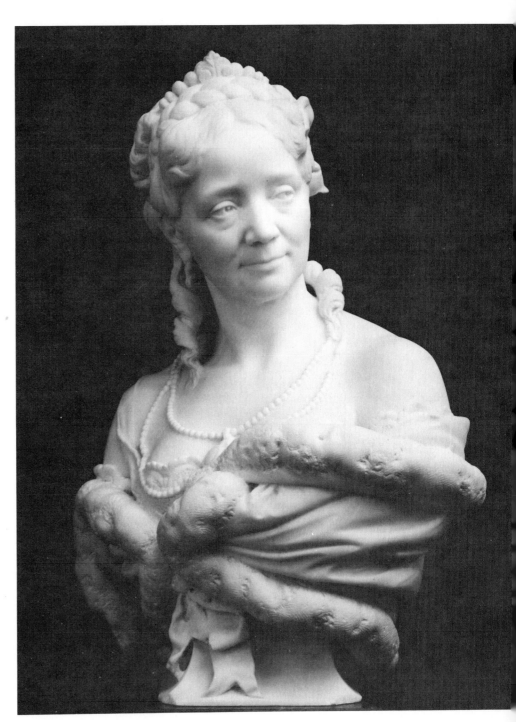

219.

About, E., *Salon de 1866,* Paris, 1867.

Albert, M., "Le Salon des Champs-Elysées," *Gazette des beaux-arts,* 1890, IV, pp. 59–68.

Agulhon, M., "Imagerie civique et décor urbain," *Ethnologie française,* 1975, V, pp. 33–56.

_____, "La 'statuomanie' et l'histoire," *Ethnologie française,* 1978, VIII, pp. 145–72.

_____, *Marianne au combat, l'imagerie et la symbolique républicaine de 1779 à 1880,* Paris, 1979.

Aubert, F., "Salon de 1861: Sculpture," *L'Artiste,* 1861, XI, pp. 272–77.

Auvray, L., *Le Salon de 1866,* Paris, 1866.

Avery, C., "From David d'Angers to Rodin: Britain's National Collection of French Nineteenth-Century Sculpture," *The Connoisseur,* April 1972, CLXXIX, pp. 230–39.

Baignères, A., "Le Salon de 1879," *Gazette des beaux-arts,* 1879, XX, pp. 146–61.

Ballu, R., "Salon de 1878," *Gazette des beaux-arts,* 1878, XVIII, pp. 169–95.

Baltimore Museum of Art, *The Partial Figure in Modern Sculpture: from Rodin to 1969,* exh. cat. by A.E. Elsen, 1969.

Bapst, G., "La sculpture chryséléphantine," *Revue de famille,* 1892, II, pp. 334–43.

Barbedienne, F., *Catalogue des bronzes d'art,* Paris, 1862, 1875, 1877, 1880, 1884, 1893, 1900.

Bart, V., "Les Statues monumentales entourant la Cour d'Honneur du Palais de Versailles," *Réunion des sociétés des beaux-arts des départements,* 1896, pp. 432–43.

Baudelaire, C., *Le Salon de 1845 de Charles Baudelaire,* ed. A. Ferran, Toulouse, 1933.

_____, *Curiosités esthétiques: l'art romantique et autres oeuvres critiques de Baudelaire,* ed. H. Lemaître, Paris, 1962.

_____, *Art in Paris 1845–1862: Salons and Other Exhibitions Reviewed by Charles Baudelaire,* trans. and ed. J. Mayne, Greenwich, England, 1965.

_____, *Charles Baudelaire critique d'art,* ed. C. Pichois, Paris, 1965.

_____, *Baudelaire, Salon de 1846,* ed. D. Kelley, Oxford, 1975.

Beaulieu, M., "Deux bronzes romantiques d'inspiration classique, *La revue du Louvre et des musées de France,* 1975, XXV, no. 4, pp. 269–74.

Bellier de la Chavignerie, E. and L. Auvray, *Dictionnaire général des artistes de l'école française depuis des arts du dessin jusqu'à nos jours,* 3 vols., Paris, 1882–87.

Bénédite, L., "Les Salons de 1899: La Sculpture," *La revue de l'art ancienne et moderne,* 1899, V, pp. 410–18, 473–84.

Bénézit, E., *Dictionnaire critique et documentaire des peintres, sculpteurs, dessinateurs, graveurs,* 8 vols., Saint-Ouen, 1966; 10 vols, Paris, 1976.

Benoist, L., *La sculpture romantique,* Paris, [1928].

_____, "Sculpture et Romantisme," *L'Amour de l'art,* 1928, IX, pp. 293–98.

Berman, H., *Bronzes Sculptors & Founders 1800–1930,* 3 vols., Chicago, 1974–77.

Bizardel, Y., "Les statues Parisiennes fondues sous l'occupation 1940–1944," *Gazette des beaux-arts,* 1974, LXXXIII, pp. 130–48.

Blanc, C., "Salon de 1866," *Gazette des beaux-arts,* 1866, XX, pp. 28–71; XXI, pp. 497–520.

_____, *Les artistes de mon temps,* Paris, 1876.

_____, *Les Beaux-Arts à l'Exposition Universelle de 1878,* Paris, 1878.

Bogart, M., "Nineteenth Century French Sculpture: The Art of Compromise," master's thesis, University of Chicago, 1975.

_____, "In Art the Ends Just Don't Always Justify the Means," *Smithsonian,* X, 1979, pp. 105–7.

Boime, A., "The Teaching Reforms of 1863 and the Origins of Modernism in France," *The Art Quarterly,* 1977, I, no. 1, pp. 1–39.

Bournon, F., *La voie publique et son décor,* Paris, 1911.

Brouilhet, H., *Exposition de 1900: l'orfèverie Française 1800–1860,* 2 vols., Paris, 1910.

Brownell, W.C., *French Art: Classic and Contemporary Painting and Sculpture,* New York, 1901, (first published 1892).

Brune, Abbé P., *Dictionnaire des artistes et ouvriers d'art de la France: Franche-Comté,* Paris, 1912.

Bruton Gallery, Somerset, England, *French Sculpture,* exh. cat., 1979.

Burger, W., *Salons 1861 à 1868,* Paris, 1870.

Burollet, T., "Le dépot des sculptures de la ville de Paris ou la survie de la statuaire parisienne," *Gazette des beaux-arts,* 1979, XCV, pp. 114–24.

Burty, P., *Salon de 1883,* Paris, 1883.

Busquet, A., "Bronzes modernes et bronziers contemporains," *L'Artiste,* 1856, II, pp. 205–9, 248–51, 269–75.

Butler, R., *Western Sculpture: Definitions of Man,* Boston, 1975.

Callias, H. de, "Salon de 1863. La Sculpture," *L'Artiste,* 1863, II, pp. 3–7.

Cambridge, Fogg Art Museum, Harvard University, *Daumier Sculpture: A Critical and Comparative Study,* exh. cat. by J. Wasserman, 1969.

_____, *Metamorphoses in Nineteenth Century Sculpture,* exh. cat., ed. J. Wasserman, 1975.

Cantrel, E., "La monnaie de l'art: les bronzes de Barbedienne," *L'Artiste,* 1859, VIII, pp. 179–80.

_____, "Salon de 1863," *L'Artiste,* 1863, I, pp. 185–95.

Caso, J. de, "Bibliographie de la sculpture en France, 1770–1900," *Information d'histoire de l'art,* 1963, VII, pp. 151–59.

_____, "Sculpture et Monument dans l'art français à l'époque néo-classique," *Stil und Uberlieferung in der Kunst des Abendlandes,* (Acts of the 21st International Congress for Art History, Bonn, 1964), Berlin, 1967, pp. 190–98.

Castagnary, J.-A., *Salons, 1857–1878,* 2 vols., Paris, 1892.

Champfleury, J., *Histoire de la caricature moderne,* Paris, 1865.

Champeaux, A. de, *Dictionnaire des fondeurs, ciseleurs, modeleurs en bronze et doreurs depuis le Moyen Age jusqu'à l'époque actuelle [A-C],* Paris and London, 1886.

Chastel, A., "L'Exposition du Fogg Art Museum de Harvard: la découverte de la sculpture du XIX^e siècle," *Le Monde,* January 8, 1976, p. 15.

Chesneau, E., *L'art et les artistes modernes en France et en Angleterre,* Paris, 1864.

_____, E., *Peintres et statuaires romantiques,* Paris, 1880.

Chicago, The David and Alfred Smart Gallery, The University of Chicago, *An Introduction to Nineteenth Century Bronze Sculpture,* exh. cat. by D. Anderson, 1977.

Claretie, J., *Peintres et sculpteurs contemporains,* Paris, 1873.

_____, *L'Art et les artistes français contemporains,* Paris, 1876.

_____, *Peintres et sculpteurs contemporains,* 2 vols., Paris, 1882–84.

Cleveland Museum of Art, Ohio, *Aspects of Nineteenth Century Sculpture,* exh. cat., ed. H. W. Janson, 1975.

Coligny, C., "Les Artistes fondeurs: M. Victor Thiébaut," *L'Artiste,* 1864, II, pp. 14–16.

_____, "Exposition de la Sculpture Moderne au Faubourg Saint-Denis," *L'Artiste,* 1866, I, 178–79.

_____, "Paris Artiste: l'Art et le bronze," *L'Artiste,* 1868, XVI, pp. 117–20.

Cooper, J., *Nineteenth Century Romantic Bronzes, 1830–1913,* Boston, 1975.

Courajod, L., *Histoire du départment de la sculpture modern au Musée du Louvre,* Paris, 1894.

Culme, J., *Nineteenth Century Silver,* London, 1977.

Cumberland, G., *Thoughts on Outline, Sculpture and the System that guided the Ancient Artists in Composing their Figures and Groups,* London, 1796.

Darcel, A., "Bronze et fonte moderne," *Gazette des beaux-arts,* 1867, XXIII, pp. 419–41.

Dayot, A., *Les médaillés du Salon,* Paris, 1868.

Delteil, L., *Le peintre-graveur illustré (XIX^e et XX^e siècles),* VI, Paris, 1910.

Desjardins, P., "Les Salons de 1899: Sculpture," *Gazette des beaux-arts,* 1899, XXII, pp. 283–92.

Devaux, Y., *L'univers des bronzes et des fontes ornamentales (chefs-d'oeuvres et curiosités, 1850–1920),* Paris, 1978.

Dowley, F.H., "D'Angiviller's 'Grands Hommes' and the Significant Moment," *Art Bulletin,* 1957, XXXIX, pp. 259–77.

Ducamp, M., *Le Salon de 1859,* Paris, 1859.

Eaton, D.C., *A Handbook of Modern French Sculpture,* New York, 1913.

Eméric-David, T.B., *Recherches sur l'art statuaire considéré chez les Anciens et chez les Modernes,* Paris, 1805.

_____, *Histoire de la sculpture français,* Paris, 1853.

Fontainas, A., and L. Vauxcelles, "La Sculpture," *Histoire générale de l'art francais de la Revolution à nos jours,* Paris, 1922, II, pp. 143–315.

Forrer, L., *Biographical Dictionary of Medallists,* 6 vols., London, 1904–16.

Fourcaud, L. de, "Le Salon de 1884," *Gazette des beaux-arts,* 1884, XXX, pp. 50–63.

Fournel, V., *Les artistes français contemporains,* Tours, 1884.

Frémy, J. N. M., *Notice historique sur les douze statues élévées sur le Pont Louis XVI,* Paris, 1828.

Gabet, C., *Dictionnaire des artistes de l'école française au XIXe siècle,* Paris, 1831.

Gaudibert, P., *La Scultura francese della prima metà dell "800,* I Maestri della Scultura, fasc. no. 98, Milan, 1966.

Gautier, T., *Les Beaux-Arts en Europe,* 2 vols., Paris, 1855–56.

_____, "Salon de 1857," *L'Artiste,* 1857, II, pp. 161–63; 183–85.

_____, "Une visite chez Barbedienne," *L'Artiste,* 1858, IV, pp. 6–8.

Gigoux, J., *Causeries sur les artistes de mon temps,* Paris, 1885.

Gonse, L., *Les chefs-d'oeuvre de l'art au XIX^e siècle: La sculpture et la gravure,* Paris, [1893].

_____, *La Sculpture française depuis le XIV^e siècle,* 2 vols., Paris, 1895.

Grangedor, J., "Le Salon de 1868," *Gazette des beaux-arts,* 1868, XXV, pp. 5–30.

Grate, P., *Deux critiques d'art de l'époque romantique: Gustave Planche et Théophile Thoré.,* Stockholm, 1959.

Gregoire, *Itineraire de l'artiste et de l'étranger dans les églises de Paris, ou l'état des objets d'art commandés depuis 1816 jusqu'à 1830,* Paris, 1833.

Guillaume, E., *Essai sur la théorie du dessin et de quelques parties des arts,* Paris, 1896.

Hamel, M., "Salon de 1887: La Sculpture," *Gazette des beaux-arts,* 1887, XXXVI, pp. 35–56.

_____, "Salon de 1889: La Sculpture," *Gazette des beaux-arts,* 1889, II, pp. 20–26.

Hargrove, J. E., "Carrier-Belleuse, Clésinger, and Dalou: French Nineteenth Century Sculptors," *The Minneapolis Institute of Arts Bulletin,* 1974, LXI, pp. 28–43.

Hauptman, W., "Reviews: *Nineteenth Century Sculpture* by Maurice Rheims; *Nineteenth Century Romantic Bronzes,* by Jeremy Cooper; and *Metamorphoses in Nineteenth Century Sculpture,* ed. by J. L. Wasserman," *The Art Quarterly,* 1978, I, pp. 402–5.

Honour, H., *Romanticism,* New York, 1979.

Horswell, J., *Bronze sculpture of "Les Animaliers": Reference and Price Guide,* Woodbridge, Suffolk, England, 1971.

Houssaye, A., "Salon de 1845, XI, la Sculpture," *L'Artiste,* 1845, IV, pp. 1–5.

Houssaye, H., "L'Antiquité au Salon de 1868," *L'Artiste,* 1868, XV, pp. 307–32.

Hubert, G., *Les Sculpteurs italiens en France sous la revolution, l'empire et la restauration, 1790–1830,* Paris, 1964.

_____, *La Sculpture dans l'Italie Napoléonienne,* Paris, 1964.

Jamot, P., "Les Salons de 1897: La Sculpture," *La revue de l'art ancien et moderne,* 1897, I, pp. 143–54.

Janin, J., "Salon de 1839: Sculpture," *L'Artiste,* 1839, II, pp. 301–11.

_____, "Le Salon de 1840," *L'Artiste,* 1840, V, pp. 269–81.

Janson, H. W., "Observations on Nudity in Neoclassical Art," *Stil und Uberlieferung in der Kunst des Abendlandes* (Acts of the 21st International Congress for Art History in Bonn, 1964), Berlin, 1967, pp. 198–207.

_____, "Rediscovering Nineteenth Century Sculpture," *The Art Quarterly,* 1974, XXXVI, no. 4, pp. 411–14.

_____, *Nineteenth Century Sculpture Rediscovered,* Mellon Lectures, National Gallery of Art, 1974.

Jahyer, F., *Salon de 1866,* Paris, 1866.

Jouin, H., *David d'Angers,* 2 vols., Paris, 1878.

_____, "Salon de 1883: La Sculpture," *Gazette des beaux-arts,* XXVIII, pp. 59–76.

_____, *La Sculpture aux Salons de 1881, 1882, 1883, et à l'Exposition Nationale de 1883,* Paris, 1884.

_____, "La Sculpture dans les cimitières de Paris," *Nouvelles archives de l'art français,* 1897, XIII, pp. 97–348.

_____, "Lettres inédits d'artistes français ...du XIXᵉ siècle," *Nouvelles archives de l'art français,* 1900, XVI, pp. 1–388.

Kjellberg, P., *Le Guide des statues de Paris,* Paris, 1973.

Krauss, R. E., *Passages in Modern Sculpture,* New York, 1977.

Lafenestre, G., *Le Salon de 1889,* Paris, 1889.

La Fizelière, A. de, *Exposition National, Salon de 1850–1851,* Paris, 1851.

Lagrange, L., "Salon de 1861," *Gazette des beaux-arts,* 1861, XI, pp. 145–71.

_____, "Salon de 1864," *Gazette des beaux-arts,* 1864, XVII, pp. 5–44.

Lami, S., *Dictionnaire des sculpteurs de l'école française au dix-neuvième siècle,* 4 vols., Paris, 1914–21.

Lapauze, H., *Histoire de l'Académie de France à Rome,* 2 vols., Paris, 1924.

Larroumet, G., *L'Art et l'Etat en France,* Paris, 1895.

Laubriet, P., "Balzac et la Sculpture," *Gazette des beaux-arts,* 1961, LVII, pp. 331–58.

Lausanne, Switzerland, Galerie des Arts Décoratifs, *Les Animaliers du XIXᵉ siècle,* exh. cat., 1973.

Le Clère, M., *Cimitières et sculptures de Paris,* Paris, 1978.

Lemoine-Molimard, M. F., "Le décor extérieur du Nouveau Louvre sous Napoléon III: La Série des 'Hommes illustrés,' " *La revue du Louvre et des musées de France,* 1978, XXVIII, pp. 374–79.

Lengyel, A., *Les sculpteurs français du XIXᵉ siècle dans les collections des Etats-Unis,* Ph.D. diss.,Université de Paris, Faculté des Lettres et Sciences Humaines, 2 vols. 1964.

Le Normand, A. and A. Pingeot, "Atlantes et cariatides à Paris," *Revue de l'art,* 1979, pp. 67–69.

Lenormant, C., *Les artistes contemporains, les salons de 1831 et 1833,* Paris, 1833.

Licht, F., *Sculpture: 19th & 20th Centuries,* London, 1967.

Lievre, P., "Petits portraits sculptés de l'époque romantique," *La Revue de l'art,* LXVII, 1935, pp. 107–16.

London, The Royal Academy and the Victoria and Albert Museum, *The Age of Neo-Classicism,* exh. cat., 1972.

London, Hayward Gallery, *Pioneers of Modern Sculpture,* exh. cat. by A. E. Elsen, 1973.

London, Heim Gallery, *Forgotten French Art from the First to Second Empire,* exh. cat., 1978.

Lostelot, A. de, "La Sculpture au Salon de 1882," *Gazette des beaux-arts,* 1882, XXVI, pp. 497–507.

_____, "Salon de 1886," *Gazette des beaux-arts,* 1886, XXXIV, pp. 17–34.

Louisville, Kentucky, J. B. Speed Art Museum, *Nineteenth Century French Sculpture: Monuments for the Middle Class,* exh. cat. by R. Butler Mirolli and J. van Nimmen, 1971.

Mackay, J., *The Animaliers: A Collector's Guide to Animal Sculptors of the 19th and 20th Centuries,* New York, 1973.

_____, *The Dictionary of Western Sculptors in Bronze,* Suffolk, England, 1977.

Maltese, C., *La Scultura dell "800 in Europa,* I Maestri della Scultura, fasc. no. 108, Milan, 1966.

Malitourne, P., "La Sculpture en 1847," *L'Artiste,* 1847, IX, pp. 170–73.

Mantz, P., "Salon de 1859," *Gazette des beaux-arts,* 1859, II, pp. 129–41, 193–208, 271–99, 350–71.

_____, "Les envois des pensionnaires de Rome: Les concours," *Gazette des beaux-arts,* 1861, XI, pp. 462–67.

_____, "Salon de 1863," *Gazette des beaux-arts,* 1863, XV, pp. 32–64.

_____, "Salon de 1867," *Gazette des beaux-arts,* 1867, XXII, pp. 512–48.

_____, "Salon de 1869," *Gazette des beaux-arts,* 1869, II, pp. 5–23.

_____, "Salon de 1872," *Gazette des beaux-arts,* 1872, XVI, pp. 33–66.

Marmottan, P., *Les statues de Paris,* Paris, 1886.

Martin, J., *Nos Peintres et Sculpteurs, Graveurs, Dessinateurs: Portraits et biographies, suivis d'une notice sur les salons français depuis 1673, les sociétés des beaux-arts, la propriété artistique, etc.,* Paris, 1897.

Metman, B., "La petite sculpture d'édition au XIXᵉ siècle," unpublished thesis, Paris, 1944.

_____, "Le théâtre de la vie à l'époque romantique," *Art et industrie,* 1948, no. 13, pp. 39–41.

Michel, A., "Exposition Universelle de 1889: Sculpture," *Gazette des beaux-arts,* 1889, II, pp. 57–66, 281–309, 389–406.

_____, "La Sculpture en France de 1850 à nos jours," *Histoire de l'art,* Paris, 1926, VIII.

Millard, C. W., "Sculpture and Theory in Nineteenth Century France," *The Journal of Aesthetics and Art Criticism,* 1975, XXIV, no. 1, pp. 15–20.

Montifaud, M. de, "Salon de 1867: Sculpture," *L'Artiste,* 1867, XIII, pp. 272–78.

_____, "La Sculpture à l'Exposition Universelle," *L'Artiste,* 1867, XIII, pp. 347–55.

_____, "Salon de 1868: La Sculpture," *L'Artiste,* 1868, XVI, pp. 56–64.

Newhall, B., "Photosculpture," *Image,* 1958, VII, pp. 100–105.

New York, M. Knoedler and Co., *The French Bronze 1500 to 1800,* exh. cat., intro. by F. J. B. Watson, 1968.

New York, Shepherd Gallery Associates, *Western European Bronzes of the Nineteenth Century: A Survey,* exh. cat. by R. Kashey and M. L. H. Reymert, 1973.

Novotny, F., *Painting and Sculpture in Europe, 1780–1880,* Harmondsworth, England, 1971.

Ottawa, National Gallery of Canada, *The Other Nineteenth Century: Paintings and Sculpture in the Collection of Mr. and Mrs. Joseph M. Tanenbaum,* exh. cat., ed. L. d'Argencourt and D. Druick, 1978.

Ottin, *Méthode en Sculpture,* Paris, 1864.

Paris, Musée des arts décoratifs, *Le Décor de la vie a l'époque romantique,* exh. cat., 1930.

Paris, Palais de Toyko, "Atlantes et Cariatides de Paris sous le Second Empire et la Troisième République," *Le Petit Journal des Grandes Expositions,* 1978, no. 71.

Paris, Hôtel de la Monnaie, *Images de Jeanne d'Arc,* 1979.

Pauli, G., *Die Kunst der Klassizismus und der Romantik,* Berlin, 1925.

Peladan, J., "L'Esthétique au Salon de 1883," *L'Artiste,* 1883, II, pp. 8–47.

Pessard, G., *Statuomanie parisienne: étude critique sur l'abus des statues,* Paris, 1912.

Philadelphia Museum of Art, *The Second Empire: Art in France under Napoleon III,* exh. cat., 1978.

Pierron, S., *La Sculpture en Belgique 1830–1930,* Brussels, 1932.

Pinedo, *Bronzes d'art,* [1896].

Planche, G., *Portraits d'artistes: Peintres et sculpteurs,* 2 vols., Paris, 1853.

_____, *Etudes sur l'école française,* 2 vols., Paris, 1855.

Polzer, J., "Rodin and Carpeaux," *Information de l'histoire de l'art,* 1971, XVI, pp. 214–24.

Pradel, P., *La Sculpture au XIXe Siècle au Musée du Louvre,* Paris, n. d.

Rayet, O., "La Sculpture au Salon," *Gazette des beaux-arts,* 1880, XXI, pp. 534–53.

Réau, L., *Les Sculpteurs français en Italie,* Paris, 1945.

_____, *Histoire du vandalisme, les monuments détruits de l'art français,* 2 vols., Paris, 1959.

Rheims, M., *La Sculpture au XIXe siècle,* Paris, 1972.

Rodin, A., *Les Cathédrals de France,* Paris, 1950.

Romdhal, A. L., "Notes sur la sculpture française de la Néo-Renaissance," *From the Collection of the Ny Carlsberg Glyptotek,* vol. III, 1942.

Rousseau et Lassalle, *Les principaux monuments funéraires du Père-Lachaise et autres cimitières de Paris,* Paris, n. d.

Roux, A., "La chapelle de la famille d'Orléans à Dreux et ses monuments funéraires," *Gazette des beaux-arts,* 1920, II, pp. 189–94.

Saint-Victor, P. de, "La Sculpture en 1878," *L'Artiste,* 1878, XXXVIII, pp. 221–27.

Salmson, J., *Entre deux coups de ciseau, souvenirs d'un sculpteur,* Paris, 1892.

Schneider, M. *Denkmäler für Künstler in Frankreich: Ein Thema der Auftragsplastik im 19 Jahrhundert,* Friedberg, inaugural diss., 1977.

Schneider, R., *L'Esthétique classique chez Quatremère de Quincy 1805–1825,* Paris, 1910.

Schommer, P., *L'art décoratif au temps du Romanticisme,* Paris, 1928.

Scott, N., "Politics on a pedestal," *Art Journal,* Spring 1979, XXXVIII, no. 3, pp. 190–96.

Seigneur, M. du, *Art et artistes au Salon de 1880,* Paris, 1880.

Selz, J., *Modern Sculpture, Origins and Evolution,* New York, 1963.

Shirley, D., "Rodin, Carpeaux, Cabanel: Excesses of Sentimentality and Melodramatics," *Arts,* May 1868, XLII, pp. 50–51.

Silvestre, T., *Les Artistes français,* Paris, 1878.

Strachan, W. J., *Towards Sculpture: Drawings and Maquettes from Rodin to Oldenburg,* Boulder and London, 1976.

Tabarant, A., *La vie artistique au temps de Baudelaire,* Paris, 1942.

Taft, L., *Modern Tendencies in Sculpture,* Chicago, 1917.

Tancock, J. L., *The Sculpture of Auguste Rodin,* Philadelphia, 1976.

Thiébaut, *Liste des principaux bronzes executés par la maison Thiébaut,* Paris, 1893.

Thieme, U. and F. Becker, *Allgemeines Lexikon der Bildenden Künstler von der Antike bis zur Gegenwart,* 37 vols., Leipzig, 1907–50.

Thoré, T., *Salons de T. Thoré, 1844, 1845, 1846, 1847, 1848,* Paris, 1868.

Timbal, C., "La sculpture au Salon," *Gazette des beaux-arts,* 1877, XV, pp. 529–46.; XVI, pp. 30–47.

Vaisse, P., "Charles Blanc et la musée des copies (1873)," *Zeitschrift für Kunstgeschichte,* 1976, XXXIX, pp. 54–66.

Van Dycke, J. S., *Modern French Masters,* New York, 1896.

Veyrat, G., *Les statues de l'Hôtel de Ville,* Paris, 1892.

Vitry, P., "Liste des bustes d'artistes commandés pour la grande galerie et les salles de peinture du Louvre," *Bulletin de la société de l'histoire de l'art français,* 1930, II, pp. 137–45.

_____, *La Sculpture classique de Jean Goujon à Rodin,* Paris, 1934.

Wennberg, B., *French and Scandinavian Sculpture in the Nineteenth-Century,* Stockholm, 1978.

Yriarte, C., "Salon de 1876: Sculpture," *Gazette des beaux-arts,* 1876, XIV, pp. 121–37.

Los Angeles County Museum of Art